She Changed the Nation

POLITICS AND CULTURE IN
MODERN AMERICA

Series Editors: Keisha N. Blain, Margot Canaday,
Matthew Lassiter, Stephen Pitti, Thomas J. Sugrue

Volumes in the series narrate and analyze political and
social change in the broadest dimensions from 1865 to
the present, including ideas about the ways people have
sought and wielded power in the public sphere and the
language and institutions of politics at all levels—local,
national, and transnational. The series is motivated by
a desire to reverse the fragmentation of modern U.S.
history and to encourage synthetic perspectives on
social movements and the state, on gender, race, and
labor, and on intellectual history and popular culture.

She Changed the Nation

Barbara Jordan's Life and Legacy in Black Politics

Mary Ellen Curtin

PENN

UNIVERSITY OF PENNSYLVANIA PRESS

PHILADELPHIA

Published by
University of Pennsylvania Press
Philadelphia, Pennsylvania 19104-4112
www.pennpress.org

Printed in the United States of America on acid-free paper
10 9 8 7 6 5 4 3 2 1

Hardcover ISBN: 978-1-5128-2580-0
eBook ISBN: 978-1-5128-2581-7

A Cataloging-in-Publication record is
available from the Library of Congress

Dedicated to the memories of Zachary Schnitzer,
Larry Goodwyn, and Raymond Gavins

The hallway of every man's life is paced with pictures; pictures gay and pictures gloomy, all useful, for if we be wise, we can learn from them a richer and braver way to live.

—Sean O'Casey

My opposition to this nomination [of Robert Bork to the US Supreme Court] is really a result of living fifty-one years as a Black American, born in the South, and determined to be heard by the majority community.

—Barbara Jordan, 1987

CONTENTS

A Southern Black Woman Democrat

On the morning of January 10, 1967, hundreds of Black Houstonians rose early and boarded chartered buses destined for the Texas state capitol in Austin. Three hours later, the travelers filed into the senate chamber, took their places with other visitors in the balcony, and waited. Most who came that day were middle aged or older. They were church members and campaign workers, housewives and union members. And when Barbara Jordan, the first Black woman ever elected to the Texas Senate, walked into the chamber, her supporters responded with applause so loud she held her finger to her lips to quiet them. Their enthusiasm, however, paled in comparison to the animated sounds of the crowd on Lyons Avenue in Houston's Fifth Ward on May 8, 1966. On that election night, Jordan had claimed victory in her primary race against a white male opponent, and the streets filled with sounds of "We Shall Overcome." As Barbara Jordan— the main event—approached her campaign headquarters, cars honked, jamming the street, people spilled out to the sidewalk, and onlookers leaned out of upstairs windows. A scream went up: "HERE SHE COMES!"[1] Jordan's electoral victory represented a triumphant civil rights milestone for Houston's Black community, and they showed up on her election night and her swearing-in day seven months later to celebrate.

But there were other, mixed, emotions expressed in Austin on that January morning. When James Stanley, a retired Black teacher, saw Jordan take the oath, he bunched his fist in his coat pocket and cried. He thought of his grandmother, who "carried with her to her grave, on both her soul and her body, the ineffable scars of human slavery," and whose sorrowful prayers had haunted his youth. He thought of more recent times, during segregation, when courageous Black Texans were "beaten with axe handles at the polls." When Stanley looked at Jordan, he imagined generations of struggle, sacrifice, and sheer human

endurance triumphing over racial violence. He saw the past personified and the future unfolding. The new state senator, dressed in a beautifully fitted suit, stood 5 feet, 10 inches tall. As she raised her right hand to be sworn in, Stanley thought, "Grandmother, your prayers are answered. . . . Not only do we vote, we hold office." Texas had entered a new era of interracial democracy where Black woman politicians represented Black interests. In Stanley's eyes, this single, young, African American attorney and politician was "the most beautiful woman in the world" and "a symbol of all Negro womanhood."[2] A victory, a watershed, a blessing, and a harbinger, Barbara Jordan's election to the Texas legislature signaled a shakeup in more ways than one.

Jordan returned to Houston for yet more celebrations, including a photo session with Muhammad Ali, the Black Muslim heavyweight champion labeled as an outspoken, unpatriotic critic of America. While awaiting a Houston court ruling regarding his draft status, the prizewinning boxer, new in town, wanted to meet "an important Negro who has made a name for herself," and Jordan happily obliged. The two were swamped with well-wishers, and for hours signed autographs side by side at a large Black community event.[3] Much of the excitement in Black Houston escaped the notice of the *Houston Chronicle*, which focused on the meaning of Jordan's election for a possible powershift among ruling Democrats in the upcoming legislative session. The liberal *Texas Observer* noted the "strong liberal contingent" in the Texas Senate, adding that "Miss Jordan, who is 30, is expected to add a young strong voice to that bloc."[4] Balancing the varied hopes and expectations of Houston's Black community with the conventions of holding office, while also creating common ground with white liberals to pursue legislation, would not be an easy task.

Over the next twelve years, however, Barbara Jordan pursued a career in Democratic Party politics that succeeded beyond everyone's expectations. After six years as a state senator, she won election to Congress in 1972, becoming the first Black woman from the South to enter that chamber. Spurred on by the momentum of the civil rights and Black power movements, Jordan joined a new generation of Black political leaders in Washington, DC, all determined to use federal power as a vehicle for social change.[5] Jordan and her colleagues embraced the Democrats as a party that championed civil rights, help for the poor, equal opportunity, rights for labor, and sexual equality. Refusing to cede patriotism to conservatives, Jordan used the power of her platform to argue that the liberal ideals of equality for all, inclusion, and justice best expressed

real American values. When Jordan first won office, many in the Democratic Party—still rife with old segregationists and southern conservatives—refused any bold challenges to the status quo. But four years after coming to Washington, DC, and ten years after her first electoral win, Jordan stood in Madison Square Garden before a cheering crowd of thousands, and a television audience of millions, as she delivered the keynote address to the 1976 Democratic Party convention. For most of the party's history, she told the cheering crowd, it would have been "most unusual" for a Black woman to be leading the faithful. "And yet tonight, here I am."[6]

When she heard Jordan's speech, Donna Brazile, who later became the first African American woman to chair the Democratic National Committee (DNC), felt inspired by how Jordan told "our story" to the nation, and she began to imagine herself running a presidential campaign. Watching the convention from her family's home in New Orleans, the teenager felt uncertain about her future. But when she heard Barbara Jordan say sentences such as, "We (the Democrats) are attempting to fulfill our national purpose, to create and sustain a society in which all of us are equal," the point of politics came alive. "Barbara Jordan just woke me up," she recalled, and "I suddenly got very clear about my life and goals, and I saw Louisiana politics as a means to an end."[7] Brazile, and millions of others, felt persuaded that government could become a meaningful instrument to achieve the common good and that a southern Black woman Democrat could lead the way.

Race and the Democrats

Barbara Jordan's reference to the Democratic Party's past reluctance to accept a Black woman as a party leader understated the central paradox of American democracy, which was that a political system ostensibly dedicated to individual rights and equality denied representation to so many on the basis of race and sex. After emancipation, southern Black voters loyally supported the Republicans, the party responsible for new constitutional amendments guaranteeing racial equality, but through violence and lack of enforcement of federal law, the Democratic Party emerged as the sole political party in much of the South, and it used its power to preserve and promote white supremacy by means of disfranchisement and segregation. It was an oppressive, and often violent, force.[8] Southern Democrats wanted to keep Black voters not only out of the party,

but out of politics altogether. As recently as 1960 not a single Black legislator served in the South, and at a local level, the Democratic party still often served to repress Black rights.[9]

Today African American voters, politicians, and operatives are deeply embedded in the structure of the Democratic Party, and the origins of their party loyalty is usually attributed largely to the work and legacy of one towering political figure: Franklin D. Roosevelt. According to Nancy Weiss's foundational study, *Farewell to the Party of Lincoln,* Black migrants to northern cities appreciated the president's willingness to use federal power to promote equality. But even before Roosevelt issued Executive Order 8802 (banning racial discrimination in war-related work), according to Weiss, the commitment of Eleanor Roosevelt to justice, the New Deal agenda of labor rights, and other urban reforms led Black voters to move their support from the Republicans "overwhelmingly to the Democratic column."[10] Black activism during World War II prompted a partial reckoning on race in the party. At their 1948 convention the Democrats, by a close vote, adopted a civil rights plank, and Democratic party organizations, called "machines," allowed more opportunities for Black politicians.[11] Such gestures, however, could not conceal the party's deep divisions regarding race. Segregation was still the law of the land, and conservative southerners in congress remained vigorous proponents of states' rights, not federal power.

During the civil rights movement, attitudes of many powerful Democrats shifted sympathetically toward the cause of racial justice, and yet time and again, liberal Democrats walked away from promises made to Black Americans. President John F. Kennedy enjoyed widespread Black support, but his appointment of ardent segregationists to the federal bench, such as William Harold Cox of Mississippi, frustrated and angered the civil rights community. After Kennedy's death, the party failed again in the eyes of Mississippi activists when the 1964 Democratic convention in Atlantic City rejected the Mississippi Freedom Democratic Party's (MFDP) bid for official recognition. Activists Bob Moses and Fannie Lou Hamer, sickened by the murders of Mickey Schwerner, James Chaney, and Andrew Goodman during Freedom Summer, and disgusted by the behind-the-scenes dealmaking at the convention, lost faith in conventional politics and politicians. Such sentiments were powerfully articulated by Malcolm X, who warned Black Americans, in his 1964 speech "The Ballot or the Bullet," not to trust a party full of white racists. Even passage of the 1964 Civil Rights Act and the 1965 Voting Rights Act failed to change the Democrats' immediate prospects

in the South. Third party movements, such as the Black Panthers in rural Black Alabama, often appealed to Black voters. Stokely Carmichael and other Black power activists posed key questions: How could the party that had orchestrated generations of violence to end Reconstruction, uphold segregation, and institutionalize white supremacy possibly be redeemed? And even if it could, why should Black southerners join it?[12]

Civil rights leaders, including Martin Luther King Jr., had pushed for the movement to ally with the Democrats because the party had the power to pass necessary civil rights legislation. He also wanted to bring those alliances at the federal level down to the nitty-gritty of statewide and local politics. In his influential 1965 essay, "From Protest to Politics," King's advisor Bayard Rustin urged that the movement turn away from nonviolent direct action and toward electoral politics and the Democratic Party, "where the only meaningful primary contests in the South are fought." Rustin argued that if the social and economic conditions of Black people were to improve, Blacks had to step into the fray and engage with local party politics. He urged Black activists to seek allies and join a "coalition of progressive forces" to "broaden our social vision and develop functional programs with concrete objectives." Many in the antiwar movement felt betrayed by Rustin's plan and refused to believe that the party led by a president committed to carnage in Vietnam could be a vehicle for social change. Yet Rustin remained convinced that organized labor, religious groups, and the liberals who had supported the 1963 March on Washington, together with Black voters, could build an effective coalition that would become a political majority.[13]

In theory, Rustin's essay made sense, especially in light of the 1965 Voting Rights Act, which offered federal protection to new Black voters in the South. But putting his theory into practice involved far more challenges than even Rustin, a seasoned activist, anticipated. Of course, racist attitudes remained a roadblock for any coalition, but the problems went deeper. Rustin failed to comprehend the suspicions Black voters harbored against their "natural" allies—white liberals and labor—or the difficulty Black candidates would encounter as they sought to attract white votes. He failed to appreciate that, in the South, the political system had long been designed to derail Black candidates unable to compete in enormous "at-large" districts or in "runoffs" where Black voters would always comprise a minority. Aside from overcoming a system that for decades had been rife with racist rules, there were other practical considerations. How would inexperienced Black candidates raise money, gain endorsements, and run

campaigns? How could they persuade Black voters to come out to the polls? And, once elected, how could they be effective if they still comprised a minority in legislative bodies? Rustin never laid out a blueprint for any of these challenges or considered the competing interests within the coalition he envisioned. In a system where proportional representation was unknown, and candidates needed a majority to win, could groups of social actors who had little history of working together and whose interests often collided find a way to unite?

That exact question is central to understanding the context of Barbara Jordan's political origins and her significance. For some time, scholars have focused on how the civil rights movement transformed southern politics by ushering in a realignment of the party system and a rebirth of the Republican party as a conservative institution.[14] Nixon strategist and political scientist Kevin Phillips famously said "the secret of politics is knowing who hates who" and predicted the shift of so called "Negrophobe whites" to the Republicans as part of his "southern strategy" to win votes for conservatives.[15] And yet, this focus on understanding the behavior of white voters who left the Democrats has prevented an understanding of those white voters who remained, along with the new Black voters who joined. Barbara Jordan's success as a politician demonstrates an individual Black woman's triumph over enormous odds, for certain, but her larger achievement exists as an inspiring practitioner of coalition politics and a mobilizer of Black women campaigners. A feminist and a progressive legislator, Jordan sought to forge a lasting relationship between Black voters and the Democrats. Through nonviolent direct action and new federal laws, the civil rights movement cracked open the door to Black political participation in the South, but it took Black politicians such as Jordan to break down the gates and introduce the practice of multi-racial democracy. Could the Democratic Party be the instrument to make the inclusive and egalitarian ideals of the civil rights movement real? Jordan thought so, and she inspired a new generation of voters to think so as well.[16]

Electoral Activism

For the most part Jordan has not been perceived as a key figure in the civil rights movement because she took the path of electoral politics. But a close analysis of her career shows, first, that Jordan did engage with local activism and with the

Houston NAACP, and second, that her campaigns for office were part of a wider strategy for advancing civil rights and Black interests. Jordan's turn to politics should be seen as part of a larger movement among Black activists throughout the nation to create new space within the Democratic Party for Black voters and progressive allies. During the 1960s and 1970s, Black activists in many cities took aim at those entrenched within the Democratic machine, some of whom were Black politicians.[17] Practicing what historian Matthew Countryman called "electoral activism," the Black People's Unity Movement (BPUM) of Philadelphia, for example, urged Black voters to take back the political process. "Let the politicians know that we demand representation," one candidate urged his audience. "Right now, the leaders do not consult the people in the community on anything. They just vote the party line."[18] Further examples of Black urban voters in major cities who swept aside incumbent Democrats include the 1967 mayoral victories of Carl Stokes in Cleveland, Ohio, and Richard Hatcher in Gary, Indiana. Shirley Chisholm, who had worked tirelessly for the Democratic Party in New York, became one of its most vocal critics after her election to the New York State Assembly in 1965. Refusing to be "bossed," Chisholm galvanized a grassroots movement to become the first Black woman elected to the US House of Representatives in 1968.[19] Black electoral activists in the North criticized the terrible living conditions of poor urban dwellers largely ignored by machine Democratic Party bosses. They pushed the party to address poverty and racial discrimination and give local Black residents more power over their lives.

The history of violence, segregation, and disfranchisement by the Democratic Party in the South created a political dynamic that made the emergence of Black politicians almost unthinkable. Yet Julian Bond, the director of communications for the Student Nonviolent Coordinating Committee (SNCC), challenged the status quo in 1965 when he won a seat in the Georgia legislature. Fellow SNCC activist Dave Dennis explained, "We were using the idea of running as an organizing tool. It wasn't a surprise that Julian ran. Running black people was part of this."[20] Bond and other SNCC workers believed that the next logical step for the freedom movement was not just to register voters but to win elections. Other Black candidates ran against Bond in his primary race, but Black voters in Atlanta flocked to the young SNCC leader because a vote for Bond was a vote for the movement's quest to gain political power. Black candidates in other southern cities began to join the fray. The disappointment felt by the MFDP after failing to be fully recognized by the Democratic party in Atlantic city in

1964 turned into determination as members of the group, including Fannie Lou Hamer, pursued political office in Mississippi.[21]

In Texas, Jordan built on a tradition of Black voting in Houston that had been revived in the 1940s. Her family minister, the NAACP leader Rev. Albert A. Lucas of Good Hope Missionary Baptist Church, joined forces with Thurgood Marshall and local labor leaders to challenge the state law that excluded Black voters from the Democratic primary elections. Good Hope members raised money and sponsored an NAACP membership campaign on behalf of the effort. Reverend Lucas even provided Marshall with a plaintiff, Good Hope church member Dr. Lonnie Smith, who had been denied a ballot to vote in a primary election. The Supreme Court's 1944 *Smith v. Allwright* decision ended the "white primary" and enabled Black Texans to become registered Democrats and vote in key primary races. Although the case has been compared to *Brown* (1954, 1955) and called a "significant landmark victory in the litigative effort to win black equality and freedom," *Smith* left the apparatus of segregation intact.[22] Nevertheless, by allowing Black voters to participate in Democratic primary elections, *Smith* opened the door to a new era in Black political power.

"Electoral activism" is associated with northern cities, but southern urban activists used the strategy as well, particularly in Texas, where labor unions, white liberals, Blacks, and Latinos created new political alliances known as "the Democratic coalition." In his pathbreaking study, *Blue Texas*, historian Max Krochmal has documented how this multiethnic civil rights movement used both voting and nonviolent direct action to challenge segregation, racism, and economic inequality. In local and statewide races, and through referendums, the Democratic coalition gave Black and Brown Democrats new opportunities to challenge conservative control of the party. The movement experienced some internal clashes and disappointments, but throughout the 1950s and 1960s, it pushed the civil rights agenda in Texas forward.[23]

Jordan gained valuable organizing experience working with the Democratic coalition during the 1960 Kennedy presidential campaign. She was sent out to organize block workers, and fellow volunteers observed how her orations inspired others to act: "She would go to a church, and make one of those speeches, and we'd have volunteers running out of there . . . people volunteering to be registration clerks. The results were phenomenal."[24] For the next six years, Jordan organized voter registration drives, served as the Houston director of a statewide campaign to end the poll tax, and worked to revive the local

chapter of the NAACP. She also joined liberal Democrats to challenge conservative control of the Texas Democratic Party. John Connally, for example, was an early nemesis. The Black press reported on Jordan's travels to numerous cities, North and South, where, as a newly elected state senator, she spoke alongside Rev. Martin Luther King Jr.[25] She joined other Black politicians and activists, including Coretta Scott King and Julian Bond, to formulate new political strategies. Along with US Congressman Charles Diggs and Black power leader Amiri Baraka, Jordan attended the 1972 Black Political Convention in Gary, Indiana. Jordan has been celebrated in Texas as an individual woman with unique local achievements, yet even before she went to Washington, she was part of a larger, national Black and progressive campaign of electoral activism.

It should never be forgotten, however, that Black leaders such as Jordan owed their rise to the ordinary Black men and women who took up the task of not just voting, but political education and party-building. Their daily efforts represented the beating heart of electoral activism in Houston. Black women, and a small number of white women supporters, played key roles in Jordan's electoral army, which needed political strategists, dedicated party workers, block workers, fundraisers, and institution-builders. Their largely unsung role behind the scenes in Jordan's campaigns is a concrete example of those whom historian Martha S. Jones identified as the "vanguard" of forward-thinking electoral politics.[26] The work of these women in Houston to support Jordan and other Democrats anticipated the crucial work that Black women provided to the party in the years to follow, and today. Studies of segregation have shown Black women at the core of institution building in their communities during segregation, and Jordan's candidacies as well as her inspiring oratory drew more Black women into the new, essential work of party-building for the Democrats.

Race and Class in Houston

Jordan's story begins in Houston, Texas, the city that served as her cultural and political wellspring. Racial repression, slavery, and support for the Confederacy made Texas an unlikely home for a Black voting-rights revolution. After the Civil War, Black Texans experienced some of the worst violence in the South, with one historian estimating that in the first three years of freedom, 1 percent of the Black male population between fifteen and forty-nine years of age were murdered.[27]

Union soldiers brought news of slavery's demise, but the press insisted that emancipation would not happen "for at least ten years."[28] Black sharecropping families lacked political power and suffered the whims of white landholders.[29] Courageous African Americans joined the Republican party and served in the Texas legislature in the post–Civil War era, and even established state-funded public schools in Houston, but they could not maintain their status.[30] When Democrats swept the local elections in 1874, Black political power in Houston city government ended. North of Houston in Grimes County, a violent 1900 coup by the "White Man's Party" overthrew a coalition of Black Republicans and white populists, fueling a large exodus of Blacks citizens from the area.[31]

A growing number of segregation laws entrenched white political power, and elites grew singularly determined to exclude Black Texans from politics completely. In 1911 the famous Black educator Booker T. Washington traveled from Tuskegee, Alabama, to Austin, Texas, to promote Black institution-building and Christian character, but he met resistance and jeers. "Capitol Not for Negroes: Texan Lawmakers Boo-Hoo Resolution to Let Booker T. Washington Speak," proclaimed a newspaper headline.[32] Barring Washington from setting foot in the halls of the legislature represented what historian John W. Cell called "the crux of segregation . . . the monopoly by the dominant group over the political institutions of the state."[33] Segregationists grudgingly allowed some Black southerners to become teachers, small business owners, and ministers, but not politicians. Political power was "not for Negroes."

Such bold efforts to suppress the Black vote sometimes can lead to the mistaken assumption that political conflicts in Texas amounted only to Black interests versus white, but class also shaped the political divide in Jordan's hometown of Houston. Harvard professor and political scientist V. O. Key pioneered the use of quantitative analysis to understand elections in his native Texas, yet as he concluded in 1949, "politics generally comes down, over the long run, to a conflict between those who have and those who have less."[34] In Houston, wealthy white elites controlled banking, as well as the construction, oil, and gas industries, but they still relied on a growing Black and white working class whose unions were becoming increasingly politicized. During the 1930s, these labor interests had pledged support to Roosevelt and the national Democratic party and posed challenges to the power of the white business class. In the late 1950s and 1960s, Senator Ralph Yarborough epitomized the white liberal, pro Roosevelt politicians who pledged to fight for the interests of ordinary working

families.[35] In the 1960s, his adherents would try to build a coalition with Black and Latino voters, and Black candidates, including Jordan, but segregation, culture, and self-interests were powerful obstacles to unity among these groups.

And although racial segregation fostered a Black community, class differences shaped Black life in Houston as well. Houston, with its port and manufacturing, developed a strong economy, and rural Blacks from Louisiana and East Texas flocked to the "Bayou city" for industrial jobs and community. Born in 1936, Jordan—the daughter and granddaughter of migrants and a child of the urban South—grew up in a largely Black, solidly working-class neighborhood. Cocooned and nurtured within Houston's busy urban neighborhoods and its Black churches and schools, Jordan had relatives, teachers, and role models who encouraged her to develop her voice, pursue higher education, and envision a bold future for herself as a lawyer. Jordan grew up in a Black community proud of its traditions of organized labor, education, nightlife, Black enterprise, and women-led civic organizations. Segregation fostered strong Black institutions, race pride, and solidarity.

But segregation also sharpened divisions, worsened poverty, and created fear. Houston's Black business community, for example, criticized protest and nonviolent direct action, and expressed skepticism when they perceived Black activists were engaged in a struggle without hope of victory. They knew that Texas was still a one-party state, and that conservative Democrats dominated the party. They knew that white elites ran the city's police, real estate interests, local schoolboard, universities, banks, corporations, as well as its major newspapers. They saw Houston's powerful white business community put the brakes on racial change to control its outcome. Federal funding for the War on Poverty, for example, was carefully overseen by Houston's white businessmen, who shut down grassroots efforts to lead city projects for the poor.[36] Houston's Black businessmen and Black elites saw where power resided, and it was not with idealistic liberals. They favored forging alliances with conservative business leaders and building up Black institutions, and they donated money to white conservatives, including John Connally. Some were suspicious of integration.[37]

Jordan respected her elders, but as a Black leader she rejected their strategy. After her election to the state senate in 1966, she urged a gathering of the well-connected at a Houston banquet to embrace the changing times: "For those of you who say, 'give me the simple life,' there is no simple life. We are in the midst of change. Change is a constant factor. We must deal with our situation

as it is and not wish for a less complicated one. . . . 'We shall overcome' is a nice song, but we will overcome only when all men recognize they have a stake in the future."[38] Jordan witnessed how segregation isolated, discouraged, demeaned, and even divided Black Houstonians. Houston's example suggests that strong Black institutions alone did not guarantee a robust or united response to segregation.[39] The Black male race leaders in Houston who had navigated the waters of segregation were perhaps not the best fit for leading the next wave of attack. For political change to happen, new leadership had to emerge.

Why Biography

Biography can be criticized for overemphasizing how one individual shaped events, but common sense dictates that people walk among us who possess great goals and extraordinary ambition. They push themselves to overcome obstacles, and their talents, as well as favorable circumstances, give them the tools to do so. Without descending into a "Great Woman" theory of history as an explanatory model, this study argues that Jordan's traits, talents, and personal life help to explain her success in politics. It also suggests that understanding the people who influenced Jordan, and the broader culture in which she lived, allows for a more thoughtful probing of her political contributions as well as her life story. What motivated this young Black woman to go to law school and then engage in activism and politics? What did she care about? What sustained her? Whom did she love? How did she create safe places and a private life for herself while under the relentless scrutiny of the press and the pressures of public life? How can biography shed light on her approach to politics and her talents as an orator and leader?

A mix of personal motives, the broader movement for racial justice, and the local context of Texas politics, led Jordan to pursue elected office. Her speeches, autobiography, and personal interviews all reveal her anger and outrage at the injustice of segregation and widespread assumptions of white superiority. Traveling across the country as a champion college debater gave her confidence and a window into the world. Living in Boston for three years as a law student in the late 1950s introduced her to the radical ideas of minister Howard Thurman and the youthful optimism of Massachusetts senator John F. Kennedy. These and other local and outside influences combined to lead Jordan toward electoral

activism after her return to Houston. But Jordan wanted to do more than run—she wanted to win. She abhorred the institution of marriage and valued economic self-sufficiency. She wanted to live a free, independent life, and ambition to succeed at whatever she did was deeply ingrained in her character. Politics suited Jordan's competitive, spirited temperament as well as her cause.

Jordan's deeply religious upbringing centered on the Black church, an institution that shaped her culture, family life, personality, and her style of public speaking. Numerous patterns of references and expressions—gained from the osmosis of a lifetime of Sunday mornings listening in churches—as well as her own public speaking throughout her young adulthood—anchored her speeches. Colleagues and listeners often commented that her deep, distinctive voice made Jordan sound like God, but that was only partially true.[40] Jordan's ringing authority also rested on the structure of speaking used by effective ministers. When King scholar Richard Lischer, author of *The Preacher King*, suggested that civil rights leader Martin Luther King Jr. "sounded" like the Bible, he meant that King did not leave room for equivocation when he presented his message for justice. King's speeches are well known for using metaphors to cement an idea—the "iron feet of oppression," the "daybreak of freedom and justice"—but he, like Jordan, also often used tried and tested rhetorical devices such as synonymia, the repetition of analogous or similar words, in order to push home a point. In his 1963 eulogy "Martyred Children in Birmingham," for example, King memorably stated, "We must be concerned not merely about who murdered them, but about the system, the way of life, the philosophy which produced the murderers." As Lischer notes, "A truly *public* orator like King does not present shaded options but clear choices whose mode of presentation leaves no room for indecision. These antitheses do not *suggest* a truth, they nail it down. In doing so they echo a biblical 'sound' with which most of his audiences would have been familiar."[41] So too with Jordan. Traditions deep within her Black church and community schooled her in what audiences expected and appreciated from a speaker.

She spoke largely on political subjects, but with the power and certainty of a minister with a moral message. When she called for the impeachment of Richard Nixon in the summer of 1974 in a televised primetime address by stating, "I am not going to sit here and be an idle spectator to the diminution, the subversion, the destruction, of the Constitution," millions of Americans watching at home latched on to the moral authority and decisive tone that Jordan brought to her statement. At the start of the hearings, she was a little-known first year

representative from Texas, but by evening's end, Jordan had become one of the most famous politicians in the nation.⁴² As a Black woman representative, Jordan symbolized a certain moral authority, but the structure and construction of her brief speech, including her use of synonymia and other rhetorical devices, made it persuasive and meaningful.

Jordan gained great personal satisfaction from stirring a crowd with her words. In addition to speeches she made on committees and on the floor of the House of Representatives, Jordan spoke to an astonishing range of audiences— white and Black, convention-sized and intimate, gatherings of the party faithful and adversaries on television. She appeared on talk shows, news programs, and telethon fundraisers. Halls filled with members of largely white labor unions or Black journalists or feminists all rose in applause. The larger the venue, the better. United States senator Bill Bradley had played professional basketball at Madison Square Garden with the New York Knicks, but the thought of giving a speech in that arena made him freeze.⁴³ Not Jordan. The relationship she shared with an audience made her feel in control, free, and alive, like a walker on a tightrope. "I surrender to the pleasure of being on the wire," stated the man who walked between the World Trade Center Towers, Philippe Petit. "To me, it's the safest place on earth."⁴⁴ Cultural forces, experience, brilliance, and practice help to explain Jordan's excellence at public speaking, but culture and family dynamics give some insight as to why she felt drawn to do it from the time she was young.

This book is primarily about Jordan's role as a public figure, but it also explores the tension that existed between her desire to be an effective politician and her need for privacy. Frequently called aloof and impenetrable, Jordan could certainly be cool and deliberate. As a child of segregation, she learned early the importance of emotional control, and that trait proved crucial to her efficacy as a politician, as well as her emotional survival in a hostile world. She freely admitted she worked hard to keep a lid on her anger and that she often suppressed her feelings.⁴⁵ And yet, although she subdued her emotions in certain settings, in a host of others she did not. Barbara Jordan enjoyed life. She socialized and she traveled. She loved to ride her bike, sing, relax with a drink, joke with friends, and play the guitar. Jordan did not keep a personal diary, but oral histories, photographs, private correspondence, the Black press, first-person accounts, as well as her autobiography reveal a warm, intimate side of Jordan as a child, a teen, a college student, a young lawyer, an aspiring politician, a teacher, and an adult.⁴⁶ She loved being in charge—a leader. She loved winning. From

high school forward she was busy and engaged with friends, school, family, and community. She was a woman of emotional depth and complexity. She had a circle of trusted family and friends, and one of the most important people in that group was her partner, Nancy Earl.

Jordan's lesbian relationship with Nancy Earl—a white woman who worked in psychological testing services for the University of Texas at Austin—has long been an open secret.[47] The two women met in Austin, lived together for a time in the nation's capital, and then built a house that they shared in the Onion Creek neighborhood in south Austin. They hosted large parties at their home and attended events together both in Austin and Washington, DC. Devoted to Jordan, Earl was a trusted confidant and occasional speechwriter. She worked in the congresswoman's DC office for a time and organized Jordan's personal schedule. She often accompanied Jordan when she traveled, including to New York City in 1976. Earl's presence in Jordan's life is woven into her 1979 autobiography, *Barbara Jordan: A Self-Portrait,* and the two women lived together in Austin until Jordan's death in 1996. Jordan's committed relationship with Nancy Earl was public enough, and apparent, to many friends and colleagues.

Without more evidence from Jordan herself, however, any answers to questions concerning how she perceived her sexual identity and orientation, how it influenced her decisions, or about other relationships remain speculative. What term, if any, she would use today to describe her relationship with Earl also remains unknown.[48] The facts of Jordan's personal life will always be subject to interpretation, and this study seeks to begin a conversation rather than end it. Evidence suggests that knowing she had a supportive, loving partner and community to turn to helped Jordan cope with the relentless pressure of public life and numerous health challenges that included multiple sclerosis. As a Black woman who worked in overwhelmingly white spaces and in the public eye, Jordan lived with racism, sexism, ableism, and homophobia every day, but she rarely discussed how these issues affected her personally. It appears that Jordan's decision not to volunteer discussion of any aspect of her private life arose from a deep need to create and sustain spaces where she could, in her words, feel nurtured and "safe."[49]

Similar, although not identical, tensions and ambiguities permeated Jordan's refusal to discuss her health and disability. Mary Beth Rogers, a Democratic Party activist who had worked with Texas governor Ann Richards and who knew Jordan at the University of Texas, published a biography that contributed

essential new information about the congresswoman's health and private life.[50] Significantly, Rogers documented that Jordan experienced symptoms of multiple sclerosis during her first year in Congress and that she kept her illness a secret. Using information provided by Jordan's physician and others in her circle, Rogers presented a humane, up-close account of Jordan's struggles with illness and disability. But in emphasizing Jordan's stoicism, Rogers also characterized the congresswoman as "self-contained" and as uninterested in, if not incapable of, intimacy, sexual relations, or love. She also dismissed the suggestion that Jordan was a lesbian.[51] At the time of her death, Jordan's closest friends and allies were still seeking to protect the congresswoman's privacy. But Rogers's account of Jordan's personal life, including the emotional capacities and needs of people with disabilities, must be reconsidered.

Jordan's refusal to discuss her health and her love life was certainly the norm for politicians at the time. Studies of John F. Kennedy's illnesses, for example, as well as FDR's struggle to hide his paralysis brought on by polio, reveal how the stigma of chronic illness disqualified individuals from positions of power.[52] Therefore, plenty of people surrounding these well-known figures were committed to keeping their "open secrets." The same was true for Jordan. During her last months in Washington, Jordan used canes to assist her mobility and soon afterward, a wheelchair. But Jordan's obfuscation and denial about her illness, even after she could no longer mask her symptoms and had left Congress, suggests that her denials were not just about politics or power. Like most people who encounter loss because of illness or disability, it took her time to establish her own new criteria for "normal."[53] Once she did, she lived an active and full public life. From 1979 until she died in 1996, Jordan taught at the University of Texas School of Public Affairs and clearly relished her role as a public figure. She spoke at two televised Democratic national conventions, testified before Congress, chaired a commission on immigration, regularly gave invited talks at forums and universities, accepted honors, and traveled the world on official business.

Jordan's approach to public disclosure of private matters raises many important questions about how individuals navigate a hostile world, but it was hardly exceptional. From her own experience as a politician, Jordan realized that much of the aura of public life, paradoxically, rested on secrets and silences. Her white male colleagues in Congress occasionally blundered and sometimes their secrets became public.[54] The secrets Jordan kept included not only her own but also

the behavior of others. Ample evidence shows that, throughout her career, Jordan was subjected to hostile remarks aimed at her sexual identity, her disability, her gender, and her race. Yet when her autobiography, *Barbara Jordan: A Self-Portrait*, came out in 1979, one friend expressed amazement at her silence over what she had endured. "People don't want to hear that stuff," Jordan responded. "Those of us who know, know. I thought that was enough at this time."[55] Despite the silences she enforced around her private life, Jordan deeply felt the emotions related to all her life experiences. And in many instances, Jordan's actions spoke louder than her words.

Black Women Leaders: The "Lost Prophets" of American Democracy

Jordan achieved so many "firsts" in the white male world of politics that it is tempting to place her in a league of her own. Yet to do that obscures the qualities and aspirations that Jordan shared with Black women leaders of the past. Like them, Jordan sought to claim the rights of citizenship—and the fruits of fair governance—for all. "Instinctively I felt that leadership was needed," said Mary McLeod Bethune, founder of the National Council of Negro Women, in a 1940 interview, "someone to inspire and build a program to tell the people something else aside from this very scanty life we were called upon to live."[56] During segregation, Bethune set to work building educational institutions and Black women's organizations, but she viewed inspiring others as central to her task of leadership. Generations of southern Black women similarly felt a call to bring emotional energy, hope, care, and healing to their community-building.[57] Segregation pushed Black voters out of politics, but it could not stop Black women from building institutions and instilling hope for the future. Society prevented them from voting or holding political office, yet these women viewed leadership as an act of purposeful imagination.

Black ministers built churches on the labor of such women. As historian Manning Marable has argued, the rigid, patriarchal hierarchies in the Black church often confined women to "lower-level organizational tasks" in Black political organizations.[58] Sociologist Belinda Robnett depicted Rev. Martin Luther King Jr. as a leader concerned with reinforcing a strong male image; he envisaged women primarily as wives and mothers. In the leadership hierarchy of an organization dominated by ministers, she argued, women were constrained. They

were "often channeled away from formal leadership positions and confined to the informal level of leadership." Septima Clark, for example, who headed the Southern Christian Leadership Council's Citizenship Education Project, recalled that "those men didn't have any faith in women, none whatsoever. They just thought that women were sex symbols and had no contribution to make. That's why Rev. Abernathy would say continuously, 'why is Mrs. Clark on this staff?'"[59] For too long, as historian Christina Greene argues, the Black women who participated in local Black freedom struggles remained "invisible, elusive, or unappreciated."[60]

And yet, as scholars have shown, Black women in the civil rights movement overcame such prejudices and forged new paths of organizing and leadership. "Leaders have been generally defined as those who hold titled positions, have power over members, make decisions on behalf of the organization and are perceived by the public and the state as the leaders," states Robnett. In contrast, she points to the deeds of the unheralded Black women whose work as "bridge leaders" extended and communicated the movement's message to ordinary people. Black women appreciated those who set an example, and inspired initiative. As Mississippi activist Victoria Gray observed, admiration for women leaders such as Ella Baker depended on the "loyalty that [she was] able to elicit" from the people around her.[61] Black women's organizing in the civil rights era offers a more complex, community-based portrait of mobilization. Leaders could come and go, but women's networks remained.

As a Democratic candidate and political leader, Jordan was freed from the constraints of working within the Black church or a male-dominated civil rights organization. She created her own organization that drew upon the energy and commitment of the Black women in her community. They had sought to influence the political process through community activism and voting, but Jordan's emergence gave them the chance to work on behalf of a Black woman candidate, and they became newly inspired. Part of the excitement that Donna Brazile felt after listening to Jordan's convention speech was imagining her as president, and she vowed to work for that dream. "Jordan was my new candidate . . . My little light was shining again. This time more radiantly."[62] Jordan, along with Fannie Lou Hamer and Shirley Chisholm, represented what political scientist and analyst Melissa Harris-Lacewell called the "lost prophets" of American Democracy, Black women politicians who had been overlooked in the nation's excitement over Barack Obama's candidacy and victory.[63] All of them drew on the legacy of

the Black women's organizing traditions to reframe the party's agenda, inspire others, and bring new voters—particularly women—to the Democrats.

By the 1970s, feminism, voting rights legislation, greater educational opportunities, the Black power movement, and a changing media, among other social forces, opened up new avenues for Black women to enter the political arena. In that decade, Black women activists, artists, novelists, political leaders, and others garnered unprecedented national attention. SNCC activist Fannie Lou Hamer cofounded the National Women's Political Caucus, an organization designed to recruit, train, and support women candidates for office. Shirley Chisholm battled the political machine in New York City and captured the nation's attention with her presidential run. Assata Shakur and Angela Davis advocated for Black nationalism and third world liberation struggles, becoming the best-known female political fugitives of the 1970s. The flamboyant, outspoken attorney Flo Kennedy expressed the anger of Black feminists while building new coalitions. Alice Walker, Toni Morrison, and Faith Ringgold brought attention to Black women as writers and artists. All these women, and many more, forged new paths of Black resistance and gave voice to the struggles of Black women.[64] They differed in their political ideologies and approaches but shared a determination to be heard and an insistence on following their own "inner compass"—a phrase Jordan used to describe her decision-making process.

While Jordan was part of the surge of Black women's activism in the 1970s, her pioneering role as a congresswoman put her within the system rather than outside it, and she often positioned herself as the representative of Houston's "tri ethnic" population. Her election, she told *Ebony* magazine, was historic "because it involved a very strong coalition of Blacks, whites, and Mexican-Americans," and she was pleased to be part of the movement toward "better race relations" in Texas. These were not the most radical of words, but to achieve her goals and gain cooperation, Jordan relied on her powers of persuasion. "That's how we do things in the Texas delegation . . . nothing heavy handed, just openness and good relations," she told *Ebony*.[65] Jordan believed that legislation involved skillful engagement with peers, risk-taking, political negotiation, and compromise—skills that democracy, as a form of government, demands.[66] Throughout her entire political life, Jordan grappled with the frustrating puzzle of interracial coalition politics. She sought to balance, rather than meld, the interests of numerous marginalized groups toward a greater purpose. To say she wielded power is an

exaggeration, and yet being put in the unusual position of negotiating directly with white men as an equal, not a subordinate, gave her the opportunity to persuade others to help and support her objectives. Her methods may not have seemed radical, but her goals often were.

In the late nineteenth century, the great orator and abolitionist Frederick Douglass urged Black Americans to support and work for the political party that had crushed the confederacy, declaring "the Republican party is the ship and all else the sea."[67] Douglass knew the faults of the Grand Old Party better than anyone, but understood that as a minority, Black citizens needed the protection of the federal government, and he thought it wise to ally with the party most willing to use that instrument. In the 1960s and 1970s, southern Black voters faced a similar crossroads. They could have stayed home, or they could have joined a third party, but instead, largely because of Black political leadership, they chose the Democrats. For all of its faults, the modern Democratic Party was indeed "the ship" for Yancey Martin, a veteran who headed Black voter outreach during George McGovern's 1972 presidential campaign. "As a man who has been in the Democratic party for a long time," he wrote to a skeptic, "I know for a fact that Blacks have yet to receive their parity in terms of what the Democratic party has given to us as opposed to what we have given to the Democratic party. Yet I along with many of my friends stay with the Democratic party structure and we fight, and we struggle and we organize. . . . We oppose the idea of an all black or third party. We oppose it basically because we see it as a way of keeping us totally out of the political process."[68] White supremacy would not end quickly or easily. And turning America into a multicultural, racially integrated democracy would take a lifetime of what Jordan called "chipping away" at existing power structures. The Black Democrats of the 1970s were underfunded and unappreciated but they understood that electoral politics was the logical next step in the Black freedom struggle.

Barbara Jordan's contribution to the unfolding story of race, civil rights, and modern American politics has remained obscure, yet she was a key figure in moving the Democratic Party away from its racist past toward a more inclusive future. She persuaded audiences with her oratory, creatively reimagining political possibilities to forge fresh alliances with those in power. Tagging Jordan merely as a realist or a conventional politician risks distorting her motives and overlooks the numerous times in her career she challenged the conventional wisdom and pushed against the odds for change and inclusion. Jordan should

be viewed as a strategic idealist rather than a pragmatist, a Black woman who sought to use the power of coalition politics to pursue goals that would benefit the many, not the few. In her determination to be heard by the majority, she pushed the Democratic Party to expand its political base and vision. In a political world dominated by white men, she anticipated the new political strength of Black women and the leveraging power of Black voters.

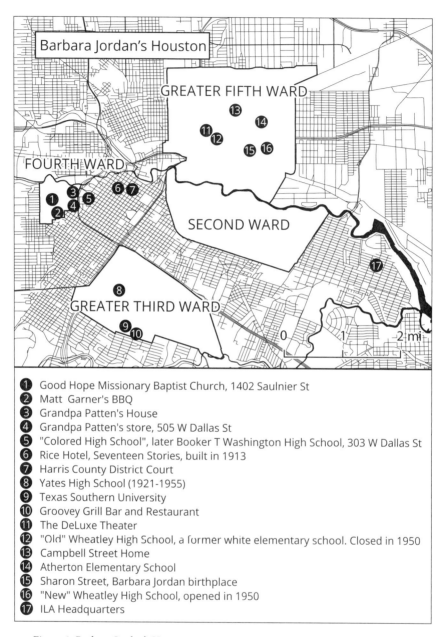

1. Good Hope Missionary Baptist Church, 1402 Saulnier St
2. Matt Garner's BBQ
3. Grandpa Patten's House
4. Grandpa Patten's store, 505 W Dallas St
5. "Colored High School", later Booker T Washington High School, 303 W Dallas St
6. Rice Hotel, Seventeen Stories, built in 1913
7. Harris County District Court
8. Yates High School (1921-1955)
9. Texas Southern University
10. Groovey Grill Bar and Restaurant
11. The DeLuxe Theater
12. "Old" Wheatley High School, a former white elementary school. Closed in 1950
13. Campbell Street Home
14. Atherton Elementary School
15. Sharon Street, Barbara Jordan birthplace
16. "New" Wheatley High School, opened in 1950
17. ILA Headquarters

Figure 1. Barbara Jordan's Houston. American University Geospatial Research Lab.

Figure 2. Barbara Jordan's Texas. American University Geospatial Research Lab.

CHAPTER 1

Origins of a Voice

How did you learn to talk that way? At my grandfather's knee.
 —Shelby Hearon and Barbara Jordan, 1977

Throughout her life, Barbara Jordan's voice attracted attention. The *Houston Post* invoked popular Black singers, calling Jordan's sound "a cross between Sarah Vaughan and Ethel Waters. . . . Each word a polished pebble, chosen for precision to create the right ripple in her pool of rhetoric."[1] Others heard the Black church. She sounded "like God," wrote Molly Ivins; "like the heavens have opened up," agreed Rev. Andrew Young.[2] To her old classmates, Jordan the politician sounded as she always had. In high school, remembered Anna Curtis, "it was what she said and the way that she sounded that would just sort of rivet your attention to her." She was admired. "She could make the menu sound like the Gettysburg address," said Judge Andrew Jefferson, a fellow politician who worked with Jordan on their college yearbook.[3] Yet before she became an attorney, activist, and politician as an adult, and before she became a champion college debater, and even before she recited for her father's congregation as a young teen, Barbara Jordan's voice and personality were shaped by the people closest to her. Her Black family history, her Black culture, and the origins of her unique voice, intertwine.

Barbara Jordan was born and raised in Houston, Texas, a city located along a stream-fed bayou approximately sixty miles inland from the Gulf of Mexico. Established in 1837, shortly after Texas declared its independence from Mexico, Houston began as a trading nexus. Cotton arrived via mule-driven wagons or railroad, and then was transferred to barges that traveled down the twisty waterway to the gulf port city of Galveston. As part of the confederacy, Houston

surged as a place of commerce and military planning during the Civil War, and by 1893 it became the largest cotton-trading city of any interior port in the United States.[4] The discovery of oil in nearby Spindletop in 1901 diversified the economy, bringing oil refining and eventually steel manufacturing to the region. Hughes Tools, which held a monopoly on the rotary bit needed to drill through rock, had its home in Houston, as did many thriving construction businesses and petrochemical companies. Other Texas cities had commerce and industry too, but Houston stood out because its white elites had strong ties to the federal government. During the Great Depression, Houston banker and real estate entrepreneur Jesse Jones controlled federal finances as director of the Reconstruction Finance Corporation (RFC) under both Herbert Hoover and Franklin Roosevelt. Jones—known among insiders as "the fourth branch of government"—ensured the city's fiscal solvency and fostered its growth. Federal dollars deepened the "Turning Basin" in the Houston Ship Channel, dramatically increasing the flow of commercial traffic. By the 1930s, the decade of Jordan's birth, Houston had eclipsed Galveston as a key international port and was home to some of the wealthiest people in the nation.[5]

The city's dynamism attracted immigrants and migrants, and throughout the late nineteenth and early twentieth centuries, families and single men and women from Mexico, Greece, and Italy, as well as Louisiana and rural Texas, streamed into Houston. They sought work, safety, a place to prosper, and a chance to rise. By 1940 the city's Black population grew to 86,000, the second largest in the urban South after New Orleans, and Black residents established a presence in three main residential areas known as wards.[6] Although each of these neighborhoods had its own places of business, schools, and institutions where residents gathered, geographic boundaries were not absolute. Black Houstonians worked in white homes and even sometimes lived and toiled alongside white and immigrant laborers, but they focused their energies on their own families, churches, and institutions. "Black Houston" was not a single place but a culture.

It was commonly understood that these three Black neighborhoods reflected rough class distinctions. The Fifth Ward, located closest to the Ship Channel, was home to Black Houston's industrial working class. Noxious fumes from the nearby oil and chemical plants and the city's sewage vats wafted through its streets, depending on the wind.[7] Semiskilled laborers, who earned two to three dollars a day, and domestic workers lived in tiny wooden homes on unpaved streets, while members of Black unions and a small but growing

professional and business class, including Black ministers, owned larger properties. Working-class wages supported a main commercial artery called Lyons Avenue. Black institutions, including schools, shops, civic clubs, businesses, social organizations, and, eventually, a plethora of jazz and blues clubs, served its residents.[8] The Fourth Ward, known as Freedman's town, had once been the center of Houston's Black life. Located south of the bayou and adjacent to Houston's growing downtown, the Fourth Ward was increasingly overshadowed by white development to the east and the wealthy white River Oaks residential neighborhood to the west. Although it contained residences, small businesses, and Black churches, the Fourth Ward remained the city's oldest and poorest neighborhood. Finally, the Third Ward, located to the south of downtown, was home to Emancipation Park and a fine array of large Victorian style homes. It boasted a diverse Black professional class, the Dowling Street Business district, and a Negro Chamber of Commerce.[9] During much of segregation Houston's Black middle class of ministers and businessmen emerged as the dominant spokesmen for the race, and they supported Booker T. Washington's ethos of economic advancement, accommodation to segregation, and embrace of white paternalism.

This influential group felt a special connection to the Tuskegee leader partly because Houston native Emmett J. Scott, the former editor of the *Texas Freeman*, had become Washington's close advisor and secretary. During Washington's 1911 visit to Houston, Scott returned home to introduce the famous educator to a packed audience. Exceedingly proud of the wealth and property Black businessmen had accumulated, as well as Houston's Carnegie Library and the schools attended by Black children, Scott believed Houston proved the wisdom of Washington's 1895 "Atlanta Compromise" speech. He lauded his home city as a place where "Negroes and the whites have literally seized upon the pregnant passages of his epoch-making Atlanta address. . . . In Texas we practically have no race problem." Scott took pride in his hometown and bathed in what he called "the radiant glory of the golden crown which encircles her imperial brow. No matter where I find myself, I am first of all a Texan!"[10] Scott honored ordinary laborers, but his belief in capitalism and commerce, and a respect for the business community, reflected the aspirations of many Black Houstonians in the early twentieth century, especially new migrants hoping for a prosperous future. Jordan grew up in a working-class family and community that valued those Washingtonian ideals of economic success and self-sufficiency. Both of

her parents strove to achieve more than what they had when they were born. In Houston, segregation was the law, but Black progress seemed possible.

Barbara Jordan was born at home in Houston's Fifth Ward on February 21, 1936. Her parents, Benjamin Jordan and Arlyne Patten Jordan, were the children of migrants who had traveled to Houston from rural communities. Her father, Ben, grew up toiling on a tenant farm in Edna, Jackson County, nearly one hundred miles south of Houston, where life was hard and often brutal. When Ben's younger sister, Carrie, died at age thirteen, her death certificate listed her occupation as "farmer." In 1920 seventeen-year-old Benjamin and his parents Charley and Mary Jordan worked alongside white and Mexican tenants.[11] Consolidation and fluctuating cotton prices, however, forced many sharecropping families in Texas to leave the land. Charley and Mary Jordan moved to Houston.[12] Ben left for Tuskegee to learn blacksmithing, but when he ran out of funds, he withdrew before graduating. Sometime in the early 1920s, Ben joined his parents in Houston where he found work in a warehouse at the Ship Channel. His father Charley drove a truck for a paper company and Ben's mother, Mary, pursued her work as a Baptist missionary. All the Jordans joined Good Hope Missionary Baptist Church, a church located in the downtown Fourth Ward that welcomed the rural poor.[13] It was a momentous decision as for decades to come; Good Hope anchored the lives of all the Jordans, including Barbara.

Good Hope began in the 1870s under a "brush arbor"—an open sided outdoor shelter—located close to the shallow Buffalo Bayou, which connected Houston to Galveston Bay. The church's charismatic founder, Reverend Samuel Grantham, transported goods to and from the bayou with his mule. Good Hope's next leader, Elder Charles Hunt, "rich with the word of God," baptized "long lines of converts" along that same bayou. When Charles and Mary Jordan joined Good Hope, Rev. Henry C. Cashaw, a country-born minister lauded for his "dynamic power," had assumed leadership.[14] Ben Jordan and his father, along with other recent migrants, looked to Reverend Cashaw for guidance, and Good Hope's membership grew.[15] The congregation moved to a building on Saulnier Street in the Fourth Ward, around the corner from the home of young Arlyne Patten and her family. Arlyne's mother, Martha Patten, became close to Reverend Cashaw's daughter Alice Reed (also called "Gar"), an English teacher and Martha helped take care of Reed's daughter, Mamie. Through Reverend Cashaw, the Jordans met the Pattens and the families became close. Two years after Mary Jordan died, widower Charley Jordan, age forty-six, married Alice Reed,

age thirty-five, in her father's home at 4505 Sharon Street in the Fifth Ward. Six months later, on June 16, 1931, Reverend Cashaw performed another marriage in his house. Twenty-six-year-old Benjamin Jordan married Arlyne Patten, age twenty.[16] Benjamin and Charley Jordan had purchased a home on Sharon Street two doors down from Reverend Cashaw, and after the double nuptials the two couples, now both related to Good Hope's minister, moved in together.

Ben and Arlyne quickly started a family. They had three daughters. Rosemary, the eldest, was born in 1932; Bennie, the middle girl, in 1934; and Barbara, the youngest, in 1936. Money and space were tight in the two-bedroom house, and for years the three girls slept on a pullout sofa in the living room with Barbara in the middle. Nevertheless, living in segregated Houston was a vast improvement over a weary life of rural want. In fewer than ten years, the Jordan men had moved from tenant farming to paid employment, a home of their own, new marriages, and a respected status within their adopted church. Charley became a deacon and prayer leader at Good Hope. Ben, a talented singer, joined the men's choir and aspired to the ministry. Gar continued to teach, and Arlyne, a young wife, took up the responsibility of raising the three girls and doing the domestic work for both families.

It is not clear how Arlyne felt about being the youngest woman in a household with three older adults, each of whom had strong personalities and paid employment. But by marrying Ben Jordan, she raised herself out of dire poverty. Arlyne's parents, John Ed Patten and Martha Fletcher Patten, had migrated to Houston around 1905 from the small community of Evergreen in San Jacinto County, about one hundred miles north of Houston. At first they lived in a crowded boarding house in the Fourth Ward with at least nine other people, and that is where their oldest daughter, with the unusual name of Phothrie Arlyne (Barbara's mother) was born in 1910. Next came a sister, Johnnie, and then a little brother, Ed, who died when he was only three.[17] By 1910 Arlyne's father John Ed owned his own restaurant on San Felipe Street in the Fourth Ward, but the business failed. When Arlyne met Ben, she lived in a home without electricity or running water, while he had a house and a job. Poverty was common in Black Houston in the 1930s, but the poverty of the Pattens, like many residents in the Fourth Ward, seemed worse because, although adjacent to a downtown lined with skyscrapers, they lived like rural folks.

Yet Arlyne had something Ben would never possess: a formal education and a diploma. Shortly before her marriage, Arlyne had graduated from Houston's

sole Black high school, the "Colored High," whose principal, E. O. Smith, created
a strong academic curriculum in addition to the industrial and domestic educa-
tion designed to train "Negroes" for employment.[18] She had done well at school,
and at Good Hope the teenager commanded immense respect as a superb orator.
Mamie Reed, Gar's daughter and Barbara Jordan's "Aunt Mamie," recalled that
"if Arlyne was going to speak, you knew you were well taken care of. She was
the speaker de luxe." Arlyne specialized in preparing and delivering welcoming
addresses at Baptist conventions. "I wrote those speeches myself," Arlyne told
Shelby Hearon, Jordan's first biographer. "I would search around and read up on
the kind of books that gave examples of the different types of speeches, and then
I would add a little something of my own to it. I liked doing that at the time." "At
the time" meant when she was only in her teens and before her marriage.[19] Arlyne
Patten gained great praise for her orations. "The neighbors told us how good
she was," recalled Jordan's eldest sister, Rosemary. "She was the most eloquent,
articulate person I ever heard. If she had been a man, she would have been a
preacher," proclaimed Mamie Reed.[20] But sex roles mattered in the Black Baptist
church, and sexism added to racism in the secular world meant that Arlyne could
not turn her talents into a profession. During the 1930s, more than 80 percent of
Black women in Houston made their living as domestic servants—regardless of
their education—and Arlyne went to work as a private nurse for a white family.[21]
When she married Ben Jordan, the praise and recognition for her speaking
ended. Now that she was a wife, her husband's ambitions became her own.

But in this era, Black women Baptists like Arlyne carved out new respon-
sibilities for themselves based on their roles as wives and mothers. Although
Black women were not expected to exercise the public leadership of male minis-
ters, they could, as the theologian Anthea Butler suggests, "wield power through
a traditional office in a subversive yet spiritual way."[22] The Women's Convention,
a women-led organization within the Baptist church, introduced what histo-
rian Evelyn Brooks Higginbotham called a "gender dimension" to the Baptist
church's mission of racial uplift. The convention's founder and leader, Nannie
Helen Burroughs, saw mothering as political work. She became widely known
for her passionate defense of the crucial duties performed by Black mothers
in Black homes. Burroughs rallied Black women, urging them to refuse and
resist segregation's demeaning racial and sexual stereotypes. Black children, she
pointed out, were born in homes, not in segregated trains or streetcars. And if
Black mothers provided clean, upright, and devout Christian homes, Burroughs

insisted, their children could thrive in a world of racist onslaughts.[23] Burroughs's eloquence and her charisma moved audiences to tears. These Black Baptist women, with their doctrine of worth and equality, no doubt inspired Arlyne Patten.[24] Envisioning themselves as missionaries not only to their race but to the nation, they sought to redeem America from its racism.[25] Arlyne, the talented speaker, now used her influential voice and intelligence at home.

Thus, Barbara Jordan spent her early childhood on Sharon Street under her mother's close watch. But sometimes, she resisted the rules. Prohibited from going into other people's homes, Jordan still sought out neighborhood friends. She liked to compete, recalling that "in those days, as a child, I had an extreme dedication to playing. There were a couple of kids who lived in the block and we played all the childhood games. . . . Jacks, a great deal of jacks. I liked that, playing hard."[26] She enjoyed the outdoors. In summer Jordan rode her bicycle up and down the sidewalk in front of the house. When she walked on grass, she preferred bare feet, wearing shoes only when it was time to attend Atherton, her neighborhood public elementary school. Jordan's mother, her extended family, and the familiar neighborhood made the little girl feel safe and secure. And unlike other young Black southern girls who lived during the Great Depression, Barbara Jordan and her sisters were not sent out to work in white people's homes.[27]

Everyone in the Jordan household had their place and purpose. Ben, the head of his family, earned $938 a year working at a warehouse on the Houston Ship Channel. Over the years he supplemented his wages by loaning money to co-workers, launching a small business called Your City Soda, and starting his own church. Charley Jordan drove a red truck for the Southwestern Paper Company, and his wife Alice, also called Gar, taught English in a neighboring town. In 1940 these three adults brought home a combined income of less than $1,500 a year.[28] They never took vacations and rarely traveled outside Houston. Their days, their lives, followed routines. During the week the three employed adults went to work, the children went to school, and Arlyne stayed home, cooking, ironing, and washing clothes by hand.

Arlyne's arduous domestic routine filled Barbara's mind, giving her a lesson in gender roles. Washing machines were unknown. On washday Barbara watched her mother orchestrate three tin tubs outside in Houston's searing heat and brutal humidity: "After you had heated the big washtub with a lot of soap and stirred everything with a stick until you had sudsy water, you had bleach water, and you had a tub called bluing. And it took all of my mother's time attending to

these things."[29] Jordan was not sure if this life of relentless labor was for her, but she did not rebel. "I guess I assumed that I would grow up and marry a man like my father and spend all of my time washing and pressing his khakis, washing and pressing the children's clothes, and making sure that my husband had all he wanted to eat when he got home." Arlyne's domestic labors at home lifted the Jordans' status; she worked for her own family, not for another. Her hard work, her neat appearance, and her firm, clear voice set an example. "We were with her all the time," Barbara recalled, "and she was working for us all the time."[30]

The ideals of Baptist motherhood demanded that Arlyne make sure her family dressed well and ate well even on a small budget. Barbara remembered the meals her mother produced on a shoestring, healthy meals full of vegetables and grains, homemade rolls, and fruit pies for dessert, but with very little meat, perhaps reflecting its expense and the healthy diet recommended by the Baptist Women's Convention.[31] Her mother's extraordinary efforts demonstrated that poverty and racism could not keep a family from looking right and behaving properly. Arlyne kept her outside commitments to a minimum. Every other week she sang with the church choir at Good Hope, and then she dedicated the rest of her time to her husband and her children.[32]

Ben and Arlyne shared a commitment to the Baptist creed, and they looked to the power of words—written, spoken, and sung—to establish their place in a changing world. Each had suffered through poverty and the loss of a younger sibling, and both were intelligent, ambitious people who wanted to rise within segregation. But the pressures of work, Ben's domineering manner, and the need to stretch every penny took an emotional toll. For all their ability to orate in church, neither Ben nor Arlyne seemed able to express their emotions at home. Jordan recalled, "I don't remember my parents at this time as ever talking to one another and never sitting down and talking to the children. My father worked all the time at a warehouse and was gone most of the time at night to his singing quartet."[33] Arlyne, too, enjoyed immersing herself into places outside of her home, especially imaginary situations. In the afternoons she listened to radio dramas such as *Stella Dallas* and *Portia Faces Life*, soap operas about women in troubled marriages who sacrificed and faced down adversity. When Barbara came home from school, she cuddled up to listen. "They were just members of my mother's family and I liked that."[34] Even as a child Jordan recognized her mother's loneliness. Barbara and Arlyne were close, but they held their emotions inside, and feelings were left undeveloped and unspoken.

Arlyne's isolated life differed from that of other Black mothers in the Fifth Ward, where an ethos of mutual responsibility reigned. "I grew up under the neighborhood concept," recalled Anna Curtis, "which meant that mother could go to work." Curtis's parents had much less education than Jordan's, and her mother worked full time. But the neighbors watched their comings and goings, and took on the role of overseeing the household until her mother got home. "What did your mother tell you to do?" the neighbors would ask. "Well she told us to sweep the porch and clean the tub." "Have you done that?" Neighborhood women had the right to inquire, to chastise, and even to punish. "If they saw you leaving the yard," Curtis remembered, "They'd say, 'where are you going?' 'I'm going to the store.' 'Did your mother tell you to go to the store?' 'Yes Maam.' You had to SHOW them, you know she gave you fifteen cents. . . . The neighborhood, really helped." In contrast, Ben and Arlyne seemed to have held themselves apart from their neighbors and they both imposed strict Baptist rules to protect their daughters from the outside world.

Barbara Jordan's parents measured their daughters' respectability by their adherence to the Baptist creed. One saying from Jordan's childhood went, "Only one life, it will soon be past; Only what's done for Christ will last."[35] Houston, home to bluesman Lightnin' Hopkins, had a thriving Black popular culture and nightlife, but Ben Jordan wanted to keep his daughters at home or at church. "We called him unusually strict," recalled Rosemary, the eldest. "No movies, no dancing, no nothing."[36] Arlyne approved of these prohibitions as well. The Jordans rejected any secular entertainment and did not allow their girls to attend movies, a ban that shocked Anna Curtis, who grew up spending her Saturdays with friends at the tri-movie theater complex on Lyons Ave. "To be kept from going to a movie for me, would have been like being sentenced to the penitentiary for life," Curtis recalled.[37] Jordan did not appreciate her family's strict rules. When she was a bit older, she heard her father telling a friend that his daughters did not smoke or drink, dance, play cards, or go to the movies, and she cringed, thinking, "How could he go around bragging about the fact that he has three freaks."[38] But Ben was boasting about his family's ability to adhere to the demanding and difficult expectations of the Baptist faith. To him and to Arlyne, the words of their creed gave essential life guidance.

In the Jordan home pleasure came from singing and music. With Bennie at her side, Grandmother Gar played gospel tunes on the family's upright piano, and in the Sharon Street home, everyone sang together. Gar's daughter, known to

the family as Aunt Mamie, was a formally trained musician and Ben envisioned his three daughters would follow in those footsteps and become music teachers. For most of her girlhood, Jordan took piano lessons and later she learned to play the guitar. Like Marian Anderson, she sang in a wonderful contralto voice that her Aunt Mamie remembered fondly. Gar's enthusiastic "thumping away" at the piano brought joy into the home, and Aunt Mamie gave vocal lessons to all three of the Jordan girls. "I was a diction specialist and I insisted on that with them . . . you've got to be able to paint a picture to whomever you're singing."[39] It was Mamie Reed who taught Barbara Jordan that performers did not just vocalize— they communicated.

When she was young, Jordan gladly accepted her family's routines, and the most important event of the week happened on Sunday. On that day the two families rose early and ate breakfast together. Grandfather Jordan and Ben led a prayer and read scripture aloud by the stove. Arlyne wore an elegant suit with a matching feathered hat, handkerchief, and gloves, and the girls had their hair pressed with special oil. When all was ready, they drove in two cars to Good Hope. After attending morning services, the Jordans shared a meal with Arlyne's parents, rested, and then returned to church for more prayers and meetings. That old neighborhood was where Arlyne had been raised in poverty, where Ben and his father, Charley, had arrived as rural migrants, and where Ben and Arlyne had met. Traveling from the Fifth Ward to the Fourth was a short distance, but a long, metaphorical journey back into the Jordan and Patten past and Black Houston's origins. Nevertheless, new ideas and forces began to enter young Barbara Jordan's cocooned world. She began to spend Sunday afternoons with her mother's unconventional father, her grandpa Patten. And when she attended morning church with her family, she observed the tensions between the old and the new in Black Houston.

After the beloved Reverend Cashaw died in 1935, a new pastor brought energy, optimism, and an unorthodox preaching style to Good Hope. Rev. Albert A. Lucas, a Texas native with a divinity degree from Conroe College, had previously headed Baptist congregations in Galveston and Waco and served as the elected treasurer of the National Baptist Convention. An experienced minister with a formal education, Lucas and his wife, Rena—known as "the money-raising queen"—took charge of the leaderless, indebted congregation with enthusiasm. He launched a fundraising campaign. Within a few years, Lucas transformed Good Hope's old church into a neighborhood community center

with a baby clinic and erected a new stone church that held nearly two thousand people. Good Hope's tower dominated the city block on Saulnier Street.[40] Lucas wanted to build big, but he respected the church's past. When Barbara Jordan and her family took their seats on Sunday morning, they saw a large portrait of Reverend Cashaw hanging behind the pulpit. As relatives of the late minister, they sat in preferred spots in the front rows, while Reverend Cashaw's mentee and son-in-law, chief deacon Charley Jordan, greeted the attendees and took his place facing the congregation.

The service officially began when Jordan's grandfather delivered the opening prayer, an event she remembered vividly: "He gave it out in words and the congregation repeated it in singing. 'I love the Lord, he heard my cry,' my grandfather would say, and then the congregation would pick it up."[41] As prayers went back and forth between the leader and the congregation, her grandfather's emotions escalated, and Jordan watched as he fell to his knees, shouting, and moving around on the floor. "When he was winding up his prayer, he would ask Jesus to ride for us. He'd say, 'Ride on!' And then he would list all the places he wanted Jesus to ride. Ride in the streets, and ride in the homes, and ride in the schools. 'Ride on Jesus!' he would be on his knees in front of that church, and it just seemed to me that if Jesus failed to ride he would be doing us a disservice."[42] Although she saw how her grandfather's devout evocation stirred strong emotions in the congregation, which expected and appreciated his fervent, moral message, even as a child Barbara Jordan could not respect this emotional, dramatic method of prayer.

Then Reverend Lucas spoke. A stern, tall preacher, Lucas had encountered some trouble gaining the acceptance of the congregation. According to a church history, when he first arrived at Good Hope, Lucas preached "a series of sermons that required much thinking," and "many expressions were made about his inability to preach."[43] But the old and the new learned from each other. As president of Houston's local chapter of the National Association for the Advancement of Colored People (NAACP), Lucas began to bring a measure of political awareness to his ministry, and he found ways to deliver his message. For example, strict Baptists agreed that moviegoing was sinful, so Lucas told his congregation that sitting in the upstairs seats in a segregated movie theater was doubly degrading. "Don't do it," Reverend Lucas said. "Don't take the back steps to hell." Good Hope librarian Sara Scarbrough called him a crusader. Lucas, she said, was "dynamic, forceful. You were learning something

from him." Lucas had plenty of political ideas, but gaining the congregation's trust took time.

No one doubted he believed deeply in the Baptist creed. Jordan remembered the church's tremendous reactions as Lucas preached and described the suffering of Christ dying on the cross. "The congregation would scream and shout. They might say 'Jesus,' they might say 'hallelujah,' they might say, 'Lord help me!' But they would shout and it was very loud."[44] Sara Scarbrough saw Lucas as a skilled, yet sincere, preacher. He balanced the emotions of the congregation with his own. "Some of those old people really touched him," she recalled. "He could really get you caught up in the emotion of the thing, but he would get caught up in it too but not enough where he would lose control. . . . But these people would lose control, and boy they would be hollering and screaming, and when that happened, Reverend Lucas would give a laugh, hahaha, he would give a little laugh, and then he would stop, he would calm down, and he would go back to that straight talk."[45] Lucas blended the holy, the heart, and the head, and he led the Good Hope congregation for nearly thirty years, until his death in 1963. Jordan heard him preach on countless Sundays and saw how a minister could both stir and quiet a congregation, as well as educate them by explaining something new. When her own father was called to the ministry, Jordan expressed skepticism, because in her view only Reverend Lucas was qualified to preach.[46] To her, Lucas represented an early model of a Black leader and orator, and Jordan respected him immensely.

Much as she respected Lucas, however, Jordan loved her maternal grandfather John Ed Patten, who sought out a connection with his youngest granddaughter soon after her birth: "My mother tells me that she could leave me with him as a baby and I wouldn't whimper, that there was just no problem with that. So that attachment was formed at the beginning."[47] Jordan's middle name was Charline, a form derived from her deacon grandfather Charley, but she could not hide which grandfather she preferred: "This grandfather was so jealous of my relationship with my Grandpa Patten he could hardly stand it. He'd come up to me with: 'You like your grandfather Patten better than you like me?' Of course I did not answer that."[48] Throughout her life, Jordan had John Ed Patten's picture in her wallet, while he rewrote her name as "Barbara Edine"—after himself—on the back of the photo of her he carried. Unlike the pious deacon Jordan, John Ed Patten refused to attend church. And instead of working for someone else, he operated a junkyard alongside his home in Houston's old Fourth Ward.

His unconventional independence spoke to Barbara, and while she was young he claimed her and sought to mold her.

On the surface their relationship seemed simple. After the family finished the midday meal on Sunday afternoon, Barbara's sisters and parents returned to Good Hope while she remained at the junkyard to work with Grandpa Patten. During the week, John Ed hitched two mules to his wagon and traveled around town collecting castoff clothes, old newspapers, wire, and scrap metal.[49] On Sundays Barbara helped him sort out, tie up, and stack the rags, metal, and paper. He used a large scale with a hook to weigh his wares, and she wrote down the amounts. Then after "Old Man Moses," another junkman, came by in his truck and bought what he wanted with cash, Jordan counted the money and kept it for them in her own money belt. The entire experience remained a treasured memory. "I was his bank. And I tell you, it would be a great wad. Because we had a successful business. We had that."[50] This work made Jordan feel special, and she contrasted her willingness to "put on old clothes and get down in the horse manure" with the piety and primness of her sisters. She felt proud of her grandfather and not the last bit bothered by his poverty or smelly junkyard. "Other people said my grandfather was eccentric," but Jordan disagreed. She recognized that he "felt himself quite different, just a little cut above the ordinary man, Black or white." Grandpa Patten's independent stance in life made being different acceptable, even valuable, to Jordan. He constantly told her not to worry about what other people said or did. She needed to "trot her own horse." [51]

A keen understanding of her own needs seems to have propelled Jordan toward her Grandpa Patten and the attention he offered. At times she too had been made to feel like an outsider. Jordan had heard that her father, Ben, had reacted to her birth negatively, saying, "Why is she so dark?"[52] In a school performance, at the age of six, Jordan was assigned to play a maid, and it remained a troubling memory. "My mother went on a bus to J.C. Penney to buy my outfit . . . a blue maid's uniform with little white cuffs on it." Even at the time, Jordan later stated, she questioned this demeaning depiction. "I thought: Why would this little elementary school, all black, have presented a play with a maid? That struck me as ironic."[53] That Jordan could express the injustice of such a personally hurtful situation speaks to her sensitivity and intelligence, but, except in the eyes of her Grandpa Patten, she seemed to be in the background. She poignantly recalled, "In those early years it was certainly the case that he was the only one who talked to me."[54] And perhaps John Ed would have said the same about her.

Eager for attention and ready to listen, Jordan became close to her Grandpa
Patten. Despite her grandfather's rejection of conformity and organized religion,
he had a need to teach, and Jordan became his rapt pupil.

The young girl often wondered why her Grandpa Patten was so different
from the other adults in her life. There seemed to be some mystery about him.
He talked to her about his own father, who he said had been a lawyer in Wash-
ington, DC, which confused her: "I didn't know about that, what that meant, but
it all sounded just fine."[55] Arlyne told her that John Ed had once owned a café,
and then a confectionary store, and that the ventures had failed because he was
too generous with credit.[56] Something else whispered about his past alarmed
her. "I heard at one point that he'd been to prison. Not from my mother and
father, no. But that's what I say; I just pick up these little things from various
people. I heard that he'd killed a white man, but I also know that back then he
couldn't have killed a white man and lived. Now we know that. That would have
been the end of him and I never would have known my grandfather."[57] Jordan
never knew for certain whether her grandfather Patten had been to prison until
she agreed to write a book about her life.

At that point she discovered some grim and harsh facts about John Ed
Patten's past. Born in 1879 in Evergreen, Texas, San Jacinto County, John Ed had
an older brother, Steve, who died in an accident at a blacksmith shop. The family
sold the lad's corpse to medical students in Galveston. Heartbroken, a teen-aged
John Ed came to Houston on his own. By 1905 he opened a grocery store on San
Felipe Street, the main east–west commercial street in the downtown Fourth
Ward, which later became West Dallas Avenue. He married and had a family;
his oldest daughter, Arlyne, was born in 1910, then another daughter, Johnnie,
and then a son, Ed. The life of the Patten family in Houston's poor Fourth Ward
hardly resembled the racist-free panacea praised by Emmett Scott. White police
regularly abused the locals, randomly arresting women for prostitution and
men for petty gambling. "This is a sheer waste of time always to be dragging
the negroes into court charged with shooting a nickel," one judge declared. Few
Black citizens, no matter how respectable, could escape police harassment, with
one Black minister declaring that he feared the police far more than he did any
"highwayman."[58]

John Ed Patten weathered increased violence in the Fourth Ward during
what became known as the 1917 Houston Race Riot. Black soldiers stationed
at nearby Camp Logan rebelled after police detained a Black serviceman who

had protested a segregated streetcar. Believing their comrade had been abused and killed, outraged soldiers at Camp Logan—who had long endured racist incidents involving the Houston police—took to the streets. They fought the lawmen through the streets of the Fourth Ward, where Black residents were "cheering them on and hollering. 'This is what we call a man!'" For two hours police battled the Black soldiers, and when it all ended by 11 PM on August 23, 1917, four Black soldiers were dead, and fifteen white men, including four police officers and two soldiers, had been killed.[59]

Fear of a Black uprising took hold in Houston that night. White mobs looted hardware stores and pawnshops, taking guns and whatever ammunition they could carry. A crowd of a thousand assembled in front of a police station armed with "shotguns, rifles, and pistols." Men and women "rushed pell mell here and there," shouting, "The negroes are coming; clear the way."[60] The Fourth Ward was sealed off, and troops surrounded the San Felipe district where John Ed and his family lived. "By nightfall they had rounded up 138 black suspects."[61] Two weeks after the riot, Houston police shot and killed two black residents.[62] NAACP investigators from New York recorded eyewitness testimony from Black residents who complained that Houston police had kicked suspects in the head, beating them and shooting them. One Black man in the Fourth Ward told NAACP investigator Martha Gruening, "There's been a lot of dirty work here. I've seen three more colored men beat up without any cause by the police since the riot. There's a lot more I could say, only I'm afeard."[63] Any Black soldier who took part was arrested and then court-martialed. On the morning of December 11, 1917, thirteen Black soldiers court-martialed for their involvement in the mutiny were secretly executed by hanging in San Antonio, Texas. The Black-owned *Cleveland Gazette* condemned the deaths as "the South's 'Pound of Flesh.'"[64]

A few months later, John Ed Patten had his own tragic encounter with the Houston police. On May 6, 1918, a man entered Patten's candy store, took some money or merchandise from the counter, and ran. John Ed grabbed his gun. Shouting, he followed the suspect into a crowded bar. Then, on the street, the confused shop owner was suddenly confronted by two white police officers. John Ed testified that "I heard someone say, 'catch that nigger; he has got a gun' and as I turned somebody was shooting at me, one or two people, and as I got to the corner, I threw up my hands to surrender, and that is the time I got shot through the hand, and that is the time I shot at the officer. . . . I do not remember

shooting . . . I was so excited when they shot my hand I don't know what I did."
Even in 1919, "hands up" meant "don't shoot," but W. J. Riney, a white police
officer only six months on the force, shot directly at John Ed. He testified that
he did so in self-defense. He alleged that John Ed Patten had turned on him and
shouted, "Stop, you white son-of-a bitch," and shot him six times "with the intent
to kill me." However, his partner, Officer Hight, admitted that he was too far
away to confirm Riley's account. "I am stouter," Hight testified. "I knew I could
not outrun him. He was a Negro, and I knew from my experience that I could
not outrun one of them. I did not see who fired the first shot. I fired two shots
myself. I fired two shots and the darky was running." John Ed Patten's attor-
ney denied his client ever shot the officer, explaining: "This court ought to judi-
cially know from records appealed from Harris County, Texas, that the police of
Houston, when a Negro runs from them, immediately begin shooting."[65] When
he was arrested and jailed, John Ed's hand was bleeding profusely. A few days
later a grand jury charged shop owner Patten, the victim, with attempted mur-
der of a police officer.

John Ed had a trial, but fear of the police silenced those who might have
helped him. Two eyewitnesses sitting in the courtroom both admitted they saw
the two officers fire first at John Ed, but in separate affidavits each stated that
he "did not want to be subpoenaed as a witness, and did not wish to incur the
ill will of the police department."[66] Much to Patten's distress, his first attorney
failed to call either man. In his charge to the jury, the judge failed to give the
option of finding Patten guilty of attempted manslaughter, a considerably lesser
charge than attempted murder, which implied premeditation. The jury swiftly
convicted him of attempted murder, and the judge sentenced him to ten years in
the Texas penitentiary. Suddenly, John Ed Patten—a peaceable, struggling small
Black businessman and a father with three children—became a convicted felon
on his way to prison.

Friends rallied, and fellow shop owners raised $5,000 for John Ed Patten's
bail, an astonishing amount of money for that time. He hired a different attorney,
J. M. Gibson, a white lawyer who lived and worked in the Fourth Ward. Gibson
filed a motion for a new trial and appealed directly to the Court of Criminal
Appeals in Austin. He charged that John Ed was the victim of racism, pure and
simple. Gibson claimed that "the jury in rendering their verdict was actuated by
race prejudice and passion, which the average white men hold against negroes."
Gibson claimed that the district attorney inflamed "prejudice and passion" in his

argument when he "repeatedly urged a severe sentence because the negro had shot at a white officer," ignoring the evidence that John Ed did not know the men chasing him were the police.[67] Patten had a reprieve for several months while he was out on bail, but he lost his appeal.[68] On February 12, 1919, nine months after the incident, John Ed Patten was sent to Ramsey State Prison Farm, south of Houston in Brazoria County, to begin his sentence. On his prison papers, his sole identifying mark was a bullet hole: "shot through left hand at thumb."[69]

He entered one of the most corrupt, cruel, and racist prison systems in the nation, a gulag of thirteen state-run prison farms stretching over thirty miles west and forty miles south from Houston.[70] Slaves who had grown sugar and cotton were replaced by convicts who worked on the state-owned farms. Prison plantations produced nearly one million dollars in sugar cane, cotton, and other agricultural products every year. State wardens disciplined and beat prisoners with a whip known as a "bat"—a leather strap two and half inches wide and two feet long, attached to a wooden handle.[71] Forced to wear stripes, prisoners were shackled together by chains threaded through brace collars around their necks. Torture was routine.[72] Younger men incarcerated with John Ed died in prison.[73]

John Ed's dreams of independence and economic success now turned to an unrelenting struggle to survive. For six years he worked on state-owned sugar and cotton plantations, all located along the Brazos River. After beginning his sentence at Ramsey State Farm, John Ed went to Blue Ridge in Fort Bend, back to Brazoria County, and Darrington Prison (all comprised of African American prisoners), and then to Retrieve prison farm, also in Brazoria, before returning to Ramsey State Farm to finish his sentence.[74] John Ed was thirty-nine years old when he was incarcerated, and forty-six when he was released in 1925, but he survived.

Scholars have credited the tradition of the Texas prison work song, or what Black convicts called "river songs," as a key to understanding the prison experience, and the tradition of such songs can illuminate how an older prisoner could survive such brutal conditions. In hoeing and farmwork, as folklorist Bruce Jackson documented, field songs regulated a rhythmed pace of labor. River songs were not sung as laments or, primarily, to express emotions. They served a life-saving function because they paced the speed of work and kept men from being singled out and punished for laziness. But neither were these just rote songs. Lead singers incorporated minute observations of the landscape and the white men on horseback who ruled over them into the lyrics. John Ed's time in Texas

prison overlapped with that of a more famous counterpart, Huddie Ledbetter, also called "Leadbelly," who later gained acclaim as well as some notoriety for his prison past. Ledbetter spent years calling out as a "pace-setter" on the sugar plantations, but all Texas prisoners used their voices to keep to the pace and rhythm of the work. They sang river songs to survive.

Like other Black prisoners, John Ed Patten used his voice every day, to direct others, keep stride, retain his sanity, and stay alive. John Ed may or may not have been familiar with gang labor as a youth, but years on a Texas prison farm immersed him in the rhythms of the Texas work song. Bruce Jackson noted that many of the songs kept to a "long meter"—eight syllables—which contributed to the slow, steady pace. Long meter is also a pace used in sung hymns. At such a pace John Ed would have spoken the songs loudly and slowly.[75] In the 1950s and 1960s, work songs at the Ramsey and Retrieve plantation/prison farms, two of the four places where John Ed Patten had been incarcerated, were recorded. "I'm Chopping in the New Ground," "Let Your Hammer Ring," and "Go Down Hannah" are just a few of the collective songs whose rhythmic pauses between lines left time for a man to raise and lower his hoe or axe. It is no exaggeration to surmise, as Professor Jackson states, "that a man who could not sing and keep rhythm might die." One poignant recorded song men used to chop trees, sever cane, or hoe a field in unison includes the lyrics: "Back is weak and I done get tired /yeah, yeah, yeah, yeah / Got to tighten up just to save my hide / yeah, yeah, yeah, yeah."[76] According to his prison record, during his last year in prison John Ed was a "trusty," a prisoner given some responsibility over other men, and the benefits of that position also may have contributed to his survival.[77]

John Ed Patten's release came suddenly, from a higher power.[78] The state's first woman governor, Miriam "Ma" Ferguson, a Democrat elected in 1924 with the support of Black voters across Texas, issued hundreds of pardons, and John Ed Patten came home to Houston on July 17, 1925. He had served a total of eight years and two months. His family welcomed him, but they had suffered too. His youngest son, Ed, a three-year-old toddler, had died in Houston on May 12, 1919.[79] His wife, Martha Patten, had kept the confectionary store open for a while, but soon moved to smaller quarters near Good Hope, where she became a devout church member. His daughter, Arlyne, stayed in school but was fifteen when he returned home. It could not have been easy for her to be known as the daughter of a convicted felon, so it is little wonder that years later she held

herself slightly apart from her Fifth Ward neighbors and relied on the safety of the supportive environment at Good Hope.

John Ed had no one to talk to about his past, but he came to love his smallest, youngest, granddaughter, Barbara. There was an order, a routine, to their relationship that they followed every week. Of course what John Ed really wanted from Barbara was not her work, but her ear. But "before we talked we had to eat," she remembered fondly. John Ed walked two blocks from his home to Matt Garner's Barbeque, a legendary Houston establishment, to get a paper bag full of "reg'lars."[80] Barbara waited in the house with great anticipation. "These were ends of the beef barbeque, and the ends of the ribs and the ends of sausage, and these would be thrown away," unless her grandfather came to get them, she remembered. Arlyne rarely served meat at home, and Barbara enjoyed this Sunday treat with her Grandpa Patten. It made her feel special and deserving. "The meat all by itself from a brown paper bag. That was the highlight. I remember it as a super time."[81] After eating barbecue, she remembered, "We would talk."

John Ed eschewed church, but he considered himself a preacher, and he interpreted established texts from the lens of his own experiences. He wrote out large sayings in red crayon and put signs out in front of his junkyard that said, "THE LORD IS MY SHEPHERD" or "THE DAY OF WRATH IS COME" and signed them "St. John." When he sat with Barbara, John Ed put on his glasses and read passages that he had marked in red crayon from his Bible and from his "inserts." He called his texts the "Gospel According to St. John." Barbara thought he had written the sayings himself, but no. John Ed Patten distilled complicated ideas into simple language, and he gave his granddaughter short sentences from contemporary writers and theologians to memorize. John Ed's experiences of injustice, cruel dilemmas, racism, and evil could not be explained or justified by the Baptist fundamentalist creed of obedience to God's will. He read passages to her taken from Christian thinkers of the day who sought answers to questions that haunted him.

Given the horrors humans visited on each other, why should we love one another or even care about the world? One of his favorite pamphlets was *The Greatest Thing in the World*, an interpretation of St. Paul's "Message on Love" by the Scottish geologist, theologian, and evangelist Henry Drummond.[82] Drummond argued that Paul embraced action over piety. Love was "the greatest" quality, superior to faith and hope, for two key reasons. First, since God loved man, it was logical that people must love each other. And second, love was

superior to faith and hope because to truly love, Drummond taught, a person had to act and participate in the "stream of life." Unlike knowledge, which faded, love was a relationship with God and with the world that lasted, it endured. John Ed made Jordan memorize a passage from the work, which she recited for Shelby Hearon. "Just remember the world is not a playground, but a school room. Life is not a holiday but an education. One eternal lesson for us all: to teach us how better we should love."[83]

John Ed did not ask Barbara to think about her personal salvation. Instead he asked her to ponder bigger questions. How can an individual lead a moral life in an immoral society? Why should a person be an optimist? As Jordan remembered it, their conversations frequently focused on how to understand the world so that one could decide how to act in it, how to love. Barbara listened intently as he simplified the concepts. "He would read about the life of Christ. And I could understand Jesus and God better from my grandfather talking than from the church." John Ed talked about Jesus as someone who had undergone tremendous hardship, sacrifice, and suffering on behalf of people, which meant everyone had to be worthy of that sacrifice. "He was also saying you couldn't trust the world out there. You couldn't trust them, so you had to figure things out for yourself. But you had to love humanity, even if you couldn't trust it. That's what he said the message of Jesus is." Jordan associated this wisdom with her grandfather, but the source of his aphorism on trust was G. K. Chesterton's 1908 book *Orthodoxy*.[84]

Together, John Ed and Barbara read aloud verses from the Bible and sang hymns. One song, taken from a Methodist hymnal, urged Christians to take the "narrow way," which meant making difficult choices and following your own path.[85] Following the prescribed rules did not make a person a Christian. The message of Jesus, according to Grandpa Patten, was "Don't get sidetracked and be like everybody else. Do what you're going to do on the basis of your own ingenuity." Grandpa Patten's overwhelming message, she remembered, "was self-sufficiency and independence." Churchgoing was not important; following the crowd was not important; even obeying rules was not important. What Jesus cared about was how you lived your life and whether you loved.[86]

And God? God, according to Grandpa Patten, was neither a kindly paternal figure nor a punishing force. Instead, God was simply power, "the power that controls us all."[87] And everyone was subject to God's power, regardless of race. Grandpa Patten's understanding of God's power shaped his evenhanded, rational

response to life's unfairness and cruelty. In the eyes of his granddaughter, it also accounted for the lack of deference he showed to local, white authorities. Jordan remembered, "The city health authorities were always out there telling him these mules and the rags and the paper and the scrap iron and the manure were an eyesore. The inspectors would come and say, 'Clean this up,' and he was never cowed by those people at all . . . white people . . . and he would just say, 'I'll clean it up.'" She noted that he made the junkyard "presentable," but simply kept an even tone and refused to show deference.[88]

Despite John Ed Patten's brutal suffering in prison, his humanity remained intact. His lessons to his granddaughter emphasized the Godlike nature of her own possibility. His protofeminism was rooted in his disdain for authority, and he advised her, at various times, "Never marry," "Look at your mother," "Don't take a boss." At Good Hope and at home, Barbara and her sisters were expected to comply with rules promptly and obey. But Grandpa Patten emphasized values beyond obedience, and because of him, Jordan, from a young age, became alert to the hypocrisy and self-delusion of adults. She once overheard a conversation between her father and a minister friend. They quoted scripture and debated: What happens if a person should leave the church? "You go down," down from Jerusalem, according to her father's pious friend. Barbara, not yet a teen, rejected the idea that disobedience kept good people out of heaven. "You idiot," she thought to herself. "My grandfather's going to be there opening the gates for you."[89]

Barbara Jordan's distinctive voice made an impression on all who heard it, and many wondered how she learned to speak "like that." Shelby Hearon described hearing Barbara Jordan talk about her beloved grandfather, John Ed Patten, and to relive those early memories of reciting for him, singing with him, and listening to him by the light of a kerosene lamp. Much of her voice, it seems, channeled his: "Each time that Barbara recounts him, recreates him, brings his presence back into her own, . . . the cadence and the timbre is what is known as 'the Barbara Jordan voice.' How did you learn to talk that way? 'At my grandfather's knee,' she said."[90]

Jordan deeply loved her Grandpa Patten, but she found herself torn between his criticisms of religion and the demands of the established Baptist church. Around the age of ten, tired of the other kids in the neighborhood putting her on the "sinners" side when they played "saints versus sinners" tag, she agreed to be baptized.[91] Even though she still spent Sundays with her grandfather and

not with the other children in the Baptist youth group, Jordan felt connected to Good Hope and to its minister, Reverend Lucas. Then one day in 1947, two or three years after her baptism, Jordan's father made a surprising public announcement. He confessed to the congregation that he struggled with drinking. He had hit a man with his car, and that event had brought him to his own religious reckoning. Unexpectedly, he announced an intention to preach. When her father delivered a practice sermon one evening at Good Hope, an initially skeptical Jordan found herself listening with approval. "I remember the text exactly. It was from Philippians and it went, 'I press toward the mark for the prize of the high calling of God in Christ Jesus.' 'I press toward the mark.' I liked that."[92] As stunned as she was by his personal revelations, she felt proud of her dad for wanting his own congregation and was impressed with his sermon. Only slowly did she realize the implications of her father's decision: the family would have to leave Good Hope.

Ben Jordan's new start left Barbara and her sisters saddened, shocked, and uncertain. Good Hope's congregation of two thousand members supported large choirs for both men and women and a full-time staff. Although Jordan's sisters had passed the collection plate, Barbara had never even helped with the young ones at Sunday school. At Good Hope adults did the real work, but at Benjamin Jordan's new ministry, the Greater Pleasant Hill Baptist Church, things would be different. Now on Sundays the Jordans went to Houston Heights, an isolated neighborhood, and worshipped with only a few families. Furthermore, Ben Jordan expected his daughters to work at his church. These changes made Jordan tremendously angry. "So he had this old church and it was a small church, I guess there were a dozen members. And I was accustomed to a lot of people being in church and here was a little church."[93] When Ben announced that his family had to quit Good Hope so that he could pursue his dream, Jordan's sisters cried, and her resentment rose. Why should she and her sisters suffer? She suggested a sit-down strike. "I recall saying to Bennie that night, 'what do you think would happen if we just refuse to get up? He couldn't come down and bodily drag us up there? What if we just sat?' But that was out of the question at that time."[94] She was around eleven or twelve, and it was hard to keep her rebellion and anger under wraps.

At Greater Pleasant Hill Baptist, the girls and women worked to provide the foundation for the services while the male ministers preached and wielded

authority. Ben was known for being exacting and demanding, and Arlyne went along with him. He earned the money, he was head of the family, and his word was law. "Just to have him question you, frightened you," said Rosemary.[95] Although upset about leaving Good Hope, Rosemary defended her father's decision. She felt close to Ben and shared his religious faith. She saw how her father served on the deacon board of Good Hope, acted as president of his choir, and went to Bible study twice a week. Ben Jordan had ambitions for leadership: "He felt he had a message to give to the people."[96]

In contrast, Barbara perceived his move to start a new church only from her own perspective. She hated ending her routine with Grandpa Patten, and she resented the extra work at Greater Pleasant Hill. For years she had avoided returning to church for Bible study. Now she found herself attending night services, choir practice, and additional prayer meetings—she even had to lead the Sunday school. Benjamin Jordan's church needed money, so Barbara and her sister Bennie formed a singing duo. The teenaged Jordan Sisters toured Houston churches with the Count Sisters, the daughters of another minister who also preached at Greater Pleasant. Barbara's special song was a recently released gospel tune, "Let's All Go Back to the Old Landmark," which in all recordings (from the 1940s onward) is sung at a very fast tempo and depends on a "call and response" rhythm.[97] Jordan had no clue what a "landmark" was, but she knew the main message was "Let's all go back," and she sang it that way.[98] Although she doubted her talent as a singer, Jordan became more confident as a performer and began to learn how to communicate with an audience. For the rest of her life, she sang and played the guitar at parties, and she enjoyed the communion and fun that came with musical self-expression. Music had long been a source of pleasure in her old Sharon Street home, but at Greater Pleasant Hill, singing felt like work.

Her father's demands made Jordan feel rebellious, but she had to quell and control those emotions. "We did it all . . . because we had to," she claimed.[99] She missed her grandfather's attention and resented bowing to her father's authoritarian demands. She tried to impose some limits. One night, when he ordered her to pray out loud during a special "speaking meeting," the preteen turned to subterfuge. "I was ready for that," she recalled. "I prayed so softly that no one could hear a word I said. And that was the end of my being required to pray." As Jordan navigated her way around her father's power, she softened her public voice and created an active inner voice, one that engaged in affirming self-talk.

Speaking to herself in the third person became a lifelong habit and helped her feel in control during difficult situations. Young Barbara congratulated herself for outwitting her father and eluding public prayer: "'Yes, ma'am,' I said to myself, 'this is one you can handle.'"[100]

Yet Ben Jordan had another plan. He discovered that his seemingly shy daughter could not only sing—she could recite; and he put her talent for memorizing to the test. "The Creation" is a 1919 sermon in verse by James Weldon Johnson that retells the Genesis story from the perspective of God. At nearly one hundred lines long, "The Creation" takes a full five minutes to perform, but it was a favorite at Black churches and oratory contests throughout the South. Jordan recited it for her father's small Baptist congregation "on about a thousand occasions."[101] "The Creation" put Jordan on a stage by herself, and she began to feel the pressure, as well as the pleasure, of public speaking.

The first verse of the poem requires the speaker to imagine and assume the voice of God.

> And God stepped out on space,
> And he looked around and said:
> I'm lonely—
> I'll make me a world.

Johnson, an NAACP cofounder and author of the words to "Lift Every Voice and Sing," the Negro national anthem, wrote a draft of "The Creation" late one evening while listening to a Black minister in rural Mississippi. As the minister's voice and beautiful imagery took hold of the audience, a sleepy, late-evening church service suddenly came alive. An "electric current" ran through the crowd, Johnson recalled, and the booming preacher's voice sounded like "a trombone, the instrument possessing above all others the power to express the wide and varied range of emotions." Johnson took up his pen and "somewhat surreptitiously" began to write down what he had heard.[102] A full range of emotions—loneliness, joy, humor, wonder, and power—come alive in "The Creation," as does the voice of the rural Black South. Johnson meant for the poem to be spoken out loud, and he brought what he described as the "peculiar turns of thought and the distinctive humor and pathos" of the older Black world into the new. By employing southern imagery and simple language, he made a known story feel fresh to urban Black audiences with rural roots.

And far as the eye of God could see
Darkness covered everything,
Blacker than a hundred midnights
Down in a cypress swamp.

What a role for a speaker! A young girl who was otherwise ignored now had permission to take on the voice and persona of a great, all-powerful God who flung the earth, and life, into being with his bare hands, "spat" the seas into existence, and stepped on the earth to create valleys and mountains. In this poem God fills the world with warmth and beauty. When he smiles, the world divides between light and dark, and a rainbow appears to "[curl] itself around his shoulder." The reprise, "And God said: That's good," paces the poem, punctuating each section, and allowing the speaker to pause. Extolling Black women and summoning an explicit "racial spirit," the climactic end compares God to a nurturing Black mother, turning a stereotype into a holy archetype.

This Great God,
Like a mammy bending over her baby,
Kneeled down in the dust
Toiling over a lump of clay
Til he shaped it in his own image;
Then into it he blew the breath of life
And man became a living soul.
Amen. Amen.[103]

Delivering the quiet ending to the poem pleased Jordan enormously—"I liked that," she recalled.[104] As she imbibed the spirit of that Black Mississippi folk preacher and brought an old ethos into her urban world, she moved an appreciative audience with her voice. As much as she claimed to resent her work in her father's church, she came to associate public speaking with private satisfaction.

To the great relief of Jordan and her sisters, their father eventually allowed the family to return to Good Hope. Although Ben's new church failed to thrive, he preached in rural communities on the weekends, and he continued to encourage his youngest daughter's pursuit of public speaking. Whether it was high school declamation, speech contests, or college debating, Jordan's successes gained her father's rapt attention and he often cried during her orations. Over

the years, Benjamin Jordan's expectation that his youngest perform and excel created an inexorable tension between them. Her father's incessant quest for success bothered Jordan, yet she could not deny that his pushing allowed her to develop a great gift. Her voice became an inspiring instrument that launched the young woman into Black Houston's "stream of life."

As Jordan became an accomplished orator and debater, it was sometimes assumed that because she was the daughter of a minister, she inherited her gift for speaking from her father. And while it is true that Benjamin Jordan's church provided the setting for her first public orations, and while it is also the case that Jordan certainly appreciated the personal dimension to her father's speaking style, the "Black church" in Jordan's family was a house with many mansions. The extreme emotionalism embraced by her deacon grandfather Charley Jordan she rejected completely—that type of performance was never hers. Instead, Jordan leaned into the example set by her mother, Arlyne, a product of the Baptist Women's Convention, who took pride in her appearance, researched and wrote her own speeches, and cared about her audience. Jordan's Aunt Mamie, a musician, trained Jordan's voice and stressed that singers communicate a message. Reverend Lucas, a towering figure of moral certainty, modeled how to command the attention of a large congregation every week as he sought to educate as well as inspire. Jordan's Black audiences, first at church and then at school and other competitions, provided a weathervane of reactions that helped hone her skills. And finally, Jordan drew on the thoughtful intellectual prodding posed by her beloved grandfather John Ed Patten. His rejection of organized religion belied a deep belief that all had a moral obligation to contribute to the world. His example of independence nurtured her own self-confidence.

John Ed Patten kept the hardships, horrors, and burning disappointments in his life a secret from his granddaughter. Instead, he gave her his full attention and wise counsel. As a forced Black laborer in a brutal prison, John Ed had sung river songs tinged with hope, defiance, and bitter irony. He participated in creating a collective voice of deep, powerful tones that mourned oppression, but chose survival. Obedience may be necessary at times, to be sure, but ultimately it represented no rational strategy for meeting life's challenges. John Ed might indeed have inspired Jordan to imbibe and imitate the deep tones and slow pace that characterized her renowned voice, but his greatest gift was making her believe she could choose her future for herself.

A Seed Takes Root

The New Black Democrats of Houston

My strongest supporters are the working class, the blacks, and labor, organized labor.

—Barbara Jordan, 1972

In the 1940s Black Houston buzzed with life, fueled by the wages earned by working people. The city boasted more than 268 Black churches, twenty-eight public schools, a Black college, three Black newspapers, three branch libraries set aside for "Negroes," a Black hospital, and a Black Chamber of Commerce.[1] Black Houstonians worked as schoolteachers, barbers and beauticians, food proprietors, garage workers, shopkeepers, housekeepers, dressmakers, chauffeurs, domestic workers, entertainers, morticians, and medical professionals.[2] They earned less than their white counterparts, but as historian Bernadette Pruitt has documented, the opportunities for employment transformed the lives of African American migrant families, establishing stability and community.[3] The Jordans were working-class, but not impoverished; their lives were steady and predictable. As Barbara Jordan grew up, she took the existence of Houston's Black unions, schools, churches, civic organizations, and businesses for granted. These institutions served and often protected Black lives, but they could not, by themselves, successfully challenge the racially based laws and restrictions that ensured the racial and political subordination of Black people.

Segregation was not easily contested, let alone slain. It was the law of the land, and part of its resilience was its flexibility, its ability to adjust to new realities. Every advance made in economics or education could be met by a new response

that frustrated meaningful Black progress and blocked out opportunity. During the 1940s and 1950s, Barbara Jordan enjoyed far greater material circumstances and security than her parents had ever experienced. Yet segregation as a practice seemed deeply entrenched, and that fact felt discouraging. Jordan remembered thinking that she wanted segregation to change, but "it just seemed so big that it was everywhere."[4] Jordan's classmate and high school friend Charles White recalled that on the emancipation holiday Juneteenth, Black children and their families were allowed to attend Houston's enormous Playland Park with its Skyrocket rollercoaster, the largest in the nation.[5] Yet even on a holiday that celebrated freedom, the system of segregation made him feel demeaned. As an adult, he reflected back on those conflicted emotions. "Playland Park, OH! Wonderful Playland Park where we were permitted the rare privilege of gracing this lily white paradise once a year, the 19th of June. Supposedly, as it was thought then, the day when Lincoln freed the slaves . . . a day when the 'colored people' were permitted to frolic and scamper around on this, day of days."[6] Now it is a federal holiday, but to Charles White, Juneteenth marked Black exclusion and oppression.

Simple shopping trips into Houston's downtown were perilous reminders to Black children of their second-class status. White recalled an incident where he had once defied segregation, or "the code of 'big Brother,'" by drinking from the Woolworth water fountain on Main Street with a "white only" sign hanging above. His friend Joe Hopkins nearly went into shock. "He stood next to me, sweat beading from his brow and trembling with fear, exclaiming, 'Charles, why do you want to get us lynched?' Oh! The fear was with me also."[7] Jordan did not express fear, but perhaps something even worse: a "fatalistic acceptance of what was." Segregation, she recalled, was "bigger than anyone I knew." Jordan understood that Houston's segregated drinking fountains, buses, businesses, and bathrooms represented white control and power. "It wasn't just the school system, it was everywhere. The church, the city." Changing that system seemed impossible.[8]

Yet in the 1940s, Black Houstonians, including the Good Hope Missionary Baptist Church, took a stand. They decided to wage a struggle against "the white primary," a racist set of practices and laws that prevented Black citizens from joining the Democratic Party and voting in the primary races that determined the candidate for the general election.[9] This tactic of disfranchisement had been upheld by the Supreme Court numerous times, but during the 1940 statewide meeting of the Texas NAACP, chapter president Albert A. Lucas announced a renewed campaign to end it. "The time is ripe." he said. "We need in Texas today

real men and women who are willing to make large sacrifices." [10] A four-year struggle ensued that put Lucas and members of the Good Hope congregation—including Black dentist and future plaintiff Lonnie Smith—into the same orbit as civil rights giant Thurgood Marshall. In 1944 the US Supreme Court put an end to the white primary in *Smith v Allwright* (1944), a decision that changed American democracy and opened up new possibilities for Black Democrats in Texas. That court case also put Good Hope and Black Houston at the center of an NAACP national organizing campaign, making *Smith* a social as well as a legal and political turning point in the Black struggle. Barbara Jordan was still a child when Lucas delivered his 1940 speech to the NAACP state convention, but when she grew up and became a successful Black Democrat, she reaped the harvest of the seeds he planted on that day.

As World War II approached, Black Americans pushed against the laws of segregation with greater energy, zeroing in on the contradictions between the ideals of America and its racist practices. Membership in southern NAACP chapters rose, Congress of Racial Equality (CORE) members engaged in direct action campaigns, and labor unions challenged racial discrimination in the workplace.[11] The NAACP had already chipped away at "separate but equal" laws in graduate education; now they started to plan a refreshed assault on racist voting laws, particularly the "white primary," as part of a larger strategy to undo segregation. As Judge William Hastie explained in an interview, the NAACP understood that weakening segregation with court challenges had its limits: "Unless the Blacks in the south were effectively franchised. . . . Unless blacks had the power as voters to influence their local governments, the enforcement of these other rights would be so unsatisfactory that we wouldn't have gained very much by winning those battles.[12] The NAACP envisioned a future when Black voters could safeguard and expand their rights and usurp racist laws by exerting collective pressure in politics.

Black activists in Houston had long championed Black voting, but the Houston branch of the NAACP lacked effective leadership. When NAACP executive Daisy Lampkin traveled from New York in 1939 to investigate the troubled branch, she found a "hornet's nest" of infighting and malfeasance—"Ye Gods, this is the worst I have ever seen!" she wrote. "Charges and counter charges of dishonesty, much of which is true. The branch is in question here and it's really a sad commentary on the NAACP local leadership." She knew she had to find

an honest leader and offered the presidency of the Houston chapter to Reverend Lucas.[13] He accepted. His entire Good Hope congregation joined the NAACP, and for the post of vice president, he tapped former minister Freeman Everett, the leader of local chapter 872 of the International Longshoreman's Association (ILA).[14] Under Lucas, the Houston NAACP went all out to recruit ordinary, church-going, working people.[15]

Reaching out to the Black dockworkers showed that Lucas meant serious business. The Black union held a special, even revered, status among the working classes in Black Houston. Organized in 1912, the segregated ILA agreed to sign a ninety-nine-year contract that split the loading work, and the pay, on the Houston docks equally with a white union.[16] The two unions, one white and one Black, worked together in their negotiations with management. When President Franklin Roosevelt promoted union rights in the 1930s, he and the Democrats gained the support and loyalty of the Black chapter of Houston's ILA. Black attorney Carter W. Wesley, owner of the *Houston Informer*, applauded the union men and their wives, who had organized a women's auxiliary: "They have bought property together; they have cast their votes together; they have paid their poll taxes in a united program; they have pooled their funds to help sick members and the widows and orphans of deceased members of their group."[17] The union's example of racial solidarity made them a respected group within a Black community whose leadership was otherwise dominated by businessmen, journalists, and ministers. Now Lucas's NAACP chapter could count on the Black union's support.

Certain myths cloud a clear understanding of the Black struggle in this era. It is sometimes assumed that World War II brought prosperity to Black working people, but although some may have benefitted from wartime work, few in Houston did so. In a dissertation chapter called "Forgotten Houstonians," historian Paul Levengood documented that Black workers in search of decently paid employment found "the same old barriers in place." It was white workers, largely, who gained the benefits of wartime industries, leaving Black laborers to take on lower-paying jobs in the WPA that whites had abandoned. Unwilling to antagonize racist whites, the shipbuilding industry in Texas placed newly hired Blacks in the lowest skilled jobs. Black workers fared no better in the oil industry. In 1943 Humble Oil and Refining employed only one Black worker among its 1,160 skilled employees.[18] Throughout the war, Houston's Black population was much poorer and more likely to be under- or unemployed than the city's white majority.

And the problems they faced were more than economic. Black Houstonians remained more likely to live in unsanitary conditions and in dangerous, substandard housing. Many lacked indoor plumbing or lived on streets with potholes so large a journalist recommended "hipboots" to navigate the garbage floating in the waters when it rained.[19] Black Houstonians still lived under white political control and the threat of white violence. Problems with the white police, a lack of city services in Black neighborhoods, and the underfunding of Black schools comprised a partial list of grievances. Many left for California during the war years to work in Oakland's better-paying wartime industries. Despite the size of the Black community and its numerous institutions, Black Houstonians lacked a political voice.

But it had not always been so. After Emancipation, Black labor organizer and businessman Norris Wright Cuney of Galveston drew thousands of Black voters to the Republican Party and rose to become chairman of the Texas state Republicans. Between 1870 and 1898, thirty-seven African Americans served in the Texas legislature, but then there were none. Violence, disfranchisement, and political repression stifled Black political participation.[20] The state legislature imposed a poll tax in 1902, and the percentage of Blacks voting in presidential elections dropped from 32 percent in 1900 to 2 percent in 1912.[21] The disfranchisement of Black voters destroyed the state's Republican Party, and the "lily white" faction took control of the organization's corpse in the 1920s. The Democratic Party, strongly influenced by the Ku Klux Klan, in effect held a monopoly on political power in the state, but it banned Black voters from joining its ranks.[22] In 1923 the state legislature passed a law codifying the whites-only primary.[23] Black Texans could not join the Democratic Party or vote in the primary elections that chose the candidates.

In theory, those who paid their poll taxes, such as the ILA members, could vote in the general elections, but racist violence and intimidation kept many Black voters home. *Houston Informer* editor C. F. Richardson noted that Black Houstonians believed "somebody will do them bodily injury if they appear at the polls," but he urged them to vote anyway.[24] Such bold, opinionated Black leadership on these matters—especially from newspaper editors—was extremely dangerous. Testimony in a KKK trial in the 1920s revealed the organization's plan to "lure Richardson into a doctor's office, cut him in small pieces, and carry the remains off, each Klansman taking a small part of the body."[25] Richard Grovey, a Black barber and head of Houston's Third Ward Civic Club, launched a legal

action against the 1923 law.[26] But factionalism and a desire to assert independence from the national NAACP led to competing legal strategies and conflicting lawsuits.[27] As historian James SoRelle has noted, Black Houston between the wars experienced several starts and stops in the movement to promote and protect the Black vote.[28] When the Supreme Court confirmed the constitutionality of the white primary in *Grovey v. Townshend* (1935), ruling that political parties could exclude members on the basis of race, the cause seemed lost.[29]

But the local NAACP branches in Texas decided to take up the fight once more. Reverend Lucas joined forces with Lulu White, an independent activist with ties to Houston's Black business community, and A. Maceo Smith, a Dallas-based attorney. The trio breathed new life into the Texas NAACP.[30] In March 1940 Lucas organized a citywide mass meeting in Houston to formulate a planning strategy. In May he invited all Texas branches and the national leadership, including Thurgood Marshall, to a statewide NAACP meeting in Corpus Christi.[31] The meeting proved to be a key turning point. Lucas, now the newly elected president of the Texas NAACP State Conference of Branches, called for a renewed fight against the white primary. He used the language of patriotism to argue the case for action: "The American Negro must embrace his rights wholeheartedly by bringing together every available legal and political weapon at his command, and then have courage enough in these weapons to the limit in the securing of these rights, privileges, and immunities under the Constitution and the Laws of the land." Lucas told his audience that their fight was universal: Democracy must include "the Caucasian, the Jew, the Negro, the Mexican, the Chinaman, the Japanese, the Indian." There can be, he said, "no God for anybody until there is a God for everybody."[32] The minister wove Christian and democratic themes into a patriotic quilt. Black Texans, he said, should take "neither order nor advice from communists, Nazis nor fascists, Christian-front American Bunds nor the Ku Klux Klan, nor any other anti-American radical bunch whose purpose is the destruction of our democracy. This is the Texas Negro's fight and under God we shall win it in the good old American way." At the end of the conference, Thurgood Marshall joined the Black Texans to hammer out an ambitious ten-year, three-point plan: educational equality, an attack on the laws of segregation, and abolition of the white primary.[33]

Fired up, Lucas traveled to Philadelphia one month later to attend the NAACP's annual meeting, where he proposed Houston and Good Hope as the site for the organization's next annual gathering. He argued his case vigorously.

Holding the 1941 NAACP convention in Houston "would stimulate, it would inspire, it would boost this courage that is already in action in Texas and the South.... The generals and lieutenants should visit the battle ground upon which the soldiers are fighting."[34] Lucas added the promise of Black financial support to the white primary fight. Lucas's colleague, C. V. Rice, backed up his friend, telling the committee that "when Mr. Marshall came to speak, [Rev. Lucas] had the largest crowd he ever had. When Mr. Marshall left that church that night $1,006 was left on the table to carry on the fight."[35] In a narrow vote, the NAACP committee rejected Los Angeles in favor of Houston for the next annual meeting. It was the first time, noted Roy Wilkins, that the NAACP planned to gather so far down in the Deep South.[36]

Good Hope suddenly emerged as the center of the NAACP's renewed drive to end the white primary. When Lucas returned to Houston, he consulted with Thurgood Marshall and others in the NAACP on how to proceed with the fight. Litigation required money.[37] The NAACP also needed new plaintiffs, who had to be steady, reliable, and independent enough to be free from white intimidation.[38] Lucas suggested two men who worked with him in the local NAACP branch: Dr. Lonnie Smith, a dentist and member of the Good Hope Board of Trustees, and Sidney Hasgett, a hod carrier (a laborer who carried bricks on his back) and treasurer of a local labor union.[39] On July 15, 1940, Smith went to the office of the voter registrar and requested an absentee ballot for the July 27 primary. He was refused one. Hasgett tried to vote in person on July 27 and was turned away. In August 1940 Hasgett and three others tried to vote again in a runoff election and were denied ballots. In January 1941, on the basis of that second incident, the NAACP filed suit against the election judges.[40]

As they waited for the outcome of the hearing, Good Hope prepared for the 1941 NAACP annual convention. Jordan's aunt, Mamie Lee Reed, led the musical program for the four-day conference; other Black churches assisted in organizing hospitality. Good Hope had hosted Baptist conventions but never a political event that involved welcoming NAACP representatives from thirty-two states. In Philadelphia, Lucas had said that he wanted the convention to "inspire" and boost the courage of local residents, including the working classes of the Fourth and Fifth wards. By offering Good Hope as the primary gathering spot, he intended that the congregation participate fully in the convention.

The four-day program focused on how Black voting could increase Black political clout.[41] Herbert Agar, white editor of the Louisville *Courier Journal*,

lashed out at American hypocrisy with an opening address titled "The Negro and the Franchise."[42] "We should get rid of this poll tax situation in the next two or three years," he declared.[43] Dallas NAACP leader A. Maceo Smith laid out the legal options for challenging the white primary. Arthur D. Shores, a Black attorney from Birmingham, Alabama, focused on voter registration.[44] History happened that evening, too. Black labor leader A. Philip Randolph, scheduled to speak on "Employment in Defense Industries," announced from the pulpit of Good Hope that President Roosevelt had issued Executive Order 8052, banning racial discrimination in the defense industries. His proposed "March on Washington," said Randolph, had been called off.

In the following day's sessions, spirits soared. A discussion of community organizing was followed by a musical program, an invocation from the Rev. Julius S. Scott, and then a ceremony awarding the twenty-sixth Spingarn Medal to the author of *Black Boy* and the recently published *Native Son*, Richard Wright, who was then a member of the Communist party. An overflow audience at Good Hope heard Wright declare that "we are not fighting for enough in a world torn by human strife. . . . To ask only for justice is too late." Wright's presence showed the NAACP's desire to reach the masses, its impatience with America's existing racial politics, and its hopeful vision for a better world.[45]

Walter White's closing address on June 28, 1941, urged the audience to imagine how ending the white primary could spark a surge in Black political power that would give Black voters a real voice in local government. "Practical democracy" meant reliable city services, better infrastructure, and paved roads, and White was all for it. "I have learned a number of things in Houston during the past week," White said, "and one of them is this: that I can get into a motor car and shut my eyes and tell whether I am in a white or a Negro neighborhood." The locals laughed. They knew all about the potholes and the unpaved streets. If Black voters could influence who controlled the Bridge and Street Departments, White argued, their roads might improve and so would their daily lives.

His tone then became serious as he began to discuss the life-and-death stakes of the crusade. Two weeks before the NAACP convention, a shocking murder had taken place in nearby Conroe, Texas. Bob White (no relation), a Black defendant whose conviction in a rape case had been overturned by the US Supreme Court, was about to leave the courtroom as a free man, but he never made it. Bob Cochran, the husband of the alleged rape victim, approached the innocent Black man, shot him in the back of the head, and walked away. Shortly after, Cochran

went free. "Not only was Bob White killed but the law was slain by the bullet from Cochran's pistol," Walter White thundered from the Good Hope pulpit.[46] The need to end the white primary had never felt so urgent. If Black voters exercised political power, Black lives could be protected, and white politicians might cease their inflammatory and racist rhetoric.[47] People could not be brought back from the dead—Walter White knew that. But he believed that American democracy could come alive if Black southerners had a political voice.

As he took stock of the 1941 annual meeting, one national officer of the NAACP felt buoyed and optimistic. "I suppose you have heard by now from several sources that the Houston conference was one of the best we have ever had," wrote Roy Wilkins, the assistant secretary of the NAACP, to Gertrude Stone, vice president of the Washington, DC branch. Wilkins thought that holding the meeting in a Fourth Ward church with a poor and working-class congregation marked an important shift in the NAACP's approach to organizing. "There were a great many aspects of it that I feel you would have applauded personally chief among which was the fact that the conference was held 'in the masses' and was not in any sense a 'class' conference." Wilkins acknowledged, however, that some of Houston's wealthier Black residents did not appreciate sitting alongside their poorer brethren: "We received many slight remarks on this aspect from the 'society' folk of Houston," he wrote. Wilkins seemed surprised that members of Houston's Black middle class considered the Good Hope congregants uncouth. Nevertheless, the NAACP wanted to expand its reach, and the Houston conference showed a depth of popular support. Wilkins expressed excitement that "we met in the district we did meet in."[48]

The legal battle continued. When the Houston conference ended, Thurgood Marshall received the discouraging news that the *Hasgett* case had failed, but he remained optimistic. He knew that the Supreme Court had recently ruled in an opinion called *United States v Classic*, that the right of qualified voters to participate in a primary was "secured by the Constitution." The *Classic* decision in effect reversed the court's previous opinions on primary elections in *Grovey*. Marshall returned to Texas to find a new plaintiff. On November 8, 1941, Lucas arranged for him to meet with Dr. Lonnie Smith, a member of the Good Hope congregation, who confirmed that more than a year ago he had been denied an absentee ballot for the July 27, 1940, primary.[49] Five days later, on November 13, Marshall filed a new suit, *Smith v. Allwright*, which, citing *Classic*, argued that primary elections in the Democratic Party were subject to federal law and

that Black voters could not be banned from participating. Hearings were held in Houston and damning testimony from the top officers from the State Democratic Executive Committee in Texas kept the case in the news.[50] After losing in the federal district courts, Marshall appealed *Smith* to the US Supreme Court.[51]

The struggle also continued in the neighborhoods, churches, and businesses of Black Houston. Thurgood Marshall, Rev. Lucas, and Dallas attorney A. Maceo Smith agreed that since "the national office was going to take over financing of the new case, we would have to build up the branches and make money out [of] it."[52] Lonnie Smith, the Good Hope trustee, Fifth Ward resident, family dentist, and now a famous plaintiff, joined in the campaign and spread the word. He delighted in his new role in the crucial court case, and he enjoyed the full support of his congregation. Good Hope librarian Sara Scarbrough recalled sitting in Smith's dentist chair, having no choice but to listen as he rattled on while examining her teeth. The constant topic of conversation was Good Hope and politics. "He would be talking, my mother would be sitting there waiting for him to finish, and he'd be talking the whole time he's working on your mouth; he loved to talk, he loved to talk about politics; the part that Good Hope was playing in it and the part that Rev. Lucas [was playing]."[53] Marshall suggested that Walter White come to Texas to start the fundraising campaign, followed by a field representative who could stay for a few months. "Next year is an election year," Marshall noted. "We can build a part of our program around this case and raise some real money."[54] In the spring of 1943, NAACP organizer Donald Jones arrived in Houston to lead the membership campaign. He stayed with Albert Lucas and his wife, Rena.

Black Houston answered the call to fund the lawsuit and support the NAACP. The Texas State Conference launched a fundraising campaign, and the Houston branch was charged with raising $1,500. Good Hope went into action. Freeman Everett, president of the ILA Local 872, swung the union behind the effort.[55] "The longshoremen backed [Rev. Lucas] with money, they backed him morally," Sara Scarbrough recalled. It was her impression that Good Hope had more longshoreman in its membership than any other church in the city. "That was the strength of the whole movement in getting something done."[56] Lucas also urged the many Good Hope members who worked as domestics to contribute money. "Rev Lucas would say, 'Just keep your mouth closed,'" Scarbrough recalled. "The employers had no idea that their maids and chauffeurs and their nursemaids were part of what was going on, Rev. Lucas would say, 'Just don't say

anything, keep your mouth closed.' You go to work you earn your pay, and it is good to use it for this purpose."[57]

In March 1943 Donald Jones and Daisy Lampkin traveled from New York to Houston to implement an organizing strategy. Dubbed the "Houston plan," it introduced the concept of block recruitment. When individuals joined Black civic groups and labor unions, they automatically joined the NAACP. The new plan was designed to appeal to postal workers, teachers, women's organizations, longshoremen, and other union members who were used to paying dues. As Jones wrote, "The plan provides for the NAACP branch to become the single community agency through which civil matters affecting Negroes are to be cleared." Organizations would send representatives to monthly NAACP branch meetings and report back: "Thus, although the majority of negroes in a community may not attend branch meetings, or indeed may not even belong to the branch, they are enabled to throw the full weight of their force upon a common problem at a given time."[58] The organizing drive emboldened Houston's Black teachers to threaten a lawsuit against salary discrimination. The prospect of being sued "scared the school board to death," Jones reported. "They at once called a meeting and began blubbering about some sort of 'friendly' suit to get the thing settled." When Jones saw "$5,100 in cold cash on the table at one afternoon's meeting," he knew the teachers meant business, and that "Houston very soon will take its place among the outstanding Branches of the nation."[59]

Lucas impressed the NAACP leadership with his enthusiasm and his commitment to communitywide, church-based organizing. A "prince of a man if I ever saw one," Jones said of him. "The campaign here," Jones reported to Walter White, "is organized around churches. Lucas is covering the town fighting these ministers into line."[60] Nearly seventy-five churches cooperated with the drive; NAACP meetings included prayers and hymn-singing.[61] Lampkin echoed the importance of Lucas and the churches: "The campaign will close with a city wide mass meeting tomorrow at Good Hope Church, when we are very hopeful of reaching the goal of 5,000 members. . . . The whole committee had planned the campaign through the churches."[62] In April 1943 the Houston branch reported 5,700 members, and the success of the drive enabled the branch to employ a full-time executive secretary, Lulu White. "The Houston Branch is going to carry through and be the wonder of the nation in another year," Jones predicted. It has the leadership and the followership, which is equally important."[63] Jones, who stayed with the Lucases during the membership drive, saw the couple as a strong

team. When he returned to New York, he thanked them with an appreciative letter. "I am telling my friends of the two fisted Houston preacher who, on the last day of the campaign, had NAACP memberships lying beside his Bible on his pulpit, symbolizing the fact that he places the physical welfare of his people beside their spiritual salvation."[64] With his dedication and effective leadership, Lucas had drawn his church into the movement for Black equality. He established the precedent of using Black churches to organize the Black vote, and he set an example by working alongside Black women leaders such as Lulu White and Daisy Lampkin. Eventually, congregations would hear Black candidates, not just ministers, from the pulpit.

Good Hope's efforts to upend the white primary were finally rewarded. On November 12, 1943, Marshall argued *Smith v. Allwright* before the Supreme Court. After the justices ruled in his favor a few months later, the illustrious lawyer traveled to Good Hope to celebrate the victory. When he saw how the Black crowd celebrated their victory and mobbed Dr. Lonnie Smith, Marshall felt excited. "Mass meeting on the night of the 11th was the largest meeting I have seen in Texas," he reported. "Church was packed at seven for an eight o'clock meeting . . . the crowd outside was as large as the crowd inside . . . the only way the plaintiff could get in the church was by climbing through the window at the back of the church." The infectious enthusiasm he witnessed gave Marshall a good feeling about what the *Smith* decision might mean for the South. "Don't know about other states but bet even money that the Negroes in Texas are going to vote."[65] As Marshall's comment suggests, the NAACP expected the legal victory to spur a surge in Black voting, and perhaps even have immediate political consequences.

But those at the top of the civil rights chain failed to appreciate how Black people on the ground experienced the intricate, even devious, systems of disfranchisement. Sara Scarbrough emphasized the confusion the average person felt about elections. "We thought we were doing the right thing by paying our poll taxes and voting. But the candidates were only the 'states' righters'—they weren't any candidates for us." Reverend Lucas, she recalled, patiently explained to his congregation that being denied the right to vote in a primary race made voting in the general election nothing but a sham. "They've already chosen the candidate" he told his congregation. "Your vote does not count; it does not mean anything." Introducing the concept of a meaningful ballot was a complex, but essential, part of the start of a new phase in Black political organizing. In a

church history published right after the victory in *Smith*, the Good Hope congregation praised Lucas for breaking down the laws, "which deprived us from voting in the Democratic Primary," and celebrated how he fought "to the very end to see that victims be given a fair trial."[66] Lucas persuaded his congregation that ending the white primary, and righting the wrong of racial injustice, fit with the mission of the church, but political education, although ongoing, was slow going. It was a project that started in the Black churches and then eventually spread through political campaigns, but it took time.

Favorable court decisions and statewide activism centering on voter registration changed Black political behavior. *Smith v. Allwright* triggered a gradual—yet significant—increase in Black voter registration. In 1944 only 6 percent of the Black adults in Harris County (home to the city of Houston) were registered to vote, compared to 47 percent of white adults. By 1956, the number of Black registered voters in the county had increased to 35 percent of the Black adult population. Voters who paid their poll tax could now vote in Democratic Party primary elections, and they did so in ever-increasing numbers. Nevertheless, the process of registration and paying poll taxes remained cumbersome; gerrymandering and at-large districts diluted the power of Black voters in primary elections, leading to discouraging outcomes. Most significantly, the state of Texas sought to smash Black activism. In 1956 the state attorney general sued the NAACP and forced it to disclose its list of members. The consequences were devastating: Most branches folded.[67] A small, active, core of the Houston NAACP brought lawsuits against school and bus segregation. But legal challenges alone, as Judge Hastie understood, could not force popular compliance, especially when the local school board threw up one roadblock after another to stall the process of integration. In the 1950s Black voter registration leveled off; it would not start to rise again until the mid-1960s.[68]

In the meantime, Black organizers in Houston had to regroup. When the NAACP receded in the 1950s, the Harris County Council of Organizations (HCCO), a new coalition of more than sixty Black civic organizations in Houston, emerged.[69] The HCCO became loosely aligned with the "Democratic Coalition" and the left-leaning Harris County Democrats, and Barbara Jordan worked with all of them during the 1960 Kennedy campaign. Her first run for political office came in 1962, when she was twenty-six, and three years out of law school. She certainly understood the significance of *Smith* and referred to it in

an early campaign speech from around 1963. She praised the case for contribut-
ing to the "cracking" of the solid South, and she reminded her audience of just
how recently it was that the "Negro in the South achieve[d] the right to vote in
elections that were meaningful, that is in the Democratic primary elections."[70]
The power of the Black vote was just getting started, Jordan suggested, and the
reference to *Smith* and other legal victories was intended to spur hope.

But some curious questions remain about the impact the crusade against
the white primary had upon Jordan and her family. Her autobiography, *Bar-
bara Jordan: A Self-Portrait*, does not refer to the NAACP conference, the *Smith*
case, or to Reverend Lucas's crucial involvement in the crusades of those years.
Moreover, Jordan never commented on the political beliefs of her parents. Her
Aunt Mamie was involved in the 1941 NAACP convention at Good Hope, but
it is not known whether Ben or Arlyne became involved in the NAACP or the
white primary crusade. Many possibilities could explain that silence. After all,
Jordan was a child at the time, and perhaps her parents simply never discussed
politics with her. Or perhaps later in life she took knowledge of the case for
granted. It is likely that Shelby Hearon, Jordan's coauthor, did not know about
the struggle over the white primary and the *Smith* case and so did not ask her
interviewees about it.

Yet it is also possible that Jordan's parents were wary of the whole enter-
prise and suspicious of politics. Benjamin Jordan, who had spent his childhood
plowing a cotton field, had his thoughts trained on how he might rise finan-
cially through starting his own business or leading his own church. Jordan's
mother, Arlyne, had spent much of her youth in poverty, praying for her father
to survive prison, and did not appear to be involved in a women's civic organi-
zation that would have pulled her into the NAACP organizing and fundraising
drive. Her dedication was to Good Hope, to her faith, and to her family. Perhaps
Jordan's cautious parents simply found segregation too discouraging and sad to
discuss. Each had lost a younger sibling at a young age. Both knew how easily
the violence of white racism and segregation could rob them all of dignity and
security. It could also be the case that they did not believe that segregation could
end, and so, like many Black Houstonians, they set their sights on rising within
the system rather than opposing it. We simply do not know the details of how
the campaign surrounding the *Smith* case affected the Jordan family, or how it
affected Jordan when she was a youth. It did not seem to have politicized her.

But the crusade deeply affected many in the congregation at Good Hope, including Reverend Lucas. Lucas possessed an optimistic vision of what the NAACP and the churches could achieve and remained dedicated to the cause of organizing to end segregation. After the victory in *Smith v Allwright*, he stepped aside from the presidency of the Houston branch but remained politically active.[71] In the spring of 1946, Lucas orchestrated a statewide NAACP membership campaign with a goal of 100,000 new members and 89 new branches.[72] (One of his many innovations featured a traveling "speaker's bureau" to lecture at rallies.) He, along with Lulu White, became committed to the NAACP's cause of school integration, and he served on the committee to support Heman Sweatt's lawsuit against the University of Texas law school. On December 16, 1946, on the eve of a crucial court decision in *Sweatt*, Lucas playfully and prayerfully encouraged the integrated crowd of 2,000 at Doris Miller Auditorium in Austin. "Let us not give up the struggle," he urged. "Whatever the decision tomorrow in our favor or against us, it's just the beginning. The time is not far distant when we shall study together, work together, live together, and go to heaven together—and those who go elsewhere, let them go together."[73] Speaking to the NAACP State Conference in Waco in June 1948, he praised the report of President Truman's Committee on Civil Rights. "Branding us as communists will not stop us. . . . As sure as God is God we shall be free someday."[74]

Segregation presented new challenges to each generation that faced it. The decision of *Smith v Allwright* (1944) could not and did not end segregation in Houston, but more was accomplished during the four-year campaign to end the white primary than has been recognized. The NAACP gained money and members. The struggle for salary equalization for Black teachers was launched. Most importantly, Black Houstonians acquired a more sophisticated understanding of the complex and biased electoral system that governed them. The crusade to end the white primary taught the average citizen that voting in the general election in a one-party state was an inadequate approach to gaining political power. The campaign also created a new political culture within Black Houston based in the churches and the unions. It encouraged a significant rise in the number of registered Black Democrats, including Black women. It created space for organized labor, churches, and secular organizations to work together. Congregants became accustomed to discussing politics in the pews, participating in registration drives, and being asked to donate money for political causes. That growing

organizational structure gave young people like Barbara Jordan a place to start when she decided to enter politics.

In Houston, the struggle during the 1940s to achieve the right to vote in a party primary left a significant legacy. By the 1960s, a significant percentage of Black Houston's union members, domestic workers, and common laborers were ready for a viable Black Democratic candidate to appear on the political scene. This older generation's sacrifice and activism set the stage for Barbara Jordan and her liberal peers to emerge as contenders for power in the state's Democratic party.

A Sure Foundation

Teachers and Role Models

I take great pride in letting the world know that I was inspired by you and still hold you in great esteem.
—Letter from Barbara Jordan to Edith Sampson, Esq., 1977

Barbara Jordan's parents, especially her father, had her life mapped out for her. They expected that she, like her eldest sister, Rosemary, would graduate from Phillis Wheatley High School and attend Prairie View College. Then, like her Aunt Mamie, she would become a music teacher, a profession that offered respectable, steady employment for Black women. And then, like her mother, she would get married. But Jordan developed other ideas. By the time of her senior year in high school, she decided to become a lawyer. And her reasons seemed to have little to do with civil rights. Instead, in a prize-winning speech on the value of higher education she delivered at a speech contest in Chicago, the sixteen-year-old, dressed in a formal gown, asked her audience, "Do you want to be a free human being, standing on your own feet, accepting the responsibilities, the duties that go with that position as an effective member of society?" Self-sufficiency and civic duty: Jordan's address recapitulated the values of Cold War, progressive Black America. As she pursued ambitions large and small while attending Phillis Wheatley High School and Texas Southern University in Houston between 1948 and 1956, Jordan received support and recognition from family but, most important, from those who provided the foundation of her education, her Black teachers.

Twelve-year-old Barbara Jordan entered Phillis Wheatley High School in 1948, during a time of transition. Her oldest sister, Rosemary, had just left home

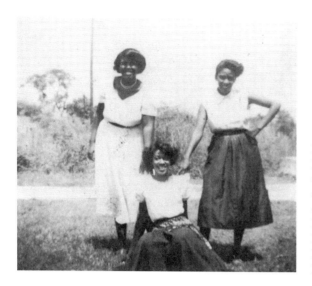

Figure 3. Barbara Jordan (left) and her sisters, Bennie (right) and Rosemary (center), circa 1950. MSS 0080 PH 014, Houston Public Library, African American History Research Center, Houston, TX.

for college, Ben Jordan had just started his own church, and the Jordan family had recently moved out of the house they had shared with Gar and Grandpa Jordan into a new home on Campbell Street in the Fifth Ward. The house was larger and had a cheerful coat of bright pink paint, but it sat in front of a noisy railroad depot on an unpaved street, a location Jordan found "a bit of an embarrassment."[1] She also felt overwhelmed by her new, crowded school with 1,500 students. To get there, Jordan, her sister Bennie, and some neighborhood friends walked over a mile every day, passing movie theaters, small businesses, and restaurants on busy Lyons Avenue. The youngest Jordan's world was expanding and stretching beyond church and family.

In the period between the 1944 *Smith* case and the 1954 *Brown* decision, segregation in Houston lived on, and even gained strength. Wanting to prove that "separate" could be equal, the Houston school board responded to the NAACP's persistent legal challenges by spending more money on Black education. New buildings for Phillis Wheatley High School (1950) and Texas Southern University (1949)—both of which Jordan attended—literally cemented segregation deep into the ground. The defeat of fascism should have signaled the end of any justification for racial segregation, and yet the city's fierce anticommunism gave credence to forces wishing to cripple or silence organizations and individuals supporting integration. The public Black schools Jordan attended were far better than anything her parents had experienced, and above the educational

opportunities offered to most Black southerners, but they were still separate, and they were unequal. Segregation remained the norm.

Nevertheless, a nurturing environment in Houston's Black schools steered Jordan toward big dreams. Since it first opened in 1927, Phillis Wheatley High School inspired pride in generations of Fifth Ward families. Barbara's classmate, Anna Curtis, recalled the excitement she felt as a ten-year-old thinking about herself as a future student at Wheatley: "The Elementary school [Atherton] was on one end of the street where I grew up and the old Wheatley was just about twelve, thirteen blocks away, so when we got out of elementary school, we'd run over to Wheatley right quick, and we'd carry the books of the kids in high school, make people think we were going to high school." To Curtis, this behavior simply reflected youthful enthusiasm. "You know how kids are," she chuckled in the interview, as she recalled running a mile just to carry someone else's books. She identified Wheatley's orchestra, sports teams, clubs, and service organizations as key institutions that created strong bonds of affection between students and adults in the Fifth Ward and made education meaningful.[2] Attending Wheatley was "a great experience, a lot of fun," said another classmate, Otis King, who would later become dean of the law school at Texas Southern University. King described Wheatley as one of the "strange benefits to living in a segregated society."[3] More than a school, Wheatley was a community institution and a source of tremendous race pride that had emerged in response to Houston's growing Black population but which became a beloved haven for the neighborhood.

Until the 1920s, the only high school for Houston's Black students was "the Colored High," located in the Fourth Ward. Seeking to reassure white elites, its principal, E. O. Smith, asserted that education trained better workers and allowed Black citizens to rise "within" their race.[4] Yet Smith balanced Booker T. Washington's model of industrial education with academic subjects and worked with Houston's new school superintendent, Edison Oberholtzer, the son of German immigrants and a native of Indiana, to direct the creation of new and better Black schools. With graduate degrees in education from the University of Chicago (MA, 1915) and later Columbia University (PhD, 1934), Oberholtzer came to Houston in 1923 dedicated to John Dewey's beliefs in progressive education. He maintained segregation, along with the policy of disparate funding for Black children, who comprised 25 percent of all the students in the system.[5] Nevertheless, Oberholtzer agreed to create new schools for the Black populations in each of Houston's three wards with the largest concentration of Black families.

The Colored High in the Fourth Ward, renovated and renamed Booker T. Washington High School, and the Third Ward's new Jack Yates Senior High School, named after the minister of Houston's first African American church, both opened in 1926. Yates had its own library, a science laboratory, two gymnasiums, forty faculty members, and several hundred students; it soon became recognized as the city's premier Black high school. The school also contained a startup campus for a new Houston Colored Junior College, later Houston College for Negroes. Finally, in 1927, Phillis Wheatley High School was created in the Fifth Ward and placed in a previously all-white elementary school. This institution, called "Old Wheatley," soon tripled in size, and Barbara Jordan attended it for her first two years of high school.

As the educational direction in Houston began to shift toward the theory and practice of progressive education championed by John Dewey, Houston's Black educators jumped to join the movement. Between 1924 and 1930, according to historian Ira Bryant, Black public education in Houston transitioned to "a new era."[6] The curriculum revision handbook for senior and junior high schools in 1933 Houston stated the change to progressive education frankly: "The old curriculum was made by text book makers . . . it was static . . . it was made for adults, a summary of the experiences of other people, offering little if any opportunity for getting experience on the part of the learner. The new curriculum is made by men and women who know children and how they learn. . . . It is far more vital than the cataloging of facts and information." In a nutshell, teachers were told that "the old curriculum was tested in terms of the mastery of facts; the new curriculum is tested in terms of *power to do*."[7] Although they had fewer resources and larger classes, Black teachers fully supported the new progressive direction in the curriculum that pronounced education as a path to self-development and self-sufficiency.

Progressive education embraced a democratic, inclusive ethos that focused on developing individual talents. Phillis Wheatley became especially well known for its array of clubs and student-centered learning. "Not everyone could be a lawyer or a doctor," remembered N. Joyce Punch, a Wheatley graduate from the 1930s, "but everyone could be self-sufficient." A member of the Golden Nuggets, an active alumni group, and a science teacher at E. O. Smith Junior High for thirty-six years, Punch quickly rattled off the activities, clubs, and skills imparted to students back in her day. Honor societies, stage crafters for plays, trade dressmaking, traffic patrol, fine arts competitions, metal shop and furniture building,

the orchestra, and glee club were just some of the organizations she recalled. "'Do for yourself,' that is what we were taught," she stated proudly in a phone interview, which expressed in a nutshell how the progressive philosophy shaped generations of Black Houston students, including Barbara Jordan, at both Wheatley and Yates.[8] The progressive ethos of education dovetailed with many of the practical ideas of Booker T. Washington but had more resources for students and lacked the old subservient tone.[9]

Black organizing and optimism during the 1940s ushered in more changes in Black education. Throughout wartime, Black activists repeatedly used American ideals to hold a mirror up to the nation and force a reflection on the contradiction between its creed and its deeds. The fight to end the white primary expanded the influence of the NAACP among Houston's Black teachers, who threatened to launch an equal pay lawsuit in 1943. The board acquiesced and agreed to equalize teacher pay.[10] Black education activists in Texas pushed the school board and the state from all angles. Lulu White and the NAACP continued to argue for integration and for open admissions to white-only universities, and in 1946 they brought a lawsuit, *Sweatt v. Painter*, that challenged the refusal of Black postman Heman Sweatt's application to the University of Texas law school. At the same time, attorney Carter Wesley's organization, the Negro Conference for the Equalization of Education, led the crusade to increase funding for existing Black institutions.[11] Such pressure led a Texas judge to order time for the state to create "a separate and equal" institution to train Black law students. In 1947 the Texas legislature established the Texas State University for Negroes and stipulated that the courses it offered "shall be equivalent" to any offered at other state institutions. The Houston school board, led by Oberholtzer and his supporters, including white progressive Dr. Ray K. Daily, who served on the elected school board from 1928 to 1952, also supported improvements in Black education in Houston.[12] They allocated funds for a new Phillis Wheatley High School in the Fifth Ward, scheduled to open in the fall of 1950. In that same year, the University of Texas law school admitted its first black students, but the college for Black students, now known as Texas Southern University, continued to grow. Segregation still held firm in Houston. Yet political pressure yielded improved facilities for some Black students, achieved better pay for Black teachers, and planted the seeds for a new Black college that Jordan would later attend.

By the time Barbara Jordan entered Phillis Wheatley in 1948, the progressive philosophy of the "power to do," which demanded student involvement with

local organizations, had established strong ties between Black schools and the communities they served. At Phillis Wheatley, good grades were not just for the kids who wanted to be in the honor society; if students wanted to participate in popular school clubs, they had to maintain a certain grade point average. "It was fun," Anna Curtis recalled. "You looked forward to it." She paged through the Wheatley yearbook, recalling the array of organizations that taught students how "to do." "Book Lovers, sponsored by the library. . . . You had the projectionists club, the Drivers Ed. Club. . . . Explorer scouts. . . . The Esquire Club did community projects like work with the Red Cross, or work with Community Chest or United Way." Barbara Jordan dove into these clubs, took driver's education, and earned her driver's license when she was only fourteen.[13]

The progressive philosophy of education fostered pride. Learning how "to do" created close ties among individuals, families, schools, and neighborhoods. Far from being considered boring or out of touch with life, Black schools *were* Black life. Children looked forward to wearing the school colors, taking courses from beloved teachers, and participating in local rivalries, like the Wheatley versus Yates "Turkey Day Classic" football match played every Thanksgiving. Judge Andrew Jefferson became highly animated when asked to compare his alma mater, Jack Yates High, with Wheatley. During the interview, some confusion arose about where he had gone to high school, but Judge Jefferson set the record straight. "Even now when you say you thought I had gone to Wheatley, I resented that." The two schools, he stated, were "like the Hatfields and McCoys, Wheatley in the Fifth Ward and Yates in the Third Ward. The two high schools were extremely competitive in every field. Thanksgiving football game was an occasion for wearing your Sunday best and your school colors, it was just a fierce rivalry."[14] Jordan agreed: "The rivalry between the Fifth and Third ward kids was intense." On Thanksgiving "it was load-up-the-car-time and go to that game." Ben Jordan liked his daughter's new interest in football, and she enjoyed being part of the crowd. "I wasn't a cheerleader, but I should have been," she remembered.[15] High school activities and sports added a welcome edge and meaning to Barbara Jordan's school life, and reflected the importance of winning and competition in Houston's Black culture.

Barbara wanted to enter the social whirl at Wheatley, but she was shy and might have remained unnoticed had it not been for the encouragement of certain teachers. Wheatley's teachers, Anna Curtis recalled, "were surrogate parents. They were not only interested in what you learned up here [pointing to

her head.] They were interested in your physical appearance, that you came to school looking neat." Curtis recalled that "Ms. Cunningham [the Dean of Girls] was always in the hallway, and if you were walking by and you did not have socks or stockings on, and she would give them to you until the next day, or if she talked to the young lady and the lady did not have, then she saw to it that she had it. Because she wanted us to look like we were high school students." Boys were expected to dress neatly too, even if they could only afford overalls.

> We had the Dean of Boys, Mr. Ladner, who did the same thing with the boys. And we had one teacher all of us remember, you could not go to her class without a tie on. . . . Ms. Ella Walls. And what the boys would do, they'd have their ties in their lockers, they might have on overalls and a t-shirt, but they had their tie on because this was the way that you had to dress to go to her class. We felt that the teachers that we had were really interested in us, and it added something to the feeling that you had to succeed not because your parents wanted you to, but your teachers also. They'd go the last mile for you.[16]

This nurturing tradition affected Black students profoundly. Otis King, later dean of Texas Southern University Law School, Houston's first Black city attorney, and Barbara Jordan's college debate partner at Texas Southern University, graduated the same year as Jordan. He summed up his high school years thoughtfully: "I was reading a book and it was talking about Boston and Chicago, places like that. It dawned on me—the Black kids were in segregated schools taught by white teachers who didn't want to be there, and how much love there was in our schools. . . . We really had the feeling that the teachers really cared about us. They really did."[17]

Special teachers who believed in Jordan and gave guidance included Exa O'Daye Hardin, who taught tenth grade geometry. According to Jordan, Hardin "gave me a good deal of tough talk about confidence, and she'd tell me about what kind of head I had, that sort of thing."[18] Jordan began to realize that she was "a little brighter" than the majority of her classmates. She took pleasure in geometry and chemistry, and she realized she liked feeling on top. Jordan could not play sports, but she loved to compete.[19] And her voice made her stand out. As Anna Curtis recalled, "When you listened to her speak, that is not an affectation that she had, this is the way she always spoke."[20] Jordan drew the attention

of Ashton Jerome Olivier, the teacher who headed Wheatley's oratory group. Olivier drove the students to Prairie View to compete in the statewide contests, and took them to all the other local, regional, and district level meets in between. Jordan traveled with the team to competitions as far away as Tennessee. Speech and debate became her specialty, and she felt enormous pride.[21]

The hard work of its teachers, however, could not compensate for Wheatley's defects. Shoddy equipment and inferior facilities had been the norm through-out the 1940s, and during Barbara's first two years, the horribly overcrowded school held classes in shifts. But political pressure on the school board led them to dedicate $2.5 million to build a brand-new school building on Commerce Street. The modern facility, inspired by the architecture of Frank Lloyd Wright, was alleged to be the most expensive high school in Houston, and the *Houston Chronicle* dubbed it the best "Negro high school" in the South. The new Wheatley had a swimming pool, an industrial arts complex, a gymnasium, and an auditorium that held fifteen hundred students. It was ready for the fall term of 1950, and the school hosted an open house with tours given by Wheatley students. At the cornerstone ceremony, Wheatley junior Barbara Jordan gave the dedication speech.[22] She was fourteen years old.

Jordan developed her own circle of friends at Wheatley, including her sister Bennie, Eva Lynn Justice, and neighbor Charles White. Every day they walked home as a group via Lyons Avenue, stopping for soda and hamburgers. Yet Barbara also recalled feeling removed from the popular crowd. For one thing, she was conscious of her dark skin. Some of her peers used bleaching cream to lighten their features. Teachers, too, could be prejudiced: "There was one teacher I didn't like too well, because I felt that she was color-struck. . . . I felt that she favored all the people who had fair skin and good hair. Teachers of her bias favored those who had hair that wasn't nappy, hair that didn't require Excelento, straighter hair. That's what it was: a better grade of hair."[23] Dean of Girls Evelyn Cunningham encouraged Barbara to run for the position of "attendant" to Miss Wheatley, but Jordan rejected this suggestion out of hand. "I am not the right light color, and I don't have the clothes, the whole thing." Later on, she reflected, "I had accepted the judgment of the times and decided I wasn't going to change any attitudes."[24] Nevertheless, Jordan did not defer. At school she allowed herself to be brash and confident. Her humor was quick and sharp. Anna Curtis remembered that "Barbara had a real serious side, but she also had a humorous side. You know one minute you're talking about the war that's going on over in Japan or wherever,

and then the next minute she might come up with something funny, and you've got to change over right quick. She was very much admired. I'm sure the teachers would have loved to have had at least two hundred more of her [laughs]." At one point, Jordan's penchant for science made her consider pharmacy, but she reconsidered. "Who ever heard of a famous pharmacist?" she thought. A desire to reach for something special slowly took shape. Political forces larger than the social struggles within Wheatley also shaped Jordan's outlook.[25]

The Cold War added another dimension to Houston's racial politics and school board debates. Fears of a lurking yet organized internal communist conspiracy dedicated to undermining American values became a reigning cultural norm that shaped politics and did a great deal of harm to Black Houstonians. The Texas NAACP integration efforts faltered as the organization was picked apart by hostile lawsuits. Hot lunches were halted at the insistence of Houston's notorious white "Minute Women," who cited an alleged communist conspiracy to infest schools. Maury Maverick, a state senator from San Antonio, recalled that "when it came to anti Red legislation, Texas was in a class of its own, with legislators scrambling to be known as the most principled opponents to the crime of communism." Maverick, a member of the iconoclastic Texas family who refused to brand their cattle, lamented the fear and ignorance he encountered during his six years in the Texas House of Representatives at the height of the McCarthy era: "They had bills before the legislature such as to remove all books from libraries that were critical of American history, Texas history, religion, or were in any way agnostic, atheistic, or made fun of God or whatever, which, of course, would remove all good books from the library. It got so bad, for example, that the high school teachers' lobby of Texas, the Texas State Teachers Association, endorsed the bill and not one college professor in the whole state of Texas, I remember, spoke in opposition to that or any other Red legislation."[26]

The white conservative anticommunist movement was strong enough to silence even privileged white Texans. Maverick recalled how all legislators were called on to denounce professors accused of indecency or treason or face ostracism and defeat. As a lawyer and veteran of World War II, Maverick felt humiliated and stupid making such speeches, but he feared a backlash if he voiced opposition. So he spent a lot of time in the men's bathroom stalls, feet up, and ashamed. He hid to avoid a vote that may have been construed as aiding and abetting communists. The term "shithouse liberal" was a colorful colloquialism, but a bitter reminder to the state senator of the humiliation liberals endured

as they sought to maintain a voice that mattered in the legislature during these repressive times. "There were bills such as 'anyone who invokes the Fifth Amendment and works for the State of Texas will be automatically fired.'" When he decided to join three colleagues and oppose a piece of legislation that made membership in the Communist Party in Texas a crime punishable by death, Maverick took his political life in his hands. Recalling the debate brought a grim smile to the retired senator: "I remember that I had a hand in reducing that to life imprisonment. That was a great liberal move at the time. [Laughter] Well hell, it sounds silly today, but you know, God almighty, I was at least trying to keep the Reds from being put in the electric chair and now, I feel like a damn fool even talking about it."[27] The Houston school board required teachers to sign loyalty oaths, and in October 1950, it approved a revised curriculum that included "Americanism and American values."[28]

Extreme as it was, anticommunist fanaticism carried out in the name of Cold War patriotism could sometimes be used by Black citizens to their advantage. Mounting pressure against segregation tarnished the image of American democracy abroad, much to the fear of those who sought to extend American influence into nations newly emerging from European colonialism. Legal analyst Derrick Bell noted that a "convergence" among certain Black and white leaders regarding the undesirability of communist and leftwing forces helped to push forward a consensus necessary for the *Brown* decision to occur.[29] Young people within America were also alert to the contradictions posed by segregation at home and America's grand schemes abroad. Although acknowledging the conservative nature of the decade, sociologist Todd Gitlin observed that "the Fifties were a seedbed as well as a cemetery. The surprises of the sixties were planted there."[30] In Houston the battle against communism spurred inflated rhetoric of America's grandiose vision of its democracy. Both Black and white students, including Jordan and her peers, were fed a steady diet full of idealism. They embraced American exceptionalism and seemed newly inspired by those patriotic values of freedom, liberty, and democracy. Self-sufficiency now seemed to be a modest goal for the citizens of the world's only superpower, and by 1950 the Cold War added patriotism and "Americanism" to the progressive ideal. Wheatley students never thought they were being groomed for subservience; on the contrary, they assumed they were being trained to be soldiers of democracy.

The Houston school board never discussed the contradiction between segregation and democracy, but the teachers at Wheatley made the point, albeit

subtly. Lessons about "practical democracy," as Walter White had called it in 1941, and then "Americanism," became central to civics classes, where all students engaged in group projects examining local government. "We had 'Civics and Social Problems,'" recalled Anna Curtis. "That wasn't an elective. That was required. You would learn about the government, especially about the state and city government, what the role of the Senate and the House was, the role of the mayor and the city council person, how you went about getting a law introduced and getting a law passed." Curtis remembered teachers insisted students take a hands-on approach. "You had the theory in class, but you had to actually carry it out in the community." Her student group compiled information about garbage pickup, raised the issue with members of the city council, and wrote up a report.[31] Students thus discovered for themselves how local government in Houston did not work to the benefit of Black residents. Such projects showed students the reality of white-run local government.

Edith Sampson's appearance at Wheatley also showed the racial contradictions of the Cold War. Tall, robust, and assertive, this Black attorney from Chicago, "with a voice like Tallulah Bankhead," had inspired admiring articles in the *Crisis*, the *Chicago Defender*, and the *Negro Digest*. Dubbed the "Negro Portia," Sampson had served as a member of the 1949 "World Town Hall Seminar" and then as an alternative delegate to the United Nations, where she gained a reputation as a charismatic opponent to communism. Sampson was by no means the only Black woman in America who sought to capture an international audience, but she was uniquely sanctioned by the State Department in her travels, and her message, unlike that of other Black women internationalists and leftists of the period, was explicitly anticommunist, pro-American, and lukewarm on the ravages of segregation.[32] "Mrs. Sampson to Battle Reds," declared the *Chicago Defender*, on September 2, 1950, in a favorable piece. "She is no apologist for abuses of democracy at home, but she will not permit the communists to get away with their lies about Negro life in America."

Sampson, a Democrat, had served in the political machine of Cook County in Chicago while building a successful law practice. In 1949 she championed the role of Black women in politics. She embraced her consensus-building role, which united Black and white against communism: "The time has come for us, as Negro women, to take our proper place in the front lines of the political life of this country. Ballots are powerful weapons. We need to groom more Negro women for places of leadership, to get behind those women who are qualified."[33]

Her outspoken anticommunism and optimism about America made her a well-known public figure, and Sampson's speech at Wheatley sparked unusual excitement. Otis King vividly remembered the UN representative's talk and how hearing her made him switch his professional choice from doctor to lawyer. Sampson was, he said, "very dynamic," and the entire school assembly became "just very excited. Everybody in the school went to hear her."[34]

Edith Sampson's message of confidence, democracy, and a bright, shining future for Black youth resonated with Wheatley's progressive and patriotic principles. To Jordan and her cohort, Sampson represented the positive role that Black Americans could play in their nation's contest with the Soviet Union. The heady mix of racial progress and patriotism appealed to young people ready to support the United States in its struggle against communism. After hearing Sampson speak at Phillis Wheatley's new auditorium, Jordan had no doubts that she wanted to be a lawyer. From that day on Edith Sampson became her image of what a successful Black woman attorney looked like. "I take great pride in letting the world know that I was inspired by you and still hold you in great esteem," Jordan wrote to Sampson after she was elected to Congress.[35] Otis King remembered that at the time optimism about America prevailed: "We weren't looking at the system changing or coming down, not yet, but I guess there was something subliminal, there was more about the possibilities."[36] Jordan shared the dreams of her ambition with her family, her sisters, her aunt, and several of her teachers. In her high school memory book, her sister Bennie joked: "My dear sister, you must make a good lawyer so you may get my first divorce." For her future plans, Jordan wrote that she wished "to become an outstanding and competent lawyer." Aunt Mamie Lee expressed the hopes of the family when she responded, "To My Barbara, with God helping, and you remaining as you have, I hope to live to see you become the 'lawyer' you so much want to be. Remember I am with you ALWAYS!!! Aunt Mamie."[37] Jordan's Aunt Mamie supported her, but putting "lawyer" in quotes perhaps demonstrated a smiling knowledge that the reach of youth often exceeds its grasp. Nevertheless, surrounded by her family's love and hope, and inspired by Sampson, Jordan believed in her future.

Jordan may not have been the most popular girl at Wheatley, but she was one of the most accomplished. With her excellent grades, participation in numerous clubs, and victories in speech contests, Jordan was chosen as Wheatley's "Girl of the Year," an annual award given by a national Black sorority. Math teacher Exa Hardin offered to buy Jordan's dress for the prize ceremony, but Aunt Mamie

used her credit card with a local department store and bought a special white frock that cost $35, the equivalent of more than $300 today. Jordan's mother paid her back in installments. Although she wanted to make her teachers and family proud, it is evident from her autobiography that Barbara's most appreciative audience was her father: "My acceptance speech was really super. . . . I had people in tears. It was so moving that my father couldn't stand it. I know it began, 'This is the happiest moment of my life.'"[38] Not for the first or last time, Ben Jordan openly cried as he listened to his youngest speak in public.

Barbara faced one last major hurdle before she started Texas Southern University. In July 1952, during her senior year, the sixteen-year-old took a train to Chicago with her mother to compete against speakers from nine other states in a nationwide speech contest sponsored by the Ushers Association, a Black Baptist organization. Jordan loved the journey and spent most of it conversing with a Black train porter. The bright lights and excitement of the big city captured her imagination and fit in with her optimistic speech about the future. She asked, "Is the Necessity for Higher Education More in Demand Today Than a Decade Ago?" Jordan answered with a robust affirmative; her reasoning will puzzle a present-day listener, who might expect a sermonlike prescription on the importance of education for gaining secure employment. On the contrary, Jordan took a broader view. "We need higher education," Barbara told her audience, because of the "increasing attempts on the part of our foreign neighbors to do away with our democracy." In addition, she argued, higher education can turn confused youth into independent individuals. She asked her audience, "Do you want to be a free human being, standing on your own feet, accepting the responsibilities, the duties that go with that position as an effective member of society?" Race, gender, and class-based barriers facing Black youth in the workplace were omitted, as she had yet to be introduced to those ideas in any critical way. Everyone competing in the Ushers' contest was African American, as was everyone she met and spoke with on that trip. She loved the train journey and savored the bright lights of Chicago ("the most wonderful, enjoyable, exciting, adventurous, adorable, unforgettable, rapturous . . . it was just the best doggone trip I have ever had").[39] As she told the Houston *Informer*, winning the contest was "just another milestone I have passed; it's just the beginning."[40] She received a medal and a $200 college scholarship. Youthfully optimistic and full of hubris, Jordan wanted to be student body president at Texas Southern University but had to settle for running for president of her freshman class. She lost by one vote to Andrew Jefferson.

When she started that fall at Texas Southern University (TSU), Jordan was still a sixteen-year-old adolescent and not always as mature as her high school achievements might suggest. College gave her freedom, and she enjoyed it, but she misused her adult privileges. She overextended her Aunt Mamie's credit at the gas station and lost use of her father's car. She signed up for general courses, joined the Delta Sigma Theta sorority with her sister Bennie, and continued with her social drinking. In her high school memory book, Jordan listed "champale" as one of her favorite foods and beverages, and her friend Charles White alluded to their neighborhood fun and their "special club (TACT) Teen Age Tightening Club in which we vowed to drink our youth into oblivion."[41] Now she could drink beer in the numerous college haunts by Texas Southern, including the Groovey Grill. To earn her own money, Jordan worked odd jobs, housecleaning and babysitting. Late nights out caused conflict with her father, who hated the "hell fire" sorority that encouraged dancing and drinking. One night Jordan came home and saw him yelling at Bennie and making her cry. A church member had seen the sisters drinking at the Groovey Grill. Barbara yelled back, "If somebody said that's all we do, they lied. They lied." She went to her room and slammed the door.[42]

Jordan began to notice and resent the daily indignities of segregation. To travel to Texas Southern, she rode a slow, segregated bus that chugged for five miles south out of the Fifth Ward, through downtown, and into the Third Ward's Cleburne Avenue. "I had to ride the bus from my house to school across town," she recalled. "There was a little plaque on the bus near the back that said, 'colored' and when I'd get on, I'd have to go all the way back to that little plaque and I was passing empty seats all the time."[43] Jordan had spent her whole life walking to school and driving to church. But now she looked out the window from the back of the segregated bus and felt like a stranger in her own city. White people, she noted, dressed up, enjoyed life, and looked prosperous. The Black workers she observed walked with caution; they made their backdoor deliveries and left. The entire city followed the law of segregation, and Jordan knew no white people.

Once again it was a teacher, Thomas Freeman, who helped Jordan successfully adjust to new challenges. Freeman had earned a PhD in homiletics from the University of Chicago and joined the TSU faculty in 1949, soon after the college opened.[44] He had an undergraduate degree from Virginia Union University in Richmond and a theological degree from Andover Newton, now part of Yale University. He taught philosophy at Texas Southern and had already established

a speech and debate team when Barbara arrived in 1952. Freeman mentored his students, pushing them to think and to aim high, much like Jordan's teachers at Phillis Wheatley. A key difference, however, was that Freeman minced no words about racism: "I was single then and they'd all come to my house. I had a kind of pal relationship which involved intimacy and interactions. I gave them a sense that they could handle themselves anywhere as most of them had been robbed of the sense of worth due to the oppression put upon them."[45] Freeman never sidestepped how racism could prey on the minds of his young charges. Segregation, Jordan recalled, "was something bigger than anyone I knew." But Freeman wanted his debaters to develop confidence in uncomfortable situations and know they could compete with any students, white or Black. His refreshing and sobering frankness contrasted with the high-minded idealism of teachers or silence on the subject from parents.

Jordan acknowledged Freeman's influence. "He stretches your mind," she recalled. "He places you on your own, teaches you to stand on your feet, think, and open your mouth and talk."[46] Freeman also shared some of her Grandpa Patten's philosophy that life was not a playground but a schoolroom. As Freeman said on the occasion of his ninety-ninth birthday, "If you don't bring anything to life, you won't get anything out of it. You're not here for your enjoyment, but for what contribution you can make to the enjoyment of others."[47] He wanted his debaters to be prepared for any situation. Otis King remembered that he and Barbara "worked hard at being capable of switching sides. We could walk in one room and debate a topic from the affirmative position and then we could give the other side. That was a strategy that a lot of other teams did not have. . . . Barbara and I said that we were going to be prepared."[48] They competed individually and also as a team. Barbara usually spoke first. Both knew how to structure an argument, but "our strength," King said, "was her ability to speak. She spoke so well."

Encouraged by Freeman, Jordan delved more deeply into the art of elocution. She had already developed a distinctive oratorical style in high school, but her classmate and debate partner King asserted that all the club members emulated Freeman: "We would try to do some phrasing based on his pattern of speech." Freeman was so meticulous about his pronunciation that it was impossible to mimic him completely. "You have to hear it," King said. "Imagine how Moses would have sounded." When one listens to recordings of Thomas Freeman speak, especially at Barbara Jordan's own memorial service, it is clear, as Jordan said herself, "the one thing I shall never be able to forgive Tom for is

inflicting on me a pattern of speech that I have not been able to eradicate."[49] She did not copy his hand gestures, and she kept her tone low, where he went high. But like him, she had a voice that "boomed," and she tended to pronounce each letter of every syllable. One of Jordan's trademark styles—her steady and precise pronunciation—can be traced directly to Freeman.

Travel with the Texas Southern debate team is perhaps the first example of how Jordan's willingness to join an otherwise all-male environment gave her unique opportunities. Membership on the debate team meant "intimacy," as Freeman put it, including traveling and deep discussions about life. Could a young woman fit in? At first Freeman did not think so, but he changed his mind for Jordan. Otis King remembered that "we basically just treated Barbara like one of the fellows. We didn't think about it that much. Barbara was not a very feminine or attractive young lady, and I guess maybe that made a difference."[50] King's statement notwithstanding, however, Jordan certainly was treated as a young woman. When the group traveled, Jordan had her own room. And although the 1950s are often perceived as a time when male sexism held women back, the male debaters respected and admired Jordan's talents; no one thought there was anything wrong with her. Jordan enjoyed being part of the group. "We'd sing in the car to break the monotony," said King. "Barbara had a good voice . . . [and] she was a very good dancer. Very good. She was a very regular person. She wasn't stilted, not with us. She didn't seem to have any attitude about that. She wasn't shy."[51] Barbara had enjoyed her sister Rosemary's stories about dorm life at Prairie View—stories that would "just send your hair standing on end"—and now debate trips let her have her own set of stories.[52] Travel, talking to new people, eating meals together on the road, all appealed to her and stretched her. Simply put, on these trips Jordan learned to feel comfortable in the company of men, especially when all were part of a team getting a job done.

Every debate trip had additional tensions because of racism, and Jordan shared the hardships of segregated travel and competition. While on the way to compete against white students, Tom Freeman's team had to accommodate themselves to segregation. They packed their own food and stayed in Black homes or Black-owned hotels. King remembered that "traveling by car through the south was not pleasant. Whenever we pulled into a service station we always asked if they had a restroom for colored people, which is what we were called back then." Often, they were told no. Sometimes, they had to go to the "back door" to eat, and they slept in dormitories or with relatives—or in the car if they

had to—and drove for long stretches of sixteen or eighteen hours. They debated at Black schools in the South, driving all the way to Tallahassee, and then up to Hampton in Virginia and Morgan State in Baltimore. Over time Barbara and her teammates became practiced travelers, and they figured out how to get in and out of new places with confidence. Jordan met discomfort and segregation on these trips, but she was respected as a woman member of the team. Despite complications and racial discrimination, for her, travel meant freedom.

One of the most important lessons Jordan learned from Freeman was how to frame a persuasive speech. In the opening statement, recalled King, Freeman taught his debaters to establish a general premise or general principles that everyone could agree on (such as "we want to live in a safer world"). Second, show that your argument fits into that premise. The closing, the perorations, should always return to the beginning question. In her speeches as a politician, Barbara used this effective, persuasive technique. Her legal training schooled her in using evidence, but debate gave her an early foundation in persuasion.[53]

The debaters rarely took on issues directly related to race. King remembered that many of the subjects concerned Cold War politics, the politics of Greece and Cyprus, and whether Hawaii and Alaska should be admitted as states. The duo traveled with their own stack of *Time* magazines as a source of information. When he and Jordan debated as a team, they had different roles. She spoke first, and he followed with rebuttal and defense. They collaborated to organize the structure and reasoning of their arguments. For King, the biggest impediment to their success was not the intellectual challenge but their lack of experience in "being in the circumstances," that is competing at larger, white schools. The Jordan-King team knew they had to impress skeptical white judges. "One of the things we had to deal with at that time was the idea that we knew that to win we had to be SO good that there could be no question. We felt that the judges—all white—were not so prejudiced against us that they would take it against us if we had clearly won, but we felt that if it were close, they would. So we felt that we would always, always be really really good. We worked at doing that."[54] Debate schooled Jordan on the realities of competition, the importance of being prepared, and the fact that she and her partner were always competing against a headwind. Never could they assume; always must they be prepared.

The racial pressure started on the road and continued with their arrival at the tournament. On one occasion, Texas Southern was the only Black team participating in a debate at Baylor University in Waco. King and Jordan shared the

drive in one car, and Freeman took the rest of the team in his. The two groups got separated. King remembered, "When we got to Waco we didn't know where we were supposed to be . . . so we were registered downtown at the Roosevelt Hotel and we walked through the front door, and people look up and are amazed." After they got settled into their accommodation, Freeman just laughed. "I knew you'd work it out."[55] At another tournament in Waco, Barbara competed against white women for the first time in a one-on-one oratorical contest. She won first prize, and she thought, "Why you white girls are no competition at all. If this is the best you have to offer, I haven't missed anything."[56] When the Jordan-King team debated competitors from the University of Chicago, however, King was especially nervous. That debate, he recalled, "was a real turning point in my confidence and myself because we had heard so much about the University of Chicago. I was personally scared to death." The two worried that their opponents would talk over their heads, but "we really cleaned their clock."[57] The pair realized with pride that they could compete with white students from the nation's best universities.

Their success brought national recognition. In March 1956, Barbara Jordan and the rest of Texas Southern University's debate team returned to Houston in triumph after touring a series of Midwestern schools where they competed with students from the University of Illinois, Northwestern, the University of Chicago, Cornell, and Purdue. The Texas team earned several medals from the "Big 10" debate at the University of Iowa, where Jordan and King tied for first in the "discussion" category, and Jordan placed third in oratory. An admiring article in the *Chicago Defender* displayed a photograph of Barbara Jordan accepting the team's medal.[58] While at the competition, Jordan commented on the debate for a local radio and television station. Her poise, confidence, and team leadership made her stand out from the crowd.

Later that April an even more memorable contest occurred when Jordan and King debated a traveling two-man team from Harvard. The event, vividly remembered by at least two of the debaters, pitted Jordan-King against Jared Diamond (now a Pulitzer Prize–winning geographer) and his partner, Harvard student Jim Sykes, who hailed from Odessa. Diamond recalled that the two came to Texas as representatives of the Harvard Debate Council, ready to compete with any institution willing to contribute money toward their travel expenses. At this tournament, Texas Southern provided the judges, and the four young people held the debate at the Texas Southern campus. Diamond remembered

the debate as resulting in a tie but also wrote that his partner told him at the time that he believed they should have won.

Jordan had a different view. In a draft of her 1977 Harvard commencement address, Jordan prefaced her remarks by noting that she "didn't understand why representatives of this school so revered by me would come to debate TSU, a school whose sole reason for being was to keep blacks out of the University of Texas." Jordan omitted this reference to segregation from her formal address, but in her final remarks claimed retrospective victory. "The judges' decision was that the debate ended in a tie," she told the Harvard graduating class. "It occurs to me that if Harvard students were as superior as everyone thought, they should have won. If the score was tied, *we* must have won. So before beginning my speech I hereby declare . . . that in a debate between Texas Southern University and Harvard University, Texas Southern won. If you have any surplus trophies around, I will take one home to the team." Jordan smiled when she spoke, but her joking masked not only her competitive nature but also her mixed memories of segregation.[59] She resented the assumptions that deemed students at elite white schools more intelligent than those who attended Black ones. Characteristically, she kept that resentment under wraps.

In 1959 James Baldwin, who grew up as the son of a preacher in Harlem, wrote, "I remembered myself as a very small boy already so bitter about the pledge of allegiance that I could scarcely bring myself to say it, and never, never believed it."[60] Jordan's world in Black, Cold War Houston either did not permit such feelings or forced her to push them down. The experiences of Jordan and her Houston peers gives another voice, another angle, to Black culture during the Cold War, which pushed talented young people into higher education and individual achievement. Jordan stood on the firm foundation provided by neighborhood schools and optimistic Black teachers. She saw living examples of determined Black leadership in her proud pastor and in Black professionals such as Exa Hardin, Edith Sampson, and Dr. Thomas Freeman. As a college student she had triumphed over white students, both men and women, in debate contests. By the time she finished college in 1956, Jordan retrieved her old ambition to emulate Edith Sampson and decided to attend law school at Boston University.

She could have stayed in Texas. Although the *Brown* decision failed to change business as usual in Houston's segregated schools, the University of Texas law school had begun to admit Black students. But Austin, the city, as well as the

University of Texas, still enforced segregation in student housing and accommodations. None of that appealed to Jordan, who had already traveled outside of Texas. She set her sights on Boston because it was the city associated with Harvard, her ideal of excellence, but also because BU was known for admitting Black students. She would live in an integrated dorm. Her perspective on race was neither acquiescent nor conservative but cautiously optimistic. She believed the racial situation in 1956 called for Black Americans to prove themselves, to show that they could compete and that they could thrive in any environment. "I woke to the necessity that someone had to push integration along in a private way if it were ever going to come. That was on my mind continually at that period—that some Black people could make it in this white man's world, and those who could had to do it. They had to move."[61]

The Unknown Road

Pursuit of Independence

What in the world, Barbara Jordan, are you doing here?
—Barbara Jordan, 1956

In the fall of 1956, Barbara Jordan spent three days driving to Boston with two Houston acquaintances, Issie Shelton, who was also planning to study law at BU, and George Turner, a TSU student who had been accepted by Andover Theological Seminary. Jordan rode in the back seat along with the trio's luggage and a case of motor oil. This journey felt different from her road trips with the TSU debaters, when travel meant cheerful singing, a medal ceremony, and a triumphant homecoming. As Houston receded and Jordan thought about not seeing home again for nine months, anxiety about the unknown road she had chosen crept in. On her first night, alone in a temporary dorm room, she thought about driving around in Houston with her sister Bennie, drinking beer and eating barbecue. As usual, Jordan had a conversation with herself, working out her feelings. Wouldn't she be happier at home? Her ambitions now seemed somewhat misplaced. As she lay awake, she asked herself, "What in the world, Barbara Jordan, are you doing here?"[1]

Boston had been her dream. To her the city represented freedom from segregation, although she was uncertain what that meant in practice. A city of 1.7 million people, Boston had almost twice the population of Houston, but the number of Black Bostonians hovered at 60,000, far fewer than the 200,000 Black residents of Houston.[2] Black Bostonians lived in three distinct areas that had different histories, yet they all suffered from racism, de facto school segregation,

and a lack of political power. In the 1950s Black Bostonians put their political energies behind John F. Kennedy, who had worked for civil rights as a congressman from Massachusetts and pioneered what one historian called a new approach to "black electioneering" in Boston.[3] Kennedy reached out directly to Black voters, and their overwhelming support sent him to the Senate in 1954. Historians now see Kennedy's racial outreach as calculation rather than absolute commitment, but at the time he succeeded in persuading many Black Bostonians of his belief in civil rights, an impression that would stay with Jordan her whole life.[4] Boston was a city that attracted ambitious Black southerners such as Martin Luther King Jr. and his future wife, Coretta Scott, who had both graduated before Jordan arrived but who maintained personal ties with the city. How Barbara Jordan could fit in to this new urban racial mix, and with whom, remained to be seen.

Boston University's law school was located at 11 Ashburton Place, in Isaac Rich Hall, an imposing former Congregational church built in 1896 and named after one of the university's founders. To Jordan's surprise, it was located downtown, several miles from her dorm. She took the streetcar and then had another surprise when she saw Beacon Hill. "That was a hard climb," she remembered.[5] The impressive, granite, three-story building with a classical exterior was a far cry from anything at Texas Southern. It had large lecture halls, a spacious law library on the second floor, seminar rooms, and an area in the basement for general student use. Adjacent to the Boston courthouses, Isaac Rich Hall was no "ivory tower"—its central location on Beacon Hill placed its ambitious law students close to the city's legal and business communities.[6]

On orientation day she walked into an auditorium and saw an entering class of around 250 students, all white men except for six white women, several Black men, and two Black women: herself and Issie Shelton. When Barbara expressed interest in the law review, Issie chuckled, understanding better than did Barbara at the time the academic challenge that awaited them both.

Boston University was the first law school in the nation to require an admission exam and offer a three-year course of instruction. In the early 1950s, BU revamped its curriculum, increased the number of required courses, and allowed for only two electives. In addition to torts, contracts, property, and procedure, first years learned legal history, legal ethics, attorney-client relationships, and legal writing. The second year focused on trusts and estates, wills, and estate planning. Seminars throughout introduced students to the enactment

and interpretation of legislation, the drafting of papers in real estate transactions, labor law problems, negotiations and drafting of commercial instruments, personal injury practice, planning and administration of estates, and social legislation. Course grades were determined by a single final exam, and students needed an average of 75 percent to pass.[7] Out of the entering class, only 117 made it through, and the only two women to graduate from the Boston University School of Law class of 1959 were the two Black Houstonians from Jack Yates and Phillis Wheatley, Issie Shelton and Barbara Jordan.

Jordan's nebulous ideas about law school soon dissolved. She felt some familiarity with divorce law and criminal law, but first-year courses focused nearly entirely on corporate law. "Contracts, property, torts, were strange words to me. Words I had not dealt with. And there I was."[8] As a winning debater, she had thrived in a male environment, but now she felt left out. Women "were just tolerated. We weren't considered really top drawer when it came to the study of the law."[9] Edith Sampson, her Black female role model, had exuded confidence and optimism. But now Jordan learned that she was expected to be something other than what she was: a professional man. "When a man enters law school," wrote Dean Ellwood Hettrick, "he crosses a bridge over a very substantial divide. . . . The law school is not simply an extension of college but is the beginning of the profession."[10] Did she have a place in this profession? Could she even compete? On the first day of class, Jordan's contracts professor marched down the aisle and told everyone to say goodbye to their boyfriends and girlfriends "because you won't see them anymore this semester. But don't tell them you will see them later, no, tell them you will see them subsequently. You have to learn to talk that way."[11] For the first time in her life, Jordan experienced serious self-doubt.

She began to think more deeply about the consequences of segregation. Pondering her previous education, Jordan levied some pointed criticisms at Texas Southern University. "My deprivation had been stark," she stated in her autobiography. "I realized that the best training available in an all-Black instant university was not equal to the best training one developed as a white university student. Separate was not equal; it just wasn't. . . . I was doing sixteen years of remedial work in thinking." Looking around, she saw that many classmates had prior experiences in law offices or with family members who practiced law. She realized how family ties and class background tipped the scales: "It was not a matter of trying to catch up. You couldn't. . . . It would take a lifetime. I'd have to be born again and just come from another mother's womb. . . . My whole life

would have to be different." Even her experience in debate seemed inadequate preparation. "In the past I had got along by spouting off . . . speechifying . . . but I could no longer orate and let that pass for reasoning." Jordan examined her educational and family background and, at that moment in Boston, she found it wanting. It must have been a brutal time.[12]

Some of her Houston peers took issue with Jordan's harsh assessment of their college education. Otis King and Andrew Jefferson, TSU graduates, both attended law school at the University of Texas at Austin and did well. King, being philosophical, said, "Law school is such a change . . . almost nobody is prepared for law school. . . . There's nothing you've done before in your life that is parallel to this." He realized that law school had very little to do with building on knowledge from his undergraduate major. Andrew Jefferson contradicted Jordan's assessment of TSU. "I never felt ill prepared," he said flatly. "I just don't agree with her at all, I just don't."[13] Jordan's interpretation of her situation may have been rooted in her initial isolation and her realization that for the first time in her life she faced a true academic challenge. She had sailed through college, easily balancing her studies in government with debating, editing the yearbook, and socializing with her sorority sisters. Now she faced an unfamiliar academic challenge alone in a new city.

Racism and sexism affected all the TSU grads who attended law school but in different ways. Andrew Jefferson was compelled to live in a segregated male dorm in Austin, a former army barracks, apart from the other law students: "I know there was a disadvantage in not being able to eat, sleep, and talk law. Lunch rooms were [also] segregated." Although Jefferson got a job on Austin's "strip" and then at the post office, he spent a lot of his social time with other Black students on the east side of town; he even started attending a Baptist church instead of his usual Congregational church. It was even worse for Black women students. Jefferson remembered that "they didn't have any place on campus."[14] They lived so far away, the university sent a station wagon to pick them up every morning. Black students like Andrew Jefferson in Austin still lived under the thumb of segregation, but being close to home, and being part of a larger Black community in the city, made the situation familiar and bearable.

Jordan also felt isolated, but for different reasons. She lived in an integrated women's dorm on campus, not in Boston. She had little basis for connection with the city's Black residents. The only other woman law student in her dorm, Louise Bailey, who was white, did not concern herself with studying. Bailey,

Jordan was astonished to find, always had the latest copy of *Redbook* magazine and did not mind if professors caught her ill-prepared during class.

Jordan did care. For her, law school was a do-or-die situation. Her dignity, and her family's finances, hung in the balance. How could she tell her father, who had spent his hard-earned savings on her tuition, or her sisters, who each sent her ten dollars a month for spending money out of their small teacher salaries, that she had "punched out?" It was unthinkable. She was not invited to join existing study groups, and she floundered: "I did not want my colleagues to know what a tough time I was having understanding the concepts, the words, the ideas, the process. . . . So, I did my reading not in the law library, but in a library at the graduate dorm, upstairs, where it was very quiet." Jordan kept to herself. After taking her first exam in a half-credit course in criminal law, Jordan went to the movies alone and rehearsed how she was going to tell her father that she had failed law school. To her relief, she received a passing grade, 79 percent, but she still spent most of the fall worrying and feeling lonely.[15]

Integration was no picnic. Her relationship with Bailey, which she recounts in *Barbara Jordan: A Self-Portrait*, is an acute, painful recollection of insensitivity that added to her first-semester confusion. Louise, Jordan reflected, was "a typical rich white girl" who had sought Jordan out on their first day in the dorm. Well connected (her father was chairman of the Massachusetts Democratic party), friendly, and outwardly open, Louise seemed to be a potential friend, and Jordan was initially thrilled when she saw Louise's beautiful car, a Black Lincoln. "I was out of my skull" with excitement, she remembered. Soon, however, Jordan felt crushed by Louise's breezy insincerity and insouciance. "We would not be driving around, I knew that," she recalled. Oblivious to Barbara's financial straits, Louise casually borrowed ten dollars one weekend, leaving the young Houstonian to wonder how she would get to class if Louise forgot to pay her back on Monday. When the Christmas holidays came, Louise went home without inviting Jordan, who had to move to a temporary dorm. The rejection felt even more hurtful because it seemed that Jordan had a crush on Louise. Even after these slights, Jordan continued to walk up to Louise's attic room in their dorm to talk about their law cases, but found her friend "always reading *Redbook*." These incidents reveal the sting of both personal and racial rejection, and they uncharacteristically lingered in Barbara's mind. Jordan, who was very careful later in life never to voice any criticism of the slights directed her way, was not so thick-skinned as a young law student.[16]

Jordan eventually found friendship among a small group of Black BU students. Beginning in the spring, they met for regular study sessions at an off-campus apartment. These gatherings helped Barbara academically and socially. She laughed at the stories some of the men shared about their adventures in Boston, and she enjoyed the camaraderie. "We would just gather and talk it out and hear ourselves do that. . . . Once you had talked it out in the study group, it flowed more easily and made a lot of sense."[17] The friends ate together or went out for pizza. Jordan got out to see a bit more of Boston, although she disliked walking. "She wouldn't go out to eat with us unless we could afford a cab," her law school friend Bill Gibson recalled.[18]

Jordan's classmates included Maynard Jackson (the future mayor of Atlanta), Clarence Jones (future attorney to Martin Luther King Jr.), Issie Shelton Jenkins, and Oscar Wasserman, a future tax and real estate attorney in the Boston area. Jordan and Wasserman, a white man, struck up a friendship that lasted.[19] Half a century later, Wasserman fondly referred to a picture he still had of him and Jordan, and remembered her interest in and appreciation of his Jewish faith. Like many of the other male students, Wasserman had served in the army before he went to BU for his undergraduate degree. A few years older than Jordan, he focused on the law as it related to business, real estate, and taxation. He thought of himself as a conservative, and yet he was certainly aware of racism. He and Clarence Jones studied together on Saturdays, and it may have been through Jones that Jordan met Martin Luther King Jr., who had graduated from BU in 1955 with a divinity degree. According to Wasserman, Jordan had met the young civil rights leader several times and had mentioned her positive impressions of the man. Wasserman also recalled that, during their student years, Sen. John F. Kennedy spoke at the BU campus. Wasserman thought Jordan was mainly concerned with what he called social issues; she had a political bent: "She was concerned about people and civil rights." Jordan must have commented on the poverty and segregation she knew in Houston because he remarked, "Texas—you couldn't have a worse place to grow up."[20]

Jordan enjoyed friendly relationships with the other women in her dorm who were not law students but who supported each other regardless of race or class. Over the course of three years, she settled into her room at 2 Raleigh Avenue, located a short walk to the Charles River, right in the middle of the Back Bay, one of the nicest areas of the city. The large communal residence, formerly known as the Arthur Little House, had a warren of rooms, some singles

and others shared. The house residents interacted daily in the spacious living areas and bathrooms. The women had access to a kitchen, a small library, and various quiet places to study. Jordan's relationships with the women in her dorm blossomed. When she became a congresswoman, she received many warm letters of congratulations. Her roommate during that first year, LaConyea Butler, or "Connie" as she was known, later a psychology professor at Spellman College, remembered Jordan with great pride: "I'm sure you haven't forgotten that when we were roommates at BU we all said that you were destined for great things—that we knew we would be hearing from you later."[21] Some of the housemates overlapped with Jordan for only a year, but they still wrote to congratulate her and remark on her work ethic. "I recall how hard you worked and studied and made my conscience bother me because you were studying when I was leaving for a concert."[22] Many of the women had lost touch over the years but still retained good memories of their time together in the dorm. One housemate sent Jordan a group photo of the women in the house.[23] After her election to Congress, Barbara made time to have lunch with Vera Katz, a theater professor at Howard, Norma Scott, another one of her roommates, and Dorothy Clark. "It was quite a reunion," wrote Jordan with evident pleasure.[24] These women, white and Black, came from different religious and geographical backgrounds, including Illinois, Georgia, and Alabama. Jordan, who was seen as "one of the boys" on her debate trips, had no problem being "one of the girls" in her dorm. She clearly felt comfortable in the integrated, female, group setting.

That openness drew her toward the spiritual community at Boston University's Marsh Chapel, led by the Black theologian Howard Thurman.[25] Thurman had come to Boston in the fall of 1953 to develop a larger version of his interfaith, integrated, and multicultural Fellowship of All Peoples church, which he and his wife, Sue Thurman, had started in San Francisco. Thurman's services sought to provide a setting for true community, a meeting of souls through meditation, music, dance, and the spoken word. He reached out to students and the academic community to create a new religious experience. From the start of her second year, Jordan attended Thurman's weekly Sunday services and found herself rediscovering religion. Howard Thurman's words echoed in her head and changed her. "I would carry the program home and often preach his sermons to my roommates once I got back, whether they wanted to hear them or not. I was making sure I had it all. If I could preach it again, I really did have it."[26] A sermon by Howard Thurman was a carefully crafted emotional and intellectual

experience. He inspired a generation, including Martin Luther King Jr., and his effect on Jordan rippled through the rest of her life.

Jordan arrived in Boston ambivalent about religion, particularly the Baptist Covenant, which she saw as a "mode of prohibition" designed to provoke guilt. She loved Good Hope Missionary Baptist Church but chafed at the memory of her strict religious upbringing. "I do not recall joy related to my experiences of these years at church," she reflected later in life. "What I got from them was a charter, a single plan offered to you that you must fulfil because that was the only acceptable way. . . . It was a confining, restricting mandate."[27] Exactly right. Black Baptists in Good Hope's congregation supported a strict code so that their children developed the mental fortitude required to rebuff white racism. But Howard Thurman had a different approach to navigating the slings and arrows of the outside world.

Thurman's spiritual message, derived from hard personal experience with poverty, segregation, and racism, offered Jordan another path to asserting human dignity in a white-dominated world. Born in 1899, Thurman suffered through the ignominy of his father's early death, his mother's work as a washing woman, and the brutal inequality of life in Daytona, Florida, where the local Black public school ended in the seventh grade. He drew strength from the example of women in his life, particularly Mary McLeod Bethune, whose school served the Black poor in Daytona.[28] Thurman gained a scholarship to Morehouse College. As a young man he traveled to Haverford College to study with a Quaker mystic, and then attended Rochester Theological Seminary where, after great soul searching, he lived with three white male classmates and integrated that university's dorms. In and around Rochester, he was often the first Black minister to preach to white audiences and recalled facing threats of white violence. After graduation he kept moving: first to Howard University, and then to Asia and India, where he met Mohandas Gandhi. Hindus and Buddhists pressed him: How could he profess faith in Christianity when Christians had enslaved and murdered his people? He replied that "the religion of Jesus projected a creative solution to the pressing problems of the minority of which he was a part in the Greco Roman world. . . . Jesus Christ is on the side of freedom, liberty, and justice for all people."[29] In 1949 he published *Jesus and the Disinherited*, a text that inspired Rev. Martin Luther King Jr. during the Montgomery Bus Boycott.

Thurman's services at Marsh Chapel allowed Jordan to experience how the power of words, spoken by a Black minister, could unite people from all

faiths, races, and ethnicities. On Sundays at Marsh Chapel, she joined with Boston locals and students and professors from surrounding colleges including Wellesley, Northeastern, Harvard, Simmons, and Tufts. In the years that Jordan attended Marsh Chapel between 1957 and 1959, Thurman delivered many of the sermons that defined him as a compelling moralist and theologian. These included excerpts from "Jesus and the Disinherited"; six sermons called "The Moment of Crisis," which addressed the moral dilemmas of individuals in history, including Abraham Lincoln; and another series called "The Moment of Truth," which pondered the choice between whether to be unknown and anonymous—and thus "free"—or to satisfy a yearning to contribute to a larger community and to life.[30]

A Black southern woman living and studying alongside whites in a northern city, Jordan might have been particularly drawn to Thurman's thoughts on the complexity of multicultural communities. Jordan had grown up in a protective, almost cocooned environment in Houston. She wanted more, but reaching out meant risking rejection and failure. Thurman made those risks seem warranted, even necessary. He warned that "the community cannot feed for long on itself; it can only flourish where always the boundaries are giving way to the coming of others from beyond them." We belong to each other, he said, and "if we shut ourselves away, we diminish ourselves."[31] Trained in homiletics at Morehouse College, Thurman paid attention to the sound of his words and the rhythm of his cadences, but his delivery was even-toned, certainly not bombastic. He wanted his congregation to think about their daily moral choices. Jordan appreciated how "Howard Thurman focused on how we walked around every day; he did not try to get us to live because of the great lure of something beyond."[32]

Thurman believed that religion had to speak directly to the dilemmas faced by those who lacked power. In his sermon "Jesus and the Disinherited, Part 1," he pondered the "relevancy of compromise in living one's life." Did people have meaningful choices? And was deception an acceptable way to respond to oppression? Thurman insisted that such questions were relevant to everyone, not just the poorest. Any individual who disagreed with injustice, he argued, "who abides in a society of which he cannot fundamentally approve . . . lives his life on the basis of compromise." So, if everyone compromised, he continued, the issue was not whether to do it. Instead, every individual had to ask themselves, "Where do I draw the line? And what does God require of me?"[33] Sometimes circumstances demanded action, which included speaking out.

Throughout her life, Thurman remained an enduring example to Jordan of the power of the spoken word to change minds for the cause of justice. "Many good causes are hindered," he said in one sermon, "because those whom it behooves to speak remain silent. . . . There is no limit to the power of any single voice when that voice is the only outlet, the only channel for justice or righteousness in a given situation." Thurman preached a gospel of moral confidence. Individuals could make a difference. "Do not be silent," he urged. "There is no limit to the power that may be released through you if you speak."[34] Quoting extensively from Lincoln's Gettysburg and Second Inaugural addresses, Thurman drew attention to that president's evolving thinking on slavery and how he framed the Emancipation Proclamation as a great moral choice. Listening to Thurman likely inspired Jordan to visit the collection of "Lincolnalia" at Boston University's Chenery Library. There she would have seen on display the quotation from Lincoln that she used to end her 1976 speech to the Democratic National Convention: "As I would not be a slave, so I would not be a master. This expresses my idea of democracy. Whatever differs from this to the extent of the difference, is no democracy."[35]

Thurman did not offer pat answers to moral dilemmas, but he did offer guidance as to how individuals could navigate injustice with integrity. Facing dilemmas was part of life. He helped Jordan to think through thorny real-life quandaries, which involved venturing into integrated settings while still holding fast to Black culture and identity: "One thing for us is true. The future is never quite a thing apart from all that has gone before. We bring into the present ingredients and precious cargoes from the past and these are with us as we take the unknown road."[36] As Jordan said, "His sermons were focused on the present time that all of us were having difficulty coming to grips with."[37] He gave guidance about compromise that raised it above mere acquiescence to injustice. His focus on moral reasoning as a guide for making choices, rather than strict obedience to a set of rules, appealed to Jordan. Thurman's teachings finally allowed her to believe in Christianity as a meaningful force for personal liberation.

Thurman's influence on Jordan was so profound that, in her last year at Boston University, she engaged in serious self-reflection about whether she should leave law school for the field of theology. She wrote to her father about her thoughts, and he called her immediately, "ecstatic" at the prospect. His mother, Mary Jordan, he told her, had been a missionary, and perhaps he saw some of that fervor in his youngest daughter. Barbara quickly realized that her

family's view of the ministry differed dramatically from what she might have hoped to pursue. She decided to stick with law school.

When she received the final computation of her grade-point average and saw that she had passed, she invited the Jordan family to come up to Boston to celebrate her law school graduation. Her father, mother, and two sisters drove up, and along with thousands of others watched Jordan walk across the stage in the Boston Garden to receive her diploma. That night, alone in her room, she opened the scroll, saw her law degree from Boston University, and cried. "Well, you've done it," she said to herself, "you've really done it."[38] Barbara remained in Boston for the summer to study for the Massachusetts bar exam. Now she debated with herself over another decision: whether to stay in Boston or return to Houston.

Houston had lost a bit of its luster. "It was so flat," said the new lawyer, who climbed Beacon Hill every day. "I couldn't get oriented to the flatness." And her home on Campbell Street could not compare with the grandeur of Boston's Back Bay. "Why is this ceiling so low?" she noticed about her family's home. "It's closing in on us."[39] But the real issue was racism: "It was the whole integration thing; that was just it. I thought: The air is freer up here. I'll stay here and not go back to Texas."[40] Toward the end of her second year, a helpful law professor suggested that she talk with Edward Brooke, the Black congressman from Massachusetts. The interview did not lead to any further contact. She considered taking a job at a large insurance company in Boston. However, when confronted with the tiny cubicle in the John Hancock tower, she walked away. It seemed an apt metaphor for what she did not want to be: a small fish in a vast ocean. No one in Boston, she concluded, "was interested in Barbara Jordan." Maybe, she thought, it made more sense to go home "where people will be interested in helping you."[41] When she told her mother her decision, Arlyne revealed that she had been praying for such an outcome. Jordan laughed. She was not a believer, like her mother and father, but she shared their faith in her own abilities.

Jordan returned to Houston. Boston had given her a knowledge of corporate law, practice in the intricacies of integration, exposure to up-and-coming Black professionals, and a new moral compass. She passed the Massachusetts bar, and in the fall of 1959, she studied for the Texas state bar exam, passed it, and became one of only three Black women lawyers in the state of Texas.[42] Her friend Andrew Jefferson started his own law firm with his brother-in-law, George Washington, but Barbara was on her own. Men and women attorneys did not work together in the same law firm. She gained a few clients from Good Hope and began to

work out of her parents' dining room in their Fifth Ward home on Campbell Street. She was twenty-three years old.

While Jordan was in law school, the city of Houston had bowed to legal pressure and integrated city busses, public libraries, and golf courses. Black firemen had been hired. As for politics, 1958 saw the election of a Black woman, Hattie Mae White, to the Houston school board. White became the first African American since Reconstruction elected to office in Harris County. Her election held immediate, not just historical, relevance.[43] Four years after the *Brown* decision, Houston's school board continued to ignore the Supreme Court's order to integrate "with all deliberate speed." White, a well-known supporter of school integration, won office with overwhelming Black support but also received a significant percentage of white votes. As the *Houston Post* put it, "Voters integrated their school board yesterday in one of the most surprising elections ever recorded here."[44] The largest segregated school district in the nation now had a Black representative.

Hattie Mae White was an educated, polished and dedicated teacher, wife, and mother of five children, who emerged as a race leader and spokeswoman because of her work with the YWCA and the Black Parent Teachers Association. She epitomized outspoken middle-class respectability. Born in 1916 in Huntsville, Texas, White moved to Houston when her mother remarried after the death of her father, a minister. She attended Booker T. Washington High School, graduated from Prairie View Agriculture and Mechanical College of Texas, and taught home economics before she married Dr. Charles White, an optometrist. Her children were born during the 1940s and early 1950s, and she explained that her role as a mother stoked her conscience over the injustice of segregation. When her oldest son asked why they could not stop at a place to have pony rides, "I just couldn't tell him we could not go there because we were Negroes." White acknowledged that her class status to some extent protected her against white abuse: "It wasn't until I saw my own children growing up in a segregated world that I really objected. I guess it's natural for people to be more willing to accept injustice for themselves than for their children."[45] She began to devote herself to the PTA and was the first African American to serve on the board of the Houston YWCA. When an ad hoc organization of parents, community groups, and the NAACP sought to challenge the school board's refusal to let Black children attend "white" schools, Mrs. White emerged as the spokesperson, and her televised presentation to the school board was met with acclaim.

Her appearance demonstrated the power of television to dispel racist stereotypes. One white viewer told the *Houston Post*, "Mrs. White gave by far the most lucid and compelling talk before the school board that night. She had the facts—statistics on Negro teachers' heavier student loads, the lack of libraries and kindergartens in many Negro schools, and many other inequalities—and she delivered them beautifully." She was described as "an educated, intelligent, attractive Negro."[46] However, her speech did not change policy. The board continued to ignore the petitions of Black students. Resistance to school integration seemed to grow, and the legal deadlines for the board to come up with a plan stretched several years into the future. In response Black community groups encouraged White to run for a vacant seat on the board. Her husband agreed to support her. Her statements to the press were firm but measured. The school board, she averred, perhaps had not known the extent of the problems in underfunded Black schools. She was running "to make a positive contribution to peaceful desegregation."[47]

White ran a "well organized campaign." The process of running for the school board, however, demonstrated the electoral barriers designed to keep minority candidates out of office. In the 1958 race there were three vacancies on the board, but the winners were not the three top vote-getters. Instead, candidates chose to run against designated opponents in a "place" system. Voters did not get to choose their top preferences but were only allowed to vote for a favored candidate in three races. Withholding votes from others, and only voting for one candidate, known as "single-shot voting," could not be used as a strategy to help the minority candidate. Place voting was implemented to prevent minority groups from concentrating their votes in one basket.[48] Voters could cast ballots for up to three candidates, but regardless of the total votes she received, Hattie Mae White had to gain more votes than the opponents running for her "place." In 1958 she entered a race against two conservative segregationists, and to the great surprise of the city, she won with a plurality.

Most of the press coverage about "Mrs. Charles White," as she was also called, emphasized her charm, education, light skin, calm demeanor, and middle-class status. And yet her election ignited violent resistance. A few nights after her victory, someone burned a five-foot-tall cross on her family's front lawn.[49] Her car was shot into.[50] Undeterred, White downplayed the violence, telling the press, "Certainly it was no reasonable citizen. I'm sure it doesn't reflect the sentiment of the people." During her first school board meeting, which was televised, she

calmly refused to go along with a "vote of confidence" for an administrator who admitted to padding his budget with fake receipts. Partly because of her intervention, he resigned. She pursued an antiracist, pro-integration agenda, and she defended the public schools against conservative attacks fueled by anticommunist extremism.

With no Black representatives on the city council or in the Texas legislature, White remained the lone Black elected official in Houston until Barbara Jordan's 1966 election to the legislature. Her victory was thus a milestone that indicated the growing power of the Black vote, as well as the beginnings of white support for integration. Her victory also showed that a Black woman could emerge as a recognized leader of Black Houston. White was not tied to any political party; she represented concerned parents, and her political reach could not extend beyond the school board. Nevertheless, she emerged as an important public voice.

Since *Smith v. Allwright*, working-class Black women in Houston had also been dedicating themselves to politics. The Black women in the Fifth Ward Civic Club, formed in 1947, worked to increase Black voter registration and encourage payment of poll taxes. Helen Glover Perry, the club secretary, was born in Houston's Fifth Ward in 1920. Her mother operated several small businesses, and after Helen graduated from Phillis Wheatley High School, she moved to California during World War II to work in the defense industry.[51] She returned to Houston, married postal worker John Perry, and became a successful cosmetics saleswoman. Unlike Hattie Mae White, Helen Glover Perry never went to college, and she was not middle class. But she served as secretary of the Fifth Ward Civic Club, volunteered for the Red Cross, and joined the Houston NAACP. The photos Mrs. Perry donated to Houston's Metropolitan Research Center archive give a unique perspective on working-class Black community life and activism under segregation and show a nearly all-female voting membership of the Fifth Ward Civic Club.[52]

The class differences among Black Houstonians, such as that between Hattie Mae White and Helen Glover Perry, illuminate the different cultural and social worlds of Black Houston that Jordan, who was now a college-educated professional who still lived in the Fifth Ward, began to bridge. Hattie Mae White lived in her own two-story brick house in the Third Ward with her optometrist husband and five children. Perry's photos, however, testify to the crude physical conditions of the poorer Black neighborhoods in Houston, where Black income was less than half that of white Houstonians.[53] She and her husband, both

gainfully employed, lived on an unpaved street in the Fifth Ward replete with shotgun shacks and outdoor toilets. A rare photo shows John Perry with the couple's pet rooster, "Baby," inside their tiny house with a low, slanted, wooden roof, clothes hung from interior lines.[54] Many homes in the Fifth Ward still lacked basic sanitation and running water. Though their physical circumstances were a far cry from the elegant homes of the Third Ward, near Texas Southern University, or even the solid respectability of Reverend Lucas's abode, all the residents of the Fifth Ward, including the Perrys, identified as members of this proud community. The Perrys enjoyed the cultural riches of their neighborhood. In the evening the couple, like many of their neighbors, gravitated with their friends toward the Fifth Ward's many clubs and restaurants. They danced at the El Dorado, feasted on steak at Reed's, or listened to music at the Bronze Peacock. There are photos of Mr. Perry at work at the post office, of Helen's various social events, young men dressed as Uncle Sam for the Fourth of July, and photos of Houston Boy Scouts excitedly going by train to California to participate in the organization's annual jamboree. The Perrys and their friends formed an intersecting web of social and political networks.

Throughout the 1940s and 1950s, Black women of all classes in Texas worked for progressive candidates. They wrote poll tax receipts and worked for precinct judges.[55] In the 1940 NAACP convention at Good Hope, Walter White presciently suggested that Black voting would encourage white politicians to abandon racist rhetoric. In 1952 Black Houstonians helped to elect a white progressive mayor, Roy Hofheinz, and they also supported Governor Preston Smith, whose wife wrote a note of thanks to Perry.[56] Politics lived inside the lively, vibrant social spaces central to Black urban life in Houston, where it was common to see Black women with their books, accepting poll tax payments. "Everybody wanted to get out, to go to the music—gospel in the churches, rhythm and blues in the city. The wages were low, and the music talked to the people." So said award-winning bluesman Johnny Copeland recalling the Houston of his youth in the 1950s: "There were hardly any televisions and only two black radio stations. KCOH and KYOK but dances were held on Monday, Thursday, Friday, Saturday, Sunday and sometimes Wednesday at the Eldorado Ballroom, Club Matinee, Diamon L. Ranch, Club Ebony, Shady's Playhouse, Double Bar Ranch, and Club Savoy."[57] A photo from 1961–62 shows Helen Perry sitting at the entrance to a Black nightclub where she registered African American voters and collected a $1.50 poll tax from every voter. For every person she registered, Perry received five cents.

Before Barbara Jordan came on the political scene, Helen Glover Perry and Hattie Mae White were the warp and weft of Black politics in Houston.

Even with the decline of the NAACP, Houston's Black civic clubs, business associations, and neighborhood organizations thrived and came together under an umbrella called the Harris County Council of Organizations (HCCO), a coalition committed to persuading elected officials to improve city services. The Black leadership in the HCCO was largely professional, middle class, and male. Black students were getting active too. In the spring of 1960, in the aftermath of the Greensboro lunch counter confrontations, more than a dozen students at Texas Southern organized a sit-in at lunch counters at the Houston bus station, the city courthouse, and Weingarten's drug store. The local student movement, which included Eldrewey Stearns, Holly Hogobrooks, and future Houston politician Curtis Graves, went forward with its first protest despite being discouraged by campus minister Rev. Bill Lawson. On Friday March 4, 1960, a group of seventeen students walked from campus to Weingarten's lunch counter and sat down, demanding to be served. As they sat, white customers left, and dozens of other Black students filled the empty stools. The lunch counter closed, the police arrived, but the students remained seated until the store shut down at 8:30 PM. They were not arrested, but they gained some publicity on the evening news as "the first sit-in west of the Mississippi River."[58]

Over the next eight months, scores of TSU undergraduates continued the protests. The *Forward Times* published several photos of the students, whose actions it commended.[59] Later in April the paper published more photo spreads of demonstrators at Wiley College in Marshall, Texas, and of student protests around the country.[60] Dr. Samuel Nabrit, the president of TSU, said he was proud of the students and refused to expel them. "We stand with our students," he stated unequivocally, a position that put his own job in jeopardy.[61] Like their peers across the south, Houston students wanted to use the sit-ins not only to integrate lunch counters but to leverage for bigger changes in the community. They agreed to suspend the protests while "community leaders" worked to resolve the issue. But these negotiations proved fruitless.

Impatient, the students regrouped to form the Progressive Youth Association (PYA) and staged further protests and sit-ins through May and June. But then all press coverage of the issue ceased. Houston's elite business community, led by Bob Dundas of Foley's Department Store and the publishers of the major newspapers in Houston, met and agreed to end segregation in stores, restaurants, and

public buildings quickly, without any publicity. Although the protestors had not been arrested, there were some reprisals from "local toughs," and one Black student from TSU had "KKK" carved into his stomach by Klansmen who kidnapped him. Determined to avert a "race war" akin to the 1918 riot, Houston's white elites, with the knowledge and cooperation of older Black leadership, including TSU's president Nabrit, gave the green light for change. Abruptly, "White only" signs disappeared in Houston, individual Black residents were invited to dine and sit in the city's eateries, and the most egregious examples of segregation in public accommodations and hotels came to an end. The lunch counter at Foley's Department Store was integrated in the presence of police—specially chosen African Americans were allowed to eat at previously segregated restaurants. The movement disappeared from the headlines, and segregation in Houston suddenly, and quietly, ended.[62] The businessmen of Houston had spoken. They did not want violence, bad publicity, or public protests to mar the city's image or disrupt the flow of commerce. The support of John T. Jones, publisher of the *Houston Chronicle*, nephew of Jesse Jones and president of the Houston Endowment, was crucial. In controlling the pace of integration, Houston's white business community established a pragmatic pattern of endorsing change only when inevitable, if deemed unavoidable, and implemented with the least disruption possible.[63] The student sit-ins forced the hand of local elites and drew more Black Houstonians into electoral politics.

Barbara Jordan must have observed the sit-in at Weingarten's, but like her fellow lawyer, Andrew Jefferson, she did not join in with the students. As an attorney she could not break the law. Yet she remained shut out from the mainstream legal profession. Her parents remained mystified about her next steps, and so was she. She lived with her parents and worked at home. She had her own business cards, and she drove a green Simca that her father had bought and for which she was slowly paying him back. Still, her church and her community expressed pride in her achievements. She gave speeches at local events, and shortly after the first sit-in at Weingarten's, on March 27, 1960, Good Hope celebrated the twenty-fifth year of Reverend Lucas's pastorship. Jordan was the sole luncheon guest speaker.[64] She was twenty-four.

Determined to be more independent, she took a temporary summer job teaching government at Tuskegee University in Alabama. Jordan saved that money, returned to Houston, and shared a law office in the Fifth Ward on Lyons Avenue with another Black attorney, Asbury Butler. Jordan found herself

between worlds. Too old to be a student, too inexperienced to be a professional, too poor to be independent, she was also a Black woman in a man's profession. Though she shared an office with Butler, she worked her cases on her own. Work was slow in coming.

The upcoming presidential election between John F. Kennedy and Richard Nixon drew Jordan into politics. Recalling her humble start in politics in the fall of 1960, she explained that "I was just a lawyer with no business and I was interested in the campaign . . . and I ended up in the Harris County Democrats office. Of course, nobody there knew me, but I just offered to do what I could do, so I addressed envelopes and I licked stamps."[65] The Harris County Democrats (HCD) had been organized in the early 1950s by white liberals and organized labor leaders who opposed the conservatives who then controlled the Texas Democratic party. When Gov. Alan Shivers supported Eisenhower for President, the HCD supported Adlai Stevenson and the platform of the national Demo-cratic Party. In 1960 they ardently supported Kennedy, as did Jordan, and used the presidential campaign to bring more Black voters into their movement to take control of the Democratic party in Texas. Jordan, who had known about Kennedy since her law school days, recalled that "I worked very hard for the elec-tion of the Kennedy-Johnson ticket in 1960 in Houston. And I was very enam-ored with John Kennedy."[66]

The Harris County Democrats had tried to win over Black voters in the past but with little success. Bob Hall, a labor lawyer and organizer for the progres-sive group, recalled that in the aftermath of *Smith*, white liberal activists had had little direct contact with Black citizens, preferring to go through designated middlemen, such as precinct captains or ministers: "The way that liberal white politicians had dealt with Black voters in the past, was like ambassadors going to foreign countries. They had a preacher, or an NAACP rep. There would be these surreptitious secret meetings, [we would] give over a handful of cash and they would agree to hand over their votes. It was disgusting and dishonest. We had been playing those games since 1952. We had to get past that."[67]

The 1960 Kennedy campaign in Houston decided to reach out to Black voters directly. Kennedy labor organizer Eddie Ball and Houston CIO head Don Horn asked the HCCO to send them somebody they could train to lead a voter registra-tion campaign, and the HCCO sent Jordan. Ball remembered his first encounter Jordan: "I met her then in 1960. I had never met her, didn't know anything about her, knew she was recently graduated from law school, Boston University and was

setting up a law practice in Houston." Jordan, "useless in the office," started accompanying him to public events: "Where she really was great was recruitment. She would go to a church, and make one of those speeches, and we'd have volunteers running out of there . . . people volunteering to be registration clerks. The results were phenomenal." He credited Jordan for the success of the voter registration campaign. Up until that time, only 15,000 Black voters in Harris County were registered, but in 1960, "we wound up with over 60,000 registered to vote."[68] Jordan enjoyed her work as an organizer. "It was a waste of time for me to lick stamps and address envelopes and be an all-around generalist. They [Dixie] decided that I ought to be put on the speech-making circuit for the Harris County Democrats."[69] She spoke to political groups, civic organizations, clubs, and churches. A new respect for Black voters in the Bayou city began to emerge within the Texas Democratic party, and more Black citizens became committed to voting.

Kennedy's national campaign expressed hope that increased registration could bring victory, while Lyndon Johnson's place on the vice-presidential ticket in 1960 drew Texas Democrats together. They knew they faced long odds. But Timothy May, a Kennedy advance man in Houston, said that his candidate could "win in Harris County (and in Texas) by concentrating on Democratic voters who didn't go to the polls in the last two presidential elections."[70] Thus Texas Democrats embraced voter registration as their main strategy. Kennedy made Houston the place where he publicly addressed concerns about his Catholicism. On September 12, 1960, in a room packed with ministers, he stated that "contrary to common newspaper usage, I am not the Catholic candidate for president. I am the Democratic Party's candidate for president, who happens also to be a Catholic. I do not speak for my church on public matters, and the church does not speak for me."[71]

Kennedy made a positive impression, but some Black business leaders expressed distrust of Kennedy's position on race. After Alabama and Virginia Democrats endorsed Kennedy, one Black newspaper opined, "We are beginning to wonder just what commitment Kennedy has made to make him so strong in the South."[72] The *Informer* also castigated Lyndon Johnson for not doing more for civil rights in Texas. Noting that Black men in the state were banned from admittance to basic shop training courses, such as refrigeration, the paper questioned the depth of Johnson's and Kennedy's commitment to racial equality.[73]

Pro-Kennedy activists in Texas emphasized the national Democratic Party's civil rights platform. At a meeting in October 1960, fewer than three weeks

before the election, Jordan joined county chairman Woodrow Seals—who later became a federal judge—to speak before a gathering of 150 Black precinct judges and precinct chairmen, many of them HCCO members, during a luncheon at Pleasant Hill Baptist Church in Houston's Fifth Ward.[74] Jordan "read the official Democratic Party position on Civil Rights and Equal Opportunity" and exhorted those present to throw their weight behind Kennedy. She urged each precinct judge to recruit ten block workers for the campaign. The Get Out the Vote committee had placed all 52,000 Black voters on lists, she told the group, and was prepared to give any volunteer a list of names near their home.[75]

Jordan's efforts focused on gaining votes for Houston, but as historian Max Krochmal has documented, the Democratic Coalition sent Black organizers to Black and Brown communities throughout the state to register voters for Kennedy and drum up support for their campaign to end the poll tax and recruit local progressive leaders to the Democrats. The dynamic Mrs. Erma D. LeRoy and her husband, Moses LeRoy, a member of the railroad union, traveled to numerous working-class communities in small East Texas towns. Mrs. LeRoy was especially effective in reaching out to local Black beauticians, barbers, and fraternal and civic organizations to recruit block workers. All seemed eager to join and pay their poll tax so that they could participate in the election. The coalition succeeded in transforming the voting campaign for Kennedy into a vehicle for promoting the greater cause of racial equality and ending conservative control of the party.[76]

Kennedy won Texas. His razor-thin 50.52 percent majority gained him the state's twenty-four electoral votes and the presidency.[77] Jordan felt proud of her part in that achievement: "Of the forty boxes in those precincts we worked, there was a turnout of some eighty percent of the vote. It was the most successful get out the vote that anybody could recall in Harris County."[78] The Kennedy campaign spurred voter registration efforts among the Harris County Democrats, elevated Jordan within the organization, and helped her hone her political skills. She began to realize her strengths as a political organizer.

When Jordan started down the unknown road of college debate and law school, she had wanted to succeed as an individual and show that a Black woman could compete and flourish in integrated environments. She had no ambition to become an activist or a Black leader. Yet her idealism along with the confluence of new, liberal forces at the national and local level drew her into electoral politics. A working-class yet professionally trained woman who spoke with a

persuasive voice, Jordan's efforts on behalf of the Democratic Party sparked a new wave of Black voting and organizing. No longer between stools, she discovered a new identity. She was not a middle class "Mrs. Charles White." She was not a student. She was not a minister. And she was not a Fifth Ward housewife in a civic group. She was Barbara Jordan, attorney and Democrat.

Can This Marriage Be Saved?

The Strains of Coalition Politics

The feeling I had was that I had been used to get black people to vote. And that nobody else on the ticket brought that kind of strength to me in return . . . the votes were just not there from these fine white people. That was very puzzling to me, and disturbing.

> —Barbara Jordan, (1978) reflecting on her 1962 campaign
> for the Texas House of Representatives

In April 1962, several dozen members of the Harris County Council of Organizations (HCCO) met in Houston's Black Southcentral YMCA to endorse a Democratic candidate in the upcoming gubernatorial race. The *Forward Times* reported that "the best organized forces on the floor were the John Connally supporters." The former Secretary of the Navy under President Kennedy, Connally enjoyed a close friendship with Vice President Lyndon Johnson and had the backing of Texas oil tycoon Sid Richardson. He also had the support of many Black business leaders in Houston. They believed the candidate's "New Vision" program could stimulate economic and professional opportunities. The forces in Connally's favor urged the HCCO to move away from an alliance with the labor-liberal coalition that was bound to lose. The conservative candidate's silence on civil rights did not bother his Black supporters, who argued that "the core of the Negro's shortcomings lie in the economic, not the social, sphere."[1]

Barbara Jordan thought differently. Her candidate in the race was Don Yarborough, a young, white, liberal Houston attorney and World War II veteran. Yarborough lacked business connections, but he held an enthusiastic

commitment to the ideals of Kennedy's New Frontier. This was his second crack at running for statewide office, and the press noted that attorney Jordan "made a stirring speech on his behalf." Her break with the Black businessmen in the room was noted by the *Forward Times* with some astonishment: "More dramatic yet is Miss Barbara Jordan['s], a state legislative candidate, attachment to the liberal slate of candidates."[2] Since neither Connally nor Yarborough reached the required fifty votes (or two-thirds) of the seventy-five representatives present, both failed to win the HCCO's official endorsement. Thanks to Jordan, however, Yarborough earned the support from the majority of the Black delegates present, which boosted his campaign. In leading the effort to take the HCCO's endorsement away from Connally, the young Black Democrat from the Fifth Ward showed her power to persuade. Moreover, by taking a public stand against HCCO's elders, Barbara Jordan laid claim as a liberal Black leader within Houston's Democratic Coalition. The question then became whether a coalition of Black and white liberal voters in Houston could unite with enough strength to put more liberals in the legislature, or perhaps even win the governor's race.

Jordan entered the 1962 race for a seat in the Texas House of Representatives with the encouragement of Chris Dixie, a labor lawyer who had collaborated with her and the Harris County Democrats (HCD) on the Kennedy campaign. In the 1950s Dixie had helped to launch Texas Liberal Democrats (TLD) and Democrats of Texas (DOT), statewide organizations that opposed conservative, anti–New Deal adherents. With the success of the Kennedy campaign, opposition to conservatism in the Texas Democratic Party now had a new moniker, "the Democratic Coalition." The *Houston Post* commented that "right now it is a loose knit alliance of the top executives of about nine different organizations, including the state AFL-CIO, the Democrats of Texas clubs formerly the DOT; negro political groups, the Latin American organization known as PASO and the Farmer's Union."[3] In the upcoming 1962 primary races, liberal Democrats matched up against conservative opponents. Dixie took charge of the "candidates committee" for the Harris County Democrats, and he persuaded Jordan to run for the liberal at-large "position 10" seat in the Texas House of Representatives against a conservative white Democrat, Willis Whatley. He paid her $500 filing fee.[4] While Jordan's campaign pushed to register more African Americans voters, she also spoke to white union members and to any audience that would hear her.[5]

In 1962 Jordan's stump speech did not specifically mention race or integration. When the twelve candidates endorsed by the HCD spoke to the coalition

of liberals, labor, and African Americans, they focused on economic fairness. Jordan endorsed breaking up the "University Fund," which favored the University of Texas over other institutions, and changes to the state's budgeting procedures. She echoed classic liberal, Gladstonian themes of "retrenchment and reform," and was the only Black and the only woman candidate on the liberal ticket: "I talked a lot about welfare and how we had the obligation to take care of people who couldn't take care of themselves. I thought it all sounded wonderful." Her eloquence, her person, and her positions on the issues offered something to everyone in the racially mixed audience. When she concluded, Jordan received a standing ovation. She felt special, and singled out: "I didn't know what had really turned them on, what had given them the spark and I needed to know so that I could keep doing it throughout my campaign."[6] The *Forward Times* featured a front-page photo of Jordan and endorsed her progressive program: "We have in Atty. Jordan a candidate who seeks to gain office upon the basic issues of good government for all people regardless of race, creed, or color."[7] Other Black candidates had run for office in the past. However, "one fact stands out about Attorney B. Jordan," noted the *Forward Times*. "Aside from her very adequate qualifications, Atty Jordan possesses a will to win."[8]

White liberals appreciated how Jordan energized Black voters and block workers. With Houston's growth, Black residents had been moving into new areas of the city, changing the racial composition of some neighborhoods. As the election approached, Dixie wrote to Hank Brown, president of the AFL-CIO, to relay important news regarding the growth of the liberal voter registration campaign. Using poll tax lists to target registered voters, Dixie estimated that more than 10,000 Black votes could be found in those racially mixed precincts. He noted that in the "white precincts," they had only five hundred block workers as compared to "1600 block workers in the Negro areas." And in the forty predominantly Black precincts in Harris County, the number of registered voters was "60,613 as compared to 51,870 in the last presidential year.... All in all, this is most gratifying."[9] Now that the HCCO had failed to endorse either Yarborough or Connally, the Black vote was in play—what the *Forward Times* called the "mad scramble for the estimated 75,000 Negro voters in Harris County."[10]

Ironically, Dixie's excitement about the growing numbers of Black voters diverted his attention away from Jordan's campaign for the legislature. After her endorsement of Yarborough, the *Forward Times* reported that Jordan was short of funds. Had key financial support dried up? Her campaign now emphasized

Jordan's significance as a Black candidate, not as an HCD member. "We fear that many people do not realize what Miss Jordan's election would mean to our community, to our children, to Texas, and the nation," said Jordan's finance chair.[11] "Your one vote IS important," stated an election-eve campaign advertisement. "Please go to the polls Saturday and vote for Barbara Jordan, position #10." In the same edition, however, the *Forward Times* also carried a full-page advertisement supporting John Connally, who also enjoyed the support of Jordan's former debate partner, Otis King, Julius Carter (publisher of the *Defender*), Carter Wesley (publisher of the *Informer*), Judson Robinson, Black businessman Hobart Taylor, and lawyers Hamah King and George Washington.[12] When she sided with labor against Connally, Jordan opposed some of the most powerful and financially prominent African Americans in her community. Nevertheless, Jordan believed her coalition could defeat the conservatives. Jordan remembered Dixie telling her, "You're great, you're going to win. . . . You're going to get ninety per cent of the black vote, thirty percent of the white vote. There's no way you can lose."

But Jordan did lose. A closer look at the rules of the race helps to explain why. In the primary race, Jordan had to campaign for the votes of one million people across Harris County, where Black voters comprised a distinct minority. Seats in the state legislature were determined by a system of "at-large" voting, which meant that there were twelve seats up for grabs. Under the "place system," however, a liberal candidate was pitted against a conservative in each of the twelve races. Jordan had to beat an individual opponent and not just place in the top twelve. Furthermore, voters could choose only their top three candidates, which was another disadvantage to a little-known, first-time candidate. In the end, she received thirty-six thousand votes, and Willis Whatley, her conservative opponent for the tenth place on the ballot, received sixty-five thousand. "And that was that," Jordan wrote.[13] A strong Black voter turnout with some white support was not enough to triumph. The structure and organization of the Democratic primary made it nearly impossible for minority candidates to win.

After the huge buildup from Dixie and the favorable press publicity, Jordan felt crushed. She knew that at-large voting, and the place system, put her at a disadvantage; yet she also felt let down by the HCD: "The feeling I had was that I had been used to get black people to vote. And that nobody else on the ticket brought that kind of strength to me in return . . . the votes were just not there from these fine white people. That was very puzzling to me, and disturbing."[14] Jordan wondered why more liberal white voters did not support her. She had

always received an enthusiastic reception when she spoke to white audiences and to organized labor. She believed, along with received wisdom, that "in the liberals, the Negro works with a group which understands and respects his peculiar problem and generally shares like economic goals."[15] The outcome of her first election educated Jordan on the realities of coalitions. Black voters could be a force, but not a controlling one.

Don Yarborough also lost the governor's race to Connally, confirming some African American pessimism about their voting power. "Long Lines, Impatience, Defeat," were the headlines of the *Forward Times*. Only 33 percent of 75,000 registered Black voters in Harris County came to the polls that day. The *Forward Times* pointed out that Don Yarborough did better with Black voters than any other white candidate, including J. C. Whitfield and Bob Eckhardt, whose House districts represented large numbers of Black voters. Yarborough won in forty-four predominantly Black precincts, with John Connally a distant second. "Blacks only really voted in large numbers for Jordan and Yarborough," noted the *Forward Times*. "[The] long marriage of the liberals and the Negro remains intact. The results indicate that Negroes only showed interest in two children of that marriage, Jordan and Yarborough."[16] Jordan's loss on her first attempt demonstrated the structural obstacles she faced, yet it also confirmed her popularity and influence among Black voters.

Dixie told Jordan to shake off the loss, and that she would do better next time. But others in the liberal orbit felt more skeptical, and one in particular told her so directly. Jordan recalled that, "A professor at Rice University who came into my campaign headquarters during that first race had said to me: 'You know it's going to be hard for you to win a seat in the Texas Legislature. You've got too much going against you: you're black, you're a woman, and you're large. People don't really like that image.'"[17] Jordan could not have failed to understand which "people" the professor meant. Black women had exercised leadership in Houston's NAACP and won a seat on the school board; they also comprised most of Black Houston's civic organizations. White voters, not Black ones, had a problem with Jordan. When the campaign started, Jordan had sensed her community's impatience with older Black conservative leadership, but now she faced the condescending attitudes of her liberal white colleagues in the Democratic Coalition, and the racism of white voters. Could this "marriage" of white liberals and Black voters really work?

Jordan sought advice, and her growing friendship with Quaker activist Garnet Guild, an organizer with the American Friends Service Committee (AFSC), became an important turning point in her political life. Guild was new to Houston, but as the director of the AFSC office in town she was well-equipped to understand the challenges of coalition politics. Twenty-four years older than Jordan, Guild already possessed a lifetime's worth of organizing experience and world travel. Born in 1912 on a dairy farm in Portland, Oregon, Guild attended Pacific College for women and volunteered at a Quaker-run summer camp for Native American youth in South Dakota. After she graduated in 1935, Guild received an AFSC fellowship to travel to Ramallah, Palestine, where she stayed through World War II and taught at a school for girls. After the war she returned to the United States to work with impoverished youth on a Native American reservation in Minnesota where she persuaded local authorities to build a center for Indigenous youth with a focus on job training. Guild worked closely with fellow AFSC leader Jean Fairfax, an African American organizer who would join the NAACP's Legal Defense Fund in 1965. In the late 1950s, Guild and Fairfax worked together to set up the first AFSC offices in Texas.[18] Guild moved to Austin, and the two women launched the Employment on Merit (EOM) program, an initiative that sought to persuade white-owned businesses to hire African Americans.

Guild loved her new home: "It is a fabulous place," she wrote in 1959, "it is beautiful, hilly, has lots of trees, has very friendly people." Outgoing, optimistic, and enthusiastic, Guild saw her position working for civil rights in Texas as a fresh and exciting challenge. "I wish I could share with you some of the excitement of a new job in a completely new world."[19] Later that year, Guild and Fairfax visited Houston for the first time. They met with Black members of organized labor, religious groups, and small business owners and shared their plan of opening a headquarters in Houston to work on issues of Black employment, education, and integration. After several days of meetings, dinners, and frank discussions with political organizations such as the Committee for Peaceful Desegregation, Fairfax found Houston "a terribly exciting community in which to work with an opportunity for our staff for stimulation from many likeminded individuals." But she was puzzled by the reticence of individuals, such as newspaper publisher Carter Wesley, to challenge racial segregation. She predicted, correctly, that it was going to be very important for the AFSC staff to know how to "find people" in the Black community who were ready to pioneer "and to support

those who do."[20] In January 1962, Guild moved from Austin to Houston to open a new AFSC office.

No one laid out a welcome mat. As she set up the organization's new head-quarters in the Third Ward, near Texas Southern University, Guild received harassing phone calls from the White Citizen's Council, and she also knew that the integrated school for practical nurses in her building had received bomb threats.[21] However, "Houston has another face," she wrote. "Here is the largest single group of liberals in the state." Living in a largely Black neighborhood, Guild joined the Harris County Democrat's "Wednesday Group," for regular lunches where she set about making connections and contacts and where she most likely met Jordan.[22] Skilled in cross-cultural communication and dedicated to pragmatic reform, Guild had lots of experience with clueless and even racist white liberals—indeed she counted herself as someone who recognized her own ingrained racist assumptions.

Guild had begun her activism right out of college when she volunteered to work with Indigenous youth at a summer camp in South Dakota. That experi-ence led her to question any presumption of a superior white civilization. In a personal reflection from 1935, she wrote, "For the first time in my life I became acquainted with a minority group of human beings that is being exploited by the rest of society (the Indians). . . . Is our civilization so successful that we should be attempting to wipe out one that has existed for centuries?" A Quaker activ-ist, Guild felt called to serve, but she also understood the necessity of humility. "I have learned the necessity for patience on the part of any individual who is attempting any reform. Without patience, he would allow himself to get into a condition in which he would be nothing but a hindrance to his cause." Guild wrote these reflections while teaching in Ramallah, where she realized that any philosophy of life should be engaged with the practical. "Most of the people that I have contacted judge a religion by its 'workableness'—how you do it rather than what you think you should do. This should be based on Love, love for my neigh-bor, Beauty, seeing something good in everyone, and Truth."[23] In Houston, Guild and Jordan became close friends, with the older woman serving as an important mentor, confidant, and campaign worker. And although she was a relative new-comer to Texas, Guild introduced Jordan to a broader civil rights community.

After her disappointing defeat, and most likely at Guild's urging, Jordan attended a two-week-long summer civil rights conference that had been started by Quakers and was now held at the Institute of Race Relations at Fisk University,

spearheaded by the prominent Black sociologist Charles S. Johnson.[24] The wide-ranging sessions on race and politics got Jordan out of the particulars of Houston and into a bigger world of ideas. Jordan was the only participant from Texas at the conference. Also present was Antonia Pantoja, a leader in the bilingual education movement and a well-known Puerto Rican activist.[25] Jordan attended sessions on civil rights activism, legal challenges to racial discrimination, educational policy, and a host of other issues. The sessions gave Jordan the opportunity to connect her political platform with the larger social movements around her. She decided that her politics had to include activism and involvement in organizations beyond the HCD and the HCCO, and after returning home Jordan took a renewed interest in reorganizing the Houston branch of the NAACP. On February 14, 1963, she joined Guild and 175 others at a special meeting dedicated to reviving the defunct branch. The group organized a membership drive and devised a plan to pay off its outstanding debts.[26] Both women were named to the five person Committee on Reorganization, with Jordan the treasurer and Guild the assistant secretary. Jordan responded to her 1962 loss by becoming more outspoken and active on race issues.

In addition to her work with the NAACP, Jordan became involved in the citywide movement for school integration, vocational training, and education equity, issues that continued to energize the Black community. In 1963 Dr. Ira B. Bryant, principal of Kashmere High School and former principal of the Colored High School in Houston, complained that "Negro inmates in Texas prisons get better vocational training than Negro students in the Houston public schools." His assertion angered Houston school board president Joe Kelly Butler, but Bryant was backed up by Hattie Mae White, still the lone Black voice on the school board. Bryant spoke "the whole truth," she asserted. "Go to Wheatley and see the inferior type of training that nursing students get there and then go to San Jacinto and see those facilities. They are lovely," said White.[27] In the summer of 1963, when the board refused to integrate the all-white San Jacinto Vocational High School, a group of nine Black leaders, along with the Inter-Faith Group committee of Greater Houston, wrote to the school board threatening "overt reactions." The letter, which Jordan signed, defined "overt reactions" as "peaceful demonstrations on the part of dissatisfied persons if there is no redress." White pressed the issue, stating, "I feel the board's attitude toward integration does not comply or show good faith in the Supreme Court's desegregation ruling."[28] That was the understatement of the year. In 1960 a federal judge had ordered the

Houston school board to begin a "grade a year" integration program, starting with the first grade. By 1963 the first three grades had been integrated, but the slow pace of the process and the continued discrimination faced by Black people of high school age seeking vocational or professional education remained acute.

Jordan then became involved in a new organization to force the issue of school integration called PUSH (People for the Upgrading of Schools in Houston), led by Rev. William Lawson, whose church was attended by many college students from Texas Southern. When the school board appointed a conservative Black principal to a key administrative position, PUSH spoke out against the move, which it criticized as a stunt to delay integration and shift attention away from the board's flagrant disregard for *Brown*.[29] Joining one hundred protesters who picketed a school board meeting, Jordan read a statement opposing the appointment: "It is clear that such a position and the selection of the person to fill this position would be designed not to elevate the status of Negroes but to further degrade them." One of the placards read, "Down with Uncle Toms."[30]

Jordan and the NAACP used the issue of inferior education to highlight economic inequality and discrimination in the workplace. According to the 1960 census, the median income of Blacks in Texas was less than half that of whites. In the spring of 1963, "the issue of jobs for Negroes has come to the surface with the fierceness of a pent up cause," said the *Texas Observer*.[31] Segregation "was [all] around you," Houstonian Alvia Wardlaw remembered. "You knew what it meant from an early age. You encountered it in the grocery store. There was a colored water fountain and a white water fountain. Every adult in the community made you aware of segregation and discrimination, but at the same time you could forget about it when you were doing things that were part of your community, like going to the games and pep rallies or hearing civil rights activists like Barbara Jordan or the Reverend William Lawson speak."[32] By 1963 Jordan had established a reputation as an outspoken opponent of segregation and racial injustice.

The day after a quarter of a million Americans gathered in Washington in August of 1963 to march for "jobs and freedom" and hear Martin Luther King Jr. and other Black leaders make the national case for an end to segregation, Texans staged their own march in the state's capitol. They pressed their case for greater economic opportunity before Governor John Connally. It was a tense time. On August 29, approximately one thousand marchers took to the streets of Austin in what was probably "the largest civil rights march Texas has yet had."

All were singing freedom songs and carrying signs that read, "Segregation is a new form of slavery," "We are tired of gradualism," "no more 50 Cents per hour," and "Freedom Now."[33] Speakers at the rally in Rosewood Park in East Austin after the march to the state capitol included "Barbara Jordan, Houston lawyer."[34]

In addition to her activism on behalf of civil rights and integration, Jordan worked hard on behalf of the Democratic Coalition. In her speeches she set out to persuade Black voters that coalition politics could work, and that a political "realignment" was slowly tilting the Democratic Party in the South in a more liberal direction. She conceded that Black voters were a minority, but if they registered in greater numbers, she argued, they could hold the balance of power within a coalition. "With Negro voter registration on the rise and Industrialism increasing, the long term prospect is that Negroes, union forces, and assorted liberals will take over the dominant role" in the southern Democratic party, she declared in a lengthy speech delivered shortly after her first defeat. Jordan cited the support she and other progressive Democrats gained from white voters as evidence of change within the party. Conservatives were leaving, and progressive victory, although not certain, was within the "realm of the possible." Urging her audience to redouble their registration efforts, she stated, "You can help this national balance of power become a reality by your successful voter registration effort. You can help free yourself and your country, you can become involved in the electoral process in a meaningful way . . . you can register, you can vote. This you can do for yourself and your country." The echoes of Kennedy's first inaugural address ring through in this optimistic address to block workers as she urged them to register and get out the vote for the liberal coalition in Texas.[35]

The Democratic Coalition also began to confront racism in its ranks directly. Organized labor in Houston began to move away from its support of segregation. Thanks to progressive New Deal legislation and the hard work of the AFL, and then the CIO, many of the workers who did the gritty, dirty jobs laying down pipe, sweating in the steel mills, and working in the chemical plants that lined the Ship Channel had joined unions, which became important institutions in the city's industrial landscape. White and Black laborers, however, lived in separate worlds and operated in segregated unions. Coalition politics had led white labor leaders in Houston to reach out to Black voters, but growing activism forced them to face the reality that too often unions benefited white workers over Black. In the summer of 1963, Texas labor leaders, inspired by President Kennedy, issued statements recognizing the moral justice of racial equality in

their ranks. In a speech to members of the electrician's union, state AFL-CIO president Hank Brown argued the case for integration: "I know this is unpopular with many of you, but there is going to have to be room for Negroes in the labor movement. The weapons Negroes are using today to seek rights are the same weapons used by organized labor 30 years ago to bring us to the position we hold today. I think the Negro, the one who is qualified, ought to have the same chance that such tactics brought to the labor movement 30 years ago."[36] Organized labor was willing to work with Black members and Black leadership, but it had to be pushed.

Despite such progress, some observers noticed a lack of enthusiasm among Black elites and passivity among the masses. According to *Houston Chronicle* journalist Saul Friedman, most Black residents in Houston seemed indifferent to the social revolution sweeping the nation. He noted that fewer than twenty people traveled on the bus chartered for the 1963 March on Washington and criticized Black leaders for failing to foment more protests. He argued that the integration of public accommodations had come at little cost to white patrons, adding that these changes mattered little to Black Houstonians too poor to eat out or stay in previously all-white hotels. "Nearly 61 percent of the Negroes of Houston earn less than $4,000 a year," he noted, "[and] a quarter earned less than $2,000 per annum." Job discrimination remained rampant, particularly in the skilled trades. "There is not a single Negro engineer, draftsman, union bricklayer, union electrician, plumber, or crane operator. Without exception, Negroes are laborers on construction projects." School integration, he added, remained at a standstill.[37]

Friedman singled out for criticism Black attorney George Washington Jr., who, he alleged, profited from Governor John Connally's patronage. But Washington defended his support for Connally. "We have worked our guts out for liberals and they give us nothing even if they win." He riposted, "What has trade union labor done for us in 20 years?"[38] But Friedman lamented the weakness of Black political leadership: "In Houston, the Negro community continues to sup from the back door on rights that are thrown like bones from the table of the white power structure." Washington's skepticism about white laborers was shared by other members of Houston's Black middle class who also opposed nonviolent direct action. Julius Carter, editor of the *Forward Times*, said that "Martin Luther King's tactics would not do here. I'm against demonstrations for demonstration's sake. There's just too much demonstrating going on. Our job should be

to build the Negro economic power, to build the Negro market. Then the whites will respect us." Booker T. Washington could not have stated it better. When Friedman asked Carter what "Negro action organization he felt closest to," he replied, "The Riverside National Bank."[39]

Although Carter endorsed her in all her races, Jordan disagreed with his view that protests and alliances with liberals and labor were futile and lacking in purpose. In the fall of 1963, she became involved in voting-rights activism. The Democratic Coalition led by activist and journalist Larry Goodwyn in Austin took charge of a statewide campaign to register new voters and repeal the poll tax in a November referendum. Jordan directed the Democratic Coalition's Houston operation.[40] Goodwyn, who headed the statewide effort out of an Austin office, emphasized the importance of the Bayou city. "The biggest job in Texas is being handled by the headquarters in Houston," he noted. "Some 70,000 Negro voters are eligible to vote and that means that 3,500 Freedom Kits have to be distributed! . . . Barbara Jordan is doing an around-the-clock job of directing her staff on the distribution of kits and the recruiting of block workers. They'll be working on both jobs right up to the time the polls close Saturday. Over 60 precincts are involved in this big effort . . . the biggest one in Texas."[41] Calling the voter registration packets "freedom kits" cemented the connection between the movement and the upcoming vote. Jordan was paid $300 for leading the Houston effort, an amount second only to Goodwyn's fee.

The effort to repeal the poll tax failed. Still, thousands more Black Houstonians became registered voters eligible to cast a ballot in 1964. The coalition also gained more support for liberal Democratic candidates. As Goodwyn pointed out in the *Texas Observer*, "The tremendous rise in the voting power of Negroes and Latin Americans . . . gives an ever broadening base to the liberal labor minorities coalition. Leaders of these minorities will play increasingly powerful parts in the political decision making of the liberal wing of the party."[42] And although Latinos in Houston were not a recognized faction in the HCD, the off-year 1963 election and poll-tax repeal movement propelled the emergence of a new Latino voice in the city.

Lauro Cruz, a native of the Fifth Ward who later became a member of the Texas House of Representatives, decided to run as a precinct judge in his district. Born in 1936, he had attended local schools in Houston, joined the Marine reserves, and then got called up to basic training at Camp Pendleton, where he earned his high school equivalency, a GED. On his return to Houston, he

became the first Latino hired to drive a city bus. He subsequently bought a local store (his mother had also owned one) and decided to become involved in politics: "In that community we had had a precinct judge who had been a conservative, she had never been challenged; I just decided on my own to run against her."[43] One year earlier, Latinos, like Black Texans, had split on whether to support Connally or Yarborough for governor.[44] Cruz supported Yarborough, but when he decided to run he knew he could not rely on the Harris County Democrats, and he managed his own campaign: "I was running that grocery store [and] I knew a lot of people; I set it up to where I had a lot of Hispanic people at the polls." When Cruz won, he received an unexpected call from Mrs. Frankie Randolph: "The phone rang; and this old gravelly voice said . . . 'This is Mrs. Randolph,' and said, 'well I think you did good boy.' Later on, I found out that was the highest accolade she gave to anybody." Cruz was thrilled. A timber heiress who became involved in liberal causes in the 1950s, Mrs. Randolph, as she was called, was the "den mother" of the Texas liberals. She bankrolled the *Texas Observer*, had become a national committeewoman of the Democratic Party, and despised Lyndon Johnson, a man she regarded as wholly unprincipled. Randolph's congratulatory call made Cruz realize that he could bring a Latino voice into the coalition in Houston.[45]

After he became a precinct judge, Cruz teamed up with Otis King and Barbara Jordan on a project for the non-profit Crescent Foundation to find employment for "hard core unemployed people." Cruz met King and Jordan in "an old house" on Lyons Avenue, in the Fifth Ward, outside a pool hall. Cruz remembered the wintertime cold. "We had an open fire heater, [and] you could see by the flames that it was not an airtight building. We were on the second floor, and we were sitting around there trying to get this thing together."[46] Jordan's work with the foundation showed she remained tight with King and Washington despite their support for Connally. Antipoverty work, voter registration, and NAACP activism introduced her to a wide range of activists in Houston, Dallas, and Austin. She began to think about the next election and what the defeat of the November anti-poll tax referendum meant for her campaign. And then in November 1963 a life-changing event occurred in Dallas.

President Kennedy's death devastated Jordan. Houston hairdresser Wilma Brown recalled that Jordan had been with her when the news came on television. Jordan stared at the screen and wept. "Kennedy will always be my president," she told Brown. "If only I could have been that person instead of him;

if I could only have Oswald shoot me, my life would have been well worth it." Brown told her that she was "crazy," but Jordan's reaction showed her feeling for Kennedy and his stated ideals.[47]

By 1964 Jordan had been involved in voter registration drives and the anti-poll tax movement for four years. She had marched with the NAACP and become an advocate for immediate compliance with school integration. She was better known than ever, had more contacts than ever. In this period she never stopped speaking; wherever she was asked to go, she went. As Rev. Bill Lawson remembered, "She would make herself available to every kind of little group. Barbara would come to your church, union hall, school."[48] She traveled outside Houston, where her public speeches took on a more critical tone. In spring 1964 she delivered a banquet keynote address in Chicago honoring Charles F. Armstrong, a long-serving African American Illinois state legislator who had championed school integration. The eight hundred guests attending the elegant dinner in the Sherman House included attorneys, school board members, Cook County superintendents, civil rights activists such as Daisy Bates, and Jordan's friend and fellow attorney Ernestine Washington. According to the *Chicago Defender*, Jordan's speech "brought down the house, with the line: 'Negroes today reject Uncle Toms and Uncle Thomases—Uncle Toms with PhD degrees.'"[49] Thrilled to return to a city she had loved as a teen, Jordan had moved miles politically since the 1950s. Individual Black achievement was not a substitute for racial justice. Black Americans needed to demand full equality.

In 1964 Jordan ran for the state legislature again. Initially she had wanted to oppose a nonincumbent, but a more experienced candidate convinced her that she should challenge Willis Whatley once again. As soon as she left that meeting, she knew she had made a huge mistake, that she had allowed herself to be talked into something that went against her better judgment. But she vowed to make the best of it. Black turnout was better than ever, and she gained 20,000 more votes than her previous run in 1962, but still she lost to her better-funded conservative opponent. She criticized the HCD for their incompetence and lack of support. When she sought computer data on the voters in her district, the HCD sent the information to El Paso. "By the time we got the data the campaign was over," complained Wilhelmina E. Perry, a sociology professor at Texas Southern and a Jordan campaign advisor.[50] Perry was another older woman professional Jordan had looked to for guidance. A dedicated member of the HCCO, Perry had worked closely with Jordan on the poll-tax referendum, and

she remembered the candidate's frustrations at the inefficiency and the arro-
gance of the HCD during the "chaos" of Jordan's 1964 campaign. Jordan felt hurt
and frustrated by the indifference shown by her white political colleagues. Once
again, it seemed, she had worked hard for the coalition, and she felt let down by
white voters in her city as well as by the coalition.

After her loss, she recalled, "I didn't go to campaign headquarters. Instead,
I just got in my car and drove around most of election night. The question was: 'is
a seat in the state legislature worth continuing to try for?' I asked myself—'why
are you doing this?'"[51] In her depression, she even neglected to thank her cam-
paign workers: "After I got home and had gone to bed, my campaign manager
and campaign coordinator came to my house asking, where have you been? The
people are all waiting for you at headquarters. I said: I've been driving around.
And when Chris called to say, 'well we've got the analysis for you,' I snapped at
him: 'I've got the analysis for you: I didn't win.' And went back to bed."[52] Shock-
ingly, Jordan walked out on her campaign staff and left her workers hanging.

The second loss brought home the reality that she may never win an elec-
tion. And if she could not be a politician, then those around her talked of mar-
riage as the next logical life step.

Jordan had never had a boyfriend or a fiancé, yet the significance of that fact
failed to resonate with her family. It seemed they would accept her decision to
remain unmarried only if she had a successful career as a politician. Discussions
of marriage in the context of her recent loss at the polls triggered tremendous
anxiety. Jordan recalled that after her second defeat, "My family and my friends
out there started in on the refrain that if I was not going to be winning, I ought
to want to get married."[53] Her married sisters and her parents had supported her
educational and professional endeavors, but they now expressed concern for her
future. Although Jordan had a law practice and income from speaking engage-
ments, she still lived at home with her parents. Marriage was the respectable life
choice for women; it was a sign of adulthood, and in Jordan's Black family and
community, it was expected of women.

But Jordan held a negative and distasteful view of marriage, an opinion that
seemed to be rooted both in her sexual orientation and in her budding feminism.
For her the institution epitomized society's low expectations of women's capac-
ities for thought and leadership: "People didn't expect a woman to make rough
decisions. She was the ward of her man; she was always to be available at her hus-
band's side no matter where he had to go or what he had to do. She must always

be prepared to turn and kiss his puckered lips."[54] Nevertheless, going against the expectations of her friends, family, and community made Jordan uncomfortable. In the traditional female coming-of-age story, the decision to marry a particular man, or being asked to marry, is the key turning point in a woman's life. But Jordan had come to terms with the fact that she would not, indeed—could not—marry. This decision, she understood, meant challenging not only her family but "the public." In interviews with Shelby Hearon, Jordan reflected on her own self-perceptions at the time: "The public believed that a woman had to have, over and above and beyond other aspirations, a home and family, that was what every normal woman was supposed to want. And any woman who didn't want that was considered something a little abnormal."[55] Jordan elaborated on her response: "And I don't argue this point, I don't debate this point with anybody because it is futile. But I would hope that one of the things I have done with moderate success is have the public understand that there are some women for whom other expectations are possible."[56] Jordan thought her choices could expand public acceptance of women who rejected marriage in favor of independence.

At the same time, she understood that gender roles were deeply embedded in culture and politics. She connected society's reluctance to see women in positions of power with its insistence that they marry. In the South, she told Hearon, "it is the southern belle who is held up, the southern beauty, [she is] the woman who is never expected to be required to make tough decisions. That is almost unamerican that you would place that requirement on a woman." Jordan saw the grim humor in the situation. "So consequently I suppose that I will be answering the question 'what do you think about marriage' when I'm 85 years old, and I'll still be saying well, there's still time."[57]

But Jordan also knew that she was not being completely honest with her parents. In her interview with Hearon, Jordan thought back to the times she told her family that she would get married "later," even though she never intended to do so: "I knew when I was saying that, that I couldn't do that, but I thought my mother wants me to be married, my father wants me to be married, but they also want me (my father not my mother) to be successful in what I'm trying to do over here. And I can just lie to them and in the process of course lying to myself that, 'Look it's not too late, it won't be too late.'" Hearon replied, "Down the road." And Jordan repeated, "Down the road a piece."[58] If she framed her decision as a consequence of pursuing political goals, then staying single was acceptable. Therefore, everyone in Jordan's family had a large stake in Jordan winning her

next election. In their eyes, only victory, nothing else, would explain her personal decision not to marry.

It seems that Jordan may have had a partner at this time. One journalist claimed that after Jordan's second loss some of her political advisors had warned her not to bring her "female companion" with her on any future campaign trail. The image of "two women working so closely," she was told, could damage her reputation.[59] Allegedly, Jordan agreed to put distance between herself and her companion. Jordan decided that if she were to run for office again, she would do it alone. "I made a decision," she told Hearon. "Politics was the most important thing to me . . . if I formed an attachment over here, this total commitment would become less than total. And I didn't want that. I did not want anything to take away from the singleness of my focus at that time."[60] Jordan felt alone and embattled but determined. Too much was at stake. She took real umbrage at Chris Dixie's cheerful demeanor when her second loss pained and frustrated her in ways she could not fruitfully express. "I did not like losing. I intended to devote my full attention to figuring out the way to succeed." And she told herself "not to let anybody else get inside my head."[61] Jordan reassessed how she had been running her campaigns and her life.

When Dixie and other organizers with the HCD urged her to see her loss as part of the bigger picture, she could not and did not share their perspective. Organizer Billie Carr, the wife of a steelworker and a legendary Democratic party activist who later served as a committeewoman for the Democratic National Committee (DNC), resented Jordan's attitude toward the Harris County Democrats. Jordan believed that her losses were of no concern to the organization; as long as she drew in the Black vote, they would let her run, win or lose. Carr, in turn, thought of Jordan as a typical self-centered politician who could not appreciate the work of activists and organizers. And she felt offended at the insinuation liberals would rather fall on their swords than win. "I hated to lose," said Carr. "Yeah, I was probably telling some of her supporters when she lost some of those races, it's OK to lose, but we voted for the right person. That's the difference between an organizer and a candidate." Carr knew she needed to maintain her organization's morale: "I'm going to tell people, losing is not a bad thing, we'll do better next time. You can't complain about losing to a bunch of people who had been working their hearts out. She mentioned me in her book as someone who liked to lose. NO I don't like to lose at all, but you can't let the workers who are crying see you say we wasted all of your time, money and energy." Carr worked

with many competitive candidates, but she especially resented Jordan. "With her if you win that's good, if you lose it isn't worth a goddam."[62] Certainly, Jordan's losses in her first two races strained her relationship with white liberals in the Harris County Democrats almost to the breaking point. No one in the organization seemed to understand the pressure on Jordan to fulfill rising Black political hopes or, failing that, her family's personal expectations. And no one realized the myriad of personal reasons behind Jordan's drive to embrace professional success and independence. And, almost certainly, no one in the HCD truly understood Jordan's anger about racism.

Her determination to turn things around notwithstanding, at the end of 1964 Jordan wondered whether her political career was at an end. Kennedy's assassination had elevated the popularity and the prominence of the wounded governor, John Connally. When he spoke out against the public accommodation section of the 1964 Civil Rights Act on the eve of the vote, Jordan felt despair. Chris Dixie called to see if she saw Connally's televised remarks. "Did I see it? I cried all night about it," she told him. That fall, Jordan suffered another blow when Connally vetoed her nomination to serve on the executive committee of the state's Democratic party, alleging that the party was not ready for a "Negro." Still, there were bright moments. After the 1964 Civil Rights Act passed, albeit with only four votes from the twenty-four member Texas congressional delegation, Jordan joined Chris Dixie and some members of the steelworkers' union for a celebration. "Barbara, we all want to go to a restaurant together to try out *your* new civil rights," he told her, and she laughed.[63] Despite her frustrations with the HCD, Connally's opposition to integration, and the governor's personal stifling of her rise within the party, she still wished to stay in politics and remain with the coalition. Perhaps that marriage could last, but on different terms.

Victory!

Black Power and Electoral Politics

Can a white man win? I say to you NO. Not this time. Not . . . this . . . time!
——Barbara Jordan, 1966

In the early 1960s Houston's economy boomed; petrochemicals, steel, and oil were just a few of the growing modern industries. In Jordan's Fifth Ward, however, an increasing number of impoverished Black residents endured miles of unpaved streets, open sewers, and a high unemployment rate. Municipal neglect and deteriorating schools destroyed hope. According to the American Friends Service Committee, even with college degrees "many Negroes find they must accept jobs far below their training."[1] The median Black income in Houston was approximately half that of whites.[2] "The whole community is a bomb," Black sociologist Wilhelmina E. Perry said. "Negroes are repressed and there is this latent anxiety. It's just a matter of providing the situation that will ignite the bomb."[3] More than two hundred thousand Black Houstonians comprised a city within a city, a poor and excluded group within a southern metropolis that boasted wealth and modernity. Black institutions and Cold War patriotism could no longer mitigate the awful oppression of white supremacy. The passage of the 1964 Civil Rights Act made little immediate difference in the lives of Black Houstonians. For the majority, the devastating generational consequences of racism could not be reversed overnight.

Fears of urban rebellion prompted a white Houston researcher to pay undercover informers to investigate the risk of a riot.[4] "Listening posts" in Houston staffed by thirteen Black and a dozen white informants gathered information

at barbershops, taxi stands, an employment agency, an ambulance service, and two bars. They uncovered the obvious: Black Houstonians were angry, discontented, and frustrated with their marginal role in city life.[5] Armed self-defense was a recurring theme. The Ku Klux Klan held a highly publicized rally and invited police officers to attend, but Black Houstonians were ready. Informants noted the feelings of Black people on the streets: "I got me a shot gun, a rifle, plenty ammunition and two or three pistols around the house and I think most of the other colored people are just about the same way. This ain't Mississippi and no Klan man or any other white man had better try to beat up a colored person."[6] Black residents also expressed anger at the school board ("full of damn fools," according to one taxi driver), resentment at police brutality, and the frustration felt by poor people trying to get food—staple goods, including Spam—from government offices. After the Watts riots in Los Angeles in August 1965, racial tensions in Houston heightened.[7] As one social worker put it, "These people have hostility for any and all, white, black, you name it. And someday it's going to spill over."[8] When asked to name their most-admired local leaders, anonymous respondents named Rev. Bill Lawson first, and Barbara Jordan a close second.[9] Despite her second electoral defeat, Black Houstonians admired Jordan as a strong voice for racial justice.

Jordan could understand the anger of poor and working-class Black Houstonians. She had grown up in the Fifth Ward, and she still lived and worked in the neighborhood. And even she, with her law degree, suffered from employment discrimination, as the Houston Bar Association did not yet accept Black members.[10] She worked from her own law office on Lyons Avenue, but in the spring of 1965 Jordan received an opportunity, in the words of her peer Andrew Jefferson, to "get out the Fifth Ward and into downtown."[11] In a surprise move that made headlines across the state, Judge William Elliott, a Harris County magistrate who presided over the "commissioner's court," appointed Jordan to the post of chief administrative assistant, making her the highest-ranked African American in any county government in Texas. Jordan's job involved overseeing the administration of key county programs, including prisons, roads, and health and welfare. With this notable "first," Jordan's appointment began the integration of Texas county governance. As a liberal supporter of the Harris County Democrats and civil rights, Elliott knew of Jordan's work in the community and with local Democrats. While she took on her new job, he allowed her time to continue her activism.[12]

A strong advocate for school integration, Jordan continued her work with PUSH (People for the Upgrading of Schools in Houston), an organization created by Rev. Bill Lawson, to protest Houston's slow pace of school integration. Deploying her army of block workers, she started a house-to-house drive to defeat a $58.9-million school bond measure at the ballot box.[13] She also supported a PUSH-led 9,000-student-strong boycott of classes at the city's five Black high schools. She charged that the Houston school board was not complying with the Civil Rights Act of 1964, "and they know it." Applauding direct action, Jordan stated that "the barriers against us will fall if we push, and we will push."[14] The NAACP's national office questioned some of these tactics and voiced concern that Lawson was an interloper, but Jordan's professional status and reputation gave PUSH's school boycott credibility. She bridged the two organizations, and the NAACP accepted PUSH as an ally rather than a gadfly.[15]

Jordan's speeches took on a new tone. Anger at American hypocrisy and insistence on the right to protest became central themes. In August 1965, one day after the passage of the Voting Rights Act, she gave a "provocative" address to a large audience at Valparaiso University in Indiana: "No nation state has excelled America in the nobility of her pronouncements. The time-honored words of the Declaration of Independence continue to excite and inspire the spirit of this country. Yet we continue to struggle for their meaning. We are still trying to define America; to affirm and actualize its promise." Instead of praising Congress and President Johnson, she drew attention to the nation's racist history, contrasting the "pious traditionalism of the law" with the reality of the Black experience. Despite some outward appearance of docility, she argued that Blacks had always opposed injustice, and that protests led to fruitful resolutions in politics, culture, and individual temperament: "Nor can power be received as a gift; it must be taken, for it is in the process of striving for power that people become powerful; it is in the process of fighting for freedom that they become free."[16]

The Valparaiso speech did not reveal the full depth of Jordan's anger. In a draft entitled "The Rage and the Republic," she quoted James Baldwin: "To be a Negro in the country and to be relatively conscious is to be in a RAGE almost all of the time." She attacked the hypocrisy of the American creed and its reliance on violence to keep Black people down: "'Land of the Free'—what does it mean? Free except for the black man? Home of the Brave—Brave enough to live in the slum ghettoes of a Harlem or Brave enough to throw a bomb and destroy a defenseless Negro Church in Birmingham and kill four innocent young?"

She insisted on the federal government's legal and moral obligation to enforce civil rights: "For those who say that integration is a matter of the heart—we say that it is apparent that this country has had one big heart attack (for 300 years), and the Law, persuasion, negotiation, and action are the only treatments to be applied to this ill." If Black demands of full inclusion and citizenship were perceived as radical, the times demanded nothing less. "We are in every sense of the word in the midst of a social Revolution. The revolution must run its course and it will under its own momentum. No Bircher, no Minute Man, no Klanner, no Goldwaterite, nor Goldwater himself—can reverse the revolt. Its course is fixed—and will be run."[17] Like many Black Americans, she felt impatient, exasperated, and angry. How could Black Americans fight back against a system that excluded them at every turn? Jordan began to express the impatience and anger she had been taught to suppress. For her, simply being able to express forthright criticism of America's racism was a gift from the Black power movement.

"Black power" is a phrase casually used but one that had numerous meanings depending on place and context. For those who had been deeply embedded in the civil rights movement, the turn to Black power meant separating from white allies. In 1966, SNCC (the Student Nonviolent Coordinating Committee), the integrated student organization that had led nonviolent direct action and voting rights struggles in the South, voted to expel its white members. Black power could also mean a rejection of nonviolent direct action as the sole method of protest, and an embrace of armed self-defense when provoked. The slogan "Black power" was also taken up by the Black Panther Party, an organization with southern roots but which flowered in Oakland, Chicago, and other urban settings. In those places Black power came to mean an emphasis on Black control of local community services, such as schools and housing. It meant taking a more confrontational stand toward both white and Black politicians perceived as representing the status quo. The militancy of the Black power movement, and its refusal to conform to the white majority's view that deemed Black Americans inferior, made it threatening to the white majority in a way the civil rights struggle was not. Black power advocates turned the tables and focused more explicitly on white racism rather than building consensus. Black power advocates were also more willing to criticize America's role as an imperial power. They supported third world liberation movements and condemned the Vietnam War. Black power also meant an emphasis on the beauty of Black culture, on Black music, dress, hairstyles, and artistic expression as

forms of cultural brilliance that expressed protest but also unique sensibilities special to Black Americans and their fusion of experiences.[18] Black power as a term captured so much more of the Black experience in America than "civil rights" had ever done.

As she progressed through her political life, Jordan often expressed an appreciation for how the term captured the feelings held by so many, including her. At the same time she persisted in her thinking that elections and politics were the way forward, and she continued to pursue office. The movement helped to abate her feelings of discouragement from her first two losses and buoyed her as she pursued another attempt in 1966. Her next primary contest revealed the racial anxiety among some white liberals in Houston, who wanted the Black vote but felt uncomfortable endorsing Black candidates. Because Jordan continued to push for a place in the legislature, these tensions within Houston's Democratic Coalition were brought to a head. Jordan's bold determination to take on a white liberal challenger, along with her insistence on placing her campaign headquarters in her Fifth Ward community, caused various reactions among her white liberal allies, but also signaled that a new day had arrived in Houston's Democratic Coalition. Black candidates would assert the significance of their race when they campaigned.

Jordan gained fresh hope for her political future when a series of court decisions related to representation and redistricting opened up new opportunities for Black politicians in Houston. In *Baker v. Carr* (1962), the Supreme Court ruled that plaintiffs had the right to challenge the constitutionality of legislative districts in court. Courts, not just legislatures, could now enter into the "political thicket" of redistricting. In *Wesberry v. Sanders* (1964) and *Reynolds v. Sims* (1964), the Supreme Court decided that legislative districts within a state had to contain a rough population equivalence, establishing the principle of "one person, one vote."[19] These decisions led to more legal challenges in Texas, where plaintiffs claimed that disproportionate representation—often called "malapportionment"—gave sparsely populated rural voters far more influence than urban voters. Attorney Tony Korioth, who served in the Texas legislature from 1957 to 1961, argued *Kilgarlin v. Martin* (1966), a case that challenged disparities between existing districting schemes in Houston, where a single senator represented a district of approximately 1.2 million people, and rural districts in which a senator represented fewer than 150,000 people. Korioth and William Kilgarlin, both pro-union, Texas legislators, wanted to weaken the power of rural Texans who,

stated Korioth, "were totally out of touch with our society. They were against any change."[20]

A three-judge federal panel declared the apportionment of senators and representatives in Texas unconstitutional; their decision increased the number of representatives in Harris County from eight to nineteen. And instead of just one state senator, Harris County would now have four. The court called for newly drawn "single member" districts for each new seat. Kilgarlin noted that African Americans did not have the influence in the senate needed to draw a district in their favor, and he and Korioth did not envision Jordan as part of their reapportionment crusade. Nevertheless, given the geography of Houston's neighborhoods, he stated that it was "impossible to draw a district within the county that would not favor a minority."[21] The *Kilgarlin* ruling opened up fresh possibilities for Jordan. The new Eleventh District for the state senate, comprised of precincts Jordan had won in her two previous races, had a small Black majority with no incumbent. It was winnable. Jordan felt real excitement. Surely she was the obvious HCD candidate for that new single member senate seat.

But not everyone agreed. Charlie Whitfield, a liberal white labor activist and former member of the Texas House, believed his progressive voting record on civil rights and his incumbency in the House made him the rightful heir to the new Texas Senate seat. However, "Negro supporters of Miss Jordan bluntly reminded leaders of the AFL-CIO and the Teamsters Union that Negroes had supported labor backed candidates in the past. Now, they said, it was time for labor to repay the debt by backing a Negro."[22] Labor activist Eddie Ball and HCD representative Chris Dixie agreed. They decided to have Jordan speak to a packed house of labor leaders and organizers so that she could gain the HCD endorsement. Ball recalled that "we decided to call a meeting of all our leadership. 13 officers. All the committee chairmen and all the members of the political PAC committees and all of our members who were active in politics, precinct chairs of the Democratic party, over 600 people. I introduced Barbara and I thought I made a great speech but when I got through there wasn't a single applause. Dead silence." Then it was Jordan's turn. "Barbara got up [clears his throat], and the first thing she said was: 'If I worked in an industrial plant I'd want to belong to the United Steel Workers of America.'" Ball believed that Jordan's performance in that meeting settled the matter. "She made another one of those great speeches and she got a standing ovation. When she finished, we didn't have any more trouble."[23]

But Ball overstated the extent of the consensus. Jordan's endorsement by the HCD and organized labor sent Charlie Whitfield into a rage. No "trouble" with the union members, perhaps, but Whitfield could not accept the outcome. The *Texas Observer* reported that he and at least fifty other HCD members staged a walkout of the meeting. Ball remembered that Whitfield "got very upset when we endorsed Barbara and finally decided he was going to run anyway, and did."[24] No one knew what to expect. Whitfield was an experienced politician and an incumbent who represented Black precincts in the legislature. Although he lacked the HDC endorsement, he ran a serious, aggressive primary campaign. Whitfield questioned Jordan's affiliation with the Crescent Foundation—the employment project she had worked on with Cruz and Otis King—and accused her of corruption. "He says she's working while running and getting $10,000 a year for administering War on Poverty programs."[25] Jordan denied any impropriety. A few weeks later, Whitfield alleged Jordan had brought in out-of-state labor organizers. Jordan denied any knowledge, telling the press that she did not "need any outside help whatsoever."[26] Whitfield filed complaints with the US Attorney about voter registration in the Fifth Ward, alleging fraud. He also talked directly about race in a way that no other opponent of Jordan's had ever done. Whitfield stated that "Negroes should support him on the basis of his record, even though Miss Jordan is a member of their race."[27] In what the *Texas Observer* called a "grim turn," Whitfield stated that if Black voters failed to support him, they would "fail the test" of racism, an assertion the paper called inflammatory and presumptuous. The liberal paper condemned Whitfield for trying to make Black voters ashamed of supporting a Black candidate. It supported Jordan unequivocally, calling her a better qualified candidate and asserting that it would be a step forward for everyone, not only Black voters, for Jordan to win.[28] Still, the race seemed tight. "Political observers," according to the *Dallas Morning News*, "regarded the Jordan/Whitfield race as a 'toss-up.'"[29]

Whitfield's tactics pushed Jordan into dramatic action. She opened her own campaign headquarters on Lyons Avenue in the Fifth Ward and enlisted the services of Dr. Wilhelmina E. Perry, the first Black woman to earn a PhD in sociology from the University of Texas at Austin.[30] Perry came from an academic family. Her father was Dr. William H. Jones, the president of the HBCU Huston-Tillotson College in Austin from 1944 to 1952.[31] Perry provided Jordan with sociological analysis of her voting district and advice regarding the campaign's relationship with the Harris County Democrats.[32] One night during the 1966

campaign against Whitfield, Jordan called Perry to ask if she could come by her house and talk. She wanted Perry's advice about a crisis concerning the Harris County Democrats. Jordan did not want a repeat of her 1964 loss. "She wanted to exercise more control over her campaign operations," Perry recalled.[33] But somebody from the HCD, a liberal, said to Jordan, "We made you. We expect you to follow our agenda. If you don't, we'll withhold the money." Jordan felt confused and frustrated. She felt that in her first two races she had supported the white liberal candidates, spoken on their behalf, and brought in Black voters. Now she wanted to move forward and appeal directly to the voters in her single-member district. "She wanted to *win*," Perry emphasized. She wanted to become a politician. "She wanted me to evaluate the situation from a sociological point of view. . . . She did not sense that there were racial motivations that would explain what she had been told. She was not the type to ask for help. But she really did want help. I too perceived that these were not racial motivations."[34] And yet the HCD did not appear to understand why Jordan needed to reach out specifically to Black voters.

Perry understood the HCD position that its endorsed candidates share resources and office space, but she still felt angry over the lack of attention Jordan's race was receiving from the group. Once again she felt that Jordan was being used to bring Black voters to the coalition without getting white support in return: "I began to share some of this anger. What I did was to tell her that I thought we had to understand coalition politics." And to Perry, coalition politics depended on each coalition bringing strength to the organization. The Harris County Council of Organizations (HCCO) had a devoted core of Black voters and workers. Labor, including the CIO, brought money and organization. The liberals were highly educated professionals who had connections with prominent individuals; they could articulate a governing philosophy and bring expertise and strategy to campaigns. "I was angry because maybe they thought that Barbara wasn't smart enough to see that they needed us," remembered Perry. "Maybe it is time to test the Black community. They [the HCD] had promised her 5 to 6 thousand dollars . . . so let's go ahead and see what we can do with fundraising." Perry felt confident that the campaign could organize its own precincts and block workers. The real question concerned money. "Let's test the black community," she told Jordan. According to Perry, Barbara went home to think and consulted with two others on the advising committee, including Garnet Guild.[35]

The next day Perry received a call from the HCD. She recounted the pan-icked white voice at the other end of the phone. "Why did you say those things to Barbara? You have been reading too much Black Power material!" No, said Perry, "I'm reading sociology, race and power concepts!" Still, she was con-cerned. "What in the world have I done?" she asked herself. "I was scared that she would follow my evaluation and pull out and really put the financial responsibility on the black community."[36] Jordan decided to exercise her politi-cal muscle. She put her own campaign headquarters on Lyons Avenue, but the HCD still agreed to cover the cost. It was to her campaign's advantage to have a separate headquarters from the other candidates, and it had to be in the heart of the new Senate district in the Fifth Ward.

With Perry's help the Jordan campaign focused intensively on voter educa-tion, block workers, and data analysis. Perry considered herself a member of the HCCO and a Jordan supporter first; she had no ties with the HCD. She knew that urban Black voters identified with Black candidates; she knew that Jordan's race mattered very much to the Black voters in her community and that race must therefore play a role in the campaign materials. In addition to her training in sociology, Perry brought political experience to the Jordan campaign. She understood that the block-worker campaign should focus on one aim: getting people out to vote. Voters did not need to be instructed about particular candi-dates or even whom to vote for: Jordan was already well-known, if not famous in the community. The challenge was getting voters out and giving them knowl-edge about how to get to the polls. Jordan encouraged Perry and her workers to be creative in her citizenship education presentation. According to Perry, the training sessions used visuals and roleplaying so that block workers knew what to say when they went door to door.[37]

Jordan gained the support of Houston's Black voters because of her race, her respect for her older constituents, and her reputation for straight, direct talk. "People recognized her integrity," said Perry. Barbara "grew up in church. I think she had respect for teachers." Black women, such as Jordan's seventh grade teacher from Atherton Elementary, became Jordan campaign workers, and so did domestic workers, small business owners, and housewives. Perry noted the effectiveness of Jordan's speaking style: "She had a way of clarifying and sim-plifying." Perry appreciated Jordan's respect for her academic training, yet the candidate "made her own decisions." According to Perry, Jordan respected her audience and advisors, yet always projected political "strength."

Black voters admired Jordan's speaking style, but they also appreciated how Jordan looked and presented herself. Sometimes, according to Perry, "Barbara saw her size as her liability, as a female liability." But Perry was impressed with how Jordan knew how to buy the right clothes. "I think she had them altered. She knew how to wear her clothes well." Jordan's height—she was five foot ten—also allowed her to project a sense of strength. Continued Perry: "I loved her hair. Her beautician was a good friend of hers. Wilma. I liked her hair grooming. She had a way of presenting herself—so she looked good."[38] In this period Jordan was frequently photographed by Benny Joseph, a Black photographer who covered events for the *Houston Informer* and the *Forward Times*. Black Houstonians took great pleasure in arranging formal photographs of themselves and their organizations. "The photographs were essential vehicles for maintaining a positive sense of self," remarked one analyst of Houston's culture. "There is a formality to a lot of the [Benny Joseph] pictures that reflected the very polished image that photographers were able to provide to people. Physical dignity was especially important during the period of segregation. Those kinds of images were the bread and butter for black photographers."[39] Joseph, who took numerous photos of Black clubs and musicians in the Fifth Ward, also took formal photos of Jordan that were widely distributed. The word "respectability" captures some of what Jordan was trying to project, but not entirely. As a Black woman professional who was a public figure and an attorney, Jordan preferred tailored suits, earrings, and short, professionally styled hair. She always seemed comfortable with her clothes and with her appearance. When she was not at work, Jordan dressed casually—a photo of her in white pants, playing her guitar gives some idea of what she might wear while relaxing. But on the campaign trail, Jordan dressed in a way that conveyed her status as a professional woman and not as a member of what Tanisha Ford identified as the denim-wearing "youth rebellion" uniform of many SNCC women.[40] Her dress conveyed her seriousness of purpose and her ability to both confront and work with white and Black elites, a trait her constituents expected and appreciated.

Jordan drew other highly educated women campaign workers into her orbit, including Garnet Guild and Cecile Harrison. Perry recalled: "I knew Garnet was a good friend [of Jordan's]. She was part of the group that worked on a daily basis. She was a Quaker." Guild worked at Jordan headquarters on Lyons Avenue. "When you're in that HQ you have to have a good informal group. She [Garnet Guild] knew Barbara and knew when she was in a good mood. Good liaison

with Barbara. She was a good liberal and a hard worker."[41] Cecile Harrison, a young Black woman with a degree from Bennett College in North Carolina, was pursuing a PhD in sociology at the University of Texas at Austin. Harrison came from a Third Ward family. Her father had worked at Hughes Tools and as a precinct judge. She had grown up watching him on election day. Guild, Harrison, and Alice Laine, a white woman also pursuing a PhD in sociology at UT Austin and Harrison's partner, all worked tirelessly at Jordan's campaign headquarters. Perry also cited one close but unnamed white male supporter as an "honorary Black," and George Nelson, a Black barbershop owner, who possessed "wisdom without the training. He was a person who had integrity."[42] This core group of white and Black workers provided Jordan's 1966 campaign with a solid organizational foundation. The chaos that had characterized 1964 had been exorcised.

Taking Perry's advice, Jordan and her workers decided to focus on bringing out the Black vote. Jordan called on Black volunteers who had been block workers in her previous campaigns against the poll tax and school board bonds. She later recalled that "in '66, the block worker program was the primary factor" for encouraging voter turnout. She had lists of all the precinct judges and the names of all the willing workers in each neighborhood. Mass mailings included sample ballots and instructions about when and where to go on election day. The Black vote did not automatically come out, she later told Julian Bond in an interview. To be a Jordan block worker was to be an instrument of political education. "Breaking that down, each worker has been furnished with a block worker kit, a letter of instruction and [other] campaign material."[43] Perry, a key organizer of the block worker program, believed that the campaign needed accurate data about the people who lived in the district. It turned out, for example, that contrary to everyone's assumptions the Eleventh District had a sizeable number of white voters, something that the HCCO had overlooked. Those voters could not be ignored.

Jordan's campaign was so efficient that other candidates wanted to take advantage of the organization she had developed. They "came in with boxes of material," recalled Perry, "and expected us to deliver those materials, expected us to transfer over the campaign." But campaigning for Jordan and her job at Texas Southern University left Perry little time to spare for the HCD.[44] But Perry's resistance toward the HCD arose from resentment, and not just time constraints. In this race little reciprocity existed between Jordan campaign workers and the HCD. As Perry explained, Jordan's candidacy—and no one else's—motivated her and the other block workers. "I had my daytime job! I had a career. Those of

us who worked for Barbara chose to work for her."[45] Tensions with the HCD, however, paled in comparison to the emotions provoked by Whitfield's negative campaigning.

Jordan's primary contest was highly unusual in that she faced a white liberal as opposed to a white conservative. Whitfield and Jordan therefore both reached out to the same group of voters. What divided them were not issues but race. Harris County Democrat organizer Bob Hall remembered the contest well: "She really was the issue, her black face was the issue." Like Perry, Hall understood the power dynamics of coalition politics: "This is something that had to be taught on both sides. That it had to be a bargain. And had to do with the selection of candidates and agreement on issues. Everybody had to be empowered and they had to have something to say about it. . . . It was a complicated thing . . . no matter how liberal we claimed to be we had all grown up in a totally segregated and racist culture, and we had to change things we did not want to confront. . . . We're going to be changing things and that means dealing with Black people in a different way."[46] Jordan's race against Whitfield forced white liberals in the HCD to recognize not only the power of Black voters but the necessity of Black political leadership.

At the end of the campaign, Jordan answered to Whitfield's attempts to discredit her because of race with a proud, racially conscious theme that perfectly reflected the feelings of her constituents. "Our time has come," she said at a public rally. For the past twenty years, Black voters had voted for white candidates, and sent whites legislators to hold office. Now Jordan urged Black voters to seize the day: "Can a white man win? I say to you NO. Not this time. Not . . . this . . . time!"[47] She was right. The 1966 Democratic primaries in Texas sent three Black representatives to the Texas legislature for the first time since the late nineteenth century, and two of them, Barbara Jordan and Curtis Graves, were from Houston. The expanded number of at-large House seats allowed Graves in by a whisker, and Jordan won her senate seat in a landslide.

Fears of a tossup were unfounded—Jordan crushed Whitfield. She received 98 percent of the Black vote in her district, the highest percentage of the Black vote received by any candidate, white or Black. The Eleventh Senate District was racially mixed, and Jordan did well with white voters too, but the Black turnout for Jordan was so large that she only needed twelve white votes to win.[48] Jordan never believed that the HCD was fully with her in this race.[49] She was not alone in this view.[50] Even though she received a significant number of white votes and

had been endorsed by the HCD, she emerged from this race as a symbol of Black political empowerment.[51] After Jordan won, her emotional campaign workers, largely female, sang a civil rights medley, including "We Shall Overcome."[52] "We needed a victory," Jordan stated. "This is the only way. We've been talking a long time, but they always come back and say, 'We don't see anything.' They don't win. A victory in a body like the statehouse will do more to help the Negro recognize his voting strength than anything I can think of."[53]

Her victory over Whitfield for the Senate seat, along with the election of Curtis Graves to the Texas House, made national news. The *New York Times* ran her photograph, and another photo of her and Curtis Graves appeared in *Time* magazine under a sign that said VICTORY.[54] President Lyndon Johnson called to congratulate the young politicians, and a photo of Jordan and Graves appeared in the nation's major Black newspapers. This election was not just a local story but one that inspired oppressed people throughout Texas. On Labor Day 1966, Jordan spoke at a rally in Austin supporting farmworkers who had marched 490 miles from the Rio Grande Valley to demand a minimum wage only to be told by Governor Connally to go home.[55] Progressives turned the event into a push for justice, better pay, and equal rights. At the gathering in Zilker Park, Jordan said: "You've heard enough words today; what you really want to see is us pass a minimum wage bill. Take heart today, for no one is trying to give you anything but what you justly deserve. You are not begging for anything. You are not requesting anything; you are making your demand."[56] As a new senator, Jordan would have a say in minimum wage laws. Her status as a political leader now dovetailed with her reputation as an activist.

Jordan's spot in the limelight took her to Washington, DC. In February 1967, just as she started her term in the Texas Senate, President Johnson invited her to a meeting to discuss a wide range of proposed civil rights legislation with him and other Black leaders. Jordan joined Dorothy Height, Whitney Young, and Roy Wilkins around a table with the president. When Johnson looked at her and said, "Barbara, what do you think?" she responded by proposing that his new federal jury bill contain a "ban on sex discrimination" because this would help "get the Negro women of the country mobilized."[57] Jordan had been a senator a little over a month, but after this meeting she was mentioned in the *Washington Post* as an up-and-coming Black leader. When Vice President Hubert Humphrey came to Houston, Jordan became part of his entourage. She was emerging as a nationally known Black Democrat.

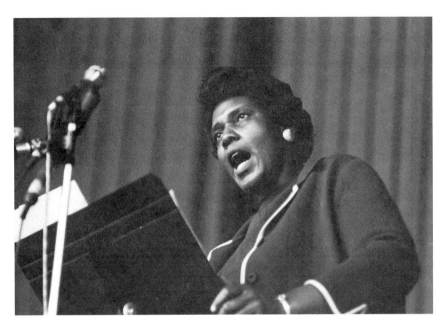

Figure 4. State Sen. Barbara Jordan speaking at Miller Memorial Theater in Houston, Texas, October 15, 1969. Barbara C. Jordan Archives, Texas Southern University, Houston, TX.

In June 1967 the Democratic National Committee invited Jordan back to Washington along with 130 other African American elected officials. The party leaders sought to form a task group dedicated to cementing African American loyalty to the Democratic Party. Criticism of the war in Vietnam proffered by Martin Luther King Jr. and efforts to form third party challenges by Black power advocate Stokely Carmichael threatened to undermine the fragile ties between a divided Democratic Party and Black voters, particularly in the South. Deputy Democratic chair Lewis Martin admitted that it was not safe to assume that Negroes would automatically vote for Democrats in 1968; the party looked to "elected Negro officials" to hold on to the Black support.[58]

Martin had reason to worry; much had changed in the nation between 1964 and 1967. Although the Civil Rights Act and the Voting Rights Act increased Black participation in mainstream politics, more than one hundred riots in major urban centers occurred between 1965 and 1967. Black activists throughout the country questioned the efficacy and sincerity of Lyndon Johnson's racial policies, and the president was frequently at odds with Black critics. Johnson

and the Democrats wanted the help of newly elected Black political leaders to attract Black voters to the party.

Thus, when asked to comment on the concept of Black power, most of the Black politicians who came to Washington, DC, that summer denounced the "disruptive slogan." Maryland state senator Clarence Mitchell of Baltimore called Black activists "all mouth and no action." Mose Cooper, recently elected to a small Illinois farming town's six-member council, condemned both the individuals and their cause: "I'm strongly against people like Stokely," he said. "They just made things worse." Carl Russell of Winston-Salem averred that demonstrations had served their purpose: "Now it's up to the courts and the politicians." Yvonne Brathwaite, a California state legislator who would go on to serve with Jordan in Congress, compared Black power activists to white supremacists: "There are extremists of all kinds—Negro militants, white ultraconservatives. I think it's better to have these things out in the open." A former Phoenix policeman elected to the Arizona legislature rejected Black power as a slogan and as a goal. "The Negro wants opportunity, not power," he stated. Nearly every Black politician interviewed said something negative about the Black power movement. The one exception was Texas state senator Barbara Jordan, who simply stated that she preferred to work through the political process, and offered no comment or condemnation of the Black power slogan or those who propagated it.[59]

Jordan continued to explore new ways of talking about racial differences without endorsing racial separation. In March 1967 she appeared in Dallas with Charles Evers, older brother of murdered civil rights activist Medgar Evers. "The Negro wants to participate in the decision-making," she told the audience.[60] But she also gave a thoughtful analysis about the nuances of racial domination. Both she and Evers "urged understanding of the differences between races rather than attempting to apply Anglo Saxon white protestant standards to all citizens." Jordan elaborated on this theme of racial difference in a speech she gave a few days later in which she attacked the myopia of middle-class whites. "Social workers," she said "should stop trying to apply middle class, white standards to the Negro welfare class . . . maybe we don't all want to be a part of white, Anglo-Saxon Protestant America. . . . Whites should listen a while to the 'Negro's views,' instead of just bringing your own standards into the conversation."[61] The *Dallas Morning News* interpreted Jordan's remarks as a retreat from integration: "Pressure for all-out integration appears to be waning. In its place, the more responsible Negro leaders urge whites to understand the problems and differences of their people,

weighed against a background of slavery, discrimination, and broken promises."[62] The paper's perverse misinterpretation of Jordan's comments shows how Black power's call to set priorities beyond integration was sometimes met with a sigh of relief by the white power structure. An acceptance of racial differences did not begin to approach all that Jordan and others were asking for, but she nevertheless took up the theme in her speeches. Black power made her conscious that the movement for Black liberation concerned more than legal rights.

Events proved that voting and elections alone could not solve the problem of racial inequality in a city like Houston. In April 1967 a series of protests at Jordan's alma mater, Texas Southern University, lasted more than two weeks and involved more than a thousand students who protested against dismal food, the dismissal of a popular professor, and women's curfew hours. The protests attracted the attention of local police and the FBI. Students blocked Wheeler Avenue, sang freedom songs, and threatened to block traffic and access to classrooms. Demonstrators were arrested and bonded.[63] Tensions exploded on May 17, 1967, when Houston police alleged that gunshots were heard on the campus. Police surrounded the dorms and sealed off the buildings. Students from the men's dorm erected a barricade, and then the police attacked. At two o'clock in the morning, more than a hundred officers stormed the dormitories and began shooting directly into the buildings. Officer Louis Kuba was killed by a bullet to his forehead that was later determined to have been shot by the police. The "3,000 rounds of pistol and automatic gunfire" from the police shattered the dorm windows. Students were driven out of the dorms, ordered to lie on the lawn, and taken to jail; 489 students were arrested.[64] "The cops acted as though they were fighting a war," said one female student. No guns were ever found in the student dorms. "We're no criminals."[65]

Five students were charged with rioting, a felony, and later charged with the murder of Officer Kuba. The mainstream papers, the mayor, and even some of the Black leadership at Texas Southern supported the police action against what the *Houston Tribune* called an "armed rebellion against lawful authority."[66] It took many months, even years, for the truth of the events to come out, thanks largely to the NAACP. Polls taken at the time indicated that the police action had made Black people more sympathetic to the Black power concept.[67] The NAACP sent lawyers from its head office to represent the students. On July 30, 1967, Jordan urged the release of the five incarcerated students at a public rally sponsored by the Houston Legal Defense Fund Committee of the NAACP.[68]

Jordan was not above using the fear of Black violence to mobilize middle-class Blacks out of their apathy. In a speech to the Sigma Delta Theta Sorority in Dallas in August 1967, a few months after the police riot at Texas Southern, Jordan told her audience that "the Black slum dweller hates us as much as he hates whitey" and that America's "educated Negroes" must take responsibility for preventing a "national holocaust."[69] In this passage Jordan wanted her educated audience to wake up to the reality of Black deprivation and anger among the poor. Individual Black achievement could not substitute for justice. Bridging class differences between Black Americans must be part of the Black movement.

Jordan continued to argue that voting was a necessary act of racial pride and solidarity. In the fall of 1967, she organized a multiday workshop called the "Texas Leadership Conference," funded by the Southern Regional Council's Voter Education Project. More than three hundred Black activists attended the event in Wimberley, a rural retreat outside of Austin. Jordan emphasized Black self-reliance and independence. "Negroes for too long—for reasons of survival—have practiced the art of 'followship,'" she observed, and she urged Black candidates to build up their own organizations, as she had. "If NEGROES are going to lead, the leaders must talk to each other. . . . YOU must get the voters registered; YOU must get your registered voters to the polls."[70] Alliances with whites were essential for Black success, but Black candidates also needed to strengthen racial solidarity. Her confident performance at the conference impressed observers and gave hope to Black activists.[71] She declared herself "not nervous and not frightened" about "being a Negro senator or a woman senator," but instead looked forward to the job. "I know it will cause a lot of attention to focus on me," she said, "but I don't want to avoid it." Jordan said she "wanted to make a favorable impression in the Senate to pave a path for future Negroes and future women in politics."[72]

During Jordan's first legislative session, she had fully emerged as the face of Black leadership in Texas. She continued to address the public at church gatherings, sorority events, dinners for block workers, and ribbon-cutting ceremonies at new buildings. She appeared on local television in Houston.[73] She also gave speeches outside of Texas. At the invitation of Martin Luther King Jr., Jordan traveled to Atlanta to speak at a gathering of Black state representatives sponsored by the Southern Christian Leadership Conference. Yvonne Brathwaite Burke, a state legislator from Los Angeles, remembered Jordan started off her speech by singing a gospel song: "They loved it, and I think Dr. King really enjoyed having

her there."[74] When King was assassinated, Jordan was sitting with Governor Connally at the Hemisfair celebration in San Antonio. At that tragic moment, she heard Connally state that Martin Luther King Jr. had "contributed much to the chaos, and the strife, and the confusion, and the uncertainty in this country, but whatever his actions, he deserved not the fate of assassination." Grieving and outraged at the governor's callousness, Jordan left San Antonio to rush back to Houston to be with her constituents and arrange a memorial service for King. Her enmity for Connally only grew deeper, and she, along with the NAACP, demanded he apologize for such a "dastardly statement."[75]

After King's death, Jordan confronted white audiences on the deleterious effects of racism on Black lives. At a newspaper and media convention in Austin at the end of May 1968, she contributed to a panel titled "The Role of News Media in Race Relations." Her audience consisted of "owners and executives from the majority of the major white newspapers, and radio and television stations." The crowd heard Jordan lay out Black frustration with the slow pace of political change in the nation. According to the *Forward Times*, she "held the packed house spellbound" as she spoke for over an hour."[76] She talked about the failed promise of the American Revolution and the Constitution: "The real question which now arises is, did anybody believe these promises of America? Were the spokesmen of this country serious? I submit that the Negro believed—and that white America could not risk belief." She quoted Black psychologist Kenneth Clark about the effects of racism on mental health, and she asked the audience: "Have you ever questioned the extent of your own contribution to the perpetuation of this kind of system? Do you in your contacts with minority people serve their further dehumanization and self-doubt and sense of unworthiness? Can you define the promise of America—and if you define it, can you help make it real?" Explaining the appeal of Black power, she stated that the excluded "become tired of empty promises, meaningless phraseology, exploitation, and intimidation. They became tired of a thousand blatant and subtle indignities heaped upon their heads and stored in their gut, a thousand different times, on a thousand different days." Jordan offered a blunt assessment: "Prejudice and discrimination based on race has produced a society which has a cancer built into it. Palliatives and bandaids cannot cure the ills." She ended by asking: "Who Speaks for the Negro? NO ONE. He: the Black Man, stands silhouetted against a thriving abundant America. . . . He wants IN. He wants America to hear him—understand his condition and support his humanity. He knows that

if this country does this, it will save him; you will save this country and you will save yourselves."[77] Jordan's readiness to confront a white audience with their own complicity in perpetuating inequality on every level, from the institutional to the personal, astonished the *Forward Times*, which noted that "an almost instant mood of acceptance" fell over the white audience. "She wrapped up her masterpiece of oratory by demonstrating how the person listening to the sounds from the Negro community was the one to be concerned about and not the one making the sounds."[78]

Sometime after this speech, Jordan, like many others, dropped the word "Negro" entirely and began using the word "Black" to describe herself and her constituents.[79] The shift in language also seems to signal a broadening perspective. Jordan read the books and statements published by Black power leaders, and she readily gave her opinions in a 1970 oral history interview on the condition that it be released after her death.

She described what it was like for her to navigate the dynamics of "the white man's world" she encountered first in law school and then in the Texas Senate: "I tried to learn his rules, you know. 'The Man,' as many of our young people call him writes the books and knows the rules and makes the decisions. And so I decided in order to cope with the world as it is and not as we would like for it to be. . . . It was necessary to find the door for getting inside just a little bit to find out what 'the man' is doing and how he acts and how he thinks and how he reaches decisions."[80] Ever since the days of slavery, Blacks had to scrutinize the ways and psyches of whites to survive. Her tactic was to "try to get a little corner at the decision-making table where you can hang on and maybe get a word in here and there or a sentence or a dot, you know." But instead of ending on an upbeat note celebrating the gradual acceptance of Black voices at the table, she abruptly concluded: "I suppose I was in the process of learning to lose, as I still am."[81]

The interviewer moved on to Black leaders. What did she think of Malcolm X? "One of the most misunderstood of the civil rights leaders," she replied. She said she wished everybody would read his autobiography. Malcolm X was "a good man and had a vital part to play in the whole civil rights movement" because he fostered Black pride. The fact that Malcolm X frequently denounced the civil rights movement and Martin Luther King Jr. did not seem important to Jordan. To her, in 1970, these elements of identity and pride remained key components of the freedom movement. Jordan praised King, Roy Wilkins, Adam Clayton Powell, and Ralph Abernathy, but spent more

time talking about the Black figures who were rising rather than those who had died or were in decline. Muhammad Ali? He was a "great fighter" in her view. But more important, "Muhammad Ali gave Black young men an image and a figure to sort of identify with which they have not had in the past."[82]

Without prompting from the interviewer, Jordan expounded on the lack of confidence she found so prevalent in Black men. She disputed the interviewer's assertion that Black men had suffered "a loss" of confidence. "When you say loss of confidence, that means they once had it." But, she said, "What I'm saying is they never had it." The reasons were complex but boiled down to how white people "in the main have catered to the Black woman." White supremacy in slavery, according to Jordan, had only valued the labor of Black men out in the field, but "the woman was in the house and had the confidence of the master and the mistress and the rest of it. And she raised all of the children and became the real strength. . . . So, you can follow this historical pattern until right now." Echoing the widespread belief that slavery had distorted the Black family, she argued that "there is still this feeling that it is the Black woman who can be trusted by whites, and this has served to make the man just feel like he's less than a man, and he continues to feel this way."[83] Some Black women activists at the time, such as SNCC leader Ruby Doris Smith Robinson, were so persuaded by this kind of analysis about the power differences between Black men and women that they retreated from leadership positions out of concern that their exercise of authority did damage to Black men.[84] But to Jordan, the rage of Black men at being marginalized in society had less to do with women's achievements and more to do with white society; it was a rage she professed to understand, but in these interviews her references to her own rage were muted, oblique, even flattened.

Jordan believed that ideas associated with the Black power movement provided a necessary vent for pent-up emotions for all Black people, not just men. Stokely Carmichael, she said, "provided an outlet for feelings which had been repressed over a period of time. . . . His activities really gave us the catalyst for unlocking repressed emotions and feelings in Black people and made it credible to say what you feel." In noting Jordan's praise of Carmichael, it is intriguing to note what Jordan did not say. She did not denounce him as an extremist or a troublemaker. Instead she noted his positive effect in the emotional healing of Black people, a healing that had to take place because of the damage done by slavery and segregation. Similarly, she declined to denounce the Black Panthers, contending that they "help with a definition of person . . . help with

consideration of feelings of Black awareness." She thought it was clear that the Panthers were being targeted by the government, but why? "They haven't really done anything ... but it's just the way they talk, the way they sound, that gets people upset." Jordan then went on to discuss *Soul on Ice* by Eldridge Cleaver, a book she had read and thought about. She believed Cleaver "overused" shock value "as a way of reaching people." And even though he had fled to Algiers, she saw him as an American who one day would want to come home. Cleaver, she said, was "smart ... and I think he could be a more valuable person if he were to change his rhetoric a bit."[85]

As much as she valued the insights of Black power advocates, Jordan understood that Black power often made her job more difficult because it raised expectations among Black voters that she would spend all her time criticizing the system: "Your constituents worked to get you there, and then after you get there, you're working hand and brow with the Establishment, with the system, and you ought to be fighting it every step of the way."[86] But Jordan seemed resigned, even philosophical, about how the perception of moderation might adversely affect her: "If they ever get dissatisfied ... too dissatisfied with my stance, then, of course, they have the power to retire me from political life."[87] She seemed confident, however, that would not happen—perhaps because she knew her constituents so well.

All Black politicians of the era wrestled with their role as race leaders. During her first year in the Texas Senate, Jordan traveled to the University of Chicago to attend a weekend conference of "Negro Elected Officials." It was a bipartisan gathering dominated by Black Democrats. The desire for racial accord led to a call for "nonpartisan unity" and a refusal by the officials to take positions or issue resolutions. Doris Saunders from the *Chicago Defender* noted "the large number of Negro women present at this conference representing all spectrum of political opinion and holding high state elective offices." She called the gathering "a historic meeting, the first of its kind, not perfect, but holding the promise of a kind of togetherness and unity that has not been present in a political gathering before."[88] But "togetherness and unity" remained elusive, especially as the number of Black voices in politics grew.

In Newark during October 1967, more than one thousand delegates from twenty-six states attended a four-day meeting that included activists and Black elected officials. The gathering passed numerous resolutions, ranging from a call for a "buy Black" campaign, a national guaranteed income, and the election of

more Black congressmen. The conference also called for a "national Black grass-roots political convention" to be held four years later, after both major party conventions.[89] The call for a Black political convention gained momentum. By 1970 national Democrats were still recovering from the election of Richard Nixon. But in the early 1970s, a new crop of African American politicians, in concert with an array of Black activists, faced forward. No single voice defined this group. The Black power movement, the labor movement, the Black arts movement, and Black feminism all brought "Blackness" to the center of American life as never before. In 1970 Black power activists met in Atlanta to plan for the 1972 convention.[90]

Black elected Democrats reached out to activists. At Northlake, Chicago, in September 1971, a secret planning group that included activists as well as politicians met to develop a new political agenda. The *Chicago Defender* was one of many news and television organizations that planted themselves in the hotel lobby and noted the participants coming and going. They identified Jordan as one of the forty national leaders who gathered in "secret" in a weeklong parley to hash out a strategy.[91] Participants included activists Coretta King, Julian Bond, Roy Innis, Vernon Jordan, Maynard Jackson, Dick Gregory, and Amiri Baraka.[92] They all shared the same goal: to defeat Richard Nixon and influence the Democratic Party platform.[93]

Baraka supported forming a third party, or a "Black party strategy," because he believed that the existing two parties held little promise for Black voters. Georgia state legislator and former SNCC leader Julian Bond disagreed, advocating instead for a "favorite son" strategy in which each state would field the name of a Black candidate to the Democratic Party convention and then use those votes to gain leverage within the party.[94] A third approach emerged in the summer of 1971 when Brooklyn congresswoman Shirley Chisholm announced that she was "exploring" a presidential run. Chisholm received a lukewarm reception from other Black officeholders, yet her candidacy excited many students, feminists, and Black activists.[95] The upcoming presidential campaign energized Black voters and politicians, but no single strategy took hold.

Even though Jordan was still only a state legislator at the time, her appointment by former president Johnson to a committee to study welfare, her participation at the Northlake conference, and her reputation as a dynamic speaker gave her national stature. In November 1971, she attended the Congressional Black Caucus gathering in Washington, DC, and appeared on a panel titled "The

Development of Black Political Power in the 70s." The four male politicians discussed the nuts and bolts of widening Black participation in voting and integrating more Blacks into city government. In her presentation Jordan looked at the bigger picture. She cited statistics showing the growing number of potential Black and female working-class voters. Jordan hoped that by the time of the presidential race in 1972, more than thirty-seven million women—fifteen million of them African American, and half of them young—would register as Democrats. She also stressed the importance of building coalitions with white voters. She warned of dire consequences for coalitions if whites fled the cities for the suburbs: "If these conservatives cannot be reached and brought around to reasonable thinking, Blacks can forget it." Black journalist Ethel Payne of the *Chicago Defender* supported Jordan's analysis and called for a "brave new ideology which must find new ways to buck the rising tide of conservatism in this country and develop new coalitions of interests and goals and the actualization of power."[96]

In March 1972, Jordan attended the National Black Political Convention in Gary, Indiana.[97] This highly anticipated gathering of Black political leaders and activists from across the nation met to put forward new strategies for maximizing Black political influence and power. Their slogan, coined by Amiri Baraka from a saying by Ron Karenga, was "unity without uniformity." Gary attempted to bridge the major differences among Black politicians and activists. Black elected officials were in the minority. Local and national activists who supported the now better-known leaders such as Amiri Baraka, Roy Innis of CORE, and Bobby Seale, the chairman of the Black Panthers, comprised the majority. Ethel Payne of the *Chicago Defender* put the number of delegates, press, and attendants at nearly eight thousand.[98] The convention garnered enormous publicity.[99] The most prominent photo of the event, which appeared in several newspapers, was a group shot of Rep. Charles Diggs of Michigan, Amiri Baraka, and Mayor Richard G. Hatcher of Gary.[100] Unfortunately, no photos exist of a press conference in Chicago that took place the day before the convention, where Jordan appeared with those same three men, along with Jesse Jackson and DC mayor Walter Fauntroy. She was the only Black woman elected official at the table.[101]

Jordan came to Gary in good faith. At the beginning of the three-day convention, Black politicians were slated to control the procedures of the gathering. Diggs was scheduled to act as chairman, and Jordan had been tapped to chair the Resolutions Committee, a position deemed "thorny." According to the original program, printed on the front page of the Gary *Post Tribune*, Jordan was

listed to speak to the convention on Sunday, March 10, at 10:15 AM, at West Side High School, right after Shirley Chisholm.[102] Yet neither Jordan nor Chisholm ever appeared on the podium. Chisholm, chagrined at the lack of support given to her presidential bid by other Black congressmen and skeptical of Black nationalists like Baraka, never attended.[103] As for Jordan, she was bumped from her position as Resolutions chair.[104] She later described what happened. "I was chairman of the resolutions committee. But Baraka and his family had clearly set out to control that convention. And they did a good job, inserting people here and there. You didn't know how they did it or where these people were until you tried to put forth a resolution. I would lose a resolution, win it again, lose it. It was absolute chaos. The black caucus lost control of that convention before it even started."[105] Activists summarily eliminated the public roles of Black elected officials; Baraka replaced Diggs as the convention chair.

Baraka could not combine his desire to influence politics with cooperating with actual Black politicians. Chisholm recoiled at the lack of democracy and the bullying. "It was uniformity without unanimity," she wrote of Gary.[106] Tensions erupted over Israel, bussing, and integration. Members of the NAACP walked out, as did Detroit labor activist Coleman Young. Jordan stayed until the end. Given all the planning that had gone into Gary, she had expected an outcome that would have given Black politicians some kind of mandate: "When people asked me what I thought of it, I said the fact that 5000 black people came together in one place was an accomplishment. And it was. But unity?"[107] Harry Belafonte posed a similar question: In the absence of a unifying figure like Dr King, "Could there be a consensus? Could there be a conclusion arrived at that would give uniformity and give a sense of purpose?"[108] The answer, he said, was no.

Shirley Chisholm wondered why Baraka, a man of evident talent, never "tested" himself by running for political office. She also expressed confusion about why such a strong separatist kept trying to associate himself with "those of us who still believe that, in spite of the inequities and grievances that persist, America can become a just, democratic, multifaceted society."[109] Yet Baraka's criticisms were not as simple as Chisholm implied. He supported participating in electoral politics, but he dismissed existing Black politicians as members of the "middle class" only interested in the "status quo."[110] He wanted Black nationalists to challenge incumbents and run locally and statewide. He wanted Black activists to exercise influence on "candidates running for Congress, Senate, mayors, and everything else to try to really get some kind of a consistent,

you know, Black political presence."[111] Gary sent energized activists back to their communities, which expanded Black participation in the political system.

Despite all the tensions at Gary, the big tent of racial unity still prevailed in the 1970s. Serious differences existed in theory, but in practice such divisions were merely the latest manifestation of disagreements that had waxed and waned in the Black community since the antebellum era. The early seventies remained a period when a growing number of Black voters continued to support an ideological range of Black candidates for office. Jordan supported integration. She disagreed with some of the underpinnings of Black power, but she understood its appeal and tried to engage with its ideas and find common ground. The Black power movement gave Jordan a bigger platform and a wider set of ideas she could draw on to promote her agenda of racial inclusion and equality. Her statements and her deeds demonstrate that she was willing to reach out to Black power advocates; she thought many had valuable contributions to make.

By the early 1970s Jordan had emerged as a unique figure: an African American woman state senator and a political insider who also felt comfortable working with a range of Black activists. She had been charged with the triple task of representing her constituents, integrating and educating the Senate, and building an effective political organization to ensure the election of more Black representatives. At the same time, she addressed the aspirations and anger of Black people in her district while advancing a substantive political platform. Her electoral victory demonstrated that coalition politics could work, but only if issues of race were put front and center, rather than diluted down. Pioneering figures like Jordan created our modern understanding and expectations of how issues arising from the civil rights and Black power movement could be pressed forward in electoral politics.

A Seat at the Table

Senator Jordan in Action

People should become aroused before they are penny taxed out of proportion.

—Barbara Jordan, 1969

In September 1966, shortly before she took her seat in the Texas Senate, Barbara Jordan joined a protest against the state Democratic party's conservative majority. The number of Harris County representatives to the party's governing body had been cut from eight to four, and in response, Jordan and more than 150 Harris County liberals walked out of the party's convention in Austin. "To hell with [Texas governor] John Connally," chanted the group as they marched a mile to the capitol to hold an impromptu rally. Jordan got the troops fired up: "We are here to make our stand," adding, "the SDEC [State Democratic Executive Committee] are wreaking havoc with the Great Society, and we don't want any part of that."[1] At the beginning of the legislative session, Jordan kept up her criticism of Connally, stating that the governor "may have his way in the Texas House, but not in the Senate." She promised to "dissent where dissent is called for."[2] While a senator, Jordan never hid her dislike of Governor Connally.

And yet she had also probably participated in her last protest against him. Now she was a senator, and she changed her behavior to match what she thought of as the proper decorum for a senator. She did not shout or lead protests. She developed good or at least neutral relations with all her colleagues. She mastered the rules. She cast some questionable votes. Some of Jordan's harshest critics suggested that these changes in behavior meant she had sold out her liberal principles. A. R. "Babe" Schwartz, a liberal senator from Galveston, described

Jordan as "someone who goes along to get along." An anonymous critic told a journalist that having "watched Barbara Jordan for almost ten years . . . I have yet to see any evidence she is interested in anything beyond the advancement of Barbara Jordan." And Lauro Cruz, who served alongside Curtis Graves in the Texas House of Representatives, recalled that "Barbara did not believe in shaking the trees; she let other people shake the trees and she picked up the apples, and that's fine."[3] The oft-repeated view that Jordan was merely "pragmatic" does not answer the accusation that she was too flexible with her principles and too willing to concede to conservatives. Was this the case? A close look at her six years as a legislator in Austin illuminates her development from an outside critic to legislator and—almost—party insider.

Since the senate neither kept records of committee meetings nor recorded debates on the floor, tracing Jordan's approach to governance, or understanding how her race and sex affected how she was perceived by her peers, remains a challenge.[4] Nevertheless, oral histories and interviews given by several Texas senators (including Jordan, while she still served in office), along with newspaper accounts and other oral interviews, allow an examination of Jordan the legislator and politician.[5] How did Jordan approach her new position as the only Black woman in the Texas senate? Was she effective? In retrospect, probably the most important lesson she learned from her work in the senate was that legislative victories hinged on personal relationships, not big speeches. "In this body, you bet on the jockey, not the horse," Jordan's friend and fellow senator Max Sherman recalled being told during his first weeks on the job.[6] The evidence shows that during her time in the senate, Jordan established cordial relationships with many conservatives, but maintained her liberal convictions. Like many of her liberal colleagues in that body, however, she faced steep challenges turning the poetry of campaign promises into the prose of legislation.

A gust of change came to Austin in 1966 when the first round of redistricting since 1920 introduced fresh liberal faces to the Texas Senate. Barbara Jordan from Houston, Oscar Mauzy from Dallas, Charlie Wilson from East Texas, Don Kennard from Fort Worth, fellow Houstonian Chet Brooks, Joe Christie from El Paso, and Bill Patman, the son of Congressman Wright Patman, comprised the new progressive crew joining such older liberals as Babe Schwartz of Galveston and Joe Bernal, a Mexican American from San Antonio. This was a diverse group, but all Texas liberals at this time agreed the state needed a fairer system of taxation.[7] The group called for a corporate income tax, a minimum wage, and

new utility regulations. In a legislative body made up of only thirty-one mem-
bers, eleven votes could prevent a bill from reaching the floor, and a majority
of sixteen could make it pass. For the first time in ages, the senate promised to
be a place of real disagreement: The *Houston Chronicle* predicted an "explosive"
session.[8] The *Dallas Morning News* announced that redistricting had "virtually
ended . . . rural conservative domination. . . . January will likely see a freewheel-
ing Senate."[9] The sixtieth legislature, the *Texas Observer* noted, "has a strong
liberal contingent—13 liberals or swing moderates—and Miss Jordan, who is 30,
is expected to add a young, strong voice to that bloc."[10] The new liberal group
appeared determined to represent labor, urban, Black, and Latino Texans and
their interests with more vigor.

On the first day of the 1967 legislature, the liberals—confident they had the
sixteen votes necessary to change many of the most oppressive Senate practices—
had planned to challenge the rule that gave the lieutenant governor the power
to appoint the members of all the senate committees. Nearly immediately, how-
ever, they realized they were one vote short. (Oscar Mauzy later blamed "gutless"
Bill Patman for switching sides.) Babe Schwartz instead introduced a narrower
amendment to do away with "secret sessions and executive sessions," but that
gambit failed when the lieutenant governor ruled that a two-thirds vote, rather
than a simple majority, was needed to amend the rules.[11] Mauzy remembered
that "many people criticized us for making this fight the first day, because nor-
mally the first day's only supposed to be about thirty minutes, you know. You're
supposed to adopt the caucus report, adopt the rules; everybody loves every-
body. And everybody hugging each other's neck, and you cut out. Well . . . and a
lot of people got mad. . . . And they were kind of disturbed with me because we
didn't get to go to lunch until about 2:30 that afternoon."[12] The drawn-out and
unsuccessful challenge left everyone hungry and in a bad mood.

The fight during that first day of the session established a pattern. Liber-
als might gain steam on a particular issue, form a loose coalition, but then be
unable to muster enough votes to win. But Mauzy, Jordan, and those who sup-
ported greater democracy in the senate had to start somewhere. As Mauzy put
it, "The people of Texas and the lieutenant governor and the press and every-
body else needed to understand at the beginning that this was going to be a ses-
sion with conflict in it. And that we—the newcomers to the senate, particularly,
were not going to fiddle faddle around and engage in this old crap that's been
going on down there for years. And if we had eleven [votes], we were going to

block [bills coming to the floor] when we could. And by God, it wasn't going to be any holds barred." Mauzy spoke like a hard-charging radical, but liberals like him were more invested in the existing political system than they realized: "We wanted the old guard to understand at the outset that we were rookies, many of us, and we were going to be respectful, but by God we were going to be voting, we were going to be heard, and we were not going to be intimidated. Now I think we pretty well established that the first day."[13] Despite their opening salvo, all the freshman senators still wanted to earn the respect of the more experienced legislators, and the result was often many exercises in futility. "I was determined to try my best the first thirty days to be seen and not heard," Mauzy recalled, "to act like a rookie is supposed to act, to do my homework and to be conscientious."[14] Mauzy went on to serve twenty years in the Texas Senate and later became an associate justice of the Texas Supreme Court. A labor lawyer from a working-class Greek American background, and related to Democratic Party organizer Chris Dixie by marriage, Mauzy believed in reform, but he was part of the political culture of Texas that demanded more than a modicum of deference to the older heads. It was difficult to be "seen and not heard," yet still "heard" and unintimidated at the same time.

Jordan, like Mauzy, accepted the need to prove herself. "I decided I would walk softly," she said. "I would do my homework. I would read the bills. I would be knowledgeable about the issues, and I would be able to vote intelligently. And I think that it was ultimately my desire to learn the job and do it that won these men over."[15] Jordan worked hard in what she considered to be major committees: Jurisprudence, Education, State Affairs, and Labor and Management Relations.[16] Mauzy concurred with Jordan's strategy, yet he acknowledged the racism and sexism she faced: "A lot of them privately hated her guts just because she's a Negro, but she worked hard. . . . She's very diligent. She never missed a committee meeting. She asked intelligent questions. She never asked a question if she didn't know the answer. She's a damned good lawyer."[17] As much as they disagreed with the establishment, the new liberal legislators saw themselves as professionals who wished to master the intricacies of governance, and they respected the senate's traditions.[18] Indeed, when they began to think of innovative ways to rebel, they always worked within the rules of the system.

After the unsuccessful attempt to change the rules, the liberals next chose to filibuster a proposal for a new city sales tax. Without an individual or a corporate income tax, Texas relied on property and consumer taxes for the bulk of its

revenue, a practice many liberals considered an excessive burden on the poor. Although they did not have enough votes to block the consumer tax increase, they thought a filibuster could draw some press attention. In March 1967, about midway through the session, they sprang the surprise move on the conservatives. At that moment, Jordan took the opportunity to make her first major speech on the senate floor, and, according to Mauzy, her nearly two-hour-long presentation was the highlight of the entire event: "She really impressed the gallery and the lobby because when she got up to speak it was her maiden speech, and boy, she was ready. And man, she was quoting from Galbraith and all the great econo-mists and was VERY dynamic."[19] "Where is the equity," Jordan asked, "when the people who make the most pay the least and the people who make the least pay the most? It is absolutely urgent that we think about alternatives."[20] She noted that the people most adversely affected by a city sales tax were "underprivileged Negroes and Latin Americans of Texas." Mauzy recalled the positive response Jordan garnered was "one of the few times I've ever heard the Senate applaud any member of the Senate for anything. I mean even the people that disagreed with her. Her delivery was good. She was so well prepared. She had everything right there at her fingertips—completely germane."[21]

Jordan had campaigned against raising sales taxes since 1962, but unfortu-nately the hastily called filibuster clashed with her subcommittee's scheduled hearing in support of the Fair Wage Bill, another signature issue. When the sen-ate majority refused to allow the Labor and Management Committee to meet during the filibuster, valley farmworkers who had traveled to Austin to sup-port a minimum wage found themselves without a platform to make their case. When the group held a rally on the steps of the capitol, Jordan stepped outside and gave hope to the cheering crowd. "You've been waiting a long time to get a fair wage," she told those gathered. "This minimum wage is just going to be the start of a great new movement. We're going to finish this job."[22] Jordan returned to the filibuster on the sales tax, promising the farmworkers that the subcom-mittee would hear their testimony in the morning.

But that promise could not be kept. Unexpectedly, liberals lengthened their filibuster overnight. They "busted" the required twenty-one-person quorum when Jordan and nine other senators "hid out" at an undisclosed hotel in Aus-tin. Two senators were just absent and one was ill, so it took only nine leaving the floor for the debate to cease. Without the required quorum of twenty-one, business stopped. The speakers on the floor could rest, and the filibuster and

protest against the city sales tax could continue. Lieut. Gov. Preston Smith sent a sheriff to pursue the absentee senators, but the liberals had rented hotel rooms under assumed names so they could not be found. The next morning, bad moods prevailed. "GOD ALMIGHTY they came unhinged," remembered Mauzy. Senator A. M. Aikin told him, "Oscar, that's the worst thing that's ever happened. Boy that's hard on us having to sit there all night." In reply, Mauzy flaunted his relative youth, and frustration, at the older senator: "I'm god damn sick and tired, and a lot of people are sick and tired of the way you'all are running that damn Senate. The establishment's running it, and we don't like it, and if we can punish you physically, we're going to. And we're younger than you are, and we can sit up all night."[23] Mauzy, at forty, was considered young for the senate; Jordan, Charlie Wilson, and several other rookies were even younger. For a time the filibuster created a feeling of solidarity among the liberals. As Mauzy put it: "Our side are the Wilsons, and the Schwartzes, and the Mauzys and the Jordans and the Brooks. Were just 25 years younger than they are, and we taught them a lesson with that."[24] But that lesson failed when the coalition of eleven liberals who opposed the city sales tax fell apart. As Mauzy related, "Eleven of us were philosophically in agreement that an increase in the general sales tax was bad. . . . [But] two of them finked on us. Bill Patman and Jim Bates both sold out and went south, just like they did in the regular session last year."[25] The filibuster was a flop.

Not only did liberals fail to stop the sales tax, they also disappointed the farmworkers. Disgruntled conservatives on the subcommittee—in no mood to meet at 8:30 AM—failed to show, leaving senators Jordan and Joe Bernal of San Antonio to face a chamber filled to the brim with angry farmworkers and their supporters. Jordan had not known the day before that the filibuster would preempt the hearing, and now, with only a minority of members present, the official proceedings could not begin. Jordan had been up all night and was junior to Senator Bernal, but she faced up to the crowd and the blunder: "If we were to convene this committee this morning and take testimony, the act would be useless, according to the ruling of the parliamentarian. It is the second time within 24 hours that we have apologized to you. Before this session ends, there will be a hearing on the Fair Wage Bill in the Senate, and I hope that you will come back."[26] During the previous summer, she had spoken to marching farmworkers at the large protest in Austin and had promised to act on their behalf, yet she could not come through on that disappointing day.

She must have been discouraged. But Mauzy, often depicted as the leader of the liberals in the senate, was pleased with the filibuster. As he acknowledged, however, complex political alliances in the senate made it impossible for the liberals to stick together. The legislature was comprised of more than just two camps. On issues such as workman's compensation, civil rights, corporate income tax, and minimum wage, a "liberal" and "conservative" split was evident. But on a host of other topics, including Sunday closing laws, liquor by the drink, water resources, taxing beer and whiskey, and appropriations, the liberal-conservative divide broke down.[27] To be sure, the single-party state in Texas divided into liberal and conservative factions within the Democratic Party on election day, but actual governance created ever-shifting alliances. Enthusiasm and unity gave way to the reality that all senators were accountable to their constituents, subjected to pressures from the more powerful people in their party—such as the governor and lieutenant governor—and vulnerable to the persuasive financial powers of the "fourth branch" of the Texas government: the lobby.

The lobby was an accepted part of Texas political life. It comprised what today would be called corporate special interests. Mauzy put it this way: "Well, it's your oil and gas lobby, the insurance lobby, the bank lobby, the financial lobby, the vested interests. They still run things down there. . . . They're the ones that go in to see the speaker every morning before the session, and the Lieutenant Governor before the session. They're the ones that determine which bills are going to be heard and which ones aren't and what's going to happen to them. The lobby still runs the legislature."[28] Lobbyists also wielded power through the Texas Research League, which was, according to Mauzy, a "total unofficial thing," funded by the special interests, that provided much-needed research for senators who simply did not "have the resources to do our homework properly."[29] The lobby was also expected to "take care of" senators not through outright bribery but by means of campaign money. "You pass an important bill for the insurance lobby in Texas and they'll take care of you when you run for reelection," Schwartz explained. "You pass a bill for the beer lobby; they'll take care of you."[30] Teachers had a lobby, and so did organized labor. But the industries that paid the most were the state's powerful industries: oil, gas, banks, and insurance. Any political coalition in the legislature had to acknowledge that senators were influenced by their ties to lobbyists and not just to an abstract set of ideas.

Huge loopholes in the disclosure laws left few safeguards against corruption; legislators could conceal their finances. As Schwartz indicated, senators relied on

lobby money for reelection as well as for recreation. Lobbyists provided almost unlimited funds for food, drink, and fun. A group of lobbyists, for example, regularly took senators duck hunting. Schwartz described this seemingly innocuous pastime: "This is a lobby that's got a nice place to hunt ducks—the sulfur lobby. They've got a place down there they've been taking sulfur out of for twenty years and they've got a bunch of abandoned pits. It's possibly the best duck hunting on the gulf coast . . . and the food's good and the whiskey's good and the company's good. And there'll be a bunch of members down there. I won't go—not because I dislike the lobby particularly, but because I'm just not that crazy about duck hunting."[31] The danger, as Schwartz pointed out, is that receiving gifts and hospitality made senators psychologically beholden to the lobbyists, whom they saw all the time, rather than to their constituents or to their allies in the senate.

Another reality liberals faced was the power wielded by Gov. John Connally. Determined to keep the pro–labor-liberal coalition in Texas from gaining control of the state Democratic party, the conservative governor still held the party in his grip. As political commentator David Broder wrote in the *New York Times*, "The day still seems distant when Southern politics is realigned on the national pattern of competition between a predominantly liberal Democratic party and a predominantly conservative Republican party."[32] Even with redistricting, conservatives still dominated the Democratic Party in Texas.

Pragmatism also influenced how liberal senators cast their votes. For example, Mauzy agreed with Connally on issues related to the budget (that it should be yearly) and urged others to vote with him. Schwartz agreed, stating that "we wanted a one-shot appropriation bill because we were going to get more out of it in terms of total dollars spent."[33] He accused liberals such as Bill Patman and Chet Brooks of voting against Connally merely out of self-interest. Jordan was also part of the anti-Connally camp, but Mauzy saw her position as something personal rather than political. Mauzy attributed Jordan's anti-Connally views to her oversensitivity as a woman: "Senator Jordan, whom I admire and respect greatly, I think flaked off on us because she, after all, is a woman first. And she got her feelings hurt because she hadn't ever been invited to the governor's mansion."[34] At least three other senate liberals shared Jordan's distrust of Connally, but to Mauzy, Jordan's dislike rose from a deep well of womanly irrationality.[35]

Jordan based her budget vote on a reasonable mix of the personal, the political, and the pragmatic. Her place in the anti-Connally coalition in Harris County had not wavered since the early 1960s, when she spoke out for Don

Yarborough.[36] Moreover, she enjoyed the official backing of the AFL-CIO, which opposed Connally.[37] At the end of the first session, she was one of the few senators who voted against Connally's appropriations bill, saying that she thought "we could do better" on taxes.[38] Whatever her position on the budget, it seems reasonable to think Jordan did not join Mauzy and others because of her long-standing political opposition to Connally's conservative views and her opposition to his control of the state party.[39]

Politics does create strange alliances; even staunch conservatives in the senate disliked Connally, including Dorsey Hardeman, the man universally acknowledged as the "brains" of the conservative faction. A story Jordan often related about her relationship with Hardeman concerned her early proficiency in the senate rules: "Senator Hardeman knew the rules of the Senate better than any other member. In order to gain his respect, I, too, had to know the rules. I learned the rules." One day, she almost succeeded in introducing a pollution control bill "by obfuscating some parliamentary fine points." When Hardeman asked what she was doing, she replied, "It's simple, I'm using the tricker's tricks." At that moment, according to Jordan, a new understanding emerged. "Hardeman could not contain his appreciation for what I was doing, nor his mirth."[40] "Friendship" is too strong a word, but Jordan did establish cordial social relationships with some conservative members. She quickly recognized that in the senate her oratory—effective as it might be—would not sway votes. It was the relationships developed in committees and behind the scenes that mattered. Her relationship with conservatives such as Hardeman caused many to question her loyalty to liberalism. Lauro Cruz recalled Jordan as a "very careful" legislator: "Her style was to work things out with these people; she paid the price. Those die-hard liberals—to find out you were talking to a conservative in those days was like anathema." Jordan recognized that conservatives held power and the votes. Cruz contrasted the "macho," aggressive tone of the house, where fistfights could break out ("It's a riot over there sometimes") with the more "gentlemanly" atmosphere of the senate.[41] Conservatives said racist things about Jordan behind her back, but when they met her face-to-face, they worked with her. In the senate, everyone had to pretend to be cordial.

Liberal senators also played a similar game. As much as they criticized Jordan's relationship with Hardeman, in their interviews they spoke of him with respect. Senator Mauzy said, "Dorsey is a master of the rules, and he's got a tremendous tongue. I mean, boy, he can cut you up something fierce."[42] Babe

Schwartz called Hardeman "a relic of the age of rural domination of the legis-
lature," yet he also expressed admiration: "You can't ever discount Dorsey on
any basis. Certainly, he's intelligent and certainly he's shrewd."[43] These liberals
also approved of how Hardeman rewrote, and got passed, the Texas criminal
code, which for the first time adopted US Supreme Court guidelines that placed
restrictions on the police and the Texas Rangers. Schwartz had sparred with
Hardeman during his whole time in the senate, but in his 1967 interview he
said, "I really need to say a kind word for Dorsey Hardeman." Before Hardeman
rewrote the code of criminal procedure, Texas Rangers could commit "anything
short of murder."[44] Mauzy and Schwartz appeared to admire many of the same
qualities in Hardeman that Jordan did, and they spoke of him fondly.[45]

White liberals had their own blind spots. Throughout her time in the sen-
ate, Jordan continued to disagree with her fellow liberals about Preston Smith.
To Mauzy, Lieutenant Governor Smith epitomized the older, conservative, rural
politician; he was a "reactionary" and "the worst." Schwartz called Smith "a rem-
nant of the bronze age, maybe the Neanderthal age."[46] Jordan, however, was less
dismissive, especially after Smith became governor in 1968. In her 1970 inter-
view, she said, "The problem with the governor has primarily been one of com-
munication. . . . He does not get credit for much of what he has done. . . . His
goals for Texas indicate there's some highly enlightened views on education and
rehabilitation of prisoners and other citizens. . . . He does not get credit for what
he has done in terms of appointments of black people to various positions in the
state."[47] To Jordan, Smith's attention to racial issues made a difference.

Jordan's white liberal colleagues did not express overt concern about racial
issues in their interviews. For example, neither Mauzy nor Schwartz remarked
on Jordan's major legislative triumph concerning voting rights. For years Jordan
and other Texas liberals had been waging a battle to outlaw the poll tax, which
required voters to register and pay a tax of $1.50–$1.75 before January 31 of each
year. In February 1966, however, a three-judge federal panel declared the Texas
poll tax unconstitutional.[48] This ruling was a great victory, but efforts to discour-
age Black voting continued. In 1966 Connally supported a bill that still required
annual voter registration in Texas, calling it "an honest, fair, and responsible
bill calculated to encourage the right to vote"—even though it would certainly
reduce registration.[49] Jordan fiercely opposed the measure. One year later, during
her first session, she managed to block a voter registration bill introduced by
Sen. Tom Creighton, a conservative. The bill had numerous punitive measures

designed to freeze, thwart, and reduce registration that harkened back to the worst of southern disfranchisement laws of the turn of the century. It would have prohibited registration by mail, compelled voters to reregister every year within a window between October 1 to January 31, and imposed costly fines and misdemeanor charges on registrars who could not produce exact records. The bill came out of committee, where Jordan was the only senator to vote against it. "It is my firm intention to oppose this measure on the floor of the Senate," she assured her constituents.[50] She needed ten votes besides her own to block the bill: "I made a list of ten senators who were in my political debt. I went to each one and said I was calling in my chit." When she and Creighton met, the senator smiled sadly: "I too, can count; the bill is dead Barbara." Jordan used this story as an example of how her presence in the legislature made a difference. Later on in her career, Jordan used this same story to illustrate how legislative victories could shift attitudes. In contrast to the image of intolerance and racism, she argued, these conservative Texans possessed a "prevalent strain of reasonableness, compassion and decency."[51]

Was getting this piece of legislation blocked a major triumph? Jordan does not mention whom she persuaded, and, of course, thanks to redistricting there were indeed liberal votes present that could be rounded up. Thus, given the presence of men like Mauzy, Schwartz, Wilson, and other liberals, defeating the voter registration bill might appear to be a straightforward task. Yet it was Jordan, and not one of the white liberals, who took up the issue. Furthermore, Jordan knew that the liberal coalition had caved against Connally on numerous occasions. Given the power of the lobby and the divisions between Connally and Smith, many unpredictable factors remained in play; she could not assume that all liberal senators automatically opposed this bill. Her defeat of the measure reflected a new acknowledgment, among both liberals and conservatives, that a tide had turned. Black voting was going to increase, and Jordan's influence as a Black politician mattered.

Oscar Mauzy looked back on his first senate term with some wonder. He entered the session thinking he was on the opposite side of John Connally but then found himself in alliance with the governor. Others with whom he voted consistently he disliked intensely.[52] Mauzy also expressed disappointment in Chris Cole ("no convictions") and Chet Brooks. He valued honesty and a sense of humor. Charlie Wilson, a young man of thirty-three and a sharp dresser, for example, never flinched when the elderly conservative George Parkhouse made

fun of his clothes and called him "stupid." Mauzy related: He [Parkhouse] would
say 'hey stupid,' and old Charlie would just gig back, and say 'what'd you say Sen-
ator Outhouse" [laughter]."[53] At the end of his first session, Mauzy singled out a
few exceptional individuals.

> I've got a high regard—Babe Schwartz, Charlie Wilson, Barbara Jordan—
> I've got a *real* high regard for these folks. They're all damn good human
> beings and I *like* them. They're good to work with, and they'll level with
> you. And they'll play the game. You know, if you need a favor done,
> they'll do a favor for you and take you off the hook and take the heat
> themselves. And I asked a couple of them to do it for me a couple of times
> during the session when there was a local thing that I was against, but
> I couldn't afford to be against publicly. And they helped me, and I didn't
> . . . of course, I did the same thing for them. You've got to scratch each
> other's back to get along down there.[54]

Mauzy's positive assessment of Jordan was shared by a majority of the senators,
who named her the outstanding freshman of the sixtieth session.

"You've got to scratch each other's back to get along down there" is a phrase
worth repeating. Mauzy was simply acknowledging the dilemmas faced by leg-
islators who felt compelled to vote against something they believed in because
their constituents would punish them if they did not. Unable to stop the new
city sales tax or change any of the most important rules, liberals did succeed in
blocking some terrible legislation. Their power came from making sure the most
objectionable proposals did not make it to the floor. As Mauzy put it: "I think
I can accomplish some things by being there. And we had a lot of 16–15 votes
this year that we won. So I feel like the fact that I was there was meaningful."[55] In
addition, some troubling senate traditions, such as the habit of senators speak-
ing inaudibly on the floor, were going to stop. Mauzy remembered that "the last
day of the session we adopted a resolution after bitter debate. We are going to
have microphones in the Senate next January . . . and someone says that the
twentieth century has finally come to the Senate." Instead of "mumble, mumble,
mumble," senators would be able to actually hear what was being said.[56] Debates
would not be recorded for another ten years, but putting in microphones was a
start. Mauzy remained frustrated with the slow pace of legislation and the reluc-
tance to adopt reasonable procedural changes. "You know, we meet at 11:00 in

the morning and adjourn at 11:20 until the next day. We haven't done a damn thing. We've eulogized five people who died last week. We pass more resolutions for dead people than we pass bills for live people; and this is absurd."[57]

Despite their admiration for Jordan, liberal colleagues criticized some of her votes. Mauzy was aghast that she went along with the majority to allow police on college campuses to carry firearms. (The vote was thirty to one with Mauzy the only dissenter.)[58] And Schwartz thought it was terrible that Jordan voted for Sunday closing laws and for a bill that made it a misdemeanor for a tenant to give a landlord a bad check. In both instances she felt pressure from local constituents that he believed she should have ignored. "There were some, I thought, violent omissions in her liberal philosophy," he said. "It just didn't make sense. Why give them that kind of a stick? But I never got over to Barbara on that vote and she would not vote with me. I never got to Barbara on the Sunday closing law." In a slightly condescending tone, he remarked that "Barbara needs to be aged in the Senate"—she simply did not adhere to his vision of how a Black senator should behave: "When she recognizes that she has a responsibility to the minority and that she's got to be the expression of that minority voice and the expression of that liberal philosophy, then I think she'll be a lot more militant." Schwartz had been battling against conservatives for so long that he had given up on compromise. "I think everybody ought to start charging from the beginning and just charge ahead all the way. If they believe in something, then I think they ought to just let the chips fall where they may."[59] But Schwartz was not entirely consistent either. After all, he supported Connally on some of his measures. He also had a relatively safe district.

It seems like Jordan's white liberal colleagues in the senate could justify how pragmatism shaped their own votes and choices, but not Jordan's. Mauzy frankly admitted that his political "courage" could depend on the practical issue of reelection. Senators drew lots to take turns over who would be elected to a four-year term or a two-year term. Mauzy observed: "You know I might not be nearly as courageous as I was if I had only drawn a two year term. I would like to think I would have been but truthfully I'm not sure I would have been. . . . That's part of what representative democracy is."[60] They had a preconceived idea of Black militancy, and when Jordan did not meet that expectation, she was deemed lacking in principle. For all their criticism of her for a lack of militancy, neither ever identified Jordan as someone who lied, went back on a vote, or was solely responsible for turning back a liberal cause. Indeed, she stood out as a strong supporter of the

liberal position on economic and civil rights. If Jordan was "playing the game" by going along with the majority when it was pointless to dissent, then that was a necessary political skill that others also possessed and utilized.

As Jordan learned about politics and governance, she also sought and found love and companionship. These years in Austin represented a time of transition in Jordan's private life. She struggled to cope with the emotional demands of being a public figure in a racist political culture, but she also experienced personal happiness.

After becoming a senator and moving to Austin, she realized she needed friendship and a community: "One of the things I learned at Boston was that you can't work all the time. You can't maintain a public face all the time. You need friends you can be with who don't care what your title is." She felt comfortable with and close to her Houston family and friends, some of whom were white, but Austin represented an unknown "white world." And in that context, "it took a long time to decide the criteria for whom you would trust, and it was a judgment call every time. I would not be able to write down the rules for judging people, but it was just there in my head. Some people fit, and some people didn't."[61] She moved into an apartment close to the capitol and began to socialize with Anne Appenzellar, a friend of Garnet Guild.[62] Appenzellar lived in an apartment close by and worked at the local YWCA. Through her Jordan met a new circle of Austin friends, women who enjoyed going out to Inks Lake to camp, drink, and have fun: "We would camp out in tents and light fires and get dressed in the morning and sleep on air mattresses and all that sort of business."[63] Jordan had only known life in cities, but she discovered that she liked fishing and trolling in streams and being outdoors. One of the women in the group was planning to purchase her own land, which allowed for greater privacy and freedom. Music and camping festivals for "womyn" became commercially popular later in the 1970s, but enjoying the freedom of the outdoors in a group setting is a kind of timeless experience. In this particular context camping allowed Jordan to share feelings with women she trusted. She could truly relax and remove herself from political pressure.

One evening, she joined the group of women on a camping trip, "and at some point in the evening Nancy Earl arrived, and that was the first time we'd met face to face." Barbara had heard Anne talk about Nancy, who worked with a mutual friend named Betty at the University of Texas. Jordan remembered the evening vividly: "Nancy and I sat there playing the guitar; we had just met but

Figure 5. Barbara Jordan
playing the guitar, 1970.
MSS RGD0006N-1970-1528-27,
Houston Public Library, Houston
Post Collection, Houston, TX.

we were singing and drinking and having a swell time. All of us were, although Anne wasn't a real drinker and Betty wasn't either." The two women parted ways that evening, but the memory remained. "I had a great time and enjoyed myself very much. I remember I thought: This is something I would like to repeat. I'd like to have another party like that. Nancy Earl is a fun person to be with."[64]

Nancy Earl was a white woman who had grown up in New Castle, Pennsylvania, a rural community just north of Pittsburgh. She attended Keuka College, a private women's college located on Keuka Lake in upstate New York. The college was known as a place of progressive education, where women students were expected to be engaged with their communities and in politics.[65] Earl graduated in 1955 with a degree in psychology and history. An excellent athlete, she played tennis, served on the honor board, and was chosen as a member of "Who's Who" of college students. In her yearbook she was called "a loyal defender of the cause of right." A "loyal Democrat" who supported Adlai Stevenson, Earl was

respected by her college peers as a serious thinker.[66] Despite their differences in race, regional background, and athletic ability, Jordan and Earl shared a common political vision, and they both loved to sing, party, and play the guitar. Over the course of the next decade, Nancy Earl shared Jordan's political life and interests. Earl organized Jordan's papers and clippings, helped with speechwriting, accompanied her to events, and lived with her for a time in Washington, DC. She gave Jordan the gift of a warm personal space.[67] They did not always live in the same place, but for nearly thirty years they were partners. After they built a house together in South Austin, Earl described her personal life with Jordan as a "relationship which in a word or two has been characterized in the main by compatibility and companionship."[68] Their relationship was, evidently, a love match as well as an open secret, and it endured for three decades, until Jordan's death.

Soon after they met, Jordan introduced Earl to her sisters, Rosemary and Bennie. She also introduced her to colleagues in the senate. Jordan did not hide how important Earl was to her. Schwartz recalled that "we assumed it, but there never was a denial." He saw Nancy Earl as "totally devoted" to Barbara. Schwartz's impression of their relationship was that "she didn't play it in the closet." It was a case of don't ask, and don't tell, or as the lesbian writer Ann Allen Shockley put it, "Play it but don't say it."[69] "Persons who knew her best knew that she did not hide that relationship, [but] she did not flaunt it either," remembered Schwartz.[70] Jordan and Earl were a "mixed couple," and as feminist writer Barbara Smith has observed, seeing a Black woman and a white woman together in the South at this time "was a dead giveaway because this is such a completely segregated society." Thinking about her own experiences before the 1969 Stonewall rebellion, Smith recalled the isolation she felt as a southern Black lesbian: "You don't usually see people of different races together in this country, it was almost by definition telling the world that we were lesbians."[71]

Jordan may have felt that no one would speak to her directly about her personal life because senators had extramarital affairs that were common knowledge but not reported in the press. Frances "Sissy" Farenthold, who was the only woman to serve in the legislature when Jordan was a senator, said she was asked more than once not to attend certain "stag" functions held for male legislators and their companions.[72] Austin was also known for its liberal attitudes. When Jordan was in Austin, Schwartz said, "she had not yet run into the homophobics."[73]

Farenthold recalled that Jordan procured her own restroom (something the state legislature did not have for women) while also upending many gendered

expectations.[74] Jordan adapted to the clubby ways of the male senate, where an individual gained acceptance through informal banter and friendly conversation. She mastered humorous putdowns. She put her feet up and discussed the senate's arcane rules in Dorsey Hardeman's office while holding a drink in her hand. She smoked. She could swear, and sometimes she did. Over the course of her life, Jordan developed a way of joining in with men, especially when she became part of a team getting a job done. Reflecting on her time as a Texas state senator, Jordan's friend Andrew Jefferson offered this analysis: "My sense is, that she was treated like one of the boys eventually. That's how she dealt with these guys, she became one of the boys. She drank with them, she partied with them, and she got the job done with them. She just dealt with people and got the job done." When asked to elaborate, he added, "That just means that she could kick it, talk that talk and walk that walk, in the language of men." To Jefferson, Jordan's ability to feel comfortable in an all-male environment said something about her sexual orientation. He saw sexual attraction as incompatible with politics. Just as Thomas Freeman might not have allowed Jordan to travel with the male debate team if he had sensed any sexual tension, Jefferson noted Jordan's ability to enter the social world and manners of her male peers. "She could be in the room with the guys."[75]

Yet Jordan was not always as comfortable as she may have appeared. Jordan appreciated Nancy Earl's companionship, home gatherings, and being part of a circle of women friends because only then could she truly relax. In her autobiography she recalled that "I liked to be part of those parties. I had discovered I could relax at parties like that where I was safe."[76] The reader is left to wonder, safe from what? Jordan was certainly aware of the racism hurled against her behind her back. In Austin, Jordan was the sole Black senator and the first African American peer and colleague many of the men had ever associated with on a daily basis. "There was one senator who always referred to her as 'that n-gger bitch,' but only when she wasn't around," Mauzy told Molly Ivins. "Why that n-gger girl is the smartest member of the Senate," said Sen. Jim Wade of Dallas to a Black audience, in what he alleged was a statement of praise.[77] Jordan's colleagues freely admitted they had never before addressed a Black woman as an equal.

Jordan soon discovered that when the senate was in session, the workday spilled over into the evening. During the sales tax filibuster, she brought her guitar and sang with the liberal senators as they hid out in a local hotel. Carrying her guitar became a habit especially when she attended parties and social events

involving the senators, their wives, and their staff. Perhaps more singing meant less talking, less opportunity for awkward chitchat, and more laughter. Music provided a common ground, easing the social awkwardness in situations that brought together individuals from different backgrounds and political beliefs. One spring evening, for example, saw Jordan at the country home of conservative senator Grady Hazelwood. Other guests included Vicki Austin, a senate staffer and recent winner of the Miss Austin Aqua Beauty Pageant, and Mrs. William Patman, spouse of the "gutless" senator who so often went back on his vote. "Senator Jordan played her guitar and sang," according to the press.[78] At this kind of social event, her guitar served as both social armor and ice-breaker.

"I feel most colored when I am thrown against a sharp white background," said Zora Neale Hurston.[79] Jordan did not necessarily wish to be friends with everyone she met in Austin—as she wrote, some people she met "fit" with her personality and others did not. Yet the same boundaries that others might expect for themselves did not seem to apply to her. In some social situations, Jordan was suddenly expected to be everyone's best Black friend, forced to absorb all the insensitivities that flew around when she was the only African American in the room. Jordan worked with Texas land commissioner Bob Armstrong, a well-known and well-loved liberal, who fondly remembered an evening spent with Jordan at Charlie Wilson's house. They drank, sang gospel and folk songs, and played their guitars: "We stayed up all night, just pickin' and singing. I really felt like she was my sister. I just—loved her." But when Armstrong saw Jordan at work the next day, he felt deflated by her merely cordial manner. "I just never got back that really good feeling with her that I had that night." Word went around that Jordan was "aloof" and had "snubbed" well-meaning folks.[80]

Even a perceptive observer like journalist Molly Ivins felt puzzled by Jordan's refusal to conform to certain white people's ideas of how she should behave. "She won't fit the stereotype," Ivins wrote, before using another stereotype to demean the senator. "Aside from the vicarious kick a white lib can get from watching Jordan speak to a new audience—they tend to snigger and assume that anyone who looks that much like a mammy is going to be pretty funny to hear—she's not much use as a token."[81] This would not be the last time that Jordan would be compared to a "Mammy" figure in the liberal press. Uncomfortable racial dynamics in the 1966 election had left Jordan feeling more isolated from the Harris County Democrats, but in Austin the criticism she faced took on a new, more caustic tone. Jordan's attitudes toward the liberals of Austin became more reserved.

During her last term in the legislature, she became close friends with Sen. Max Sherman from Amarillo, Texas, a graduate of the University of Texas law school and a history major from Baylor University. Sherman, a Baptist, had sold Bibles door to door to pay for his education, and he and Jordan connected on numerous levels. They shared twelve of thirteen committee assignments. Jordan served as a mentor to Sherman, who found the arcane rules and practices of the senate challenging, at best. When he noticed her mumbling through a bill, she replied, "Max, you'll hear me when I want you to hear me." Sherman recalled how Jordan had helped him navigate some of the practical problems of serving in the senate. "Her interest was in you," he recalled. He remembered Jordan not as a riveting speaker but as a persuasive committee member who became a widely respected and trusted moral force in the body. Both he and former Lieutenant Governor Bill Hobby recalled her dignity, as well as her ability to pick battles.[82]

Working as the only Black woman in the Texas legislature in a new city subjected Jordan to a host of new, stressful experiences. If she was going to legislate, Jordan had to socialize, and in Austin she was surrounded largely by white men, both liberal and conservative. These legislators were so unused to working with a Black woman as a peer that Jordan's social interactions with them could provoke what sociologist Erving Goffman called "an anxious unanchored interaction" or what today might be called "microaggressions."[83] Jordan negotiated these situations as best as she could, but in Austin came to rely on her close women friends, especially Nancy Earl, to feel, in her words, "safe." It seems likely that, after Austin, Jordan's response to experiencing stigma—whether it was based on race, sexual orientation, or disability—arose from the need for self-protection. The beginnings of this response can perhaps be traced to her life in Austin as a Black woman who lived and worked in an uncertain and hostile atmosphere.

Texas liberals who did not like Lyndon Johnson took notice of the favorable impression Jordan had made with the Democratic Party establishment in Washington, DC, as well as her admiration for Johnson. In February 1967, shortly after her senatorial swearing-in, Jordan was summoned to the White House to participate in a daylong summit that included major civil rights leaders such as Dorothy Height.[84] In 1968 Johnson tapped Jordan to serve on a welfare reform commission. In 1968 she also served as a member of the Texas delegation to the Democratic National Convention in Chicago. At that controversial and chaotic convention, she had also voted not to seat Julian Bond's minority delegation from Georgia, and she declined to support the peace plank of the Democratic

platform. Still, she was the first in the Texas delegation to refuse to support John Connally as a "favorite son" candidate, telling her friends, "Why, that son of a bitch. How does he think he can be anyone's favorite anything?"[85] Jordan genuinely admired Johnson's work for civil rights and felt gratified by his interest in her career. And she was also aware that a new congressional district for Texas was going to be drawn.

After running unopposed in 1968, Jordan resumed her place in the Texas Senate for a four-year term. During the sixty-first legislature, which started in 1969, Jordan returned to the liberal economic agenda that had been thwarted the previous year. She worked with Mauzy, Wilson, and Schwartz to pass a minimum wage bill; it started at $1.25 an hour and included farmworkers. A workman's compensation package for those injured on the job started at $49 a week. The legislature also repealed at least a dozen segregation laws that were still on the books. Every liberal senator, including Jordan, who spoke about these legislative achievements did so wryly, acknowledging them as inadequate responses to the enormous problem of poverty. Why were these baselines for minimum wage and workman's compensation so low? "It was a compromise measure," Jordan explained. "I wasn't happy with it, but I was pleased that we did increase benefits by the amount that we did. I'll be back next session trying to raise it. But you have to start . . . and of course that's the way you do. You compromise."[86] Jordan was hardly the only liberal politician to use the "C" word. Mauzy frequently referred to the importance of compromise. "I'm a half a loaf man too," he admitted. "If that's the best I can do, I'll settle for half a loaf and I'll come back next year and try to get a little more. Some of these folks would rather be 110% right and lose, than be 99% right and win."[87] The measure for a minimum wage, he said, was more symbolic than anything: "It gave people hope."[88] Removing the segregationist laws in Texas was "nothing to be proud of." Although workman's compensation got raised, Texas still ranked thirty-second in the nation.[89] He wanted to do better in the future.

In her second senate session, Jordan continued to speak out against increased consumer taxes, addressing issues of economic equity with the power and certainty of a minister with a moral message. A rare recording of a 1969 radio broadcast illuminates this point. At the time, Jordan, a Texas state senator, and Bob Armstrong, a representative in the Texas House, were leading members of the "Texans for Tax Reform Committee." The liberal group wanted to

spur public opposition to the conservatives' proposed hike in consumer taxes and garner support for their own proposed tax on corporations. Armstrong and Jordan each recorded a fifteen-second pitch for radio and television. Representative Armstrong emphasized what "we"—the liberal legislators—were proposing: "We're after a balanced kind of program that keeps the burden somewhat evenly divided. We don't want it to be penal in nature, but it ought to be fair and that's the kind of thing we want to show the people Wednesday night, a fair, balanced tax program as an alternative to the current House measure." In contrast, Jordan did not waste time balancing sides. She got to the point and placed power in the hands of the listeners, not the legislators: "You have the opportunity in the next few days to help us do what I consider, the right, the fair, and the equitable thing by the average working citizens of Texas. People should become aroused before they are penny taxed out of proportion." "The right, the fair, and the equitable"— this technique of using a succession of synonyms, known as synonymous parallelism or synonymia, allows the listener to think through the meaning of a concept word by word. "Fair" becomes more meaningful when associated with what is right and equitable.[90]

The fair tax campaign was gaining steam. In 1969 Jordan sponsored a "corporate profits" tax that received only ten votes and failed. "We play on words," she said. "Everybody wants to avoid the word 'income' so we called it a corporate profits tax. And I think it's a very fair measure. I think we'll be introducing that again. Over forty states have it."[91] She also felt the senate did the right thing in removing an imposed ceiling on welfare payments, but then was powerless when the house wrote that ceiling back into the budget. "This made me unhappy," she said. "I have a lot of people who are on welfare, and they're not freeloaders. They're people who can't work because they're too old, or they're too young or they're too incapacitated to work, so this is a vital issue in my district."[92]

Despite the passage of several important bills, both Mauzy and Schwartz expressed disappointment with Jordan at the end of their second session together. They had expected her to express more militancy. Schwartz considered the outcome of the minimum wage struggle pathetic; in a legislature dominated by the lobby and the conservatives, compromise lacked meaning. "This whole idea of negotiating in the atmosphere we have in the legislature is not one of compromise, it's knuckling under." He thought that Jordan "sold out cheap," meaning that she compromised too quickly. The opposition, he stated, "were no goddam good.

Any effort to get along with them you know was essentially a sell-out." Schwartz expected Jordan to conform to his idea of a race leader. Her style disappointed him: "She never understood [that] it was her place up here to be a spokesperson for the minority community on everything." He thought he could define for Jordan what "her place" in the senate should be. He also thought Jordan could have pushed harder—not only for Black rights but for gay rights as well: "She really did know and had deep feelings. The fact that she had a companion, she would have placed that issue a light year ahead."[93] Decades later it seems incredible that Schwartz thought Jordan should expose her personal life to the public—consequences be dammed—but such was the double if not triple standard she faced.

The liberal senators around her always thought they knew best, an attitude that may have made Jordan realize that their condescending tone came from not just racism but sexism. "Senator Jordan says Women Brainwashed," proclaimed a 1970 headline about a talk Jordan had just given at Texas Women's University in Denton. A "southern man's desire to protect his woman" only made her ignorant, Jordan bluntly told the students. And there were more laws on the books that discriminated on the basis of sex rather than on the basis of race. She voiced support for abortion rights and urged the women in the audience to get into government. Jordan's time in the senate clearly sharpened her feminist proclivities and she had no qualms about expressing her feminist views in public.[94]

Many people around Jordan simply thought they knew better than she did about how to deal with unequal power relations. Many seemed quick to assume that an even attitude toward the powerful equaled acquiescence. One especially damaging criticism voiced by many white liberals was that Jordan had sold out her support for a corporate income tax in exchange for Lieutenant Governor Ben Barnes's backing her for a newly formed congressional seat. University of North Texas interviewer Ron Marcello raised the issue in an oral history he conducted with Babe Schwartz. He put the situation this way: "The reason I mentioned Barbara Jordan a while ago and what her stand was on the corporate profits tax was that some liberals—some of the people that I've talked to—have accused her of selling out in this session for a congressional district. Do you give very much credence to this accusation?" Schwartz rejected that notion entirely, stating flat out that Jordan supported the corporate tax.[95]

In fact, it was Charlie Wilson who cast the deciding vote when the corporate tax fell in the senate, 16–15. In another oral history, former senator Joe Christie elaborated on what happened:

[W]e needed [Charlie] Wilson's vote. And Wilson had already promised us to vote for it. And it got down to Wilson when Charles Schnabel called . . . and Wilson voted "No." Barbara Jordan jumped out of her seat and started charging across the Senate floor like she was gonna whip Charlie [laughter].

SOSEBEE (interviewer): That would've been the sight to see, wouldn't it? [Laughs.]

CHRISTIE: But there was this famous and funny lobbyist up in the balcony. . . . And they just knew they'd lost because it was down to Wilson and Word. And Wilson changed his vote, or voted against corporate income tax, the lobby was stunned, just dead quiet. They couldn't believe it, that they'd beaten it. And this one little lobbyist just said, "Let's hear it for Wilson" [laughter].[96]

The loss of the corporate income tax surprised everyone present, including the lobby, and especially Barbara Jordan. But such was her reputation as being something other than what she appeared to be, suspicion over her personal reticence, and perhaps jealousy at her rapid rise, that many—certainly not all—simply thought the worst.

Yet Jordan's voting record in the senate is clear. On class and economic issues, Jordan voted with the liberals consistently to promote a fairer system of taxation. She voted against and worked against the sales tax and against the food tax. She took the lead in stopping an oppressive voting bill. She absolutely supported a corporate profits tax. She participated with other liberals in filibusters. She was staunchly anti-Connally, even more so than other liberals. Other issues, such as liquor by the drink, could break down in any way—no single liberal position on that issue prevailed. Interviews with Mauzy, Schwartz, and others show without a doubt that other liberal politicians admitted to making numerous compromises and deals, and that they often found themselves supporting individuals and positions they never thought they would. Yet because of her race, her sex, and her demeanor, Jordan was held to a different standard by the white liberals in the Texas legislature and in the press.

The happiness and support she experienced in her private life in Austin surely helped Jordan withstand the pressures of the job. And her work in planning and attending the National Black Political Convention in Gary, Indiana, for

example, demonstrates her deep involvement in national efforts among Black politicians and activists to form a coherent agenda to benefit Black America. She most likely did not discuss those efforts, or many of her true feelings about race, with her Texas colleagues. Furthermore, as Molly Ivins's columns suggest, some white liberals in Austin simply could not get comfortable in her presence or understand her approach. Yet her Houston constituents continued their support. Jordan's newsletters spelled out her positions minutely, and Black voters in Houston, unaware of her personal relationships or struggles with racism, remained loyal. That loyalty would be tested in 1972, when Barbara Jordan decided to run for Congress.

As in her 1966 race for the Texas Senate, redistricting opened the door to a new opportunity. Lieutenant Governor Ben Barnes appointed Jordan vice-chair of the Senate redistricting panel, and she played a major role in drawing the boundaries of the new Eighteenth Congressional House district; Black voters made up about 50 percent of the population, and white and Latino residents roughly comprised the other half.[97] The new district was designed to favor a liberal Black candidate, and Jordan was assumed to be one who would win it. But once again she faced an unexpected liberal challenger. This time it would be Black representative Curtis Graves.

Collision Course

Jordan Versus Graves

If there's a collision course between Mr. Graves and me, I shall not defer.
I shall not defer to him or anyone else if I think I can win.

—Barbara Jordan, 1968

In the summer of 1971, seventy years after the last Black representative from
the South left Congress, Barbara Jordan began work on her congressional cam-
paign, confident that she had the support of Black Houston. Vox pop inter-
viewees in the *Forward Times* reflected enthusiasm for the Black woman
candidate. "An Ode to Black Womanhood" praised Jordan for her outspoken
leadership: "Senator Jordan means much to Blacks—men and women alike—
for there are many who will rally to her and applaud her black consciousness."
Said one interviewee: "With her articulate debating style, she has pulverized
political opponents in a matter of minutes." "We need more Barbara Jordans,"
stated a woman who was waiting for the bus. "We can win our freedom if we get
the representation to demand what we want. She's not the type of person to beg
for rights of the people. She knows the law and uses that to fight them racists
with."[1] Although the article assumed she would win with ease, she remained
cautious. "I try not to get too excited," Jordan told a reporter from the *New York
Times*. "No one else has announced, but I can anticipate some kind of competi-
tion in the Democratic party."[2]

Jordan was right. On August 21, 1971, Curtis Graves, a Houston state leg-
islator, created a stir by announcing his candidacy for the coveted seat. "Black
on Black for U.S. Congress," announced the *Forward Times*.[3] Graves came out

swinging, attacking Jordan for her "blind loyalty to the Democratic Party Machine." Jordan was a "tool" for big-name Texas politicians, Graves said; she was too compromising.

For the next nine months, until the primary election in May 1972, the Jordan-Graves rivalry took center stage in Black Houston. Both were ambitious politicians, but this race was not merely a battle of the sexes, or primarily a debate about moderation or militancy. In this contest Graves took Jordan's Black womanhood, an identity that Black Houstonians appreciated, and turned it against her. He alleged that Jordan had sold out to white men. Not only did he challenge her integrity, he questioned her respectability by making insinuations about her sexuality. Jordan won the primary handily, demonstrating her superior grassroots support and organizational strength. Nevertheless, this bitter race produced great enmity and caused a longstanding rift that was never resolved between Jordan and her opponent's Houston backers, both Black and white.

Graves and Jordan had not always been political rivals. A native of New Orleans, Graves grew up in a middle-class family and came to Houston to attend Texas Southern. He participated in the 1960 student sit-ins and joined the Progressive Youth Association (PYA). After graduation, he took a job with a Black-owned bank and built up a favorable reputation in the local community. When redistricting created additional seats in the Texas legislature for Houston in 1966, he ran with the support of the Harris County Democrats, and he won. In the same year that Jordan was elected to the senate, Graves and Lauro Cruz became the only African American and Mexican American representatives in the entire Texas House of Representatives, a body of 150 members with only a handful of liberals.[4]

Jordan and Graves each possessed a distinctive personality, but their contrasting approaches to governance can largely be explained by the structure and size of their respective legislative bodies. With few allies in the house, Graves had a slim to none chance of passing legislation, so he used the press and his flamboyant personality to bring racial injustice into public view. He criticized the lack of Black and Latino representation on draft boards and deplored the negative portrayals of Black history in Texas school textbooks.[5] When refused admittance to one of Austin's exclusive clubs, Graves complained publicly, prompting even the *Houston Chronicle* to urge the club to mend its ways: "Wake up! This is 1967!"[6] He asked for hearings on police brutality, attacked the power of lobbyists, opposed Medicaid cuts for welfare recipients, spoke out against the

Vietnam War, and opposed cutting off student loans.[7] Using the forum of the legislature, Graves held unofficial hearings, paid for by himself, to investigate the use of tear gas at Gatesville and Mountainview state schools for boys as well as several suspicious deaths that had occurred in those institutions.[8] To protest the "food tax," he stood on a table in the legislature. Ben Barnes thought Graves mentally unstable—he "wasn't firing on all eight cylinders."[9] The liberal *Texas Observer* thought him "too emotional to be effective." Yet Sissy Farenthold, the only woman in the house and the emerging leader of the house liberals, considered him "courageous."[10]

Graves enjoyed widespread support in Black Houston; however, in 1969 he stumbled. Graves challenged Houston mayor Louis Welch, but instead of making Black empowerment and police brutality the major issues in the campaign, he eschewed issues of race.[11] Graves pronounced the need for law and order and expounded on Houston's water problems. The *Texas Observer* thought it a "timid" campaign for a crusader like Graves. The paper "fear[ed] that by running a middle of the road campaign," he was "creating apathy and lethargy in the black community." Jordan agreed, stating, "There is not much work going on in the black precincts. That's what's worrying me."[12] Still, she supported Graves and spoke for him at an outdoor rally in Hermann Park.[13] When the vulnerable Welch cruised to an easy victory, critics cited Graves's lack of outreach to labor and his deficient organization.[14] Nevertheless, Graves received a significant number of Black votes, and shortly after his loss, speculation started about whether he would run in a new congressional district. When Jordan was asked if she saw Graves as a rival for the Democratic nomination, she replied with candor: "If there's a collision course between Mr. Graves and me, I shall not defer. I shall not defer to him or anyone else if I think I can win."[15] The primary system almost ensured that the two talented Black politicians would oppose each other.

Black voters now faced a race that pitted Black contenders against each other, making personalities, rather than issues, central to the race. Astute Black Houstonians wondered why on earth Graves challenged Jordan.[16] Judson Robinson, who would become the first African American to serve on the Houston City Council, expressed his disappointment: "This created division in our ranks when unity is what we need." A TSU student agreed: "Of course a lot of smear will come out in the campaign. It doesn't make sense for us to destroy each other."[17] Pluria Marshall, director of Operation Breadbasket in Houston, considered Graves's campaign a fool's errand. "Curtis Graves is committing political suicide," he flatly

stated. Marshall noted that Jordan had the "solid support of the black precinct judges . . . [and] has the support of the churches." People liked Graves, but they simply deemed Jordan a better leader, with a larger and more committed voter base. As Marshall pointed out, "She has been to so many people what she needed to be–an image to identify with."[18] No one thought Graves had a chance.

At first Jordan's campaign took the high ground, depicting her candidacy as a new start for Texas. At the beginning of October 1971, some of the wealthiest and most influential people in Texas paid tribute to the senator at a fundraiser and appreciation dinner at the Rice Hotel. Attendees included Frank Erwin, the head of the University of Texas; Mayor Louis Welch of Houston; Ben Barnes, the lieutenant governor; John T. Jones, editor of the *Houston Chronicle*; and former president Lyndon Johnson, who spoke of Jordan as the future of the party. The Rice Hotel rarely held integrated events, and the gathering was perceived as a turning point in the city's racial politics. The *Forward Times* called the fundraiser, where a "former president was in attendance at a reception which honored a black woman," a "history making occasion." Jordan enjoyed the support of the white establishment, and their praise of her delighted many Black Houstonians. The event seemed to stamp the winner label on her.[19]

But an October surprise upended the expected. Later that month, the senate completed its redistricting work for the Texas legislature, and to much amazement, Barbara Jordan's Eleventh District senate seat had been dismantled. It had never been a Black majority district, but its core of Black and white working-class voters had been enough to elect Jordan. The new lines, however, placed wealthy white voters alongside very poor Black residents. When this new plan became known, Curtis Graves and Dr. Marion Ford, a Black dentist who wanted to run for Jordan's old senate seat, raised the alarm. "I was flabbergasted at the new lines," Ford complained. "It's killing all the blacks and it's killing me."[20] He urged Jordan to stay in the senate and not to run for Congress. Who was the man held responsible? Jordan's friend Ben Barnes. "Ben Barnes engineered all this horseshoe gerrymandering," Ford alleged. "He has dealt blacks of this county a low blow." Graves went a step further, charging that Jordan had known about the plan all along: "That woman sold her seat in the Senate and with all this gerrymandering going on she hasn't spoken up."[21] Black Houston had seen Jordan explain various issues on television, appear in the media alongside a former president, and speak in their communities from podiums and stages.

Figure 6. Barbara Jordan and former president Lyndon B. Johnson. MSS 0080 PH006, Houston Public Library, African American History Research Center, Houston, TX.

Pejoratively referring to Jordan as "that woman" rather than as a senator, or even using a title with her name, was a calculated insult.

In previous campaigns Jordan's womanhood had been her strength. But now Graves alleged that Jordan's sex showed her proclivity to align with whites rather than with her own race: "She traded your senate seat for her own seat in Congress. Redistricting was an attempt to cut down any Black man from ever having power." Graves's attacks contained sexual innuendo. He compared her close working relationship with white male senators to sexual relations: "I say that the white man has used our women too long. . . . Now they are using them in Congress."[22] It was not clear if Graves was alluding to sexual violence in slavery or whether he was accusing Jordan of being the equivalent of what Malcolm X called the "house Negro." Either way, it was a jarring characterization of a woman candidate whom Black voters knew and admired.

Black women took offense when Graves used demeaning racist stereotypes. Labor leader Don Horn averred that Graves ran a "scurrilous kind of campaign." He recalled that Graves "accused her of being an Aunt Jemima, [and] an Uncle Tom." Graves called his opponent a "sell out," and claimed that she "had no personal convictions." He also alleged that Jordan "hadn't done anything for civil rights." For women who had worked for years as Jordan's block workers, these accusations must have felt personal.[23] Tensions between the two candidates sometimes emerged at public events. Graves continued to attack her, but Jordan always kept calm.

Yet his attacks gave others the courage to voice their criticisms of the senator. Jordan had served on a senate committee investigating a student protest at Prairie View, a Black state college located in rural East Texas, Waller County. More than a thousand students marched peacefully to the home of the institution's president to deliver a list of demands: better food, improved facilities, and an end to autocratic administration and outmoded disciplinary measures, such as curfews. The situation quickly degenerated into what one report called "scattered" but "significant" destruction of property, including the burning of a security car, the looting of a student bookstore, and broken windows. Two students not directly involved in the violence were arrested, charged with inciting to riot, and jailed on $100,000 bond. The student body president was expelled.[24] The conflict at Prairie View was nothing like the violence at Texas Southern in 1967, but it demonstrated the ongoing crisis in Black higher education. In the end the senate recommended "catch-up" appropriations totaling more than four million dollars over the next two years.[25] However, the committee did not comment on the allegations of corruption in the university administration or condemn the way the students had been treated. Jordan served on that committee. When Houston students heard about the timidity of the report, they responded with "seething rage."[26]

When Jordan went to speak at the University of Houston, the anger of three hundred students erupted. "UH Student Voters Assail Senator Jordan's Political Practices," read a *Forward Times* headline.[27] One Prairie View student told Jordan, "I am disappointed in you. Whenever it comes to doing things for black people you have equivocated."[28] Jordan agreed the senate's response to Prairie View had been "feeble" but pointed out that the school had gained increased funding. She reminded the students of the importance of working within the system to make gains. Racism was the "cancer of the nation," she admitted, and she invoked the

term "apartheid." As for the Texas Democratic party, she did not apologize for her loyalty, insisting that it was the "best vehicle for bringing about change for the poor." The "time was not right" for an independent political party. She cited the candidacy of Shirley Chisholm for president: "As Shirley Chisholm has said, we can win elections by coalition politics." Jordan was consistent in her answers and remained calm. "Some of the angry students who entered with a profound dislike for the Senator left questioning themselves," the *Forward Times* reported. But others remained unpersuaded, with one stating that Graves "knows what it is to be black," adding that "Miss Jordan needs to stay where she is and try to get herself straightened out."[29] Jordan knew her candidacy faced trouble.

Graves kept the issue of senate redistricting in the news and challenged the new plan in federal court. His suit, *Graves v. Barnes*, claimed that the new lines for the Eleventh District of the Texas Senate violated the "community of interest" standard in the Voting Rights Act. In her deposition Jordan agreed. "In the old 11th district," she testified, "the white voters were primarily blue-collar workers, populist-type people on the low side of the middle income." In the new district, however, the white voters "are persons who are on the upper side of the middle income, more white collar than blue collar workers." In the old Eleventh District, white and Black residents shared "a community interest," Jordan stated. But in the new district, "that community of interest, that has been violated."[30] Jordan denied that she had any role in the redistricting process. She deemed it highly unlikely a Black candidate could now win her seat. However, she refused to concede that if she chose to run, she could not be elected.[31] To many this denial signaled Jordan's acquiescence with what had happened. She seemed to be ducking the issue of whether Black voters had lost representation. Yet she condemned the outcome both in the press and in her deposition: "I have absolutely nothing to do with Senate redistricting and if any charges are being leveled at Ben Barnes, then Ben Barnes will have to answer them for himself. I will not be his defender."[32]

Here was another opportunity for Graves to tie Jordan to Barnes. Barnes understood the growing power of the Black vote and sought Jordan's endorsement in his race for governor, but she shied away. The redistricting battle hurt Barnes, but so did a financial scandal that involved an alleged deal between banker Frank Sharp and House Speaker Gus Mutscher. In exchange for a loan, Mutscher engineered an exclusion of Sharp's Texas banks from FDIC oversight. When it came out that the speaker had earned more than $70,000 in the stock

market, and that Barnes had also received loans from Sharp, their activities drew calls for an investigation into the "Sharpstown" scandal. A minority of house members called the "dirty thirty," led by Sissy Farenthold, a liberal Democrat from Corpus Christie, kept the scandal in the news. It tarnished Barnes, and by association threatened Jordan. Not only had Jordan colluded to gain a seat in Congress, Graves alleged, she had also turned a blind eye to a corrupt deal. Jordan, he said, is "allied to corrupt politicians who have brought our state into national shame and ridicule."[33]

"White money" in Jordan's coffers now became an issue. Throughout the campaign, Graves maintained a close relationship with the Harris County Democrats, and he also had close ties with its white politicians. But he asserted that Jordan was "being financed by white Houstonians" who had no concern for the Black community, or sometimes just "white money."[34] White liberals had always helped to fund the few Black candidates who ever ran for office, including Graves. But as with the redistricting allegations, Graves had a point. Jordan's campaign drew from a wide range of sources, but the Rice Hotel fundraiser garnered sizeable donations from wealthy Houstonians, and that could not be denied. Nevertheless, his lack of mass support showed in Graves's fundraising. He depended most heavily on Black professionals—doctors, lawyers, and dentists—for his contributions. In contrast Jordan also drew from organized labor and ordinary people. She received hundreds of small donations, and she regularly attended fundraising dinners in the Fifth Ward on Lyons Avenue that charged five dollars or less. She outraised Graves by a ratio of 5 to 1.[35] But the charge of a Black woman taking "white money" added to allegations about Jordan's racial inconstancy.

On paper Black attorney Aloysius Wickliff was Jordan's campaign manager. In reality, four women ran the entire operation: Cecile Harrison, Alice Kathryn Laine, Lestine Lakes, and Garnet Guild.[36] Lakes, an African American woman, had been with Jordan as an office worker since 1965; she was the only paid member of the campaign's staff. Guild still worked with the AFSC. She had pitched in to help Jordan for years, and the two women shared a close friendship. Harrison, an African American, and Laine, a white woman, began volunteering with Jordan in 1964. Both were PhD students in sociology and partners who lived together in Houston. By 1972 Dr. Wilhelmina E. Perry had left Houston to teach in New Jersey, but Harrison credited the sociologist with teaching her how to organize a campaign when they had both worked for Mrs. Hattie Mae White's school board race and how to pay close attention to data.

These women did their uncredited work behind the scenes.[37] They came together because of their interest in politics and their commitment to Jordan. Born in 1937 in the Third Ward of Houston, Harrison had attended Jack Yates High School and graduated from Bennett College for women in North Carolina in 1959. She earned an MA in sociology from Texas Southern University in 1966, worked in antipoverty programs, and then entered the PhD program at University of Texas at Austin in 1969. Her father had been a precinct judge, an employee at Hughes Tools, and a boy scout leader. Harrison was raised in the thick of Black Houston politics. Alice Laine, a white woman, was Cecile's partner. A native of Galveston, Laine was born in 1924 and had worked for the US Navy during World War II. She earned an undergraduate degree at Texas Lutheran University and an MS in social work at UT Austin in 1953. She worked in Houston, Montgomery, Alabama, and Baton Rouge, Louisiana, as a community planner and social worker before starting her PhD at the University of Texas at Austin in 1969.[38] Her research on Black political leadership in Houston led to her doctorate in 1978, and she later taught sociology at the University of Houston. Harrison and Laine lived together in Houston for more than thirty years, until Laine's death in 2000. According to Perry, Alice Laine and Garnet Guild were the two white women in the campaign's inner circle, and both, along with Harrison, were absolutely devoted to Jordan.

Harrison had worked with Perry in Jordan's previous electoral campaigns and remembered everything her mentor did. Perry, she said, emphasized the importance of research in knowing the district. Harrison understood local Black politics because she had watched her father serve as a precinct judge in the Third Ward. Like Perry, Harrison supported the HCCO and felt loyal to Jordan, but not to the Harris County Democrats. She was awed by Jordan's confidence and admired her skill as a candidate. "She was a better speaker, campaigner, and thinker than anyone I've ever worked with," she stated. "If she did not believe she was excellent, she could not have done that. She didn't fear ordinary stuff."[39]

For the quartet of women organizers, attention to detail was essential. "Stick with the plan. Get everything organized from early in the morning to late at night. You could not leave campaign headquarters in a mess. Get everything cleared. Clean the coffee pot. Empty the trash can. Keep a schedule and know where Barbara was supposed to be." Harrison listed Jordan's speaking engagements and organizational meetings on a board that the public could come in and view: "People would get mad if she [Barbara] didn't come." They felt proud

to know someone with such influence. Being an elected official, "flying to Washington and knowing other people in DC, that was a big deal."[40] It was the campaign's job to connect the candidate with the community and make sure Jordan was accessible to people who wanted her to come and speak.

While Harrison drove Jordan to events, Laine and Guild ran the office and organized community outreach. Guild put older and retired volunteers to work on the telephones; their job was to recruit block workers. Carbon copies of names were kept, to be used again for the general election. Guild also compiled a list of voters and telephone numbers, building on lists from 1971. She also took charge of distributing posters and stakes. All were taken to the Creswells' house, where Barbara's sister Bennie and her husband, Benjamin Creswell, took charge of stacking and storing the materials. Guild determined whether the signs should go on corner houses or at busy intersections. She demonstrated how signs should be stapled and driven into the ground securely. She detailed how many signs should be reserved for Black precincts, how many for white, and how many reserved for staff cars. The Jordan campaign also put together material to be mailed to voters. Those envelopes had to be stuffed, stamped, and delivered. "Keep the telephone lines busy lining up block workers!!" Guild wrote. "That is the single most important job to be done." Listing what needed doing and giving clear assignments were meant to foster a spirit of teamwork and camaraderie in the office. Everyone had a job, and everyone knew their responsibilities. Guild created an atmosphere of positivity that abhorred complacency: "Full Speed Ahead! Let us roll up the greatest and largest victory ever!"[41]

Jordan's block workers, largely composed of Black women from local civic organizations and churches, admired her in every way. Mrs. Myrtlene Hooey was typical. Born in 1923, she came to Houston from a farm near Prairie View in 1948. Her husband worked on the Ship Channel and they lived in the Fifth Ward. She was a substitute teacher, a member of the Fidelity Club, and a congregant at Sloane United Methodist Church. Hooey joined the NAACP through her church and credited her interest in voting and the Democratic Party to her father: "[The] Democratic party was the party we were always in. My daddy I guess I got part of it from him too. He was in his 80s. He said I want to be 'close enough to walk to the store, close enough to walk to the voting place, close enough to walk to the church.'"[42] She and other women worked on Jordan's campaigns all through the 1960s and then again in 1972. Hooey picked signs up from the Jordan campaign headquarters on Lyons Avenue to put up

in her neighborhood: "We had a lot of people working. So another lady and I, we worked this area, maybe two more people would do another area. Then we use the phone on election day." Hooey remembered Jordan as an inspiring figure. Asked to recall what it was like to hear Jordan speak, she replied: "Any time Barbara Jordan stood up ... [pause] she was really on the ball." When asked, "Would she try to inspire you?" she exclaimed very quickly, in a higher voice, "Ooh! Did she! Did she! Did she!!"[43] Hooey was one of the hundreds who worked for Jordan in her electoral army. Campaign buttons usually just had her first name: Barbara. "I'm for Barbara for Congress." "A Buck for Barbara," and "I'm for Barbara for State Senator: Are You?" No one had to explain that "Barbara" was Barbara Jordan.[44] When asked about Jordan's opponent, Curtis Graves, thirty-six years after the primary, Hooey had an immediate response: "We hated him." But then she laughed, and got serious too: "I didn't hate him. I just thought we ought to have one representative. Because folks didn't have the opportunity to do this. If he had stayed out of it, then the votes didn't have to be divided. When you said Curtis ... it just popped out! I didn't hate him. But you know what politics is all about."[45] Now that Black politics in Houston had become competitive, voters chose sides.

Both Black and white unions demonstrated their unequivocal support for Jordan. She benefitted from their political experience and financial reserves. Labor leader Don Horn, who headed the CIO in Houston, recalled that the long-shoremen were "big supporters of Barbara." "Precinct 45 was a black district," said Horn, "[and it was full of] Longshoreman."[46] He pointed to the influence of John Peavy Sr., a precinct judge who had been around longer than anyone in Harris County. A political force within the Democratic Party in Houston, Peavy had a close relationship with the ILA. His son, John Peavy Jr., remembered that "politicians would come to him for his support. If he thought that they were going to be fair and do the right thing for the black community, he would support them. . . . His precinct was one of the largest black precincts in the county."[47] Peavy supported Jordan.

Local 968 of the Teamsters Union (unaffiliated with the AFL-CIO) provided Jordan with additional support. According to political scientist Richard Fenno, who observed Jordan's campaign in the spring of 1972, Teamsters came right to headquarters to help: "When Cecile and Barbara were talking about transporting high school kids to HQ to work, Barbara said, 'Let's call the Teamsters. They've always been a big help. When I think of transportation, I always think of the

Teamsters.'" Sure enough, that afternoon two Teamsters showed up, and for the next couple of days they were in and out of the HQ, stuffing envelopes and working hard. Fenno wrote, "It was interesting to see two black men with blue workshirts with 'Teamsters' on the back working at the same table with Garnet, the League of Women Voters type. But it said something about Barbara's coalition."[48]

When Graves showed up at a campaign rally for Jordan and other candidates held at Teamsters Local 968 union hall, he was turned away at the door. An internal memo in Jordan's papers reveals the group's commitment to their candidate: "We received notice that Mr. Graves was coming and intended to ask for the floor and demand that he address this group. My answer to Mr. Graves is that we are brutally and forcefully in support of Barbara Jordan. We are the Teamsters Union. We are a militant union, and we are not going to allow Curtis Graves or anyone else to crash in our doors."[49] The *Houston Chronicle* reported that after Graves was expelled, Jordan spoke to a cheering crowd of two thousand.[50] When asked about the incident, Jordan remarked that politics could be a rough business. But the campaign was sensitive about any negative publicity. A memo from the local's president, Willard Manual, and W. W. Parker, its business manager, warned members, "Please do not release any information regarding the incident between Mr. Bonner, Mr. Graves and the Teamsters at the DRIVE rally last Saturday night!!!"[51]

The Eighteenth congressional district covered a wide swathe, including the unincorporated Black community of Acre Homes north of downtown, and Jordan focused the campaign's energies on Black voters. "My strongest supporters are the working class, the blacks and labor, organized labor," she told Fenno. "And the people who were in my senatorial district of course. The Fifth Ward is low income, working class and is my base of support. I grew up there, I have my law office there and I still live there." She tacitly acknowledged that Graves's attacks and his style alarmed white conservatives, who trusted her over him. "The white business men who are supporting me now are late converts—very late. They support me as the least of the evils. They are not a strong base of support. They know it and I know it."[52] Wealthy businessmen were not Jordan's "base," but some, including Ross Perot, did contribute to her campaign.[53] They perhaps felt more confident in her victory than she did.

Jordan's appeal as a Black woman leader was never far from the minds of her supporters. Fenno observed Jordan deliver a pep talk to a small group of Democratic precinct workers in the Third Ward, mostly Black women who had

assembled during the last month of the primary campaign. Jordan came out to rally her supporters. "This can be a real breakthrough for Texas," Jordan told them. "Not in over one hundred years has a black person from the South sat in the House of Representatives." To which an audience member added, "And *never* a black woman." All in the room nodded in agreement, Fenno noted, and several repeated back, "Yes, never a black woman."[54] Jordan reminded her workers of her hard-fought campaign for the state senate against Charlie Whitfield, and she made direct appeals. "Mrs. ___ do you remember how we sang 'I'm glad I made it' in 1966?" Jordan asked. "With your help we'll sing it again."[55]

To better assess feelings in the neighborhoods, block workers wrote down comments from voters as they canvassed. In parts of the Third Ward, near Texas Southern, which was considered Graves's base of support, they encountered less enthusiasm for Jordan. In the comment column, many wrote either "undecided" or "no comments." But the workers who canvassed in the Fifth Ward had a different experience. On Hirsh Street near Kashmere Gardens, they wrote down such comments as: "I hope you win," "I like your work," "May God bless you," "I think she is tops," "She's a good leader," or "She's the kind of leader we need," and, "Yes Barbara is my lady," signed by "Senior citizen." Many comments were couched in religious terms: "Praying that you win, we need you"; "Just out of hospital and can't help, but will pray"; "Praying for you to win"; and "We need someone to do right for our race and I am praying for you ask God to help you for he is able and willing to lend a helping hand." Voters referred to Jordan's style, calling her "a very refined person and tactful politician." Others simply said: "I love you," "I love to hear her speak! Just for her (mainly because she's black)."[56] The week before the election, one of her block workers sent her a moving letter. "I have intended to write you for a long time, to congratulate you, for your great ambition and progress you have as senatoress. . . . You know you kind of feel like my daughter."[57]

A few dissenting Fifth Ward voices emerged. In the comments written down by a male block worker, one man said crudely, "Vote for a Lesbian. I liked to get whipped by a woman."[58] The comment came from a residence near Hester House in Jordan's old neighborhood. The talk about Jordan's sexuality was not just whispered among those in the know, it was in the streets as well, and the press picked it up. The *Houston Informer* reported "a widespread rumor that an 11th hour desperation smear campaign against state senator Barbara Jordan will be launched by a panic stricken opponent." The paper sought to neutralize

the gossip by citing "veteran political observers" who believed that "even if the rumor of a smear attack materializes," Jordan would still win.[59] Tellingly, people expressed amazement at such references to Jordan's personal life. One Black minister claimed to be "absolutely shocked beyond description at the low blows struck by some black men and the unclean tactics resorted to by some of our candidates. If there is any lesson that should be learned by Black men I think it is respect for Black women."[60] Another lesson could also be taken: Jordan had to be careful.

By the time Richard Fenno visited Houston in the spring of 1972, Jordan and her staff were fed up, frustrated, and angry at the accusations being lobbed at them by Graves. Fenno had arranged to be with Jordan for three days in late April, and he followed Jordan and Harrison on a schedule of public appearances. These included a tour of the Eighteenth Congressional District, a radio interview, a speech at Phillis Wheatley High School, an appearance before the AFL-CIO, a meeting with her finance committee, and a radio debate with Graves. He also dined with white liberals from the Harris County Democrats. Fenno took notes throughout his stay and eventually combined a narrative of his experiences with his polling research on Black candidates. Some of the candid comments in his notes, which remain part of his personal papers but were not published, reveal his personal curiosity in Jordan's inner circle of her secretary Lestine Lakes, advisor and campaign coordinator Garnet Guild, and campaign managers Cecile Harrison and Alice Laine. He called Guild a "League of Woman Voters type." And he noted the distinctive dress and appearance of Guild, Harrison, and Laine: "With the exception of Lestine, they are a very unfeminine group, mannish haircuts, mannish dress."[61]

The group of women campaigners told Fenno of their shared disdain for the "white liberals" of Houston who, they felt, looked down on Jordan. At the AFL-CIO meeting, Harrison slipped Fenno a note identifying the various players, including Billie Carr: "The Anglo lady in red and white that just came in is Billie Carr, our great white liberal that is going to save black Houston!"[62] Jordan and Harrison felt a "real rapport" with Fenno when he commented that "the trouble with [white liberals] is that they think they have the truth." Jordan responded, "'You're absolutely right! How did you know that?' 'I live with them,'" Fenno replied.[63] He also dined with members of the Harris County Democrats in Houston and learned that the antipathy expressed by Jordan and her staff was mutual. In his notes he wrote, "These people could care less about [Barbara Jordan].

They are dependent on the Black vote, and they fear that [Jordan's] lukewarm support (and it is) will hurt Sissy at the polls. [Jordan] has her own fish to fry."[64]

Jordan continued to campaign hard in her district. By this time, the length of the primary battle—now in its eighth month—taxed everyone's energies. "We don't have any strategy," Jordan told Fenno, "I just run.... I'm not that organized. And the campaign isn't predictable either. Things just happen day by day."[65] Jordan had been on the trail for so long that she took the efficiency of her campaign's organization for granted. She spent most of her time speaking to various groups, urging voter turnout; the details and the grunt work were all organized for her. As he followed Jordan in her campaigning, Fenno contrasted the middle-class comfort of those who lived in the Third Ward, who largely supported Graves, with the poverty of the Fifth Ward, Jordan's core of support. Not far from Jordan's home on Campbell Street he saw "tiny wooden homes, one story wooden on brick pilings, packed two and three deep in a block.... Streets ... many of them unpaved with deep holes in which your axle touched as you rode along."[66] These were the people who had been left out of the political system, but Jordan's campaign reached out to them directly. If they came out to vote for her, they would vote for other Democrats, too.

Reading a discussion of circulating "unclean" rumors that threatened to undermine Jordan's candidacy in the Black press one week before the election made all of her supporters extremely concerned. Jake Johnson, who served in the state legislature from Houston, recalled how the campaign blamed the Graves campaign for the scuttlebutt about Jordan being a lesbian. He recalled thinking, "What do we do about this? We didn't talk to her about it." He had worked with her as an advisor, and had put her in touch with Don Ritchie, an advertising executive who helped come up with her slogan, "The Sensible Choice." Johnson decided that Jordan's campaign should place a half-page ad in the *Houston Chronicle*. The advertisement showed photos of Jordan side by side with her three Black male opponents. Under her photo was a long list of her accomplishments as a legislator; under Graves's photo, one line. Under Booker Bonner's, the simple statement: "No legislative experience."[67]

Jordan clearly took Graves's challenge seriously. Her opponent had the support of many Black professionals and students. His campaign literature listed prominent individuals in the Third Ward who supported him, including former school board member Hattie Mae White and the Rev. Bill Lawson from the Third Ward. Graves also benefited from the neutrality of the *Forward Times*, which

refused to endorse either candidate.[68] But Graves's campaign seemed underpow-
ered. One newspaper reported on the eerie quiet at the campaign headquarters:
"The girls leave for an early lunch. Two young male volunteers who come and
go during the day are absent. For about an hour the headquarters is unmanned
except by Graves himself." Joanne Graves—young, attractive, fashionable, and
absolutely supportive of her husband—worked full time on his campaign. "She
wears an orange slacks outfit and a gold peace sign on a gold chain necklace."
Graves himself radiated confidence. At 6 feet, 4 inches, he was an imposing
figure. The father of three children and a practicing Catholic, Graves dressed
impeccably, always in a shirt and tie. He could command an audience, and his
criticisms of Jordan were meant to reflect the feelings of the times. In many ways
he and his supportive spouse epitomized the spirit of Black male militancy. Yet
this dynamic young couple gained little support in the Fifth Ward.[69]

One newspaper account contrasted the bustling activity at Jordan's head-
quarters with the deadly quiet at Graves's. At Jordan's office, "a group of seven
women walk in.... 'Hi Good to see you ladies, How you doing?' They go
straight to work stuffing envelopes."[70] Political scientist Fenno singled out
George Nelson, the owner of Temple barbershop, attendee of the 1941 NAACP
meeting, and 1972 Jordan fundraiser, to make a point: "He's the source of her
strength: black, independent, loyal, elderly, and community minded."[71] Jordan
depended on the support of local businesses, especially barbers and beauti-
cians. According to Harrison, "Beauticians loved Barbara! They came in, they
supported Barbara, they contributed money, they [took] her material putting
it [on display] . . . talking about what a nice woman Barbara Jordan was. You
depend on those women to go out and gossip."[72] Jordan's support in the com-
munity ran deep, particularly among those who led the institutions where
Black people gathered.

Tellingly, Jordan was one of the few candidates to whom Black ministers
willingly surrendered their pulpits. During the campaign against Graves, Jordan
said, "I speak in a church every chance I get. I've been averaging five each Sun-
day—in and out."[73] Instead of feeling threatened by Jordan, ministers sought
to gain prestige by associating with her. She spread a message that made Black
voters feel needed, but also positive and victorious. Judge Andrew Jefferson
recalled the adulation: "I remember one year when I was running, it may have
been 1972, we were on the campaign trail together. On Sundays we'd go to as
many churches as you could go to. Other politicians would have hands full of

placards and biographical materials and working the crowd and bowing and scraping. And there was Barbara above it all. People all ran to touch her. She was just worshipped. That's all you can say about it."[74]

On Election Day, Black voters got their chance to make history by sending the first Black woman from the South to congress. Overwhelming popular support for Jordan meant that African Americans all over Houston stood in lines for hours just for the opportunity to vote. Because the Eighteenth Congressional District was newly drawn, many Jordan supporters from her old senate district could not cast a vote for their candidate in this election. According to the *Forward Times*, "Several times, precinct judges in sectors of the city outside the 18th congressional district had to use public announcement systems or megaphones to tell waiting masses that the senator was not on the ballot in that particular district." They stayed in line, but still felt robbed of their chance to be part of something bigger than themselves. According to one observer, "The shoulders of black men and women drooped when they did not have a chance to vote for Jordan."[75] Jordan beat Graves by a landslide, capturing 80 percent of the vote.

The analysis of the *Forward Times* focused on Jordan's gender as the key factor: "Women from churches and social clubs . . . rallied strongly for Jordan, rationalizing that a woman—in this age of liberation—is just as good as a man, and besides, Senator Jordan outwardly just happens to be their idol, their vision of what a successful woman should be like."[76] Black women came out for Jordan, worked for her, protected her, and defended her because she represented both Black resistance and what Black women could achieve. "I love her for her ambition," said one of her supporters. Jordan's quest for higher office reflected their own desires to be seen and heard and to win.[77]

Graves, soundly defeated, moved to Washington, DC, to work for the Equal Employment Opportunity Commission. He and Jordan never spoke again, and Houston lost a Black leader. Yet his allegation that Jordan got her congressional seat by "trading" her senate seat never went away. And the suspicion that she was not what she appeared to be continued to be commonly expressed in liberal circles, in much the same way that it was claimed, falsely, that Jordan voted against the corporate tax to gain Ben Barnes's support for her congressional seat. Almost a year after Jordan's death, journalist Molly Ivins rejuvenated the story of how "she traded some public suck-up with the Texas Democratic establishment—Lyndon Johnson and Ben Barnes—and got the first black congressional district drawn in Texas. Smart trade."[78]

Jordan had testified that she thought the new lines violated the "community of interest," but after that did not vigorously denounce the redrawing of the district lines, accepting it as an inevitable consequence of economic powers greater than herself. She told Fenno that "there was some racism involved, but it was mostly economic. The big corporations, the oil and gas and insurance companies were afraid because this year the Texas senate came within one vote of passing a corporation tax—a tax on their big profits. So these big men, these big businesses were so frightened, they decided to redistrict the senate to make it more conservative. The reason was money, the green folding stuff. That's why blacks got redistricted out of a seat in the senate."[79] In economic conflicts among whites, Blacks would lose.

With Jordan going to Congress, the senators and Lieutenant Governor Barnes clearly did not want Graves in their midst, and they redrew the lines of the Eleventh Senate district to keep him out. Max Sherman observed that conservative Sen. J. P. (James Powell) Word gave up his seat so that the new districts could be drawn to ensure that outcome. Babe Schwartz thought that no matter what Jordan said or did, her liberal seat was going to go: "Barbara laid down on the senate redistricting in terms of Harris County and in that sense acceded to the establishment's demands—that they have their way in Harris County. But I'll tell you something else. The establishment had its way in Harris County in the redistricting anyhow. I'm not sure there was anything to give up and I don't say this because I'm trying to protect Barbara Jordan. She doesn't need my protection. But the establishment drew the Harris County senate district lines."[80] When Jordan went to Washington, she made her own priorities. But any representative of Houston's Eighteenth Congressional district had to deal with Houston's business interests, and once she went to Washington, Jordan faced that pressure.[81]

The conservative reaction against Graves shows how powerful and discerning the Black vote in Houston was becoming. Sissy Farenthold's bid for the Texas governorship during the same 1971–1972 election cycle also illustrates the growing power of the Democratic Coalition. Farenthold was not especially well known to Houston's Black voters, and some regarded her with suspicion. True, she was an outspoken progressive who had worked among the poor in Corpus Christi as a legal advocate, but she also was a wealthy white woman with an elite education. Democratic organizer Billie Carr recalled, "We were having trouble with the Black woman not wanting to support her. I got a group [of black women] together and asked them, we're not getting support from black women

for Sissy, why not? What's the problem? And one of them said, 'OK I'm going to tell you, Billie, she reminds us of every woman we've ever done days work for.'"[82] But Farenthold was helped in her campaigning by her ally in the Texas House, Curtis Graves. According to the *Forward Times*, they were like a hand in glove, appearing everywhere together.[83] His support galvanized Farenthold's campaign in the Black community. Black voters may have supported Jordan over Graves in the congressional race, but they still liked much of what he said and stood for.

Black support for Farenthold over Ben Barnes indicated that Black voters wanted to throw out the old guard, and so they joined forces with other liberals hoping to do just that. Farenthold was associated with what journalist Molly Ivins dubbed "moral purity" in her attacks against conservatives, and her time had come.[84] Black voters in Houston overcame their suspicions of the wealthy woman lawyer from Corpus Christi and turned decisively against candidates associated with the conservative wing of the Democratic Party. Farenthold epitomized public disgust with corruption and politics as usual. The backlash against the Sharpstown scandal, the food tax, and the general corruption in both houses—many of the same issues that Graves drew attention to—worked in Farenthold's favor. In a four-way race for governor, she earned 28 percent of the vote overall and 90 percent of the Black vote. She beat Ben Barnes and ended up in a runoff for the governor's seat with Dolph Briscoe, the largest land-owner in Texas. Though she lost in the runoff, she received 45 percent of the final vote. For an "urbane, Catholic feminist who advocated easing of abortion laws" to win such favor, it was clear that a large portion of the Texas electorate, especially Black voters, were ready for new faces in government and an end to control by the lobby.[85] Curtis Graves lost his own race, but by campaigning with Farenthold, he contributed to the defeat of Ben Barnes.

Although her feminism was not always made explicit in Jordan's campaign speeches, her 1972 candidacy chimed with the social changes sweeping through the nation. Jordan's victory and Farenthold's strong showing prompted the *Forward Times* to declare that "WOMEN ARE TOO TOUGH."[86] What few appreciated, however, was the toughness, dedication, and expertise of Jordan's staff. It is impossible to imagine her overwhelming victory over Graves without Guild, Harrison, and Laine. It was their work that sent Jordan to Congress, but, like many women who worked in the civil rights movement, they were behind the scenes. The depth of homophobia met by the campaign perhaps explains why Jordan never referred to any of these women in her memoirs, and why they fail

to appear in any other treatment of Jordan's life. Their contributions to her success, however, cannot be overstated.

Jordan's constituents had embraced her because of her womanhood, not in spite of it. Black working women—proud of Jordan and eager to see a Black woman elected—worked tirelessly in Jordan's campaign office and as block workers to get out the vote and defend her against personal attacks. In addition, her calm, decisive approach to political power, her thoughtful campaign strategy, her dedicated staff, and her ability to draw on a wide range of Houston institutions and connections all contributed to give Jordan the winning edge. But her congressional victory would always be tainted by the loss of her senate seat. It was a reminder, if she needed one, of the power of the establishment.

A Father's Death, A Black Woman's Ambition

I leave this word with you. It doth not yet appear what we shall be.
—1 John 3, as stated by Barbara Jordan,
"Governor for a Day" ceremony, 1972

On June 10, 1972, shortly after she defeated Curtis Graves in the congressional primary, and six months before she took up her new position in the House of Representatives in Washington, DC, Barbara Jordan served as "Governor for a Day" in Austin. Tradition called for an esteemed member of the senate to assume the top executive's duties while the Texas governor and lieutenant governor exited the state, and Jordan's peers had chosen her for the honor. Her good friend Judge Andrew Jefferson administered the oath of office while the overwhelmingly Black audience cheered and clapped inside the Texas Senate chamber. Jordan remains the first and only Black woman in the United States to act as governor of any state, and national newspapers, including the *New York Times*, reported on the day's ceremony.[1]

Jordan kicked off the festivities with a speech: "Anyone out there know about Fifth Ward?" The audience, her people, the hundreds of Houston supporters who had taken busses to the state capitol that morning to be with her, responded loudly and affirmatively. "There is no one who could have predicted that this would be our day, but it's ours," she told them. Celebrating a Black woman in power was only the start. "I want you to make a new commitment today that the state of Texas will not tolerate differences on the basis of race anymore."[2] She asked her audience to choose love over hate, and justice over injustice. She repeated her call—"I want you to make a new commitment today"—several times, and then asked those present to look into their hearts and see whether "it was humanly

possible for them to love their fellow man." Jordan's political speeches usually focused on issues: voting, the minimum wage, or consumer taxes. She acted as "a fence mender, fire extinguisher, or pep leader."[3] But in this four-minute extemporaneous address, she asked her audience to embrace larger ideals. "I want you to make a new commitment today," she urged, for peace, for justice, and for love.[4]

Then Jordan invited Black youth from the poorest areas of Houston onto the grounds to display their talents. Jazz bands and choirs from Texas Southern University and Fifth Ward high schools and junior high schools performed in the rotunda throughout the day. The capitol's walls displayed exhibits by Black artists. Black student marching bands paraded, more choirs sang, and hundreds of visitors enjoyed a barbecue lunch. Inside, Jordan met with visiting Black politicians, including Rep. Charles Rangel from New York, and had her picture taken with her sorority sisters and other well-wishers. White attorneys, including Leon Jaworski, president of the Texas Bar Association, politicians, and business executives showed up to speak and bestow gifts. They may have been surprised to notice the Confederate flag missing from the capitol's pole and to hear Jordan proclaim September as "Sickle Cell Disease Control Month" in Texas. "The young kids were doing the bugaloo on the capitol steps and there were some more speeches, and everybody was just having fun and getting pretty exhausted," she recalled.[5] The open, joyful display of Black culture on the capitol grounds, along with the recognition paid to the experiences of Black Texans, symbolized her race's growing presence in state politics. "You came here to have a happening and we've had it," she said with obvious pleasure.

But then she resumed her serious tone. In her closing remarks at the day's end, Jordan took up the theme of how politicians—backed by voters—had the power to transform ideals into reality: "I want you to stand behind me and help me move this country, stand behind me and help me move this state." She emphasized that individuals had to change their old ways of thinking: "I want you to stand with me so that we can sing that anthem 'We Shall Overcome' and mean it. I want us to be able to say black and white together and mean it." She claimed the mantle of both King and Johnson: "I want us to be able to translate all of the rhetoric of our time, the promise, the dream, into truth and fact." She offered herself as proof that there was room for Black people to rise and insisted that young Black Texans in despair should still dream. Fittingly, her peroration used Biblical language to express hope. "I leave this word with you. It doth not yet appear what we shall be."[6]

Figure 7. Barbara Jordan and her parents, 1972. MSS 0080 PH007, Houston Public Library, African American History Research Center, Houston, TX.

No one could have been happier or prouder that day than Jordan's father, Benjamin. This ambitious and exacting man had once dreamed of leading either a business or his own church. When those enterprises stalled, he supported his youngest daughter's foray into the law and then politics, fully expecting she would become someone special in Houston. She had done that and more. Now she was on her way to Congress in Washington, DC, the first Black woman from the South ever to do so. Jordan's father stood on the stage in a white suit with a red carnation, celebrating the family's triumph. He had not been well. The upsetting attacks levied against his daughter during the bitter primary battle with Graves exacerbated his heart condition. He had been advised to stay home that day, but he refused. He wanted to witness this pinnacle moment of his daughter's career, and as she delivered her speech, he cried for the last time. Shortly after the swearing-in ceremony ended, Benjamin Jordan suffered a stroke and was taken to a local hospital.

Later in the day, Jordan joined him. "He had the most wonderful expression on his face," she remembered, "the most wonderful smile imaginable." Jordan

went back to the capitol to continue with the day's events while her mother remained at her husband's side. When the evening came, the governor-for-a-day took her limousine back to the hospital to visit, and then returned for that evening's celebratory concert featuring Novella Nelson, a Black singer known for her extraordinary renditions of Blues and gospel music. Jordan wore a striking long-sleeved, black-and-white dress with a geometrical pattern at the neckline that set off her face and a skirt that swept the ground, emphasizing her height. She joined an audience of two hundred and fifty selected guests, friends, and family who were still celebrating her day as governor with a concert by Nelson. Jordan thought that her father was stable and resting comfortably, but at the end of the evening she learned that he had sunk into a coma.

For support throughout the day, she had relied on her numerous friends, and now she turned to Nancy Earl. "I had planned another little party," Jordan recalled, a semi-formal gathering that included Nelson. "I grabbed Nancy and said, 'Look, I'm going to the hospital, but you take everybody on out to the restaurant and I'll try to join you.'" She sat with her mother for a time, but nothing more could be done. She called Earl again: "I'll be in touch. Do everything you know I'd want done. Just have fun." Jordan eventually went back to the hotel, changed, and talked with Earl again: "I told her to meet me at the hotel with anybody who still wanted to hang on and that we would go out to her house and do a final wrap up with the guitar. And that's what we did."[7] Playing music and being in Earl's home gave her peace and demonstrated a simple truth: Public acclaim could never provide sufficient solace from life's emotional ups and downs, which could and would come. Jordan stayed awake most of that evening, buoyed by the support of Earl and other close friends.

In the morning she went to her mother and persuaded her to return to the hotel. Shortly after the two left the hospital, Ben died. Now it was her mother's turn to cry. "Is he really gone?" Arlyne asked, as the family gathered outside his hospital room. Rosemary, the eldest, urged her to compose herself, but Jordan told her mother, "No, you cry. You've lost your man." Jordan loved the blues, and the music of the evening echoed the dramatic events of the last twenty-four hours. "This is her man who's gone," Jordan said to Rosemary.[8] News of Benjamin Jordan's death made the *New York Times*—"Father Sees Daughter Sworn In, Dies Next Day"—and the headline gave Arlyne solace: "He died at a time when everybody knew it. In New York, they know that he died!"[9] She knew how much he craved recognition and attention. Benjamin Jordan believed he had played a

key role in his daughter's success, and it appeared almost predestined that her day as governor was the fitting moment for him to take his final leave. "If my father had had the option of choosing a time to die," Jordan said to Earl, "he would have chosen that day."[10]

Benjamin Jordan's lifelong pursuit of recognition affected his daughter deeply. After she retired from office, Jordan reflected that "in my *other* life, I was in the spiral to get ahead. . . . I didn't ask myself 'what are you ambitious to do?' I wanted to be all that I could be. I was propelled by a driving force and was leading what I now consider to be an unbalanced life."[11] Undoubtedly Jordan possessed the "type A" personality common among winning candidates. Columnist Meg Greenfield archly called Washington politicians adult versions of the "good children" common in high school. They were the prodigies, protégés, and "head kids" who possessed a driving force to be first, to win, and to succeed. Bill Clinton's biographers noted that as the "returning hero," his string of achievements and victories at school and scouts brought acclaim to a family that otherwise lacked distinction.[12] When Jordan brought home medals and awards, it set her apart from the high-school crowd and compensated for her father's middling status. Her family was intensely invested in her success. On the night of her victory over Curtis Graves, they started planning Jordan's race for the US Senate. When Jordan's friend Stan McLelland demurred, suggesting that Texas was not ready to elect a Black woman to a statewide office, he felt their wrath.[13] Accustomed to her winning, Jordan's family could not imagine her losing. They did not fully understand the pressures and obstacles she faced, and perhaps they did not want to know.

Undoubtedly much of Jordan's initial striving came from a desire to please her father. Initially Ben had been the ambitious one in the family. When he first came to Houston, he was a young man in a hurry. He wanted recognition as a preacher and a family he could be proud of. In Jordan's early years, Ben—a distant presence—was busy with work and his church as he tried to "make it." Yet the youngest Jordan daughter—feisty and quick with her words—gained her father's attention by puncturing his ego. Much to his dismay, Jordan piped up with embarrassing anecdotes in the presence of other adults, telling strangers that her grandfather had purchased the nice new coat she was wearing. Without consulting her parents, Jordan quit piano lessons, disconcerting Ben with her highhandedness. "She has always been, even as a little girl, very sure of herself," said one of her elementary school friends.[14] In general, Jordan seemed too independent

for her father's liking. "We did not see eye to eye on anything," she recalled.[15] But seeing her recite and sing at Greater Pleasant Hill appeared to change his attitude. During her early adolescence, her father became a more forceful presence in Jordan's life, and she began to care more about what he thought.

In high school she initially struggled to live up to his expectations. From her father's perspective, Jordan had been blessed with every advantage. Praise came rarely if at all, and the pressure to abide by his demands seemed constant. Jordan struggled with her temper. Deference to authority—a signature trait of the "good" child—did not come to her easily. During her first year at Phillis Wheatley, the twelve-year-old misbehaved. Jordan often corrected and outsmarted her teachers, and their annoyance with her quick intellect prompted her Aunt Mamie to make a threat: if the disruptive behavior continued, Ben would have to know. "That settled it," Jordan recalled. "And after a while, I got it under control."[16] She redirected her energy and attention toward pleasing her teachers and her father rather than making them upset. "Her mother was very quiet," remembered one of Jordan's childhood friends. "It was always her father who mattered."[17] Eventually Jordan became the good child who succeeded at school and won awards, if not acclaim.[18] But her success did not lead to an easy or warm relationship with Ben. In fact, Jordan was wary around her father. "He was a strict disciplinarian," she remembered. "I always had to keep the lid on."[19]

Only when his daughter performed in public did the stern Benjamin Jordan allow his emotions to flow and for his pride to appear. Jordan recalled how he sobbed uncontrollably during her "Girl of the Year" speech in high school, and she came to expect that during a good speech or performance her father would lose his stern mask and cry. As she matured, a desire to stir an audience with her words became integral to Jordan's psyche and her positive sense of self. When asked why she enjoyed politics, she once said, "It's people and the response you can get from them. You can get people excited. That makes you feel good." Jordan, conditioned to elicit a response from an audience, and gratified by her father's emotional reaction to her oratory, observed how the pattern affected her time and time again. "Then when you get elected and try to deliver on all the promises you made, it's a little frightening."[20] Propelled to speak, gain a response, and then struggle to deliver on a promise, Jordan created ever-rising and new expectations, matched by new emotional highs for herself.

Like her father Jordan also had a public and a private face. And although she resented her father's dominance, throughout her life she continued to keep the

lid on her emotions and rarely confronted him. After Jordan won "Girl of the Year" at Wheatley and the speaking contest in Chicago, Ben had expected and wanted his youngest to aim even higher and excel. But once she started attending Texas Southern, she continued her old pattern of having fun on the sly with her friends. In high school, Jordan and her sister Bennie drank, smoked, and attended forbidden dances at Hester House, a local youth center where Jordan sang her specialty song, "Money, Honey." Now, at TSU, she and Bennie openly drank beer at the Groovey Grill, joined what Ben called a "hell fire sorority," and took odd jobs as a babysitter and cleaner to pay for it. Her father felt shocked and disappointed that Jordan, with all of her gifts, apparently lacked ambition.[21] Jordan probably dreamed of escaping back to Chicago, but instead she went east, on a "mind opening journey," with Tom Freeman and the TSU debate team. She gained confidence, and when Tom Freeman arranged for a big ceremonial homecoming for the team that included receiving an award bestowed by the college president, Jordan remembered how much she enjoyed winning. College debate, travel, and recognition all reignited her old ambitions.[22]

After she finished law school, Jordan thought about staying in Boston, but despite her differences with her father, she returned home. Jordan's attitude toward her father softened. She needed and appreciated his help setting up her law practice and her early campaigns, but the old tensions remained. Her genuine gratitude toward her father was always tempered by frustration. She acknowledged her father's contributions to her career but then felt irritated when he continued to press her for recognition. He always wanted more attention. Navigating the demands of a dominant parent, another common experience among successful politicians, required great patience.[23]

Jordan had long simmered over her father's hypocrisy. She saw how he preached moral probity to others while doing as he pleased. Throughout her life she had witnessed, and resented, how he intimidated her mother, badgering her into passivity; she hated his overbearing arrogance. Jordan had some suspicions about her father's behavior, and after her election to the Texas Senate, she decided to find out the truth. One night while she was visiting her parents in Houston, she followed her father and watched from her car as he drove "straight to the home of a woman she knew." Jordan waited outside and fumed but remained silent. She lacked the courage to confront him about his affair. They never had a falling out, but she also found it impossible to forgive him. According to one biographer, Jordan condemned her father in front of her friends, and

"stayed furious with him for years." The stability of her homelife, and the tradi-
tional, religious values of both her mother and father, provided a foundation for
her achievements, yet under the surface the family dynamic could be volatile.[24]

Jordan's enormous powers of self-control may not, to many, appear healthy,
yet she harnessed that tremendous emotional discipline to her political advan-
tage, chipping away at the people in power, just as she wore down her father
and gained his acceptance. "That's the way I like to work," she said.[25] She some-
times claimed that "disruptive or divisive kind of behavior is of no help," but
Jordan had been involved in plenty of protests. She understood the importance
of nonviolent direct action and organized dissent for upsetting the racial sta-
tus quo and introducing change. Jordan believed that "all blacks are militant
in their guts; but militancy is expressed in various ways."[26] She suppressed her
aggression, imposing logic on her emotions so that she could remain calm and
negotiate the matter through. In an interview with Paul Duke, Jordan referred to
herself in the third person, and described how she used her intellect to harness,
or "suppress," her anger in the middle of a political conflict: "You see under-
neath, and you want to break out as in some kind of a display of aggressiveness.
The truth of the matter is that in the back of your mind you know that in the
long run that display of aggressiveness is going to retard the cause that you're
trying to fulfill or to bring about. So you suppress, you suppress, that's what
I meant by militant in their guts. You suppress that and then act on another
plane."[27] Suppressed anger became the yeast for Jordan's political rise.

"You suppress, you suppress," was a strategy that came out of her home,
and out of segregation; it was an approach that Jordan's family, constituents,
and many other Black notables of the 1970s could easily recognize and endorse.
One of her contemporaries, tennis great Arthur Ashe, a native of Richmond,
Virginia, told interviewer Lynn Redgrave on the BBC that "I am not emotion-
ally very open, but I don't think it's a crime." He explained how and why he had
been trained to suppress his emotions: "Control is very important to me. You
grow up Black in the American South in the late forties and fifties, you have
no control. White segregationist laws tell you where to go to school, which bus
you can ride on, which taxis to take, what you can say. And then in the sixties,
what we call the American Black social revolution, and then you had Black ideo-
logues trying to tell me what to do." Ashe resented all of it. "When do I get to
decide what I want to do?" He called the famously aggressive tennis champion
John McEnroe "frail." At the same time, Ashe admitted he envied McEnroe's

"emotional freedom to be a bad boy." That kind of behavior was something, Ashe declared, that he could never have done and ultimately did not wish to do: "My race would not have allowed me to be like that. And I wouldn't want to be like that."[28] Even as an adult in the 1990s, Ashe felt accountable to what his home community in Richmond would have wanted to see in him: dignity, composure, perhaps cunning, and, of course, victory.

"Ambition is at the heart of politics," noted political scientist Joseph Schlesinger. His research confirmed the simple observation that representative democracy depends on "a supply of individuals with strong office drives."[29] For generations ambitious Black Houstonians who wanted to gain office faced racism and impossible legal hurdles. Although the times were changing, a few favorable court decisions, by themselves, could not put a Black person in office. Someone had to take the risk and run. Jordan stepped into that breach. Running for office meant facing dangers posed by white racism, of course, as well as accepting the risk of a humiliating loss. Political strategist Billie Carr understood that successful candidates needed to have confidence and unusual drive. Otherwise, how would they have the emotional fortitude to run again after a defeat, or to ask for money when they had not yet won? "I wouldn't want to have a candidate who didn't feel confident," she said, not to mention highly invested in winning a race.[30] Black Houstonians valued anyone with strong drives who succeeded. Ending racism in American politics started with Black voting and supportive court decisions, but victory and inclusion involved developing Black candidates, people who felt driven not only to run but to win.

At the same time, a thirst for success alone was not sufficient. The Black community would not turn out in high numbers for a candidate who did not represent their interests or who failed to have a record of service. These high standards practically guaranteed that Black women would emerge as some of the first Black politicians in the civil rights era South. In Houston, Hattie Mae White had already demonstrated a Black woman's ability to garner votes. When Barbara Jordan emerged as a known activist within the Democratic Party who asked for popular support, she had to earn it. Jordan was not part of Houston's Black financial elite, and she did not have the backing of conservative white politicians—in fact, she opposed them. But she entered the political fray gradually. Like many of her peers, she entered office determined to continue her work on racial justice and equality. Jordan's ambition, combined with her professional education, organizing experience, and outspoken opposition to segregation,

made her appealing to Black Houston. In her race against Graves, Jordan made the case based on her efficacy, but if she had not been perceived as a forceful, as well as effective, Black leader, she would not have stood a chance.

Jordan's ambition to succeed in politics should not be misconstrued as an unhealthy desire to dominate others. Such a negative view of ambition has been used to discredit women who seek positions of power or simply to advance in the world. According to psychiatrist Anna Fels, many women prefer not to use the word "ambitious" to describe themselves because it connotes "egotism, self-ishness, self-aggrandizement, or the manipulative use of others for one's own ends." As Fels argues, however, ambition is a healthy emotion that involves two components: mastery of a skill and an expectation of recognition. To succeed it is not enough to be good at something. Recognition is important because without it humans feel "isolated and ultimately, demoralized."[31] Her father and her family pushed Jordan to go higher, but it was Houston's Black community that ultimately validated her ambition. They chose her to be their political leader and representative. They turned her political success into a cultural phenom-enon. She understood that members of her community had urged her to aim high because gaining political office gave her the opportunity to represent Black interests in government. For her part Jordan believed she could use her office "to move" the nation and make it more just through achievable legislation, and Black Houston supported those goals.

Jordan's political ambitions were not so different from that of the other Black women elected to the Ninety-third Congress. The early career of Yvonne Brathwaite Burke, for example, shows some interesting parallels with Jordan's. A California native who had served several terms in the California state legisla-ture before being elected to Congress in 1973, Burke had a reputation for being pragmatic and cool tempered. Like Jordan she came from a poor, but stable, working-class family. Both women were academically precocious and debate stars in college; both were lawyers and musically inclined. Both had ties to orga-nized labor and unions. And both had taken the initiative to run for the state house in the 1960s against white male candidates.[32] Given their backgrounds, both women could have easily been celebrated as representatives of larger Black interests or idealists seeking to expand the promise of American democracy.

Yet too often Jordan and Burke were depicted in the mainstream press as individual women divorced from the larger political forces and issues that had sent them to Washington. The press scrutinized their individual foibles,

examining their respective marriage status, physical appearance, clothing, hair, and class positions. The *Washington Post*, for example, dubbed Burke and Jordan "total opposites in mode and manner." In October 1972 it published a lengthy feature piece on each woman, accompanied with side-by-side photos. The articles employed a surfeit of racist, colorist, and sexist stereotypes to contrast them. Yvonne Burke was depicted as "charming," "strikingly beautiful (reminiscent of Dorothy Dandridge)," "creamy skinned," "meticulously coiffed," and "chicly dressed." "Yvonne Brathwaite likes accessories of diamonds and opals." "Don't look for a headline conscious women's libber." "She quietly overcame male chauvinistic prejudice," and "her impact as a freshman congresswoman is likely to be on the subtle side, stemming from hard work, diligence and quiet acts of personal determination." The paper hailed Burke's married status and breathed relief at her apparent eschewing of feminism, noting she went by "Mrs. Burke (she did not use 'MS')." Burke had become well known within the national Democratic Party for chairing the last day of the Democratic convention in a fourteen-hour marathon session.[33] A photo of her chairing the convention in a red halter top (she took off her jacket to ward off the stifling Miami heat) appeared in newspapers nationwide. Clearly, there was a sexual overtone to that photo; by the time she came to Washington, the press muted that angle. Please do not worry, was the message in the *Washington Post*. Burke was a conventional woman—not a "woman's libber" or radical.

Jordan, too, suffered from demeaning and sexist stereotypes in the press. Molly Ivins covered the Texas legislature for the *Texas Observer* and had been hired by the *Washington Post* to write a fresh profile of Jordan before she took her seat in Washington. In the version of the profile that appeared in the *Texas Observer*, Ivins became the first journalist to publicly associate Jordan with the image of "mammy." White "libs," wrote Ivins, took their conservative friends to the senate to hear Jordan speak to disabuse them of the notion that "anyone who looks that much like a mammy was going to be pretty funny to hear."[34] Ivins did not directly call Jordan a "mammy"—she put that thought in the minds of others. Her backhanded praise of Jordan's oratory still contained the insulting word, and her stating it made it acceptable for other white liberals to use. The image of "mammy" would follow Jordan for the rest of her days as a politician.

In the version of the Jordan profile that appeared in the *Washington Post*, Ivins did not use the word "mammy," but she depicted Jordan outright as a defeminized woman with masculine traits. Setting the tone with her title, "She's

as Cozy as a Pile Driver and Considerably More Impressive," Ivins compared Jordan to a member of a construction crew and described her as "having a personality like slate rock." Jordan had no femininity. Northern white liberals, Ivins stated, could expect to receive one of her "cold steel stares," which she likened to being hit by boxing champion Joe Frazier. In addition to using masculine imagery to define and describe Jordan's appearance and personality, Ivins proclaimed Jordan lacked traditional womanly manners. "Jordan has no social chit-chat," wrote Ivins, who solemnly reported that once, when Jordan was in the hospital, she had failed to send a thank-you note to some senators' wives for their gift of flowers. Never mind why Jordan was in the hospital. According to Ivins, this alleged oversight said something important about Jordan's lack of womanhood. Another damning example: Jordan, according to Ivins, did not care about her "size." "She seems not fat but big. She is 5'8" but never weighs herself." "She has no interest in decorating." "She wears no makeup." Jordan, she implied, had no social life or interests or friends outside politics. "Jordan still lives with her mother at 4910 Campbell Street." For good measure, Ivins extensively quoted disappointed liberals who felt snubbed by Jordan and painted her as "part of the establishment." She also quoted Curtis Graves, who called Jordan a sellout.[35]

Ivins balanced these negative descriptions of Jordan as a "large," "pile driving," politician with an "overweening ego" with some praise. Jordan, she admitted, was smart, "serious," and "self-confident," and a politician who possessed "absolute reserve and dignity."[36] But Ivins included a description of Jordan berating a "hapless" witness in the senate; when she bluntly called his testimony full of "weasel words," Jordan's anger became active, and the "lid" came partially off. Yet instead of underlining Jordan's forensic skill, or explaining the harm Jordan was trying to prevent, or even commending her for showing some emotional militancy, Ivins focused on Jordan's allegedly bullying behavior. The journalist gave great stature to Jordan's intellect, but tore her down in almost every other way and employed racist and sexist stereotypes to do it. The Houstonian's ambition to hold high office was characterized as something only personal, not political, and certainly not racial. The Ivins piece is an excellent example of how Black women's new place in politics was explained to white America by adopting an individualistic framework of self-aggrandizement. Their prior work for racial equality and their achievements as state-level politicians were watered down, if not roundly ignored.

Coverage in the *Washington Post* confirmed the double disadvantage faced by the new Black women representatives in Congress. The racism and sexism faced by ambitious Black women who ran for office in the 1960s and 1970s has not been fully acknowledged. Scholars R. Darcy and Joseph Hadley emphasized Black women's "double disadvantage" because of race and sex yet assert that their political victories demonstrated how they surmounted those disadvantages. After passage of the 1965 Voting Rights Act, they argue, proportionally more Black women were elected to office than white women. The elected Black women possessed more experience in activism than their white women counterparts. They tended to be better educated. And, perhaps most significant, Black women expressed "greater ambition for elected public office" than did white women.[37] The civil rights movement gave Black women opportunities to organize and pursue leadership. Seeking elected office and reaching out to Black people for votes felt like a natural continuation of those efforts. Black women politicians of the era sought to continue the work of racial justice in politics, yet it is misleading and wrong to suggest that the double disadvantage faced by Black women disappeared once they were elected.

Racist and sexist attitudes confronted Black women at the local and state levels. For six years Jordan had been the only Black woman to serve in either house of the Texas legislature, but in the fall of 1972, after she was elected to Congress, two Black women were elected to the House of Representatives in Texas. Eddie Bernice Johnson represented Dallas, and Senfronia Paige Thompson was elected to the legislature from Houston.[38] Both women benefited from recent court-ordered changes to the at-large system of electing representatives. Both had long histories of activism and community service, and both were part of the broader effort of African American men and women in Texas to gain political power, support the progressive faction of the state's Democratic Party, and uplift the status of their people.

Both women worked within a large body of 150 legislators, many of whom were white conservatives, and their presence had an unsettling effect on the white male majority. In April 1973, Representative Thompson of Houston had just finished her first session in the Texas legislature when, as she was walking in the halls of the building, Rep. C. C. Cooke of Cleburne County, a rural community located outside of Fort Worth, called her his "beautiful black mistress." When she objected, he took the insult further: "You mean you wouldn't make love to a white man?" Representative Thompson, a former teacher, wasted no

time in calling attention to, and reprimanding, this outlandish behavior. Shortly afterward, in a personal privilege speech delivered before the entire representative body of the Texas House of Representatives, she repeated Representative Cooke's exact words and denounced him, adding that she felt "extremely insulted and degraded." The reaction was utter silence until a liberal white male representative, Neil Caldwell, apologized for the remark. And when he did, the entire house applauded.[39] Senfronia Thompson's courageous speech signaled to the white men in the chamber that she would not tolerate their insults, but the stereotypes of Mammy and Jezebel continued to act as potent weapons against Black women in politics.

Even among Black politicians, gender emerged as a point of fissure, and sexism clouded debates. Nobody understood this better than Rep. Shirley Chisholm of Brooklyn. In 1968 Chisholm became the first Black women ever to be elected to Congress. The daughter of poor, immigrant parents, Chisholm spent her early years in Barbados with her grandparents before returning to the States to attend high school and Brooklyn College, where she excelled in debate and trained to be a teacher. She, like Jordan, also ran a heated race against a Black male politician to win her newly drawn congressional seat. Chisholm's opponent was civil rights activist James Farmer, who ran as a Republican. Chisholm, who had paid her dues with years of fundraising work in New York's Democratic club party politics, and had also served in the New York state legislature, resisted Farmer's sexist attacks on her candidacy. With her emphasis on gaining the support of Black women, community-based organizing, and voter registration, Chisholm won.

For the next four years, she worked to represent her impoverished urban constituents in Congress but tired of being assigned to committee work that had nothing to do with race, civil rights, urban issues, or poverty. She also felt frustrated with the male legislators in the Congressional Black Caucus. She believed they were not moving effectively enough to leverage Black political power within the Democratic Party. Like Bayard Rustin, Chisholm believed in working within the political system through building coalitions. In 1971 she set off a firestorm when she announced her candidacy for the presidency and sought the support of feminists, the young, liberals, and labor. The men of the Congressional Black Caucus did not appreciate what they perceived as Chisholm's highhanded approach of announcing her candidacy. And although she did gain the support of some male members of the CBC, most would have preferred a

Black male candidate for president, and many thought that any presidential run by a Black candidate was misguided.[40]

Even before she was elected to congress, Jordan was privy to some of these tensions. She had witnessed an explosive confrontation between Chisholm and the male members of the CBC in Washington, DC, in November 1971, when the organization sponsored a conference at the capital. As a state senator with a growing reputation, Jordan had been invited to give a talk on a panel workshop titled "The Development of Black Political Power in the 70s."[41] Other members of the panel included the former mayor of Cleveland, Carl Stokes, Chapel Hill mayor Howard Lee, and Manhattan borough president Percy Sutton. Chisholm had been excluded. During the middle of the session, the furious congresswoman from Brooklyn entered the hall and brought the proceedings of the conference to a halt. She dramatically asked the organizers why she, as the highest-ranking Black woman elected official in the country, had been consigned to a panel on early childhood development? Why was she not leading this discussion on Black politics in the 1970s? CBC chair Louis Stokes insisted that no insult was intended, but Chisholm denounced the group for its male chauvinism.[42] Jordan agreed with Chisholm, noting that the CBC wanted to quiet the growing controversy over the New York congresswoman's presidential campaign. "Shirley was right," Jordan stated. "She should have been on the panel. They muffed that one badly."[43] Dubbed a "matriarch" and worse, Chisholm and her ambitious candidacy nevertheless inspired many younger politicians, including Jordan, who would take up her banner of coalition politics. During Jordan's first years in Congress, debates between the men and women in the CBC continued. They tended to disagree over strategy and how best to influence the Democratic Party, but the underlying tensions regarding the aspirations and ambitions of Black women leaders continued.

As Black voters forced American democracy to respond to just claims for representation and power, the emergence of Black women as political candidates and elected leaders opened major questions: Could the nation truly embrace its own ethic of upward mobility? Were Black women allowed to be ambitious? When Jordan took her first oath of office, Houston's Black community celebrated her ambition and called her a beautiful symbol of Black womanhood. But six years later, Jordan's rise was buffeted by a storm of nasty racism, and the insinuation that her success, her ambition, proved that she represented only herself, and not her race. Could Black women in politics be perceived as leaders

of their race and of the nation? Shifting the conversation so that her race and sex worked to her advantage rather than her disadvantage would be just one of the many challenges Jordan faced in Washington.

On that June day in Austin, Jordan was full of hope. Her father's deep desire for personal recognition had been fulfilled, but his death did not diminish her ambition or cause her to turn away from her larger mission. Long ago she had outpaced his vision and had developed her own goals. Jordan's commitment to civil rights, to Black rights, to justice, and to her own personal dignity and autonomy drove her forward. Her drive was well established within her psyche, and had been pushed by the full support of her community. She had endured malicious attacks in her race for the Texas Senate, and again when she ran for the House of Representatives; she had kept the "lid" on and prevailed. Now, instead of being the only Black woman in the room, Jordan for the first time in her political life could anticipate working with a cohort of other Black women in Congress. Big changes had already happened in her lifetime and more seemed possible. As she said to her constituents: "It doth not yet appear what we shall be." Jordan relished her responsibilities as a modern Black woman leader; her ambition should be interpreted as a positive force that drove her to work harder for justice.

A Bright Star in a Constellation

Black Feminist in Congress

The message I have to my brethren—you are very good, and bright, and intelligent young men. But it is time for you to understand that power does not come from your extemporaneous rhetoric about the activities you engage in and the prowess you can exercise in relation to black females or white females.
—Barbara Jordan, "Black Women in Politics," National Urban
League Convention, Washington, DC, 1973

Because of the significant role she played in the Judiciary Committee's impeachment hearings in the summer of 1974, Jordan's public presence during her first year in Congress is often overlooked. But from the moment of her arrival in Washington, she made her mark as an outspoken Black woman Democrat. She pushed the party leadership to confront President Richard Nixon and embrace its commitment to economic justice and civil rights. She emerged as a spokesperson for the freshman class, for economic issues, and, especially, for Black feminism.

After Lyndon Johnson left the White House, liberal Democrats seemed in disarray. Devastated by the deaths of Martin Luther King Jr. and Robert Kennedy, as well as by the crushing loss of the presidency to Richard Nixon in 1968, the party seemed unable, or even unwilling, to confront the racist sentiment that oozed from the Oval Office. "In places where it counts," wrote former Johnson advisor Roger Wilkins in a scathing 1970 editorial, "America is a white country."[1] Wilkins had just attended the famous Gridiron dinner in Washington, DC, an event that brought together hundreds of the capital city's most powerful journalists and politicians. One of only two Black men present—no women of

Figure 8. Barbara Jordan and members of the Congressional Black Caucus, 93rd Congress, 1973. Photo by Dev O'Neil. Image courtesy of the US House of Representatives Photography Office, Washington, DC. Row 1: Barbara Jordan, Robert Nix, Ralph Metcalf, Cardiss Collins, Parren Mitchell, Augustus Hawkins, Shirley Chisholm. Row 2: Julian Dixon, Charles Rangel, Harold Ford, Sr., Yvonne B. Burke, Walter Fauntroy. Row 3: Ron Dellums, Louis Stokes, Charles Diggs. Missing: John Conyers, Andrew Young.

any race were allowed—Wilkins witnessed jokes about the "southern strategy" and winced at the wild applause for Julius Hoffman, the Chicago judge who had ordered the shackling and gagging of Black activist Bobby Seale at the trial of the Chicago Seven protesters. The evening ended with Vice President Agnew playing a raucous "Dixie" on the piano as a stunned Wilkins took in "the humor amidst the pervasive whiteness." After "our black decade of imploring, marching, lobbying, singing, rebelling, praying, and dying," he concluded, nothing had changed in Washington, DC. When Martin Luther King Jr. planned the Poor People's Campaign in 1968, he envisioned Congress as an essential partner in the movement's quest for economic justice. But now, Wilkins lamented, "King was dead. And this thing was petering out."[2]

George McGovern's spectacular loss in the 1972 presidential election damaged the party's morale, yet the arrival of fifteen Black representatives into the Ninety-third Congress, the largest number since Reconstruction, gave hope that an important turning point in national politics had arrived. Andrew Young from Georgia and Jordan from Texas became the first two Black southerners to join the newly formed Congressional Black Caucus (CBC). Founded in 1971, the caucus appeared on the cover of *Newsweek* magazine, which noted the growing numbers of Black Democrats and their backgrounds as local politicians and activists.[3] Since 1968 Shirley Chisholm had been the sole Black woman in Congress, but in 1973 three additional Black women joined her in the House to create the first cohort of Black women ever elected to the body. Besides Jordan and Chisholm this group included Yvonne Brathwaite Burke, a former state legislator and attorney from California who had made headlines as the first Black woman to chair the proceedings of the Democratic National Committee in Miami in 1972; and Cardiss Collins, who took office after her husband, Illinois representative George Collins, was killed in a plane crash outside Chicago at the end of 1972.[4] These four created a powerful quartet of Black female voices in Congress and in the Congressional Black Caucus. Together they played a prominent role in expressing new strategies in the ongoing Black struggle and bringing attention to Black feminism.

All the representatives in the CBC valued racial unity, but the primary system—which often pitted Black candidates against each other—sometimes exaggerated political and regional differences. Like Jordan, several successful House members had survived tough primary contests against a Black competitor, which had led them to be pigeonholed in surprising ways. In Atlanta, Andrew Young—once deemed a radical for civil rights—had been called a "tool of the white establishment" by his opponent. In New York, US Rep. Charles Rangel was linked to "black colonialism, which is worse than white racism." Parren Mitchell of Baltimore had been described as a "nationalist" who condoned "militant demonstration."[5] Once they took their seats, Black Democrats agreed on many policy points. Yet differences remained. For example, older Black politicians such as Rep. William Levi Dawson, who had retired in 1970 after representing Chicago for twenty-seven years, had expertly manipulated the "system of organization and patronage" that lay at the heart of northern party politics.[6] Party machines, however, had done little to help the Black urban poor, who rarely benefited from Democratic Party patronage.[7] Some thought the party too corrupt to be

redeemed. The *Chicago Defender* called on the CBC to ignore "the place that blacks should occupy in the reorganized Democratic Party" and not to worry about pleasing "the party bosses at home."[8] In her first memoir, *Unbought and Unbossed*, Shirley Chisholm criticized the sexism and corruption of her state's Democratic party. As a state legislator, she bucked her party bosses and supported Republican John Lindsay for mayor. Chisholm's famous claim that "of my two handicaps, being female put many more obstacles in my path than being black" was a comment on the male-dominated political clubs in New York that had supported a few Black males for office but no Black women.[9] Bill Clay from St. Louis had engaged in both civil rights activism and in ward politics, and was considered a "shoo-in" for mayor if he were to lose his seat to redistricting, but was at odds with the local machine and doubted whether holding that office could fix the city's mounting problems.[10] Although all in the CBC were Democrats, many northern Black representatives were skeptical about what the Democratic Party could do for Black people.

But Black southerners, such as Jordan and Andrew Young, the freshman congressman from Atlanta, had a different perspective. They appreciated what President Johnson had done for civil rights. "I am aware of his mistakes," Jordan told journalist Molly Ivins, nevertheless "I believe he was a great president."[11] As a representative from Texas, Jordan realized the influence that her Democratic colleagues had within the majority party and their control over powerful committees; if they could be useful she saw no point in alienating those figures. Jordan pursued her committee assignments carefully. After she decided she wanted to serve on the Judiciary Committee, she wrote to two influential Texas legislators, Omar Burleson and Wilbur Mills, and then called Lyndon Johnson. He put in a word for her. She also visited the Judiciary Committee chair, Peter Rodino, and then she called his best friend, Italian American and native Houstonian Jack Valenti, an influential Hollywood insider and lobbyist. The CBC had wanted Jordan to serve on Armed Services; others had suggested Education and Labor, but Jordan saw the pitfalls of both.[12] Her appointment to the Judiciary Committee ruffled some feathers, but she stood by it.

Initially Jordan had a more optimistic view of the Democratic Party. Her experience working within the Texas legislature had convinced her that building relationships among the powerful within the Texas caucus could help her make a difference. Economic justice remained a priority. In August 1972 she appeared with Vernon Jordan and Jesse Jackson at the National Urban League meeting

in St. Louis, attended by more than four thousand delegates. At that gathering she "electrified the conference with a speech in which she declared America has worshipped too long 'at the shrine of power, profit, and progress.'" Since 1952, she told the audience, "fear has dominated American politics and the 1970s is marked by fear of crimes and the threat of individual repression by men in robes and uniforms." Jordan echoed Chisholm's call for coalition politics and insisted that "the so-called new coalition will be valid only if all people—black, brown, and white, rich and poor—are included in the decision-making process."[13] During the fall of 1972, Jordan's name appeared on a full-page advertisement endorsing McGovern alongside those of nearly thirty other Black elected officials from around the country.[14]

Despite McGovern's ignominious 1972 defeat, victorious Black politicians, especially in the South, drew headlines and praise: "92 Dixie Blacks Vie for Elective Office," announced a headline in the *Chicago Defender*.[15] The *Defender* also showed Jordan flashing the V for victory sign.[16] "Miss Jordan and the Reverend Andrew Young of Georgia made history by becoming the first blacks since reconstruction days to be elected to Congress from the deep south."[17] Jesse Jackson celebrated such victories by merging the rhetoric of the Gary convention with that of liberal democracy. "This was black power at its finest," he proclaimed. "It's nation time." Jackson's "nation" included Black women's leadership. He praised Jordan and Yvonne Brathwaite Burke of California: "For we must project Mrs. Burke and Miss Jordan as leaders. Both are gifted, extremely competent and imaginative, and perhaps among the brightest of the current crop of black or white congressmen."[18] From their first meeting as representatives, Jordan and Burke worked well together, and Burke remembered that Jordan had enjoyed joking with her husband at conferences.[19] The two both traveled to Miami for the Democratic convention, and they came together again in January 1973 when they were chosen to participate at the Kennedy School program at Harvard designed to prepare new members of Congress. During the Harvard sessions, Jordan cemented her friendship with Yvonne Burke and William Cohen, a Republican representative from Maine, met economist John Kenneth Galbraith, and participated in seminars related to legislation and governance.

Not everything was smooth sailing. Jordan arrived from the warm climes of Houston to cold, snowy Cambridge late at night and in a very bad mood. She was tired, according to Mark Talisman, the former congressional aide who ran the institute at Harvard. He recalled her first words, spoken half in jest, during

their first meeting that evening in January: "What the fuck have you gotten me into!" "She was like a mama grizzly bear on her hind legs," he recalled. In spite of their testy introduction, the two became good friends. Jordan joined Burke and two other newly elected white male Republicans, including Alan Steelman of Dallas as well as Cohen, as the four freshman representatives chosen to participate in the program. The group was small and integrated. Nevertheless, Talisman thought Jordan's experiences at Harvard introduced her to some of the prejudices she would continue to encounter as a congresswoman.

From observing her during the stint at the Kennedy school, Talisman believed Jordan understood how her appearance led others to underestimate her.[20] He recalled how Jordan was repeatedly overlooked by the visiting speakers, who focused attention on the two white men present and then on Burke. Steelman, a young white Republican from Dallas, matter-of-factly stated why he believed Jordan faced obstacles as a politician, both related to her sex: "First she was a woman. Number two she was an unattractive woman. Yvonne was a much more conventional woman if you will."[21] Steelman, like Talisman, contrasted Burke's glamorous femininity with Jordan's appearance. Steelman said he never thought about Jordan's sexual orientation: "[Since] she was not attractive, I just assumed she was a single woman."[22] Talisman observed how Jordan repeatedly overcame such obstacles through her wit and intelligence, always posing the most pertinent questions.

Steelman recalled the congresswoman's unusual honesty and candor: "I remember one time, Charlie Wilson called me and [he told me] he had admired my campaign and congratulated me. When I met Barbara, I asked her 'What do you think about him?' as though I didn't know him. She said, 'What are you talking about: I know you all have already talked.'"[23] Talisman commented similarly on Jordan's "realness." Her frank and forthright style, which Ivins had characterized so negatively, often disarmed her peers and worked to her advantage. While at Harvard, Jordan made some important personal connections.

Jordan returned to Washington at the start of the Ninety-third Congress in January 1973, when she celebrated her achievement with family and friends and out-of-town well-wishers—one hundred people in all. Many came by bus, traveling more than two days to see her sworn in. They included senior citizens from Good Hope, campaign workers, her mother, two sisters, and their husbands. The other liberal representative from Houston, Bob Eckhardt, hosted a reception for all the Texas guests. The Delta Sorority hosted another reception

for Jordan, Chisholm, and Burke.[24] Civil rights veteran John Lewis, who chaired the Voter Education Project, hailed the election of Jordan and Andrew Young as "the most important victories" of 1972. "Their elections as Representatives in the US Congress has great meaning for blacks throughout the South," he wrote.[25] Black Texans, sorority members, Black and white southern liberals, and civil rights activists all saw a little of themselves in the congresswoman from Houston and viewed her presence as a symbol of hope for political change.

Right from the start, Jordan sought to foster unity among liberals by opposing President Nixon's policies. At the beginning of the legislative session, the fifteen-member CBC criticized the Nixon administration during their "True State of the Union" presentation held on the House floor, attended by an overflow audience of five hundred and cheered on by more than two hundred members of that body. In February, one month after Jordan took office, she and Ron Dellums "were the first caucus members to appear on the House Floor" for the CBC's presentation. Jordan noted the president's failure to enforce civil rights legislation; Yvonne Burke discussed poverty; Shirley Chisholm focused on welfare reform; and Parren Mitchell dealt with housing. The 102-page statement they produced condemned what Chisholm called the Nixon administration's "rhetoric without action." Mitchell called out "the deterioration of our cities," and Rep. Louis Stokes from Ohio denounced the "imperial presidency." The caucus vowed to "stimulate the revival of the congress as an effective, innovative, co-equal branch of government. We must begin a massive new effort to meet the needs of this country."[26] In their "True State of the Union" document, Black representatives used their platform to propose new measures to carry on the Black struggle for opportunity and equality.

Jordan's congressional peers quickly came to respect her quick wit, candor, and impressive public oratory. In April 1973 she was chosen by the freshman class in Congress as their spokesperson. They wanted her to challenge Democratic speaker Carl Albert for his failure to effectively oppose President Nixon's efforts to undermine congressional authority. Jordan was particularly outraged that Democrats had not thwarted Nixon's strategy to simply ignore congressional allocations for social programs. Twenty-eight Democrats had sided with Republicans to support Nixon's "impoundment" of congressional appropriations. Where was the party unity? Jordan wondered. In a meeting with House speaker Carl Albert, she listened patiently as he responded "fine" to all the points raised by the freshman Democrats. Finally, her patience wearing thin, she "exploded"

at the speaker, saying "in the 90 days that I've been here, I find that Congress is having difficulty finding its back and its voice."[27] In a widely reported address, she continued her robust criticisms on the floor of the House of Representatives: "The inability of the Democratic majority to decide on a course of action, and to move on it, as an articulate, responsible opposition party, has caused a deep sense of depression, not only among freshman but among some of the most senior members of Congress."[28] Jordan's confidence in calling the speaker to account was perhaps boosted by a report from the Joint Center for Political and Economic Studies, which pointed out that in eighty-six congressional districts, Black voters held the balance of power.[29] If Black Democrats seized that momentum at the polls, the party could do its work in Congress.

Speaker Albert seemed reluctant to take Nixon on, but Jordan had no qualms confronting the president. In numerous speeches that spring she denounced Nixon for breaking up the Office of Economic Opportunity, the linchpin of President Johnson's War on Poverty. But her critique went beyond policy disagreements. In a speech before the Women's National Democratic Club in Washington, DC, Jordan asserted that "when the President of the United States makes war, refuses to expend appropriated funds, eliminates programs authorized by Congress, he acts in violation of the Constitution and he acts illegally." By concentrating power in his office, she stated, Nixon was at war with the republic. Unlike Nixon, Americans understood that the problem of poverty had "its genesis in social, economic, and historical factors," and they wanted Congress to act. Congress had responded with legislation that hinged on "self-help" programs designed to allow people to find their footing in the economy and to discover their usefulness as American citizens. She wanted Congress to do more. "Ask yourselves a question," she said to her audience. "Are we investing in an America which tomorrow can have clean air and clean water, and living, breathing cities and productive citizens?" The problems of poverty and racism in the richest country in the world could not be solved by civil rights groups and social welfare organizations, she asserted. As King had envisioned, Congress developed poverty programs, and it was "still assessing the political implications of legislation designed to move more than 25 million poor people into productive lives." Congress should not relinquish its legislative mandate to the executive branch, but it needed public support to do its job. "Can change occur if the people of this country demand that their elected representatives fulfill their constitutional role? I say, yes it can," she stated. Four months into her first term,

Jordan declared that President Nixon was violating the Constitution; only Congress could stop him.[30]

Jordan enjoyed robust debate and publicly put members of Nixon's administration on the defensive. In May of 1973 she "stopped her Republican opponents short" in a debate before a gathering of the American Society of Newspaper Editors in Washington, DC. "Much has been said about the redeeming nature of President Nixon's peace success and foreign initiatives," she said, but "I just want to raise this one question: Why are we dropping bombs on Cambodia?" Jordan's question drew "strong applause" from the audience and flustered Texan Anne Armstrong, special counsel to Nixon, and Casper Weinberger, who served as Secretary of Health, Education, and Welfare. Throughout the night, Jordan decried Nixon's "one-man rule" and lamented that "the poor, the old, the defenseless are being lost in a shuffle of papers." She took a dig at John Connally, who had recently joined the Republicans. "He did give of his money," she said, "We'll miss that."[31] Jordan's efficacy as a public, partisan, debater made her a party asset and a rising star.

Jordan stepped into a larger role within the Democratic Party when she became one of the thirty-six Black members of the Democratic National Committee added by mandate after the 1972 Democratic convention.[32] Given that first-year representatives were excluded from the executive committees of both the Congressional Black Caucus and the liberal Democratic Study Group (DSG), inclusion in the party bureaucracy made Jordan stand out even more.[33] It was a sign of Jordan's stature within the party that she could tussle with House speaker Carl Albert and then, one month later, invite him to a party in her honor. Along with Albert, more than one hundred Washington, DC, luminaries attended a gala for Jordan at the presidential suite in the Watergate complex. Black architect Marion Thomas, a native Houstonian and former Wheatley classmate, honored Houston's "dynamic new congresswoman," whose election was "just another step in a consistently brilliant career."[34]

Jordan strengthened her ties with organized labor while continuing to advocate for the poor. Along with Andrew Young and Yvonne Burke, she appeared at a June conference in Washington, DC, sponsored by the A. Philip Randolph Institute, titled "The Ballot Box and the Union Card." The aim was to forge "a stronger alliance between the labor movement and the black community and to develop a strategy to counter the discriminatory economic policies of the Nixon Administration." Later in the week, Jordan also spoke at a conference of the United

Auto Workers (UAW) in Chicago.[35] In July 1973, she gave the keynote address at the gathering in Houston of the National Newspaper Publisher's Association (NNPA), the largest organization of Black-owned newspapers in the nation. In a speech before the convention, she condemned a "watered down" House bill on legal services that prevented poor people from bringing actions regarding school desegregation, abortion, or providing assistance to minors: "Each one of those amendments [sponsored by the Nixon administration] was violative of the rights of poor people," she told the convention.[36] Other Black political leaders, including Newark mayor Kenneth Gibson, California representative Willie Brown, and Urban League president Vernon Jordan, also condemned "government holdbacks and budget cuts" that hurt American cities.[37] Yet Jordan's speech stood out. She conveyed urgency, telling the journalists that amendments sponsored by "southern Republican blocs" threatened free speech, hindered activism, and deprived poor women of their right to seek an abortion. Where was the agitation? "Has a moratorium been called on the future?" she asked. Why was the nation in paralysis? The Black press, she told her rapt audience, could do more to motivate its four million readers; and ministers could eschew one Sunday sermon and lead congregations to write to their representatives. The agenda for social change must be pushed forward by Black institutions, Jordan insisted. Otherwise, the "stroke" that had plunged the nation into paralysis would become permanent.[38]

Jordan continued to champion issues related to reproductive rights and to condemn the sexual exploitation of Black women and girls. In July 1973 she joined with Burke, Chisholm, and Collins to charge HEW secretary Casper Weinberger with being "derelict" by failing to protect Black citizens seeking family-planning guidance. The quartet penned a letter pointing to the forced sterilization of the two Relf sisters, ages twelve and fourteen, whose illiterate parents had been deceived by local doctors in Montgomery, Alabama, into signing forms authorizing the sterilization of their daughters. The congresswomen criticized Weinberger's "inadequate response" to the outrage and urged the HEW to issue new regulations for the use of federally funded contraceptives.[39] Although none of the Black congresswomen represented Alabama, they used their congressional platform to speak on behalf of poor Black families who were exploited by local doctors and unprotected by federal authorities.[40]

Jordan engaged with Black community events throughout the nation and promoted the vitality and importance of Black culture. During her first year in office,

Figure 9. Jordan and Nancy Earl sitting with other attendees of the Parliamentary Conference, Williamsburg, VA, 1973. Courtesy of the Barbara Jordan Archives, Texas Southern University.

she returned to Houston twice a month (approximately twenty-three times) to attend nearly forty scheduled events with her constituents. In addition, she gave twenty formal speeches outside her home district: four speeches in DC, three in Texas, and the remainder in eleven different states, a schedule one political analyst called "extraordinary" for a newcomer. Jordan spoke at the commissioning ceremony of a US warship named after Dorie Miller, the Black World War II naval hero and native of Texas.[41] She used her prestige as a representative to promote Black institutions, cosponsoring a benefit for Black colleges at a community event held on 16th Street in Washington, DC. Her speech on that occasion drew attention to a recent film on Black celebrations in Watts called *Wattsax*: "The film shows we have soul, and nobody can destroy that," Jordan said.[42] Later that month, Jordan was honored by the Black Child Development Institute and appeared on the fundraising committee for the Black Women's Community Development Foundation.[43] In the beginning of 1974, she was scheduled to give at least ten more speeches outside Texas.[44] She used these opportunities to connect politics with people's lives.

One of Jordan's most publicized interventions occurred in July 1973, when she and the other three Black women in Congress spoke at the National Urban League convention in Washington, DC. The gathering drew a crowd of five thousand, and the panel "Black Women in Politics" drew a majority of those in attendance. Jordan, Burke, Collins, and Chisholm, along with two other local Black women politicians, fielded questions posed by a panel of four journalists from the *Washington Post*, the *New York Times*, local television stations, and Johnson Publishing Company, which published *Ebony* and *Jet* magazines.[45] The women openly discussed the friction among the sixteen men and women of the CBC. Jordan, with her usual candor, skewered Black leaders whose preening sexuality distorted their view of politics: "Representative Barbara Jordan of Houston brought most of the women, white and black, to their feet cheering, screaming, and applauding when she said: 'The message I have to my brethren— you are very good, and bright, and intelligent young men. But it is time for you to understand that power does not come from your extemporaneous rhetoric about the activities you engage in and the prowess you can exercise in relation to black females or white females.'" Six years in the Texas Senate had forced her to hold back, but now that she was in Congress, Jordan let it rip. Black women, she continued, were clear-eyed and more brilliant than most recognized: "We never thought that we were smarter than anybody else. But we've always known that we were pretty smart. Differentiate that with the black man. He has always thought that he was pretty smart but never was pretty smart." The effect of her words on the audience was immediate. "Some men in the audience of more than 2,000 shook their heads in disbelief or grinned sheepishly. A few nodded in assent." Following the applause, she asked: "Where could you find five or six brighter women anywhere in the country than you have here tonight?"[46]

Shirley Chisholm of Brooklyn echoed Jordan's message: "Our Black men have been emasculated a long time, but you can't place that burden on the black woman." Throughout her political career, Chisholm had been stung by sexist comments that sought to denigrate and stereotype her; she complained that she had been "nailed to the cross" by Black men. During her presidential campaign, she was derided as the epitome of the overbearing black matriarch, her leadership not taken seriously. "Pitting of the black woman, the so-called matriarch, against her black man" was counterproductive, Chisholm claimed. Citing the 1972 Gary convention, she urged the audience to "stop talking about Black power and move together. When men see women moving . . . they start tripping

all over themselves." Chisholm concluded by noting how she had indeed paved the way, and that if she chose to quit politics, "she would leave things in the capable hands of people like Barbara Jordan."[47]

Jordan and Chisholm were not the only panel members who openly criticized Black men for their sexist attitudes. Dr. Ethel D. Allen, a physician who became the first Black woman to serve on Philadelphia's city council, pointed out that "no man had wanted to run for the seat she now occupied." But as soon as she decided to run as a Republican and oppose the political "machine," men tried to take over her campaign. She eschewed their advice saying, "I have to be me." Her platform, she told the audience, was F.B.I.: "that is, Fat, Black, and Intelligent."[48] Emphasizing the crucial leadership of Black women, she derided people who get "hung up on 'whether it's pants or panties.'"[49] No matter which party they represented, the Black women on the panel showed unity and urged Black voters to get involved in government.

The women sought to bridge the legislative demands of their offices with representing the wider interests of marginalized groups everywhere. One slightly chagrined journalist noted, "In the moments when they were not talking about men, Rep Burke and Collins agreed that it was their role as Black politicians to represent not only their districts but also blacks throughout the nation and, Mrs. Burke said, 'throughout the world.'"[50] They possessed a far-reaching vision of how true sexual equality might manifest in everyday life. Yvonne Burke referred to the Relf sisters' sterilization abuse case and condemned the lack of federal oversight as state abuse of federal money: "We don't have to sell our soul to get what government assistance is being provided." Using language from the time, State senator Verda Welcome of Baltimore spoke up for the mentally disabled and condemned legislation that would "prevent two retarded people from getting married." Welcome, like Burke, stood for the reproductive rights of all people, including the poor, stigmatized, and marginalized.[51]

The issues raised by the Black women politicians were trivialized in an opinion piece by Louis Fitzgerald, a Black columnist and journalist. Writing in the *Chicago Defender*, Fitzgerald epitomized Jordan's wry observations about Black men and power when he began his column on the Urban League conference by expressing his "pleasant surprise" at the attractiveness of the "black chicks" in attendance: "It's been a long time since I have seen that many shades and hues of beauty under one roof. They came from Atlanta, Dallas, Houston, New York, Los Angeles, Miami, Detroit, Cleveland, Milwaukee, Pittsburgh, Chicago—from

all corners of the country! If Raquel Welch had walked into that Washington Hilton, she would have gone unnoticed in that black sea of beauty!" Fitzgerald agreed that the panel on Black women in politics had been "simply magnificent," but largely because of how amazing the women looked. "I must admit the Urban League truly brings out the best in us. For those of you who could not be in attendance you not only missed a truly informative session, but you also missed the most glamorous women in the world. All I can say is WOW!"[52]

Still, the words the Black women politicians spoke about the sexism of their male colleagues reverberated for weeks in the Black press and beyond. "The news columns were full of items about bruised Black male egos from the put down by those six soul sisters," the *Chicago Defender* noted.[53] But Ethel Payne, a Black journalist who cochaired the provocative panel, advised, "'If you can't stand the heat come out of the kitchen,' as Harry Truman used to say."[54] The controversy continued for weeks. As the *Defender* put it, "The black males apparently forgot that those black women now in Congress are tough. They know what it is all about. And sparked by Representatives Chisholm and Jordan, the women politicos are hard to touch, especially by males."[55]

Besides her pointed criticism of male leadership, however, Jordan had a larger message about coalition building and politics. Pragmatism compelled Blacks to form alliances. "We have to make a sacrifice in order to get things moving" Jordan told the packed crowd at the Urban League gathering, which might mean setting aside some demands to forge political alliances. "The votes . . . could not only come from blacks but from brown, red, females, and males alike," Jordan reminded her listeners. Black Americans needed to do more than simply vote: "It's going to take Black people who are not trying to sell anything and who are not jockeying for any position." Drawing on her successful efforts in the Texas Senate, Jordan offered hope: "I am one who still believes that there is a coalition of people of good will." The *Baltimore Afro-American* summed up Jordan's appeal: "She was witty and certainly can be described as a no-nonsense woman."[56]

The four congresswomen continued to work closely with Black sororities and Black women's organizations. A few days after the Urban League Conference, they hosted a reception at the capitol held by the National Council of Negro Women, celebrating the unveiling of a sculpture of NCNW founder Mary McLeod Bethune. The organization had raised $150,000 and hired renowned artist Robert Berks (who had sculpted President Kennedy's bust for the Kennedy Center) to create the ten-foot-high tribute to Bethune, which was placed at

Emancipation Park, facing Thomas Bell's statue of Lincoln and the freed slave.[57] A few weeks later, Jordan traveled to Atlanta as one of the main speakers at the Convention of Alpha Phi Delta, her sorority. More than five thousand Black women attended.[58]

Often regarded as a more outspoken feminist than Jordan, Chisholm held only minor political differences with her colleague from Texas. The congress-women shared similar positions on feminism and coalition politics. Jordan looked up to Chisholm, respected her bold challenges to male authority, and applauded her presidential run. Both women abhorred the sexual politics that diminished the significant contributions of Black women leaders. Jordan's fem-inism was rooted in her concern for Black women: "My view is simple," she explained. "Black women have a concern which in my judgment is more sub-stantive than sexual discrimination. The black woman concerns herself with the basics of food, clothing, and shelter. I feel that the women's liberation movement is complementary of the movement of equality based upon race."[59] She would have agreed with Toni Morrison that "Black women are different from white women because they view themselves differently, are viewed differently and lead a different kind of life."[60]

Chisholm, in contrast, was perhaps more likely to link race and sexual oppression because of her desire to generate broad support for her presidential run. In her speeches she drew direct analogies between the poor Black women in her district who struggled to support their families and the sexism suffered by all women: "For this reason, I am unable to make a clear-cut separation between the struggles of blacks and the struggles of women against discrimi-nation within the American society."[61] Making the imperfect race-sex analogy allowed Chisholm to reach out to white feminists, whose votes she needed in her bid for the White House. But Chisholm also sought to reframe femi-nism. "Collectively we've come together, not as a Women's Lib group, but as a women's political movement," she said at the 1971 National Women's Political Caucus in Washington.[62] Chisholm's approach to coalition politics was one of the first to include feminists and Black activists, along with labor and other lib-eral groups. In contrast, Jordan—who was not running for national office—did not need the support of white feminists. Although she had a few white women working on her campaigns and enjoyed close relationships with white women, Jordan garnered little political support among white women liberals in Austin, as the opinion pieces of Molly Ivins attest. Nevertheless, like Chisholm, Jordan

supported pragmatic solutions to women's economic plight. Realizing that the work of Black women like her mother often left them ineligible for federal benefits, she cosponsored a bill to provide Social Security benefits to all homemakers.[63] She understood the connections between race and sexual oppression, but until she got involved with extending the deadline for the Equal Rights Amendment in the late 1970s, she chose to focus on the issues in a way that made the most sense to her Black constituents and to her own experience as a Black woman leader.

Black politicians everywhere were experimenting and often had little guidance about how to approach their new positions of responsibility. Representative Louis Stokes, who served as chair of the Congressional Black Caucus in 1972, reflected in an interview on how Black politics had changed since he had arrived in Washington in 1969.[64] When he was first elected in 1968, along with William Clay and Shirley Chisholm, Black people in America appreciated and demanded a laser focus on race: "When we went into Congress, it was the first time in history Black people had nine representatives in the House at one time. With a sense of history, we immediately felt we had to come together and begin working on behalf of Black people all over America." The lack of Black representatives from the South, along with the heightened political awareness of their constituents, impelled these men and women in Congress to address the issues of racism that all African Americans faced. It was a historic moment, marked by renewed anti-Black violence that demanded the kind of national attention Black members of Congress were uniquely poised to give. In an interview, Stokes reflected upon how he traveled to hotspots of racism throughout his first years in congress. "We were in Chicago to investigate the killing of the Black Panthers; we went down to South Carolina and Louisiana to investigate the killing of Black students on campuses. We went to Mississippi to investigate the Mound Bayou hospital."[65] The CBC's lack of involvement in internal Democratic Party affairs was viewed as a mistake by Chisholm, which is perhaps why her presidential campaign sought to shift attention back to party politics and voting.

When more Black politicians came to Washington, DC, including Andrew Young and Jordan, the CBC began to reassess the role of Black representatives on Congressional committees. Chisholm's presidential bid introduced a broader conversation among Black politicians about how to leverage Black political influence within the Democratic Party. Civil rights veteran and Georgia state legislator Julian Bond proposed a "favorite son" strategy—running local Black

candidates for president to influence state political organizations. At the same time, the 1972 Gary convention exposed the CBC to criticism from Black nationalists such as Amiri Baraka, who complained that Black members of Congress "were really reacting to their relationship with the United States government" and not responding to their constituents.[66] The inability of activists and Black elected officials to forge a united front at Gary led many Black elected officials to reassess their future focus. Baraka and his followers seemed to demean their efforts to work within the party system, but was pulling away from the Democratic Party really the best course of action? CBC chair Stokes asked California congressman Ron Dellums to chair a committee and write a report on the future of the Black caucus.

Dellums's report suggested that Black members of Congress focus on gaining seats on particular committees and work to influence legislation. He concluded that "our role in congress was not to be civil rights leaders but to be legislators in the greatest legislative body in the world. In that respect, it focused our attention on how to expand our presence throughout the committee system in the Congress so that we could put a black perspective on any legislation." The CBC ensured that Black members sat on powerful committees such as Ways and Means (Charlie Rangel) and Appropriations and Rules (Shirley Chisholm). "We cracked all that," recalled Stokes. "We proceeded to try to utilize our presence to try to have an impact on legislation."[67] Jordan resisted the CBC's attempt to dictate her committee assignments, which, in retrospect, may have initially put her at odds with Stokes. Yet they had the same goals. By simply asserting that the priority of Black politicians was to be effective legislators, Stokes removed the CBC from the larger ideological disputes over Black power and Black nationalism. Times were changing, he thought; the civil rights movement had to rethink its strategies. Black congresspeople needed to focus on the nuts and bolts of politics to be effective and assert power.

On July 31, 1973, Stokes outlined the CBC's purpose and future strategy. "We are a coalition deeply concerned about the issues, needs, and aspirations of minority Americans," he asserted. "We are therefore interested in developing, introducing, and passing progressive legislation which will meet the needs of neglected citizens." Stokes emphasized that Blacks in Congress realize that "power politics is the name of the game." "We comprehend the game, and we are determined to have some meaningful input in the decisions of the legislative branch of the Federal Government." The caucus, he wrote, was "seeking to make

democracy what it ought to be for all Americans." The CBC was *not*, he insisted, trying to replace established civil rights groups or function as a "clearinghouse" for the "host of problems" faced by Black Americans. Stokes confessed that at times "we were unclear about our proper role." But in the past year, he wrote, the CBC had thought carefully about "what should we be doing . . . and how best to do it. And our conclusion is this: if we are to be effective . . . if we are going to make a meaningful contribution to minority citizens and this country, then it must be as legislators. This is the area in which we possess expertise." Stokes then summarized how the CBC joined the fight to rescue the Office of Economic Opportunity (OEO), pushed to create a federal holiday to honor Martin Luther King Jr., and proposed "legislation in every conceivable area."[68]

The strategy Stokes and the CBC laid out in the 1973 document echoed the philosophy of politics Barbara Jordan voiced when she came to Washington in 1973. Once elected, she continued her close connections with her Houston constituents; she sought to use her platform in Congress to draw attention to issues affecting Black communities outside Texas and to champion Black culture. In a 1975 interview with the *Wall Street Journal*, she repeated much of what Stokes said in his statement about the aims and objectives of the CBC, claiming that she was a "politician, just a professional politician." But that quote, taken out of context, has been used to incorrectly suggest that Jordan did not appreciate the importance of Black activism. Her statement explicitly supported Stokes and what the CBC had announced it was trying to achieve two years previously.[69]

Toward that end of strengthening Black influence within the party, Jordan dedicated herself to building up the Democrats. She raised money, inspired new voters to register, galvanized opposition to Nixon, and, in general, acted on behalf of the values the party represented. In September 1973, she traveled to California to appear at a Democratic Party telethon fundraiser where she and Cardiss Collins helped to raise 5.3 million dollars. "Rep. Jordan drew prolonged applause when she delivered an eloquent colloquy on how she won elected office through the support of rank-and-file people who could support only small donations," the *Chicago Defender* reported. "Miss Jordan was a perfect counterbalance to Governor George Wallace who came on later to denounce 'exotic left wing appeals' and urge the Democratic party to cater to the wishes of middle Americans."[70] As she shared a stage with Wallace, Jordan rebutted his statement that Democrats were "elite" leftists, insisting that the party represented the interests of working-class Americans.

"If you want to get along, go along," Texan and House speaker Sam Rayburn famously said as he demanded obedience from young members of Congress.[71] The congressional world that Jordan entered in the early 1970s, however, offered her some room to maneuver around that dictum, largely because of the CBC's unity and the perception that the Black vote was a growing force in politics. Party seniority was still respected and even enforced, but Jordan's wide-ranging speeches during her first term in Congress also demonstrate her unwillingness to adhere to traditional forms of deference. She challenged the House speaker, Carl Albert, and championed the causes of Black women, African Americans, the poor, and organized labor while attacking President Nixon's foreign and domestic policies. Party leaders tolerated her sharp tone, one assumes, because she was effective at raising money, debating the opposition, and arguing for party unity. Everywhere Jordan spoke, she brought the spirit of coalition politics with her. In October 1973 she addressed labor leaders at the AFL-CIO National Convention in Bal Harbour, Florida, where, according to the *Wall Street Journal*, she was "the hit of the gathering." Jordan's "eloquent defense of social welfare programs drew a thirty-eight-second standing ovation from the mostly white delegates." Sen. Edward Kennedy trailed behind at twenty-nine seconds, and federation president George Meany clocked in at twenty-three.[72] During her first year in Congress, Jordan neither pandered to nor elided race differences, but rather educated her white working-class audience, who seemed hungry for her message. As she later told a gathering of UAW (United Auto Workers) machinists (again receiving a standing ovation), "coalition politics" remained the "only viable, sensible, relevant vehicle to achieve the obvious political goals."[73]

In her first year in congress, Jordan's personal life also seemed to flourish. Until she found a permanent place to live, Jordan resided with Mark Talisman in his family home in Washington, DC's Capitol Hill neighborhood. He recalled Jordan's tender and playful interactions with his young daughter, as well as Nancy Earl's visits to DC after she took a new job at Keuka College in upstate New York.[74] Jordan also hosted and entertained visitors from Houston in her Washington office. Rufus "Bud" Myers, one of the first Black administrators to serve as a congressional chief of staff, recalled the thrill of being hired by Jordan and how attentive she was to the needs of her constituents. Jordan, he said, was "very businesslike," and strict during the workday, but "when it came time to relax she pulled out her guitar." She kept it with her at work, Myers said, and when congress met late at night she would play "Texas songs," along with

spirituals, and talk about her time in the Texas state legislature.[75] Jordan also branched out and became interested in foreign affairs. In September of 1973 she and Nancy Earl attended a "Parliamentary Conference" on US and European Union relations held in historic Williamsburg, VA. A wonderful series of photos in Jordan's archives documents this trip. One black and white shot shows the two women at a table talking, smoking, drinking, and playing cards—perhaps poker—with a small group of men, dressed in tuxedoes. Another photo shows Jordan and Earl walking down a main street in Williamsburg at the front of a group of sixteen attendees at the conference. Nancy Earl was wearing light colored trousers and a jacket, while Jordan wore a long, but casual, light-colored skirt. They stood out among the crowd, which mostly wore black. All of these photos show the two women together and clearly having fun with the group.[76]

During her first year in Congress, Jordan reveled in her new role in Washington, DC. Respected as an emerging and outspoken Black leader, debater, and orator within the Democratic Party, she sought to strengthen a liberal coalition that included organized labor, Black feminists, civil rights advocates, and anti-poverty crusaders. She rarely missed an opportunity to offer withering criticism of Richard Nixon or male pomposity. She had urged the Black press and the Black church to get more active in politics, and she and the other Black women in the CBC had begun to work together. She also seems to have achieved a balance between her personal and professional life. Yet her position as a leader on issues of social justice receded when her duties as a member of the House Judiciary Committee began to take her away from public appearances and the politics of race, sex, and class. Instead, beginning in the fall of 1973, after fewer than ten months in Congress, Jordan became completely immersed in the presidential scandal that would come to define her political career: Watergate.

No Idle Spectator

Race and Watergate

Earlier today, we heard the beginning of the Preamble to the Constitution of the United States, "We the people." It is a very eloquent beginning. But, when that document was completed on the 17th of September in 1787, I was not included in that "We the people."

—Barbara Jordan, July 25, 1974

To many in the Black press, the "hero" of the Watergate scandal was not Barbara Jordan (or Charlie Rangel or John Conyers, the other two African Americans serving on the House Judiciary Committee), but the "watchman in the night," Frank Wills, the twenty-four-year-old African American security guard on the job at the Watergate building.[1] On his rounds that fateful night of June 17, 1972, Wills noticed taped-over door locks in the basement. He removed the tape, assuming workmen had put it there during the day. After eating a meal, he returned to the basement to find the tape replaced. "Something told me not to take the tape off this time," Wills told reporters. "I knew someone had gotten in. I didn't have a gun, just my can of mace and a nightstick." Wills called the police. The two officers who arrived arrested the Watergate burglars on the sixth floor, brought them handcuffed into custody, and started the chain of events that led to the revelation that President Nixon promoted a coverup of the Watergate burglars' connections to CREEP, the Committee to Re-Elect the President, and ultimately to his resignation.

The mainstream media largely ignored the role of Frank Wills in the Watergate scandal. The Senate Select Committee, headed by Sam Ervin, which held

the hearings on the break-in, never called Wills to testify. But the Black press lauded the young man as the Watergate hero. One year after the break-in, and a year before Jordan's famous televised speech, a photo of Wills standing in front of the Democratic National Committee headquarters appeared on the front page of the *Chicago Defender*. Wills received a social justice award from Chicago's Bethel AME Church. "Had it not been for Mr. Wills, there would not now be a Senate Investigation headed by Senator Sam Ervin into the worst national scandal since Teapot Dome," said Rev. E. I. Dunlap.[2] Wills "had set in motion the wheels that now threaten to crush this entire administration," wrote a reporter. Despite his importance in the scandal, Wills remained unemployed, let go from his job at Howard University, and largely anonymous.[3] "If Frank Wills had been white," said a columnist in the *Chicago Defender*, "he'd now be in television specials, movies . . . getting advanced royalties from publishers . . . he would have been making media commercials endorsing padlock and burglar alarm devices." Wills was compared with Crispus Attucks: the quintessential unheralded Black man whose acts triggered the downfall of a mighty government but whose name would remain unknown.[4]

Black Americans were fascinated by Watergate, but hardly shocked. Civil rights activist Bayard Rustin noted that "Blacks do not find it surprising that this administration would resort to bugging, spying, and fabrication—and then lie to the American people about it." As events unfolded Watergate contributed to Black disillusionment with politics and the Nixon administration. Black unemployment had risen sharply since 1968, and Rustin saw the crisis as further evidence of how American democracy had betrayed its people. Such a government "can scarcely be expected to implement social policy with any democratic commitment to the needs of the majority."[5] Black artists and songwriters added their voices. Gil Scott-Heron, "father of rap," blues artist, and poet, was a DC resident when the Watergate burglary transpired. In 1973 he wrote and performed the "H2Ogate Blues" as a response:

Haldeman, Ehrlichman, Mitchell and Dean
It follows a pattern if you dig what I mean . . .

Scott-Heron explicitly linked the Watergate scandal to the wider and deeper disgrace of America's political corruption, as well as its ongoing racial and class injustices.

How long will the citizens sit and wait?
It's looking like Europe in '38
Did they move to stop Hitler before it was too late? (no . . .)
How long. America before the consequences of
Keeping the school systems segregated
Allowing the press to be intimidated
Watching the price of everything soar
And hearing complaints 'cause the rich want more?
And there are those that say America's faith is drowning
Beneath that cesspool—Watergate

Scott-Heron's album *Winter in America* appeared in the summer of 1974 at approximately the same time as Jordan's speech calling for Nixon's impeachment. The title song, not released until 1975, is a lament, biting in its sarcasm but still sober in its assessment.

The Constitution A noble piece of paper
With free society Struggled but it died in vain
And now Democracy is ragtime on the corner
Hoping for some rain. . . . And now it's winter, Winter in America[6]

Like Jordan, Scott-Heron used the Constitution to criticize America for failing to live up to its ideals.

It is ironic that Barbara Jordan's televised speech calling for the impeachment of Richard Nixon has become a cherished national memory about faith in the Constitution and the ideals it professed.[7] Too often her opening lines are cited without mention of her clear-headed indictment of President Nixon and the system he represented. Jordan's speech on that evening needs to be heard in context and in its entirety. A closer look suggests that Jordan's personal experiences with racism, government spying, and with conservatives on the Judiciary Committee also contributed to how she chose to frame and deliver her indictment of Nixon on that day. The speech was designed to persuade those who initially doubted the wisdom of impeachment; it also reflected Jordan's private doubts that the Constitution would ever fully protect Black people.

Jordan's public response to the Watergate crisis started with the Saturday Night Massacre—the October 20, 1973, firing of Special Prosecutor Archibald

Cox and the resignations of two attorneys general. On October 23, Jordan's office released a statement: "Possible Impeachment of the President," a two-page document delivered from her office in the Longworth Building. Using the common terminology for lethal handguns, Jordan called the Saturday Night Massacre "the ultimate Saturday night special." President Nixon fired Cox, she alleged, because he wanted to kill the controversy surrounding his refusal to release "the so-called Watergate tapes and other documents." But the president's rebuff of the court order struck Jordan as a "tragedy." Ours is "a government of laws and not of men," she stated, referring to John Adams: "We shall not be governed by kings." In refusing to hand over the requested materials, "the President has refused to obey the law." Jordan vowed to work with the other members of the Judiciary Committee and Chair Peter Rodino to determine whether the president has "committed impeachable offenses within the context of the Constitution."[8] Few could have doubted that Jordan supported impeachment.

The Saturday Night Massacre was a surprise. It occurred during a lull in the Watergate investigation, which had begun during the summer of 1973, when a parade of witnesses appeared before a Senate Committee chaired by North Carolina senator Sam Ervin. The televised committee hearings featured compelling testimony from the president's lawyer, John Dean, who revealed his role in sending hush money to the Watergate burglars. The most astonishing testimony occurred on July 16, 1973, when White House aide Alexander Butterfield disclosed that Nixon recorded all conversations in the Oval Office with a secret taping system. Judge John Sirica, presiding over the trial of the Watergate burglars, issued a deadline for the president to deliver tapes of relevant conversations to the special prosecutor. But Nixon prevaricated, and by the time that members of the committee returned from their summer recess, the public's interest in the controversy had receded. By September, according to one congressman, "the scandal was coming in a poor second, or worse, to the cost of living."[9] After the firing of Cox, however, the public mood shifted, and the Saturday Night Massacre cast Nixon in a guilty light. Watergate was in the news again, and the House Judiciary Committee chose that moment to weigh impeachment.

Yet before the Judiciary Committee could take up the question of Nixon's misdeeds, it had to address the vacancy left by the resignation of Vice President Spiro Agnew, who had abruptly left office just ten days before, on October 10, 1973, having confessed to accepting bribes when governor of Maryland. Nixon

chose Gerald Ford, a twenty-five-year veteran of the House of Representatives from Michigan, to fill Agnew's post. No one doubted Ford's candor or honesty; still, several committee members rejected Ford's appointment. With impeachment now looming, many doubted Ford's competence; they looked askance at any appointment pressed forward by an increasingly discredited Nixon.

Jordan must have already established an excellent relationship with Judiciary chair Peter Rodino, because when her turn came to question Ford, she did not hold back. On the first day of the hearings, November 15, 1973, she ridiculed the congressman for his sexism, stating: "Mr. Ford, I am sure that you will not mind if in the interest of time . . . I dispense with any cynicism that I might raise with regard to the statement you made earlier this morning about the pretty women in your office who have capabilities which run apparently to typing letters, answering the telephone, and serving coffee."[10] On the second day, she challenged the nominee to defend his numerous votes against civil rights. One by one, Jordan laid out the offensive votes. In 1965 Ford voted to omit the protection against intimidation and coercion in the Voting Rights Act; in 1966 he voted against the fair housing provisions and Title VI of the Civil Rights Act as it related to primary and secondary education; in 1969 he voted to gut the extension of the 1965 Voting Rights Act; in 1971 he voted against a bill meant to strengthen Title VII of the Civil Rights Act. Jordan posed the question: "Mr. Ford, you made the statement, which is reported in the *New York Times* back in April 1967, that in politics, and this is a quote, 'When the train is moving you have got to get on. It doesn't come around a second time.' Would it be accurate to characterize your votes on civil rights legislation as trying to stall that train as long as possible and jumping on when you felt that the train was going to move in spite of what you did?"[11] Ford denied that characterization.

But Jordan pressed him: "Do you feel that the Federal Government has any obligation to vigorously pursue policies which would improve the status of Black people in this country?" And then she asked very pointedly about the authority of the federal government to act on behalf of the oppressed: "One final question, Mr. Ford. Do you feel that the Government of the United States has any responsibility to become actors on behalf of citizens who are deprived, dispossessed, or repressed?" In this exchange Jordan got Ford to agree with her, but his acquiescence did him little good. Jordan, along with seven other Democrats on the House Judiciary Committee, voted against recommending that the House confirm Gerald Ford as vice president.[12] Jordan used her platform to make a

point about the federal government's undiminished responsibility to enforce civil rights, not just about Ford's muddy record.

A more subtle, personal, side of Jordan's thoughts on federal power and race, however, is revealed in a 1973 draft speech, "In Defense of Rights," written in her hand. This speech is a meditation on government abuse of power. Jordan argued that the First Amendment was designed to protect citizens from government repression. And yet local police and federal government agencies had repeatedly violated the freedom of Black Americans, particularly Black nationalists: "A roll could be called of those who have experienced intricate entrapments and personal and human devastation in their confrontations with constitutionally guaranteed rights . . . the roll would include Lee Otis Johnson, Angela Davis, Eldridge Cleaver, the Chicago, Boston and New Orleans Panthers, H. Rap Brown, Bobby Seale, Huey Newton and others." In lamenting the "personal and human devastation" suffered by these individuals, she was acknowledging the political origins of the private experiences of Black people. All African Americans experienced the anguish of racism, not just those well-known activists. Jordan wrote about the nightmarish personal pain of living in a racist society: "You have your private experiences which slowly eat your insides as you feel a thousand indignities per day, on days which have no beginning and no ending." And though in this speech she focused on the oppression of others, it is also likely that Jordan's own experiences prompted her vigorous defense of civil liberties and Black protest.

Jordan herself had been a victim of government spying. In February 1971 the *Texas Observer* reported that the US Army had spied on both Jordan and Curtis Graves. The Houston police's "criminal intelligence division" also had a file on Jordan that was eventually destroyed.[13] Jordan never spoke of this spying publicly, but Graves testified to the Senate Subcommittee on Constitutional Rights chaired by Ervin. He recounted how a former agent of the 12th Military Intelligence Group informed him that he and several others in Houston, including Jordan, had been targeted by the army. For Graves, the spying started in the early 1960s, and mostly likely the same applied to Jordan. Graves testified to a network of surveillance that included the FBI, state and local law enforcement agencies, as well as the armed forces. He referred to tapped phones and suspect wires and cords when he had spoken in public: "I literally have lost faith in this country as a result of the information that I have found out in the past several weeks," he testified. "If this country does not have faith in its public officials, then just where are we?" When asked why he thought he was under surveillance,

Graves said, "Because I am Black, [and] that is a sin in Texas." Former army intelligence officer Christopher Pyle testified that the surveillance was designed to inhibit political participation: "Those most likely to be deterred are not the extremists of the right or left, but the moderates who normally hold the balance of power."[14] Others testifying that day included representatives from the American Friends Service Committee. Jordan was targeted, and she was not alone.

Jordan admired the writings of Sen. Sam Ervin on individual rights, and her draft speech quoted from a 1971 article he had written for *Trial Magazine*: "The government can now take note of anything, whether it be right or wrong, relevant or not and retain it forever. Every person's past becomes an inescapable part of his present and future. The computer never forgets."[15] Such surveillance, Jordan argued, would dampen protest and spur fear: "No longer can a man march with a sign down Pennsylvania Ave and then return to his hometown, his identity forgotten, if not his cause." Was modernity making the ideals of the eighteenth century obsolete? Jordan asked: "Can the American people break their apparent paralysis and become ardent protectors and defenders of their rights? Can the Black American ever risk belief in the even-handed administration of Justice? Does this country have time to restore the faith of its citizenry in promises almost two hundred years old?" She was posing these rhetorical questions most likely to herself. Could she "risk belief" in America? Given what she was about to learn as a member of the Judiciary Committee, that question haunted her.

As she wrote these troubling reflections on racism and repression, Jordan's health was deteriorating. At the end of 1973, shortly after the Saturday Night Massacre and the resignation of Spiro Agnew, she experienced the sudden onset of a debilitating illness. The symptoms included tingling in her legs and difficulty walking. Her feet were frequently numb, and it was harder to hold her briefcase. She requested an official leave of absence from Congress and checked into the National Naval Medical Center in Bethesda between December 4 and 9, 1973. She was diagnosed with multiple sclerosis (MS), a mysterious, progressive autoimmune disease that attacks the central nervous system. White blood cells destroy the myelin that sheaths neural cells. Without myelin, neural systems cannot function properly and eventually fail. Symptoms vary but include fatigue, numbness, blindness, loss of balance, and incontinence. Eventually, MS causes organ failure and an early death. According to the latest research, MS affects more women than men, and more Black women than white women.[16] Treatments in the 1970s included immersion in hot water and prednisone,

however, as the *British Medical Journal* stated, "Sadly it is of no surprise that so far not one of them can be said to be really helpful."[17] There has been progress, but there is no cure. One expert recently described living with MS as having the "sword of Damocles" above your head: "You never know when the next relapse will take place and you never know how serious it will be."[18]

Only a few individuals knew about Jordan's hospital stay. Bud Myers, her chief of staff, was one. Bob Alcock, her legislative aide, said, "We knew—don't ask questions."[19] But word did get out, showing Jordan's part in a network of Black women. Houston activist and Democrat Beulah Shepard, the unofficial "mayor" of Acre Homes (a large Black community north of downtown Houston) and voting rights advocate, sent Jordan a telegram in the hospital, wishing her a speedy recovery.[20] Jordan also received a note from poet Nikki Giovanni, saying she had heard what happened from Delta sorority president and author Jeanne Noble. "How you gonna be president if you don't get better?" Giovanni playfully wrote. Jordan responded, "I will let you know about my future Presidential plans. Maybe you would agree to be my campaign manager?"[21] The pace of social events, committee work, travel, and the upcoming impeachment hearings made for a punishing schedule, and now Jordan learned she was afflicted with an illness that had no cure. MS has symptoms that wax and wane, sometimes brought on by stress. Jordan received her diagnosis and had the best treatment at that time. She returned to work.

In the meantime the president had agreed to turn over a select number of tapes but admitted to the existence of a mysterious eighteen-and-a-half-minute gap on a crucial June 20, 1972, conversation between himself and chief of staff H. R. "Bob" Haldeman, three days after the break-in at the Democratic Party headquarters at the Watergate building. Experts later told Judge Sirica that the erasure was deliberate, a gap caused "by at least five separate manual erasures." No one, not even Sirica, had yet heard a word on any of the "Nixon tapes," but public interest in the president's dubious activities grew. Allegations of hush money paid to the Watergate burglars swirled.[22] As anti-Nixon rhetoric heated up in the press, more members of the Judiciary Committee criticized the president in tones that echoed Jordan's initial press release.

Congress reconvened on January 21, and the following day Jordan appeared on PBS's *Bill Moyers Journal* alongside three Republican members of the Judiciary Committee: Charles Wiggins, Bill Cohen, and Henry Smith. The seasoned journalist and former aide to LBJ asked the four representatives about the

meaning of impeachment and how the committee was going to proceed. Jordan responded carefully: "What we are going to try to do is to assimilate the credible evidence and make a judgment. A judgment about what? Whether probable cause exists which would support articles of impeachment against the president of the United States. Probable cause is certainly a different standard than one of guilt or innocence." Republican Charles Wiggins disagreed. He asserted that the committee needed to determine whether there was "probable cause to believe that the President is *guilty* of impeachable misconduct." Jordan countered that she would apply a different standard: "My judgment would be, whether as a reasonable man, the man on the streets, whether I could look at that and say, not necessarily, he must be guilty, he must be innocent, but whether I could look at that and say—there is enough evidence that raises a suspicion, a question in my mind that there may be something there which a trial in the Senate could bring out as a determination of whether there is guilt or innocence."

Wiggins replied, "I most certainly disagree," but instead of continuing to argue with Jordan, he turned to fellow Republican Cohen. "Bill, I'll let you take her on," he said to the congressman from Maine. "To raise a suspicion," Cohen said to Jordan, "I don't think is the equivalent of probable cause." Here, in a nutshell, was the issue that threatened to divide the committee: Did the evidence have to prove Nixon to be guilty of a crime before they could vote to impeach? And what was the meaning of "high crimes and misdemeanors?" The representatives struggled to define "subversion of the Constitution." Wiggins admitted that "it sounds sinister ... [but we] have to be much more specific than that and I say so out of my sense of what due process is all about." Jordan agreed with Wiggins—to a degree: "It's this kind of catch all phrase, I guess for people who don't really want to wrestle with the kinds of ... offenses you're talking about." Moyers asked the representatives about how their constituents felt about impeachment. Jordan responded cautiously: "All they say is—impeach and impeach now. And my difficulty now is in trying to educate them. . . . We cannot impeach on the basis of what we read on the front pages or the editorial pages of the newspapers." The three Republicans in the room agreed. And when she stated that "I as a Democrat, take no joy and no comfort in the prospect of having to vote in impeachment of the President of the United States. That is not something any sane, rational person who cares about the Republic ... could take joy and comfort in doing," she gained some ground with Harry Smith, who voiced his agreement with a "well said, Barbara."[23]

Jordan was now shifting roles, changing her tone, and implementing a strategy that she called "chipping away." Now that the impeachment question was heating up, she moved away from her critical stance and took on the role of centrist. Her job on the committee was to engage with the undecideds, the key group who held the balance of power. She knew from her time working with the thirty white men in the Texas Senate what she needed to do. Jordan never shifted Wiggins, Nixon's most ardent defender, who hailed from a staunchly conservative district in California, but she helped to neutralize his influence. To the end Wiggins likened impeachment to an indictment and continued to insist that the committee needed more "specifics" before it could impeach. But Cohen and Smith eventually did change their minds. And their two votes were seen as key, given Peter Rodino's commitment to gaining Republican support; without bipartisan support, the public would not accept the legitimacy of Nixon's impeachment.

Jordan developed a good relationship with Rodino. Rodino, the quiet son of Italian immigrants and a long-serving congressman from Newark, had as his singular achievement after twenty-four years in Congress the designation of Columbus Day as a federal holiday.[24] At the start of the hearings, he was an unknown quantity whose leadership style contrasted sharply with that of his predecessor, the long-standing chairman Emanuel Celler, a congressman from New York who had just been defeated in a Democratic primary by Elizabeth Holtzman. Celler had chaired the Judiciary Committee for more than twenty years, and he had rarely delegated any authority to his subcommittees.[25] Speaker Carl Albert, doubting Rodino's ability, considered forming a "special select body" to conduct the impeachment inquiry. Rodino rejected the suggestion, but he did not inspire confidence. "He was a flame under a bushel basket," remembered Tip O'Neill.[26]

Jordan, however, could help the chair. Redistricting had changed Rodino's Newark constituency from white "ethnic" to largely African American and Latino. Rodino knew he was in a precarious place with his Black constituents. It was not surprising, then, that Rodino welcomed Jordan's advice; according to one journalist, "She was increasingly regarded as a prophet who would tell you what would sell politically." Aides and other members of Congress noted Rodino "listening hard" to Barbara Jordan: "If Rodino has Black opposition in the primary, I wouldn't be at all surprised to see Jordan up there making speeches for him." During the hearings Jordan often conferred with the chair and could be found chatting with Rodino in his office.[27]

Rodino's political instincts and easygoing personality steered clear of division and partisanship. The Democrats had a 21–17 majority on the committee, but Rodino did not wish to decide a question as big as impeachment on a party-line vote. For one thing, several of the Democrats, such as Walter Flowers of Alabama, were conservatives and might be reluctant to impeach the president. In addition, having studied the impeachment of Andrew Johnson, Rodino knew impeachment needed bipartisan support if there were to be any chance of convicting Nixon in the Senate.[28] He appointed John Doar, a Republican, as the committee's special counsel, and he allowed the Republican minority on the committee to hire its own counsel, Albert Jenner, a Chicago trial lawyer. And against the objections of his fellow Democrats, Rodino allowed the president's attorney, James St. Clair, to attend the committee's closed sessions. Although some Democrats on the committee thought Rodino was being too accommodating, Jordan backed him all the way. "The Judiciary Committee," she said in an interview, "is determined that this proceeding will not suffer the fate of the Andrew Johnson proceeding of more than 100 years ago. . . . We are determined to do a job that is defensible not only by those who agree with our conclusions but by people who disagree. We cannot afford partisanship."[29]

Such an approach required patience. For example, when the DC grand jury finished its investigation (conducted by Leon Jaworski), they voted to hand their report over to the Judiciary Committee. But the president's attorney refused to allow the committee access to that evidence, calling it a "fishing expedition" and portraying Nixon as the victim. The committee was outraged—even the Republicans—but "Rodino didn't want . . . anyone to give the impression we were hounding the President."[30] He refused to subpoena the president. His patience was rewarded when Judge Sirica ruled that the grand jury evidence had to be turned over. On March 26, 1974, Doar went over to the US courthouse to collect the materials.[31] Waiting was frustrating, but the deliberate pace helped the bipartisan effort.

The Judiciary Committee now had to wait for Doar to compile his report. Jordan, meanwhile, continued her intense discussions with other committee members. She gained a reputation for being cautiously meticulous, and that set her apart from the "red-hots" like Robert Drinan of Massachusetts, her Texas colleague Jack Brooks, John Conyers of Michigan, and Jerome Waldie of California. These men, according to one political journalist, "suffered that worst congressional fate of being considered ineffective: They range so far outside the

accepted rules that no one thinks they're playing the game seriously." Jordan's time in the Texas Senate had schooled her in a very basic tenet of human nature, which was, as *Rolling Stone* pointed out, that "congressmen stop listening to people whose views they can predict in advance."[32]

While the committee was meeting in May, Jordan made only a few public appearances. On May 11, 1974, two days after the Judiciary Committee began its closed hearings, she delivered a commencement speech at Howard University. Up on the dais, alongside DC mayor Walter Washington, history professor Benjamin Quarles, and Damon Keith, a federal judge from Detroit, the congresswoman was lauded by Howard president James A. Cheek as a "precedent-setter" and "an extreme example of the effectiveness of Black women in politics." She proceeded to give a version of her "Defense of Rights" speech, but she focused solely on the abuses of the Nixon administration against his perceived enemy, the Democratic Party. She referred to the edited transcripts of the Oval Office tapes—punctuated by the phrase "expletive deleted" and distorted by numerous omissions—and then turned to the Constitution. "Your government has violated civil liberties," she thundered at the graduates. "It admitted—the Government of the United States of America admitted—that it wiretapped its own employees seventeen times."[33] She claimed that the FBI had become politicized and that executive privilege had been used to justify cavalier violations of the First and Fourth amendments. Jordan quoted Thomas Jefferson and other Founding Fathers on individual liberty. She defended the Bill of Rights as central to safeguarding individual freedom.

Not once did Jordan bring up race or sex or discuss how the government had attacked or undermined the activities of Black activists. And she did not ask, even theoretically, if Black Americans could gain justice in American courtrooms. The racial dimension to the abuse of civil liberties, and the personal pain of racial discrimination—themes that played such a prominent role in her 1973 draft speech—were absent. She ended by urging the students to defend civil liberties.

The speech felt awkward rather than triumphant. To the student audience, it seemed naively detached from reality. Jordan's "shock" at the violation of civil liberties must have sounded as convincing to the Howard graduates as that of Captain Renault in the film *Casablanca* who was "shocked" to find that illegal gambling went on at Rick's bar. She quoted Jefferson on the blessings of liberty and cited with approval the fact that English common law denied even the king the right to enter a man's house uninvited. But Jordan failed to make the logical leap to denounce the Chicago police's unlawful entry into the home of

Black Panther leader Fred Hampton. She did not cite the gagging of Bobby Seale at his trial in Chicago. The references in her speech seemed so removed from everyday life and politics as lived by Black Americans that Jordan herself seemed to be guilty of doing exactly what she warned against: making the individual rights listed in the Constitution mere "empty rhetoric to be made the subject of courses in American History."[34] The original draft of "In Defense of Rights" drew connections between civil liberties and the right to protest racial oppression. The speech she actually gave did not. The audience's lukewarm reception may have given her something to think about.[35]

It is also the case that Jordan was simply not that well known among college students of any race. A few weeks later, at the urging of Nancy Earl, Jordan spoke at the graduation ceremonies of Keuka College in upstate New York, but she was not the first choice of the senior class. Earl, a 1955 graduate of Keuka College, had moved back to her alma mater to take up an administrative position, and she lobbied hard to have the graduating women in the class of 1974 invite Jordan to speak at their May 26 commencement. In a letter written in December 1973, she urged the seniors to extend an invitation to Jordan early and immediately. Quoting from the *Wall Street Journal*'s report of the "thirty-eight-second standing ovation" Jordan's speech in defense of social welfare programs had received at a recent AFL-CIO convention, Earl stressed Jordan's public importance. "Because of *who* she is and *what* she is, Representative Jordan is besieged by speaking invitations," Earl wrote to the senior class president. If they wanted Jordan, they had better ask soon. Earl took great care with the letter: "I am attaching a compilation of articles germane to this recommendation and would appreciate their eventual return." Earl got her wish, and the invitation was extended, but it took some effort. The white women at Keuka perceived Jordan as unradical or perhaps uninteresting, or simply just not known. At the top of the preferred speakers list were Shirley Chisholm and journalist Shana Alexander—Jordan, near the bottom. She spoke at the ceremony where she received an honorary degree. At the celebration luncheon, she and Earl shared seats at the head table with the Keuka College president, but it was hardly a standing room only event.[36] The irony is that Jordan's work on the judiciary committee had taken her out of the public's eye. Before the televised hearings to come, Jordan was still not that well known to the general public.

Beginning in May, Jordan spent seven weeks holed up in a room with the other members of the Judiciary Committee, listening to John Doar present

evidence gathered by his investigative team, including secret grand jury materials.[37] The closed sessions began at 9:30 AM every Tuesday, Wednesday, and Thursday and, with a midday break, continued until 5 PM. The committee could not read the material on their own, and they could not take any materials with them; they had to listen to Doar deliver "a long dry recitation of who said what to whom and when."[38] The evidence filled thirty-six black loose-leaf binders, 7,200 pages in all. The committee members, even Jordan, felt nothing but frustration.

One highlight occurred when the cloistered group finally got to hear the unexpurgated tapes. Nixon had released edited transcripts of his conversations, with "expletives deleted," but only a select few people, such as the grand jurors, Rodino, and members of the impeachment staff, had actually listened to the raw tapes. The committee did so as a group, each member wearing headphones connected to a master tape recorder. The feeling was incredulity and disgust, remembered committee member Edward Mezvinsky. No one on the committee had ever heard a president's intimate, unfiltered thoughts or conversations before. And when they did, hearing the words was "so much worse, so very much worse," than reading the transcripts. Hearing Nixon, Dean, and Haldeman laugh as they discussed the people who had to be "dealt with" was shocking. Mezvinsky recalled that "the laughter was cruel, almost sick. It had an eerie quality that I found scary. The things they were saying about people were bad enough, but the laughter was frightening. They could have as easily been a gang of criminals plotting an elaborate revenge."[39] Such shared experiences brought the committee members together across region and party.

The Constitution figured heavily in the discussions among the committee members. Just as everyone in the room revered the institution of the presidency, so did they believe in the principles of the Constitution. Mezvinsky believed that the class and racial makeup of the committee mattered. Nixon's scheming "was being heard by several people from an America far different from that of the rich bankers Nixon so admired. Here were, for example, three very different Americans—Rodino (Italian American), Sarbanes (Greek) and Barbara Jordan (black and female)—who truly understood the Constitution of the United States and knew what it meant to minorities, listening to the President disparage some of the fundamental principles of the nation."[40] White southerners, too, such as Walter Flowers, M. Caldwell Butler, and James R. Mann were shocked at the president's disregard for his oath of office, due process, separation of powers, and the spirit of the Constitution.[41] After two days of hearing Nixon on the

tapes, the committee voted thirty-seven to one to issue a subpoena asking for more tapes and documents. Nixon refused to comply.

Long before the public hearings, committee members hashed out arguments over evidence, what it meant to subvert the Constitution, and separation of powers. Making sense of their limited evidence was difficult, and the president's defenders claimed there was a lack of specifics needed to convict, and therefore no reason to impeach. And by the end of May everyone was tired of work, tired of waiting for Doar to finish, and impatient with waiting for the president to comply with subpoenas. But even when members were running in close primary races, they did not adjourn. Some, such as Alabama representative Walter Flowers, felt that the committee should open up its proceedings to the public, so as to gain popular support for their decisions. He wanted the president to know that refusing to honor the committee's subpoenas would be considered grounds for impeachment. Not everyone agreed that the committee's power reached that far. But Ray Thornton, a quiet attorney from a small town in Arkansas, placed the issue squarely within the realm of the separation of powers embedded in the Constitution. He rejected the idea that the committee's main source of power was public approval of their actions: "The real question is authority and compliance with the rule of law as distinguished from power. The standard is what the Constitution requires, not what public opinion would support." When Thornton, a graduate of Yale Law School, finished, "there was a round of applause."[42]

But public opinion had to be considered. For example, the committee knew that Nixon's refusal to submit to a subpoena amounted to obstruction of justice. But was his snub of the committee enough to justify impeachment? Rodino did not want anyone to suggest that the committee was out to get the president on a stray technicality. "The public don't give a damn about obstruction," Rodino said in frustration. "Yes," added Barbara Jordan, "that's right. The people won't support impeachment unless we give them the real goods."[43] The committee also debated whether to release to the public an unexpurgated version of the tapes, which were full of Nixon's racial and religious slurs. Rodino said no, that that would alienate the Republicans on the committee. Mezvinsky recalled that Charles Rangel suggested that the committee use it as a bargaining lever against the Republicans on the committee, "but Barbara Jordan, speaking very seriously said, 'That would be a mistake and we would live to regret it.'" Jordan, like Rodino, was thinking about how to win over those undecideds.[44]

She voiced her reservations about impeachment in a roundabout way. Since January she had insisted that an impeachable offense did not have to be an offense that would cause a grand jury to indict, but she still warned against grasping at mundane or technical reasons to impeach. Nixon's failure to pay taxes or allegations that the president had authorized bribes from the milk industry were not exactly beyond the bounds of acceptable behavior in Congress. Why should the president be singled out? On May 16, 1974, Jordan stated: "We have no evidence on the milk case at this point."[45] She sensed that the events surrounding the Watergate break-in and the cover up would be at the heart of the case.

Jordan felt that the facts as presented by Doar did not yet add up to impeachment. Her legislative aide Bob Alcock remembered her frustration: "At one point she got real exasperated. I remember her coming back from the committee one day and saying this is not working, this isn't going anywhere. And I asked why and she said, 'Well John Doar is good and thorough but he's not putting together for the members a theory of the case.'"[46] At the end of May she told television reporters that while Nixon was certainly "not innocent" of involvement in Watergate, his degree of involvement could not yet be judged.[47] As late as the end of June, Rodino had to walk back a comment that "all" Democrats were likely to vote for impeachment. According to historian Stanley Kutler, Rodino "may have been guilty of . . . unwillingness to confront reality, for some of his Democratic colleagues, including Flowers, Jordan, Mann and Thornton, complained that the case against Nixon had not been made and criticized Doar's 'slow movement.'"[48] Although an outspoken critic of the President, Jordan was still unwilling to state she would vote to impeach him.[49]

The most damning evidence against the president was not heard until the tail end of the closed hearings.[50] The committee was questioning witnesses such as Alexander Butterfield, who testified about the president's extensive knowledge of his staff's whereabouts and his penchant for control. They also heard from one of the president's attorneys about E. Howard Hunt's demand for money while he was in prison.[51] His testimony suggested that the president had to have known, but Nixon's defenders still insisted there was no "smoking gun"—despite the White House tape of Nixon's conversation with John Dean about raising $120,000. "Would you agree that that's the prime thing that you damn well better get done?" Nixon had said to Dean on March 21, 1973.[52] But Nixon's defenders on the committee insisted that such quotations were being taken out of context. As the witnesses' testimony continued, the members of the

Judiciary Committee divided into subgroups to study the evidence. After a late-breaking decision by the Supreme Court, the president was forced to hand over the unedited tapes, which made the case against him more damning.

Finally, toward the end of June, Doar brought the evidence together. Alcock remembered: "At one point [Jordan] came back from the committee session, 'Bob, John Doar's been to the mountaintop. He's begun to put together a theory of the case.'"[53] On July 19, Doar announced to the committee that he had finally reached a conclusion about impeachment. After nearly nine weeks of closed meetings, Doar presented his 306-page summary of the thousands of pages of evidence taken from witness testimony and the White House tapes. He stated that "reasonable men acting reasonably" should vote to impeach Nixon, and he proposed twenty-nine possible articles of impeachment for the committee to consider. Doar's evidence indicated that the president had participated in a coverup of White House ties to the Watergate break-in and engaged in obstruction of justice and abuse of power; he had failed to ensure that the laws were properly executed, and he had shown contempt of Congress. After many weeks of dry and impartial presentations, Doar became an "impassioned advocate" of impeachment.[54] Doar's job was done. Now the questions were: Would the Judiciary Committee vote for impeachment? And on what grounds would it do so? Their deliberations, and the evidence, had to be made public, and the best way to do that, the House of Representatives decided, was through public, televised hearings, which were scheduled to begin the following week, on July 24.

Behind the scenes, the committee drafted articles of impeachment and talked among themselves about how they would vote. The president's defenders objected to Doar's statement that there was reasonable evidence to vote for impeachment, but they had to acknowledge that several key Republicans were going to vote that way. Rodino recognized Walter Flowers was "a key man" among the seven known as the "fragile coalition"—the group of four Republicans and three southern Democrats undecided about impeachment. Other committee members complained that Rodino showed these conservatives "excessive deference," but it appears that Rodino had a plan. In mid-July, according to J. Anthony Lukas, he suggested that Flowers get the "men in the middle" together for a meeting. The group agreed that Nixon's "patterns of conduct" related to the coverup, and his abuse of power did indeed constitute grounds for impeachment. They rejected Doar's wording in his articles of impeachment as "too incendiary" and offered to redraft the language. Rodino agreed with alacrity, shoving aside the

four-man Democratic drafting committee he had already appointed. Some con-
cessions were made, but overall, the "fragile coalition" was calling the shots, and
their wording for the final articles that the committee voted on prevailed.[55] Jor-
dan paid close attention to the wording of those articles.

The public, however, still remained uncertain about impeachment. Pub-
lic opinion surveys showed that while the nation believed Nixon was guilty of
crimes, only a minority wanted him to resign or be impeached.[56] Beginning on
July 24, the committee was set to address the American public directly. Jordan's
aide Bob Alcock recalled that, "This was the first time the committee had gone
public with their proceedings and he [Rodino] gave each member 15 minutes
to speak. . . . So, we knew BJ's 15 minutes were going to happen. I went to her
and said what are you going to say?"[57] The committee members were not accus-
tomed to being on television, yet they understood they needed to explain their
reasoning to the public. Jordan's turn would come at 9 PM, on the second day of
hearings, July 25, 1974.

Members of the committee spoke eloquently and emotionally. That day in
July, according to Lukas, "belonged principally to the southerners, whose remarks
breathed a sense of history, a worship of the Constitution and the institutions it
enshrined." Flowers of Alabama warned of the grave consequences of failing to
impeach. "Do we ingrain forever in the very fabric of our Constitution a stan-
dard of conduct in our highest office that in the least is deplorable and at worst
impeachable?" Thornton of Arkansas, referring to the separation of powers, said
that if Congress failed to impeach, it "would effectively repeal the right of this
body to act as a check on the abuses which we feel have existed." Mann of South
Carolina intoned, "We have built our country on the Constitution." And Barbara
Jordan, according to Lukas, "took off on a flight of brilliant rhetoric."[58] He was
referring to her opening reference to the racial politics of the Constitution—a
reference contained in no other speech.

Barbara Jordan, thirty-eight years old, was sitting up front, attired in a bright
orange polyester dress, with a scarf around her throat. The glare from the cam-
eras off her thick, black-rimmed glasses made her eyes opaque. An hour or so
before the hearing, she had written down her opening words and given them
to her secretary to type. Jordan knew that her southern peers were focused on
Nixon's abuse of power and the committee's obligation to check the president's
abuse. But the Constitution was on her mind, too, and the original exclusion of
African Americans from constitutional protections frames the speech.

Bob Alcock, Jordan's young, white legislative aide from California, was nervous about Jordan's live television appearance. "I went to her and said, 'What are you going to say?' 'I don't know,' she said."[59] This response added to Alcock's anxiety: "I didn't want her to wing it." And so, while Jordan remained closeted in daily meetings with the Judiciary Committee, Alcock went to the Library of Congress. Not content to rely on what others had done, he decided to look at the record himself: "[I told the staff to] bring me all the papers from all the state constitutional conventions. These things are not indexed. I had to go through all this stuff, what were they thinking about this notion of impeachment. One of the things I had done, was I had pulled out all these quotes and I had them on cards. In my own head I had a better understanding." Meanwhile, Jordan had access to a history of impeachment that had been put together by Doar's team. She told Alcock to compile a list of Nixon's acts that could be called into question and used in an impeachment trial. Later, after this information was made public, Alcock thought he could use the list in another way: "I put a little chart together. So, I had the juxtaposition of what the framers had said and what Nixon had done." But as the weeks dragged on through the summer of 1974, he remained worried. Why wasn't she preparing her speech? When he could stand it no longer, he said, "I've got this chart. And I gave her the story of what the framers had done, and she hadn't known I had been doing this. Again, it was this outline, and it was this chart. And she said OK and then she took it." Jordan was scheduled to speak at nine o'clock that summer night, and she had to be in the committee room by 8:30.

At six o'clock that evening, she began to write. "She had written out an introduction . . . and an ending in her own hand. And so she had her introduction and my sheets, 4 or 5 of them, and then her ending on the bottom. And that was her speech."[60] Jordan and her two aides rushed from her office in the Longworth Building to the hearings, barely making it before the klieg lights clicked on. The draft of the speech in the Jordan papers bears out Bob Alcock's account. The typeface of the beginning pages is different from that of the middle section, which is a list of quotes describing the nature of impeachment.

She spoke for thirteen minutes, just under the allotted fifteen.

Yes, Barbara Jordan felt the sting and oppression of racism, and in general she kept that hurt well hidden. But on the evening of July 25, 1974, she gave voice to her feelings: "Earlier today, we heard the beginning of the Preamble to the Constitution of the United States, 'We the people.' It is a very eloquent

beginning. But, when that document was completed on the 17th of September in 1787, I was not included in that 'We the people.' I felt somehow for many years that George Washington and Alexander Hamilton just left me out by mistake. But, through the process of amendment, interpretation, and court decision, I have finally been included in 'we, the people.'"[61]

Jordan began with a fact. The original Constitution had excluded African Americans from its protections. "I was not included" in "we the people,'" she stated, but over time the nation, the law, and the constitution, changed, and "I have finally been included." The Constitution articulated a set of principles, and over time it had changed for the better. By introducing the topic of race, she drew attention to the nation's history and to herself. Viewers could see that she was a Black woman, but Jordan explained why her Blackness mattered: her presence on the committee symbolized how the Constitution had changed to include those who had been excluded. Jordan's statement invited listeners to think about the Constitution as a set of protective principles that was worth defending. "My faith in the Constitution is whole, it is complete, it is total. And I am not going to sit here and be an idle spectator to the diminution, the subversion, the destruction of the Constitution." Whether Nixon had violated the law was not the issue—the real question was, had he violated his oath to protect the Constitution? Listeners waited to hear what Jordan would say next.

Jordan then adlibbed. She explained why the House Judiciary Committee held the authority to investigate the president. "Today I am an inquisitor," she stated. And then she quoted the *Federalist Papers*: "Who can so properly be the inquisitors for the nation as the representatives of the nation themselves?" It was the role of the House not to judge but to "accuse." The word "inquisitor" was important. An inquisitor is not the same as a judge. In her own words, and without a written text in front of her, Jordan explained the difference between the committee's inquiry and a courtroom. Impeachment was *not* a trial. It was *not* a determination of guilt. It was a process of inquiry that *might* lead to a belief that the individual must leave office, but it might not. The House did not have the power to convict the president, and impeaching the president was not the same as convicting him. It was the role of the House to "accuse," she said, but *not* to judge.

In her own words, which were not written down, she explained Congress's role in the process of impeachment. Just as she had argued to her Republican colleagues back in January, she explained to the nation why it was not necessary for

a president to be guilty of a crime in order to be impeached: "It is wrong, I suggest, it is a misreading of the Constitution for any member here to assert that for a member to vote for an article of impeachment means that that member must be convinced that the President should be removed from office. The Constitution doesn't say that," she explained to the audience at home. "The powers relating to impeachment are an essential check in the hands of the body of the Legislature against and upon the encroachments of the Executive." Impeachment was a warning, a "check," that the president had gone too far or exceeded his powers under the Constitution. The House had one set of responsibilities, and it had the right and the duty to accuse and impeach if the evidence suggested it should: "The division between the two branches of the Legislature, the House and the Senate, assigning to the one the right to accuse and to the other the right to judge, the Framers of this Constitution were very astute. They did not make the accusers . . . and the judges the same person." Jordan repeated her point: Impeachment did not mean that the member "must be convinced" that the President should be removed from office. That final judgment was left to the Senate.

Jordan then moved to specifics. Rather than simply assert that the president's behavior was impeachable, she demonstrated it. She juxtaposed the criteria for impeachment—citing the state ratification conventions—against Nixon's deeds. Here's one example: "James Madison said in the Virginia Ratification Convention: 'If the President be connected in any suspicious manner with any person and there be grounds to believe that he will shelter him, he may be impeached. We have heard time and time again that the evidence reflects payment to the defendants of money. The President has knowledge that these funds were being paid and that these were funds collected for the 1972 presidential campaign." She then repeated the quotations for emphasis: "The words are: If the President is connected in any suspicious manner with any person and there be grounds to believe that he will shelter that person, he may be impeached." Using amplification and repetition, tried and trusted rhetorical devices, Jordan hammered home her points. She drew on Bob Alcock's chart, and from Doar's history of impeachment, which included statements made by the Founding Fathers and early members of the judiciary. She went on to quote from the South Carolina ratification convention, Justice Story, and Madison again. She juxtaposed historical definitions of impeachment with Nixon's specific acts. With each example, she went back to restate the original criterion for emphasis. "James Madison again at the Constitutional Convention: 'A President is impeachable if

he attempts to subvert the Constitution.' The Constitution charges the President with the task of taking care that the laws be faithfully executed, and yet the President has counseled his aides to commit perjury, willfully disregard the secrecy of grand jury proceedings, conceal surreptitious entry, attempt to compromise a federal judge, while publicly displaying his cooperation with the processes of criminal justice. 'A President is impeachable if he attempts to subvert the Constitution.'" Pointedly, she never referred to Nixon by name, only to "the president."

As she did with the opening paragraphs of her speech, Jordan wrote out her unique, kicker conclusion, which drew on some of her early thoughts about government surveillance. It began with an assertion: "If the impeachment provisions in the Constitution will not reach the offenses here charged, perhaps the 18th century Constitution should be abandoned to the 20th century paper shredder." She knew that in a truly persuasive speech, the listener answers the question themselves. And so, in her ending, although the answer was obvious, she purposefully left the impeachment question hanging: "Has the President committed offenses, and *planned*, and *directed*, and *acquiesced* in a course of conduct which the Constitution will not tolerate? That's the question. We know that. We know the question. We should now proceed to answer the question. It is reason, and not passion, which must guide our *deliberations*, guide our *debate*, and guide our *decision*." Jordan had delivered a brilliantly structured piece of oratory.

Although listeners inevitably focused on her tone, classic rhetorical devices gave the piece its power. Beginnings of speeches establish a speaker's authority.[62] Jordan's opening reference to the Constitution and the date it was signed was a rhetorical device, called a "reminder," in which the speaker uses a historical reference to establish credibility.[63] Jordan them employed varying rhetorical devices simultaneously. She used the technique known as epistrophe, ending three sentences in succession with the same group of words ("we the people"). For emphasis, she repeated her same point using three related words, or synonyms, in each sentence, a technique known as synonymia: "My faith in the Constitution is *whole*; it is *complete*; it is *total*. And I am not going to sit here and be an idle spectator to the *diminution, the subversion, the destruction,* of the Constitution.[64] Jordan set out to persuade a national, and interracial, audience that the president ought to be impeached and that Congress had the authority and duty to do so. In using herself as the example of the group that had been long excluded but was now included, Jordan humanized racism and established her personal investment in the Constitution and thus the impeachment question.[65]

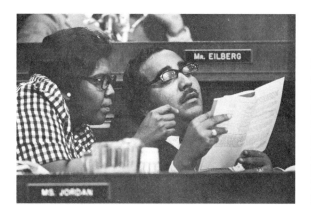

Figure 10. Barbara Jordan and Charles B. Rangel, House Judiciary Committee during the Nixon-Watergate impeachment hearings. Associated Press, July 26, 1974. Barbara C. Jordan Archives, Texas Southern University, Houston, TX.

Jordan herself became the lead story. When the committee adjourned at 11 PM that evening, she walked outside and faced a crowd of journalists and supporters. She did not know that CBS news reporter Bruce Morton had proclaimed her "the best mind on the committee" or that the *Washington Post* had called to ask for a copy of her speech—which did not exist. Her staff prepared a transcript and the *Post* published it on Saturday. The speech struck such a chord with the public that a deluge of letters and telegrams poured into her office. One letter to the *Houston Post* described how listening to the speech provoked the white author's racial catharis: "I am embarrassed to tell you my first thoughts: Hanky head, Aunt Jemima. Minutes later I sat in cold chills as attorney Jordan went to cases and used the Constitution point by point to prove President Nixon's impeachable violations of that Constitution." One Houston supporter put up twenty-five billboards with huge letters that said, "Thank you—Barbara Jordan—for explaining our Constitution."[66]

But her work on the committee was still not over. During the next few days, members debated the wording of the articles of impeachment. Rodino asked Jordan to address the charge that the president was still being denied due process. During the next televised evening session, she spoke again, clearly explaining to the public how the committee had accommodated the president and his attorneys. Rodino trusted her to be "concise and precise, but not aggressive," and she was.[67] The committee wrote up its charges. On Saturday, July 27, the committee voted twenty-seven to eleven in favor of the first article of impeachment. Over the next few days, two more articles followed. If the full House of Representatives had been given the opportunity to vote for impeachment and had a trial had been conducted in the Senate, Jordan would have been one of

the five House members to serve as a prosecutor. But that day did not come. On August 5, one of the remaining White House tapes revealed Nixon's guilt in an unambiguous fashion. On August 8, bowing to pressure from his family and remaining supporters, he resigned his office.[68]

In spite of their differences, the two parties had worked together. In the end, the undecideds could not hold out against the facts, and several Republicans and conservative Democrats voted for impeachment. Rodino, and the country, got a bipartisan process and vote. Something similar seemed to be happening in the entire House. Jordan would not predict the final outcome of the House vote, but did say to the press, "I have noticed, however, that persons who were firmly in the anti-impeachment camp now seem to have shifted to undecided."[69] To the end, as was her habit in the Texas Senate, Jordan kept her committee vote close to her chest. On more than one occasion after a long day, Mezvinsky saw Jordan back in Rodino's small office chatting with Walter Flowers. After the first impeachment vote, he saw them together again in Rodino's back office, "wet-eyed, and both emotionally choked up."[70] Rodino cried too. A lot of the members did. In contrast to the "red-hots" such as Rangel, Drinan, and Conyers, it seemed that Jordan, notwithstanding her enmity toward Nixon, took little joy in voting to impeach him. And yet could anyone ever really think that she would not? As any magician knows, secrecy is essential to the magic of illusion, and Jordan understood that too.

The Black press showered Jordan with accolades. The *Cleveland Call and Post* compared her to Frederick Douglass: "We Black people are not going to stand by and see the Constitution destroyed. We have to become the greatest defenders of the Constitution in the United States and see that every aspect of that document is executed and implemented."[71] Not everyone focused on her faith in the Constitution. Some emphasized her observation that she was not originally included in the Constitution. "Some have suggested that the way the founding fathers handled the original slavery question represented the first official 'coverup' in our government's history," wrote Louis Martin in the *Chicago Defender*. "Some may see this as too harsh, but as Representative Barbara Jordan pointed out in the Judiciary committee hearings on Nixon, the Constitution did not take much notice of us. In short, one will find that lying has deep roots in our society. We have needed a truth revolution for a long, long time."[72] Here, instead of focusing on her "faith" in the Constitution, Jordan's words were used

to criticize America and the Constitution. It is fair to say that Jordan intended to express both sentiments.

On the afternoon of August 9, 1974, Nixon boarded a helicopter and left Washington, DC. And with his departure, a cautious optimism about the future of America arrived as well as a new willingness to risk belief that a Black woman could ascend the ladder of American politics. "NOW MORE THAN EVER," wrote Black editorialist Hazel Garland in all caps one day later, "I am convinced that BARBARA JORDAN could become our second black Senator and the first black woman in the United States Senate."[73] Jordan had been in Congress fewer than two years, and no Black southerner had won statewide office since Reconstruction. Still, Garland noted how people "sat up and took notice" of Jordan's televised appearances. There was "nothing emotional" about the Texas congresswoman, who "spoke with authority and conviction" and "made the greatest impression" on everyone. But now, perhaps, Jordan could take advantage of "that great day when race is no question and one will be judged solely on merit alone." The US Senate, Garland believed, may be within reach of a Black woman because the "person making the greatest impression throughout the [Watergate] hearings was BARBARA JORDAN."

Race and Democracy

The 1975 Voting Rights Act and Party Politics

I was hanging in there, and I wouldn't kneel.

—Barbara Jordan, 1978

The impeachment crisis gave national recognition to Barbara Jordan, a junior first-term member of Congress, but whether she could turn that positive exposure into effective lawmaking remained to be seen. Representatives usually had to accumulate years of seniority before they had enough clout to shape legislation.[1] Yet less than one year after Nixon left office, there was Jordan, on August 6, 1975, standing behind President Gerald Ford in the White House Rose Garden as he handed her his autographed notecards on the occasion of the official renewal of the Voting Rights Act (VRA). "This was my first big legislative victory, and I wanted a memento," she said.[2] Jordan had every right to be proud. The 1975 Voting Rights Act extended and strengthened one of the most effective pieces of legislation to emerge from the civil rights movement, and it was Jordan's version of the bill that became law. Her version included a new language provision that required 513 jurisdictions in thirty states to hold bilingual elections. In addition, the VRA now covered all of Texas as well as language minorities in Arizona, California, Colorado, Florida, and New York. The 1975 renewal also set a precedent: The VRA could be greatly expanded, and it was not going to expire; indeed, it would be extended in 1982 and then again in 2007.

The language provision of the 1975 act was new and controversial. But Jordan's efforts to persuade skeptical members of the Congressional Black

Caucus and others of its necessity "made a tremendous difference," according to Patricia Villareal, a lawyer from San Antonio who worked on the civil rights subcommittee of the Judiciary Committee. "She took a very hard stance that it needed to be done."[3] Jordan's defense of her version of the bill demonstrated a combination of boldness, risk-taking, and pragmatism. She succeeded in convincing Black colleagues as well as conservatives in her own party that expanding the bill was not only morally right but politically smart.

Jordan's victory in the White House Rose Garden did not bring her much acclaim. The year 1975 witnessed renewed acrimony within a divided Democratic Party that caught Jordan in the middle. The coalition between organized labor and civil rights activists frayed at the seams over affirmative action within the party. She was further taxed by fellow Texan and DNC chair Bob Strauss, who persuaded her to perform favors for the party elite. Jordan had voted against Strauss for head of the DNC, but her ties with the Texas businessman caused many Black activists and white liberals to question her racial and political loyalties. So while it is true that in one short year Jordan enjoyed the singular achievement of authoring pathbreaking legislation that expanded the Democratic base, it was also the case that during these months her political reputation as a liberal Democrat took a beating. Instead of being perceived as a champion of the underprivileged, she was now in danger of being tagged, cynically, as yet another ambitious and self-serving politician. Her quest for greater inclusion of Black, Brown, and non-English speaking citizens into the Democratic party and its voter base did not run a smooth course.

Preceded by the protests and marches led by Dr. Martin Luther King Jr. and the SCLC in Selma, Alabama, during the winter and spring of 1965, the Voting Rights Act was a belated federal response to a hundred years of voter suppression and racial violence in the South. The 1965 Act was designed as a temporary five-year measure to address the egregious racial discrimination that still characterized southern elections. The law was "triggered" in states and selected counties if fewer than 50 percent of the population had voted in the presidential election of 1964. Once triggered, the act suspended literacy tests, allowed federal registrars to enroll voters, and subjected any changes in voting practices to review by the Justice Department. The law affected seven southern states and parts of eleven more. White segregationists regarded it as the ultimate federal usurpation of local and state control of elections. But when southern states challenged the VRA multiple times in the federal court, the Supreme Court upheld it.[4]

When the Voting Rights Act came up for renewal in 1970, it encountered stiff opposition from both houses of Congress.[5] Critics tried to stall passage by adding more counties and states—including some counties in New York—to make the bill less palatable to northern politicians. But the proposed bill made it through Congress and was signed into law by Richard Nixon in 1970. By 1975 the effects of the VRA were becoming clear. Black politicians, and the young of all races, were demanding a greater say in how the Democratic party conducted its business and chose its candidates. Before the act only seventy-two Black elected officials served in the South; by 1975 there were at least nine hundred. According to the US Commission on Civil Rights, the number of registered Black voters had increased. And yet the Democratic Party, and the Congress, was still dominated by white men and particularly conservative white southerners. These new Black Democrats rightly wanted more power within the party.

The majority of Democrats in Congress continued to support the VRA, but few ideas existed about how to improve it; the conventional wisdom was simply to leave it alone. In his study of Black voting activism, historian Steven Lawson emphasized the significance of the 1974 reunion of the Selma marchers for spurring awareness of the significance of the following year's expiry. At that event, civil rights veteran and Atlanta congressman Andrew Young reminded the crowd that the Civil Rights Act and other victories "didn't do anything to challenge the power relationships in the South," and "were far less consequential than the '65 Act, which began to give Blacks access to political power."[6] He urged a swift renewal. According to Lawson, the Civil Rights Division (CRD) of the Justice Department began preparing for the renewal of the law shortly after Nixon resigned. On September 24, 1974, the young, Harvard-educated assistant attorney general for the Civil Rights Division, J. Stanley Pottinger, assured the Congressional Black Caucus that he "would not lose sight of the great symbolic meaning of the Voting Rights Act." He promised not to "tamper" with the provisions, as had happened in 1970. He pledged that "politics will not be a part of the CRD evaluation."[7] On November 17, 1974, Attorney General William Saxbe recommended to President Ford that the VRA be extended with "no major revisions." Three weeks later he asked the president to endorse a simple five-year renewal of the law; the Democratic Party, the Justice Department, and the NAACP seemed in agreement with that proposal. Clearly, there existed some fear that changing the act might lead to its defeat.

In the summer and early fall of 1974, however, discussions about the Voting Rights Act within the Democratic Party were overshadowed by the growing, and often bitter, controversy over the representation of different groups within the party organization. Quarrels roiled state party conventions throughout the spring and summer. In Texas a fight for control of the State Democratic Executive Committee (SDEC) continued to pit conservatives and liberals against each other, with Billie Carr of the liberals and the conservative Wallacites (members who supported the Alabama conservative George Wallace) each seeking to wrest control from the "middle" of the party.[8] The bitterness of these state contests cannot be overstated; delegates saw themselves fighting for the soul and future of the party. The Voting Rights Act and the civil rights movement had empowered African Americans, but organized labor, supporters of George Wallace, traditional liberals, and feminists were also jostling for influence over the party machinery. Everyone seemed to want more democracy, and more transparency, but no one wanted a repeat of the 1972 McGovern debacle.

In an effort to bring order and unity to a squabbling party, Texas businessman Robert "Bob" Strauss had been appointed chief fundraiser and head of the DNC. Strauss, the son of a Jewish grocer in east Texas, grew to be a multimillionaire corporate lawyer; he brought a disarming earthiness to his role as DNC chair as he equally insulted all groups with a big smile. "It's a little like makin' love to a gorilla," he told a reporter. "You don't quit when you're tired—you quit when the gorilla's tired."[9] He sought unity above all, but immediately faced criticism from liberals over his choices for the party's Charter Commission, a group led by former governor Terry Sanford of North Carolina that had spent two years writing the party's constitution.[10] Strauss opposed the mandatory miniconventions decreed by the commission; he wanted party disputes to be settled in private, not in public. His proposal to add eleven new hand-picked members—all of whom supported his position—to the commission caused a standoff and a walk-out. The mid-August meeting in Kansas City ended in chaos, which further delayed the settling of other unresolved issues.

In addition to the conflict over the need for miniconventions, antidiscrimination rules for choosing delegates to state party conventions, supported by the Congressional Black Caucus and the majority of Black delegates, aroused opposition from organized labor. Strauss worked diligently behind the scenes in September, October, and November of 1974 to resolve the conflicts over the language of

affirmative action requirements in delegate selection. He sought to appease and persuade. Overdue recognition was bestowed on Black security guard Frank Wills, the Watergate hero. Strauss also gained approval for the appointment of Washington insider Edward Bennett Williams as the party's new treasurer. Most significant, the chairman managed to hammer out a compromise that would restrict the number of floor amendments at the upcoming Kansas City miniconvention in December 1974.[11] The main business of that meeting was supposed to be the ratification of the party's new charter. Strauss wanted that gathering to be a show of strength and unity, but the necessary compromises would be hard to come by.

In the fall of 1974, Barbara Jordan was occupied with different concerns. In early September, President Ford invited her to join a delegation to travel to the People's Republic of China along with other key Democrats, including senators Hubert H. Humphrey and J. William Fulbright. Jordan recalled, "And then there we were in China in some little province just at the foot of a mountain and sleeping on these slatted cots and straw mats," when an overseas phone call came in for her. It was a reporter from Houston asking, "What do you think about Ford's pardon of Richard Nixon?" The event was so unexpected that Jordan swore: "What the hell are you talking about?" She was convinced that Ford sent the Democrats to China to get them out of the way; the pardon made her feel cheated out of a resolution to the Watergate crisis.[12] The public felt the same way, and Democrats increased their majority in the House after the crucial 1974 midterm elections.[13] Jordan ran unopposed and returned to her congressional seat in Washington. Perhaps that post-Watergate midterm victory boosted her confidence as she plotted bold legislative moves.

Fairly quickly into her second term, it appears, Jordan decided to focus her legislative goals specifically on expanding the federal oversight provisions of the Voting Rights Act to include Texas, as well as language minorities. Her legislative aide Bob Alcock recalled:

> She liked to focus; she liked things ordered; she didn't like lots of surprises. If you were going to make a decision that you were going to focus on these three things this year, you wanted to focus on those three things and that was your agenda and that was ok.

> She understood, here she is, a member of a collegiate body of 400 plus and the senate and the president; you can't be asking for 200 things to

happen or 100 things but if your colleagues . . . know that there's two or three or four things that you want and you're focused you're going to get those things, maybe not 100 percent but 80 or 85 percent of those things.

I went to her and said this VRA is coming up and this is what is happening, and this is how to expand the preclearance provisions to Texas. . . . Memos were just a few sentences in each topic. And she said yes let's do it.[14]

Mexican Americans had been organizing against voting discrimination for decades, but the discrimination they suffered was not covered by the existing terms of the VRA.[15] Alcock's own interest in a language provision stemmed from the fact that he had a Mexican mother whose first language was Spanish. For Jordan, including Texas in the VRA would redound to her political benefit, especially if she ran for the US Senate. Including the language provision would test whether the VRA could be pushed to include even more categories. Was including a language provision going beyond the original intention of the act, or was it fulfilling the spirit of the act? Over the next eight months, members of congress debated the issue.

Jordan first publicly demonstrated her keen interest in the renewal of the Voting Rights Act during the November–December 1974 hearings on the nomination of Gov. Nelson Rockefeller to fill the vacancy of the vice presidency. For more than two weeks, the House Judiciary Committee interrogated Rockefeller about his personal wealth, the 1971 Attica prison uprising, and his views of governance. A seasoned politician, Rockefeller handled those questions with confidence. He was clearly taken aback, however, when Barbara Jordan asked: "Governor, do you favor the extension of the Voting Rights Act?" Rockefeller responded, "I am not sure I know."[16]

This disingenuous response infuriated Jordan. As everyone in the room knew, in 1970 Rockefeller had opposed the extension of the act to cover certain areas of New York State. Rockefeller feigned ignorance. ("I thought everybody could vote now," he said.) But before her time expired, Jordan set the record straight: "Well Governor, as you no doubt know, the Voting Rights Act had a time limit, and then it has to be extended if it is to continue . . . the same Voting Rights Act that you felt should not be applicable, that is, section 5, to New York, but you were overruled by the courts. It is that act which will come before the Congress for extension perhaps next year, and I would want to know whether

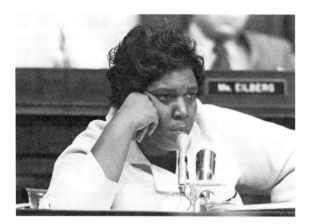

Figure 11. Jordan at
the microphone during
congressional com-
mittee hearings, 1975.
Image courtesy of the US
House of Representatives
Photography Office,
Washington, DC.

you would favor an extension of that Voting Rights Act." Rockefeller begged off, and Jordan's time was up.

At her next opportunity to question the governor, she returned to the issue. "For black people in this country, there are two pieces of civil rights legislation which are held just quite dearly to the breast and the heart of black people. That is the Civil Rights Act of 1964 and the Voting Rights Act of 1965. And I am going to use this time to cite the chronology of the VRA in New York so that we can get that into the records." Jordan then listed every twist of the governor's nearly five-year legal struggle in federal court to exempt New York from the act. Rockefeller claimed he opposed the act "because by changing the district lines, we were going to lose a black in the assembly." Jordan dismissed this concern and in a later session came back with information that undermined the governor's argument. It turned out that the opposing candidate was also African American, so no Black member to the legislature was lost. She finally elicited a statement from Rockefeller that he would support the VRA's extension.[17] Jordan showed no deference to the wealthy industrial heir: she was respectful but sharp.

She adopted a softer tone during her questioning of Black assemblyman Arthur O. Eve of Buffalo, New York, inviting him to "tell the committee about the humanitarian acts of the Attica prisoners" during the 1971 uprising. He did so— at great length—during Jordan's allotted time.[18] She playfully needled a young Black Rockefeller supporter, asking him why on earth he was a Republican and urging him to switch sides. Using her question time to highlight the experiences of the poor and the imprisoned under Governor Rockefeller's watch, Jordan was partisan, yet friendly, confident, and pragmatic.

Jordan's pragmatism always complemented her idealism. She described Governor Rockefeller's wealth as "so comprehensive that its tentacles reach and nudge and penetrate the very substance of the government," yet she joined a minority of Democrats to vote for his confirmation to the vice presidency. She acknowledged that Rockefeller had "promised to help the poor and strengthen civil rights," and agreed with one of her colleagues that Rockefeller was about as good a Republican candidate as could be expected.[19] The Rockefeller appointment was going to go forward, and Jordan saw no point in voting against it. She had used her platform to extract some concessions from the candidate on government assistance for the underprivileged, and, most important, the extension of the Voting Rights Act.

In early December 1974, shortly after the Rockefeller hearings, Jordan traveled to the Democratic Party's miniconvention in Kansas City, Missouri, where delegates discussed the party's charter, put forward new economic initiatives, and debated whether affirmative action should be used to increase the number of minority representatives in state delegations. Contentious attendees (including members of the Black caucus, mayors, and delegates) "threatened to walk out if their desired affirmative action provisions were not included in the Party Constitution." One of the delegates, Dr. Charles Bookert, of Pittsburgh, told a reporter from the *Pittsburgh Courier* that both Yvonne Burke and Jordan spoke in favor of the new provisions to give minorities, women, and the young representation in the party structure: "Ms. Jordan most notably received a standing ovation for her speech on the constitutionality of the issue." And everyone applauded, "the old guards of the South, the conservatives, and the liberals alike."[20] At the end the DNC accepted the proposal that the number of Black members in a state's delegation be proportional to the percentage of Black members in the party at the state level. The issue seemed closed, and it was good, according to Bookert, "to see black politicians standing together on principled ground."[21]

The miniconvention then focused on economic issues. Senate Majority Whip Robert Byrd of West Virginia promised quick congressional action on a $2-billion emergency unemployment bill, tax cuts for low- and middle-income families, and a national health insurance plan. Byrd was toying with running for president, and the press watched with fascination as Jordan, "one of the leading black spokesmen in congress," was called on to introduce him. Byrd was a former member of the Ku Klux Klan, but Jordan praised him as "an unmistakable leader who has shown willingness to do what is difficult as well as right." The

symbolism of the speech was obvious, wrote one journalist, "as the party sought to demonstrate that liberals and conservatives could join together in common goals."[22] Jordan received an ovation after her introduction, and when she spoke again at the final session, she made unity her theme: "Let the word go forth from Kansas City that the Democratic Party is alive, and it's substantive and it's real."[23] As the *Washington Post* noted, "This was clearly a liberal agenda ... but the key Blacks here were not civil rights workers but the heads of governments of some of the nation's largest and most hard-pressed cities. ... Blacks and women, and mayors and governors—with Southerners notable in each category—put together the final agreement on the antidiscrimination plank."[24] Black delegates and political leaders had demonstrated their political muscle.

Jordan in particular exercised noticeable influence, with a UPI reporter observing that, with the exception of Sen. Edward M. Kennedy, Jordan was "the most charismatic" figure in the Democratic Party: "Her cold outrage at corruption and her clarity of expression make audiences stop and listen to what may be the most powerful speaking style since Adlai Stevenson restored elocution and intelligence to public oratory."[25] By the end of 1974, Jordan was on record as supporting both the extension of the VRA and affirmative action to increase Black representation in the Democratic Party. She was also recognized as one of the most unifying political leaders in the Democratic Party. It had been a swift ascent, but at that time Jordan could play these varying roles comfortably; no one accused her of hypocrisy.[26]

But the party's significant affirmative action policy was not yet settled.[27] Black delegates to the convention understood that the much-lauded façade of unity covered deep divisions. They believed that the party's Compliance Review Commission (CRC), which had the final say on the compromise but contained only six Black members out of twenty-five, would be tested. Black delegate Earl Craig, a college professor from Minnesota, was circumspect. "You could say we won an important battle here," he said, "but for Black people, other minorities, and women our position must be that the struggle has just begun." Craig and others remained concerned that the CRC would fail to enforce the provision that marginal groups would be given a fair chance to participate at "all party levels."[28]

As some had expected, shortly after the Kansas City miniconvention, ten top AFL-CIO officials threatened to resign from the DNC over the new affirmative action rules. "They feel that labor was being excluded, along with senior citizens, and ethnic groups ... by rules and regulations that cater to youth,

women, and minorities," said Al Zuck, the federation's spokesman. The union men complained that chairman Strauss had been too accommodating to those groups. Under the new charter, "it was easier for the party's women, youth, blacks and other minorities to challenge the convention delegate selection process on grounds of discrimination."[29] Union representatives feared the imposition of quotas. Disputes over what constituted discrimination within the party, and the proper means to address it, remained unresolved.

Similarly, disputes over the VRA began to surface. In January 1975, the Justice Department recommended that Congress renew the VRA "without expanding it to cover more Northern cities." The department's approach was supported by Clarence M. Mitchell, chief lobbyist for the NAACP. According to Mitchell, the civil rights organization had rejected "some suggestions, mostly from Southerners," that the VRA should be expanded to bring more northern communities under its scope. With only seven months remaining until the law expired, he worried that any major changes would provoke a "drawn out battle that might endanger the law." But not everyone was convinced. Mitchell "acknowledged that Mexican Americans had wanted the act to 'cover some local complaints about voter harassment in Texas and Arizona,'" the *New York Times* reported, "but he anticipated that those complaints could be addressed during Congressional hearings." In general Mitchell downplayed evidence of voter suppression and discrimination against Spanish-language voters. According to the NAACP's chief lobbyist, the existing VRA was strong enough.[30] Hispanic and Mexican American Democrats disagreed.

So did the US Commission on Civil Rights. On January 24, "in a last minute decision," the commission "endorsed a move to expand the 1965 Voting Rights Act to protect many more Spanish speaking people."[31] In a 478-page report, it recommended that the act be extended for another ten years and that Congress "ensure the right to vote of non-English speaking minority citizens."[32] The report produced evidence that in Arizona, Mexican American candidates and their supporters had been subjected to intimidation.[33] "There is reason to believe that minority citizens in other jurisdictions encounter discrimination in the electoral process," it added.[34] The commission did not specify exactly which new jurisdictions should be included, but by highlighting the language barrier and recommending a ten-year extension, it moved beyond the recommendations of the Ford administration and of NAACP lobbyist Mitchell.[35] Jordan's friend and fellow Delta soror Frankie Freeman, the first woman to join the commission, also

recommended that literacy tests be entirely abolished, not merely suspended for ten years: "Lack of facility in written English does not absolve a person of the responsibilities of citizenship. There is no reason why it should deprive a person of the rights of citizenship."[36] The commission's statement gave Jordan a boost, for it laid the foundation for the bill she was busy preparing.

In the meantime, the issue of Black representation in state delegations to the Democratic Party refused to go away. In mid-January 1975, as many Black delegates feared, the momentum of the affirmative action initiatives adopted in Kansas City came to an abrupt halt. During a meeting of the DNC's Compliance Review Commission in New York City, the Kansas City agreement fell apart. Gary Mayor Richard Hatcher, a member of the CRC, lost several close votes on proposals "to ensure detailed monitoring of state affirmative action programs." Sensing the direction of the meeting, Hatcher abruptly got up and left this "crucial" meeting. His departure broke the quorum and halted the proceedings. Such headlines as "Political Disaster for Blacks Averted by Hatcher at Democrats' Meeting" emblazoned the pages of the *Chicago Defender* and *The New Pittsburgh Courier*.[37] Delegates were shocked. "What?" shouted one over the phone, "Everything we fought for in Kansas City could have been washed right down the drain."[38] Few could understand why support for the affirmative action plan had collapsed.

The problem seemed to be, according to Black journalist Ethel Payne, a dereliction of duty by four Black members of the CRC who had failed to attend the meeting.[39] Only one of the absentees had given their proxy to supporters of reform. Two other members had allowed their proxies to go to white opponents of the provisions. The most surprising absentee was Jordan, "the only Black who not only missed the meeting, but also failed to assign her proxy to any member of the CRC."[40] Jordan did not explain her absence from the CRC meeting on that day or her failure to give her proxy to a sympathetic committee member.

The CRC reconvened a week later and voted to apply affirmative action to "all party affairs." But that phrase was narrower than it appeared. It applied only to the selection of delegates to the 1976 Democratic National Convention and to the selection of state party offices. Lower levels of party representation were not included. According to Basil Patterson of New York, "The action [of the CRC] today slams the door in the faces of Blacks, women, and other minorities who—based upon the Kansas City meeting—thought there was some feeling in the Democratic party that they should be included at all levels of party

activity." At the precinct level, Patterson explained, party organizations were free to discriminate. Present at this CRC gathering, Jordan voted with the reformers to apply affirmative action at all levels. She left before the final vote, however, which defeated the reformers version, fourteen to nine.[41]

What happened? By the time of the second CRC meeting, it was clear that the reformers had failed to gain support for affirmative action at the precinct level. Jordan therefore voted for the reforms and then left before the final vote. One could argue that her vote would not have made a difference, but given her previously persuasive support for the measure, her charisma, and her moral authority, critics were not convinced. They found Jordan's behavior puzzling. Even though in the end she voted with the reformers, her absence from the first meeting was deemed unacceptable. "Observers have speculated that she has been absent, because a vote in support of the Black Democratic position would anger her white Texas supporters."[42] Some suspected that Jordan had "sold out" to please Bob Strauss, or to increase her chances of securing the party's nomination for a seat in the US Senate. No one knew for sure.

A few weeks later, a deceptively laudatory article on Jordan in the *Wall Street Journal* advanced the thesis that Jordan was mainly a self-interested politician guided by outsized ambitions. The piece began by quoting Jordan's rousing introduction of Senator Byrd at the Kansas City miniconvention, the one that got her an ovation. But rather than praise her commitment to party unity, the article questioned her motives and values. "The incident shows a side of Barbara Jordan not fully perceived by the public: she is a very ambitious politician who uses her eloquence not only on behalf of high principle but also to get ahead. Whatever his views on race, Senator Byrd is, after all, No. two in the Senate Democratic leadership."[43] Jordan was cast as an individual out for herself: "A lot of her fans are wondering why Representative Jordan said all those nice things about Sen. Byrd." The author rehashed material from Molly Ivins's columns about Jordan as a state senator, emphasizing her ties to Houston's white elites. The article alleged that Jordan, as a congresswoman, was following a similar pattern of ignoring her Black and female peers to stay "on the right side of Houston's white business community." The author made crass, unfeeling observations about Jordan's appearance ("overweight,") and "indifferent health," (a second mention of being overweight), which "she says causes her high blood pressure and maybe related to periodic numbness in her arms and legs." The piece quoted "friends" who called her "arrogant," and who noted her "limitless ambition."

Jordan's jokes with male colleagues were called "put downs." The article also brought up something Jordan surely thought she had put to rest: her marital status. "Rep. Jordan's inability to suffer fools may have something to do with her failure, so far, to get married. But of marriage she says: I haven't written it off."

The title of the article seemed to signal positive recognition of Jordan's rise—"Barbara Jordan's Star Reaches Dizzy Heights for House Sophomore"—yet the tone and content almost singularly shifted the perception of Jordan as a pioneering and principled Black leader to that of a dishonest, unattractive, unmarried Black woman—and an unprincipled failure in the eyes of her peers. The article quoted Houston's Rev. Bill Lawson to bolster its case: "There are times when we wish Barbara would stand up and be counted for something controversial and nitty gritty." The article ended on an ominous note: "So Barbara Jordan has made her choice." But what was she choosing exactly? "I do believe I can do more by quietly working my way in and seeing that change is brought about, and that it's solid change, not elusive or knee jerk." The piece did not mention the most obvious criticism that could be made of Jordan—her absence from the CRC meeting and her failure to give her proxy vote to an ally in the affirmative action debate. That error of omission angered and emboldened Jordan's detractors, many of whom called themselves "friends."

Although Jordan's introduction of Byrd at the miniconvention now began to raise eyebrows, it also had some positive consequences. As the senator and the congresswoman walked off the platform, Byrd told Jordan, "If there's anything I can do for you, don't hesitate to let me know." A month later, while telling the story to the *Wall Street Journal* reporter, Jordan added, "and I won't."[44] For Jordan, the entire incident had a positive outcome: a show of party unity and an implied promise from the influential senator and party whip in the senate. Jordan may have already been thinking that Byrd could play an important role when the Voting Rights Act came to the Senate floor, but first the bill had to make its way through the House.

The House Judiciary Subcommittee on Civil and Constitutional Rights held hearings in February and March 1975 on several proposals to extend the VRA, and Jordan was one of the first to testify. Appearing before the subcommittee on February 26, she cited the January conclusions of the US Commission on Civil Rights: "In spite of what we have done in terms of gain, we need to do more, and we need to do better."[45] For the first time, Jordan told her own story of being a Black woman in Texas electoral politics. She focused on the discriminatory

effect of at-large districts, which had frustrated her bids to be elected to the Texas House in 1962 and 1964. If the provisions of the VRA had been in place in Texas at that time, "I might have been able to begin my political career much earlier, but we did not have the Voting Rights Act." She noted how at-large legislative districts were still being created and still having a discriminatory effect upon Black candidates.

Next, she detailed the plight of Mexican Americans who "today in Texas . . . have lost their teaching jobs as a result of filing for candidates." She recounted previous testimony of Mexican Americans who had lost their businesses because they supported minority candidates. She detailed the intimidating aspects of voting procedures, where there was no privacy: "the person who is voting has to mark his ballot on a large table in full view of everybody." Registration forms were "tossed out" because the applicant did not know their exact date of birth.[46]

She then introduced her bill, HR 3247, which would extend coverage of the VRA to the whole of Texas and parts of New Mexico, Arizona, and California: "If less than 50 percent of those eligible actually vote, and if, and this is the key, the registration materials are presented only in the English language, when at least 5 percent of the population of a jurisdiction speaks a mother tongue other than English, they would be covered." The "trigger" then, included English-only voting materials when more than 5 percent of the voters did not have English as a mother tongue—defined by the US Census as "the language spoken in the home." Jordan exhibited a color-coded map to show the subcommittee the covered jurisdictions. It was time, she told the committee, to consolidate the gains that have been made in the South "as far as black people are concerned. But I think we ought to go one step further. We ought to include the states like Texas, my home state, with its large Mexican American population and see to it that these people are also included in the covered jurisdictions under the Voting Rights Act and its extension."[47] Congress heard testimony from many illustrious Black leaders that day, including Andy Young, John Lewis, and Charles Rangel, but the "word around the press table," according to Black journalist Alfreda L. Madison, was that Jordan "was one of the most brilliant persons in government."[48]

She then took questions. Representative M. Caldwell Butler, from Virginia, tried to flatter her by suggesting that "if you'd been elected to the Texas Assembly in 1962, you would be president by now," but she easily made light of his suggestion that states that implement the act should be removed from oversight.[49] Her most interesting colloquy came with an exchange with Representative

Herman Badillo from New York, who felt her trigger did not go far enough. Badillo worried that under the Jordan plan Los Angeles, "which has 7 million people and 1.5 million Mexican Americans," would not be covered because California had greater than 50 percent voter turnout in last three presidential elections. Badillo's bill would cover the entire state of California. Jordan expressed caution: "I have some difficulty with covering the entire state of California when most of the state, the overwhelming majority of the state, does not fit the triggering criteria presented in the 1965 Act." She continued: "I am not interested frankly in making this act apply to jurisdictions where there is no necessity that it apply. I just do not think we ought to be in that business." Then she noted that in Los Angeles County the voter turnout was 58.8 percent, and "I confess to being ecstatic about any jurisdiction where the voting participation was above the national average, and that it was so high in comparison to Texas." Jordan acknowledged that the percentage of Spanish speakers in Los Angeles was probably not as high, but she would not budge on her formula. She was reluctant to make the bill apply only to one language or one ethnic group. To her the Fifteenth Amendment wording of "race, color, or previous condition of servitude" applied to many different groups, including Native Americans, Mexican Americans, and Asian Americans, not just African Americans. She introduced a statement from J. Stanley Pottinger from the Justice Department on the meaning of "race or color" for the purposes of defining the Fifteenth Amendment. She used evidence from the Justice Department, the Civil Rights Commission, Supreme Court decisions, the prior testimony of Mexican American politicians, the US Census, and her own experience as a Black politician in Texas.

The Ford administration seemed to shift toward including protection for Spanish-speaking voters. Pottinger agreed to help draft a bill dealing with "problems," a concession hailed as a "significant breakthrough" by Manuel Fierro, president of the National Congress of Hispanic-American Citizens.[50] Yet the Department of Justice still found fault with the bill supported by Jordan, calling it too broad, and that of Badillo, whose bill singled out Spanish speakers but did not employ the same trigger mechanism as Jordan's. Pottinger argued that there was insufficient evidence to support inclusion of language minorities. In addition, Clarence Mitchell of the NAACP still expressed opposition, saying he might support a separate bill for Spanish speakers but not a change to the VRA itself.[51] Black columnist William Raspberry of the *Washington Post* remained solidly in Mitchell's camp, painting supporters of the language provision, such

as John Lewis, as unrealistic and unwilling to acknowledge the danger of sudden shifts in strategy. He repeated Mitchell's warning that "if you've got something that is working, you want to be very sure you don't improve it out of existence."[52] The pragmatists in the NAACP and the Democratic party favored a retreat, if not a more cautious approach, to the language provision.

But Al Perez, the lead lawyer for MALDEF (Mexican American Legal Defense and Education Fund), thought it was misleading to blame Spanish speakers for risking the bill's failure. Merely renewing the VRA without changes was bound to cause controversy, he said, "but now the focus has been shifted—to us. If the act is defeated—and I don't think it will be—it won't be because of including Chicanos."[53] Mitchell was a powerful individual, but the overwhelming sentiment among the African Americans who testified before the subcommittee supported inclusion of language minorities. Andy Young showed excerpts from the documentary film *From Montgomery to Memphis*, including brutal scenes of the violence inflicted on civil rights marchers in Selma. Eddie Williams, president of the Joint Center for Political and Economic Studies, testified, as did John Lewis, former leader of SNCC and executive director of the Voter Education Project. These activists emphasized the need for renewal because of the ongoing abuses against Black voters. They also drew attention to the continuing discrimination faced by Mexican American voters in Texas, California, and the Southwest, and they supported the language inclusion.[54]

By April, Jordan joined forces with representative Edward R. Roybal from California and Badillo and their joint bill, HR 5552. The *Washington Post* supported the broader proposal: "There is little reason to fear losing the entire Voting Rights Act in the course of trying to fashion legislative relief for the Mexican American Community."[55] The Leadership Conference on Civil Rights also supported the Jordan-Roybal-Badillo bill, which was then introduced in the Senate by Sen. Birch Bayh. Finally, on April 10, Arthur S. Flemming, chair of the US Commission on Civil Rights, testified in support of the language provision. In the words of civil liberties lawyer Joseph Rauh, "a new consensus" in favor of the language provision was emerging.[56]

Jordan spoke about her support of the language provisions of the act to Paul Duke in a televised interview, where she called the extension and expansion of the Voting Rights Act a part of the civil rights movement. "The civil rights movement is not gone. The steam is not really out," she insisted.[57] She sought to connect with Black audiences. In March she made a trip to Pittsburgh to speak to

twelve hundred Black church members and, on being given the 1975 Outstanding Black Image Award, Jordan attacked Ford's economic policies. She reminded her audience that Black unemployment was twice that of the already high 8.2 percent faced by whites. She criticized middle-class Black Americans for thinking that they had "made it" when the median white income was still twice that of Black Americans. She urged her audience to pull together and stop "mimicking" the white middle class: "We carry a cultural heritage of familyhood that is too good to forget about; and we're going to have to use it."[58] At the end of the evening, everyone in the audience stood and sang the Black national anthem, "Lift Every Voice and Sing."

Perhaps because of her health, or because of the controversies within the DNC, Jordan resigned her seat on the Democratic Party's Compliance Review Commission.[59] In an interview with Black journalists, Jordan stated that she had withdrawn because the commission's work was too time consuming and frustrating: "Every time they had a meeting, there was a conflict," she complained. She voiced her support for affirmative action in the party, but said she was "terribly exasperated" at how much time was spent defining those rules. And she explicitly ruled out running for the US Senate, citing the racism of white voters in her home state: "I don't delude myself into thinking that there will be any reversal of attitudes in the state of Texas," she said. She also criticized the *Wall Street Journal* article for saying she did not sit with Black members and was too close to conservative southerners. But she was also candid: "I have a natural affinity for Southerners, because I'm a Southerner."[60]

White southerner was often equated with conservative, but Jordan saw what others missed. More white liberals being were being elected from the South. After the 1974 midterms, the *New York Times* reported that "the shifting political sands in the South have led some to wonder whether conservatism is finished in that region."[61] Nevertheless, Jordan had to reckon with the power that conservative white southerners still wielded in Congress, especially as committee chairmen. Jordan's friendliness to certain conservatives furthered her legislative strategy. Explaining that strategy to the public, however, was not easy.

Jordan's decision to testify at the corruption trial of her enemy, former Texas governor and Democrat-turned-Republican John B. Connally, for example, baffled even her most enthusiastic supporters. Even before he became governor and she a Texas state senator, Jordan had detested Connally. She had experienced his

racism firsthand. She had no love for the man. And yet when Connally stood accused of accepting $10,000 in illegal cash from a Texas lobbyist when he served as Secretary of the Treasury under Richard Nixon, Jordan testified for him as a character witness.[62] In doing so, she joined a host of others including "Lady Bird" Johnson, widow of the former president. Jordan later wrote, "People could not understand how, when he had ignored me so totally when I was in the Senate, and he was governor for that one term, and when my eyes had filled with tears when he said what he did about Martin Luther King, that I would be a character witness for him in the bribery trial. Nobody could understand that."[63] Some of her colleagues in Congress just shook their heads and called it "one of those Texas tribal things."[64] On the stand she gave no more than monosyllabic answers, agreeing only that Connally had a reputation for honesty. Although others, such as evangelist Billy Graham, spoke on Connally's behalf with greater energy and conviction, her old adversary called Jordan to thank her.[65] When Connally was acquitted, Jordan suffered the condemnation of aghast white liberals in Texas. Her choice to say good things about Connally in front a Black-majority jury in DC was clear evidence, if any more were needed, of her willingness to bow and kneel to the powerful.[66]

Although at the time Jordan said she testified because it was the right thing to do, she clearly felt some emotional coercion. Connally's indictment pained many people in Texas whom Jordan respected and had befriended, including Lady Bird Johnson. Jordan also admitted that DNC chair Robert Strauss and DNC treasurer and Connally's defense attorney Edward Bennett Williams laid on the pressure. Yet Jordan may have had her own reasons for appearing that day. In her book, she wrote that she liked the feeling of Connally being in her debt.[67] Moreover, she understood that in the eyes of "conservatives and business types" testifying for Connally would show her to be "somebody who was fair and open and not just locked into a knee-jerk position." She wanted their support.[68] Connally's trial took place in February of 1975, just as Jordan was putting together her bill renewing and extending the Voting Rights Act. The wider affect of her testimony during this crucial time must also be considered. At the Democratic Party miniconvention in Kansas City, Jordan made an important connection with Senator Robert Byrd, and she might have believed that her gesture towards Connally would have been appreciated by the influential senator. The two men were close. Only a few years prior, Connally, acting on

behalf of President Nixon, asked Byrd if he might consider a Supreme Court nomination, but the senator declined.[69] Although it would not be appropriate to call her testimony for Connally a quid pro quo, it is also probable that Jordan—understanding Byrd's value as an ally for the voting rights legislation—put her personal feelings of enmity toward Connally aside to do Senator Robert Byrd another small solid.

In March and April of 1975, the civil rights subcommittee of the House Judiciary Committee wrestled with several amendments to the VRA, some of which sought to undermine the language provision as well as the continuing inclusion of southern states such as Virginia. Throughout it all, Jordan and her staff worked diligently in the background. Legislative aide Bob Alcock remembered the obstacles Jordan had to overcome: "The press in Texas started writing about this; she was the first to introduce this bill and a lot of people didn't understand why this Black woman was concerned about people speaking Spanish . . . [but it was] very meaningful." When it became clear that Jordan wanted voting procedures in Texas to be subjected to oversight by the Justice Department under section 5 of the act, Alcock grew pessimistic.[70] But Jordan kept at it.

> When we were working on the subcommittee she took the time to sit down personally with every member of the Texas delegation and explain to them what this meant in factual terms to help them understand from a policy point of view why she was doing this.
>
> All she was saying was, don't have a gut reaction, know what you're talking about, and if you try and debate me on this, I'm going to run all over you. . . . In effect she was also telling them this is important to me.
>
> But she got some very conservative Texans to vote for that bill, and that was quite an accomplishment.

Jordan also pushed civil rights supporters and their allies to support the bill. Sensitive to how the changes in the act would affect states such as California, the home of subcommittee chair Don Edwards, she went to see him in person. Bob Alcock recalled how Jordan worked behind the scenes to explain the bill to the right people in the right way so that her staff could get the necessary support.

She went to Don Edwards, chair of the subcommittee on civil rights; beautiful man, the world is indebted to him.

She went to him, and he was predisposed, but the bilingual things were giving him problems, and he was not opposed to it, but he didn't need those problems, so we worked through the California people to make that easier for him . . . and shoot, they had to print Chinese ballots in San Francisco and getting his support was so important because therefore I had access to his subcommittee staff, and I didn't have to go alone to ask for information from the census.

Jordan knew that the bill needed wider support from the civil rights community, and it needed to be strategically worded for when it came before the entire House of Representatives. Alcock recalled what she did next.

She went to Andy Young and explained to him what she wanted to do. He was on the rules committee, which was really a creature of the speaker, it has to go to that committee before it goes to the house floor; it writes a resolution that governs the rules for the debate of that bill, and the house has to adopt that resolution before it can debate the bill. If you want to offer an amendment, the rules might be stated in such a way that would prevent you from offering the amendment.

She explained to him what she wanted to do, and bless his soul he saw the beauty of it.

Andy Young enthusiastically gave his support. Both he and Jordan stymied attempts by Republicans on the rules committee to shut down amendments.[71]

The judiciary subcommittee brought out a "clean bill," HR 6219, on April 23. It contained all the points of Jordan's original bill: If less than 50 percent of the population voted in an area where 5 percent of the population spoke a non-English mother tongue, then the coverage under the bill was "triggered." The measure also contained provisions for bilingual ballots and the inclusion of all of Texas and parts of other states. Committee chair Rodino and Civil Rights Subcommittee chair Edwards, the two most powerful men on the Judiciary committee, cosponsored the final bill, giving it a greater authority. Jordan

undoubtedly was content with that arrangement. As Rep. Bob Eckhardt put it in the *Wall Street Journal* profile, "Barbara indicates quickly a willingness to follow and be loyal to a leader. She avoids positions where leadership could imagine she is in any way a threat to them."[72] Eckhardt meant this as a veiled criticism, but he correctly noted that Jordan acceded to those who wielded power if such proximity advanced her agenda. The bill moved forward, but it did not leave her attention.

She resisted efforts to amend the bill in subcommittee hearings, including a proposal to exempt Texas altogether.[73] The Texas legislature had hurriedly passed a bilingual ballot law, but Jordan and Mexican American activists saw through the subterfuge. "We need more than bilingual ballots," she said. "That won't solve the problem of political, economic, and invidious forms of discrimination." Spanish speakers in Texas ought to have a lifeline to the Department of Justice. "The minority voters need the psychological, spiritual, and emotional boost that comes from knowing that you have a forum for correction of abuses," she said.[74] Mark White, the Texas secretary of state, acknowledged in hearings before the Senate subcommittee that the bilingual ballot legislation would not cover gerrymandering and other abuses, an issue highlighted by the bill's growing number of supporters from Texas to California.[75] Jordan's message was clear: the Texas attorney general might have good intentions, but state legislation was no substitute for federal oversight.

Jordan worked closely with the Congressional Black Caucus (CBC) to gain their full support. On April 24, 1975, Charles Rangel outlined the present state of the bill in a memo to members of the group. "The bill calls for a ten (10) year extension of the Act, a permanent ban on literacy tests, and includes an expansion of the act to cover Texas and other language minorities, in other states, and also to require bilingual ballots." The Rangel memo acknowledged the ongoing debate about language inclusion. During the CBC discussion over the bill, he explained, "The only major issue for the CBC has been the inclusion of Spanish speaking and other minorities under the act's protections. . . . We have not yet taken a position on a specific bill and method of such inclusion." The memo recounted that, at the previous day's meeting, eight of the nine members of the CBC expressed support for the subcommittee's bill, with only Parren Mitchell from Baltimore expressing reservations. "Barbara Jordan has been deeply involved in drafting the bill and strongly supported HR 6219," Rangel wrote. "She pointed out that coverage of Texas under the act would protect Blacks as well as Chicanos, that

the most invidious type of discrimination exists in Texas, and that Texas still has multi-member state legislative districts." Rangel hoped that everyone on the CBC would support HR 6219. They did, with Andy Young writing "AMEN" in the slot where members put their initials.[76]

But Parren Mitchell was still unsure. In an attached memo he wrote, "I have initialed off on this primarily for the sake of maintaining a unity front. One area of concern is whether or not as a matter of strategy extension should be accomplished by adding another title to the law rather than adding a title to the bill. Have we fully resolved the issue of constitutional challenges which may result in endless litigation thus rendering the act impotent while it is in litigation?"[77] These were the same concerns raised by Clarence Mitchell, who still opposed the wording of HR 6219.

The bill still roused objections from liberals, while some conservative southern congressmen tried to stop it outright. On April 30, Rep. Jack Brooks tried to exempt Texas again when the bill came before the entire Judiciary Committee. He was defeated.[78] The Judiciary Committee also narrowly blocked the attempt by M. Caldwell Butler to exempt Virginia if it reached at least 60 percent voter registration. Jordan called his proposal "vague and amorphous, and an obvious attempt to weaken the Voting Rights Act."[79] Finally, on May 2, the entire House Judiciary Committee voted twenty-seven to seven in favor of HR 6219, the Rodino-Edwards bill to extend the Voting Rights Act for ten years.[80]

When the bill went before the full House of Representatives, it faced amendments designed to weaken federal oversight of southern states. In a letter sent from the Congressional Black Caucus to five thousand Black elected officials and community leaders, Jordan and Rangel urged Black voters to contact their representatives and express their support for the bill.[81] When the bill was debated on the House floor, Don Edwards, Herman Badillo, Andrew Young, John Conyers, and Jordan all gave powerful speeches defending the legislation against attacks raised by Butler of Virginia, who was still pushing for a bailout provision. He claimed few understood how the act made those in the affected states feel stigmatized, to which Andy Young riposted—to much laughter—"I'm from a state that's covered by the Act, and I feel wonderful." In truth, the voices of white southerners from the affected states varied. Walter Flowers from Alabama, Jordan's friend on the Judiciary Committee from the Watergate hearings, went to the microphone and said, "I too am glad to have the Act in my state and I'm going to vote for it."[82]

Jordan spoke several times. She "used her most persuasive eloquence to influence the House to add on the bilingual provisions," noted the *Chicago Defender.* "That was not only smart politics, but good sense." Ohio congressman Louis Stokes recalled that "whenever she took the podium in the house there'd be a hush over the house. She was just such an extraordinary orator that the whole house gave her the respect of listening to her whenever she walked into that house to speak."[83] When Rep. Charles Wiggins of California introduced an amendment that would have allowed states to escape coverage if more than 50 percent of Black voters participated in the previous federal election, a journalist noted how Jordan took him to task: "She looked directly at Wiggins, and said that an over 50 percent black turnout did nothing to affect discriminatory problems such as 'school boards which have been abolished or reduced to prevent minority membership on them; multi member districts; polling places removed without notice; and annexation by cities and counties in an effort to dilute minority votes.'"[84] There were many ways to disenfranchise minority voters, she pointed out, which was why federal oversight was needed more than ever.

After thirteen days of hearings and forty-eight witnesses, the House beat back all challenges and passed the extension bill, 341 to 70. "In a congressional season most noted for its failed promises, at least one measure passed by the house—the extension and enlargement of the voting rights act—stands out as a memorable achievement," noted the *New York Times.*[85] But there was little time to celebrate. The VRA was due to expire August 6, and it still had to pass the Senate, where long-time Mississippi segregationist senator James O. Eastland chaired the Judiciary Committee. As the *New York Times* noted, Senator Eastland represented "an ominous impediment to the enactment of this legislation." The senator was not even willing to permit the Senate Judiciary Committee to hold a hearing on the bill.[86]

In the meantime, the Senate Judiciary Subcommittee on Constitutional Rights, headed by California senator John Tunney, held hearings. They heard much of the same testimony that had been given to the House subcommittee. The subcommittee agreed with the ten-year renewal period as well as the other provisions of the House bill. It cleared the bill to go forward. But Tunney was reluctant to release the bill to the Judiciary Committee for fear that Eastland would sit on it, thereby allowing the VRA to expire. To prevent that maneuver, he and Mike Mansfield, the majority leader, held the House bill "at the desk," where it could be voted on without going to committee. Tunney then had

leverage to goad the Judiciary Committee to complete its work.[87] Time dragged into July, and tensions mounted. Eastland, hospitalized after a fall that left him with several broken ribs, finally called a meeting of the Judiciary Committee to consider HR 6219. Strom Thurmond of South Carolina tried to get his state exempted from the bill; after his amendment was defeated, he wanted to prepare a minority report. The stalling tactics angered Tunney. "I'm trying to be fair about this," he said. "We could have the House bill called up on the floor at any time. We don't have to wait." "Do it! Do it! And see what happens," Senator Thurmond shouted.[88] Emotions cooled, and it was agreed that the Judiciary Committee would vote on the bill the next day. They approved it by a vote of 10 to 4. The bill then moved to the Senate floor.

With time running out, Mansfield and Majority Whip Robert Byrd called up the bill immediately for debate instead of waiting for the Judiciary Committee report. Byrd then "filed a debate-limiting cloture petition on it." His motion prevented a filibuster by limiting each senator to one hour of debate.[89] During the following week, Byrd outmaneuvered senators James B. Allen of Alabama and Jesse Helms of North Carolina. During an "unusual Saturday session," he refused to give up the floor except for "relatively short statements by others, and on the condition that he be recognized to speak again as soon as they had finished." He was hoping to keep the floor from Allen "for fear that, with many senators absent, Allen might demand a snap vote, or might force the Senate into a situation where the first crucial vote on the bill could come at 1 AM. He said he would surrender the floor to Allen only for a specific amount of time." Allen objected vigorously, claiming that he deserved time to respond, but the Senate adjourned until Monday after a procedural vote showed a quorum was not present.[90]

On Monday came the first vote on Byrd's cloture motion, which passed 72 to 19. But Allen had one more maneuver planned. He called for the Senate to vote on cloture for another bill, and if he had succeeded, the Senate would have spent several days debating that proposal before it could get back to HR 6219. Once again, Byrd saved the day, raising a point of order against Allen's motion. Eventually Allen's cloture motion was ruled out of order.[91] The Senate finally began debating the merits of the legislation on July 22. Southern senators protested that the act singled out the southern states for coverage, but their amendments were defeated.[92] An unexpected letter from President Ford, however, created confusion. "I urge you to make the Voting Rights Act applicable nationwide," he wrote. What a surprise. Ford had consistently supported a five-year renewal

period; his sudden call for such a drastic expansion would dilute the law, make it difficult to enforce anywhere, and nullify out the trigger provisions that applied to the covered states. Ford, it seems, wanted to kill the provisions keeping the South under special coverage for ten more years. Tunney argued that such a broad bill might well be unconstitutional because the federal "pre-clearance requirement wasn't justified unless there was evidence of discrimination."[93] An amendment by Herman Talmadge of Georgia that would have applied the act to every state went down to defeat.[94]

Given the open hostility to the bill by southern senators, Byrd proposed a compromise amendment that extended the bill for seven years instead of ten. The South, he explained, was entitled to "some consideration" for its efforts to comply with the 1965 law. He also said that the law would remain in effect through the 1980 census and the reapportionment of Congressional and state legislative districts. When objections were raised that such an amendment would require a conference with the House and cause further delay, Byrd was dismissive: "I am not about to believe that the House is going to kill this bill."[95] After the most objectionable amendments were defeated, the Byrd amendment was adopted; two days later the Senate approved the entire bill, 77 to 12. Before the vote, Rodino and Edwards stated they would recommend that the House simply endorse the Senate version and send it to President Ford.[96] With less than a week remaining before expiring, the 1975 Voting Rights Act passed the House. Ford added his signature in the Rose Garden on the tenth anniversary of the 1965 Voting Rights Act.[97]

Barbara Jordan was in Houston for Congress's recess, but she flew to Washington to be present when Ford signed the bill. For much of 1975, she had been under the fire of critics who labeled her an establishment sellout. But in fighting for the inclusion of Texas in the Voting Rights Act, she went against nearly every elected official in the state, including her colleagues in the House, Jack Brooks and Henry Gonzalez. Her co-author Shelby Hearon stated that "Barbara enjoyed bucking the whole state of Texas on this matter." "I was hanging in there," she said, And I wouldn't kneel."[98] Jordan was amused by the fact that the president signed a bill he did not support. "So, he had a stack of three-by-five cards and he read about how he had worked for its successful passage, and I said: 'your remarks are most interesting.' And he perked up and said, 'would you like to have them?' And I said 'Certainly, Mr. President.'"[99]

The updated Voting Rights Act battle had unforeseen complications, not all of them helpful to Jordan. But she looked at legislation as something that had to be done through debate, intellectual force, persuasion, and appealing to mutual interests. Alcock observed: "She knew how to do her job! It's not what you learn about in school. It's about the people who are there and taking the time to sit down with them." Never in its history, he added, had the Senate Judiciary Committee reported favorably on a civil rights bill until it voted out the VRA amendment in 1975. Conservative white southerners still exercised enormous power, but Jordan believed that some people, such as Byrd and Flowers, could be persuaded, especially if they thought they needed Black votes to advance their own careers. And could it be a coincidence that, in January 1976, Robert Byrd announced that he was going to seek the Democratic nomination for the presidency?[100] If he had gone through with that idea, he may have been planning to ask Barbara Jordan to introduce him one more time. Whether she would have agreed is another matter.

Jordan was only one of many Democrats who fought for the bill, yet she played a uniquely pivotal role in its success. Unlike the pragmatists in her party, who argued that the safest course was the easiest road, Jordan fought for the language provision. And it was Jordan, the strategic idealist, who persuaded the most influential Democrats on the judiciary committee to take charge of the bill and for the CBC to support it. Using her most persuasive powers of oratory, she spoke out on the House floor and in committees against attempts to weaken it. Questions still remain about why her efforts to pass such monumental legislation did not receive the same attention as did her testimony for Connally and her perceived failure to act as a strong advocate for affirmative action for local Democratic delegates.[101] Perhaps Jordan did sense that she needed to back off from criticism of the party's corporate leaders in order to gain their acquiescence for expanded voting rights. The basis of all negotiating, of course, is giving in order to get. Jordan's critics may have been right in that she could have pushed harder in the fight for stronger affirmative action policies within the party, but perhaps she judged it best to leave that fight alone and focus instead on voting rights. Such hidden calculations and miscalculations are part of any effective politician's thought process as they seek to gain what they want. What Jordan was actually thinking was never written down.

Jordan's reputation as an orator has caused her skill as a legislator to be overlooked. And her reputation as a pragmatist has overshadowed her gritty,

and strategic efforts to turn the ideal into the real. Journalist Meg Greenfield might have had Jordan's role behind the 1975 Voting Rights Act in mind when she wrote, "Whether or not it should be the case, it is true that maintaining one's standing in political/governmental Washington is a condition of getting anything to happen." Jordan knew that her public acclaim from the Watergate crisis gave her a unique moment in Congress to put pressure behind the legislation she cared most about. "What a winner must win," wrote Greenfield, "is the consent of others, whether out of respect or admiration or political agreement or mere expediency, to get something done. To get the machinery going at all, it is necessary first to elicit the cooperation—active or passive, freely or grudgingly given—of many other players."[102] Great speeches alone do not result in great legislation. Rather, as Greenfield suggests, gaining cooperation to support legislation takes commitment, persistent pressure, and attention, but also sacrifices.

Jordan's determination to include Texas, and language minorities, in the 1975 Voting Rights Act demonstrated what she valued most as a politician: vigorous federal protection for voting rights and enforcement of the law on behalf of racial fairness. All her political life, she worked not only for the right of minorities to vote but also for those votes to be meaningful and for minority candidates to have a fair opportunity to gain office and to be fully protected by the Constitution. She therefore worked to end all practices that militated against minority candidates, including at-large districting, English-only ballots, and more obvious forms of economic, racist, and social intimidation. Such laws were essential to her vision of what the Constitution required if American democracy was to include and protect Americans of all racial and ethnic origins.

Hitting the Black Glass Ceiling

The 1976 Democratic Party Convention

I don't want to abandon patriotism to the right wing.
> —Barbara Jordan, March 24, 1975

On July 4, 1976, Barbara Jordan and Nancy Earl hosted a special celebration, the "first annual around-the-clock, all-weekend-picnic-on-the-ground, for Barbara's oldest friends from Houston." Jordan wanted a big bicentennial bash to celebrate the groundbreaking of what would become the couple's new home in the rural Onion Creek neighborhood in south Austin.[1] They imagined it as a retreat from the pressures of Washington and a wonderful spot for gatherings. More than a dozen friends and relations attended the bicentennial party. Visitors from Houston camped out, Jordan and Earl stayed at a rental house close to the site, while others lodged nearby, but everyone gathered to eat, drink, celebrate, and sing. Jordan referred to the circle of intimate friends as "special." "We felt our group was very select," she said, "and we were protective of it. Most of us had known each other for the past forty years, and we all had fun together."[2]

The group was mixed racially and economically. They shared a love and appreciation for Jordan and Earl and a commitment to maintaining the congresswoman's privacy. In the safety of those parties, which lasted for several days, Jordan loved to drink and play her guitar: in an interview she explained that "I have my specialty numbers which I always do—'Sunny' and 'St. James Infirmary Blues.' And I never remember the words as I am on my twentieth drink at that point, but that never deters me and I can always make them up and make them fit, which I do. From year to year they change. Never the same

song but always the same tune."[3] The poignant jazz soul song "Sunny," by Bobby
Hebb, celebrates how special people help ease hard times; it is easy to imagine
why Jordan sang it.

> Sunny, yesterday my life was filled with rain.
> Sunny, you smiled at me and really eased the pain
> Now the dark days are done and the bright days are here
> My sunny one shines so sincere
> Sunny, one so true, I love you.[4]

"And I play my guitar although I never did play it well but it's like my singing,
ceremonial. Barbara will play her guitar whether you want to listen or not."[5]
Friends barbecued and churned ice cream; they feasted and set off fireworks. At
the end of the evening, Jordan and her two sisters, Bennie and Rosemary, joined
their old friends from Houston, the five sisters from the Justice family, and sang
around the rented piano. In an interview, Jordan recalled, "That was always the
way we topped off the evening. At first we all sang together. We sang spirituals
and the Battle Hymn of the Republic. Then we each did our specialty." Jordan
relaxed into the rituals of festive occasions: "Everybody retired and pretended
to sleep for two or three hours . . . but then we started in again with breakfast.
I always cook the breakfast, bacon and eggs and biscuits, because everybody
likes my eggs—scrambled eggs with cheese and chives."[6]

Jordan had always enjoyed parties, but this gathering marked her commit-
ment to putting down roots in Austin. After the guests returned home, Nancy
Earl received a note from the five "Justice Sisters and their Husbands," thank-
ing her for the invitation to the weekend party: "It was a blast!" And it ended
poignantly: "Barbara is our most precious possession: our sister, our congress-
woman, and our friend. We shall be eternally grateful to you for your providing
such a picturesque setting for our celebration of the nation's birthday and of our
friendship. Until we meet again."[7] The letter acknowledged Earl's role in Jordan's
life, and the importance of the Onion Creek home as a secluded, private place
for Jordan and her circle to relax and retreat.[8] Over the next few years, Jordan's
life would gradually move away from Houston and Washington. The couple's
home in Onion Creek provided a solid foundation as Jordan came to terms with
serious changes in her health and engaged with ever-growing public responsi-
bilities during one of the busiest years of her life.

After the bicentennial celebration, Jordan went back to work. The next week, at Madison Square Garden in New York City, in front of a live television audience of millions, she delivered the keynote address to the Democratic National Convention. Her eloquent speech lifted the Democrats toward the mountaintop of the presidency and made her one of the most famous people in America. Jordan's speech that evening marked the zenith of her short political life, but after it, her career disappointingly dropped down to its nadir. Events in the year leading up to the speech, along with the reaction to it, help to explain why.

Jordan had spent nearly an entire year before the 1976 convention shepherding her voting rights legislation through congress and speaking on behalf of the Democrats. She relished her emerging role as a well-known political pundit and gave monthly commentaries on *The CBS Morning News Show*.[9] In March 1975 *Newsweek* editorialist Meg Greenfield devoted an entire page to an interview with the Texas congresswoman. In a piece called "The New Lone Star of Texas," Greenfield, known for her own intimidating, dry style, felt like she had met her match: "I can't remember being more apprehensive about an interview with a public figure than I was before (and occasionally, during) my talk with her. The message is conveyed in every word and gesture: 'Don't tread on me.'"[10] Jordan was now a commanding "public figure" rather than just another politician, but Greenfield, sensing that Jordan aspired toward even greater influence in the party and the nation, appreciated the Texan's efforts to cross boundaries. Jordan told Greenfield that after her speech during the House judiciary hearings on impeachment, letters poured in from average Americans who identified with her comment about being excluded from the original Constitution. Jordan said she "heard not only from blacks, but also from women and a miscellany of embattled others who believed she was talking about them. There was something amusing to the misperception, but also something that goes to the heart of what she is all about. 'Listen,' she said to me, 'whoever they thought I was talking about, I *was* talking about.'"[11] Greenfield treated Jordan as a political visionary, and clearly she sparked the public's imagination too. In July 1975 *Redbook* magazine announced that of the seven hundred men and women polled, 44 percent named Jordan as their top choice of American women "who could be president."[12] The public expected great things from Jordan. In the run up to the nation's bicentennial celebration, Jordan's public appearances caught the optimistic mood of the nation and served as a unifying tool for the Democrats.

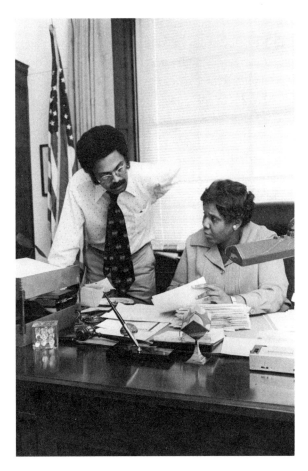

Figure 12. Barbara Jordan and one of her staffers in her congressional office in Washington, DC, 1975. Photo by Moneta Sleet Jr., Barbara C. Jordan Archives, Texas Southern University, Houston, TX.

In 1975 Barbara Jordan traveled from coast to coast, using her public acclaim to benefit Black politicians and raise money for the Democratic Party. In California she spoke at fundraisers for Ron Dellums and Yvonne Burke.[13] Ohio congressman Louis Stokes asked Jordan to visit his Cleveland district, and she agreed. Chair of the CBC and a trial attorney who had argued cases before the US Supreme Court, Stokes was a prominent politician whose brother Carl had been the first Black mayor of a major American city. But in 1975, he realized Jordan's appeal eclipsed his own: "I wanted her there. It was an honor to bring her into my congressional district."[14] Fourteen different civic organizations sponsored Jordan's appearance, and the mayor presented her with a key to the city. A Black journalist from *The Cleveland Call and Post* described the scene: "The doors to the vestibule of the Grand Ballroom had to be left opened to allow persons

seated at tables outside the door to view and hear the superb and tremendous program."[15] Jordan's criticisms of Republicans who denied funding to cities took her to new metaphorical heights. Referring to the legendary phoenix, "Ms. Jordan said that for the past 200 years American has been consumed by its own fires of 'racism, poverty, unemployment, inflation, and the like.' 'I have no problem seeing America consumed by its own fire,' she said. 'But I do have difficulty with seeing it rise in youthful freshness from its own ashes.' If there was hope, she stated, 'it must begin with our elected officials.'"[16] Jordan acknowledged urban blight and problems, but she usually brought her message back to the positive role that politics and the Democratic Party could play in people's lives, a message her audience was eager to hear. Wherever she spoke, she inspired others.

She continued to pitch the message of coalition politics while showing an appreciation for Black culture and Black activists. In a thirty-minute interview with Paul Duke on the PBS program *Washington Straight Talk*, Jordan addressed a range of issues, including whether the nation could anticipate a Black president (yes, she answered), or an alliance between Blacks and poor whites at this time (no, she said, referring to the racial resentment of whites). The civil rights movement, she insisted, had not died but merely shifted tactics. She discussed the upcoming renewal and expansion of the Voting Rights Act and why it was so important to include the language provision. She criticized President Ford and anyone who said the "urban crisis" was over. They had not been to America's cities. Duke asked, "Where have all the black radicals gone?" Jordan replied, "Well, I think they are in the various offices of the mayor, city councils, state legislative bodies, county commissioners court. They've gone political . . . and they are going to radicalize politics in a good way."[17] She described herself as a progressive liberal, someone who was willing to listen to others, explaining why compromise and communicating with people who held different views were important to getting anything accomplished in politics. And when Duke asked whether Black Americans should share her absolute "faith" in the Constitution, she quickly interjected. "You need to remember," Jordan emphasized, "what I said at the beginning of that speech." The original Constitution had not included her. But, as she explained, Black Americans had faith in the Constitution today because it had been changed, and because court decisions based on the Constitution had broken down racial barriers.

Duke probed more personal topics as well. When asked to respond to critics who called her "aloof," she responded with a wry smile: "I don't know who

they are talking about!" He quoted a Republican Judiciary Committee member who claimed that "Barbara Jordan had a gothic fascination with power." Jordan admitted feeling consumed by her job, quipping that she spent at least 75 percent of her time on it. But then she responded seriously. Politics was about power, she told Duke. "Those who feel that power is distasteful and to be disdained ought not to be in politics." Was she out to gain power for herself? No, she responded. She was out to represent her three hundred thousand constituents in Houston, Texas. Many of these questions were uncomfortable and would never have been posed to a man, but Duke had been respectful and spoke admiringly about Jordan's possible future in the US Senate, as speaker of the House, as vice president, or as a Supreme Court justice. His tone allowed Jordan to address criticisms and voice some of her own.

Jordan did not allow media attention to distract her from the gritty work of turning civil rights ideals into effective legislation. Title VI of the 1964 Civil Rights Act gave congress the power to withhold federal funds from states that practiced discrimination. Working with the CBC, Jordan introduced legislation that gave individuals the power to sue states for civil rights violations in massive federal spending programs, including the General Revenue Sharing Act and the Law Enforcement Assistance Administration (LEAA). "I proposed civil rights amendments which were designed to strengthen civil rights enforcement at that time. What we wanted to do was to give the Law Enforcement Assistance Administration the early option to cut off funds if a jurisdiction was found to be discriminating."[18] "The goal of the bill," she wrote, "is compliance."[19] Sometimes called "Title Sixers," Jordan and her allies pressed for widespread adoption of legislation that would, in the words of her aide Bob Alcock, "prohibit people and organizations which received federal money from using the money to discriminate."[20] She also introduced legislation that required all federal agencies to meet the same strict standard. Those early victories were important. Yet Jordan felt frustrated when the Democratic House failed to override Ford's veto of a jobs bill, and she expressed outright disgust at the success of the Hyde Amendment, which banned federal funding for abortions. Her powers of persuasion worked on her fellow Texan, Jim Wright, but the Hyde Amendment still passed.[21]

While in Washington, Jordan faced frightening changes in her health. She lived in an apartment on the southwest waterfront in DC, but she was rarely there. She worked long hours at her office, went to receptions in the evenings, and got up early in the morning to work some more. Every two weeks, Jordan traveled

to Houston, and she continued to accept speaking engagements throughout the country. Exhausted from keeping a grueling schedule, Jordan weighed close to 250 pounds, more than she ever had. And then in the summer or fall of 1975, Jordan suffered a frightening recurrence of multiple sclerosis symptoms. One evening she felt tingling, looked in the mirror, and was stunned to see the right side of her face had dropped. She tried to smile, but the right corner of her mouth did not move. Immediately, she went to see her neurologist in Bethesda, and he confirmed the symptoms came from MS. He prescribed another round of steroids but predicted the attacks would happen more regularly. He diagnosed Jordan as "chronic-progressive." The diagnosis depressed her.[22] She now knew the periods of remission would be shorter.

Her declining health pushed Jordan to make some life-changing decisions. She and Earl moved forward on the purchase of land for their new home, and she decided to lose weight. She did it to help her symptoms with MS, but also because the persistently negative press about her personality and her weight bothered her. She was offended by the media's physical descriptions of her as "hulking" or "massive." "I did not like people saying I was fat; big to me was different from being fat. It's a downer, it's not an attractive thing. I had become a fat lady. They [the press] did not present [me] in a positive framework."[23] Earl left Keuka to move back to Austin, and she traveled to Washington, DC, more regularly to help in Jordan's office. With Earl's encouragement, Jordan used charts, rewards, and incentives to tackle her weight and improve her health. She cut back on eating at receptions and as the pounds dropped off, Jordan took pride in what she saw as a positive achievement.

As Jordan devoted more attention to her personal life and health, the race for the Democratic presidential nomination intensified. Twelve candidates, representing a wide ideological span, vied to win the primaries under a system designed to be less reliant on the party convention for choosing a candidate. A little-known former governor of Georgia began to make his way through the primary process. James Earl "Jimmy" Carter described himself as a Washington outsider and took advantage of the poor ratings of both the Democratic-dominated Congress and Republican president Gerald Ford. Carter had the backing of Rep. Andy Young of Georgia. But in April 1976, during a news conference in Indianapolis, Carter surprised his growing army of Black supporters. "I see nothing wrong with ethnic purity being maintained in Indianapolis," he proclaimed. "I have nothing against a community trying to maintain their

ethnic purity at their neighborhoods." When asked to elaborate at a news con-
ference on April 6, he said he favored enforcement of "open occupancy" laws:
"Any exclusion of family because of race or ethnic background I would oppose
very strongly and aggressively as president." Pivoting again, he added, "I think
it's good to maintain the homogeneity of neighborhoods if they've been estab-
lished that way." And that "if the purpose is simply to create some sort of racial
percentage that would destroy the makeup of a community, then I would be
reluctant to do that." Ignoring the contradiction, Carter supported neighbor-
hood homogeneity but opposed discrimination.[24]

His Democratic opponents seized on the incongruity. "He can't have it both
ways," complained Arizona Democrat Mo Udall, "preaching ethnic purity and
voluntary busing on the white side of town and soul brother on the Black side
of town." Jordan similarly decried the "separatist and segregationist undertones
in what Carter said." Yvonne Burke chimed in: "There's no question he's been
getting a free ride from Black voters—he's campaigned in Black neighborhoods,
he's the only one who's gone after Blacks organizationally, and he's the man who
stopped Wallace. But this statement about ethnic purity is the sort of thing that
is going to turn Blacks away."[25] But it was exactly the kind of statement meant
to reassure white voters in Indiana and Pennsylvania. On May 29, 1976, Jordan
appeared on *Meet the Press* with several other Black leaders. "We cannot stand
mute or silent," she said. "Busing is only one tool [for achieving school deseg-
regation]. Busing has worked well."[26] Yet Carter skirted the busing controversy,
and he remained troublingly ambivalent on solutions to racial inequality. He
continued to win primaries.

In January 1976, before Carter emerged as the front-runner, Bob Strauss had
asked Jordan to serve on the rules committee for the upcoming Democratic
convention. She declined. Next, he approached her in her Washington office
with another proposition: Would she give one of the keynote addresses at the
convention? Strauss hoped that Jordan, the Black woman from Texas, and vice
presidential hopeful Sen. John Glenn, the former astronaut from the Midwest,
would provide unity, something the party desperately needed after two consec-
utive presidential losses. Jordan agreed. The convention speech gave her some-
thing meaningful to anticipate.

But her health worsened, particularly her mobility. In the months before the
convention, Jordan found it increasingly difficult to walk—just putting one foot
in front of the other took all her concentration. She now had to be driven to the

House floor. Determined to keep her illness hidden, she started to avoid people, but this only fueled more stories about her supposed snobbery and arrogance. As she struggled with pain and discomfort, comments about her being aloof and unfriendly increased. Jordan retreated even more, insisting on maintaining her privacy. She even refused to disclose her diagnosis to her family. "I don't want to become the poster child for the Multiple Sclerosis Society," she told Earl. She did not want pity. She walked with a limp but insisted she had a "bum knee." As walking became more difficult, she started to use a cane.[27]

Jordan continued to attract media attention, but unlike her earlier interviewers in 1975, journalists eschewed questions concerning policy and did not treat her with deference. They instead scrutinized her motives, and they increasingly dwelt on her appearance, including her slow, deliberate walk. William Chaze, a thirty-something reporter, interviewed Jordan at her Capitol Hill office: "Only one member of the Texas Congressional delegation gets a second look from the crowds of tourists, . . . a 40-year-old Black woman from Houston who moves her imposing bulk with magisterial dignity and whose voice is like Jehovah's might have been had he been a member of the U.S. Congress."[28] Journalists such as Ivins had already written about Jordan's size, but "imposing bulk" was a new term. Jordan candidly responded to Chaze's questions, but she also opined on Washington politics. She called President Ford a singularly "unimaginative leader," derided his veto of a public jobs bill, and voiced despair at the reluctance of Republicans to do anything to help working families: "You think of all of those people in Boston, Detroit, and New York struggling to survive and what one of those jobs would have meant to them. You relate all of this to them." Jordan felt frustrated that the political system was failing ordinary people. "Some days I just don't feel there's any use going to work because it appears futile," she said to him. Her comments avoided cheerful bromides or paeans to American institutions or the brilliance of the Constitution. Instead, Jordan criticized Congress, the president, and even her Texas colleagues. Following the interview, Jordan was scheduled to attend a Texas "tall tale" luncheon; however, she had no stomach for such good-old-boy antics. "I can't think of any funny stories about Texas," she admitted. "Maybe that's the funny story I will tell."[29]

Jordan dismissed idle talk about her political future. Asked if she thought about spending the rest of her life in Congress, she simply said, "No I don't. I'm not really thinking in those terms." Chaze did not believe her. He pointed out that according to House speaker Carl Albert, "It is the safest bet you can make

in politics" that Jordan would have his job one day. Chaze reminded her that Curtis Graves and others claimed that Jordan wasn't a true liberal, and that she "doesn't mind selling out to get her way." Jordan appeared undisturbed by these remarks. "If my accusers mean I am willing to compromise, yes I am. If they mean I am willing to compromise a principle of the people I serve, I am not. If it is possible to yield in one place to get another gain, I will." So what exactly was the controversy? Chaze noted that her explanation "could have been easily made by Lyndon Johnson"—and, he might have added, by any number of liberal Black or white politicians. Still, Jordan denied she was a Johnson protégé. "That is a word the media uses—not me," she said.[30]

Her frustration with Gerald Ford grew. When the president claimed that private schools had the right to reject students "as they see fit," Jordan blasted him: "Mr. Ford's statement is a political sham—a cheap rhetorical ploy during an election year to appeal to the worst instincts of a certain constituency." The CBC, she added, finds the president's position "unacceptable, inexcusable and void of sensitivity to minorities in this Great American Society."[31] Jordan was not finished: "President Ford's recent statement on segregated private schools," she stated on the floor of the House, "contradicts the Constitution—extends encouragement to non Black citizens who continue their blatant disrespect for the law, as manifested through outright violence—and greatly intensifies all resistance to busing orders." Jordan minced no words referring to the recent violence in Boston over school busing and to the unforgettable photo of a white man about to skewer a Black man with the American flag: "It is this type of statement—this type of attitude—which serves as the catalytic force creating such incidents as Black men being beaten with the American flag during our Bicentennial year, or frightened little Black school children having to be escorted by law enforcement officials past a throng of violent whites."[32]

Fed up with Republican inaction on civil rights, Jordan reached out to the public. At her commencement speech at Hampton University on May 29, 1976, and at her June 20, 1976, speech at the University of Cincinnati, she urged students to protest. "Why have you become so silent?" she asked the graduates, "Why can't we hear you?" She extolled the power of activism and democracy: "Don't be afraid of the sound of your own voice in the crowd. Do not be afraid to be patriotic. Do not be afraid to care about this country, to talk about it, to believe in it."[33] For Jordan, protest was patriotic. In a similar vein, former SNCC leader John Lewis, head of the Voter Education Project (VEP), used the bicentennial to

point to the patriotic heroism of Black women and youth who pushed America to embrace its ideals: "When we marched for voting rights on 'Bloody Sunday' in Selma, Alabama, in 1965 it was mostly Black women and young children who had the raw courage to nonviolently face the brutality dealt out by Alabama Highway Patrolmen." Now, he noted, 220 Black women currently held public office in eleven southern states.[34] Professing patriotism may have sounded conservative and old fashioned, but in that bicentennial year Black leaders claimed the high moral ground.

Journalists continued to allege, however, that Jordan was a conservative masquerading as a liberal. Days before the Democratic convention, Nicholas Chriss, a reporter from the *Los Angeles Times*, interviewed Jordan critics Billie Carr and Rev. Bill Lawson. "In Washington," Chriss wrote, "she [Jordan] is sometimes supposed to be a liberal, but more often than not she has confounded liberals." Alluding to her minister father, the author asserted that "her roots are more conservative than liberal." In the Texas Senate, Jordan had supposedly been coopted by white conservatives. Her motto, her critics said, was "To get along, go along." Jordan's work on behalf of the Voting Rights Act, civil rights, or Nixon's impeachment received scant mention. Chriss's most outlandish claim was that Jordan was really a close friend of President Ford: "Miss Jordan opposed Gerald R. Ford's confirmation as Vice President but has ended up being a friend, being invited to the White House, and being one of seven members of Congress chosen by the administration to visit China."[35] To use Jordan's trip to China as an example of presidential favoritism was preposterous. Ford wanted Jordan out of the way when he pardoned Nixon. And in the last few months, she had denounced him as an opportunistic racist who did not care about working families. The pattern of attacking Jordan continued. Mary Russell in the *Washington Post* acknowledged that although Jordan may "set an ear-catching cadence" at the Democratic convention, and "is likely to express concern for the poor, the unemployed and minorities," the congresswoman held an "almost conservative belief in American institutions and processes."[36] Jordan's attempt to claim patriotism for Democrats just seemed to confirm that she was a closet conservative.

Robert Strauss and others were determined that the 1976 Democratic National Convention would not repeat the chaos of Miami in 1972—where nominee George McGovern gave his acceptance speech at nearly 3 AM—or the violence of Chicago in 1968. Party leaders knew that the public did not want to see demonstrations, arrests, and discord. DNC chair Strauss hoped "to avoid any

visible clashes of interest because the party faces stiff opposition from the Repub-
licans who want to keep control of the White House."[37] The plan was to keep the
show in Madison Square Garden uncontroversial, even dull. "I'm delighted that
the American people will bear witness to our spirit of harmony after watching
us tear each other up for several long years while Nixon and Ford became our
presidents," Strauss told the *New York Times.* Carter had enough delegates to win
the presidential nomination. The only suspense concerned his vice-presidential
choice.[38] The convention was meant to showcase the Democrats as a united
political party that could govern.

As the months passed, Jordan felt uneasy about Carter as a candidate and
as a person. "She doesn't know enough about Governor Carter to develop an
impression about this man," stated the *Wall Street Journal.* When pressed, she
was reduced to attesting, "I believe that Governor Carter is telling the truth
when he says he can run on the Democratic platform and that he will do the
things the platform calls for to be done." Jordan's underwhelming endorsement
provoked musings about party division. "If the keynote speaker doesn't know
the presidential candidate, and isn't quite sure about his platform promise,
what are the American people to believe?"[39] Still, no one expected open battles.
Jordan had worked with a speechwriter—showing a few paragraphs to Strauss
and to her friends. They were not overly impressed, but they were more worried
about her health and how she was going to get up on the stage given her limited
mobility. They just wanted Jordan to get through the evening in one piece.

Jordan traveled to New York with Nancy Earl, Bud Myers (her chief of
staff), and Stanley McLelland, a white Texas lawyer who had been a friend
and confidant for several years. The group had a suite of rooms across from
Madison Square Garden and a chauffeured car. Strauss had originally wanted
Jordan and John Glenn to walk through the crowd and up on to the stage, but
Jordan refused, citing her knee trouble.[40] She could no longer walk unassisted.
So instead of walking down the aisles, Jordan waited with Myers and Strauss
beneath the stage while John Glenn gave his speech first.[41]

On the first night of the convention, the delegates in Madison Square Gar-
den were noisy and excited. Senator Glenn, a quintessential American hero
and a man touted as a possible nominee for vice president, spoke first. Despite
his sterling personal attributes, on-stage that night he came across as dull; his
speech was "a disaster." As the noise level on the floor rose, Glenn seemed to
be talking only to himself. R. W. Apple of the *New York Times* lamented that in

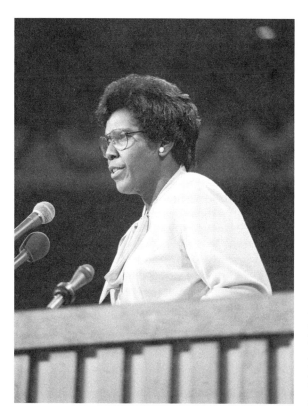

Figure 13. Barbara Jordan giving the keynote address at the Democratic National Convention, Madison Square Garden, July 12, 1976. Library of Congress LC-U9-32937-32A/33, Washington, DC.

a few minutes, Glenn had destroyed his chances of becoming vice president: "Although his Ohio friends sent him into the podium with a great cheer, the former astronaut generated no great enthusiasm with his speech, which he delivered in an almost conversational tone." Journalist Jimmy Breslin wrote an entire column castigating Glenn's performance. "The heritage of this nation sent Glenn into space, but it failed to give him a verb that can move a simple sentence."[42]

Then it was Jordan's turn. Strauss and Bud Myers pulled her up the six steep steps to the stage, and she used a cane to make it to the podium. The lights came on, and the crowd became very quiet. "I looked up," Jordan said later, "and the people were not milling around . . . the response was startling, as startling to me as that first standing ovation I got from the Harris County Democrats. Everything had been dullsville at the convention up to then, and I just thought: This is the way it will be."[43] The typed speech lay in front of her, but most importantly Jordan knew her purpose—to unite the crowd—and she set to it.

Echoing themes about American's history of racial exclusion she had first raised during her judiciary committee speech on impeachment—when she reminded the audience that when the Constitution was first written, "I was not included,"—she opened her convention speech by noting that in all the time since the Democratic Party first met 144 years ago, "it would have been most unusual . . . for any national political party to have asked a Barbara Jordan to deliver a keynote address. But tonight here I am."[44] In the Watergate speech she had said, "Through the process of amendment, interpretation, and court decision, I have finally been included in that 'We the people.'" Now she said, "Notwithstanding the past, my presence here tonight is one additional bit of evidence that the American Dream need not forever be deferred." The Democratic Party—like the Constitution—had changed, and expanded. And it now included her and people like her.

Few anticipated the convention's emotional response to her address, but Jordan's evident pleasure and pride at being on the podium in front of a packed house was infectious. The crowd quietly listened while Jordan expressed the hopes of the assembled and of the nation for what the Democrats and the nation could become. Again she echoed her House judiciary speech on impeachment, slightly altering the opening phrase of the Constitution—"We the people"—into "We are a people": Repetition made the speech soar. "We are a people in a quandary about the present. We are a people in search of our future. We are a people in search of a national community. We are a people trying not only to solve the problems of the present, unemployment, inflation, but we are attempting on a larger scale to fulfill the promise of America. We are attempting to fulfill our national purpose, to create and sustain a society in which all of us are equal." She then explained why the Democratic Party was the right instrument for fulfilling that national purpose. Without mentioning the party's racist past, she noted that the Democratic party now sought to include everyone who believed in its principles. As in the Watergate speech, she took time to lay out the evidence. The Democratic Party was inclusive, it was heterogeneous. It believed in *actively* (Jordan emphasized this word) removing barriers that discriminated against people. The Democratic Party was innovative. It believed in welcoming all and that all were equal. At the same time, Jordan recognized the party's missteps and its tendency to overpromise and underdeliver: "Even as I stand here and admit that we have made mistakes, I still believe that as the people of America sit in judgment on each party, they will recognize that our mistakes were mistakes of

the heart. They'll recognize that." Here was the pragmatic Jordan speaking, trying to get the undecideds at home to come over to the Democrats.

In that bicentennial year, Jordan sought to spark selflessness and warned against interest groups and individuals seeking to fulfill only their private wishes and wants. In an interesting parallelism, she equated "America" with the "common good." "If that happens, who then will speak for America? Who then will speak for the common good? This is the question which must be answered in 1976: Are we to be one people bound together by common spirit, sharing in a common endeavor; or will we become a divided nation?" Jordan insisted that everyone, every single individual, had a role to play in promoting the public good. She inspired the audience to believe in a future where all worked toward a higher purpose and a better nation. And she called on politicians, as public servants, to set exemplary standards of behavior. Employing the technique of repetition, she stated "I have confidence that we can form that kind of community. I have confidence the Democrats can lead the way. I have that confidence."[45]

And then in a stroke of genius, in her peroration she claimed for the Democrats the legacy of the Great Emancipator and concluded with the words of Abraham Lincoln: "As I would not be a slave, so I would not be a master. This expresses my idea of Democracy. Whatever differs from this, to the extent of the difference, is no Democracy."[46] With one speech, Jordan had erased the past, cutting the cord of white supremacy that had been tethered to the Democratic party for generations. Instead, she defined the Democrats as the party of the future, the party of opportunity, and the party of inclusion and equality for all. If these old-fashioned and patriotic ideals had lost their emotional power, it was not evident. Her presence on stage proved that a Black woman from the South could rise to one of the highest levels in politics and inspire millions to work toward the ideals of the American promise.

The crowd inside Madison Square Garden cheered her "to the rafters," as did the men and women clustered around the television in the bar across the street.[47] Jordan had lost nearly sixty pounds before she came to New York, but R. W. Apple still took note of her size even as he sung her praises: "It was Miss Jordan, an ample woman of considerable presence, whose words were paid the closest heed last night. . . . When Miss Jordan appeared on the podium in a pale green dress, the Garden rocked with shouts and cheers for almost three minutes. When she began speaking, the chatter among the delegates subsided. And when she reached her punch lines, she was repeatedly applauded."[48] Jordan received

twenty-four standing ovations for her twenty-five-minute speech.[49] John Glenn had circled the earth, but on this night, Barbara Jordan was the brightest star at the Democratic convention. After the speech the *New York Times* declared, "She is, no doubt, a hero of the party."[50] And the crowd chanted, "We want Barbara."

But even Jordan could not completely upend the party's troublesome and racist history. African American leaders demanded, in vain, that Jordan's name be placed in nomination for the vice presidency. "I think we know that if a white male politician had accomplished what Congresswoman Jordan did tonight, he would be in the running for the vice presidency," said Rev. Jesse Jackson on NBC news.[51] Some journalists, unable to acknowledge Jordan's brilliance, attributed her eloquence to a higher power. "It was stunning," stated Dave Rosenbaum of the *New York Times*. "The words had rolled from her lips in that formal speaking voice of hers, like a Shakespearean actor, some said, or, as one of those in the audience remarked at the time, as if the gates of heaven had opened." Hearing a Black woman pose fundamental questions about democracy to a national audience stirred the awe and emotions of the reporters, who were unable to set aside their racist and sexist biases. As Rosenbaum wrote with some confusion, "She was selected to give the keynote address to the DNC last night in part to be sure because she is Black and a woman, but in part also because at age 40, she is one of the most prominent Democrats in the country, her color and sex notwithstanding." So, she was selected to speak *because* of her race and sex, but at the same time, she was selected *despite* her color and sex. Were her color, sex, and age barriers or advantages? Jordan posed a paradox. She represented the American ideal that merit would be rewarded. And yet, prejudice against Black women was so great that journalists such as Rosenbaum could not accept that Jordan possessed the intelligence and eloquence they had just witnessed with their own eyes and ears.

Hers was a classic American success story, Rosenbaum wrote, where talent and ambition were rewarded. But where would those qualities ultimately take her? Rosenbaum was not sure: "Some believe that in a Democratic administration, she will be offered a cabinet post or a seat on the Supreme Court." But he admitted it was also unrealistic to think that she could be nominated to any of those positions. A high-level appointment should be just reward for a stand-out orator, but Jordan, he alleged, wanted something more than was her due: "One comment she made to an interviewer proves a clue to her boundless ambition. 'I never intended,' she said, 'to become a run of the mill person.'" Jordan's

"boundless ambition," a trait associated with the American creed and heralded in white men, was somehow inappropriate for a Black woman. Jordan's story was indeed incompatible with the classic American success story—she could not rise higher—but no one dared voice the unmentionables: her race, her gender, her sexuality, her disability, and finally her marital status all stood in her way. "What the future holds for Jordan, who is single, is anyone's guess" concluded Rosenbaum.[52]

The presidential nominee also felt flummoxed. When Carter returned to his hotel headquarters that first night, he found it "covered with 50 neat stacks of telegrams. Four women were opening Western Union envelopes, taking out more yellow messages and placing them on stacks. They were all addressed to Jimmy Carter and said basically the same thing: Pick Barbara Jordan for vice president."[53] He called and asked for her support if he won the nomination, and she said yes. Jesse Jackson insisted that her name be placed in nomination for the vice presidency, but Jordan refused, saying she did not wish to be a "token" nominee. Members of the CBC urged her to reconsider, but she considered the subject closed. The next morning her picture appeared on the front page of every major newspaper and glowing reviews of her speech came from all corners of the country.[54] Although pleased to receive praise, Jordan remained uninterested in asking for a job she knew she would never receive. Plus, she needed a breather. Three days later Carter accepted the nomination and chose Minnesota senator Walter Mondale as his running mate.

The publicity from the convention died down, and Jordan joined Andy Young and campaigned hard for the Carter-Mondale ticket.[55] Many assumed that their work on Carter's behalf entitled them both to positions in his administration. As she campaigned, the press queried Jordan relentlessly on her possible role in a Carter administration. After addressing a rally for Carter and Mondale at a Pittsburgh hotel, a Black reporter pressed Jordan on what Carter would do specifically for African Americans should he win. How might Carter shape his cabinet? She became frustrated: "Look I don't know the answers to any of your questions and I don't have time for anymore!"[56] Others expressed annoyance with Carter's campaigning style, which held back from Black audiences. An African American state legislator from Pennsylvania urged Carter to do more to energize Black voters: "There's a lot of apathy out there."[57]

Jordan worked tirelessly to elect a white southerner to the White House, without any foreseeable reward, but she still faced hostile journalists who

focused on her "boundless ambition." Skepticism was evident in two articles that appeared in the October 1976 edition of *Texas Monthly* magazine. "What Does This Woman Want?" asked journalist Walter Shapiro, while William Broyles penned a biographical profile titled "The Making of Barbara Jordan." The cover of the magazine displayed a sketch of Jordan wearing a crown, with the headline, "Is Barbara Jordan for Real?"[58] Both articles gave Jordan credit for working for the minimum wage, fair labor practices, and antidiscrimination laws, and for winning a stronger Voting Rights Act. Yet both pieces reflected a deep-seated assumption that Jordan lacked a moral core. As Broyles put it, "The central dilemma about Barbara Jordan is that while almost everyone *believes* she has this central core beyond politics, this ultimate devotion to longstanding principles, no one really knows what it is. No one can point to many long-standing principles she has made the establishment recognize."

Broyles recited a barrage of criticisms against Jordan from liberal whites who felt Jordan shut them out: "Her friends say she is really only comfortable with southerners, including blacks like Georgia's Andrew Young, but also some of the most reactionary members of Congress."[59] In effect Broyles implied that Jordan was a closet conservative who lacked scruples. Broyles also reinvigorated the mammy stereotype invoked by Ivins:

> She has been called Aunt Jemima by both her friends and enemies, and although she doesn't like it, the metaphor is apt. In appearance she conjures up the common memories of a culture—she is every black maid, black cook, black mammy. She comes to us direct from *Gone with the Wind* or *Uncle Tom's Cabin*, an enduring stereotype of the Black woman who lived closest with whites, who sustained the web of mutuality. The awesomeness of her presence is rooted in her explicit destruction of that image, as if every black mammy and Aunt Jemima had risen up with their rolling pins to take over the world.[60]

Broyles' claims notwithstanding, his piece on Jordan's success, and even renown, as a politician, perpetuated the "mammy" stereotype rather than upending it. It confirmed the words of the professor from Rice University back in 1962 who had told Jordan that "you're black, you're a woman, and you're large. People don't really like that image."[61] For many, including Broyles, that was still true. Despite Jordan's fourteen years in politics, along with numerous electoral

victories, legislative achievements, and fame as an orator, journalists would not let go of that "black maid, black cook, black mammy" image. Did Broyles really fear that Jordan was going to "take over the world"? Apparently.

"Mammy" was a white myth invented to soften the horrors of slavery. Jordan, in contrast, was a Black woman elected to one of the main branches of government who wielded real power, a fact that many whites, including liberals such as Broyles, apparently found hard to accept. Depictions of Jordan as a "mammy" in revolt recalled Curtis Graves's taunts that she had never done anything for civil rights and was colluding with white men. It erased her years of work for voter registration and her anger at segregation. Her education, intelligence, oratory prowess, activism, and achievements were deeply rooted in Black—not white—institutions yet they brought criticism and cynicism. Jordan could never be what she appeared to be.

After Carter's victory, the Black press predicted that Jordan's work would be rewarded.[62] Although she easily won reelection in her own district, the 1976 elections did not increase Black representation in Congress. "We don't have all the figures yet, but we don't expect the number of Black elected officials to change much as a result of yesterday's election," said Eddie N. Williams of the Joint Center for Political Studies.[63] In Congress the status quo remained: one Black senator and sixteen Black members in the House of Representatives.[64]

However, many remained optimistic about Jordan's political prospects. The question seemed to be only which job Carter would offer. The Black press seemed gleeful and confident: "Big Jobs Tempt Jordan, Young" ran one headline; both representatives "can have prestigious jobs—if they so desire."[65] The *Washington Post* was less certain. Jordan "expected much, and may end up with nothing." Carter's own people gave a false impression to the press. According to the *Chicago Tribune*, "sources close to Carter" suggested that he was going to name a Black person as attorney general.[66]

Jordan met with Carter in mid-December, one week before he announced his cabinet. *Washington Post* columnist Walter Pincus reported that she went into the Blair House meeting expecting to be offered either secretary of Health, Education, and Welfare or attorney general. However, "Jordan's chances for Attorney General had been hurt by opposition from some congressional and Texas Democrats as well as the Congresswoman's political ambitions." According to Pincus, one Texas politician claimed, "She wants statewide office [and] that's why she was interested in an administration job. She has to stay in the

limelight." More negatives were quoted, again emphasizing that Jordan was not what she seemed to be. A Texas congressman emphasized Jordan's alleged duplicity: "Barbara's real character and interests have been obscured by her charismatic public image," citing her testimony on behalf of John B. Connally at his bribery trial. Her "debts" to the former Nixon cabinet member weighed against her. Others averred she was an unabashed supporter of Texas oil and gas interests: "She's a Texan first, a black second and a woman third [one] leader of the women's political movement said yesterday." The meeting between the congresswoman and the president-elect ended early: "Jordan emerged with a cold, fixed, expression, according to a reporter on the scene." Pincus implied that Jordan lacked the qualifications for any cabinet position.[67] The article was full of unnamed sources, innuendo, and outright distortions—indeed, the *Post* printed a partial retraction two days later: "In its Thursday editions, the *Washington Post* reported that support of oil and gas interests by Rep. Barbara Jordan was being cited by congressional sources as one of the negative factors in consideration of her for Attorney General in the Carter cabinet. Review of Jordan's voting record, however, shows that she voted against oil interests on many issues, including the end of oil depletion allowances."[68]

The shrinking number of African American officials considered for cabinet posts, or even assistant secretaries or deputy directors, was a growing area of concern for Black leaders. Andrew Young defended Carter by stating, "The thing I'm concerned about is not the number of Blacks in top jobs but who is setting the policies." Yet columnist William Raspberry pointed to the growing feeling that Carter felt no debt at all to Black voters, although they had supported him with greater than 93 percent of their votes.[69] Raspberry wrote: "Wouldn't it be ironic if Carter gave serious attention to more blacks than any president in history and wound up appointing no more than Jerry Ford, who got maybe 5 percent of the Black vote?"[70] Carter tapped Andrew Young to serve as US ambassador to the United Nations. He picked conservative white Georgian judge Griffin Bell, a personal friend, for attorney general.[71] Young defended Carter's choices and called Griffin Bell "a good friend." Despite opposition to Bell from the NAACP, the Senate confirmed him.[72]

Jordan continued to be criticized for turning down Carter's alleged offer of a post; a letter to the editor from a confused voter sought clarification: "If the lady was, in fact offered the job and refused it, she owes many people an explanation. . . . On the other hand, if she was never considered for the position, being

a woman and a black, the President-elect has the convincing to do, after all the black voters, figuratively speaking, broke their necks to elect him."[73] Gradually the real story emerged. Jordan had never been offered any position within the Carter administration.[74]

Perhaps in an effort to repair her public image and set the record straight about Carter, Jordan agreed to appear on a televised *Barbara Walters Special*. Although her interviews were marketed as a chance for Americans to get to know the private side of public figures, Walters was a serious journalist. Never shy, she opened the interview with Jordan by bringing up longstanding accusations that would never be posed to a man. Walters repeated the tiresome descriptions of Jordan—that she was "much admired but also much criticized for being blunt and aloof." She quoted Jordan's critics: "Blunt, cold, aloof, rude— that's how people describe you." Once again Jordan dismissed the accusations. "I can read those descriptions and wonder who are they talking about. They're certainly not talking about me." Yet she also felt defensive in a way that she was not when Paul Duke posed similar queries the previous year. "I am not in the business of remaking my personality. I let people think what they want to think."

Walters asked about Jordan's meeting with Carter and whether he had offered her a cabinet position. Jordan stated that Carter had called her up on December 9 and invited her to Blair House to talk about a cabinet position. She called the meeting "very cordial, very friendly, and very open." She was not seeking a cabinet position and told Carter that the only position she might consider "is one in the Justice Department . . . I have not second or third choices." She told Walters that she was not offered the position, partly because Carter had someone else in mind and partly because "some individuals in the South would have felt offended and uncomfortable if she had been appointed attorney general."[75]

Walters suggested that Jordan had not done much for civil rights or for women, noting that Jordan had failed to become a "team player" in Washington. "You're not a leader in the Black caucus. You're not out there waving the banner when women's groups get together." The accusations exasperated Jordan: "Well I think I've been contributing to the work of the team every time I get out of bed and go to work. There's a Black and there is a woman on the job, doing things hopefully beneficial to the interests of Black people and of women. If I don't choose to lead the cause or be chairwoman of the board, then so be it."

Walters then switched the subject and asked Jordan about rumors that she liked to drink alcohol and that she "goes to parties that last two or three days."

Jordan decided not to take offense: "I think I'm really fun at a party." Walters: "Are you really?" Jordan replied, "I am," and she then laughed and smiled. Walters, however, remained serious, even dour, asking, "Do you drink?" "I drink modestly," Jordan replied. Walters then asked her what she sang at parties. For some reason, this question made Jordan self-conscious, and she seemed to turn away somewhat bashfully. "They're mostly ummm . . . spiritual gospel music, that combination." Then Walters pounced, abruptly asking Jordan, "Is marriage something that comes into your thinking?"

Jordan jumped, clearly startled by the intrusive query. She removed her arm from the sofa and brought her hands together. She started to fiddle with her nails. "Oh, from time to time it comes into my thinking," she responded. Walters followed up and asked her, "What do you do when it does?" With a stone-faced expression, Jordan said, "I look around and see who's available, and I usually come up with a blank." Then she started to chuckle: "So then I don't get married." Walters then adopted a more concerned tone, and asked Jordan, "Would you mind if it didn't happen?" Jordan looked down momentarily, and then looked straight at Walters and furrowed her brow. She then confidently replied, "I don't think I'd take to my bed over it. As a matter of fact, I think I could survive it." A long, awkward pause followed. Walters's expression changed from concern to confusion, and the long silence continued. Clearly, Jordan had not anticipated Walters would ask such personal, even insulting, questions. Within her work environment, Jordan was treated with extreme respect. But the mainstream press no longer abided by such decorum.

Jordan ended the interview with a strong denunciation of Richard Nixon. "I feel he is a president who shouldn't have happened to the country. Richard Nixon, I can never forgive him for the way he—the cavalier treatment he gave our best institutions of government. I regret the experience of Richard Nixon for the country. Now does that mean it's all negative? There's nothing positive that I can still bring myself to say about Richard Nixon? I recognize that he made some significant breakthroughs in the area of foreign policy, and I am willing to concede that, but I also believe that those breakthroughs would have occurred eventually without Richard Nixon."[76] The conversation turned back to politics, but Jordan's attempts to control her image, or at least put forward a different side to her personality, failed.

Black journalists also contributed to cementing Jordan's negative image as a conservative and as a "sellout." Many of the same critical quotes that had

appeared in pieces by Broyles, Shapiro, and Ivins were repeated by a young Paula Giddings in a 1977 article in *Encore* magazine. In "Will the Real Barbara Jordan Please Stand?" Giddings noted that, after the Carter attorney general debacle, Jordan's "once rapidly ascending political star seemed to have been braked, at least temporarily. Within twenty-four hours the politician who had seemed above critics was being criticized by both colleagues and the press." According to an unnamed Black politician, "She is the most vindictive person I know, and she holds our political futures in her hands." Chris Dixie questioned her bona fides as a Black leader: "She's not a champion of the black cause," he stated. Giddings also invoked the mammy image. "To some whites, her visual appearance also symbolized the kind of solace that [*Gone with the Wind* actress] Hattie McDaniel provided on the screen." Jordan's appearance and her working-class roots were ridiculed: "Among Houston's blacks Jordan is the home town child who made it big. . . . She is the less than rich, less than attractive studious lady from the 5th ward who hobnobbed with the powerful and emerged intact."[77] It was hard for old class prejudices among Black Houstonians to wither. Personal barbs combined with fear and jealousy—whatever the origins of such comments, the bad and the cynical that was said about Jordan offset her achievements.

Nevertheless, such pieces did not reflect the views of the majority in her district, or even in the nation. "I remember the pride we felt in Barbara as a successful Black leader," said Judge Andrew Jefferson.[78] When she campaigned for Carter, Jordan spoke in Pennsylvania, New York, Ohio, Indiana, and California, and she drew crowds and acclaim. Not surprisingly, she loved it. "The reaction to me was what turned me on. I really enjoyed that."[79] Jordan's connections with her audience gave her energy and the optimism she needed to continue. She also temporarily dampened cynicism about the political process. Voters perceived that Jordan served her race and her constituents, and so they applauded her ambition and wanted her to rise even higher. "You know, you're telling me to vote for Jimmy Carter and I guess I will," said one student in Ohio, "but I sure would feel a lot better if I was voting for Barbara Jordan for president."[80]

To her many critics, however, her success and ambition reinforced a perception that she was a concealed conservative, and a "protégé of Lyndon Johnson who spoke Bob Strauss's language."[81] Criticism of Jordan's success and popularity came from many directions. In his book *Convention*, journalist Richard Reeves concurred that Jordan was merely being "used" by the Democrats "as a symbol that America worked." He then added a bizarre and grossly racist insult,

implying that even though Jordan may represent Black women, she simply did not belong as a party leader. Her place in that slot could only bring discredit and confusion to the Democrats, because "if a very large black woman who looked, to many Americans, like a maid, could become a national leader, well . . ." He left the ellipses hanging, but he had implied that Jordan's ascent proved the party's weakness, not its strength.[82]

Literary critics have observed that when "otherworldly" creatures, such as disabled Black women, intrude into spaces where they are neither expected nor accepted, the majority experiences fear.[83] Jordan's critics, unaccustomed and uncomfortable with a Black woman in a space and place of power, believed that she was not what she appeared to be. Her unmarried status and allegedly "aloof" indifference produced anxiety, confusion, and horror. Racist stereotypes like "mammy" were dredged up by liberal and conservative critics. Liberal white southerners like Broyles evoked the "Revenge of Aunt Jemima," who was "taking over the world." A Republican on the House Judiciary Committee told a reporter "that Barbara Jordan has a gothic preoccupation with power," hinting at something monstrous in her character.[84] The response to Jordan by white liberals and conservatives, and even by some of her Black peers, bordered on the hysterical.[85] Yet she remained calm, cool, and collected, explaining her position, and setting out why she—according to the nation's founding ideals—and the people she represented, had earned the right to exercise power and leadership.

Nevertheless, the Black congresswoman dubbed the star and hero of the Democratic Party had been completely left out of the newly triumphant Democratic administration. Jordan hit a Black glass ceiling. Although she saw the collision coming, it still hurt.

CHAPTER 14

From Virtue to Power

Last Battles

From virtue to power. What we are now about will require no small amount
of virtue and a great deal of power.
　—Barbara Jordan to the National Women's Conference, November 18, 1977

Jordan's last two years in Congress lacked the televised drama of the impeach-
ment hearings, and she did not have the opportunity to inspire millions of view-
ers as she did during the Democratic convention. But her work as a legislator and
Democratic Party leader continued. She focused her attention on the pressing
issue of extending the ratification deadline for the Equal Rights Amendment.
She also engaged in a protracted behind-the-scenes battle with southern con-
servatives who were threatening to upend the makeup of the Fifth Circuit Court
of Appeals, whose rulings had consistently enforced civil rights legislation. She
began to address feminist issues in her speeches and warned Democrats of the
growing conservative backlash. She also pondered whether she wanted to con-
tinue in Congress. As Jordan weighed her future, she also took on a personal
project, one that influenced her to think more deeply about her past.

　In the spring of 1977, Jordan started to collaborate with Texas novelist Shelby
Hearon to produce a book about her life. *Barbara Jordan: A Self-Portrait*, came
out in 1979 with Doubleday, a major commercial press. The timing of the proj-
ect suggests that Jordan may have wanted to answer her critics. A ghostwrit-
ten book would have been the ideal opportunity for the congresswoman to set
the record straight, tell colorful stories about other legislators, and recount her
bona fides as a civil rights activist. But *Self-Portrait* is not that book. "If I did a

book," Hearon told Jordan, "I see it as how you got from There to Here." Jordan responded by asking, "Where do you think here is?" Knowing that Jordan "operated from a basic distrust of journalists," Hearon replied, "I think here is on the road to Barbara Jordan." This was Hearon's way of saying that she wanted to present Jordan as an individual and not first and foremost as a politician. "Do you think I'll ever get there?" Jordan asked. "No, but I think you'll die trying." Hearon responded. "I want you to do the book," said Jordan.[1]

Hearon framed Jordan's story through the lens of popular psychology. Simplifying the theories of psychologist Erik Erikson, she saw Jordan's life as a series of "stages." She also drew on Abraham Maslow and Carl Jung.[2] Digging into Jordan's past, Hearon believed that by reconstructing the family environment she could explain Jordan's personality. She also wanted to hear Jordan's own version of events, with a focus on her political victories but not her struggles. Over the summer and early fall of 1977, Hearon interviewed Jordan extensively in Austin and in Washington, DC, and then dove into family research. She procured the legal documents regarding John Ed Patten's trial and took two research trips to Houston with Jordan and Nancy Earl. They "walked the bounds" of Houston's Black neighborhoods, visited Good Hope Church, and interviewed Jordan's family members, including her mother, her Aunt Mamie, and her sisters.[3] Nancy Earl arranged the travel, researched a Jordan family tree, and organized Jordan's interview schedule with Hearon. Earl acted as a research assistant, gave Hearon her version of some events, and made sure the writer had access to Jordan.

For that spring and summer, Hearon joined Jordan and Earl's special circle and agreed to keep the book a secret. "I hesitated to write Barbara feeling that staff might read mail anywhere I sent it," wrote Hearon to Earl.[4] Hearon wanted Earl to thank Jordan for spending time with her after their initial meeting: "Thank her also for letting me consume her gin and cigarettes as well as the lovely shrimp, shells and all." Jordan smoked, and Hearon took up the habit again. That meeting had gone well, and Jordan invited Hearon to their next party. "I'm really pleased," Hearon wrote, "to be invited to the Memorial Day weekend, incognito. Plan to bring my Kentucky chess pie and double fudge chocolate cake. . . . Will arrive at your place that Saturday in jeans, not as a writer."[5] Even Jordan's family and friends did not know she was embarking on a book.

Jordan and Earl's home on the five-acre lot in Onion Creek had become a place of retreat as well as a place to gather. The single-story home offered privacy but also simplicity. Visitors drove down a gravel road to reach the residence

located behind the side of a mound that hid the main entrance. The house had an open plan, with a stone fireplace in the center and a galley kitchen located to the right of the front door. Floor to ceiling glass doors and windows looked out onto an enormous meadow, making the living room and dining area almost part of the landscape. Trees shaded the back porch. Nancy Earl had worked with an architect to design the house, and she and Jordan enjoyed the tranquility of their home.[6] On special occasions they continued to share it with friends and family, following many traditions of singing, drinking, and eating.

The Memorial Day party was a great success. Hearon, in high spirits, typed out a letter to Jordan the minute she got back to Dallas: "Got back from Austin at 8 PM, trashed. Ate half cold baked chicken I'd left myself. Had two bourbons as Leontyne Price sang heart out in Il Trovatore." At the party Hearon met some of the couple's inner circle in Austin that defended Jordan against her critics. Some were liberals who made a distinction between themselves and those who criticized Jordan. DeCourcy Kelley, a loyal Democrat and the spouse of a prominent University of Texas psychology professor, told Hearon "that liberals are anathema." The Austin crowd joined the old friends and family from Houston's Fifth Ward. Hearon watched Jordan enjoy herself, drinking, playing music, and singing. "The five Justice Sisters and the three Jordan sisters singing Battle Hymn of the Republic—!" Hearon was thrilled to step lightly into this inner world. In the letter, Hearon wrote to Jordan but also about her; there is intimacy but also a clinical distance. "Was moved by the grand Memorial party," Hearon wrote. "Seeing and identifying with, your drinking to become, with difficulty and for that piece of time, a participant and not an observer."[7] How Jordan responded to these observations is not clear, but the fact that she decided to go ahead with the project after receiving the letter suggests she was not offended.

Most of the interviews with Jordan took place during the summer of 1977 in Austin.[8] Hearon knew she wanted to trace the stages of Jordan's life and gave her prompts for what they would discuss the following day. Hearon imposed chronology, order, and an interpretive gloss to Jordan's life. "I gave her the outline of the book at the start, and then each day told her what we would talk about the next day and why, so that her conscious and her unconscious and even her atavistic memories could work in our absence."[9] Both felt excited and fully immersed with the project. Hearon wrote to her editor at Doubleday, Sally Arteseros: "I want every afternoon to tell you how fabulous this has been with Barbara. We have both been on a two-week high, thinking about it around the

clock. Reporting in on what we each woke up in the night to note and remember. The two things she has said the most are: 'No one has ever understood that before,' or, 'I never saw that before; I never made that connection.'"[10] For Jordan, the interviews were a welcome opportunity to reflect on and think about the dynamics of her family past with a willing listener. The project was a relief from politics, not a deeper dive. For a person who had always focused on achieving the next big step, and planning the next big move, these therapeutic sessions gave Jordan a new kind of personal attention. Hearon wrote that she and Jordan "operated on the same precise wavelength." "It has been fabulous," she wrote to her editor, "for both of us. And I hope for everyone who reads it. I honestly feel for many reasons too lengthy for a letter, that no one else in the world could have done this book."[11] By the end of the summer of 1977, Hearon's first session of one-on-one interviews with Jordan was finished. The collaboration resulted in a book with two voices: excerpts from selected interviews in Jordan's voice telling her own story, followed by Hearon's background and analysis. Hearon included some context for Jordan's victories, but primarily she envisioned the book as narrating the creation of a singular character.

Hearon seemed to take for granted Jordan's significance in the movement for racial equality; she focused on Jordan as an individual. A white woman and a native of Kentucky, Hearon came from an established, elite family.[12] She was heterosexual, divorced, and the mother of a daughter. Her novels usually dealt with the life struggles of mature, white woman protagonists, particularly the efforts of wives to gain independence and meaningful work, and the relationship between mothers and daughters.[13] *Self-Portrait* was Hearon's first, and only, nonfiction project, and although the book touches on issues of race and class, Hearon, a feminist, was interested primarily in using birth order and family dynamics as a framework for understanding Jordan's personality. She treated the civil rights movement as something in the distant past. The interviews touched on Jordan's personal relationships or friendships outside her family. The parties at Onion Creek and how Jordan met Nancy Earl on a camping trip were included in the final text. At Hearon's prompting, Jordan spoke at length about marriage, and she began to think more about psychology. Earl's work on psychological testing at the University of Texas put the couple in close contact with activist and feminist DeCourcy Kelley, and her husband, Dr. Paul Kelley, both involved in feminist issues and school integration in Austin.[14] Some ideas from this circle of Austin scholars, writers, and feminists emerged in Jordan's

speeches in 1977 and 1978; she began to speak more often on the issues of women's rights and feminism.

Jordan joined other feminists who sought to implement a national legislative agenda. Before leaving office, President Gerald Ford had authorized a five-million-dollar grant to the International Women's Year (IWY) commission to hold a convention that would formulate a national plan of action. Through much of 1977, plans were afoot to organize the first National Women's Conference in Houston, Texas, in November of that year. To prepare for the main gathering in Houston, the commission sponsored events in each state.[15] In those smaller gatherings, a range of speakers celebrated the contributions of women to states and communities, identified obstacles to women's achievements, and developed policy proposals to increase the status of women. Delegates from local conferences would then attend the conference in Houston to develop a women's agenda for the nation. During the spring and summer of 1977, Jordan spoke at numerous forums and events across the country, including a "Womankind" conference at Duquesne University in Pittsburgh, an event that drew nearly four thousand participants.

Jordan took up the theme of why women needed to develop political courage. "Women," she said, had to "organize politically at every level—country, state, and national." Otherwise, "politicians won't listen to you. . . . That's the way politics works."[16] At Duquesne, Jordan pointed out that the numbers of women involved in elective office were miniscule. She probed her audience and asked why that might be so; she talked about "psychological conditioning." She called for a major effort to educate women who had been "brainwashed" by "traditional taboos" into "believing the myth that women are not as competent as men." From infancy, she claimed, "We have been conditioned . . . to be subservient to male dominance." She urged women to take on leadership roles and become political actors. "But government alone cannot eliminate deeply rooted prejudices," she cautioned. "Our first task is to win over other women."[17] Jordan then went on to discuss race and class, linking her support for the feminist movement with policies designed to help the poor and the struggling middle class. She criticized her own party leader, President Carter, and warned the audience that "women's rights are being hurt by a perceptible shift of America to the right." President Carter's upcoming "welfare reform" policies, she said, "will hurt most of the people it ought to help most." She pointed out that more than nine million women were on welfare, "most are young and some are uneducated." She called for passage of the Equal Rights Amendment.[18]

Jordan's speeches galvanized her audiences. Young women responded with great emotion, even reverence. During the Watergate era, Black journalist Hazel Garland had covered Jordan's appearances in front of Black crowds in Pittsburgh on numerous occasions. The journalist seemed taken aback to see Jordan evoke a similarly enthusiastic response from an audience of white women. So many wanted to hear her that the Hilton Hotel moved Jordan's speech to its grand ballroom. When Jordan entered the room, "she was given a standing ovation even before she was introduced." And after the introduction, "another thunderous ovation was given her. One would have thought Jesus had walked into that room." No one in that audience doubted Jordan's sincerity or the power of her message—which was extremely personal—or her strength and overwhelming confidence. Before equality could be achieved, said Jordan, women needed to start believing in their own worth. Garland saw "the predominantly white crowd applauding wildly. . . . Several young female students, wiped their eyes during Ms. Jordan's talk. They were really moved by her presence." Another standing ovation followed Jordan's conclusion.[19]

The state conferences leading up to the Houston convention were well attended. Jordan's speech at the Pittsburgh event was covered by the *New York Times* as well as by the local press and the Black-owned *Pittsburgh Courier*. Inspired by the feminist movement, more young women considered running for office. And yet, they had doubts. Jordan had called for increased grassroots activism and for winning over other women. But women candidates needed practical help with strategies and organizing. When Jordan was in Pittsburgh, the other seventeen women in the House of Representatives attended a "Washington workshop" aimed at helping women interested in politics run for public office.[20] Only eighteen women from across the nation attended; most but not all had already been elected to some position. Their comments at the workshop conveyed the dilemmas faced by women candidates.

The women at the conference identified as feminists, but they knew that if they made feminism the center of their campaigns to "win over other women," they would lose. Janet Watlington was planning to run for the congressional delegation from the Virgin Islands; she told a reporter that though she considered herself a feminist, "I'm not running as a woman, by the way, or as a black. I'm running as an individual. You can't be talking feminist issues when people are out of jobs." This approach reflected the conventional wisdom of the day. David Garth, who had directed the successful campaigns of Mayor John Lindsay and

others, told the women to "do an issues campaign, but not an exclusively feminist one." He boosted the women by acknowledging the prejudices they faced. "You have to have the facts more than the men," he said. "Women should be more concerned with jobs, because in people's minds, for some unknown reason, that's not what people think that women are concerned about." He also told them to avoid tears; to do so would hurt them just as much as it had Edmund Muskie. The atmosphere was supportive, but the women candidates received no financial help from the DNC. One of the organizers bluntly stated that if a woman did not have enough money to pay her own way to DC, "then they weren't going to be viable candidates."[21] There was no EMILY's List to support women candidates, few consultants to help, and—according to the would-be candidates—very little media interest. Budgets were tight. Campaign paraphernalia ranged from T-shirts to old grip disks that opened jars. Throughout much of the country, if a woman ran, there was no feminist network to support her. Even during the "International Year of the Woman," women candidates needed to downplay women's issues. According to conventional (male) wisdom, the word "feminism" was politically toxic.

But somehow those political realities did not temper certain criticisms of Jordan that kept coming. Shortly after Jordan's appearance at the Womankind Conference, journalist Myra MacPherson wrote "Looking Over Jordan: Black, Women's Groups Complain as the Eloquent Texan Goes Her Own Way." (It was later reprinted as "Rep. Jordan in Eclipse.") The piece, which appeared in the *Washington Post*, asserted that "many liberals, blacks and women on the Hill have been angered, not so much with what Jordan is but because she does not fit their vision of what she should be. To them, she is a paradox who votes liberal most of the time but pals with the conservatives. They see her ambition leading to cautious politics at the expense of issues." Whether that was actually the case, MacPherson did not weigh. She gave no examples of any issues that Jordan had compromised. MacPherson's sources commended Jordan's work ethic and her liberal voting record, but MacPherson repeated the usual complaints, usually anonymous, unspecific, or coy, about Jordan's alleged conservatism and aloofness toward other women and African Americans in Congress. MacPherson concluded that the negative perception of Jordan in Congress was so great that she was in "eclipse," and her career was largely "over."[22] MacPherson was but one voice in an echo chamber among liberals. For example, Jordan had been tapped to give the opening keynote in her home city of Houston for the upcoming

National Women's Conference, but the publicity surrounding her appearance took on the same critical tone. Jordan, according to the organizers, was "no militant for black or women's rights. Jordan is both praised and condemned as a pragmatist."[23] In much of the press, Jordan's image as a closeted conservative was seemingly established.

Such statements, however, never much influenced how popular audiences received Jordan. On November 18, 1977, a crowd of two thousand women delegates and ten thousand observers gathered at the Albert Thomas Convention Center in Houston for the unprecedented National Women's Conference. A surprisingly diverse number of delegates came from every state, representing an extraordinary number of women's interests and issues. Three first ladies, Betty Ford, Lady Bird Johnson, and Rosalynn Carter, appeared at the opening-night gala and sat on the platform for the first day's festivities, but the real stars were local feminist activists who came to demand change and to honor the women who were breaking barriers.[24] Female Olympians ran 2,600 miles, carrying a torch from Seneca Falls, New York, to Houston. Bella Abzug and Gloria Steinem came, and so did gay and lesbian women, women of every ethnicity, women who supported the rights of sex workers, and women who aspired to political office.[25] The federally funded convention was meant to be big, bold, and bipartisan. Whether all these factions could unite remained to be seen.

After a rousing rendition of the "Star-Spangled Banner" and the reading of a Maya Angelou poem, former first lady Lady Bird Johnson opened the convention and introduced Jordan, the keynote speaker. Jordan opened by turning a biblical quote on its head. "In the 31st chapter of Proverbs," she began, "there is a litany of praise for the worthy woman which begins with, 'who can find a virtuous woman? For her price is far above rubies.' From virtue to power, [dramatic pause] . . . what we are now about will require no small amount of virtue and a great deal of power."[26] In America, women possessed virtue, but men wielded power. If women were going to be truly equal in America, those gendered assumptions about politics had to change. Jordan understood why women had to project themselves as moral and virtuous, but to gain equality women needed to move beyond this gendered paradigm. Women had to see themselves as powerful and be comfortable with power.

But Jordan did not frame the debate as that of an oppressed group struggling against an oppressor. She did not allude to the statement by abolitionist

orator and activist Frederick Douglass that "power concedes nothing without a demand. It never did and it never will." She took a different tack. Riffing on the Carter administration's "emphasis on human rights in the conduct of America's foreign policy," Jordan suggested that the nation needed to look no further than its own treatment of women to see abuses of human rights. Jordan told the crowd, "Human rights apply equally to Soviet dissidents, Chilean peasants, and American women. Women *are* human; no one disagrees with that. When our rights are limited or violated, a domestic human rights effort is required."[27] Jordan moved her audience by proceeding from an undisputed premise, that women were human beings and deserved equality. Bella Abzug was a better-known feminist, and certainly far more flamboyant than Jordan. But it was Jordan who had the crowd "on their feet in a wave of ovations."[28]

Jordan then discussed the relationship of the women's movement to freedom: "Each of us should be free to define the meaning of 'total woman' for ourselves—and without externally imposed encumbrances." She insisted that differences among women were natural and did not automatically lead to divisive disruption. "This conference is inclusive in its representativeness," she stated. "There are racial, economic, social, political, cultural, and ideological differences. Those differences cannot and should not be ignored. . . . No one person, nor no one sub-group can have *the* right answer." But difference and diversity need not preclude unity over essential principles. Do not fall into the trap of believing that women could not unite, Jordan urged. Women must "refuse to be brainwashed by those who predict chaos and failure, keep their goals in sight, and be aware of the forces arrayed against them." Give a little and share a little, she said.[29] "At a time when the country is drifting, if not shifting, to the right, civil rights and affirmative action efforts are lagging. Intra-women's movement rancor should be displaced with a declaration of inter-dependence and commitment to goals that are achievable. This is a time for foot soldiers, not kamikaze pilots."

Watching the emotional response to Jordan's speech from the packed auditorium—the "foot soldiers" Jordan was addressing—journalist Sally Quinn noted that "many delegates felt exultation toward the end of the morning session, felt a high they had never expected."[30] That "high" perhaps came from being exposed to a new way of framing the feminist debate, an approach where everyone could be included. Instead of being querulous and fractious, Jordan had bridged divisions, cut through arguments about gender roles, and cast the differences among the women delegates as surmountable. The nation professed a sacred

belief in individual rights, and that idea, in her view, was true of the women's movement, too.

Of course, for many feminists in that period, the fight for individual legal equality failed to address deeper cultural practices related to patriarchy and the family. That same framing failed to address prejudice against lesbians, and institutional racism faced by Black women. But Jordan wanted her audience to feel unity, not division. Like many women in America, Jordan was increasingly drawn into the debate over the Equal Rights Amendment when the conservative pushback against it began to gather steam. To feminists throughout the country, the ERA debate symbolized the direction the nation was going to take when it came to women's rights and gender equality. Back in the early 1970s, when the amendment was first passed by Congress, its passage seemed inevitable. But by the fall of 1977, conservative women had grown more organized, and they too began to see the amendment as not just a question of law but of culture and values. Who would win?

The very weekend of the National Women's Conference, some twelve thousand conservative women, led by Phyllis Schlafly, gathered in the same city to attend an antifeminist, "pro-family" conference. The policies endorsed by the NWC—gay rights, federally funded abortions, social security for homemakers, and the Equal Rights Amendment—were anathema to the conservatives. Jordan had emphasized the right of every woman to shape her own life, but the women at Schlafly's event pitted feminists and lesbians against "homemakers." "They're going to drive the homemaker out of the home," Schlafly said. "If you make us equal it takes away the right to have the mothers in the home," "The ERA will only benefit homosexuals. We reject the ERA." Betty Ford, Lady Bird Johnson, and Rosalynn Carter were attacked for supporting the IWY conference. One speaker said, "I watched three First Ladies, dressed according to White House protocol, approving sexual perversion and the murder of unborn babies. What a Disgrace!" The issues of abortion and lesbian rights stirred Schlafly's audience like nothing else; and the conservative women tied them both to the Equal Rights Amendment. "If you stay with us the ERA will die," Schlafly confidently predicted.[31]

Jordan had begun her speech by stating that "the goals of the conference are non-controversial," but the Schlafly-led conference showed that assertion to be wishful thinking.[32] Attempting to frame the debate in terms of human rights did not succeed; instead the "pro-family" unity rally placed the IWY feminists on the defensive. The urgency was clear. Ratification of the ERA was still three states

short, and Congress was considering a joint resolution to extend the deadline from March 22, 1979, to March 22, 1986. When Jordan returned to Washington, the ERA deadline extension debate would draw the same two opposing sides.[33] Jordan felt so strongly about the ERA that she suggested that if the amendment were not ratified, a new ERA amendment should be introduced.[34]

But first she had an unexpected announcement to make. Just weeks after the Houston convention, on December 10, 1977, Barbara Jordan called a press conference to declare that she was retiring from the House of Representatives. She would not run for a fourth term. No one could believe their ears. "A stunned disbelief greeted her repeated assertion that she has no plans, as yet, for her future." During nine minutes of skeptical questioning, Jordan reiterated her lack of plans: "I don't have a hidden agenda, believe it or not," she said. "I really don't." Jordan dismissed rumors that she was retiring because of poor health or to seek a judgeship.[35] She framed her decision using the most personal language possible: "for reasons predicated totally, and I need to underscore totally, on my internal compass directing me to do something different . . . I shall not seek elective office in 1978."[36] Jordan's explanation threw legions of admirers, supporters, and critics into a whirl of confusion. Surely she had an underlying motive. Some in Houston speculated that she would run for mayor, as no one could imagine her out of politics altogether.[37] The irony was that a few weeks prior to this announcement, journalist Myra MacPherson had labeled Jordan as "eclipsed" and discredited, with nowhere to go. But now, according to the press, she was at the height of her career and being dishonest about why she was leaving. "Barbara Jordan Won't Reveal Why She Is Quitting Congress."[38]

The Black press also registered disappointment. Some journalists could not resist getting in a dig. The Black-owned *Los Angeles Sentinel* announced Jordan's departure by describing her as "not particularly physically attractive in accordance with Western standards."[39] Many Black women journalists, however, felt devastated. Ruth Washington, also writing in the *Sentinel*, expressed great sorrow, but also appreciation. "In my entire life," she wrote, "rarely if ever has anyone made the impression that Congresswoman Barbara Jordan has made. This woman has made all Black women proud of her since the day she was sworn in as a member of Congress." Washington rued the missed opportunity to appoint Jordan to the Supreme Court and asserted that Carter refused her a cabinet position because Jordan "was just too smart for some members of that Administration." She ended her column by summing up Jordan's significance not just

as a legislator and orator, but as a symbol: "She has shown millions of people that a black woman can do anything she puts her mind to and that a southern black woman can become one of the most influential people in the world."[40] Such reverential statements, although sincere, did not go to Jordan's head. She once remarked to congressman Ron Dellums that she could "just do nothing but walk in a room, and get a standing ovation. You and I both know how much time it would require me to gain the power and influence that they already think I have."[41] Jordan did not confuse her celebrity status with real power. She had been deeply disappointed to be left out of Carter's cabinet, but to the end of her time in Congress, she continued to exert influence as best as she could.

After her retirement announcement, Jordan remained on the job. She had important work to do. Toward the end of the fall term, her co-author Shelby Hearon went to Washington, DC, to observe Jordan and her staff. Hearon's notes emphasize the disconnect between the warm, human world of Jordan's life in Austin with her impersonal surroundings in Washington: "Barbara's office—as with her life in Washington—was crowded and public."[42] It was still not public knowledge that Hearon was writing a book about Jordan, and the secret was kept: "Word was passed to all the constant flux of journalists—plowing through scrapbooks for secondary sources to turn into third hand stories—that I was working on a master's thesis. Which gave me license to wander around carelessly attempting to commit serendipity in a public place." Hearon observed that Jordan's office contained her portrait by Richard Avedon (which showed her looking slim, hands on hips, wearing a white suit, and looking, unsmiling, into the camera). Hearon reflected that "much of my time was spent climbing stairs" to get coffee: "Watching, listening, absorbing the atmosphere, I made at least two trips daily down six flights of stairs to the basement cafeteria and back again." Two floors up, she found boxes that contained "the accumulated outpourings of the passions of strangers"—letters to Jordan from her constituents and fans. She used excerpts from those letters in *Barbara Jordan: A Self-Portrait.*

On the wall in Jordan's inner office hung a Polsky Morgan painting of a "tender black man bending over a small black girl," a comforting reminder of Grandpa Patten; but overall Hearon thought that "Barbara's private office seemed empty of her." Jordan sat behind a giant walnut desk, while Hearon sat across from her in a "stiff navy leather chair." The office struck the writer as businesslike and impersonal: "It was a distance farther than past and present time from her place on Onion Creek with cypress and watercress or my place in the

hill country with red oaks and dogs on a spread of sunsets." Hearon noted the "ceaseless jangling of bells notifying members of calls to sessions," but the only legislative matter that caught her attention was the ERA extension ratification. She heard Jordan promising to make a personal approach to majority leader Jim Wright: "I'll take care of him."

During Hearon's visit to DC, she and Jordan met on Saturdays in the condo Jordan shared with Nancy Earl down on 6th Street by the waterfront. Hearon reflected on Jordan's serious demeanor, a far cry from the laughter and warmth of Austin. However, even in that setting Hearon had experienced some of Jordan's personal rigidity that carried over to Washington. "First item was arrangement for lunch. Now Barbara doesn't cook and when we had done the taping session in Onion creek this had become a fine delicate matter. If she was not going to cook for me and I was not going to cook for her and we were not going to trek up the highway for barbeque, which would then have got into an arm wrestle over who drove which car, then we had to solve the problem which we did by the most agonizingly equal division of synchronization of the preparation of two hamburger patties on the grill or two portions of chicken in the microwave oven." The problem of lunch and labor was more easily solved in Washington. Jordan simply called one of her administrative aides to come up with barbecue, coleslaw, and two sixpacks of lite beer. The two women settled into the apartment; "done in browns tans and blacks," it felt more like "home," according to Hearon. They talked about whatever came to mind. They talked about her weight and her efforts to lose it. They talked about her attitude toward money—"a favorite topic," according to Hearon. Hearon spoke, too, about "my vexation about the endless repetitions in news stories taken from other news stories, the apocryphal that has become legend, taken as gospel, put into quotation marks with impunity. The *New York Times* has used as source the shaky *Texas Observer* piece." Hearon was referring to the piece by Molly Ivins that contained some very unflattering remarks about Jordan from some of her old teachers at Wheatley. "She showed me the cover on *Encore* Magazine with a photo of her in which they had placed a string of pearls. 'I don't own any pearls,'" she said. Both women cared about Jordan's image in the press but felt powerless to challenge or shape what was being printed.

Back at the office, Hearon followed Jordan at work and experienced first-hand Jordan's celebrity status among adoring fans who did not care how Jordan was depicted in the press. After she gave a speech to the Civil Rights Division

at the Department of Justice, Jordan walked down the hall with office manager Bud Myers on one side and Hearon on the other. The crowds came at her. "It was like traveling with a film star in the 40s," wrote Hearon. "Strangers and acquaintances tugged at her jumper, clawed her arm, almost knocked her off balance as they shouted, wheedled, pleaded for attention and favors. A typical entourage of groupies who wouldn't let us go. As the elevator door closed—I told her 'You've got to get out of here.' 'What did I tell you,' she said." Hearon attended a fundraiser for the Congressional Black Caucus that included "black luminaries" such as Alex Haley, Andy Young, and Shirley Chisholm. Jordan "continued to be kissed, hugged, poked, pulled, mauled by passing hordes shouting, 'How's our Barbara—Hey Barbara you remember me don't you?' all wanting only to make contact with the legend, to touch the soft shirtwaist." They went to the ladies' room, and when Jordan had finished they heard a woman shout, "Barbara Jordan used my bathroom stall!" They laughed, and Hearon quipped, "Even black Jesus needs to pee."[43]

Such descriptions of the emotionally charged atmosphere surrounding Jordan in Washington provides some of the context for her decision to leave Congress, but not all. Jordan never mentioned her illness to her co-author, and Hearon never remarked on Jordan's physical difficulties getting around at this time. Hearon, like everyone else, had to accept Jordan's story about her "bum knee." Bob Alcock remembered the increasing difficulty Jordan experienced simply getting from her office to the floor of the House. An office worker he said, "had to go down to the basement get the car, park on the Rayburn horseshoe, and he'd drive her across the street or over to the House." People in her office remembered her stoicism. Alcock recalled: "It hurt. You knew she was in pain; That's a pain she lived with 24/ 7 that's got to do something, that must be rough."[44] But it seems that everyone around Jordan never mentioned her pain and her disability.

Despite her discomfort, Jordan made her way to the floor of the House. Once there, she took her place in an aisle seat, where it was well known that she spent much of her time meeting with colleagues and conducting business. Jordan chose a location where other representatives could easily approach her. Those who knew her, or needed to see her, came by. Some, however, attributed her sitting by herself to an unwillingness to sit with members of the CBC, or to an aloof, superior manner. Indiana Democrat Lee Hamilton recalled that "Barbara was not a particularly friendly person; she was not a Charlie Rangel. There

was an aloofness to Barbara that was hard to penetrate." He believed that her increasingly visible disability affected her work and contrasted Jordan's sedentary style on the House floor to his own: "Barbara was already beginning to be immobile. That has a big impact. She moved very slowly. I believe she was using canes by the time she left the Congress. That was a huge hindrance for her." Hamilton believed it was essential for a representative to talk to others over the course of the day, especially before a vote, and he could not conceive how any congressperson could do the job sitting down. In an interview he recalled, "Barbara would come to the floor of the House and she'd sit down. Most members would use the time on the floor to contact other members . . . and almost every member of Congress would carry around a card." Hamilton used his thumb and his middle finger to snap an index card in his upper left-hand suit pocket. On that card, he said, was a list of all the people he needed to see that day, and to him, those meetings required movement. How else was a congressman supposed to talk to people and do their job, without walking around? "So the immobility was a very large handicap for Barbara. She was never very mobile, and toward the end of her stay she was almost immobile."[45]

Hamilton's comments illustrate how a stigma associated with illness and disability permeated Congress. Not until 2002 did a candidate for the US Senate "come out" to the public about his multiple sclerosis.[46] Hamilton and others perceived Jordan's immobility as a bar to competent functioning—even a disqualification from holding office. Such attitudes help to explain Jordan's reluctance to be open about her illness, as that knowledge would be used to denigrate her and undermine what she hoped to accomplish. And yet Jordan was not completely masked. Everyone saw her using support. But the dominant political culture of her peers, even her staff, called for an alternative explanation. The expectations, both within her own mind and in the prevailing culture, for a rigid adherence to the so-called normalcy of able-bodiedness, led Jordan to avoid acknowledging her illness, referring instead to a "bum knee." Using that explanation protected herself as well as those around her and allowed everyone to avoid acknowledging the truth of her disability.[47]

Jordan seemed to regard her illness as something to patiently endure, and perhaps even as a test of her independence and moral character.[48] Oscar Mauzy, her old friend from the Texas Senate, recognized her symptoms and suggested she see an MS specialist he knew at a hospital in Dallas. "I don't have anything like that," she snapped, and cut him off. Yvonne Burke also felt excluded: "She

changed. It was just so difficult for her to get around, and she was not as free and easy as she had been before." The phrase "free and easy" was not one that many of her peers had ever used to describe Jordan at any point in her life. She was always known for her work ethic, but now her colleagues noticed that she was taciturn and inward. Jordan was always used to holding in her emotions, but these comments give some idea of the severe challenge she now faced and how she struggled. "Barbara used to be able to go on and on," said Colorado representative Patricia Schroeder, describing the social demands of evening receptions followed the next day by endless meetings. "But then she couldn't do it."[49]

People who considered themselves close to Jordan professed not to know about her illness. A letter from Hearon gives some indication how shocked Texans were when they heard of Jordan's retirement, as well as her own discomfort when asked about it.: "Liz Carpenter (press secretary to Lady Bird Johnson) called late last night to ask about Barbara getting out of congress how could she, & I am still feeling all those fingers & eyes, but there's no way to say that." Hearon continued to insist that Jordan was not sick. The writer had been presiding over a luncheon in Austin honoring "outstanding women" when Elspeth Rostow, a dean at the University of Texas and spouse of economist and former White House assistant Walt Rostow, approached her. "She said she hoped B would do something with LBJ school. And I said that sounded nice. Whatever. I'm going to get little cards printed saying: she's not sick. Don't ask me anything."[50] This revealing exchange shows that Jordan still had not told Hearon about her condition. It also suggests that Jordan had not made definite plans concerning her retirement.

But keeping quiet about her illness, however difficult, was clearly important to Jordan. Despite what others might have thought, her lack of physical mobility did not impede her political nous, and she still commanded great respect among her peers. After a monthlong recess, she returned to Washington, DC, in January 1978 for her final session. She continued her work on behalf of the Democratic Party and the ERA. In March 1978, she was the keynote speaker at a Democratic fundraiser in President Carter's home state of Georgia. In what proved to be a prescient speech, she urged her audience of fifteen hundred prominent Democrats to get busy: "The Republican party is ready to do battle, and we'd better get ready too." She worried that Republicans were gaining ground among Black southerners, and that Democrats would lose seats in the midterm elections. She added that she was glad to be in Georgia because it also gave her an opportunity to campaign for ratification of the Equal Rights Amendment.[51] In April

Jordan and nine other women in Congress wrote a letter to the *New York Times* denouncing the paper for opposing the extension of the ERA deadline: "Some opponents of the ERA have launched a nationwide scare campaign. They have spent enormous sums to frighten, mislead, and confuse the American public." The representatives insisted that Congress had the responsibility to ensure that informed debate took place; they called for a seven-year extension and pushed back against the original timeline as wholly arbitrary.[52] A bill to extend the time for states to ratify the Equal Rights Amendment was in the hands of the House Judiciary Subcommittee on Civil and Constitutional Rights, headed by Congressman Don Edwards of California. Edwards favored extension, and his subcommittee heard the testimony of Ruth Bader Ginsburg—then a Columbia University law professor—Phyllis Schlafly, and Barbara Jordan.

Appearing before the subcommittee on May 18, 1978, Jordan pressed for extending the deadline for ratification: "If more time were allowed for a full and free discussion of the issue," she contended, "there may be sufficient understanding so that ratification could occur within the time frame of the resolution before you." Jordan argued that the timeline of seven years was not "traditional" (only four of the twenty-six amendments had that timeline). But Jordan's most interesting argument was that Congress was still not finished debating the meaning or significance of other constitutional amendments, such as the Fourteenth: "The debate will not cease. It will not cease with the passage of time." She felt that, as with every other constitutional amendment, the meaning of the Equal Rights Amendment would always be subject to debate, interpretation, and implementation by Congress and the courts. She also argued that although the Declaration of Independence put forward ideals of liberty and equality, "it took the Constitution to give it some structure." She insisted that Congress had the responsibility to translate those implied rights into law, and the Equal Rights Amendment represented a logical statement of the individual rights of all citizens idealized in the declaration. For those who claimed to support the amendment but not the extension, Jordan had an answer: "This is a political question." She challenged them not to hide behind the alleged technicality of the law to deny "the absolute essence of what this republic is supposed to be about."

Under questioning, Jordan poked fun at her adversaries. Massachusetts representative Father Robert Drinan asked Jordan to reflect on the strongest argument on the side of the opposition. Jordan replied, to appreciative laughter, "That is a question that I really can't answer because the argument on the other side is

so hollow and empty." As she discussed the issues, she spoke to the committee but also played to the appreciative audience in the House chamber. Jordan personally identified with ERA activists and used the pronoun "we" in her responses. When Congressman Robert McClory from Illinois asked whether it might be better to focus on getting three states to ratify in the next two years rather than expend energy on extending the deadline, Jordan deadpanned, "Whether you can believe it or not Mr. McClory, we are very versatile people and we work on both fronts." Illinois had not yet passed the amendment, and she asked the congressman to assure her his state is "going to somehow revert from its careless ways and become champions of human rights." When McClory told her that some state legislators, supportive of the amendment, opposed the extension because the issue was becoming too divisive, Jordan's response was simply: "I disagree with those state legislative members and I say that they are wrong."[53]

The ERA extension debate continued through the summer. In July more than fifty thousand women gathered on the National Mall to march in support of the extension bill. It was the largest public gathering of women in American history thus far.[54] In August, after a full day of debate, the House agreed to a compromise extension of thirty-nine months. Jordan was there on the floor of the House for the entire debate. Representative Trent Lott from Mississippi indicated that the entire vote was pointless: the Senate would most likely not act. "Why are we going through the agony and the ecstasy," he said, calling the whole vote "an exercise in futility." But Barbara Jordan called him out: "Women," she said, "have been going through the agony and the ecstasy all of their lives and we will continue to go through it until the ERA is part of the Constitution."[55] President Jimmy Carter signed a joint resolution, passed by a simple majority in both houses of Congress, which extended the deadline until 1982.

Jordan had one more big battle ahead of her. During her final months in Congress, in the spring and summer of 1978, she fought against the impending breakup of the Fifth Circuit Court of Appeals. Since his election President Carter and his attorney general, Griffin Bell, had attempted to create scores of new federal judgeships in the nation to deal with the crushing caseload. But the Senate bill creating those judgeships also split the six southern states contained in the Fifth Circuit into two districts. The new plan put Louisiana and Texas in a marginal district of their own, leaving Alabama, Georgia, Mississippi, and Florida in the Fifth Circuit. The civil rights community feared that splitting the Fifth Circuit would destroy an institution that consistently ruled against

racial segregation and discrimination. Legendary judges on the court, such as Elbert Tuttle, John Minor Wisdom, and John Brown, had been described as "the institutional equivalent of the civil rights movement itself," and they had turned the *Brown* decision into a sweeping mandate for racial justice.[56] These mostly Republican judges suffered reprisals and threats with dignity; the impact of their decisions had been—and continued to be—profound. The plan to split the court threatened to dilute their power and create a new, more conservative, circuit. Elaine Jones of the NAACP Legal Defense Fund recalled the significance of the battle: "So here we have the most active court that made a difference in the quality of life for all Americans, especially African Americans in this country, because the rules apply to all of us. . . . And the Fifth Circuit Court of Appeals was the Deep South circuit: Alabama, Florida, Georgia, Louisiana, Texas and Mississippi, the Deep South circuit. All the post-*Brown* cases . . . came through there. They were some brave judges on that court, brave in their time."[57]

What made the proposal particularly concerning to the civil rights community was that the split was championed by arch-segregationist James Eastland, a Mississippi senator, chair of the Senate judiciary committee and foe of civil rights legislation since the 1950s.[58] Using his power as committee chair, Eastland had made the split a condition to creating more judgeships. Carter and Bell did not seem to think that ending the power of the legendary Fifth Circuit mattered, and they both supported Eastland's bill. But the NAACP Legal Defense Fund disagreed, as did Judge John Minor Wisdom, who was seated in Louisiana. Judges from Texas also opposed the split and testified against it. Elaine Jones recalled, "That bill would have killed us. . . . I went to Barbara Jordan and I said, 'Ms. Jordan this is what they're getting ready to do in the Fifth Circuit.' And she understood it. . . . I went to Ted Kennedy on the Senate side. . . . They held that bill up for a year. They would not let it go."[59] But eventually the senate committee did allow the bill forward to the House. As a member of the House judiciary committee, Jordan was determined to oppose the measure and keep the circuit together.

Political scientist Deborah J. Barrow interviewed Jordan about the Fifth Circuit dispute for her book coauthored with Thomas G. Walker, *A Court Divided*. In a chapter called "A Game of Chicken," Barrow described the clash between Eastland, chair of the Senate committee sponsoring the bill, and Jordan, an influential member of the House subcommittee handling the bill. Jordan knew that Black southerners had achieved many gains through the rulings of the Fifth

Circuit and worried that progress might stall if the court's jurisdiction were diminished. Although Jordan was not even chair of a subcommittee, her relationship with House Judiciary Chairman Peter Rodino was so strong, that he promised to defer to her will. He told her, "Barbara, nothing's going to happen that you don't want to happen on this." Jordan explained the significance of his support to her interviewer: "You are in a very strong position to begin with when you've got your chairman working with you, because Rodino was both chairman of the subcommittee and chairman of the full committee."[60] She acted with confidence.

Jordan was appalled that the liberals on the Senate committee had managed only to stall some of the undesirable aspects of the Fifth Circuit bill rather than kill it: "What was the surprise to me was that friends of civil rights who were members of the Senate let the split of the circuit get through without any opposition being voiced, as far as I could tell. And once it got to us on the House side, we were looking around. Well, where's Senator Kennedy? Where's Senator Bayh? Where were those people?"[61] The Senate version of the bill split the circuit, just as Eastland had wanted it to be split. Jordan was given charge of the conference committee tasked with coming up with a compromise version of the House and Senate bills. Both versions agreed to increase the number of federal judgeships, which is what Attorney General Bell and President Carter wanted. But the House side refused to split up the circuit. Since the split was still included in the Senate's version of the bill, however, Jordan's refusal to let it go threatened to stop the expansion of the entire federal judiciary, something Bell, a former judge on the Fifth Circuit, desperately wanted to achieve.

The House subcommittee held hearings. When Griffin Bell sat down to testify, Jordan lectured him on why she could not support his proposal to split the Fifth Circuit. Bringing up her southern roots and describing Black life under segregation, she praised the Fifth Circuit "as a bulwark of civil rights and individual liberties." She chastised Bell for implying that the increase in judgeships had to be linked to the breakup of the circuit, telling him there was no reason why the two issues could not be decided separately. Furthermore, the process would not be rushed: "There is going to be no effort, certainly on the part of this chairman or any members of this committee, to cut off further testimony on the splitting of the Fifth Circuit, and we are going to reach a decision, and when the majority rules, that is going to be it and we will all abide by it." Jordan did not allow Bell to speak. He could only listen. She ended her lecture, and her time,

by stating, "I have no questions Mr. Attorney General, but I did want to make those statements."[62]

The hearings continued through the late fall of 1977 and early months of 1978. Several of the judges in the Fifth Circuit, including Judge Wisdom of Louisiana and Judge Brown of Houston, also disagreed with the split and testified to that effect. In addition to the circuit split, there were other conflicts to be ironed out. Carter had promised the judiciary dozens of new positions, but members of Congress wanted guarantees that the new judges would be chosen from a more diverse pool, while others were concerned that traditional prerogatives for choosing judges would be upset. A compromise was enacted—more judges for appointments, and no imposed racial or ethnic quotas, but some reassurances were given that more African Americans would be chosen. Carter and Attorney General Bell did not, in the end, force the Senate to create anything other than nominal, rather than independent, "merit boards" to vet and recommend federal judges. Jordan, upset with the lack of attention paid to racial diversity on the bench, called the language in the bill "hollow, vain, and useless."[63] In early February 1978, the House of Representatives voted by a wide margin in favor of the new judgeships. "My support is not unqualified and not enthusiastic," said Barbara Jordan. "The committee deferred to politics, to certain political realities."[64]

But the issue of splitting the Fifth Circuit still needed to be decided between the House and the Senate. Barrow and Walker detailed Senator Eastland's strategies to get his way by making the House subcommittee bow to his will and agree to the split. The pressure was on. President Carter was demanding that the whole bill be enacted. The chief justice of the Supreme Court pleaded for its passage. Congress was close to adjourning, and if the bill did not pass, the measure would die. Now the tables were turned, and instead of Eastland holding up a vital bill, as he had with the 1975 Voting Rights Act renewal, it was Jordan who stood in the way of something the old segregationist wanted to accomplish before he retired. Eastland searched for a way to get his bill through before it failed completely. Indeed, he threatened to have the whole bill die—which would have included the provisions expanding the number of judgeships— rather than compromise. A staff member called the standoff between Eastland and Jordan "a game of chicken."[65]

The first conference session was held on April 11, 1978, and five more were held before May 17, when the House conferees voted six to four against splitting the Fifth Circuit. Eastland said he would wait until July to vote again, when

members of Congress would be feeling pressure to go home. Jordan recalled that, in this period, Eastland met one-on-one with members of the House sub-committee. "What Senator Eastland did not know," Jordan said, "is that as soon as they would meet with him they were coming back to me saying, 'This is what happened.'" When she asked her colleagues on the committee what they said to Eastland, they replied, "'I told Senator Eastland that as you go I go.' I said, well now, that's the proper position. So we'll keep it at that."[66]

Eastland finally requested a meeting with Jordan herself. When she arrived at a room in the middle of the Capitol, she found Eastland and his friend Sen. John Stennis, also of Mississippi. Jordan, double-teamed by the two old segrega-tionists, sat and tried to reason with both senators: "The three of us sat there to try to break this deadlock. . . . Senator Stennis was very complimentary of me. He said, 'You made a fine speech at the Democratic National Convention.' And I thanked him and all for that. And he [Stennis] said 'Can't we work out this Fifth Circuit business?' And I said, 'Well Senator, what you have to understand is that the reason many people who are Black have progressed is because the Fifth Circuit has been a citadel for fairness and that's something we don't want to lose.'" Jordan then tried to separate the issue of the split from the judgeships. "Why don't we just leave the circuit as it is," she suggested, "because you have announced that you are retiring from the Congress after this session, and I have announced that I am retiring from the Congress after this session, so why don't we let a subsequent Congress take care of this issue?" But that didn't get any-where. Undeterred, Jordan would not be intimidated, and she held firm.[67]

Time was running short. Congress had set its adjournment for October 7, 1978. When Chairman Rodino had to leave Washington, DC, because of a family illness, his position was taken over by Jack Brooks, who tried to pressure those Judiciary Committee members loyal to Jordan. Jordan was retiring—what power did she have? Yet she felt confident: "It was just going one to one and making sure that there were no soft spots in terms of the members and what they were going to do and how they were going to vote. . . . We were a pretty close-knit group. I don't know how Judiciary is now, but we had been through a lot together, that particular Judiciary Committee. So there were alliances formed and friendships formed."[68] And in the end, Jordan's position prevailed. Griffin Bell came up with a compromise that allowed an administrative split that could be voted on by the judges themselves and which applied to all circuits, not just the Fifth. Jordan had doubts the plan was workable, but with assurances

from all the parties involved, including Kennedy and Rodino, she supported the compromise. Desperately needed judges were appointed, semiautonomous administrative units were created, and, for the moment, the Fifth Circuit was maintained as a single entity. Elaine Jones never forgot Barbara Jordan's determination to keep such an important circuit whole. She recalled seeing Jordan just before the congresswoman died: "I said Ms. Jordan, I'll never forget it. I was there. I said I will never forget what you did. And that meant so much to her. She said she didn't think anybody would remember, those kind of battles we fought day in and day out."[69]

Eastland retired. Long-time political observer Meg Greenfield remarked that "those long-gone geezers of the once mighty southern coalition succeeded in imposing their will for so long, even in their shrinking numbers, because they knew what they wanted and they knew how to organize power. . . . [T]hey were all part of a deliberate program to accomplish an unswerving end. And they didn't care what it cost." She noted that "quality of commitment" existed only among the very few in Washington.[70] Barbara Jordan possessed a similar commitment, but of a higher order. She used her power, developed relationships, and stood her ground to promote and protect civil and political rights, not undermine them. She understood why politics mattered to people's lives, and why experienced and principled politicians mattered for the future of democracy.

Determined to Be Heard

We know that America cannot be neutral on the question of race. Neutrality locks Blacks into an underclass of the society with little likelihood of moving out.

<div align="right">—Barbara Jordan, 1984</div>

As her retirement from Congress approached, Jordan felt conflicted. After all, she was still "probably the best-known member of the House of Representatives."[1] Only a few years earlier, 44 percent of Americans polled had named Jordan as the woman they could envision as president. She also was widely touted as a vice-presidential candidate, a Supreme Court nominee, or a member of Carter's cabinet. Other colleagues were sure she would be speaker of the House.[2] But at the end of her third term in Washington, she had more pressing concerns. Health and finances were on her mind. "Women are capable but men have the money," she mused to an audience of students at Harvard. It was hard to imagine Jordan leaving the public sphere entirely; as she pondered retirement, she maintained her party allegiance: "I want the Democrats to be in control."[3] She moved home to Austin and began teaching at the Lyndon Baines Johnson (LBJ) School of Public Affairs at the University of Texas.

Even though Jordan was no longer in Congress the press continued to speculate about her health. On January 17, 1979, a Dallas newspaper published a front-page story asserting that Jordan suffered from multiple myeloma, a serious bone-marrow disease, citing Jordan's difficulty walking and thinner frame as further evidence of her illness. The piece appeared in newspapers across the country.[4] Jordan issued a strong denial: "My weight loss was voluntary and I wish I could be congratulated for it rather than viewed with suspicion of grave

illness." The furor was so great, however, that officials at the University of Texas called a press conference. Appearing before a roomful of reporters without her cane, Jordan refuted the story as false even as she leaned on the arm of her attorney friend, Stan McLelland.[5] The paper had indeed confused multiple sclerosis with multiple myeloma—a malignant bone cancer—so Jordan could truthfully state: "I do not have, nor have I ever had, the illness described in the news story. My knee has for some three or four years received more attention than my mind, heart, or soul. . . . For better or worse, my knee is mine." The subject was closed. She then answered questions about teaching at the LBJ School of Public Affairs and whether she had truly quit politics. She claimed that she had: "If a political opportunity were presented to me on this day, January 18, 1979, I would express a total lack of interest."[6]

Jordan was sincere about eschewing electoral politics, but she did not want to leave the public stage entirely. She and Hearon promoted their forthcoming book, *Barbara Jordan: A Self-Portrait*, traveling to New York, Chicago, Cleveland, and Los Angeles, and arranging for excerpts to appear in the *Houston Post*.[7] Hearon had anticipated that a book about a woman as famous and unique as Jordan would be a bestseller. Yet *Self-Portrait* received little acclaim. Hostile reviewers directed their ire at its subject. Writing in the *Washington Monthly*, Joseph Nocera bashed Jordan for failing to live up to her potential and for her towering ambition. "What Barbara Jordan reveals in her new autobiography," he scathingly remarked, "is how little she accomplished." Black reviewers also panned the book. Journalist Charlayne Hunter-Gault detected an unpleasant "simmering bitterness," in Jordan's candid disclosure that party elites "were all kissing my ass" after her convention speech. Hunter-Gault also winked at Jordan's struggles with weight, minimized her achievements, and singled out her appreciative view of the business community as a sign that Jordan was taking cues from "more conservative quarters." African American historian Alton Hornsby also dismissed the project. Hearon's occasional attempts to summarize milestones in Black history, such as Booker T. Washington's 1895 address to the Atlanta Exposition—which she awkwardly called his "hand speech"—left him underwhelmed. Jordan's rise, Hornsby concluded, was a rather inconsequential tale that might appeal to admirers of Horatio Alger, but he saw little in her story to illuminate the Black struggle for equality and power. He picked up what she had said about marriage, however, dryly noting that Jordan "seemed more devoted to the question of women's rights."[8]

The response from Texas was similarly critical and dismissive. In a review for the Sunday *New York Times*, Kaye Northcott, former editor of the *Texas Observer*, described Jordan as a "regal, somewhat forbidding loner with a fine sense of humor and nary a whit of self doubt." Northcott nodded to Jordan's role in breaking barriers and passing the Voting Rights Act extension, but then, zeroing in on her testimony for John Connally, she quoted Jordan about trading political favors and "chits." Northcott suggested that the former congresswoman cultivated relationships with white elites for personal gain and appointments to corporate boards. She voiced suspicions about Jordan's sincerity. "Assuming she is as healthy as she claims," Northcott wrote, Jordan might still be angling for a political comeback. Then again, "It's hard to imagine that Barbara Jordan the pragmatist could harbor any hope that a big, black, lame, single woman could land one of the nation's most important offices."[9] The insulting sentence combined all of society's worst racist, sexist, and ableist prejudices. No response to any of the reviews appeared. *Self-Portrait* failed utterly to enhance or establish Jordan's place in the civil rights struggle or even as a pioneering Black Democrat.

In retrospect, however, that was not the goal of the project. *Self-Portrait's* mix of concealment and revelation reflected a new genre of political biography that was emerging in the late 1970s.[10] Hearon had indeed set out to write a kind of "psychobiography" that emphasized Jordan's family dynamics, life stages, and personality traits. Jordan willingly shared details about her childhood, her Grandpa Patten, and her friendships, including stories about Nancy Earl, whom she called a "special person." But the general public seemed uninterested in the personal story of an unconventional Black woman. The absence of a serious discussion of Black politics or details of her activism gave ammunition to those who saw Jordan only as a centrist or conservative. Jordan acknowledged Earl's role in her life, yet instead of seeing Jordan as a closeted lesbian, or even acknowledging the personal challenges Jordan faced in her career, reviewers ignored Earl's presence in the book, and Jordan's emotions, entirely. Reviews included unkind remarks about Jordan's weight and appearance. *Self-Portrait's* reception says as much about the public as it does about its subject. The negative reception of her book cemented the break between Jordan and her liberal critics.

She settled in. The University of Texas became her new institutional home, and Jordan enjoyed teaching and socializing. She and Nancy Earl regularly hosted gatherings at their Onion Creek spread for her students, and Jordan became a great fan of "Lady Longhorns" basketball. She attended dinners and

events at the university, especially those hosted by LBJ's widow, Lady Bird. In addition to her family and friends from Houston, and Earl, her partner, Jordan's circle included Lady Bird Johnson's nephew Philip Bobbitt, a renowned constitutional scholar, and Walt and Elspeth Rostow, both professors at the University of Texas and close former associates of Lyndon Johnson. Judge Andrew Jefferson remained in touch; when visiting with Jordan at her Austin home he, like all her friends, kept Jordan's open secret. "I don't have any information on that sexuality question," Jefferson volunteered. "She had that friend, but that wasn't any of my business."[11] Her two sisters and their husbands, and the Justice sisters from Houston and their husbands, still attended her annual Fourth of July party. As her illness progressed, Jordan's hands became too weak to play the guitar, but she still sang her specialties—"Sunny," "The Battle Hymn of the Republic," and the "St. James Infirmary Blues"—with gusto. Other Austin friends in the eclectic group included Max Sherman, her former colleague in the Texas Senate, and her physician, Dr. Rambie Briggs.[12]

Jordan hired drivers, often students, to take her places and she openly used a wheelchair, yet the cause of her disability remained undisclosed to those around her. For years the only individuals in Austin who knew about her MS diagnosis were Nancy Earl and Briggs. Candor was difficult even for Dr. Briggs, who found it hard to gain consensus among his famous patient's specialists about her treatment. "Briggs, no one wants to be responsible for killing Barbara Jordan!" one friend told him.[13] Everyone in Jordan's circle knew more, and felt more, than what they were allowed to say, not just in public but even to her. Jordan's lesbianism and her disability were "open secret[s] compulsorily kept."[14] Many who interacted with Jordan knew she was in physical pain, but they did not inquire or ask her for specifics. As critic Tobin Siebers has said, "The closet often holds secrets that either cannot be told, or are being kept by those who do not want to know the truth about the closeted person."[15] Jordan's friends knew not to inquire about, or mention, her personal suffering. They understood that she would not tolerate any expressions of sympathy or personal queries. With few exceptions, silence and distance was a precondition for friendship.[16] Protected by her circle, Jordan sought to maintain her privacy, yet she still wished to remain involved in public affairs and politics. From the time of her retirement in 1978 to her death in 1996, her life was often a whirlwind of activity and travel, filled with serious purpose.

In public, Jordan eschewed self-pity, in herself or in others. In the fall of 1978, she visited Harvard as a public policy fellow and gave several informal

talks to gatherings at Kirkland House, a Black student residence. Seemingly out of the blue she began one speech by reprising an old theme, "You cannot succeed in politics if you are to withdraw into some self-concept that 'because I am a woman, I can't.'" At a later discussion she added, "We shouldn't use Black as a crutch. I don't feel like hobbling on the crutch and making it an excuse for mediocrity."[17] Jordan unconsciously used ableist metaphors to distance herself from any negative connotations that the public may be drawing about her reasons for retirement. In many of her public speeches from this time, Jordan usually included the importance of individual will for overcoming obstacles.

And yet, she continued to address the structural barriers faced by women, people of color, and marginalized communities in her district. In Congress, Jordan had worked closely with Houston's local community service organizations to fund daycare and health facilities, veteran's programs, and bilingual education programs.[18] After her retirement, Jordan continued her hands-on approach to community needs. As a member of the board of Texas Commerce Bank, she served as the director of community reinvestment. The Community Reinvestment Act, cosponsored by Jordan and signed into law by President Jimmy Carter in 1977, mandated that FDIC regulators examine the level of bank investment in local communities. It did not require that banks make investments or loan money, but the legislation gave Jordan a lever as a board member to demand that the bank do more.[19] She traveled from Austin to Houston at least once a month to oversee the bank's community engagement. She made sure that Texas Commerce opened a branch in the Fifth Ward and that the bank wrote mortgages for Black and Latino residents. Algenita Davis—a Fifth Ward native, tax specialist, and graduate of Howard University Law School—served as the bank's officer of community affairs. Jordan's efforts to bring much-needed investments to the underserved Black and Latino neighborhoods, Davis asserted, was not "talked about enough." In an interview, Davis reflected on Jordan's work with the bank. "For years, she chaired that [community reinvestment] committee from her wheelchair and every day was 9 to 5, so that she could be there, so she could speak, she could run those meetings. . . . She made such a tremendous difference because she brought with her that ability to convey the correctness of what corporate responsibility really was."[20]

Jordan brought a moral tone to the discussion of race and community investment. Skeptical bankers who believed that Black and Latino people posed financial risks had to face Jordan's withering opposition. Davis recalled what she

witnessed at the meetings Jordan chaired with bank representatives. "It was that kind of conversation that constantly flowed. 'Why do we want to do applications for mortgages when it counts against us if we have a higher rate of declinations?' But Jordan said, 'I don't care. We are going to do applications wherever we can because we know that there are people out there who want to do loans.'" Jordan insisted that Texas Commerce open a new branch on Lyons Avenue. "She made the presentation," remembered Davis. "She was the one who did it." Using blunt moral persuasion, Jordan dealt with the FDIC regulators, spoke with those at Texas Commerce who expressed doubts about the venture, and spearheaded outreach to the local community, pushing Davis to work through churches to find borrowers. To encourage community trust, Jordan's picture was put up in bank branches. Davis insisted that investing in these underserved neighborhoods worked for the bank as well: "We never made anything less than our standard [profit]."[21]

After Jimmy Carter's 1980 loss to Ronald Reagan, Jordan reemerged as a force within the Democratic Party.[22] Her anger at Carter for shutting her out of his cabinet never dissipated, but she remained a fervent liberal Democrat.[23] In early 1981 she worked with Norman Lear and other progressives to form the People for the American Way Foundation, a group that took aim at the Moral Majority.[24] She joined the Center for Democratic Policy, a liberal think tank.[25] In 1982 she condemned the deleterious effects of Reagan's policies in a blistering speech given at LBJ's alma mater: "We Black people know that whenever Republicans have been in power we don't fare terribly well," she told the students at Southwest Texas State University in San Marcos. "A lesser people—I mean people of weaker constitution and fortitude—would have given up on this country long ago. But we didn't. We are going to force this country to live up to what it is supposed to be about or we'll die in the attempt."[26] Jordan's battle against racism took on an international dimension in 1985, when she was appointed to an eleven-member United Nations panel tasked with examining the role of transnational corporations in perpetuating apartheid in South Africa and Namibia.[27] Confronting racism in the corporate boardroom, in international affairs, and in the Republican Party drew her back into the speaking circuit, where her debating skills and pointed criticisms gave hope to a floundering liberal opposition to Reagan and the Republicans.[28]

During the Reagan years Jordan spoke less about coalition politics and more about racism. In her "Salute to Black Elected Officials," given in the spring of

1984, Jordan urged her audience to "exude pride and confidence." To be a Black elected official, she insisted, "is to make race work FOR us rather than against us." In a forceful denunciation of Reaganomics, she called out the extraordinarily high numbers of unemployed Black teenagers, which hovered near 47 percent, calling it "an intolerable inequity." She decried the cuts to daycare, health care, and education. Racism, she implied, was rampant. But she urged Black lawmakers not to despair, pointing to the strength of the Black community. "We are survivors," she stated. "Blacks have long had the stamina for survival as a race. Our faith has sustained us. A lesser people would have succumbed long ago to hostile political, social, and environmental forces." Recognizing the indifference of the federal government, Jordan pivoted toward themes of racial solidarity, drawing on the example of her Houston community and family: "My father," she said, was a "conservative. He just didn't know how he was supposed to label himself. He was self-reliant, had faith, and believed in hard work and didn't desert his family." Such values were at the heart of the Black experience. Jordan supported racial unity and institution building but then urged her listeners toward the path of political organizing. "The power of the Black vote is a somnolent hulk waiting for ignition. You can be the spark," she told her audience. "You are the Black Leadership of the Eighties. Your message is one of selflessness, justice, and equity." Concluding on a note that could have been taken from Lyndon Johnson's speeches urging a war on poverty, Jordan said, "It can be done and we will do it."[29]

Jordan was convinced that liberals could still flex their political muscles in the Reagan era. All was not lost. Democrats still controlled the Senate, and in 1987 Jordan joined in the liberal fight to oppose the nomination of Robert Bork to the Supreme Court. On the CBS Sunday program *Meet the Nation,* she debated Utah senator Orrin Hatch. In Washington, DC, she joined Andy Young and Black Republican Bill Coleman, former Secretary of Transportation under Reagan, for a day of testimony against Bork's nomination. Just as she had done during the Watergate hearings in 1974 and her the address to the 1976 Democratic convention, Jordan began her remarks by centering on racism and herself. Her opposition to Judge Bork, she said, "grew out of living 51 years as a black American born in the South and determined to be heard by the majority community."[30]

Jordan's prepared testimony that day was really a speech, and it was a great one. She took her audience back to the beginning of her political career in Texas. When she first ran for office and lost, "I was trying to play by the rules and the rules were not fair. But something happened. A decision was handed down:

Baker v. Carr." That 1965 Supreme Court ruling led to the reapportionment of the Texas Senate. "I ran again. The third time. This time in one of those newly created state senatorial districts. I won. My political career got started." In telling her own story, Jordan explained how the Supreme Court breathed new life not only into Black voting, as it had done with *Smith v. Allwright*, but into Black political leadership. The court "[threw] out a lifeline when the legislators and the governors and everybody else [refused] to do so," and enabled a new generation of Black political leaders to emerge. Her testimony anticipated Bork's illogical rebuttal: "Now you know what Judge Bork would say. "Listen. I approve of the results of the reapportionment cases . . . but my problem with the whole matter is that I don't like the reasoning which was used. . . . What you really ought to do is let the democratically elected bodies make these decisions. That is the proper way to proceed." Gentlemen, when I hear that, my eyes glaze over. If that were the case, I would right now be running my 11th unsuccessful race for the Texas House of Representatives. I cannot abide that."[31]

Jordan then took aim at Bork's ideology, laying out, puncturing, and even ridiculing some of his legal writings: "He has disagreed with the principle of one person, one vote many times. . . . 'I do not think there is a theoretical basis for it,' [he said]. My word. . . . Maybe not, gentlemen. Maybe there is no theoretical basis for one person, one vote, but I will tell you this much. There is a commonsense, natural, rational basis for all votes counting equally."[32] She expressed alarm about what Bork's theories meant for individual rights, as well as for the obligation and right of Congress to regulate business through antitrust laws, telling Sen. Howard Metzenbaum, "I will match my wits with Judge Bork at any time, and I would invite him to come into the forum and let us discuss the issue and see who has the proper point of view in anti-trust matters." Jordan urged the Senate to do its job and not to fall back on ABA (American Bar Association) ratings or pronouncements of Bork's alleged brilliance. "More is required," she stated. The senators had an obligation to dig into the consequences of Bork's ideology. "A new justice should help us stay the course, not abort the course." Jordan kept her remarks within the allotted ten minutes, and then parried with conservative Senators for another hour.[33]

The campaign to oppose Bork's nomination drew cries that the judge was being treated unfairly, but in a letter to the *New York Times* Jordan dismissed those objections: "When I think back to my constituents who were disenfranchised by policies Bork condoned and enfranchised by a decision he condemned,

I realize that they could teach . . . a lesson about what's fair and what's unfair in American politics."[34] The Senate rejected Bork by a vote of fifty-eight to forty-two. The fight energized Jordan. She garnered more awards and accepted numerous invitations to speak. She used her public platform to bluntly ask, "What is the problem? Why do we see a resurgence of racism across America? . . . White America, what's bugging you?"[35]

Jordan traveled to Atlanta to speak at the 1988 Democratic convention. Appearing at the podium in her wheelchair, she seconded the vice-presidential nomination of Texan Lloyd Bentsen. But she was indeed weak and ill and utterly exhausted from the convention and travel.[36] She returned to Austin, and on July 30, 1988, as she took her daily morning swim in the searing Texas heat, Jordan blacked out in the water. Nancy Earl, who had just returned from shopping, saw Jordan's body floating lifeless in their pool and jumped in. She grabbed Jordan, pulled her to the shallow end, and used a portable telephone to dial 911. Earl held Jordan's head out of the water and waited for two paramedics and other emergency technicians to arrive, but Jordan remained unconscious. She was flown by helicopter to an emergency room in Austin, where a medical team revived her and put her on a respirator. Jordan was fortunate. She suffered no brain damage from the lack of oxygen, but fluid had built up in her lungs, and her breathing remained weak. It was no longer possible to keep her illness a secret. Dr. William Deaton told reporters that Jordan suffered from multiple sclerosis, which would impede her recovery: "Her muscle strength is not as good. Her breathing muscle strength is not normal." For the first time Jordan's friends as well as the public finally knew the real cause of her disability. Three days later, Jordan invited the press into her hospital room, but even though the "secret" had been revealed, no one asked about her MS.[37]

The near-drowning incident changed Jordan's life. Nancy Earl had saved her, but Jordan had come close to dying. She now dealt with repeated blood clots in her lungs and required a series of aides to change her catheter, perform physical therapy, and help her prepare for the morning routine of teaching. But Jordan did not retreat from public service. The incident strengthened her resolve to carry on, and the Democratic Party always had a role for her. She became one of the cochairs of the 1988 Dukakis-Bentsen campaign in Texas, and although she had been friendly with George H. W. Bush, she denounced his Willie Horton political advertisement in a sharply worded letter to the

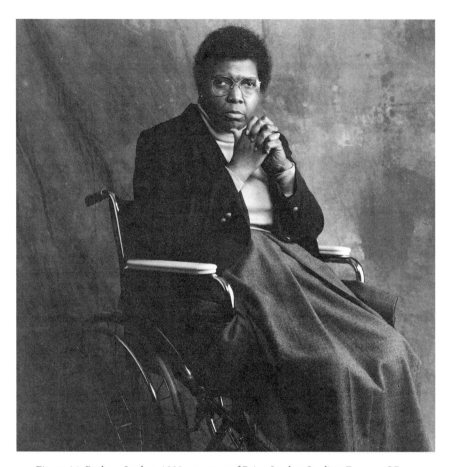

Figure 14. Barbara Jordan, 1989, courtesy of Brian Lanker Studios, Eugene, OR.

Washington Post: "The vice president has created a divisive campaign with subliminal messages which evoke fear."[38]

At this time, Jordan's image began to circulate more widely. One of the best-known photographs of her was taken by Annie Leibovitz for an American Express advertisement.[39] This photo was intended to represent Jordan as a patriot, and it is created in a style the literary critic Rosemarie Garland-Thomson calls "the sentimental." A sentimental depiction of disability according to Garland-Thomson, "places the disabled figure below the viewer, in the posture of the sympathetic victim or helpless sufferer needing protection or succor. The rhetoric of sentiment diminishes that figure to evoke pity, inspiration, and

frequent contributions." In the original photo, the camera angle is above Jordan. She is shown sitting, but her wheelchair is invisible, covered by a flowing black skirt. The presence of the wheelchair is implied, but still unseen. Her shirt is white, the color of purity. A long, wide dirt road opens up behind her, with the enormous sky above. She holds an American flag in her lap and against her chest, and her eyes look away from the viewer. Annie Leibovitz's portrait creates both spatial hierarchy and distance between the audience and Jordan. Our eyes are drawn not to her but to the American flag she cradles in her arms, "gratefully receiving," as Garland-Thomson says, what it represents. It appears that in the Leibovitz photo Jordan represents the spectacle of suffering, a "stigmata of suffering," rather than the reality of suffering. The threat of disability is contained, and the viewer is empowered to feel pity or perhaps condescending amazement on Jordan's behalf. In sentimentality photos, Garland-Thomson argues, "disability operates as the manifestation of suffering, a seemingly undeniable sign that makes what is internal and unnarratable into something external and narratable." The visual narration here traces Jordan's American journey, her American dream, and her body wrapped in the American flag. She is literally unsupported—the illusion is that she floats.[40]

Leibovitz's decisions in this photo reflect our culture's discomfort with disability, an unwillingness to acknowledge the reality of a disabled person's existence and humanity. As Garland-Thomson notes, in a "realistic" depiction, fitting for a democratic society, it is important to show the wheelchair. For example, in analyzing an official photo of public servant Judy Heumann, whose legendary activism contributed mightily to the Americans with Disabilities Act, Garland-Thomson points out that the wheelchair in the photo "is clearly an aspect of her identity, an integral element of who and what the photograph says she is. The glimpse of her chair is descriptive, as fundamental to her image as the shape of her chin, the cut of her hair, or the tint of her skin. In its ordinariness, this photo discourages staring without prohibiting it."[41] Heumann's office, her wheelchair, and the American flag behind her all combine to represent Heumann's place and importance as a government official who is also disabled.

In contrast to Leibovitz's shot, Brian Lanker's 1989 photograph of Jordan, which appeared in his collection *I Dream a World: Portraits of Black Women Who Changed America*, represents what Thomson calls "a radical reimagining of disability" in its realistic depiction. In this black-and-white photo, a model of verisimilitude, Jordan's entire face and body confront the camera; she sits above

the viewer—her head is at the top of the frame, nothing else is above it. Her gaze meets the viewer's eye, and we see her staring at us, even though one eye is wandering (a consequence of her medication for MS). Her stare invites us to look twice at her, and her gaze at the camera reverses the power relation; it is she who is looking at the viewer rather than the other way around. The photo evokes a powerful feeling of Jordan's breaking that "fourth dimension," similar to the way the image of an outstretched hand extends beyond the bounds of a work. But in a classic expression of power and authority, Jordan's hands are folded, and her elbows are elevated from the chair, not sunken in. She needs no background, no metaphor of a red, white, and blue flag or a winding road or an open sky, to give her life meaning. She projects great strength and determination as a leader, while simultaneously representing one reality of disabled Black womanhood.[42]

Jordan agreed to be photographed and led a public life in her wheelchair with Earl often by her side. She did not hide her disability or her sexual orientation, but she also did not care to discuss either subject. In her memoir of living with MS, *Waist-High in the World*, author Nancy Mairs details the continuous mental readjustments she experienced as her body changed; it took time to discard the negative myths about disability she had internalized: "Above all I felt permanently exiled from 'normality.'"[43] As Jordan wrestled with changes in her body over time, she experienced similarly difficult mental and emotional challenges that must have included anger and depression. Although she often needed to retreat into her private world, she also pushed herself back into public life to create a new normal for herself. Her choices demonstrate that no strict line between silence and full disclosure exists. As scholar Ellen Samuels observes, "Not all coming-out processes are so straightforward." In the homophobic, racist, and ableist culture that Jordan navigated, individuals rarely experience a single coming-out moment.[44] A Black woman in the public eye, Jordan continuously negotiated shifting spaces between various public audiences and her private life. Despite all of the emotional and physical challenges she faced in retirement, she still wanted to make a difference, especially in the realm of race, politics, and democracy.

Jordan believed that politicians, as public servants, needed to practice the highest ethical standards. She called the 1980s the decade of greed and denounced the deteriorating standards expected among elected officials in Texas. She traveled the state to support Ann Richards in her 1990 campaign for Texas governor, and when Richards won, she appointed Jordan her "guru" and

"special counsel" on ethics. In that capacity, Jordan interviewed dozens of political appointees, particularly judges, querying them about their commitment to public service and conflicts of interest. Ever candid, Jordan warned public policy students that "if you ever decide you want to get rich, then get out of government, because if you don't, I'll visit you in jail."[45] To Jordan ethics involved more than eschewing personal gain; a truly ethical government was an inclusive body that included representatives from all people: "We, as the people of the United States of America, with all of our rhetoric and promises, still have the problem of color."[46] In the summer of 1991 Jordan traveled to South Africa with Drew Altman of the Kaiser Family Foundation and former LBJ aide Joseph Califano to help launch a program to train township women to provide basic health care. She met Nelson Mandela and later received an award from his foundation for her work in public health. In 1992 she agreed to serve for one year on the board of Califano's new Center on Addiction and Substance Abuse at Columbia University. She remained with the project until 1995. When Bill Clinton clinched the nomination in 1992, Jordan returned to Madison Square Garden, giving one of three keynote nominating addresses. She knew the Clintons from their time in Texas working for McGovern. She was not deeply involved in their campaign, but the end of the Bush administration delighted her.

In 1993, when Clinton formed a presidential commission on immigration, he asked Jordan to chair it. Initially, she said no. Immigration was emerging as the most contentious issue in the nation. Proposition 187 in California had banned undocumented immigrants and their families from getting public benefits. The law required teachers and doctors to turn in anyone they suspected was undocumented. It fueled hatred and suspicion. The number of undocumented people in America was approximately five million, less than half of what it is today.[47] The concern was that illegal immigration was whipping up racist fears. Both Democrats and Republicans were concerned about the issue, but the positions within the parties were often conflicted. Some Democrats wished to limit immigration to protect American laborers, and some Republicans supported the flow of a cheap work force. Church groups, businessmen, and immigration advocates also had firm points of view. Even among groups that agreed, no consensus existed on how to implement policy. Finally, Jordan was persuaded that her history and moral stature could bring the conflicting parties together and she agreed to chair the task force.[48]

Jordan's work on behalf of hammering out recommendations for immigration reform consumed her for the remainder of her days. One journalist later reflected, "They packed this commission with people who are so different from each other that it's almost comical. On one side there was the guy who co-wrote Prop 187 and on the other side, a Democrat who helped almost three million undocumented immigrants get amnesty here."[49] Yet Jordan brought the disparate parties together and toward consensus. She did it by first establishing ground rules of cooperation. One of the Republican appointees, Michael Teitelbaum, recalled, "I remember her saying, 'we are nine in number but we are not the Supreme Court. If we vote 5 to 4 on something that is a meaningless set of recommendations. So I don't think we should be seeking small majorities for opinion A or B, but we should be seeking instead broad consensus.' And everybody agreed on that."[50] As the chair, Jordan acted as a respected leader who exerted authority over everyone. Meetings started on time, and she set the agenda. She sought to build consensus by beginning with items that could be resolved and agreed upon. "Let's start with an easy one," she would say to Susan Martin, executive director of the commission.[51]

Eventually, the "Jordan Commission" agreed on common principles. It denounced racist scapegoating of immigrants, but at the same time acknowledged that deportation and refusing entry to people who should not be admitted had to be part of policy as well. The commissioners met regularly in Boston and then traveled together as a group to El Paso, Chicago, Seattle, San Diego, Nogales, and other cities. In each place they held open mic sessions where community members could speak. They did "ride-alongs" with agents of the border patrol. They visited the Dominican Republic and Mexico to meet with government officials. The staff had stressed that all meetings had to be wheelchair accessible so that Jordan could participate. Few places were equipped to actually provide accessibility. When the commission arrived in Mexico City, for example, the government simply hired four strong men to lift Jordan and her wheelchair up twenty stairs, a feat that made her and all the members of commission extremely nervous. Yet Jordan carried on, always traveling with a personal aide.[52]

Committee member Bruce Morrison, a former Democratic congressman and immigration attorney, recalled how Jordan stood firm on certain issues, such as maintaining citizenship by birth as guaranteed by the Fourteenth Amendment, while also guiding the group through needed compromise: "We were making

people choose whether they should break the rules by being here illegally to live with their spouse, or whether they should be exiled. And that's a choice no family should make." After a year of discussion, the committee finally agreed that the priorities be given to spouses and nonadult children. Another recommendation was that the numbers of unskilled immigrants be drastically reduced. "I am *not* for a national identity card," Jordan explained, but the committee did support the creation of a registry that would check a worker's social security number. They wanted immigration to focus on reuniting divided nuclear families and providing needed workers. At the same time they wanted protections for refugees. The commission was roundly criticized for all these proposals.[53]

Jordan took the heat and acted as the public voice of the committee. In numerous press conferences and public hearings, she insisted that any policy had to involve consensus and compromise around a broad range of agreed principles. The commission issued two reports, one in 1994 and another in 1995, and Jordan testified on the immigration issue before Congress. Clinton's major concern was the recommendation to reduce the legal immigration of unskilled workers, but Jordan persuaded the president to accept the recommendations and the compromise. She also gained the support of the subcommittees on immigration in both the House and the Senate. In early 1996 Jordan was preparing to make a final push for Congressional adoption of the commission's recommendations, but she never made it.

In June 1994 Jordan had been diagnosed with leukemia, a side effect of the drug Cytoxan, which she began taking after her initial diagnosis of MS. Her physician recalled that when he gave the news, Nancy Earl got pale, and cried, but Jordan did not. "She just looked at me and said, 'okay.'"[54] And then for the next eighteen months, Jordan continued with her busy schedule, which included teaching, keeping up with a list of speaking invitations, traveling to Houston to see her family, and continuing to serve on her boards, all while chairing the Jordan Commission on immigration. Biographer Mary Beth Rogers recounts that, "A few close friends remembered visits to her home when they would hear her in another room, talking to herself, psyching herself up to go on. 'Come on, Barbara,' she would say. 'Get going, move . . . push . . . don't stop now.' And then she would appear and smile and be ready for whatever the day offered."[55] The side effects of her illness and the medication caused one of her eyes to drift and bulge, a trait that a cartoonist emphasized in a 1994 caricature, and which Lanker also captured in his photo portrait.[56] Throughout it all, Jordan remained

busy and engaged. A highlight of this time included traveling to Washington, DC, to receive the Presidential Medal of Freedom from President Clinton in June 1994. Both of her sisters, Stan McLelland, Nancy Earl, her old friend Azie Taylor Morton, who had served as Secretary of the Treasury under Jimmy Carter, and Sharon Tutchings, her secretary from UT, were present.

Jordan was scheduled to appear before Congress to testify on the immigration commission's latest recommendations, but on Monday January 15, 1996, she was too weak to teach, and for the first time in seventeen years, she canceled a class. The next day, when she woke up, she could barely breathe. Only then did she enter the hospital, where she died the next morning, January 17, 1996. She was fifty-nine years old.

Jordan's death shocked the members of the immigration commission. Susan Martin, the executive director who had persuaded Jordan to lead the group, had no idea the chairwoman had leukemia: "I found out because I got a call from her partner. And all of the commissioners and all of the staff were just, you know, they can't believe it's happened. But it was also a very serious political loss because she had the stature and the voice to be able to make sure that the commission's recommendations were heard." Somehow, everyone involved recognized that Jordan's absence doomed the committee's recommendations. Republican Alan Simpson, chair of the Senate's immigration subcommittee, acknowledged her crucial contribution to the process. No one else on the committee had the stature to take her place. "She wasn't there to push them. It's that simple. She wasn't there."[57] To this day no coherent immigration policy has passed Congress. Of course, like any piece of complex legislation, the commission's plan on immigration was a compromise with plenty in it to both praise and condemn. But regardless of their conflicting views, all the members of the commission felt protective of Jordan's legacy, her integrity, and what they had achieved as a group. Jordan's personal views on immigration have often been mischaracterized, and sometimes Jordan's name is invoked to justify harsh and questionable conservative policies. Bruce Morrison believed that "if she were alive, somehow you can imagine the volcano going off and burying these people under its eruption of outrage, because she always engaged in things in absolute open good faith. She didn't mischaracterize what people said. She didn't play these games of taking people's statements out of context, and sort of try to make her a symbol of something she did not represent and did not support. That's a kind of theft of a precious commodity."[58]

On a cold morning in January, more than fifteen hundred people, including President Clinton and former Texas governor Ann Richards, attended Jordan's funeral at Good Hope Missionary Baptist Church in Houston, and more mourners started lining the streets at 5 AM to listen to the service through loudspeakers while standing outside in the rain.[59] Andrew Young was there, and so was Cicely Tyson, along with hundreds of ordinary Houstonians who wanted the chance to honor "someone great in our community."[60] Nancy Earl sat in the front with Jordan's mother and sisters. After the televised two-hour service that included eight eulogies, Jordan's remains were taken to Austin, the city she had adopted as her personal home. She was buried in the Texas State Cemetery alongside the state's other major political figures, including Sam Houston, and she remains the only Black Texan included in that otherwise all-white cemetery space.

Jordan's position as the "first," even in death, honors her. Yet uncritically celebrating Jordan as the first Black Texan to receive such recognition obscures how segregation and racist voting laws kept Black leaders who came before her out of office, and thus out of the cemetery. Recognizing Jordan for being "the first" and "the only" to be buried in this space also perhaps glosses over her larger significance as a critic and opponent of segregation.[61]

Thus, retrospectives on Jordan's significance began with her death, and contemporary public depictions wrestle with how to interpret the meaning of her legacy.

In the center of the baggage claim area of Austin-Bergstrom airport in Austin, Texas, sits an enormous bronze sculpture of Barbara Jordan. Roped off from the touch of the crowds, this life-sized piece of public art, dedicated in 2002, shows Jordan sitting, Lincoln-like, on a square chair, book and glasses on her lap, fingers pressed together, eyebrows furrowed. She appears to be in deep thought, a woman of contemplation rather than action. Sensible shoes and a side satchel render Jordan as a middle-aged scholar, more attached to books than to people. Her name in bold lettering tells the viewer who they see, but not the significance of what she did. Busy travelers walk on by and grab their bags, not fully comprehending how this Black woman attorney and Houston native who grew up in segregation deeply influenced the political world we live in today. Jordan was indeed a thoughtful legislator who frequently isolated herself, just as she had done in law school, to write and read through materials.[62] Yet this staid, solemn, bookish, and sedentary depiction fails to capture Jordan's impatience

with racism. On the go, full of energy, and angry at racial injustice, Jordan was not a scholar but a woman of action, a politician and orator ready to forge coalitions to rally the voters, defeat opponents, and push the nation and the Democratic Party away from its racist past and toward a more just future. Perhaps the real incongruity of the sculpture, however, is not its depiction of Jordan, but its location. The grounds of the Texas state capitol, the place where she made her mark, integrated the state senate, and claimed the title of Governor for a Day, could provide a more meaningful context to interpret Jordan's significance than a busy airport.

Other statues, such as the one that stands on the grounds of the University of Texas at Austin, offer a jauntier version of Jordan. In 2009 the Texas Orange Jackets, the University of Texas's oldest women's service organization, commissioned a statue of Jordan to be placed on campus. In this context, Jordan was "the first" Texas woman so honored. Today her sculpture stands alongside numerous statues of white males (including Confederate generals) within the forty acres of west campus known as "Battle Oaks."[63] Created by Bruce Wolfe, the same artist who produced the sitting Jordan at the Austin airport, this statue is also large and imposing; it shows Jordan standing, arms akimbo.

Figure 15. Barbara Jordan statue, University of Texas. Photo by Jana Birchum.

This smiling Jordan exudes confidence; she is a woman who is standing up and looking down from a pedestal, a smiling champion who broke barriers. Statues of Martin Luther King Jr. and Cesar Chavez, the two other leaders of color on the grounds of Battle Oaks, are described as "activists," while Jordan is named a "trailblazer." The speeches at a 2019 commemoration ceremony generally mentioned Jordan's work for civil rights, but since hers was "the first" three-dimensional image of a woman ever placed on the campus's grounds, Jordan has by default become a symbol of gender inclusion. "Barbara Jordan's symbolic presence helps make me feel more represented on this campus as a woman," said one employee.[64] A good start, for sure. But the comment begs the question of whether mere inclusion best represents Jordan's significance.

The standing statue of Jordan at UT seems inoffensive, yet it has a controversial past. Originally, UT's statue committee had launched a nationwide contest and allowed the university students to choose among four different sculptures. Their first choice, the work of New Mexico artist Kim Crowley, showed Jordan sitting on a bench, reaching into a briefcase. In Crowley's statue, Jordan's visage is thoughtful, anticipatory. This sculpture was designed to be placed on a path amid trees, where students could sit on a bench next to the statue and imagine Jordan in the moment before she does what she was best known for, speaking. Crowley said that his piece "was aimed at connecting with the student body. . . . The campus already has other overblown and oversized statues, and sculpturally, that's an unsophisticated way to go." Students liked the sitting Jordan, but the committee deemed it unheroic and pedestrian, with one dean stating that there was a "need to look further to find a design that people could walk up to and be in awe." The sitting Jordan was removed. The public embraced the vertical Jordan, which was readily understood as a symbol of power and strength. "Standing," said one article, "like she stood up for the Constitution."[65]

But the "standing" metaphor elides important facts about Jordan, who used a cane and then a wheelchair for a good part of her life. One thoughtful comment about the sculpture controversy came from a disability blogger, who questioned the committee's ableist presumptions: "I agree with Mr. Crowley. Barbara Jordan isn't great because she looked like she could take out George Washington in a duel. She is great because she represented parts of America who often get overlooked. She's great because she connected with people." This blogger criticized conflating the physical ability to stand with the possession of power. It was inappropriate, if not outright erroneous, to equate Jordan's power with physical

domination and literally standing up. "I think we need different ways of thinking and talking about things," the blogger wrote. "Where strength doesn't mean power. Where gravitas doesn't mean looking like the idols of the (rather white, rather male) past. Where you don't have to be big and tall to be awe-inspiring."[66] Jordan's legacy, the blogger suggested, ought to include new ways of thinking about power that need not adhere to either ableism or whiteness or heterosexual norms of womanhood.

At many of the memorials and events held in Jordan's honor after she died, Nancy Earl was present and acknowledged by a few, but she remained invisible to many. None of the nation's major newspapers mentioned Earl in their obituaries of Jordan.[67] For nearly thirty years she and Jordan worked, traveled, and shared their lives. For much of that time, Earl did the work of a supportive partner and spouse. She kept records of Jordan's life, including photographs, guided the research for her book, worked in Jordan's office, accompanied Jordan to important events, and certainly oversaw much of her medical care, even saving her life from a near-drowning accident. Photos of Earl contained in Jordan's archive document her presence at Jordan's side at political events as well as gatherings at the couple's home.[68] When a reporter from the LGBT newspaper the *Advocate* "outed" Jordan after she died, he called Earl for a comment.[69] Nancy Earl did not deny the implied nature of their relationship, but neither did she claim it outright. After Jordan's death, Earl cooperated with Mary Beth Rogers on *Barbara Jordan: American Hero*, but Rogers denied that the two women were lesbians. After working with Rogers, Earl did not give any further interviews. She died in 2007 at the age of seventy-two on the grounds of the Onion Creek home she had shared for years with Jordan.[70]

After Jordan died, some in the gay community expressed confusion, even anger, over Earl and Jordan's joint refusal to publicly affirm they were lesbians. "If anybody had the luxury to say 'by golly I'm a lesbian and this is the woman I love,' it was Barbara Jordan," remarked *Austin American* journalist Juan Palomo. Palomo revealed he was gay in a story he wrote about a brutal hate crime—the 1991 murder of a local gay man—and lost his job at the *Houston Post*. What he perceived as Jordan's silence angered him. "She could have done it and her stature would not have been diminished one bit."[71] A lot was at stake. If Jordan acknowledged her sexual identity, many believed, she could have upended damaging stereotypes and shifted public thinking. During the 1990s the AIDS crisis often made disclosure of sexual orientation an essential act of solidarity

with a group whose stigmatization had led to medical marginalization, despair, and an untold number of deaths.[72] If she was a crusader for justice, why did Jordan remain silent? "Do you really have to write this story?" another anonymous friend asked the *Advocate* reporter. "This is not what Barbara would have wanted." But exactly why was never explained.

Others in Jordan's circle questioned the presumption that refusing to talk to the press equated "silence." Jordan "never denied who she was," insisted one friend who asked not to be identified. "It just was not the public's need to know."[73] One scholar pushed back against the 1996 *Advocate* article by asking Jordan's detractors what they had ever done to fight racism or sexism. Jordan had the right to choose her battles and her priorities.[74] Jordan may have indeed disappointed some people who looked up to her. As Black feminist critic Barbara Smith noted, during the 1970s many courageous Black lesbians, including Audre Lorde and Pat Parker, confronted racism and "heterosexism" and "risked everything for truth."[75] Yet all recognized that homophobia destroyed lives. "My words would also be dismissed, my credibility destroyed if it were known that I were a lesbian," said one writer to *off our backs*, a feminist publication. "I choose the closet. That is surely my right."[76] Jordan never claimed to be heterosexual, and her relationship with Earl was not hidden. As recent scholarship attests, however, adopting a strategy of silence concerning a host of personal issues remains necessary and too common among Black women to be attributed to Jordan alone. Secrecy, obfuscation, outright falsehoods, and, at times, silence prevail as strategies of survival and resistance.[77]

Although she honed a confident public persona, when it came to her own history Jordan suffered from a particular myopia that could track only her successes and failures. Her motivations, her anger, her deeper feelings, her health, and her personal life were not open to examination. Existing in the public eye gave her life purpose and yet made her vulnerable. Now that more people are outspoken about the importance of celebrating—rather than shaming—human differences, new interpretations of Jordan are possible.[78] "If it were up to me," one blogger wrote, "we'd have a statue of Barbara Jordan in her wheelchair, sitting next to her lesbian life partner."[79] Women and gender studies scholar Lisa L. Moore rejects the idea that Jordan's sexuality "deserve[s] a special privacy, out of 'respect' for the wishes of the deceased." In fact, she argues, "what's being respected is the oppressive circumstances that hid these relationships in the first place."[80] Tensions and disagreements surrounding how to best represent Jordan's

legacy are bound to continue. Barbara Jordan was a Black woman of ambition who pushed for civil rights, women's equality, and greater democracy for all. In fighting for others, however, she insisted on her right to live her life on her own terms. When it came to issues regarding her health and her personal life, Jordan let her actions speak, rather than her words.

Nevertheless, she may have changed with the times. Jordan had a sarcastic sense of humor, and she loved to party with her friends. She was not shut off from the outside world. A few weeks before she died, she pointed to a folder of her medical records and said to her physician, "Well, you won't have to keep all that a secret much longer." Nevertheless, when a reporter questioned him about Jordan's cause of death, Dr. Rambie Briggs felt tongue-tied: "I had been protecting her for seventeen years, and I just could not break the habit."[81] Even Jordan's doctor found it difficult to talk about her personal life, because for Jordan silence equaled loyalty and served as a form of safety and protection. Still, her remark to Briggs suggests that she did not wish to keep all her secrets shrouded forever. It is not certain, but it could be likely that Jordan would have evolved with the times and continued her public activity in support of the Democratic Party, liberal causes, civil rights, disability justice, and yes, perhaps even gay and lesbian rights.

Given the many obstacles strewn in Jordan's American path, and the abuse she took from detractors, it is supremely ironic that she is still cast in bronze as an example of the American Dream. Instead of making viewers feel complacent and cozy about the greatness of the nation, however, or serving as a symbol of any group's progress, Jordan would most likely wish for her representation to inspire individuals to push back against the status quo of power and engage with electoral politics. Jordan's outrage at injustice and her partisan belief in the Democratic Party was not derived from abstract ideas about oppression but deeply rooted in her own experiences with segregation, poverty, racism, and patriarchy. Jordan honed her skills, deciding when to take risks and push for more, learning when to find consensus with others, and knowing when to suppress her anger. Even after retirement she wanted her leadership and her voice to make a difference. A true patriot who loved the nation and the state that produced her, Jordan's continued efforts to remain useful and purposeful after leaving Congress demonstrate how much fight she had left in her. Illness did not rob Jordan of her political commitment. The tragedy was that it compelled an early retirement from the fray, stoked prejudice against her, and took her from us way too soon.

She Changed the Nation

Barbara Jordan's life in Black political leadership greatly contributed to creating a new American politics that emerged after the civil rights movement. She changed the nation in a number of ways. Here are just a few.

As a politician, Jordan was a Black woman who inspired Black Americans to risk belief in electoral politics. She showed not only that Black women could win elections, but that their candidacies could inspire widespread support across lines of race and class. She practiced toughness as well as compromise and persuasion. She pushed for the Democratic Party to become an institution where differences and disagreements could result in positive legislation that would further the goals of the civil rights movement. Jordan served as an early model for how Black legislators could succeed with the support of a Black base and a coalition that supported their efforts.

Jordan's oratory brought the persuasive passion and moral tone of the civil rights era into modern electoral politics. She used that moral high ground effectively as part of her arsenal of persuasion, both in the private committee room of the House Judiciary Committee during the closed hearings on impeachment and on television when she explained the duties of the Congress and the case for Nixon's impeachment to an audience of millions. During the Watergate crisis, she reigned in her emotions with one goal in mind: a bipartisan vote in favor of impeachment. Such a momentous decision could not be forced—it had to be genuinely nurtured—and Jordan used her moral authority and persuasive powers to achieve that outcome.

Jordan was also an inspiring private individual. She did not use her sexual orientation or illness as an excuse to stay in the background and not to pursue public service. She took the heat, absorbed criticism, and kept the high ground. A public leader determined to lead her private life in her own way, Jordan

bridged the era between secrecy and total disclosure. Nevertheless, the open secrets of her life, including her partnership with Nancy Earl and her illness with multiple sclerosis, showed courage. These open secrets drew in those who believed in her and wanted to protect her. Jordan showed that Black women were worthy of being protected. The civil rights movement and feminism greatly expanded America's pool of talent, and Jordan showed that in modern politics, Black Lesbians could be political leaders, and so could people with disabilities.

Jordan's early life illuminates the roots of the modern Democratic Party in Texas as well as the positive cultural forces her Black community created during segregation that shaped her strengths as a politician as well as her ideals. Her persuasive oratory, distinctive voice, ability to conceal her emotions and harness her anger, and her skill at balancing American ideals (what "ought" to be) with a strategic vision can be traced back to her upbringing in segregated Black Houston. Jordan's early life in Houston's Black community shaped her values concerning how to lead a meaningful life. Her grandpa Patten embraced independence; her mother leaned on the Black church. Their example, along with her father's ambitions, the activism of Rev. Lucas, and the encouragement of her debate coach Thomas Freeman all emphasized a key value: you won't get anything out of life unless you strive to contribute to it. Driven by a determination to make a difference in the futures of her Black constituents, she pushed herself to succeed in politics, an uncharted path. Against all odds Jordan carved out a life of meaning, purpose, accomplishment, and independence.

Once elected to Congress, she joined forces with other Black women and used her platform to address sexism and challenge the Democratic leadership. Wit, candor, and, at times, fury laced her speeches during committee meetings as well as speeches on the house floor. She showed daring and persistence in expanding the 1975 Voting Rights Act to include a language provision as well oversight over her home state of Texas, two new provisions that were met with resistance, even by some of her Black colleagues. That legislative achievement set a precedent for future renewals of the pathbreaking legislation.

In her own campaigns, Jordan drew upon the organizing tradition of Black women in her community for party-building. Like the Black women bridge leaders in the civil rights struggle, Jordan led the Democratic Party by inspiring Black women to believe in its purpose and to work for it. She inspired at every level. She inspired the block workers in Houston. Her speeches on behalf of the Democrats inspired gatherings across the nation, from Cleveland to Los

Angeles. She also inspired other professional Black women, journalists, and party activists that a new political future was possible.

Jordan also emerged as a voice for Black feminist leadership. She supported abortion rights, dignity and opportunity for poor women, and the Equal Rights Amendment; she publicly called out male presumption and urged all women to shed their conditioning and aim higher. As Black activists sought power within the party, Jordan emerged as a Black woman leader who commanded respect. Jordan did not hesitate to make the case that Black women could and should assume leadership at the highest levels of politics. She refused to suppress women's voices in favor of male leadership. She showed that women could make tough decisions and take the pressure. She could not get there herself, but she was the example many pointed to when they thought of the day when a Black woman would sit on the Supreme Court, serve as Speaker of the House, or be elected president.

Jordan has often been called a practical and pragmatic Black leader. But the woman who concluded a prime-time televised speech by stating, "If the impeachment provision in the Constitution of the United States will not reach the offenses charged here, then perhaps that 18th-century Constitution should be abandoned to a 20th-century paper shredder," showed great courage, not fearful reticence or obeisance. And the legislator who tirelessly worked behind the scenes to persuade many in her party to enlarge the Voting Rights Act risked certainty to gain a far more advantageous outcome. These bold moves, however, should not overshadow Jordan's less public achievements as she struggled to remain an effective public leader while enduring personal stress and illness. One determined individual can make a difference, but they also inevitably face limits. Jordan's career illuminates how one Black woman legislator and leader used the practical tools of politics to pursue the ideal.

To that point, the consequences of Jordan's work to bring the modern Voting Rights Act into fruition needs to be examined more fully. The 1975 renewal was the first time the act was significantly extended in terms of time and in terms of reach. It redefined who was included in federal voter protections, and it set a precedent ensuring that the act would not stay static. Indeed, the 1982 reauthorization further expanded the act in accordance with the 1975 renewal. In subjecting voter-suppression methods such as discriminatory at-large elections and multimember legislative districts to judicial oversight, the 1982 Voting Rights reauthorization contributed to an even greater and reinvigorated Democratic

Party, one that would eventually lead to an explosion of Black elected officials and the election of the first Black president.

Indeed, the roots of Obama's victory over Hillary Clinton in the 2008 Democratic primaries can be traced back to the humble 1980s, the era of the Reagan revolution. Republicans defeated Democrats in national elections again and again, but this was also the decade when Jesse Jackson's presidential campaign registered millions of new Black voters and forged a multiracial, grassroots "rainbow coalition." Although Jackson did not secure the nomination, a new political story was emerging in Alabama, Georgia, Mississippi, and Virginia. The proportion of the Black electorate in those states remained unchanged between 1984 and 1993, yet the number of local Black elected officials substantially increased. In Alabama, for example, the number of African American officeholders rose from 241 to 605, in Georgia it climbed from 250 to 459, in Mississippi, from 296 to 546, and in Virginia it went from 86 to 125. A minirevolution in the number of Black representatives in southern state governments was also underway. In some places legal challenges to redistricting plans denying minority candidates equal access to the political process led to the establishment of smaller districts more favorable to minority candidates. In 1980 Mississippi had one Black representative in its state lower chamber; by 1993—nine years after Congress had voted to reauthorize Section 5—the state had fifteen black representatives.

When more African Americans won state legislative office, they exerted greater influence on the congressional redistricting process and paved the way for the establishment of an expanded Congressional Black Caucus in the US House. In 1990, when state legislatures in the South reapportioned districts according to new census data, thirteen new Black representatives won election to Congress, bringing the number of African Americans serving in the House to an all-time high of thirty-eight. Thus the 1982 reauthorization of the Voting Rights Act helped to level the playing field not just for Black voting but also for Black office-holding.

Those representatives made a difference. Obama's victory over Hillary Clinton in the 2008 Democratic primaries rested on two factors: massive Black turnout and the state and local political support he received from Black elected officials, especially in the South. Obama won the majority of delegates in Georgia, South Carolina, Alabama, North Carolina, Texas, and other crucial southern states because state and local African American Democratic officials provided early endorsements, supported grassroots organizing campaigns, and vouched for him

in African American communities when he was still a White House longshot. Had Section 5 not been reauthorized multiple times, and if the Supreme Court had failed to redress the issue of minority vote dilution in the 1980s, Obama's victory would have been virtually unthinkable. Black women campaigners also played an enormous role in Obama's primary victories by doing what they continue to do: educate voters by going door to door, running for office, getting out the vote on election day, and volunteering at local election centers. The combination of grassroots activism and legal strategies to open doors were engineered decades before President Obama's victory, and they began with the expansion of the Voting Rights Act.[1] With nurturing, seeds can grow into something larger than ever imagined.

Jordan's career helps us understand why so many African American voters turned to the Democrats in the 1960s and 1970s. What drew them to the party that had been the political home of white supremacists for generations? The evidence from this crucial period suggests that Black politicians—not just Jordan—persuaded those voters that the "solid South" was cracking and that the power of northern Democratic machines could be challenged. Throughout the nation, Black politicians from a range of backgrounds and ideological convictions argued that the Democratic Party could become an instrument for social change. Inspired by the civil rights and Black power movements, they wanted to push the Democrats away from its history of segregation and "bossism" and shape it into an organization that promoted equality and opportunity for everyone, an end to racial discrimination, greater protections for workers, help for the poor, equality for women, and voting rights for language minorities and other excluded populations. These politicians supported the use of federal power under Title VI of the 1964 Civil Rights Act to enforce Black equality. They wanted to expand voting rights, and they wanted the party to reflect the diversity of America. This first generation of Black politicians who emerged during the civil rights and Black power eras has been excluded from the Democratic story and from the civil rights narrative. They belong in both.

During her six years in Congress, Jordan emerged from an impressive group of northern and southern Black representatives as one of the most successful proponents of coalition politics. A persuasive orator and shrewd legislator, Jordan had dual commitments to the civil rights struggle and the Democratic Party which inspired both Black and white voters, especially Black women. The African American women in Houston who worked tirelessly for Jordan drew on

their legacy of institution building when they took on the task of "party building." Always interested in organizing around issues to improve Black lives, Black women in Houston—inspired by seeing Black candidates such as Jordan in positions of real power—worked to elect Democratic candidates.

Nevertheless, Black voter commitment to the Democratic Party was not a given—it had to be earned and then sustained. What we now call "the Black vote" has its roots in this period when the Democratic Party was searching for a new identity. Although the 1964 Civil Rights Act and the 1965 Voting Rights Act increased voter registration and Black participation in mainstream politics, the assassinations of Martin Luther King Jr. and Robert Kennedy, along with the chaos and police violence of the 1968 convention, led the Democrats to lose the presidency to Republican Richard Nixon. After the tragedies of 1968, no new national Democratic leader immediately emerged, and the party grew even more dependent on local Black elected officials to draw in crucial Black voters. In the South more Black politicians entered the electoral arena for the first time; in the North, new activists arose to challenge the party's status quo. Everywhere, Black Democrats faced numerous structural challenges. How could a minority win a majority of votes? And how could they overcome new forms of disenfranchisement? Furthermore, as party leaders had suspected, first-time Black voters were not completely convinced that the party's racial policies had changed or even served their interests. Could local Black Democratic politicians motivate the next generation of Black voters to support the party? And could these same politicians induce other Democrats to make integration, antipoverty programs, and civil rights the party's priorities?

Between 1966 and 1976—the year Democrat Jimmy Carter claimed the presidency—thousands of Black politicians and activists, inspired by the civil rights and Black power movements, registered Black voters, ran for office, and tested new strategies designed to empower Black voters within the Democratic Party, but the significance of their efforts has not been properly studied or understood. By 1973 more than twenty-six hundred Black politicians served in local and state offices, and the number of Black representatives in Congress had grown to sixteen, including two new members from the South—the first since 1901—Andrew Young from Georgia and Barbara Jordan of Texas.[2] Along with her Black colleagues in Congress—and sometimes in conflict with the party itself—Jordan sought to cement Black voters' loyalty to the Democrats. But just as important, she sought to diversify and expand the party's base, a direction

the party still struggles to navigate.[3] In the absence of a Democratic president, Jordan became a Black leader who promoted the nation's democratic promise and persuaded ordinary people that its unfulfilled promises were still in reach. Her rise occurred, however, only because Black activists within the civil rights and Black power movements throughout the nation forced a reluctant party to include them. In the mid-1970s she became the most renowned and most successful politician among those who fought to bring the movement's goals to fruition through the machinations of that contradictory and unlikely institution, the Democratic Party.

Today, when a small number of votes can decide House majorities, Senate races, and even the presidency, the Democrats have never been more reliant on the Black vote. Its power as a voting bloc gives the Black vote its leverage. At a time when disenchanted Black voters might be thinking of shifting their loyalties, or staying home on election day, the 1970s can offer a glimpse into how today's Democratic Coalition was formed. We know why whites left the party, but less about why Black voters came into the Democratic tent and why they have largely remained.[4] The history of Jordan and other Black Democrats in the 1970s illuminates the key role Black politicians played in building and strengthening that new coalition from the bottom up.

Barbara Jordan, the individual, was always part of something bigger than herself. She operated in a unique political context forged by segregation and civil rights activism. Even so, she faced racism, sexism, ableism, and numerous other prejudices and obstacles at every turn. Once in office she sought to chip away at white supremacy and its legacy. But the ability to exercise political power required a massive constellation of forces. Raw talent and persistence were not enough to propel her to victory or to make a difference once in office. She also needed favorable court decisions to correct malapportioned districts, the support of fellow Democrats in the Texas Senate and the US Congress, and the backing of white liberals, organized labor, and Black voters. Her abilities and ambition took her a long way, but she succeeded as far as she did because she was part of an extensive political network and a Black activist tradition. As the courts and state legislatures undermine and overturn the Voting Rights Act, Jordan's example is a reminder that any diminution of Black voting is bound to diminish the pool of Black candidates and erode Black political leadership. Redistricting designs that make it harder for Black communities to elect a representative of their choosing strike blows against both racial justice and democracy.

Barbara Jordan's life in politics demonstrates that although Black voting is an important right, it is not sufficient to guarantee full participation in electoral democracy. In a multiracial nation dominated by the political and economic power of white elites who do not represent a majority of voters, Black voting must be made meaningful through the fair application of redistricting laws and other protections that give Black candidates a fair chance and Black voters the opportunity to elect a candidate of their choice and to be heard. Barbara Jordan's political career shows this basic truth.

NOTES

Note to epigraph on page vii: Barbara Jordan, Opening Statement to the Senate Judiciary Committee, September 21, 1987, Day 6 of the Bork Confirmation Hearings, https://www.c-span.org/video/?c4746926/user-clip-barbara-jordan-bork-opening-statement-excerpt

Introduction

1. Barbara Jordan and Shelby Hearon, *Barbara Jordan: A Self-Portrait* (New York: Doubleday, 1979), 134; "Negro Wins in Race for Senate Seat," *Dallas Morning News*, May 8, 1966; Mary Beth Rogers, *Barbara Jordan: American Hero* (New York: Bantam, 1998), 109–110, gives an account of the swearing-in ceremony.

2. All quotes from James Stanley, "Man's View of Barbara Jordan," *Forward Times*, January 21, 1967.

3. *Forward Times*, January 21, 1967.

4. "Senate Mixture Hints Explosive Session," *Houston Chronicle*, November 9, 1966; *Texas Observer*, May 27, 1966.

5. Key texts on Black politics in the modern South include Chandler Davidson and Bernard Grofman, eds., *Quiet Revolution in the South: The Impact of the Voting Rights Act, 1965-1990* (Princeton, NJ: Princeton University Press, 1994); Chandler Davidson, ed., *Minority Vote Dilution* (Washington, DC: Howard University Press, 1989); Bernard Grofman, ed, *Minority Representation and the Quest for Voting Equality* (Cambridge: Cambridge University Press, 1992); Jack Bass and Walter DeVries, *The Transformation of Southern Politics: Social Change and Political Compromise Since 1945* (New York: Basic Books, 1976); Steven F. Lawson, *Running for Freedom: Civil Rights and Black Politics in America Since 1941*, 3d ed. (Hoboken, New Jersey: Wiley Blackwell, 2009); Manning Marable, *Race, Reform, and Rebellion: The Second Reconstruction in Black America, 1945-1982* (Jackson: University of Mississippi Press, 1984). For local studies of civil rights, Black power, and politics, see Robert J. Norrell, *Reaping the Whirlwind: The Civil Rights Movement in Tuskegee* (New York: Alfred A. Knopf, 1985); Hasan Kwame Jeffries, *Bloody Lowndes: Civil Rights and Black Power in Alabama's Black Belt* (New York: NYU Press, 2009); Anne M. Valk, *Radical Sisters: Second-Wave Feminism and Black Liberation in Washington, DC* (Urbana: University of Illinois Press, 2008); Christina Greene, *Our Separate Ways: Women and the Black Freedom Movement in Durham, North Carolina* (Chapel Hill: University of North Carolina Press, 2008); Leonard N. Moore, *The Defeat of Black Power: Civil Rights and the National Black Political Convention of 1972* (Baton Rouge: Louisiana State University Press, 2018); David Covin, *Black Politics after the Civil Rights Movement: Activity and Beliefs in*

Sacramento, 1970–2000 (Jefferson, NC: McFarland and Co., 2009); Martha S. Jones, *Vanguard: How Black Women Broke Barriers, Won the Vote and Insisted on Equality for All* (New York: Basic Books, 2020).

6. See https://www.rev.com/blog/transcripts/rep-barbara-jordan-1976-democratic-national-convention-keynote-speech-transcript for the keynote speech as it was delivered on July 12, 1976 in Madison Square Garden. It contains Jordan's adlibs that deviated from the prepared text, accessed December 6, 2023

7. Donna Brazile, *Cooking with Grease: Stirring the Pots in America* (New York: Simon and Schuster, 2005), 53.

8. Disfranchisement techniques before the 1965 Voting Rights Act (VRA) are detailed in Kousser, *Colorblind Injustice*; Alexander Keyssar, *The Right to Vote: The Contested History of Democracy in the United States* (New York: Basic Books, 2000); Richard C. Cortner, *The Apportionment Cases* (Knoxville: University of Tennessee Press, 1970); and Richard Valelly, *The Two Reconstructions: The Struggle for Black Enfranchisement* (Chicago: University of Chicago Press, 1994). Works on violence and the Democratic party in the South include, but are not limited to Paul Ortiz, *Emancipation Betrayed: The Hidden History of Black Organizing and White Violence in Florida from Reconstruction to the Bloody Election of 1920* (Berkeley: University of California Press, 2006); Timothy B. Tyson, "The Ghosts of 1898: Wilmington's Race Riot and the Rise of White Supremacy," *News and Observer,* Section H, November 17, 2006, https://media2.newsobserver.com/content/media/2010/5 /3/ghostsof1898.pdf, accessed December 3, 2023; Adam Fairclough, *The Revolution That Failed: Reconstruction in Natchitoches* (Gainesville: University Press of Florida, 2018).

9. For the number of southern Black legislators, see J. Morgan Kousser, *Colorblind Injustice: Minority Voting Rights and the Undoing of the Second Reconstruction* (Chapel Hill: University of North Carolina Press, 1999), 19, chart. For current numbers of Black representatives in Congress, see Pew Research Center, "The Changing Face of Congress in 8 Charts," February 7, 2023, https://www.pewresearch.org/fact-tank/2023/02/07/the-changing-face -of-congress/, accessed March 22, 2023; J. Todd Moye, *Let the People Decide: Black Freedom and White Resistance Movements in Sunflower County, Mississippi, 1945–1986* (Chapel Hill: University of North Carolina Press, 2004), 149–151.

10. Nancy J. Weiss, *Farewell to the Party of Lincoln: Black Politics in the Age of FDR* (Princeton, NJ: Princeton University Press, 1983), xiii and Chapter 10, "Why Blacks Became Democrats," 209–236.

11. Harvey Sitkoff, *A New Deal for Blacks: The Emergence of Civil Rights as a National Issue*, 30th anniversary ed. (Oxford: Oxford University Press, 2008,); Robert Shogun, *Harry Truman and the Struggle for Racial Justice* (Lawrence: University Press of Kansas, 2013).

12. Attorney Constance Baker Motley was appalled not only by Judge Cox's rulings but by the racism he aimed at Black lawyers in his courtroom. Tomiko Brown-Nagin, *Civil Rights Queen: Constance Baker Motley and the Struggle for Equality* (New York: Pantheon Press, 2022); Laura Visser-Maessen, *Robert Parris Moses: A Life in Civil Rights and Leadership at the Grassroots* (Chapel Hill: University of North Carolina Press, 2016); Jeffries, *Bloody Lowndes*; Malcolm X, "The Ballot or the Bullet," speech delivered at Cory Methodist Church, Cleveland, Ohio, April 3, 1964, in *Malcolm X Speaks* (New York: Grove Press, reprint, 1994).

13. Bayard Rustin, "From Protest to Politics: The Future of the Civil Rights Movement," *Commentary* (February 1965); Rustin's biographer John D'Emilio discusses the "novelty" of Rustin's argument that "the cutting edge of progressive change involved transforming the Democratic party." John D'Emilio, *Lost Prophet: The Life and Times of Bayard Rustin* (Chicago: University of Chicago Press, 2003), 402. See also Lani Guinier, *Tyranny of the Majority: Fundamental Fairness in Representative Democracy* (New York: Free Press, 1994).

14. Political scientists have focused on how racial realignments "weakened" southern Democrats and strengthened Republicans but not on why Black southerners joined the Democrats. See Merle Black, "The Transformation of the Southern Democratic Party," *Journal of Politics* 66, no. 4 (November 2004): 1001–1017; and Alan I. Abramowitz, "From Strom to Barack: Race, Ideology, and the Transformation of the Southern Party System," *American Review of Politics* 34 (Fall 2013): 207–226 (on p. 212 the shift of Black voters to the Democrats is uncritically attributed to Lyndon Johnson "fully embracing" the cause of civil rights). For an early overview see Numan V. Bartley and Hugh D. Graham, *Southern Politics and the Second Reconstruction* (Baltimore: The Johns Hopkins University Press, 1975). For the power of racial symbolism see Michael L. Rosino and Matthew W. Hughey, "Who's Invited to the (Political) Party: Race and Party Politics in the USA," *Ethnic and Racial Studies* 39, no. 3 (2016): 325–332, DOI: 10.1080/01419870.2016.1096413. Most recently Michael Kazin, *What It Took to Win: A History of the Democratic Party* (New York: Farrar, Straus and Giroux, 2022), focuses on the economic agenda of the modern party as a unifying tool but says little about race. Jennifer Rubin, *Resistance: How Women Saved Democracy from Donald Trump* (New York: William Morrow, 2021), focuses on the role of Black women in recent Senate races in Alabama and Georgia.

15. Sam Roberts, "Kevin Phillips, 82, Dies, Political Analyst Predicted GOP Resurgence," *New York Times,* October 10, 2023. See also Dan T. Carter, *From George Wallace to Newt Gingrich: Race in the Conservative Counterrevolution, 1963–1994* (Baton Rouge: Louisiana State University Press, 1996).

16. For partial treatments of Jordan's political career, see Chandler Davidson, *Biracial Politics: Conflict and Coalition in the Metropolitan South* (Baton Rouge: Louisiana State University Press, 1972); Richard F. Fenno, *Going Home: Black Representatives and Their Constituents* (Chicago: University of Chicago Press, 2003), 66–113, 111; Ira Bryant, *Barbara Charline Jordan: From the Ghetto to the Capitol* (Texas: D. Armstrong and Co., 1977); Barbara Jordan and Shelby Hearon, *Barbara Jordan: A Self-Portrait* (New York: Doubleday, 1979); Rogers, *Barbara Jordan: American Hero*; Mary Ellen Curtin, "Reaching for Power: Barbara C. Jordan and Liberals in the Texas Legislature, 1966–1972," *Southwestern Historical Quarterly* 108, no. 2 (October 2004): 211–231.

17. "Black Politics: A New Way to Overcome," *Newsweek*, June 7, 1971, pp. 30–39, outlined the surge in Black officeholding by Black activists entering Congress. These representatives, including Shirley Chisholm of Brooklyn and William Clay from Missouri, represented a break from older members like William Levi Dawson, a Black Democrat from Chicago who served as a Chicago alderman and in Congress for twenty-seven years. Historian Edward Clayton called Dawson an "old pro" at manipulating the "system of organization and patronage" that lay at the heart of northern party politics. See Edward T. Clayton,

The Negro Politician: His Success and Failure (Chicago: Johnson Publishing Company, 1964), 104. Christopher Manning, *William L. Dawson and the Limits of Black Electoral Leadership* (DeKalb: Northern Illinois University Press, 2009). For a brief treatment of Dawson, race, and machine politics, see also Michael Kazin, *What It Took to Win: A History of the Democratic Party* (New York: Farrar, Strauss, and Giroux, 2022). See also Wil Haygood, *King of the Cats: The Life and Times of Adam Clayton Powell, Jr.* (New York: Harper Press, 2006). Powell was known as "Mr. Civil Rights," but also suffered from allegations of corruption. He lost his seat to Charles Rangel in 1970. Charles B. Rangel, *And I Haven't Had a Bad Day Since: From the Streets of Harlem to the Halls of Congress* (New York: St Martin's Press, 2008).

18. Matthew Countryman, "From Protest to Politics: Community Control and Black Independent Politics in Philadelphia, 1965–1984," *Journal of Urban History* 32, no. 6 (2006): 813–861; and Matthew J Countryman, *Up South: Civil Rights and Black Power in Philadelphia* (Philadelphia: University of Pennsylvania Press, 2006).

19. For Chisholm's struggles with the Democratic Party machine in New York, see Shirley Chisholm, *Unbought and Unbossed* (New York: Avon Press, 1970), and Anastasia C. Curwood, *Shirley Chisholm: Champion of Black Feminist Power Politics* (Chapel Hill: University of North Carolina Press, 2023). For Stokes's view on the patronizing and racist attitudes of the local Democrats in Cleveland, see his autobiography, Carl B. Stokes, *Promises of Power: A Political Autobiography* (1973), reprinted by the Cleveland Memory Project (2015), https://engagedscholarship.csuohio.edu/clevmembks/27, accessed November 21, 2023, and Leonard N. Moore, *Carl B. Stokes and the Rise of Black Political Power* (Urbana: University of Illinois Press, 2002).

20. See the Julian Bond Oral History Project, directed by Dr. Gregg Ivers, School of Public Affairs, American University, https://www.julianbondoralhistoryproject.org/transcripts (Charlie Cobb, pp. 14–17; Courtland Cox, pp. 11–15) accessed November 20, 2023; John Neary, *Julian Bond: Black Rebel* (New York: William Morrow and Co., 1971). D'Emilio, *Lost Prophet*, 393–416, discusses how members of the MFDP returned to Mississippi to run for office and the larger response to the 1965 Voting Rights Act.

21. Chana Kai Lee, *For Freedom's Sake: The Life of Fannie Lou Hamer* (Urbana: University of Illinois Press, 1999); Keisha Blain, *Until I Am Free: Fannie Lou Hamer's Enduring Message to America* (Boston: Beacon Press, 2021); J. Todd Moye, *Let the People Decide: Black Freedom and White Resistance Movements in Sunflower County, Mississippi, 1945–1986* (Chapel Hill: University of North Carolina Press, 2004); Norrell, *Reaping the Whirlwind: The Civil Rights Movement in Tuskegee*, 164–202.

22. David J. Garrow, "The Voting Rights Act in Historical Perspective," *Georgia Historical Quarterly* 74, no. 3 (Fall 1990): 381–382.

23. For analysis of the voting rights movement and civil rights in Texas, see Max Krochmal, *Blue Texas: The Making of a Multiracial Democratic Coalition in the Civil Rights Era* (Chapel Hill: University of North Carolina Press, 2016); Chandler Davidson, *Race and Class in Texas Politics* (Princeton, NJ: Princeton University Press, 1990).

24. Author's interview with Eddie Ball, Lake Livingston, TX, April 14, 2004.

25. Shortly after her election to the Texas Senate, Jordan spoke alongside King in Alexandria, Louisiana, at a meeting of the Louisiana Education Association. She also appeared

as a special guest speaker at the tenth anniversary of the founding of the SCLC in Atlanta, Georgia. *Chicago Defender*, December 10, 1966, and July 15, 1967.

26. The most recent book on the longstanding commitment of Black women to politics is Martha S. Jones, *Vanguard: How Black Women Broke Barriers, Won the Vote, and Insisted on Equality for All* (New York: Basic Books, 2020). For a fresh view of Black women and organizing for civil rights and Black power in North Carolina, see Greene, *Our Separate Ways*. See also Jewel Prestage, "In Quest of African American Political Woman," *Annals of the American Academy of Political and Social Science* 515, no. 1 (1991): 88–103; Cathy J. Cohen, "A Portrait of Continuing Marginality: The Study of Women of Color in American Politics," in *Women and American Politics: New Questions, New Directions*, ed. Susan J. Carroll. (Oxford: Oxford University Press, 2003), 190–213; Linda-Faye Williams, "The Civil Rights–Black Power Legacy: Black Women Elected Officials at the Local, State, and National Levels," in *Sisters in the Struggle: African American Women in the Civil Rights–Black Power Movement*, ed. Bettye Collier-Thomas and V. P. Franklin (New York: New York University Press, 2001), 306–331; Sharon Wright, "Black Women in Congress during the Post–Civil Rights Movement Era," in *Still Lifting, Still Climbing: African American Women's Contemporary Activism*, ed. Kimberly Springer (New York: New York University Press, 1999), 149–165; Robert Darcy and Charles D. Hadley, "Black Women in Politics: The Puzzle of Success," *Social Science Quarterly* 69 (1988); Lisa Garcia Bedalia, Katherine Tate, and Janelle Wong, "Indelible Effects: The Impact of Women of Color in the U.S. Congress," in *Women and Elective Office: Past, Present, and Future*, ed. Sue Thomas and Clyde Wilcox (Oxford: Oxford University Press, 2005), 152–175; Wendy G. Smooth, "African American Women and Electoral Politics: Journeying from the Shadows to the Spotlight," in *Gender and Elections: Shaping the Future of American Politics*, ed. Susan J. Carroll and Richard L. Fox (Cambridge: Cambridge University Press, 2006), 117–142; Marjorie Lansing, "The Voting Patterns of American Black Women," in *A Portrait of Marginality: The Political Behavior of the American Woman*, ed. Marianne Githens and Jewel L. Prestage (New York: David McKay Company, Inc. 1977), 379–394.

27. Barry Crouch, "A Spirit of Lawlessness: White Violence, Texas Blacks, 1865–1868," *Journal of Social History* 18 (Winter 1984): 217–232.

28. Howard Beeth and Cary D. Wintz, eds., *Black Dixie: Afro-Texan History and Culture in Houston* (College Station: Texas A & M Press, 2000); *W. E. B. Du Bois, Black Reconstruction in America, 1860–1880* (New York: Atheneum, 1935, 1977), 552–553; Chandler Davidson, *Biracial Politics*, 12.

29. Rebecca Kosary, "'Wantonly Mistreated and Slain Simply Because They Are Free': Racial Violence During Reconstruction in South Texas," in *African Americans in South Texas History*, ed. Bruce A. Glasrud College Station: Texas A&M University Press, 2011). Kosary documented violent landowners who prevented free laborers from leaving and colluded to hold mock trials for alleged labor infractions.

30. Beeth and Wintz, *Black Dixie*, 25; Merline Pitre, "Richard Allen: The Chequered Career of Houston's First Black State Legislator," in *Black Dixie*, ed. Beeth and Wintz, 75.

31. Lawrence Goodwyn, "Populist Dreams and Negro Rights: East Texas as a Case Study," *American Historical Review* 76, no. 5 (December 1971): 1435–1456, 1446. Black

Houstonians continued to vote in elections, but the scattered distribution of Black residents throughout the city wards prevented the election of a single Black representative. Beeth and Wintz, *Black Dixie*, 27

32. "Capitol Not for Negroes: Texan Lawmakers Boo-Hoo Resolution to Let Booker T. Washington Speak," Los Angeles *Times*, August 9, 1911, in *Booker T. Washington Papers*, vol. 11, ed. Louis R. Harlan and Raymond Smock (Urbana: University of Illinois Press), 294.

33. John W. Cell, *The Highest Stage of White Supremacy: The Origins of Segregation in South Africa and the American South* (New York: Cambridge University Press, 1982), 13.

34. Quoted in Davidson, *Race and Class in Texas Politics,* 4–5.

35. Patrick Cox, *Ralph W. Yarborough, The People's Senator* (Austin: University of Texas Press, 2001).

36. For analysis of how Houston's white elites slowed and hampered school integration, see William Henry Kellar, *Make Haste Slowly: Moderates, Conservatives, and School Desegregation in Houston* (College Station: Texas A & M University Press, 1999); for the roadblocks elites placed on local activists during the War on Poverty, along with their resistance to integration, see Wesley G. Phelps, *A People's War on Poverty: Urban Politics and Grassroots Activists in Houston* (Athens: University of Georgia Press, 2014), and Wesley G. Phelps, "Ideological Diversity and the Implementation of the War on Poverty in Houston," in *The War on Poverty: A New Grassroots History, 1964–1980,* ed. Annelise Orleck and Lisa Gayle Hazirjian (Athens: University of Georgia Press, 2011), 87–109. For further analysis of the failure of the OEO programs in Houston, see William S. Clayson, *Freedom Is Not Enough: The War on Poverty and the Civil Rights Movement in Texas* (Austin: University of Texas Press, 2010). For a detailed look at how white elites in Houston controlled the timing and pace of integration, see Thomas Cole, *No Color Is My Kind: The Life of Eldrewey Stearns and the Integration of Houston* (Austin: University of Texas Press, 1997).

37. Merline Pitre, *In Struggle against Jim Crow: Lulu B. White and the NAACP, 1900–1957* (College Station: Texas A & M Press, 2010), outlines the debates over integration in Black Houston. The ties between Black businessmen and John Connally are discussed briefly in Bass and DeVries, *The Transformation of Southern Politics: Social Change and Political Compromise Since 1945*, 333.

38. "Dynamic Femme Attorney, Texas Senator-Elect to Address Anniversary," *Chicago Defender*, November 5, 1966, quoting the Houston *Forward Times.*

39. For the links between Black institutions in segregation and Black resistance, see Bill Chafe, "The Gods Bring Threads to Webs Begun," *Journal of American History* 86, no. 4 (2000): 1531–1551; Anne Valk and Leslie Brown, *Living with Jim Crow: African American Women and Memories of the Segregated South* (New York: Palgrave Macmillan, 2010).

40. Colorado representative Patricia Schroeder, among many others, said she felt she had "God on her side" when Jordan spoke on her behalf. Pat Schroeder, *24 Years of Housework and the Place Is Still a Mess: My Life in Politics* (Kansas City, MO: Andrews McMeel Publishing, 1998). The notice of Jordan's death published by the Associated Press (AP) focuses on her "Jehovah-like oratory." It quoted Sen. Lloyd Bentsen ("she was speaking from tablets of stone") and the chair of the House Judiciary Committee, Rep. Peter Rodino. Rodino recalled that she "opened her mouth, spoke a few words [and I thought,] this is a

woman I certainly want on this committee" ("Former Rep. Barbara Jordan Dies," Associated Press, *Las Vegas Review*, January 18, 1996).

41. Richard Lischer, *The Preacher King: Martin Luther King Jr. and the Word That Moved America* (New York: Oxford University Press, 1995), 149. Italics in original. See also Simon Lancaster, *Winning Minds: Secrets from the Language of Leadership* (London: Palgrave Macmillan, 2015).

42. Barbara Jordan, "Statement to the House Judiciary Committee on the Articles of Impeachment," July 24, 1974, https://millercenter.org/the-presidency/impeachment/my -faith-constitution-whole-it-complete-it-total accessed November 23, 2023.

43. Bill Bradley, *Time Present, Time Past: A Memoir* (New York: Vintage, 1997), 17–19.

44. "At 73, Man on a Wire Philippe Petit Still Dances High above the Void," *Washington Post*, March 24, 2023.

45. Arthur Ashe, BBC interview with Lynn Redgrave, July 1, 1992. Black tennis player Arthur Ashe described how his segregated upbringing did not allow for public displays of anger or emotion: "I am not emotionally very open, no I am not, but I don't think it's a crime. Control is very important to me. You grow up black in the American South in the late '40s and '50s and you have no control." He could not show anger and go off "half-cocked" like John McEnroe because his "race"—meaning his fans, his people—would not allow such behavior: "My race wouldn't allow me to be like that."

46. Shelby Hearon's papers at the Harry Ransom Center, University of Texas at Austin, contain chapter drafts and other excerpts from interviews with Jordan that do not appear in her final book. Sources from this collection are hereafter referred to as "Shelby Hearon Papers, Harry Ransom Center." Hearon also generously shared with me court records, additional research notes, and correspondence among her, Jordan, and Nancy Earl, Jordan's partner. These are hereafter referred to as "Shelby Hearon Papers, Private Collection in author's possession."

47. Nancy Earl worked in the Measurement and Evaluation Center at the University of Texas at Austin. Rogers, *American Hero*, 142–143. Barbara Jordan gave an account of their first meeting in Jordan and Hearon, *Barbara Jordan: A Self-Portrait*, 142–145. Further discussion and evidence of Nancy Earl's role in Jordan's life can be found in documents and oral histories, and those details are woven in throughout the book. I acknowledge that neither Jordan nor Earl would have ever wanted to speak publicly about their relationship, and I also acknowledge limitations on what can be known, but I spoke with many individuals who assumed Jordan was a lesbian and one close associate, Cecile Harrison, who was also a lesbian, who confirmed it. Throughout the book, I refer to Earl as Jordan's partner and portray them as a committed lesbian couple. For a discussion of balancing, exposing, and protecting a subject's personal life, see Karen Vallgarda, "Introduction: The Politics of Family Secrecy," *Journal of Family History* 47, no. 3 (2022): 239–247, citing Eve Kosofsky Sedgwick, *Touching Feeling: Affect, Pedagogy, Performativity* (Durham, NC: Duke University Press, 2003), 123–151. For the tensions over sexual secrets and public life, see Erving Goffman, *Stigma: Notes on the Management of Spoiled Identity* (Englewood Cliffs, NJ: Prentice Hall, 1963); James Kirchick, *Secret City: The Hidden History of Gay Washington* (New York: Henry Holt, 2022). For recent biographies of Black women that wrestle with similar questions about secrecy and

disclosure, see Shanna Greene Benjamin, *Half in Shadow: The Life and Legacy of Nellie Y. McKay* (Chapel Hill: University of North Carolina Press, 2021); and Imani Perry, *Looking for Lorraine: The Radiant and Radical Life of Lorraine Hansberry* (Boston: Beacon Press, 2019).

48. Definitions of lesbianism and same-sex relationships have changed over time. For a range of approaches, see Lillian Faderman, *To Believe in Women: What Lesbians Have Done for America* (New York: Harper One, 2000); Deborah T. Meem, Michelle A. Gibson, and Jonathan F. Alexander, *Finding Out: An Introduction to LGBT Studies* (Los Angeles: Sage, 2010); Patricia Hill Collins, *Black Sexual Politics: African Americans, Gender, and the New Racism* (Milton Park, Oxfordshire: Routledge, 2005); and E. Patrick Johnson, "'Quare' Studies, or Almost Everything I Know about Queer Studies I Learned from My Grandmother," in *Black Queer Studies: A Critical Anthology*, ed. E. Patrick Johnson and Mae G. Henderson (Durham, NC: Duke University Press, 2005),124–157.

49. Jordan and Hearon, *Barbara Jordan: A Self-Portrait*, 125.

50. Rogers, *Barbara Jordan: American Hero*, contains a wealth of important details about Jordan's life. Many books about Barbara Jordan were written for juveniles, ages 4–12, or "young adults." See Rose Blue, *Barbara Jordan* (New York: Chelsea House Publishing, 1992); Diane Patrick-Wexler, *Barbara Jordan* (Milwaukee: Raintree/Steck Vaughn, 1995); Joseph D. McNair, *Barbara Jordan: African American Politician* (Chanhassen, MN: Childs World, 2000); Laura S. Jeffrey, *Barbara Jordan: Congresswoman, Lawyer, Educator* (Berkeley Heights, New Jersey: Enslow Publishers, Inc., 1997); James Mendelsohn, *Barbara Jordan: Getting Things Done* (Breckinridge, CO: Twenty-First Century Books, 2001); Lisa R. Rhodes, *Barbara Jordan: Voice of Democracy* (London: Franklin Watts Inc., 1998); Duchess Harris, *Barbara Jordan: Politician and Civil Rights Leader* (Minnesota: Core Library, 2019); Chris Barton, *What Do You Do with a Voice Like That? The Story of Extraordinary Congresswoman Barbara Jordan* (San Diego: Beach Lane Books, 2018).

51. "Barbara Jordan was soulmates with no one but herself and her God," Rogers wrote. "She was emotionally self-contained and, for much of her adult life, physically incapacitated." Rogers, *Barbara Jordan: American Hero*, xv.

52. Hugh Gregory Gallagher, *FDR's Splendid Deception* (New York: Dodd, Mead, 1985); and Robert Dallek, *An Unfinished Life: John F. Kennedy, 1917–1963* (Boston: Little, Brown & Co., 2003).

53. Nancy Mairs, *Waist-High in the World: A Life Among the Nondisabled* (Boston: Beacon Press, 1996).

54. "Rep. Wilbur D. Mills (D-Ark.) yesterday broke three days of silence and denials by admitting that U.S. Park Police found him with his face cut after they stopped his speeding car near the Tidal Basin at 2 a.m. Monday." Mills, chair of the House Ways and Means Committee, was involved with a female stripper, Fanne Fox, who had just jumped into the Tidal Basin. *Washington Post*, October 11, 1974.

55. Jake Johnson quoted in Rogers, *Barbara Jordan: American Hero*, 305.

56. Audrey Thomas McCluskey and Elaine M. Smith, eds., *Mary McLeod Bethune: Building a Better World* (Bloomington: Indiana University Press, 1999), 40–41.

57. Anne Valk and Leslie Brown, *Living with Jim Crow: African American Women and Memories of the Segregated South* (New York: Palgrave MacMillan, 2010).

58. Manning Marable, *Black Leadership* (New York: Columbia University Press, 1998), xii–xiv, xvi.

59. Belinda Robnett, "African American Women in the Civil Rights Movement, 1954–1965: Gender, Leadership, and Micromobilization," *American Journal of Sociology* 101, no. 6 (May 1996): 1661–1693, 1667 and 1671.

60. Greene, *Our Separate Ways*, 5.

61. Robnett, "African American Women in the Civil Rights Movement," 1664–1665.

62. Donna Brazile, *Cooking with Grease: Stirring the Pots in America* (New York: Simon and Schuster, 2005), 53.

63. Melissa Harris-Lacewell, "Obama and the Sisters," *The Nation*, September 18, 2008.

64. Tera Hunter, "The Forgotten Legacy of Shirley Chisholm," in *Obama, Clinton, Palin: Making History in Election 2008*, ed. Liette Gidlow, (Champaign: University of Illinois Press, 2011); Maegan Parker Brooks, *A Voice That Could Stir an Army: Fannie Lou Hamer and the Rhetoric of the Black Freedom Movement* (Jackson: University Press of Mississippi, 2014); Keisha Blain, *Until I Am Free: Fannie Lou Hamer's Enduring Message to America* (Boston: Beacon Press, 2021); Duchess Harris, *Black Feminist Politics from Kennedy to Trump* (London: Palgrave Macmillan, 2019); Sherie M. Randolph, *Florence "Flo" Kennedy: The Life of a Black Feminist Radical* (Chapel Hill: University of North Carolina Press, 2015); Barbara Ransby, *Ella Baker and the Black Freedom Movement: A Radical Democratic Vision* (Chapel Hill: University of North Carolina Press, 2003; Anastasia C. Curwood, *Shirley Chisholm: Champion of Black Feminist Power Politics* (Chapel Hill: University of North Carolina Press, 2023).

65. "Barbara Jordan: A New Power in Congress," *Ebony*, February 1975, 136–142.

66. For a thoughtful reflection on political negotiation, compromise, and activism, see Donnel Baird, "Calm Up: Dr. Goodwyn's Workshop," in *People Power: History, Organizing, and Larry Goodwyn's Democratic Vision in the Twenty-First Century*, ed. Wesley C. Hogan and Paul Ortiz (Gainesville: University Press of Florida, 2021), 43–52.

67. Quoted in Merline Pitre, "Frederick Douglass: The Politician vs the Social Reformer," *Phylon* 40, no. 3 (1979): 220–227, 220.

68. Letter from Yancey Martin to John O'Neal, Free Southern Theater, New Orleans, March 27, 1974, Papers of the Southern Election Fund and of the Chairman of the Board of Trustees, Julian Bond, Box 5, Folder 3, University of Virginia, Albert and Shirley Small Special Collections Library, MSS 10907.

Chapter 1

1. "Senator Jordan: Even as a Little Girl She was One of the Rare Ones," *Houston Chronicle*, November 30, 1969, front page.

2. Molly Ivins, "She Sounded Like God," *New York Times Magazine*, December 29, 1996, 17; Young quoted in Rogers, *Barbara Jordan: American Hero*, 219.

3. Anna Curtis graduated from Phillis Wheatley High School in 1954, two years after Barbara Jordan. She worked in the Fifth Ward running the Kashmere Community Center. Author's interview with Anna Curtis, April 14, 1999, Houston, TX. Judge Andrew Jefferson attended Texas Southern University (TSU) with Jordan. Both graduated in 1956. They

worked on the TSU yearbook together. Author's interview with Judge Andrew Jefferson, March 27, 2001, Houston, TX.

4. It traded more than one million (1,098,000) bales in 1893, and more than 2.5 million in 1898. Houston's closest competitor interior trading city was Memphis, which traded a mere 680,000 bales in 1898. Galveston surpassed Charleston, Savannah, and even New Orleans in its cotton trading. By 1899 cotton receipts for Galveston accounted for 21 percent of the nation's entire cotton trade. US Bureau of Statistics, "Internal Commerce: Cotton Trade of the United States and the World's Cotton Supply and Trade" (Washington, DC: United States Department of the Treasuries, Bureau of Statistics, 1900, GPO, 1900), Galveston, p. 2594 and table, p. 2595; Houston, table, p. 2596.

5. In 1913 Jones built the luxurious seventeen-story, 500-room Rice Hotel, and he also owned the Foster Building, which housed his newspaper, the *Houston Chronicle*, and the city's major banks. For background on Jones and his achievements see Walter L. Buenger, "Between Community and Corporation: The Southern Roots of Jesse H. Jones and the Reconstruction Finance Corporation," *Journal of Southern History* 56, no. 3 (August 1990): 481–510; Steven Fenberg, *Unprecedented Power: Jesse Jones, Capitalism, and the Common Good* (College Station: Texas A & M University Press), 2011. See also "The History of Houston's Rice Hotel," *Houston Chronicle*, May 17, 2018. See also "Hughes Tool: Its Background," *New York Times*, October 23, 1986, section D, 18. Hugh S. Gorman, "The Houston Ship Channel and the Changing Landscape of Industrial Pollution," in *Energy Metropolis: An Environmental History of Houston and the Gulf Coast*, ed. Martin V. Melosi and Joseph A. Pratt (Pittsburgh: University of Pittsburgh Press, 2007), 52–68.

6. Beeth and Wintz, eds., *Black Dixie*, 89, table 7, "Black Population in Houston, 1850–1980."

7. *Encore American and Worldwide News*, January 20, 1975, 32. Scrapbook of Barbara Jordan's Activities, August 1974–May 1975, Portal to Texas History, https://texashistory.unt .edu/ark:/67531/metapth616557/, accessed November 22, 2023.

8. Beeth and Wintz, eds., *Black Dixie*, 164–165; Tyina Steptoe, *Houston Bound: Culture and Color in a Jim Crow City* (Berkeley: University of California Press, 2015); and Roger Wood and James Fraher, *Down in Houston* (College Station: Texas A & M University Press, 2012).

9. John Wheat, "Lightnin' Hopkins: Blues Bard of the 3rd Ward," in *Juneteenth Texas: Essays in African American Folklore*, ed. Abernethy, Satterwhite, and Govenar (Denton: University of North Texas Press, 2010), 255–272; Beeth and Wintz, eds., *Black Dixie*, 165; Teresa Tomkins-Walsh, "Thelma Scott Bryant: Memories of a Century in Houston's Third Ward," *Houston Review* 1, no, 1 (2004): 48–58. *The Red Book of Houston: A Compendium of Social, Professional, Religious, Educational, and Industrial Interests of Houston's Colored Population* (Houston: Sotex Publishing Co., 1915) has photos and lists the small businesses and churches of Houston in this period. https://archive.org/details/redbookofhouston00sote /page/n5/mode/2up, accessed November 22, 2023.

10. "An Account of Washington's Tour of Texas," Tuskegee, Alabama, October 7, 1911, Booker T. Washington Papers, vol. 11, 322–329; and Horace D. Slatter, "An Account of Washington's Tour of Texas," Tuskegee, Alabama, October 14, 1911, Booker T. Washington

Papers 331–342. See also Robert D. Bullard, *Invisible Houston: The Black Experience in Boom and Bust* (College Station: Texas A & M University Press, 2000).

11. Carrie Joel Jordan, Death Certificate, June 11, 1918. Texas, US, Death Certificates, (1903–1982), ancestry.com, accessed December 1, 2023. Certificate lists her date of birth as September 18, 1907. Ben Jordan, his sister Carrie, and both parents could read and write. See also 1910 US Census, which showed a Black schoolteacher named James Taylor living next door to the Jordans. 1910 United States Census, Jackson Edna County, Texas, digital image, Ben Jordan, ancestry.com, accessed December 1, 2023. The 1920 Census shows the Jordans living alongside white and Mexican families. 1920 United States Census, Jackson, Edna County, Texas, digital image, Ben Jordan, ancestry.com, accessed December 1, 2023. Benjamin's death certificate gives his date of birth as 1904. Fourteenth Census (1920).

12. Neil Foley, *The White Scourge: Mexicans, Blacks, and Poor Whites in Texas Cotton Culture* (Berkeley: University of California Press, 1997).

13. Although not ordained, many Black women Baptists of that era claimed the right to interpret and spread the word of God. Evelyn Brooks Higginbotham, *Righteous Discontent: The Women's Movement in the Black Baptist Church, 1880–1920* (Cambridge, MA: Harvard University Press, 1993), details the spread of black women theologians in the South in the late nineteenth and early twentieth centuries (124–128). Ben Jordan told Barbara that his mother, Mary, had been a "missionary." For criticism of sexism in the Black church and its treatment of Black women called to preach, see Jacquelyn Grant, "Black Women and the Church," in *All the Women Are White, All the Blacks Are Men, But Some of Us Are Brave: Black Women's Studies*, 2d ed., ed. Akasha Hull, Patricia Bell-Scott, and Barbara Smith (Albany: City University of New York: Feminist Press, 2015), 141–152.

14. "History of the Good Hope Baptist Church," souvenir program (1945), 16–18, library, Good Hope Missionary Baptist Church, Houston.

15. E. Franklin Frazier, *The Negro Church in America: The Black Church Since Frazier*, (New York: Schocken Books, 1974), 55–57, describes the importance of the church for urban Blacks who were recent migrants.

16. The marriage certificate for Ben and Arlyne Jordan was signed by Reverend Cashaw and gives the address of the ceremony.

17. Houston, City Directory, 1905, 466, and Houston, City Directory 1911, 1326. According to the 1915 City Directory, he had a restaurant at 505 San Felipe and lived at 513.

18. For Arlyne's education see 1940 United States Census, Houston, Texas, "Arlyne Patten," ancestry.com, accessed December 2, 2023. See also Ira B. Bryant, *The Development of the Houston Negro Schools* (Houston, TX: Informer Publishing Co., 1935), 131.

19. Jordan and Hearon, *Barbara Jordan: A Self-Portrait*, 30.

20. Jordan and Hearon, *Barbara Jordan: A Self-Portrait*, 29.

21. James M. SoRelle, "'An de Po Cullud Man Is in de Wuss Fix uv Awl': Black Occupational Status in Houston, Texas, 1920–1940," *Houston Review* 1, (Spring 1979): 14–26, 19, and 25, table 3.

22. Anthea Butler, *Women in the Church of God in Christ: Making a Sanctified World* (Chapel Hill: University of North Carolina Press, 2007), 1.

23. Higginbotham, *Righteous Discontent*, 1–2, and 228–229, for descriptions of Nannie Burroughs's public speaking. See also Higginbotham, "Religion, Politics, and Gender: The Leadership of Nannie Helen Burroughs," in *This Far by Faith: Readings in African American Women's Religious Biography*, ed. Judith Weisenfeld and Richard Newman (New York: Routledge, 1995), 140–157. Nannie Burroughs, speech to the Women's Convention, 1905, quoted in Higginbotham, *Righteous Discontent*, 207.

24. Higginbotham, "The Politics of Respectability," in *Righteous Discontent*, chap. 7, 185–229.

25. Higginbotham, *Righteous Discontent*, 186.

26. Jordan and Hearon, *Barbara Jordan: A Self-Portrait*, 7.

27. Marcia Chatelain, *South Side Girls: Growing Up in the Great Migration* (Durham, NC: Duke University Press, 2015), 132–133, cites oral histories of southern Black girls who left because of lack of schooling and economic exploitation.

28. According to the 1940 census (Sixteenth Census of the United States), Benjamin Jordan earned ($938) for 52 weeks of work as a "checker" at a warehouse; his father, Charley, earned $208 for 26 weeks of work at the paper company; and Gar earned $560 for 36 weeks of work as a schoolteacher. Arlyne earned zero income. 1940 United States Census, Houston, Harris County, Texas, "Ben Jordan," ancestry.com, accessed December 2, 2023. In 1942 at the age of thirty-nine, Ben Jordan worked at Houston Terminal Warehouse Company. Benjamin Jordan, World War 2 Draft Cards, 1940–1947, ancestry.com, accessed December 1, 2023. Arlyne occasionally earned money through "day work," but she was not officially employed as a domestic.

29. Jordan and Hearon, *Barbara Jordan: A Self-Portrait*, 43.

30. Jordan and Hearon, *Barbara Jordan: A Self-Portrait*, 48.

31. Jordan and Hearon, *Barbara Jordan: A Self-Portrait*, 46.

32. Jordan and Hearon, *Barbara Jordan: A Self-Portrait*, 43.

33. Shelby Hearon Papers, Box 3, Folder 12, draft of chapter titled "Home." Harry Ransom Center, Austin, TX.

34. Jordan and Hearon, *Barbara Jordan: A Self-Portrait*, 48.

35. Jordan and Hearon, *Barbara Jordan: A Self Portrait*, 44.

36. Jordan and Hearon, *Barbara Jordan: A Self-Portrait*, 31.

37. Anna Curtis, interview with the author, April 14, 1999, Houston, TX.

38. Jordan and Hearon, *Barbara Jordan: A Self-Portrait*, 46.

39. Jordan and Hearon, *Barbara Jordan: A Self-Portrait*, 35.

40. "Rev. A.A. Lucas, Local Minister, Has Remarkable Career," *Houston Informer* (1941), clipping file, library, Good Hope Missionary Baptist Church.

41. Jordan and Hearon, *Barbara Jordan: A Self-Portrait*, 26.

42. Jordan and Hearon, *Barbara Jordan: A Self-Portrait*, 26.

43. When Lucas began his service on March 26, 1935, he was immediately considered a "very stern and unlikeable-appearing preacher. . . . Three fourths of the membership disliked him." "History of the Good Hope Baptist Church," souvenir program (1945), 16–18.

44. Jordan and Hearon, *Barbara Jordan: A Self-Portrait*, 26, describes the seating arrangements.

45. Author's interview with Sara Scarbrough, July 24, 2009, Houston, TX.

46. Jordan and Hearon, *Barbara Jordan: A Self-Portrait*, 38.

47. Jordan and Hearon, *Barbara Jordan: A Self-Portrait*, 1.

48. Jordan and Hearon, *Barbara Jordan: A Self-Portrait*, 45.

49. In 1937 "76 vessels took some 289,024 tons of scrap iron from the Port of Houston," and most of it was destined for Japan. A writer from *Fortune* magazine described the view along the "man-dredged bayou" on the way to the Port of Houston's Turning Basin. "By this time you will have passed mountains of old railroad ties, bedsprings, alarm clocks, auto fenders, and I beams, representing some 200,000 tons of stored scrap iron." Marilyn McAdams Sibley, *The Port of Houston: A History* (Austin: University of Texas Press, 1968) 186–187.

50. Jordan and Hearon, *Barbara Jordan: A Self-Portrait*, 6.

51. Jordan and Hearon, *Barbara Jordan: A Self-Portrait*, 7.

52. Jordan and Hearon, *Barbara Jordan: A Self-Portrait*, 22.

53. Jordan and Hearon, *Barbara Jordan: A Self-Portrait*, 63.

54. Jordan and Hearon, *Barbara Jordan: A Self-Portrait*, 9.

55. John Ed first appears in the 1910 federal census in Houston. 1910 United States Census, Houston, Harris County, "John E. Patten," ancestry.com, accessed December 2, 2023. Mary Beth Rogers, one of Jordan's biographers, has asserted that John Ed was the son of Edward A. Patton, a Black member of the Texas legislature from San Jacinto County who served for one term between 1890 and 1892. She cites John Ed Patten's reference to his hometown of Evergreen, and the claim he made about his father being a lawyer living in Washington DC.-Mary Beth Rogers, *Barbara Jordan: American Hero*, 7–11. For information on legislator Edward Patton, see Merline Pitre, *Through Many Dangers, Toils and Snares: The Black Leadership of Texas, 1868–1900* (Austin: Eakin, 1985); John Mason Brewer, *Negro Legislators of Texas and Their Descendants: A History of the Negro in Texas Politics from Reconstruction to Disfranchisement* (Dallas: Mathis Publishing, 1935), 99 (https://tshaonline.org/handbook/online/articles/fpawp), accessed November 22, 2023. The 1900 US Census shows an Edward Patton, clerk, from Texas (b. 1863) living in Washington, DC, with his wife, Ruth, and two teenaged children, both born in Texas. The couple had married in 1882. 1900 United States Census, Washington, DC, "Edward Patton," ancestry.com, accessed December 2, 2023. Jordan's Grandpa Patten was born in 1879. Ed Patton, indeed, could have been John Ed's father, but no census records exist to confirm that fact or a previous marriage. Jordan's sisters had never heard of this story. Shelby Hearon, Nancy Earl, and Barbara Jordan also wanted to find the identity of John Ed's father. Nancy Earl created a genealogical chart, and as part of the research for *Barbara Jordan: A Self-Portrait,* the three women traveled to Wharton, Texas, to talk to Jordan's great aunt Louisa Smith. The eighty-nine-year-old said that John Ed Patten was her half-brother but that she did not know the identity of his father. Shelby Hearon Papers, Box 3, Folder 11, Harry Ransom Center, Austin, TX.

56. Jordan and Hearon, *Barbara Jordan: A Self-Portrait*, 4. Arlyne remembered correctly: According to the 1918 city directory, John Ed owned a café and then a confectionary store at the same address, 505 San Felipe St., Houston (City Directory, 1918, 766). San Felipe Street was renamed West Dallas in the 1930s.

57. Shelby Hearon Papers, Box 3, Folder 11, Harry Ransom Center, Austin, TX.

58. Robert V. Haynes, *A Night of Violence: The Houston Riot of 1917* (Baton Rouge: Louisiana State University Press, 1976), 84–85.

59. For a full account of the riot and its aftermath see Haynes, *A Night of Violence* and Steven A. Reich, "Soldiers of Democracy: Black Texans and the Fight for Citizenship, 1917–1921," *Journal of American History* 82, no. 4 (March 1996): 1478–1504, 1484–1485.

60. Haynes, *A Night of Violence*, 173.

61. Haynes, *A Night of Violence*, 185.

62. Haynes, *A Night of Violence*, 201, 202, 203.

63. Haynes, *A Night of Violence*, quoting Gruening investigation, 232–233; and Steptoe, *Houston Bound*, 49.

64. Haynes, *A Night of Violence*, 273–274.

65. J. M. Gibson, an attorney representing John Ed Patten in 1919, Shelby Hearon Papers, private collection in author's possession.

66. Affidavits of Stafford Summers and Julius White, July 16, 1918, in Shelby Hearon Papers, private collection in author's possession.

67. "Defendant's Amended Motion for a New Trial," *State of Texas vs. John Patten*, in the Criminal District Court of Harris County, Texas, filed July 15, 1918, Shelby Hearon Papers, private collection in author's possession.

68. Documents related to the trial of John Ed Patten, Shelby Hearon Papers, private collection in author's possession.

69. Quote from Texas, U.S., Convict and Conduct Registers, 1875–1954 for John Patten, "John Ed Patten," ancestry.com., accessed December 2, 2023. According to his prison record, John Ed was six feet tall and weighed 150 pounds. He had a "limited" education of two years. Same record can be found in *Convict and Conduct Record Ledgers.* Texas Department of Criminal Justice. Archives and Information Service Division, Texas State Library and Archives Commission, (TSLAC) Austin, TX.

70. The recent discovery of 89 bodies on the site of the former Sugarland prisons in Fort Bend have drawn public attention to the hard labor and early deaths of Texas prisoners. See Amy E. Dase, "Hell Hole on the Brazos: A Historic Resources Study of Central State Farm" (2004), https://int.nyt.com/data/documenthelper/151-hell-hole-on-the-brazos /f39a6d5be573318f1fa3/optimized/full.pdf, accessed November 22, 2023.

71. Paul Lucko, "The Governor and the Bat: Prison Reform during the Oscar B. Colquitt Administration, 1911–1915," *Southwestern Historical Quarterly* 106, no. 3 (2003): 396–417, 403. Progressive reformers tried to ban "the bat" in 1912 but failed. Until the 1960s Texas authorities used the bat and constant corporal punishment.

72. In Fort Bend, eight prisoners died after guards confined them in a "dark cell," a box made out of sheet metal that was nine feet long and seven feet wide, with only four one-inch holes in the floor and six quarter-inch holes in the ceiling. Lucko, "The Governor and the Bat," 415. Robert Perkinson, *Texas Tough: The Rise of America's Prison Empire* (New York: Picador, 2010).

73. *Convict and Conduct Record Ledgers,* Texas Department of Criminal Justice, Archives and Information Service Division, Texas State Library and Archives Commission, (TSLAC) Austin, TX.

74. Ramsey Farm was located in Brazoria County. It was 8,000 acres and purchased by the state in 1907. Perkinson, *Texas Tough*, 144, on Huddie Ledbetter.

75. Bruce Jackson, *Wake Up Dead Man: Hard Labor and Southern Blues* (Athens: University of Georgia Press, 1972, reprint, 1999).

76. For Jackson quote and the songs, see "Folkstreams: African American Work Songs in a Texas Prison, 1966," https://www.folkstreams.net/films/afro-american-work-songs-in -a-texas-prison, accessed November 22, 2023, minute 21 onward, and "Negro Prison Camp Worksongs" *Folkways Records* (1956), catalog numbers FW04475, FE 4475.

77. The fact that the prison farms were failing to generate more profits seemed to spur even worse treatment. Paul Lucko, "A Missed Opportunity: Texas Prison Reform during the Dan Moody Administration, 1927–1931," *Southwestern Historical Quarterly* 96, no. 1 (July 1992): 27–52.

78. Miriam A. "Ma" Ferguson, the wife of a disgraced former governor, defeated a member of the Ku Klux Klan during the August 1924 primary race to gain the Democratic nomination. In the general election she promised to cut state spending. One of her first acts in office was to release and pardon thousands of men who had finished the bulk of their sentences. After her election in November 1924, Governor Ferguson pardoned "an average of 100 convicts a month." See "The Texas Politics Project: Miriam A. Ferguson," https://texaspolitics.utexas.edu/archive/html/exec/governors/15.html, accessed November 22, 2023.

79. Jordan and Hearon, *Barbara Jordan: A Self-Portrait*, 4, 12–20. Ed Patten was buried in College Memorial Park Cemetery in Houston, Harris County. Birth April 14, 1916, died May 12, 1919, according to "Find a Grave" memorial page for Ed Patten.

80. https://www.houstonchronicle.com/entertainment/restaurants-bars/bbq/article/A -brief-history-of-Houston-barbecue-8126319.php#photo-10325380, accessed November 22, 2023.

81. Jordan and Hearon, *Barbara Jordan: A Self-Portrait*, 9.

82. Drummond's meditation on "Paul's Message on Love" (chapter 1 Corinthians, verse 13), *The Greatest Thing in the World* (1888) sold widely in the early twentieth century and had a profound effect on readers in North America and the UK. Harold L. Bowman, review of James W. Kennedy, *Henry Drummond: An Anthology* (New York: Harper and Bros., 1953), in *The Journal of Religion* 34, no. 2 (April 1954): 148. Stable URL: https://www .jstor.org/stable/1200667.

83. Henry Drummond, *The Greatest Thing in the World* (Kessinger Publications, 1888, reprint 2000).

84. G. K. Chesterton, *Orthodoxy* (1908). In chapter 5, "The Flag of the World," Chesterton considers the position of the optimist and the pessimist and tries to reconcile the existence of evil and disappointment with love, optimism, and faith.

85. https://archive.org/details/cavnaughsselecti00slsn, accessed November 22, 2023. Taken from an (1800) Methodist hymnal/prayer book, *Cavnaugh's Selections* (1932), hymn 14: "I take the narrow way, / I take the narrow way, / With the Resolute few who dare go through, / I take the narrow way."

86. Jordan and Hearon, *Barbara Jordan: A Self-Portrait*, 10.

87. Jordan and Hearon, *Barbara Jordan: A Self-Portrait*, 10; James E. Wood Jr., "A Theology of Power," *Journal of Church and State* 14, no. 1 (Winter 1972): 107–124.

88. Jordan and Hearon, *Barbara Jordan: A Self-Portrait*, 5.

89. Jordan and Hearon, *Barbara Jordan: A Self-Portrait*, 11.

90. Shelby Hearon Papers, Box 3, Folder 11, Harry Ransom Center, Austin, TX.

91. Jordan and Hearon, *Barbara Jordan: A Self-Portrait*, 27.

92. Jordan and Hearon, *Barbara Jordan: A Self-Portrait*, 38.

93. Jordan and Hearon, *Barbara Jordan: A Self-Portrait*, 39.

94. Jordan and Hearon, *Barbara Jordan: A Self-Portrait*, 40.

95. Jordan and Hearon, *Barbara Jordan: A Self-Portrait*, 31.

96. Jordan and Hearon, *Barbara Jordan: A Self-Portrait*, 32.

97. The beloved and joyful gospel song was featured in *The Blues Brothers* (1980) starring John Belushi and Dan Ackroyd and performed by James Brown, playing the role of Rev. Cleophus James, https://www.youtube.com/watch?v=vEkpkcQZ_P8 accessed November 22, 2023, and has been sung by countless gospel and pop singers. Here is Aretha Franklin's version: https://www.youtube.com/watch?v=L4babYkY8Xs, accessed November 22, 2023.

98. Jordan and Hearon, *Barbara Jordan: A Self-Portrait*, 40.

99. Jordan and Hearon, *Barbara Jordan: A Self-Portrait*, 42.

100. Jordan and Hearon, *Barbara Jordan: A Self-Portrait*, 43.

101. Jordan and Hearon, *Barbara Jordan: A Self -Portrait*, 42. James Weldon Johnson, "The Creation," in *God's Trombones: Seven Negro Sermons in Verse* (New York: Viking Press, 1927).

102. The "colored poet," Johnson wrote, "needs a form that is freer and larger than dialect, but which will still hold the racial flavor. . . . The form of 'The Creation,' the first poem of this group, was a first experiment by me in this direction." James Weldon Johnson, introduction, *God's Trombones*. See also Benjamin E. Mays, *The Negro's God as Reflected in His Literature* (New York: Atheneum, 1938, 1968), 20–23, 65–68, which compares *God's Trombones* and slave spirituals.

103. All quotes from Johnson, "The Creation," in *God's Trombones*.

104. Jordan and Hearon, *Barbara Jordan: A Self-Portrait*, 42.

Chapter 2

1. *Houston: A History and Guide*, compiled by workers of the Writer's Program of the Work Projects Administration (WPA) in the State of Texas, American Guide Series (Houston: Anson Jones Press, 1942) estimated that Houston had approximately 268 Black churches in 1941, 172–173, 189.

2. Beeth and Wintz, eds., *Black Dixie*, 21. Before World War II, Houston employed "over 3,000 Black longshoremen, 4,000 black workers in the crude oil industry, and 3,000 employed in tool works, such as Hughes Tools, and other manufacturing. Over 9,000 black women were employed as domestics." See Ralph Matthews, "How Houston Earns Living," in *Baltimore Afro-American,* May 7, 1938, 13. Bernadette Pruitt, *The Other Great Migration: The Movement of Rural African Americans to Houston* (College Station: Texas A&M Press, 2013).

3. Pruitt, *The Other Great Migration*, 282–283.

4. Jordan and Hearon, *Barbara Jordan: A Self-Portrait*, 63.

5. Playland Park, located south of downtown Houston, operated from 1940 until 1967. The park featured a racetrack and rides; the Skyrocket rollercoaster boasted to be the largest in the country.

6. Letter from Charles White to Barbara Jordan, July 16, 1976, Personal Letters, Classmates, Barbara Jordan Archives, Texas Southern University (hereafter BJ Archive, TSU).

7. Letter from Charles White to Barbara Jordan, July 16, 1976, BJ Archive, TSU.

8. Jordan and Hearon, *Barbara Jordan: A Self-Portrait*, 63.

9. The 1923 Texas state law stated: "In no event shall a negro be eligible to participate in a Democratic party primary election held in the state of Texas." The Supreme Court decreed in 1935 that a political party could legally exclude Black citizens from membership and from voting in a primary. Charles L. Zelden, "In No Event Shall a Negro Be Eligible: The Texas NAACP Takes on the All-White Primary, 1923–1944," in *Long Is the Way and Hard: One Hundred Years of the NAACP*, ed. Kevern Verney and Lee Sartain (Fayetteville: University of Arkansas Press, 2009,) 135–153; Steven F. Lawson, *Running for Freedom: Civil Rights and Black Politics in America Since 1941*, 3rd ed. (Hoboken, NJ: Wiley Blackwell,, 2009), 18–20.

10. Address of Rev. A. A. Lucas to the Texas Conference of Branches, NAACP, Corpus Christi, Texas, 1940. Quoted in Melvin James Banks, "The Pursuit of Equality: The Movement for First Class Citizenship among Negroes in Texas, 1920-1950" (DSS diss., Syracuse University, 1962), 190.

11. Adam Fairclough, *Race and Democracy: The Civil Rights Struggle in Louisiana, 1915–1972* (Athens: University of Georgia Press, 1995); Jacquelyn Dowd Hall, "The Long Civil Rights Movement and the Political Uses of the Past," *Journal of American History* 91, no. 4 (March 2005): 1233–1263; Robert Korstad and Nelson Lichtenstein, "Opportunities Found and Lost: Labor, Radicals, and the Early Civil Rights Movement," *Journal of American History* 75, no. 3 (December 1988): 786–811; John Egerton, *Speak Now Against the Day: The South Before the Civil Rights Movement* (Chapel Hill: University of North Carolina Press, 1994); Patricia Sullivan, *Days of Hope: Race and Democracy in the New Deal Era* (Chapel Hill: University of North Carolina Press, 1996).

12. *Missouri ex el Gaines v. Canada,* 305 U.S. 337 (1938) held that states had to provide comparable in-state graduate education for Black students or pay for their education in another state. Darlene Clark Hine, 1973 interview with Judge William Hastie, in Darlene Clark Hine, *Black Victory: The Rise and Fall of the White Primary in Texas* (Columbia: University of Missouri Press, 2003, repr.), 66–67, and quoted in Zelden, "In No Event Shall a Negro Be Eligible," 278, n. 10.

13. "You talk about a hornet's nest! Ye Gods, this is the worst I have ever seen." James SoRelle, "The Darker Side of 'Heaven': The Black Community in Houston, Texas, 1917–1945" (PhD diss., Kent State University, 1980). p. 378, quoting letter from Daisy Lampkin to Richetta Randolph, Oct. 31, 1939, NAACP Archives, Box C-69.

14. See Rebecca Montes, "Working for American Rights: Black, White, and Mexican American Dockworkers during the Great Depression" (PhD diss., University of Texas, Austin, 2005), 139, 164, for poll-tax drives and the requirement of ILA, and 165–173 for

efforts among ILA men and women to pay poll taxes. For Everett background, see Montes, "Working for American Rights," 1–3, 123–124, 131. Everett's work with the ILA began in the 1910s, when he was hired as the organization's minister. He and his family migrated to Houston from Mississippi, and he initially worked in the oil industry. He lived on Dowling Street in the Third Ward.

15. Beth Tompkins Bates, "A New Crowd Challenges the Agenda of the Old Guard in the NAACP, 1933–1941," *American Historical Review* 102, no. 2 (April 1997): 340–377, identifies a shift in the NAACP to include collective, secular, labor interests largely in northern cities such as Chicago.

16. Local 872 formed in tandem with a white local 1273, and the two groups "signed a ninety nine year contract for an even division of work." For a time, the two unions worked in "mixed gangs" without any problems between the races, but an intervention by the KKK forced the unions to segregate. For the most complete history of the ILA in Houston, see Rebecca Montes, "Working for American Rights: Black, White, and Mexican-American Dockworkers in Texas during the Great Depression," in *Sunbelt Revolutions: The Historical Progression of the Civil Rights Struggles in the Gulf South, 1866–2000*, ed. Samuel C. Hyde (Gainesville: University Press of Florida, 2003), 102–132; See also Lester Rubin, William S. Swift, and Herbert R. Northrup, *Negro Employment in Maritime Industries: A Study of Racial Policies in the Shipbuilding, Longshore, and Offshore Maritime Industry* (Philadelphia: University of Pennsylvania Press, 1974), 123, quoting Herbert R. Northrup, *Organized Labor and the Negro* (New York: Harper & Bros., 1944) 151; and Maude Russell, *Men Along the Shore: The ILA and Its History* (New York: Brussel and Brussel, Inc. 1966).

17. "I would like for somebody to send me the name of a group of Negro teachers, doctors, lawyers, editors or any other group of so-called educated Negroes which has been able to do half as much." *Houston Informer and Texas Freedman*, May 25, 1935, 12, quoted in Montes, "Working for American Rights" (2005), 132.

18. For the migration of Black women out of Houston and other parts of Texas for California, see Gretchen Lemke-Santangelo, *Abiding Courage: African American Migrant Women and the East Bay Community* (Chapel Hill: University of North Carolina Press, 1996); Paul Alejandro Levengood, "For the Duration and Beyond: World War II and the Creation of Modern Houston, Texas" (PhD diss., Rice University, 1999), 384, 392, and 371–399. See also David R. Goldfield, *Promised Land: The South since 1945* (Arlington Heights, IL: Harlan Daidson, 1987), for an overview of continued racial discrimination against southern Black workers, which spurred their migration. Overall, Texas lost 75,000 Black residents in the 1940s. Jack Temple Kirby, "The Southern Exodus, 1910–1960: A Primer for Historians," *Journal of Southern History* 49 (November 1983).

19. James M. SoRelle, "'An de Po Cullud Man Is in de Wuss Fix uv Awl': Black Occupational Status in Houston, Texas, 1920–1940," *Houston Review* 1 (Spring 1979): 14–26; and for descriptions of decrepit housing, see Levengood, "For the Duration and Beyond," 372, 372–383, who cites journalist Tom Lester, *Houston Chronicle*, November 18, 1945.

20. Maud Cuney-Hare, *Norris Wright Cuney: Tribune of the Black People*, intro. Tera Hunter (New York: G.K Hall, 1995); Merline Pitre, *Through Many Dangers, Toils and Snares: The Black Leadership of Texas, 1868–1900* (Austin: Eakin, 1985); John Mason Brewer, *Negro*

Legislators of Texas and Their Descendants: A History of the Negro in Texas Politics from Reconstruction to Disfranchisement (Dallas: Mathis Publishing, 1935), .99; Lawrence Goodwyn, "Populist Dreams and Negro Rights: East Texas as a Case Study," *American Historical Review* 76, no. 5 (December 1971): 1435–1456, 1446; and Rogers, *Barbara Jordan: American Hero*, 7–10.

21. Richard M. Valelly, *The Two Reconstructions* (Chicago: University of Chicago Press, 2004), 128.

22. James SoRelle, "The Darker Side of 'Heaven': The Black Community in Houston, Texas, 1917–1945" (PhD diss., Kent State University, 1980). See chap. 7, "No Such Thing as Unity: Politics in the Black Community," 283–308, 289–290.

23. Zelden, "In No Event Shall a Negro Be Eligible," 135–153.

24. SoRelle, "The Darker Side of 'Heaven,'" 284, quoting *Houston Informer*, April 7, 1923.

25. "Wanted to Mutilate Texas Editor: KKK Planned to Cut Negro Journalist to Pieces," *New York Amsterdam News*, April 8, 1925.

26. Zelden, "In No Event Shall a Negro Be Eligible," 143; and Robert Haynes, "Black Houstonians and the White Democratic Primary, 1920–1945," in Beeth and Wintz, eds., *Black Dixie*, 192–211, p. 201–202. Pitre, *Through Many Dangers, Toils and Snares*, 23–24, cites the organizations that raised money for the suit and supported it, including the Eastern Star and the Metropolitan Council of Negro Women.

27. Michael Gillette, "The Rise of the NAACP in Texas," *Southwestern Historical Quarterly* 81, no. 4 (April 1978): 393–416, 400–401; Hine, *Black Victory*, chaps. 2–4 and 6–10.

28. SoRelle, "The Darker Side of 'Heaven.'" See chap. 7, "No Such Thing as Unity: Politics in the Black Community," 283–308.

29. Zelden, "In No Event Shall a Negro Be Eligible," 143; and Haynes, "Black Houstonians and the White Democratic Primary," 201–202.

30. Lulu White joined forces with A. Maceo Smith of Dallas, and the two are generally held up by scholars as responsible for renewing popular faith in the NAACP in Texas. In Houston the energy and enthusiasm of Lucas and White renewed the national office's confidence in the branch. For background on this era of the NAACP in Texas, see SoRelle, "The Darker Side of 'Heaven'"; Merline Pitre, *In Struggle against Jim Crow: Lulu White and the NAACP, 1900–1957* (College Station: Texas A & M University Press, 1999), 31–36; Gillette, "The Rise of the NAACP in Texas,": 393–395; Michael Gillette, "The NAACP in Texas, 1937–1957" (PhD diss., University of Texas at Austin, 1984); Patricia Sullivan, *Lift Every Voice: The NAACP and the Making of the Civil Rights Movement* (New York: Free Press, 2009), 282–283; John Ralph Wilson, "Origins: The Houston NAACP, 1915–1918 (Master's thesis, Department of History, University of Houston, December 2005).

31. Hine, *Dark Victory*, 221–222.

32. Address of Rev. A. A. Lucas to the Texas Conference of Branches, NAACP, Corpus Christi, Texas, 1940. Quoted in Melvin James Banks, "The Pursuit of Equality: The Movement for First Class Citizenship among Negroes in Texas, 1920–1950" (DSS diss., Syracuse University, 1962), 190.

33. Banks, "The Pursuit of Equality," 191–192, quoting from the conference speech of Rev. Lucas and the minutes of the statewide NAACP Meeting in Corpus.

34. Address of Rev. Albert A. Lucas, Houston, Texas to the NAACP "Committee on Time and Place," 31st Annual Conference, Philadelphia, June 22, 1940. Papers of the NAACP, Part 01: Meetings of the Board of Directors, Records of Annual Conferences, Major Speeches, and Special Reports, Series: Annual Conference Proceedings, 1910–1950, Folder Title: 1940 Annual Conference.

35. Address of C. V. Rice, Houston, Texas, to the NAACP "Committee on Time and Place," 31st Annual Conference, Philadelphia, June 22, 1940. Papers of the NAACP, Part 01: Meetings of the Board of Directors, Records of Annual Conferences, Major Speeches, and Special Reports Series: Annual Conference Proceedings, 1910–1950, Folder Title: 1940 Annual Conference. Gillette, "The NAACP in Texas, 1937–1957," 17, also refers to Lucas organizing the March 1940 meeting of Houstonians aiming for a new lawsuit against the white primary.

36. Letter from Roy Wilkins to Branch Officers, April 28, 1941. "This is the first time in the history of the N.A.A.C.P. that the annual conference has been held so far in the 'Deep South.' In 1920 we were in Atlanta; in 1934 in Oklahoma City; in 1939 in Richmond." Papers of the NAACP, Part 01: Meetings of the Board of Directors, Records of Annual Conferences, Major Speeches, and Special Reports, Series: Annual Conference Proceedings, 1910–1950, Folder Title: 1941 Annual Conference.

37. "Houston Negroes headed by Rev. A.A. Lucas, pastor Good Hope Baptist Church, who also heads both the local and state NAACP organizations, have already over-subscribed their quota." "Indications are that the entire $8,000 will be raised in time to file a case following the July primary elections." W. H. Bonds, "From a Layman's Viewpoint: Texas Points the Way," *Atlanta Daily World*, June 1, 1940.

38. Gary M. Lavergne, *Before Brown: Heman Marion Sweatt, Thurgood Marshall, and the Long Road to Justice* (Austin: University of Texas Press, 2010), 58–59.

39. Hine, *Dark Victory*, 223, and Haynes, "Black Houstonians and the White Democratic Primary," 205.

40. Haynes, "Black Houstonians and the White Democratic Primary," 205; Steven F. Lawson, *Black Ballots: Voting Rights in the South, 1944–1969* (New York: Columbia University Press, 1976), 23–54; Hine, *Black Victory*; Valelly, *The Two Reconstructions*.

41. *Baltimore Afro-American*, June 28, 1941.

42. NAACP Papers, Program, Annual Convention—1941, General Office File—II: A22, folder 11.

43. 1941 Annual Convention, NAACP Papers, ll: A 23, Folder 4.

44. See his obituary in the *New York Times*, December 18, 1996.

45. Manfred Berg argues that the anticommunism of the NAACP in this period has been exaggerated. Although local Texans were vocally anticommunist, Wright's award and warm reception indicates an acceptance of those with radical views. Manfred Berg, "Black Civil Rights and Liberal Anti-Communism: The NAACP in the Early Cold War," *Journal of American History* 94, no. 1 (June 2007): 75–96. See *Baltimore Afro-American*, July 12, 1941, for an account of Wright's speech.

46. The murderous deed was carried out in full view of the judge, prosecutors, and defense attorneys, but Cochran went free. See also Annette Gordon-Reed, *On Juneteenth*

(New York: Liveright Publishing, 2021), 34–37, on the local impact of the White case in Conroe, Texas.

47. "You may continue to send such men as Tom Connally, Hatton Sumners, and Martin Dies up to Congress but I promise you they won't be making the kind of speeches they are making today, because they will need the Negro ballot, and if they should make such speeches they would not be returned to office. That is why it is so important that this present fight against the white primary should be won." NAACP Papers, Walter White's speech, 1941 Annual Convention, Houston, ll A 23, folder 4.

48. Letter from Roy Wilkins to Gertrude Stone, July 18, 1941. NAACP Papers II: a 22, folder 10, Annual Convention 1941.

49. "Saving the Race," Thurgood Marshall to the NAACP legal staff concerning voting rights cases in Texas, in *Smith v. Allwright*, November 17, 1941. Memorandum, NAACP Records, Manuscript Division, Library of Congress (089.00.00), Courtesy of the NAACP Digital ID # na0089p1 //www.loc.gov/exhibits/naacp/world-war-ii-and-the-post-war-years .html, accessed November 22, 2023.

50. "Texas Demo Has Only to Be White," *Baltimore Afro-American*, May 9, 1942.

51. Haynes, "Black Houstonians and the White Democratic Primary," 205–206.

52. "Saving the Race," Thurgood Marshall to the NAACP legal staff concerning voting rights cases in Texas, in *Smith v. Allwright*, November 17, 1941. Memorandum, NAACP Records, Manuscript Division, Library of Congress (089.00.00) Courtesy of the NAACP Digital ID # na0089p1 /www.loc.gov/exhibits/naacp/world-war-ii-and-the-post-war-years .html, accessed November 22, 2023.

53. Author's interview with Sara Scarbrough, Houston, TX, July 24, 2009.

54. "Saving the Race," Thurgood Marshall to the NAACP legal staff concerning voting rights cases in Texas, in *Smith v. Allwright*, November 17, 1941. Memorandum, NAACP Records, Manuscript Division, Library of Congress (089.00.00) Courtesy of the NAACP Digital ID # na0089p1 /www.loc.gov/exhibits/naacp/world-war-ii-and-the-post-war-years .html, accessed November 22, 2023.

55. Ernest Obadele Starks, "Black Texans and Theater Craft Unionism," in *Texas Labor History*, ed. Bruce Glasrud and James Maroney (College Station: Texas A & M University Press, 2013), 297–314, 303, identifies Everett as the president of the ILA local, and he is listed on the NAACP Houston convention program as Lucas's VP in the Houston NAACP branch.

56. Author's interview with Sara Scarbrough, Houston, July 24, 2009.

57. Author's Interview with Sara Scarbrough, Houston, July 24, 2009.

58. Sept 7, 1943, NAACP Papers II C 193, Folder 13.

59. Letter from Donald Jones to Walter White, April 9, 1943, NAACP papers, ll: C 193, folder 13.

60. Letter from Donald Jones to Walter White, April 9, 1943, NAACP papers, II: C 193, Folder 13.

61. Gillette, "The NAACP in Texas," 354.

62. Letter from Daisy Lampkin to Walter White, April 10, 1943.

63. Jones to Lucas, April 15, 1943, NAACP Archives, Houston Branch, quoted in SoRelle (PhD diss. 1980), 381.

64. Letter from Donald Jones, Ass't Field Secretary, NAACP, to Rev. A. A. Lucas, 5109 Farmer Street, Houston Texas, April 15, 1943, NAACP Papers.

65. Quoted in Adam Fairclough, *Better Day Coming* (New York: Penguin Books, 2001), 200–201.

66. Author's interview with Sara Scarbrough, Houston, July 24, 2009. See also "Souvenir Program," 1945, Good Hope Missionary Baptist Church Library.

67. Gillette and Sapper, "The Fall of the NAACP in Texas," 53–68. Reverend Simpson ran unsuccessfully for city council and held the Houston NAACP in a tight grip. For a critical analysis of Simpson's leadership style, see Gillette, "The NAACP in Texas," 173–199.

68. Chandler Davidson, *Biracial Politics: Conflict and Coalition in the Metropolitan South* (Baton Rouge: Louisiana State University Press, 1972), 86, table 4.1. By 1960, 35 percent or 48,000 Black voters in Harris County were registered. Only after another round of court decisions and activism did Black registration start to rise. In 1966, 45 percent of the Black population in Harris County was registered to vote, approximately 78,434 people. See also Pitre, *In Struggle Against Jim Crow*, 45–55, for Lulu White and Black Houston's voting patterns in city, municipal, gubernatorial, and Senate elections between 1946 and 1950.

69. Max Krochmal, *Blue Texas*, 87–99.

70. Barbara Jordan, "A New Dawn in Southern Politics," handwritten draft of speech, 1963 or 1967, University of North Texas Libraries, Portal to Texas History, https://texashistory.unt.edu; Barbara Jordan Archives, Texas Southern University.

71. Rev. L. H. Smith, pastor of the Pleasant Hill Baptist Church in the Fifth Ward, was elected president of the Houston Branch in 1944. For a discussion of the internal strife within the Houston NAACP in the period, see Pitre, *In Struggle against Jim Crow*; Michael Gillette and Neil Sapper, "The Fall of the NAACP in Texas," *Houston Review* 7, no. 2 (1985): 53–68. Reverend Simpson ran unsuccessfully for city council and held the Houston NAACP in a tight grip. For a critical analysis of Simpson's cautious and authoritarian leadership style, see Gillette, "The NAACP in Texas," 173–199.

72. Letter from A. Maceo Smith to W. B. Lawson, April 8, 1946, Papers of the NAACP, Part 26: Selected Branch Files, 1940–1955, Series A: The South, Group II, Series C, Branch Department Files, Geographical File, Folder Title: Texas State Conference, 1946.

73. Banks, "The Pursuit of Equality," 422–423, quoting from *Houston Informer,* December 21, 1946.

74. Banks, "The Pursuit of Equality," 440, Citing minutes of Texas branch conference.

Chapter 3

1. Rogers, *Barbara Jordan: American Hero*, 37–38. "It was a bit of an embarrassment to me to have to tell my friends . . . that I lived on a street that wasn't paved." Rogers is quoting from Gay Elliott McFarland, "Barbara Jordan's Houston," *Houston Chronicle*, February 5, 1979.

2. Author's interview with Anna Curtis, Houston, TX, April 14, 1999.

3. Author's interview with Otis King, Houston, TX, July 21, 2009.

4. *Redbook of Houston* (1915).

5. Karen Benjamin, "Progressivism Meets Jim Crow: Curriculum Development and Revision in Houston, Texas, 1924–1929," *Paedagogica Historica* 39, no. 4 (August 2003):

457–476. The population of Houston's Black schools grew steadily, and by 1935 it had doubled to more than 14,000 pupils. Ira B. Bryant, *The Development of the Houston Negro Schools* (Houston: Informer, 1935), 76. Benjamin emphasizes the lack of funding for Black schools compared to white schools. But superintendent Oberholtzer, perhaps influenced by the 1925 rape and death of his Indiana niece, Madge Oberholtzer, at the hands of the "Grand Dragon" of the KKK in Indiana, was clearly somewhat sympathetic to the needs of Black students in Houston.

6. Bryant, *The Development of the Houston Negro Schools*, 77.

7. Bryant, *The Development of the Houston Negro Schools*, 88–89, emphasis in the original.

8. Nellye Joyce Punch (1921–2017), obituary, January 5, 2018, *Houston Chronicle*. Phone interview with author, April 14, 1999.

9. According to Bryant, Houston's Black high schools offered a college preparatory course and a "general course," but the two barely differed. Both curriculums required students to take algebra, trigonometry, and geometry; both required a foreign language, physics, and chemistry. And both required students to take industrial arts, home economics, and music. (Barbara Jordan's mother, Arlyne, graduated from the Colored High School in the late 1920s with these academic credentials.)

10. "Houston Teachers' Pay Equalized without Suit, Voluntary Vote Taken by Board," *Informer and Texas Freeman*, April 17, 1943. Cited in Margaret Nunnelley Olsen, "Teaching Americanism: Ray K. Daily and the Persistence of Conservatism in Houston School Politics, 1943–1952, *Southwestern Historical Quarterly* 110, no. 2 (October 2006): 240–269.

11. Historian Merline Pitre has detailed Carter Wesley's disagreements with the NAACP's policy of integration and alliances with white labor and the left. Merline Pitre, "Black Houstonians and the 'Separate but Equal' Doctrine: Carter W. Wesley Versus Lulu B. White," *Houston Review* 12, no. 1 (1990): 23–36, 25–26.

12. Olsen, "Teaching Americanism," 240–269; and Kate S. Kirkland, "For All Houston's Children: Ima Hogg and the Board of Education, 1943–1949," *Southwestern Historical Quarterly* 101, no. 4 (April 1998): 460–495.

13. Author's interview with Anna Curtis, April 14, 1999, Houston, TX; and Jordan and Hearon, *Barbara Jordan: A Self-Portrait*, 58.

14. Author's interview with Judge Andrew Jefferson, Houston, TX, March 27, 2001.

15. Jordan and Hearon, *Barbara Jordan: A Self-Portrait*, 57–58.

16. Author interview with Anna Curtis.

17. Author interview with Otis King, Houston, TX, July 21, 2009. See also Cindy George, "King, Houston's First Black City Attorney, Dies at 77," *Houston Chronicle*, November 29, 2012.

18. Jordan and Hearon, *Barbara Jordan: A Self-Portrait*, 67.

19. Jordan and Hearon, *Barbara Jordan: A Self-Portrait*, 62.

20. Author's interview with Anna Curtis.

21. "I would be the winner and I would bring home the medals. Then we would have a ceremony and a presentation of the trophies at the school." Such acclaim bolstered Barbara's

confidence. "We declaimers and debaters felt self-important with the little box of three by five–inch index cards on which we kept our notes. These were our badge of superiority over the others who could not do things like that." Jordan and Hearon, *Barbara Jordan: A Self-Portrait*, 66.

22. Debra Blacklock-Sloan, "An Application for a Harris County Historical Marker for PHILLIS WHEATLEY HIGH SCHOOL," September 7, 2012, quoting "Cornerstone Rites Slated Today," *Houston Chronicle*, October 1, 1950, A37; "New Wheatley High to Be Ready for September Term," *Houston Chronicle*, April 12, 1950, 2A; "New $2,500,000 Negro High School to Be Dedicated," *Houston Chronicle*, October 15, 1950, A15.

23. Jordan and Hearon, *Barbara Jordan: A Self-Portrait*, 65.

24. Jordan and Hearon, *Barbara Jordan: A Self-Portrait*, 65.

25. Jordan and Hearon, *Barbara Jordan: A Self-Portrait*, 64–65; and author's interview with Anna Curtis.

26. Maury Maverick interviewed by Chandler Davidson, 1975, Texas Politics Research Collection, Fondren Library, Rice University, https://hdl.handle.net/1911/93698 accessed November 27, 2023

27. "But at the time, it was damn important to win that little victory. It's a cute story, I think. They tried to be fair about outlawing the Communist party and all totalitarian organizations and I went to see Archbishop Robert Luce of the Catholic Church, who was the great left-wing labor bishop in his earlier days, and I told him, 'Your Excellency, I'm going to vote against that bill. I don't want you to fall out with me.' He said, 'Well Maury, I don't want you to outlaw all totalitarian organizations either.' [Laughter] So, he was a good guy, and he didn't fall out with me." Maury Maverick interviewed by Chandler Davidson, 1975.

28. Olsen, "Teaching Americanism," 259.

29. Bell, quoted in Mary L. Dudziak, "Desegregation as a Cold War Imperative," *Stanford Law Review* 41, no. 1 (November 1988): 61–120, 62.

30. Todd Gitlin, *The Sixties: Years of Hope, Days of Rage* (New York: Bantam Books, 1987), 6, 12.

31. "You had to get out there, to find out that was not always the way it worked, you went after school with the group." Author's interview with Anna Curtis.

32. Penny M. Von Eschen, *Satchmo Blows Up the World: Jazz Ambassadors Play the Cold War* (Cambridge: Harvard University Press, 2006); Gerald Horne, *Black and Red: W.E.B. Du Bois and the Afro-American Response to the Cold War, 1944–1963* (Albany: State University of New York Press, 1986); Brenda Gayle Plummer, Mary Dudziak, Helen Laville, and Scott Lucas, "The American Way: Edith Sampson, the NAACP, and African American Identity in the Cold War," *Diplomatic History* 20, no. 4 (Fall 1996): 565–590. For the role of media and Black women in promoting American idealism abroad, see Barbara Savage, *Broadcasting Freedom: Radio, War, and the Politics of Race, 1938–1948* (Chapel Hill: University of North Carolina Press, 1999). For discussions of Black women who embraced racial internationalism and communism, see Erik S. McDuffie, *Sojourning for Freedom: Black Women, American Communism, and the Making of Black Left Feminism* (Durham, NC: Duke University Press, 2011), and Keisha N. Blain, *Set the World on Fire:*

Black Nationalist Women and the Global Struggle for Freedom (Philadelphia: University of Pennsylvania Press, 2018).

33. Edith Sampson Papers, Box 5, Folder 109, Speech in 1949 about the "future of Negro women," Schlesinger Library, Cambridge, MA.

34. Author's interview with Otis King.

35. Letter from Edith Sampson to Barbara Jordan, February 17, 1977, and Letter from Barbara Jordan to Edith Sampson, February 23, 1977, Papers of Edith Sampson, Box 5, Folder 99, Schlesinger Library, Cambridge, MA.

36. Author's interview with Otis King.

37. High School "Memory Book," Personal Files, Barbara Jordan Papers, Texas Southern University.

38. Jordan and Hearon, *Barbara Jordan: A Self-Portrait*, 68.

39. High School "Memory Book," Personal Files, Barbara Jordan Papers, Texas Southern University.

40. Jordan and Hearon, *Barbara Jordan: A Self-Portrait*, 72.

41. Charles White, public affairs director, WBNS Radio, Columbus, Ohio, to Barbara Jordan, July 16, 1976, Barbara Jordan Papers, Personal Letters, Texas Southern University.

42. Jordan and Hearon, *Barbara Jordan: A Self-Portrait*, 76.

43. Brian Lanker, "Barbara Jordan," in *I Dream a World: Portraits of Black Women Who Changed America* (New York: Stewart, Tabori, & Chang, 1989), 31.

44. "Minister, Professor and a Masterful Debate Coach," *Washington Post*, June 21, 2020. Thomas Freeman died June 6, 2020, in Houston, at the age of 100.

45. Jordan and Hearon, *Barbara Jordan: A Self-Portrait*, 77.

46. Jordan quoted in *Washington Post*, June 21, 2020.

47. Speech at his ninety-ninth birthday party, *Washington Post*, June 21, 2020.

48. Author's interview with Otis King.

49. Thomas Freeman, Funeral for Rep. Barbara Jordan, https://www.c–span.org/video/?69467–1/barbara–jordan–funeral, accessed November 22, 2023.

50. Author's interview with Otis King.

51. Author's interview with Otis King.

52. Jordan and Hearon, *Barbara Jordan: A Self-Portrait*, 59.

53. Author's interview with Otis King, July 21, 2009. See also Mia Bay, *Traveling Black: A Story of Race and Resistance* (Cambridge, MA: Harvard Press, 2021), 107–151, for an overview of traveling by car during segregation.

54. Author's interview with Otis King.

55. Author's interview with Otis King.

56. Jordan and Hearon, *Barbara Jordan: A Self-Portrait*, 81.

57. Author's interview with Otis King.

58. "Texas Southern Debaters Back from Successful 'Big 10' Tour," *Chicago Defender*, March 24, 1956.

59. Prof. Jared Diamond recalled the contest as well, and he conveyed that his partner believed their side had won. He pointed out that Texas Southern had provided the judges

that day. Email from Jared Diamond to the author, September 3, 2003. "Barbara Jordan's Harvard Commencement Address," June 16, 1977, University of North Texas Libraries, Portal to Texas History, https://texashistory.unt.edu, accessed December 2, 2023. "Draft of Harvard Commencement Address," Barbara Jordan Papers, Draft Speeches, Texas Southern University, Houston, Texas.

60. James Baldwin, "Nobody Knows My Name: A Letter from the South," in *Nobody Knows My Name: More Notes of a Native Son* (New York: Dell, 1961), 88.

61. Jordan and Hearon, *Barbara Jordan: A Self-Portrait*, 81.

Chapter 4

1. Jordan and Hearon, *Barbara Jordan: A Self-Portrait*, 85.

2. J. Anthony Lukas, *Common Ground* (New York: Alfred A Knopf, 1985), 56–61, on Black Boston; Beeth and Wintz, eds., *Black Dixie*, 89, for Houston population figures. Houston almost doubled its population between 1950 and 1960, whereas Boston had an increase in Black population but remained steady overall. For a compelling analysis of Boston's long history of Black activism, see Kerri K. Greenidge, *Black Radical: The Life and Times of William Monroe Trotter* (New York: W.W. Norton, 2019), and Stephen Kantrowitz, *More Than Freedom: Fighting for White Citizenship in a White Republic* (New York: Penguin Books, 2012).

3. Nick Bryant, *The Bystander: John F. Kennedy and the Struggle for Black Equality* (New York: Basic Books, 2006).

4. For a detailed look at how Kennedy wooed Black voters in Boston in the 1950s, see Bryant, *The Bystander: John F. Kennedy and the Struggle for Black Equality*, 33–42.

5. Jordan and Hearon, *Barbara Jordan: A Self-Portrait*, 157.

6. Eleanor Rust Collier, "The Boston University School of Law, 1872–1960," unpublished paper, 1960, Pappas Law Library, Boston University School of Laws, Vertical File, Box 1 of 2, 29–30.

7. Collier, "The Boston University School of Law, 1872–1960," 29–30; Jordan and Hearon, *Barbara Jordan: A Self-Portrait*, 95.

8. Jordan and Hearon, *Barbara Jordan: A Self-Portrait*, 87–88.

9. Jordan and Hearon, *Barbara Jordan: A Self-Portrait*, 91–92.

10. Collier, "The Boston University School of Law, 1872–1960," appendix D; Dean Hettrick, "The Professional Attitude," *Boston Law School Magazine* (June 1955).

11. Jordan and Hearon, *Barbara Jordan: A Self-Portrait*, 88.

12. "On some rare occasions a professor would come in and would announce: 'We're going to have Ladies Day Today,' and he would call on the ladies." Jordan and Hearon, *Barbara Jordan: A Self-Portrait*, 88–93.

13. Author's interviews with Otis King, July 21, 2009, Houston, TX, and Andrew Jefferson, March 27, 2001, Houston, TX.

14. Author's interview with Andrew Jefferson.

15. Jordan and Hearon, *Barbara Jordan: A Self-Portrait*, 91–92.

16. Jordan and Hearon, *Barbara Jordan: A Self-Portrait*, 85–87, 89–90, 92.

17. Jordan and Hearon, *Barbara Jordan: A Self-Portrait*, 92.

18. Jordan and Hearon, *Barbara Jordan: A Self-Portrait*, 157.

19. Wasserman was in a different study group with Clarence Jones, who became his close friend. All information based on author's phone interview with Oscar Wasserman, July 20, 2011.

20. Author's interview with Oscar Wasserman.

21. Letter from LaConyea ("Connie") Butler to Barbara Jordan, February 4, 1973, Barbara Jordan Archives, Texas Southern University, "Personal–Friends."

22. Letter from Dorothy Tuloss to Barbara Jordan, March 3, 1973, Barbara Jordan Archives, Texas Southern University, "Personal–Friends."

23. Letter from Elizabeth Ryan to Barbara Jordan, January 16, 1973, Barbara Jordan Archives, Texas Southern University, "Personal–Friends."

24. Barbara Jordan to Dorothy Tuloss, March 21, 1973, Barbara Jordan Archives, Texas Southern University, "Personal–Friends."

25. Howard Thurman, *With Head and Heart: The Autobiography of Howard Thurman* (Orlando, FL: Harcourt Brace Jovanovich, 1979).

26. Jordan and Hearon, *Barbara Jordan: A Self-Portrait*, 97.

27. Jordan and Hearon, *Barbara Jordan: A Self-Portrait*, 44.

28. "The very presence of the school, and the inner strength and authority of Mrs. Bethune, gave boys like me a view of the possibilities to be realized in some distant future." Thurman, *With Head and Heart*, 23.

29. Thurman, *With Head and Heart*, 114–115.

30. Marsh Chapel, "The Moment of Truth" (January 19, 1958); "Moment of Crisis" (March 2 and 9, 1958), Howard Thurman Papers, Howard Gotlieb Archival Research Center, Boston University, Boston, MA.

31. J. Anthony Lukas pointed out, "Howard Thurman understood the need of all living things to proclaim the uniqueness of their own experience, to build protective walls around their community until they can feel secure in their identity." Howard Thurman, *The Search for Common Ground,* foreword by J. Anthony Lukas (Richmond, IN: Friends United Press, 1986, 1973), 78.

32. Jordan and Hearon, *Barbara Jordan: A Self-Portrait*, 97.

33. Thurman, Marsh Chapel, April 5, 1959, "Jesus and the Disinherited," Howard Thurman Papers, Howard Gotlieb Archival Research Center, Boston University, Boston, MA.

34. Thurman, Marsh Chapel, April 5, 1959, "Jesus and the Disinherited," Howard Thurman Papers, Howard Gotlieb Archival Research Center, Boston University, Boston, MA.

35. Thurman, Marsh Chapel, September 22, 1957, Howard Thurman Papers, Howard Gotlieb Archival Research Center, Boston University, Boston, MA. Jordan may also have been influenced to go to the fifth floor of the Chenery Library at Boston University's College of Liberal Arts to see the Edward C. Stone Room, which contains a collection of "Lincolnalia." Hundreds of books, pamphlets, and pictures are on display. One of the displayed photos contains a section of the quotation.

36. Taken from the Sunday morning bulletin at Marsh Chapel, Boston University, 1958. "One thing for us is true. The future is never quite a thing apart from all that has gone before. We bring into the present ingredients and precious cargoes from the past and these are with us as we take the unknown road. All that we have learned, felt and thought, all

the impact of our experience from birth to now, all the love, devotion and tenderness that nourished us at other times, all the dreams and yearnings rooted deep in our spirits that have kept the fires of our hopes kindled with urgent ambition and high courage—all these are with us as we move into the unknown way." Howard Thurman Papers, Howard Gotlieb Archival Research Center, Boston University, Boston, MA

37. Jordan and Hearon, *Barbara Jordan: A Self-Portrait*, 96–97.

38. Jordan and Hearon, *Barbara Jordan: A Self-Portrait*, 98.

39. Jordan and Hearon, *Barbara Jordan: A Self-Portrait*, 94.

40. Jordan and Hearon, *Barbara Jordan: A Self-Portrait*, 107.

41. Jordan and Hearon, *Barbara Jordan: A Self-Portrait*, 107–108.

42. Rogers, *Barbara Jordan: American Hero*, 77.

43. See also Merline Pitre, *In Struggle against Jim Crow: Lulu B. White and the NAACP, 1900–1957* (College Station: Texas A & M University Press, 1999); see Chandler Davidson, *Biracial Politics: Conflict and Coalition in the Modern South* (Baton Rouge: Louisiana State University Press, 1972), 63–65, 195, for a description of Mrs. Hattie Mae White's campaign.

44. Quoted in William Peters, "Houston's Quiet Victory," October 1959 issue of *Good Housekeeping*, reprinted in *The Negro History Bulletin* 23, no. 4 (January 1960): 75–79.

45. All quotes from Peters, "Houston's Quiet Victory."

46. Peters, "Houston's Quiet Victory."

47. Peters, "Houston's Quiet Victory."

48. Davidson, *Biracial Politics*, 61–63, describes the "place" system, and cites Roy E. Young, *The Place System in Texas Elections* (Austin: Institute of Public Affairs, University of Texas, 1965), quoting a city charter commission member, 2, 10–11, and 21.

49. "Fiery Cross Greets Negro School Victor," *Chicago Daily Tribune*, November 11, 1958.

50. Ruthe Winegarten, *Black Texas Women: 150 Years of Trials and Triumph* (Austin: University of Texas Press, 1995), 249; *Houston Chronicle*, November 11, 1958; *Houston Post*, February 8, 1988.

51. Gretchen Lemke-Santangelo, *Abiding Courage: African American Migrant Women and the East Bay Community* (Chapel Hill: University of North Carolina Press, 1996), focuses on the movement of Black women from the Gulf States to pursue war work in California. Black women from Houston, Texas, feature prominently in the story.

52. Helen Glover Perry Papers, Mss 276, Houston Metropolitan Research Center, Houston, Texas. Photographs 19, 20, and 21 show a meeting of the Fifth Ward Civic Club in a local auditorium. The vast majority of those present are women. Photograph 78 is the interior shot of the Perry home. Photograph 70 shows Helen Glover Perry registering voters at Club Matinee, Houston, in 1961–62. She began registering voters in 1947. Other Fifth Ward women, such as Lillie Portley, who served as president of the Fifth Ward Civic Club, also shown, helped the NAACP's fight against the white primary. See Ruthe Winegarten, *Black Texas Women: 150 Years of Trial and Triumph* (Austin: University of Texas Press, 1994), 249.

53. Thomas Cole, *No Color Is My Kind: The Life of Eldrewey Stearns and the Integration of Houston* (Austin: University of Texas Press, 1997), 23.

54. Houston had few housing or planning codes. The segregated black population of the 1940s and 1950s lived in shotgun shacks, and residents operated small businesses out of their homes. Barry J. Kaplan, "Houston: The Golden Buckle of the Sunbelt," in *Sunbelt Cities: Politics and Growth since World War II*, ed. Richard M. Bernard and Bradley R. Rice (Austin: University of Texas Press, 1983), 196–212.

55. Ruthe Winegarten, ed., *I Am Annie Mae: An Extraordinary Woman in Her Own Words—The Personal Story of a Black Texas Woman* (Austin: Rosegarden Press, 1983), 93. Writing in 1964, one African American journalist commented that "the majority of political workers are women, and that among Negroes they outnumber men in performing the grass roots tasks necessary to political success." Edward T. Clayton, *The Negro Politician: His Success and His Failure* (Chicago: Johnson Publishing, 1964), 122.

56. Harry Holloway, *The Politics of the Southern Negro* (New York: Random House, 1969), 240–242; Ruthe Winegarten, *Black Texas Women: A Sourcebook* (Austin: University of Texas Press, 1996), 186–192. Helen Glover Perry Papers, Houston Metropolitan Research Center.

57. Interview with Johnny Copeland in Alan Govenar, *The Early Years of Rhythm and Blues: Focus on Houston* (Houston: Rice University Press, 1990), 3. Photography by Benny Joseph.

58. Cole, *No Color Is My Kind*, 25–34, details the first days of the Houston sit-ins.

59. "Local Portrait of a Sit in Protest," *Forward Times*, March 12, 1960, 4. Five photos of sit-ins at Weingarten's drug store, and one large photo of Felton Turner, age twenty-eight, who had "KKK" cut into his belly. One week later, March 19, 1960, the paper published an editorial, "The Challenge of Change," on the sit-ins: "We know that many white people are embarrassed by the present turn of events. Many wish to do the right thing." Photograph of Turner's wounds taken by Benny Joseph and appears in Govenar, *The Early Years of Rhythm and Blues*.

60. *Forward Times*, April 16, 1960, and April 23, 1960.

61. Cole, *No Color Is My Kind*, 30.

62. Cole, *No Color Is My Kind*, 30. Chap. 1 describes the sit-ins and chap. 2 recounts the news blackout and the integration agreement orchestrated by the Houston business community, particularly Bob Dundas of Foley's Department story, and John T. Jones of the *Houston Chronicle*. See also the documentary film directed by David Berman and based on the research of Thomas R. Cole, *The Strange Demise of Jim Crow: How Houston Integrated Its Public Accommodations.* (1998)

63. Cole, *No Color Is My Kind*, 36–57.

64. Good Hope Missionary Baptist Church, Program, March 27, 1960. See also reports of local speaking engagements in *Forward Times,* February 20, 1960, and April 2, 1960.

65. "A Conversation with Miss Jordan," *Texas Observer*, May 27, 1966.

66. Transcript, Barbara Jordan Oral History Interview I, March 28, 1984, by Roland C. Hayes, LBJ Presidential Library, Austin, TX.

67. Bob Hall, interview with author, March 26, 2001, Houston, TX. After *Smith* Black membership in the Houston NAACP soared to more than 12,000 members, but then declined in the 1950s as a direct result of the Red Scare, state repression, and faulty leadership. See Pitre, *In Struggle against Jim Crow*, 107–128.

68. Mr. Ball recalled the success of the voter registration drive. "Well that [voter registration] was what I was basically working for in 1960. But up to that time, the best we had ever done was to get about 15,000 blacks qualified to vote. I set up an office with [the HCCO] and . . . we said to pick someone to train, send them over, and they picked Barbara Jordan." "So myself and Pee Wee and Chris Dixie basically did all the organizational work and clerical work, and kept Carl Smith, the tax assessor collector, happy, so he wouldn't give us too much trouble about where our registration books had been." Author's interview with Eddie Ball at Lake Livingston, outside of Houston, April 14, 2004.

69. Jordan and Hearon, *Barbara Jordan, A Self-Portrait*, 110–111.

70. September 6, 1960, *Houston Post*.

71. John F. Kennedy, "Address to the Greater Houston Ministerial Association," September 12, 1960, transcript courtesy of John F. Kennedy Presidential Library and Museum, https://www.npr.org/templates/story/story.php?storyId=16920600, accessed November 23, 2023.

72. "What Means the South's Attitude toward Kennedy?" *Houston Informer*, July 30, 1960.

73. "Texas Is Excellent Place for Him to Prove Change," *Houston Informer*, August 20, 1960.

74. *Houston Informer*, October 15, 1960. This was not her father's church.

75. *Houston Informer*, October 15, 1960.

76. Max Krochmal detailed the critical organizing work of Mrs. LeRoy during the Kennedy campaign and beyond in *Blue Texas: The Making of a Multiracial Democratic Coalition in the Civil Rights Era* (Chapel Hill: University of North Carolina Press, 2016), 259–265.

77. Kennedy's victory in Texas is usually attributed to two developments: the surge of voters in heavily Hispanic, and Catholic, south Texas, and a negative reaction among white voters to the antics of conservative Republican Bruce Alger, whom Nixon, the Republican presidential nominee, called "that asshole congressman." An anticommunist extremist sometimes heralded as the forerunner of today's "Tea Party" zealots, Alger accused Lyndon Johnson of selling out to "Yankee socialists." A few days before the election, Alger had led a group of conservative white women known as "the mink coat mob" to Dallas to demonstrate against Johnson and his wife, Ladybird. The group swarmed around the Johnsons, shouting, spitting, and accosting Mrs. Johnson by grabbing her gloves and throwing them into a gutter. They hit her on her head with a placard. When asked to apologize, Alger allegedly retorted that "I don't think it is rude to show a socialist and traitor what you think of him." Nixon had been ahead in the Texas polls, but the horrified reaction to these events put some voters in Kennedy's column. Matt Schudel, "Bruce Alger, Firebrand Republican Congressman from Texas Dies at 96," *Washington Post*, April 25, 2015.

78. Jordan and Hearon, *Barbara Jordan: A Self-Portrait*, 110.

Chapter 5

1. "A considerable and heated discussion on the floor questioned whether the liberal faction was giving a fair return of political consideration in exchange for support of liberal/labor candidates." *Forward Times*, April 21, 1962.

2. "HCCO at Work," *Forward Times*, April 14, 1962.

3. "A new organization of liberals, known as the Democratic coalition is quietly edging its way into the Texas political picture." *Houston Post*, October 22, 1961. Max Krochmal, "Making the Common Good the Common Will," in *People Power: History, Organizing, and Larry Goodwyn's Democratic Vision in the Twenty-First Century*, ed. Wesley C. Hogan and Paul Ortiz (Gainesville: University Press of Florida, 2021), 15. See also Max Krochmal, *Blue Texas: The Making of a Multiracial Democratic Coalition in the Civil Rights Era* (Chapel Hill: University of North Carolina Press, 2016), for a deep history of the Democratic Coalition in Texas.

4. In the mid-1960s, the organization was already threatening to split over Vietnam, with Dixie preferring that the organization not immediately take a strong stand on the conflict. Dixie proposed this new organization be "a marriage between the ideal and the practical." See "Texas Liberal Democrats Organize," *Texas Observer*, November 12, 1965 for an appraisal of the limitations and divisions within the newly formed statewide Texas Liberal Democrats (TLD).

5. *Houston Post*, October 22, 1961.

6. Jordan and Hearon, *Barbara Jordan: A Self-Portrait*, 114.

7. *Forward Times*, March 24, 1962. The article noted that many Black candidates for public office entered political contests purely for the publicity: "They have absolutely no hope or chance of being elected. This is not the case with Atty Jordan."

8. *Forward Times*, March 24,1962.

9. Letter from Chris Dixie to Hank Brown, president, Texas State AFL-CIO, April 9, 1962, Texas Labor Archives, Special Collections, University of Texas at Arlington Library, AR110-26-11-2. "The Negroes have also moved into 35 additional precincts which are now mixed and the counting there is impossible before election. It is possible, however that an additional 10,000 votes are scattered in these mixed precincts."

10. "HCCO at Work," *Forward Times*, April 14, 1962.

11. *Forward Times*, April 26, 1962.

12. *Forward Times*, May 5, 1962. Hobart Taylor was a millionaire who owned a taxi franchise that controlled the sale of taxi permits. Jordan and Hearon, *Barbara Jordan: A Self-Portrait*, 106.

13. Jordan and Hearon, *Barbara Jordan: A Self-Portrait*, 114–115.

14. Jordan and Hearon, *Barbara Jordan: A Self-Portrait*, 115.

15. *Forward Times*, April 14, 1962.

16. *Forward Times*, May 12, 1962.

17. Jordan and Hearon, *Barbara Jordan: A Self-Portrait*, 16.

18. See Garnet Guild, November 20, 1935 in "Excerpts From Letters from 1935 Summer Volunteers," General Files, 1935, Social-Industrial Section, Folder, Volunteer Placement Administration, Correspondence, 1935, Papers of the American Friends Service Committee (AFSC), Philadelphia, Pennsylvania. For Guild's background, see "Garnet Guild," obituary published in *Friends Journal* 46 no. 2 (2000): 37, which mentions her "deep friendship" with Barbara Jordan. Jean Fairfax's work with the AFSC and the NAACP's Legal Defense Fund described in "Jean Fairfax: Civil Rights Activist Who Helped Integrate Southern Schools, Dies at 98," *Washington Post*, March 3, 2019.

19. Letter from Garnet Guild to Elizabeth Jensen and friends, 1959, Elizabeth Jensen Papers, Coll. 1154, Box 6, Quaker Collection, Haverford College.

20. Memo from Jean Fairfax to Garnet Guild, Steve Cary, and Earle Edwards, June 28, 1959, SCRO 1959 Administration, Papers of the American Friends Service Committee (AFSC), Philadelphia.

21. Memo from Garnet Guild to Regional Executive Committee, January 19, 1962, AFSC Regional Office Houston, General Administration, 1962, Papers of the AFSC, Philadelphia.

22. Letter from Guild to "friends," June 10, 1962, Elizabeth Jensen Collection, Coll. 1154, Box 6, Quaker Collection, Haverford College.

23. "Garnet Guild," obituary published online at http://nmahgp.genealogyvillage.com /grant/grobittextg.htm, accessed November 23, 2023. "Garnet Guild," obituary published in *Friends Journal*, mentions her "deep friendship" with Barbara Jordan (37).

24. For more information on the Fisk University Race Relations Institute, see Katrina M. Sanders, *"Intelligent and Effective Direction": The Fisk University Race Relations Institute and the Struggle for Civil Rights, 1944–1969* (New York: Peter Lang Publishing, 2005).

25. Human Rights and the Public Interest, Conference (June 25–July 7, 1962), Fisk University. "Program Schedule" and "Roster," from "19th Annual Institute of Race Relations," Fisk University, Amistad Research Center. Photocopy given to the author by Joan Browning, a participant in the conference.

26. Papers of the NAACP, Houston Branch Files, 1963, letter from Gloster B. Current to Roy Wilkins, February 18, 1963, Library of Congress, with minutes of the February 13, 1963, meeting attached.

27. *Texas Observer*, June 28, 1963.

28. *Dallas Morning News*, August 16, 1963.

29. To thwart integration, the board had imposed a rule that said a younger sibling had to be enrolled in the same school as the older one, thus making sure that attendance in segregated schools would last for another generation. The rule was rescinded, but only after much protest. Harris's appointment was viewed as another ploy. *Dallas Morning News*, July 7, 1963.

30. *Dallas Morning News*, July 7, 1963.

31. *Texas Observer*, June 28, 1963, cited statistics showing annual income in 1960 Houston was $1,150 for blacks and $2,573 for whites.

32. Interview with Houston resident Arvia Wardlaw in Alan Govenar, *The Early Years of Rhythm and Blues: Focus on Houston* (Houston: Rice University Press, 1990), 16.

33. "The Austin March," *Texas Observer*, September 6, 1963.

34. *Dallas Morning News* August 27, 1963.

35. Barbara Jordan, "A New Dawn in Southern Politics," speech, 1963 or 1964, University of North Texas Libraries, Portal to Texas History, Barbara Jordan Archives, Texas Southern University.

36. "Texas Is Integrating: A Special Report," *Texas Observer*, June 28, 1963.

37. Saul Friedman, "Houston: A Backwater of the Revolt," *Texas Observer*, November 15, 1963, 8–10

38. Friedman, "Houston," 8–10.

39. Friedman, "Houston," 10. See also Krochmal, *Blue Texas*, 292–293, for an analysis of how conservative elites stymied direct action in Houston.

40. She earned a salary of $300, a sum second only to that of the executive director of the Democratic Coalition, Larry Goodwyn. Memo from Larry Goodwyn to cochairmen of the Democratic Coalition, November 15, 1963, a 13-page report on the work of the project directors throughout the state. Texas Labor Archives, Special Collections, University of Texas at Arlington Library. AR110-26-9-5.

41. Democratic Coalition mailing, "A Message for Official Block Captains," Repeal the Poll Tax Campaign, 1963, Texas Labor Archives, Special Collections, University of Texas at Arlington Library. AR-110-26-9-5.

42. *Texas Observer*, December 13, 1962.

43. Author's interview with Lauro Cruz, Austin, TX, November 4, 2003. The Democratic Coalition had drawn the support of organized Latino groups in San Antonio, but not in Houston, where Mexican American laborers were at the lowest rung, often even beneath Black workers in certain industries. Rebecca Montes, "Working for American Rights," details how Mexican workers were excluded from the ILA unions on the Houston Ship Channel. Unlike Black and white workers, they had no union, were given only the lowest-paid jobs, and were designated as unskilled.

44. See Krochmal, *Blue Texas*, 270–275, for a detailed discussion of the Latinos in that campaign.

45. "About 1963, I was running a grocery store in the 6th ward, right off of Houston Ave. and Washington Ave. It ran up all the way to include a cemetery where Howard Hughes is buried." "Then to have Mrs. Randolph call me, the den mother of the liberal movement in Texas; everybody knew who she was." Author's interview with Lauro Cruz, November 4, 2003, Austin, TX.

46. Author's interview with Lauro Cruz, November 4, 2003, Austin, TX.

47. Jordan and Hearon, *Barbara Jordan: A Self-Portrait*, 122.

48. Author's interview with Rev. William Lawson, Houston, TX, March 30, 2001.

49. *Chicago Defender*: "Keynote speaker for the banquet . . . is Attorney Barbara Jordan, pioneer in the voter registration drive in the Southwest and runner up in the race for the Texas legislature." The article on the banquet appeared in four editions: March 2, 1964; March 4, 1964; March 12, 1964; and March 16, 1964.

50. Author's telephone interview with Wilhelmina Perry, July 23, 2009.

51. Jordan and Hearon, *Barbara Jordan: A Self-Portrait*, 117.

52. Jordan and Hearon, *Barbara Jordan: A Self-Portrait*, 117.

53. Jordan and Hearon, *Barbara Jordan: A Self-Portrait*, 115–117.

54. Rogers, *Barbara Jordan: American Hero*, 91–93.

55. Jordan and Hearon, *Barbara Jordan: A Self-Portrait*, 118.

56. Jordan and Hearon, *Barbara Jordan: A Self-Portrait*, 118. A more detailed transcription of this interview with Jordan on the subject of marriage can be found in Shelby Hearon Papers, Box 3, Folder 11, "Interview with B.J. in DC, September 25, 1977," Harry Ransom Center, Austin, TX.

57. Shelby Hearon Papers, Box 3, Folder 11, "Interview with B.J. in DC, September 25, 1977," Harry Ransom Center, Austin, TX.

58. Shelby Hearon Papers, Box 3, Folder 11, "Interview with B.J. in DC, September 25, 1977," Harry Ransom Center, Austin, TX.

59. J. Jennings Moss, "Barbara Jordan: The Other Life," *Advocate*, March 5, 1996, 42

60. Jordan and Hearon, *Barbara Jordan: A Self-Portrait*, 119.

61. Jordan and Hearon, *Barbara Jordan: A Self-Portrait*, 119.

62. Author's interview with Billie Carr, Houston, TX, March 29, 2001.

63. Rogers, *Barbara Jordan: American Hero*, 96–97, quoting interview with Chris Dixie.

Chapter 6

1. Steve Wilson, Speech before the Human Relations Forum, November 18, 1960, in Employment on Merit Report, Houston, Southern Regional Council, Archives of the American Friends Service Committee, Philadelphia. Davidson, *Biracial Politics*, 106–125.

2. Davidson, *Biracial Politics*, 92. See also 50: "In 1959, only 1218 nonwhite families in Harris County had incomes of ten thousand dollars and over. There were 54,176 white families in this category."

3. Quoted in "Black Houston," *Texas Observer*, May 13, 1966.

4. For descriptions of daily life in Houston's Black neighborhoods, see Saul Friedman, "Life in Black Houston," *Texas Observer*, June 9–23, 1967. The explicit comparison with Watts is made by Blair Justice, "An Inquiry into Negro Identity and a Methodology for Investigating Potential Racial Violence" (PhD diss., Rice University, May 1966).

5. Justice, "An Inquiry into Negro Identity."

6. Justice, "An Inquiry into Negro Identity," 136.

7. Justice, "An Inquiry into Negro Identity," 141.

8. Justice, "An Inquiry into Negro Identity," 138.

9. Mrs. Charles (Hattie Mae) White, the first Black person elected to citywide office in Houston and an outspoken opponent of school segregation, was third. See Justice, "An Inquiry into Negro Identity," 249.

10. Louise Ballerstedt Raggio, *Texas Tornado: The Life of a Crusader for Women's Rights and Family Justice* (New York: Citadel, 2003), 111–112.

11. Molly Sinclair, "Miss Jordan Aims to Serve," *Houston Post*, March 7, 1965; Dick Raycraft, "Barbara Jordan Quit Legal War to Battle for Houston Needy," *Houston Chronicle*, April 25, 1965. Author's interview with Judge Andrew Jefferson, March 27, 2001, Houston, TX.

12. Elliott knew about the AFSC's Employment on Merit Program. Memo dated March 26, 1964, by Jack Haller, "Judge William Elliott," American Friends Service Committee Papers, CRD, Southern Projects, Employment on Merit, Houston, 1964, Philadelphia.

13. *Chicago Defender*, May 18, 1965.

14. *Dallas Morning News*, May 16, 1965.

15. Letter from Clarence A. Laws, regional director, to Gloster B. Current, May 25, 1965, NAACP Papers, Group 111, Box c 150, Houston, Texas, 1964–65. "Efforts are still being made to place the NAACP back in the driver's seat," wrote Clarence Laws, the regional director. Reverend Lawson was no "interloper," he said, noting that many in PUSH were

also NAACP members. "Also on this committee with Rev. Lawson and Mr. Knight were attorney Francis Williams, Attorney Barbara Jordan." Laws urged that PUSH be viewed as an ad hoc committee of the NAACP rather than as an opponent.

16. *Chicago Defender*, August 7, 1965.

17. "The Rage and the Republic," Draft Speeches, Barbara Jordan Archives, Texas Southern University.

18. The literature is voluminous. But see Bettye Collier-Thomas and V. P. Franklin, eds., *Sisters in the Struggle: African American Women in the Civil Rights-Black Power Movement* (New York: New York University Press, 2001); Laura Visser-Maessen, *Robert Parris Moses: A Life in Civil Rights and Leadership at the Grassroots* (Chapel Hill: University of North Carolina Press, 2016); Peniel E. Joseph, *Waiting til the Midnight Hour: A Narrative History of Black Power in America* (New York: Henry Holt, 2007); Hasan Kwame Jeffries, *Bloody Lowndes: Civil Rights and Black Power in Alabama's Black Belt* (New York: New York University Press, 2009); Timothy Tyson, *Radio Free Dixie: Robert F. Williams and the Roots of Black Power* (Chapel Hill: University of North Carolina Press, 2000); Curtis J. Austin, *Up against the Wall: Violence in the Making and Unmaking of the Black Panther Party* (Fayetteville: University of Arkansas, 2008); Lance Hill, *The Deacons for Defense: Armed Resistance and the Civil Rights Movement* (Chapel Hill: University of North Carolina Press, 2005); Tanisha C. Ford, *Liberated Threads: Black Women, Style, and the Global Politics of Soul* (Chapel Hill: University of North Carolina Press, 2015), and "SNCC Women, Denim, and the Politics of Dress," *Journal of Southern History* 79, no. 3 (August 2013): 625–658.

19. For background on redistricting and the evolution of the "one person, one vote" principle eventually supported by the Supreme Court, see Richard C. Cortner, *The Apportionment Cases* (Knoxville: University of Tennessee Press, 1970). See also Chandler Davidson and Bernard Grofman, eds., *Quiet Revolution in the South: The Impact of the Voting Rights Act, 1965–1990* (Princeton, NJ: Princeton University Press, 1994), 242–243.

20. See http://www.lrl.state.tx.us/mobile/memberDisplay.cfm?memberID=1070 accessed November 21, 2023. "I am the attorney who brought the suit and rounded up the usual suspects as Plaintiffs." Email from Tony Korioth to the author, March 23, 2002. *Kilgarlin v. Martin*, 252 F. Supp. 404.

21. Email from William W. Kilgarlin to the author, March 11, 2002. Judge William Kilgarlin concurred with Korioth: "I enjoyed the honor of being the named plaintiff in *Kilgarlin v Martin*. . . . I do not believe that Barbara Jordan was in mind in proceeding with the lawsuit. Our motivation was that urban areas were vastly under represented in the Texas legislature as were minorities." Neither Kilgarlin nor Korioth opposed Jordan, but their goal in the lawsuit was to bring more power to urban areas, and not necessarily to bring more Black representatives into office.

22. *Texas Observer*, March 18, 1966, 11

23. This description is similar to what Chris Dixie described when Jordan talked to steelworkers in 1962. Rogers, *Barbara Jordan: American Hero* 79. Either man may have confused the years of this event. Author's interview with Eddie Ball, Lake Livingston, TX, April 14, 2004. For a description of the conflict within the HCD on whether to endorse Jordan over Whitfield, see Jordan and Hearon, *Barbara Jordan: A Self-Portrait*, 130–131.

24. Rogers, *Barbara Jordan: American Hero*, 104. For the walkout, see *Texas Observer*, March 18, 1966, 11. "Representative Charlie Whitfield and John Ray Harrison led 50 members out of a meeting of the Harris County Democrats when that organization endorsed Miss Barbara Jordan over Whitfield." Author's interview with Eddie Ball, Lake Livingston, TX, April 14, 2004.

25. She said, "This was checked here and in Washington and I was assured there was no conflict or anything wrong as long as I put in a full day's work—as I have been doing." *Texas Observer*, April 1, 1966.

26. *Texas Observer*, April 29, 1966.

27. "A Conversation with Miss Jordan," *Texas Observer*, May 27, 1966, gives details of the campaign and Whitfield's actions. See also Jordan and Hearon, *Barbara Jordan: A Self-Portrait*, 131–134.

28. "A Question of Today," *Texas Observer*, April 29, 1966, 3.

29. "Negro Woman, Legislator Battle for Liberal Votes," *Dallas Morning News*, March 13, 1966.

30. Wilhelmina Elaine Jones Perry, "The Urban Negro with Special Reference to the Universalism-Particularism Pattern Variable" (PhD diss., University of Texas, Austin, Department of Sociology, 1967). According to the vita in her dissertation, Perry was born in Washington, DC, in 1925, and then moved with her parents to Austin in 1930. She graduated from Huston-Tillotson with a sociology degree in 1944, and received an MA in sociology from Howard University in Washington, DC. She also took sociology classes at the University of Wisconsin at Madison. She taught sociology at Texas Southern University and, after receiving her PhD in 1967, taught sociology at Rowan University in New Jersey. Perry died on January 4, 2022. https://htu.edu/16979/ht-recognizes-alumni-as-trailblazers-during-black-history-month, accessed November 21, 2023.

31. Wilhelmina E. Perry and August N. Swain, *The Huston-Tillotson University Legacy: A Historical Treasure* (Austin, TX: Huston-Tillotson University, International Alumni Association, 2007). Before she left Texas in 1968 to teach in New Jersey, Perry worked closely with Jordan, spearheading the block worker and voter registration efforts in 1963, and she also worked with Jordan's campaign in 1964.

32. Quotes from author's telephone interview with Wilhelmina E. Perry (formerly Jones), July 23, 2009.

33. In 1964 the HCD had put Jordan up against Willis Whatley, the conservative incumbent. Jordan did not want a repeat of this situation. She spoke with members of the HCCO (Harris County Council of Organizations) about what went wrong, and they decided that Jordan and her supporters needed to get better control of the campaign. Perry called the 1964 campaign "chaotic." They never received computer data about voters in the district until after the campaign was over. "We really didn't make any decisions."

34. Author's interview with Wilhelmina E. Perry (formerly Jones), July 23, 2009.

35. Author's interview with Wilhelmina E. Perry (formerly Jones), July 23, 2009.

36. Author's interview with Wilhelmina E. Perry (formerly Jones), July 23, 2009.

37. Author's interview with Wilhelmina E. Perry (formerly Jones), July 23, 2009.

38. Author's interview with Wilhelmina E. Perry (formerly Jones), July 23, 2009.

39. Alan Govenar, *The Early Years of Rhythm and Blues: Focus on Houston* (Houston: Rice University Press, 1990), photography by Benny Joseph, 13–14.

40. See Ford, "SNCC Women, Denim, and the Politics of Dress," 626–627.

41. Author's telephone interview with Wilhelmina E. Perry.

42. Author's telephone interview with Wilhelmina E. Perry.

43. "Southern Regional Council Interview with Barbara Jordan," Texas State Senate CSR Series, Organizations, General, 1967–72, Barbara Jordan Archives, Texas Southern University.

44. "I would go to Barbara Jordan's campaign, work, and go home, do lesson plans." Author's telephone interview with Wilhelmina E. Perry.

45. Author's telephone interview with Wilhelmina E. Perry.

46. Author's interview with Bob Hall, March 26, 2001, Houston, TX.

47. Jordan and Hearon, *Barbara Jordan: A Self-Portrait*, 134.

48. Davidson, *Biracial Politics*, 102, includes a vote breakdown and Davidson's impression that many Blacks Houstonians, even those working within the HCD, viewed the organization with suspicion. They resented HCD's cliquishness and its strong ties to the unions, many of which had a long history of excluding Black workers.

49. Shelby Hearon contradicted Jordan's impressions: "Had she studied the overall returns, however, she would have found that such endorsements as the Harris County Democrats guaranteed few victories for anyone." Jordan and Hearon, *Barbara Jordan: A Self-Portrait*, 119–120.

50. Davidson, *Biracial Politics*, 44–45.

51. Even though Jordan's moderation was already being contrasted with Graves's more militant posturing, it was Jordan who had gained the most support among Black voters. "Given the circumstances of their election, it is ironic that Graves, rather than Jordan, presents a more militant Negro oriented image." Chandler Davidson, "Negro Politics and the Rise of the Civil Rights Movement in Houston, Texas," (PhD diss., Princeton University, 1968), 172–173; Davidson, *Biracial Politics*, 44–45.

52. *Forward Times*, May 14, 1966, has several articles dedicated to Jordan's victory, but her electoral success also made national news. See "Negroes Victors in 3 Texas Races," *New York Times*, May 9, 1966; *Chicago Daily Defender*, May 10, 1966; *New York Amsterdam News*, May 14, 1966.

53. Molly Ivins, "A Conversation with Miss Jordan," *Texas Observer*, May 27, 1966.

54. Joe Lockridge from Dallas was another elected Black legislator. Graves associated him with the conservative Dallas establishment. He died in a plane crash in 1968, which left only Jordan and Graves as the two Black legislators in Austin. With Lockridge's death the contrast between Jordan and Graves became stark. Rogers, *American Hero*, 130. Martin Waldron, "Negroes Victors in 3 Texas Races," *New York Times,* May 9, 1966 refers to the primary victories of Jordan, Graves, and Lockridge. See also "Texas Has Negro Senator," *New York Times*, January 11, 1967. *Time*, May 20, 1966. Victory details described in Jordan and Hearon, *Barbara Jordan: A Self-Portrait,* 134–135.

55. Marilyn D. Rhinehart and Thomas H. Kreneck, "The Minimum Wage March of 1966: A Case Study in Mexican-American Politics, Labor, and Identity," *Houston Review* 11, no. 1 (1989).

56. *Texas Observer*, September 16, 1966.

57. *Forward Times*, February 24, 1967. Rogers, *Barbara Jordan: American Hero*, 132–133, describes the meeting in detail.

58. Willard Clopton Jr., "Negro Politicians Meeting Here Discuss 'Black Power,'" *Washington Post*, June 3, 1967.

59. Willard Clopton Jr., "Negro Politicians Meeting Here Discuss 'Black Power,'" *Washington Post*, June 3, 1967; David S. Broder, "Negroes to Map '68 LBJ Drive," *Washington Post*, June 1, 1967.

60. *Dallas Morning News*, March 8, 1968.

61. *Dallas Morning News*, March 10, 1968.

62. *Dallas Morning News*, March 10, 1968.

63. *Forward Times*, April 8, 1967, and April 1, 1967.

64. *Houston Chronicle*, May 18, 1967.

65. *Houston Post*, May 18, 1967.

66. *Houston Tribune*, May 25, 1967.

67. Martha Biondi, *The Black Revolution on Campus* (Oakland: University of California Press, 2014).

68. "This will also give the general public an opportunity to be informed of the status of efforts to raise funds to ensure justice for these students and to hear students who were arrested. The main speaker will be Senator Barbara Jordan, an outstanding and dynamic attorney of Houston. Senator Jordan made an outstanding record during the recent session of the Texas State Legislature. She is an unusual orator and is well known for her civic, religious, and political activities throughout the nation." "TSU Public Rally at Great Zion July 30," *Houston Informer*, June 1967.

69. *Dallas Morning News*, August 20, 1967.

70. "WE ARE HERE TO EXCHANGE IDEAS TO TAKE BACK TO OUR HOME COMMUNITIES WHICH WILL CHANGE THE FACE OF TEXAS AND THE NATION." "Texas Leadership Conference," Political Files Series, Campaign Activities, 1967–1972, Barbara Jordan Archives, Texas Southern University. Capitals in original. This event was held at Camp Wimberley, Texas, Oct 6–8, 1967. Three hundred people attended.

71. Rogers, *Barbara Jordan: American Hero*, 119–120, gives Vernon Jordan's positive impression of Jordan's performance at the conference.

72. Bill Hunter, "Negro Feels Backlash Overrated," *Dallas Morning News*, November 13, 1966.

73. A few examples of Jordan speaking at local community events include: Jordan featured at a ceremony and dinner honoring the block workers and high voter turn out of Pleasantville community, *Forward Times*, July 6, 1968; Library dedication for "Settegast Community Library," *Forward Times*, December 21, 1968; "Women's Day," Starlight Baptist Church, Houston, Guest Speaker, *Forward Times*, June 1, 1968. All these events were held in Black community centers or churches.

74. Rogers, *Barbara Jordan: American Hero*, 176.

75. Rogers, *Barbara Jordan: American Hero*, 137.

76. "She unraveled one of the best hour-long presentations that we have witnessed, and this is stating it mildly." *Forward Times*, June 1, 1968.

77. "Who Speaks for the Negro?" Handwritten speech (Jordan's handwriting), BJ Archives, Texas Southern University, Houston, Texas, n.d.

78. *Forward Times*, June 1, 1968.

79. For an excellent summary of the contemporary debate in the Black community, see Lerone Bennett, "What's in a Name? Negro vs. Afro American vs. Black," *ETC: A Review of General Semantics* 26, no. 4 (December 1969): 399–412.

80. Interview with Sen. Barbara Jordan, July 7, 1970, conducted by Dr. Ronald E. Marcello, Houston, TX, July 7, 1970, University of North Texas Oral History Collection, 16.

81. Jordan interview (Marcello), 17.

82. Jordan interview (Marcello), 23.

83. Jordan interview (Marcello), 26–27.

84. Cynthia Grigggs Fleming, *Soon We Will Not Cry: The Liberation of Ruby Doris Smith Robinson* (Lanham, MD: Rowman and Littlefield, 1998).

85. Jordan interview (Marcello), 30.

86. Jordan interview (Marcello), 31.

87. Jordan interview (Marcello), 31.

88. *Chicago Defender*, October 3, 1967.

89. Robert Charles Smith, *We Have No Leaders: African Americans in the Post–Civil Rights Era* (Albany, NY: SUNY Press, 1996), 30–31.

90. "And so, 1970 Black Power Conference was transformed into the Congress of African People Meeting. And at the Congress of African People Meeting in Atlanta, a conference, a, a congress, a conference was called, ah, to be held in 1972." Interview with Amiri Baraka, conducted by Blackside, Inc. on March 31, 1989, for *Eyes on the Prize II: America at the Racial Crossroads 1965 to 1985*. Washington University Libraries, Film and Media Archive, Henry Hampton Collection. http://digital.wustl.edu/cgi/t/text/text-idx?c=eop;cc =eop;type=simple;rgn=div1;q1=baraka;view=text;subview=detail;sort=title;idno=bar5427 .0106.009;node=bar5427.0106.009%3A1, accessed November 23, 2023. See also Cedric Johnson, *Revolutionaries to Race Leaders: Black Power and the Making of African American Politics* (Minneapolis: University of Minnesota Press, 2007), 91, on pre-Gary conference planning.

91. "Black Politicians Keep Parley Secret," *Chicago Defender*, September 27, 1971.

92. Shirley Chisholm, *The Good Fight* (New York: Harper & Row, 1973), 28–31, describes the Northlake conference and Bond's favorite-son strategy.

93. "The discussion of Northlake focused on black presidential strategy in the upcoming 1972 election." Cedric Johnson, *Revolutionaries to Race Leaders: Black Power and the Making of African American Politics* (Minneapolis: University of Minnesota Press, 2007), 91.

94. Chisholm, *The Good Fight* 38–39, outlines Bond's strategy. He alludes to it in Julian Bond, *A Time to Speak, a Time to Act: The Movement in Politics* (Chicago: Touchstone, 1972), 140.

95. Chisholm, *The Good Fight*, 27: "In July [1971] I had begun dropping hints that I might run in some primaries; this was partly a calculated move to see what the response would be and partly an honest expression of indecision."

96. Ethel Payne, "Salons Talk to Black Politics in the 70s," *Chicago Defender*, December 6, 1971.

97. "Hatcher Chosen to Keynote Black Convention," *New York Times*, March 7, 1972.

98. Payne noted that Jordan was slated to play a key organizational role in this conference: "The thorniest responsibility will rest on the shoulders of four persons: Edward Sylvester, Chairman of the Rules Committee . . . and State Senator Barbara Jordan who will head the Resolutions Committee." Ethel Payne, "Hatcher's Problem: What to Do with 8,000 Folks," *Chicago Defender*, March 9, 1972. The *New York Times*, March 7, 1972, also mentions Jordan's role as chair of Resolutions: "Walter Fauntroy Chair of Platform Committee, and Colorado State Senator George Brown as Chair of the Credentials Committee."

99. Johnson, "The Convention Strategy and Conventional Politics: The 1972 Gary Convention and the Limits of Racial Unity," in *Revolutionaries to Race Leaders*; Smith, *We Have No Leaders*.

100. "Hatcher Chosen to Keynote Black Convention," *New York Times*, March 7, 1972, photo.

101. Leonard N. Moore, *The Defeat of Black Power: Civil Rights and the National Black Political Convention of 1972* (Baton Rouge: Louisiana State University Press, 2018), 81.

102. "Black Convention Schedule," *Post Tribune*, March 10, 1972, Ethel Payne Papers, "African American National Conferences and Conventions," Box 17, Folder 1, Library of Congress, Washington, DC.

103. Chisholm, *The Good Fight*, 36–38. "They would never get *behind* me. Behind a woman? Unthinkable!" (38).

104. Unnamed Black nationalists "convened a meeting of the Committee on Resolutions without the knowledge of either Texas State Senator Barbara Jordan or Rep. Louis Stokes, Chairman of the Congressional Black Caucus and Co chair of the Resolutions. The group that had called the meeting in the Holiday Inn Downtown claimed they had been authorized by Imamu Baraka even though their names were not part of the committee. Angered by these kinds of tactics, Miss Jordan was ready to walk out of the Convention and return to Texas but stayed on for the sake of unity. Stokes later went back to Washington." Ethel Payne, "Post Convention Patchwork for Unity," *Chicago Defender* April 1, 1972.

105. Richard Fenno Papers, Box 1, Folder 1, Interviews, 1972, Archives, Rush Rhees Library, University of Rochester.

106. Chisholm, *The Good Fight*, 36.

107. Richard Fenno Papers, Box 1, Folder 1, Interviews, 1972, Archives, Rush Rhees Library, University of Rochester.

108. Harry Belafonte interview, May 15, 1989, *EOTP II*, question 38, http://digital.wustl.edu/cgi/t/text/text-idx?c=eop;cc=eop;rgn=main;view=text;idno=bel5427.0417.013, accessed November 21, 2023.

109. Chisholm, *The Good Fight*, 36–37.

110. Amiri Baraka, *EOTP* interview, question 24: "What we failed to be able to deal with, was the fact that the whole Black electoral movement, you know, which was headed up mostly by those middle class, Black politicians, that they would align themselves with the, ah, status quo institutions in many cases."

111. Amiri Baraka, *EOTP* interview, question 24.

Chapter 7

1. "Liberals Walk Out, Charging 'Robbery,'" *Dallas Morning News*, September 21, 1966; "Rebellion Jolts Texas Democrats," *New York Times*, September 21, 1966.

2. Bill Hunter, "Negro Feels Backlash Is Overrated," *Dallas Morning News*, November 13, 1966.

3. Author's interview with "Babe" Schwartz, November 5, 2003, Austin, TX. Molly Ivins, "A Profile of Barbara Jordan," quoting Curtis Graves, *Texas Observer*, November 3, 1972; and William Broyles, "The Making of Barbara Jordan," *Texas Monthly* (October 1976). Author's interview with Lauro Cruz, November 4, 2003, Austin, TX.

4. Clifton McCleskey, *The Government and Politics of Texas*, 4th ed. (Boston: Little, Brown, and Company, 1972), is a basic political science text on Texas government which describes the procedures of the body when Jordan was in office. The *Senate Journal* published how senators voted on the final version of bills, but it was impossible to know if a senator had spoken in favor of legislation or opposed it. Thus it was difficult to trace the progress of a piece of legislation and understand how it was "killed" or why it was even allowed to come out of committee and to a vote.

5. University of North Texas at Denton, Oral History Collection, Willis Library, UNT Special Collections, interviews with Oscar Mauzy, November 3, 1967, July 24, 1968, June 25, 1969, December 1, 1969, and June 23, 1971; interviews with A. R. "Babe" Schwartz, November 27, 1967, May 6, 1970, November 9, 1971; interview with Charles Wilson, January 1, 1972; interview with Barbara Jordan, July 7, 1970. Also Babe Schwartz interview with the author, November 5, 2003, Austin, TX.

6. Author's interview with Max Sherman and Bill Hobby, October 6, 2003, London, UK.

7. "A Texas liberal at this time was primarily concerned about who was going to bear the tax burden." Interview with Joe Christie, August 15, 2011, Austin, TX, Charlie Wilson Oral History Project, Stephen F. Austin State University.

8. "Senate Mixture Hints Explosive Session," *Houston Chronicle*, November 9, 1966. "[It] is significant that Tuesday's election put into office twelve senators generally regarded as conservative, twelve expected usually to line up as liberals and seven best described as moderates."

9. "Freewheeling Senate Seen," *Dallas Morning News*, November 13, 1966.

10. *Texas Observer*, May 27, 1966.

11. Mauzy interview, 1967, 23–24, 29: "And where we lost the battle and the war was the first day when we didn't get Bill Patman. And I hold that little bastard personally responsible for the whole thing."

12. Mauzy interview, 1967, 25.

13. Mauzy interview, 1967, 26.

14. Mauzy interview, 1967, 6.

15. Jordan interview, 1970, 14.

16. Jordan interview, 1970, 14–15. McCleskey, *The Government and Politics of Texas*, 146–147, discussed the senate committee system, rating State Affairs along with Finance as two of the most important.

17. Mauzy interview, 1967, 44.

18. McCleskey, *The Government and Politics of Texas*, 152, acknowledges the importance of "legislative norms and roles," such as seniority, courtesy, reciprocity, and institutional loyalty, in the US Congress, and though no similar study has been made of the Texas legislature as of 1972, it is clear such norms shaped the legislative behavior of all.

19. Mauzy interview, 1967, emphasis in the original.

20. "First Speech Made by Negro Senator," *Dallas Morning News*, March 16, 1967, 18. See also press release to the *Forward Times* from the office of the Hon. Barbara Jordan, Austin, Texas, for the week ending March 17, 1967 (Press Clippings, Media Releases, 1966, 1967, 1968, Texas State Senate Papers, Barbara Jordan Archives, Texas Southern University).

21. Mauzy interview, 1967, 44.

22. Press release, March 17, 1967.

23. Mauzy interview, 1967, 41.

24. Mauzy interview, 1967, 41.

25. Mauzy, interview, July 24, 1968, 4–5.

26. Press release, March 17, 1967.

27. For a discussion of the liberal and conservative factions within the Texas Democratic party, see McCleskey, *The Government and Politics of Texas*, 152–153.

28. Mauzy interview, 1967, 63–64. McCleskey, "The Lobby and the Legislative Process," in *The Government and Politics of Texas*, 160–175.

29. Mauzy interview, 1967, 67.

30. Schwartz interview, November 1967, 31.

31. Schwartz interview, 1967, 35.

32. "Lesson in South's Vote," *New York Times*, May 9, 1966. 19.

33. Schwartz interview, 1967, 21.

34. Mauzy interview, 1967, 31.

35. Mauzy interview, 1967, 8. "Now there were four particularly in the Senate who are fine members of the senate. They're very progressive minded, liberal people—Senator Harrington of Port Arthur, Senator Brooks of Harris County, Senator Jordan from Harris County and Senator Bernal from San Antonio. But their distrust and dislike of the governor is so intense that this tended to shade—I think it tended to shade and color their thinking."

36. Connally had publicly criticized federal civil rights legislation in 1963, spoke out against repealing the poll tax in 1963, and stayed silent on civil rights well into 1965. Joseph A. Loftus, "Liberal Democrats in Texas Embrace Johnson? Converts Rally to Old Enemy They Now Feel is 'Great'—Connally New Target," *New York Times*, March 23, 1965, 18. On the poll tax, see John Herbers, "Texans Get New Chance, in '66 to Repeal Poll Tax," *New York Times*, June 1, 1965, 22. In a speech to the League of Women Voters, Connally said that the repeal would lead to "bloc voting," and it failed.

37. "Labor Paper Says Connally Has Lost Control of Senate," *Dallas Morning News*, June 1, 1966. Jordan also had the endorsement of Texas COPE (Committee on Political Education), the political wing of the AFL-CIO, which supported Lyndon Johnson and embarked on voter registration efforts in East Texas after the repeal of the poll tax. "Texas Labor Set to Back Liberals," *New York Times*, February 27, 1966, 48.

38. Jordan interview, 1970.

39. Rogers, *Barbara Jordan: American Hero*, 140; Paul Burka, "The Truth about John Connally," *Texas Monthly* (November 1979), quotes Connally as saying on the night of King's assassination that the civil rights leader had "contributed much to the chaos, and the strife, and the confusion, and the uncertainty in this country" (https://www.texasmonthly .com/politics/the-truth-about-john-connally/, accessed November 21, 2023).

40. Barbara Jordan, "How I Got There: Staying Power," *Atlantic Monthly* (March 1975): 39.

41. Author's interview with Lauro Cruz, November 4, 2003, Austin, TX.

42. Mauzy interview, 1967, 72–73. "And I dislike . . . I disagree with Dorsey Hardeman very much politically and philosophically, but you've got to respect a man who knows his way around. . . . But I get along with Dorsey Hardeman, although I don't like him and don't agree with him, because he ain't never lied to me. Now the first time he does, he and I are going to have trouble." See also 1968 interview, 27.

43. Schwartz interview, November 1967.

44. Schwartz interview, 1967, 57. "If there's an area in which Dorsey Hardeman, for whatever his reasons might be, has been right in all of my times in the legislature, it's been on the issue of constitutional law as it applies to the trial of criminal cases in Texas. . . . He's pretty narrow minded. Schwartz interview, 1967, 57. "He recognized and rightfully recognized that the law of the land was the supreme court decisions. The Rangers violated every constitutional right of every citizen that they ever arrested in their history, as far as I can determine. Most local police forces violated every constitutional right a citizen had every time they arrested them, to say nothing of deputies and deputy sheriffs and deputy constables who never have been trained in the rights of individuals . . . nobody's ever told them what's illegal for an officer."

45. Jordan worked with Hardeman on the committees responsible for jurisprudence and state affairs. *Journal of the Senate*, 60th Legislature, 63–64.

46. Schwartz interview, 1967, 20.

47. Jordan interview, 1970, 61.

48. "Texas Poll Tax Is Held Invalid," *New York Times*, February10, 1966, 24. "Because the poll-tax paying system is the voter-registration system in Texas, a special session of the legislature maybe be required to set up a new registration system for the elections this year."

49. "Gov. Connally Asks Annual Registration of Voters in Texas," *New York Times*, February 15, 1966, 22. "Black Keeps Ban on Texas Poll Tax," *New York Times*, February 24, 1966, 22.

50. Details taken from "State Senator Barbara Jordan Newsletter," Austin, May 15, 1967. Jordan sent newsletters out to her constituents almost monthly. Newsletters also

advertised "rallies" for Senator Jordan for her Eleventh District block workers. Barbara Jordan Archives, Political Files, Texas Southern University.

51. Jordan, "How I Got There: Staying Power," 38–39. This was one of the earliest stories Jordan told about her political career and, according to Jordan, her sweetest legislative triumph. First appears in "Senator Jordan: Even as Little Girl She Was One of the Rare Ones," *Houston Chronicle*, November 30, 1969.

52. "Bill Patman, by the way this is not just my opinion . . . Bill Patman is the only man in the senate who does not have a single friend. I at least have one. He doesn't have any. No member of that senate will tell you privately that Bill Patman's word is any good, even though he votes right. Now he votes like I do most of the time, but he's gutless and he's not willing to do his homework." Mauzy interview, 1967, 29.

53. Mauzy interview, 1967, 47.

54. Mauzy interview, 1967, 85.

55. Mauzy interview, 1967, 47.

56. Mauzy interview, July 1968, 40.

57. Mauzy interview, 1967, 86.

58. Mauzy interview,1967, 79.

59. Schwartz interview, 1967, 70.

60. Mauzy interview, 1967, 48–49.

61. Jordan and Hearon, *Barbara Jordan: A Self-Portrait*, 142–143.

62. In 1966, Anne Appenzellar was executive director of the YWCA at the University of Texas at Austin. Born in 1923, she held a Master of Divinity from Yale University Divinity School. See https://www.findagrave.com/memorial/250102514/anna-buchanan -appenzellar, accessed December 1, 2023.

63. Jordan and Hearon, *Barbara Jordan: A Self-Portrait*, 144–145.

64. Jordan and Hearon, *Barbara Jordan: A Self-Portrait*, 144–145.

65. Founded in 1890, Keuka was the first college in the nation to require a "field program" of hands on, experiential learning each year from every student. On June 16, 1963, it awarded an honorary Doctorate of Humane Letters to Rev. Martin Luther King Jr. who spoke at the college commencement. See https://www.lifeinthefingerlakes.com/keuka -college/, accessed December 1, 2023.

66. *Keuka College Yearbook*, 1955, Keuka College Library, Keuka, New York.

67. She designed the house that she eventually shared with Barbara in an area of South Austin known as Onion Creek.

68. Letter from Nancy Earl to Shelby Hearon, March 2, 1978, Box 3, folder 18, Shelby Hearon Papers, Ransom Center, University of Texas at Austin.

69. Quoted in Barbara Smith and Jewelle Gomez, "Talking About It: Homophobia in the Black Community," *Feminist Review* 34 (Spring 1990): 47–55, 49.

70. Author's interview with Babe Schwartz, November 5, 2003, Austin, TX.

71. Smith and Gomez, "Talking About It," 52.

72. Author's interview with Sissy Farenthold, March 25, 2001, Austin, TX.

73. Author's interview with Babe Schwartz, November 5, 2003, Austin, TX.

74. Author's interview with Sissy Farenthold, March 25, 2001, Austin, TX.

75. Author's interview with Judge Andrew Jefferson, March 27, 2001, Houston, TX.

76. Jordan and Hearon, *Barbara Jordan: A Self-Portrait*, 125.

77. Ivins, "A Profile of Barbara Jordan."

78. Press release for week of April 21, 1967, Press Clippings, State Senate Papers, Barbara Jordan Archives, Texas Southern University.

79. Quoted in Claudia Rankine, *Citizen: An American Lyric* (Minneapolis: Graywolf Press, 2014).

80. Ivins, "A Profile of Barbara Jordan."

81. Ivins, "A Profile of Barbara Jordan."

82. Author's interview with Max Sherman and Bill Hobby, October 6, 2003, London, UK.

83. Erving Goffman, excerpts from *Stigma*, in *The Disability Studies Reader*, 5th ed., ed. Lennard J. Davis (New York: Routledge, 2017). Goffman theorized that in "mixed social situations," the stigmatized person "is likely to feel that to be present among 'normals' nakedly exposes him to invasions of privacy." And "I am suggesting then, that the stigmatized individual—at least a visibly stigmatized one—will have special reasons for feeling that mixed social situations make for anxious unanchored interaction" (142–143).

84. Rogers, *American Hero*, 132.

85. Ivins, "A Profile of Barbara Jordan," 13. Rogers, *Barbara Jordan: American Hero*, 140.

86. Jordan interview with Ronald E. Marcello, University of North Texas Oral History Collection, July 7, 1970, 45.

87. Mauzy interview, June 1969, 81–82.

88. Mauzy interview, June 1969, 18–19.

89. Mauzy interview, June 1969, 49–50.

90. Recording of Radio Communications, Texans for Tax Reform Committee, August 12 and August 13, 1969, AR 110, AFL-CIO Records (Series 28, box 6, tape 72), Labor Archives, Texas Christian University, Arlington, Texas. Even in this small clip, the contrast with Armstrong shows Jordan's technique of appealing to an audience. Jordan, using the personal "I" rather than "we," asks the audience to help her do the right thing. Rather than promising something to her listeners, she suggests they should get stirred up, or "aroused." Alliteration with the letter "P" gives the last sentence its punch.

91. Jordan interview, 1970, 42.

92. Jordan interview, 1970, 44.

93. All quotes from author's interview with Schwartz, November 3, 2003, Austin, TX.

94. "Senator Jordan Says Women Brainwashed," *Denton Record Chronicle*, March 8, 1970. Barbara Jordan Archives, Newspaper Clippings, January–June 1970, University of North Texas Libraries, The Portal to Texas History, https://texashistory.unt.edu; crediting Texas Southern University, accessed December 8, 2023.

95. Babe Schwartz interview, 1971.

96. Interview with Joe Christie, Charlie Wilson Oral History Project, 7: Christie identified as a liberal from El Paso who was elected in 1966 with Jordan and Mauzy. Jordan and Wilson remained friends after this incident, and both were elected to Congress the following year. https://www.sfasu.edu/heritagecenter/5369.asp, accessed December 9, 2023.

97. Rogers, American Hero, 157.

Chapter 8

1. "Ode to Black Womanhood," *Forward Times*, August 7, 1971.

2. W. W. Apple, "Texas Reapportionment May Bring South's First Black Congressman Since 1901," *New York Times*, June 13, 1971.

3. *Forward Times*, August 21, 1971.

4. For background on Graves, see Katy Vine, "The Agitator," *Texas Monthly* (August 2015).

5. On the makeup of draft boards, see *Houston Chronicle*, September 9, 1966. On textbooks, see *Texas Observer*, March 17, 1967, 6.; *Houston Chronicle*, March 23, 1967; *Houston Post*, March 12, 1969.

6. "Club Ejects Bob Casey Jr., Negro Guest," *Houston Chronicle*, May 4, 1967; "Club President Angry over Negro Ban Fuss," *Houston Chronicle*, May 5, 1967; Editorial, *Houston Chronicle,* May 9, 1967.

7. "Graves Asks Hearing on Police Brutality," *Houston Chronicle*, November 1971, contained in *Houston Chronicle* bio microfiche, Houston Metropolitan Research Center; *Houston Chronicle*, December 4, 1971; "Student Loans Setup Blasted," *Houston Chronicle*, March 18, 1971. See allegations of corruption in "Around the Rotunda," *Houston Chronicle*, March 21, 1971, and April 4, 1971; "Proposed Medicaid Cuts Blasted," *Houston Chronicle*, April 29, 1971; Anti–Vietnam War rally speech, *Houston Chronicle*, November 7, 1971.

8. *Texas Observer*, October 16, 1970; author's interview with Sissy Farenthold, March 25, 2001, Houston, TX.

9. Ben Barnes interview with author, April 12, 2004, Austin, TX.

10. *Texas Observer*, May 7, 1971, and author's interview with Sissy Farenthold, March 25, 2001.

11. Welch was vulnerable. The mayor "made a fortune in brokerage fees" during his four terms on the city council and as mayor. He appointed his real estate partner to the Houston housing authority, and in March 1969 Welch revealed $900,000 worth of land holdings, but this list omitted several key sites including his interest in land slated for a canal project costing eighty million dollars. The paper quoted architects who were strong-armed into contributing to Welch's campaign as a form of "insurance"; if they did not comply, they would get no work from the city. "Making Do in the Mayor's Office," *Texas Observer*, November 21, 1969.

12. "A Ho-Hum Race in Houston," *Texas Observer*, November 21, 1969. Jordan pointed out that Black mayors in northern cities, such as Carl Stokes in Cleveland, needed 90 percent of the Black vote. Houston had anywhere from ninety thousand to ninety-seven thousand Black voters, but without a strong effort, only thirty thousand would vote; in a strong campaign, maybe 40 percent.

13. "We need a man who can articulate for us our response to the future of Houston, and that man is Curtis Graves." *Houston Chronicle*, November 14, 1969.

14. "Houston Postmortem," *Texas Observer*, December 19, 1969, and December 5, 1969. On one hand, Graves was commended for stirring up a highly respectable voter turnout of 56.25 percent in the city's forty-five Black precincts. But he got only 36.5 percent of the Mexican American vote and only 12.51 percent of the vote in the largely white

working-class districts. Welch "walloped" Graves, 99,000 to 58,778. Graves clearly suffered from hubris. He failed to reach out to labor, and he failed to reach out sufficiently to Black voters. He was criticized by both the HCD and Jordan herself. Blacks were not inspired to vote for him. City fathers were scared that he came so close to Welch, but he did not come close enough to force a runoff.

15. "Senator Jordan: Even as Little Girl She Was One of the Rare Ones," *Houston Chronicle*, November 30, 1969: "After the 1970 census a new congressional district may be carved out of her senatorial district to give Harris County four U.S. representatives. Political experts say that Curtis Graves, a state legislator and unsuccessful candidate for mayor will seek the seat if the district is created."

16. *Forward Times*, September 4, 1971, 4c: "It was stupid for blacks to run against each other," said Randy Thomas.

17. "Black on Black for U.S. Congress," *Forward Times*, August 21, 1971.

18. *Forward Times*, September 4, 1971, 4c.

19. *Forward Times*, October 9, 1971. See also Rogers, *American Hero*, 158–159.

20. *Forward Times*, October 30, 1971.

21. *Forward Times*, October 30, 1971.

22. Rogers, *Barbara Jordan: American Hero*, 160–161, quoting Glen Castlebury, "Sen. Jordan's Chances for Congress Are Good," *Austin American Statesmen*, April 26, 1972.

23. Don Horn, interview with author, March 30, 2001, Houston, TX. See also Katy Vine, "The Agitator," *Texas Monthly* (August 2015). Graves called Jordan the "Aunt Jemima of politics."

24. "In Loco Paralysis at Prairie View A & M," *Texas Observer,* April 9, 1971.

25. "Prairie View A& M College," Recommended Special Catch-Up Appropriations, Appendix A, Report of the Committee Appointed Pursuant to Senate Resolution 679, Legislative Reference Library, Austin, Texas.

26. *Forward Times*, September 11, 1971, 5b.

27. *Forward Times*, October 9, 1971, 8b.

28. "It hasn't been once. It has been constant and incessant." *Forward Times*, October 9, 1971, 8b.

29. *Forward Times*, October 9, 1971, 8b: "I guess it's easy to understand that she had to do many things she didn't really want to do so she could get something accomplished," said one.

30. Jordan Deposition, Day 2, January 5, 1972. Cited in *Graves v. Barnes*, 343 F. Supp 704.

31. *Forward Times* picked up this incongruity. "While the Senator—a politically astute woman—abhors the way the redistricting board has drawn up the lines, she refuses to concede in her own mind that a black cannot get elected from the district." *Forward Times*, October 30, 1971.

32. *Forward Times*, October 30, 1971.

33. *Houston Post*, February 8, 1972.

34. "Graves Says Sen. Jordan's Campaign White Financed," *Houston Chronicle*, April 21, 1972.

35. According to the *Houston Chronicle*, April 26, 1972, "Miss Jordan reported receiving $3000 from the Texas AFL CIO, $3000 from the Texas Teamsters, $2000 from

a Teamsters local, and $750 from the United Auto Workers, with lesser amounts from the firefighters, the machinists, the lady garment workers, the meat cutters, the electrical workers, and the seafarers."

36. "They are incredibly hardworking," noted political scientist Richard Fenno, who spent three days with Jordan and her staff. "Alice and Cecile are in charge of campaign, though Al Wickliff is the putative campaign manager." "Memo Book, April 25–27, 1972," Box 12, Folder 1, Richard F. Fenno Jr. Papers, University of Rochester Special Collections, River Campus, Rochester, New York.

37. Both Wickliff and Reverend Lawson told the author to contact Cecile Harrison for details about the campaign.

38. Alice Kathryn Laine, "An in Depth Study of Black Political Leadership in Houston, Texas" (PhD diss., University of Texas at Austin, 1978), personal bio, 242. Cecile Harrison, "The Human Side of Black Political Experience" (PhD diss., University of Texas at Austin, 1977).

39. Cecile Harrison, interview with author, April 13, 2004, Houston, TX.

40. Cecile Harrison interview with author, April 13, 2004.

41. Memo from Garnet Guild to Lestine Lakes, Barbara Jordan Archives, Political Files Series, Campaign Activities, 1972, Texas Southern University.

42. Author's interview with Mrs. Myrtlene Hooey, Houston, TX, July 16, 2009.

43. Author's interview with Mrs. Myrtlene Hooey.

44. Author's interview with Mrs. Myrtlene Hooey.

45. Author's interview with Mrs. Myrtlene Hooey.

46. Author's interview with Don Horn.

47. HistoryMakers interview, John Peavy Jr., 2016. The Honorable John W. Peavy, Jr. (HistoryMakers A2016.130), interviewed by Larry Crowe, December 2, 2016, History-Makers Digital Archive. Session 1, tape 1, story 5, The Honorable John W. Peavy, Jr. describes his father's family background.

48. "Memo," Fenno Papers, Box 12, Folder 1.

49. Typed notice from A. W. Park and Willard Manuel to members, April 17, 1972, Barbara Jordan Archive, Political File Series, Campaign Activities, 1972.

50. "Teamsters Eject Rivals of Barbara Jordan," *Houston Chronicle*, April 16, 1972.

51. Typed notice from A. W. Park and Willard Manuel to members, April 17, 1972, Barbara Jordan Archive, Political File Series, Campaign Activities, 1972.

52. Richard Fenno Papers, University of Rochester Archives, Box 1, Folder 1, 1972.

53. See Rogers, *Barbara Jordan: American Hero*, 163 for endorsements and support from conservatives.

54. Richard Fenno, *Going Home: Black Representatives and Their Constituents* (Chicago: University of Chicago Press, 2003), 89–90.

55. Fenno, *Going Home*, 89.

56. Jordan's family was out on the street supporting her as well; her brother-in-law Benjamin Cresswell, a retired postal employee, went door to door and dutifully wrote down comments: "Yes, I am for Barbara." All quotes from the block worker surveys come from Barbara Jordan Papers, Political Files Series, Campaign Activities, 1972–1974.

57. Letter from Mrs. Ramsey to Barbara Jordan, May 2, 1972, Political Files Series, 1967–1972, Campaign Activities, 1972, Block Workers, Barbara Jordan Archive, Texas Southern.

58. All quotes from the block worker surveys come from Barbara Jordan Papers, Political Files Series, Campaign Activities, 1972–1974.

59. *Houston Informer*, April 29,1972.

60. *Houston Informer*, May 6, 1972.

61. "Cecile teaches at TSU; Alice at UH. They share a house. Lestine is BJ's long-time secretary. Garnet works for AFS [American Friends Service Committee] is old friend of BJ's and is LWV [League of Women Voters] type." Memo book, Fenno papers, University of Rochester.

62. Letter from Richard Fenno to Cecile Harrison, March 29, 2000, Fenno Papers, University of Rochester.

63. Richard Fenno, *Going Home*, 82.

64. "As my two dinners with academics indicate, white liberals need the black vote to elect sisy farenthold and their view of bj is that she is not cooperative because she's not running around advocating sissy farenthold. These people could care less about bj they are dependent on the black vote and they fear that BJS lukewarm support (and it is) will hurt Sissy at the polls. BJ has her own fish to fry." Richard Fenno Papers, Box 1, Folder 1, Interviews, 1972, Rush Rhees Library, University of Rochester.

65. Fenno, *Going Home*, 86.

66. Fenno, *Going Home*, 78.

67. Author's phone interview with Jake Johnson, April 19, 2004. His obituary is here. https://cemetery.tspb.texas.gov/pub/user_form.asp?pers_id=6657, accessed November 23, 2023.

68. "It Is Up to You," *Forward Times*, April 22, 1972. Harris County Democrats also endorsed both candidates.

69. "Barbara Jordan Runs Hard, Scared," *Houston Chronicle*, April 30, 1972.

70. "Barbara Jordan Runs Hard, Scared."

71. Fenno, *Going Home*, 94.

72. Author's interview with Harrison, 2003. Jordan spoke to beauticians often. According to Harrison, beauticians were "important for socializing the people about our candidate."

73. Author's interview with Harrison, 2003; Fenno, *Going Home*, 88.

74. Author's interview with Andrew Jefferson, March 27, 2001, Houston, TX.

75. *Forward Times*, May 13,1972.

76. *Forward Times*, May 13, 1972.

77. Quoted from the block worker surveys, Barbara Jordan Papers, Political Files Series, Campaign Activities, 1972–1974.

78. Molly Ivins, "She Sounded Like God," *New York Times Magazine*, December 29, 1996, 17.

79. Richard Fenno Papers, Box 1, Folder 1, Interviews, 1972; Fenno, *Going Home*, 92.

80. Babe Schwartz interview with author, 2003; Max Sherman interview with author, 2003, London UK; Schwartz interview, 1971, 11.

81. Fenno, *Going Home*, 80, 109–109, analyzed Jordan's relationship to Houston's oil and gas interests.

82. Author's interview with Billie Carr, March 29, 2001, Houston, TX.

83. Numan V. Bartley, *Southern Politics and the Second Reconstruction* (Baltimore, MD: Johns Hopkins University Press), 168–170.

84. Black voter support for Farenthold was unexpected, even among seasoned political analysts such as Molly Ivins, who did not mention Black Houston as a possible source of support for Farenthold. "She [Farenthold] seems to be in the grand old tradition of Texas kamikaze liberalism. . . . But at a time when the conservative Establishment has achieved a new nadir in public esteem it would seem that the liberal minority might be in a position to form a coalition with moderates and moderate conservatives." Molly Ivins, "The Melancholy Rebel," *Texas Observer*, April 9, 1971, 1–4.

85. Bass and DeVries, *The Transformation of Southern Politics*, p. 317. In the primary Black voters rejected anyone tainted by Frank Sharp: Ben Barnes came in third, with only 18 percent of the vote; and Governor Smith limped in at fourth place, receiving only 9 percent. For a summary of the Sharpstown Bank Scandal, see Bass and DeVries, *The Transformation of Southern Politics*, 314–319.

86. *Forward Times*, May 13, 1972.

Chapter 9

1. "Black Woman in Texas Is Governor for a Day," *New York Times*, June 11, 1972.

2. Ann Arnold, "Negro Woman Texas Governor for a Day," *Atlanta Daily World*, June 15, 1972. Audio of her speech, accompanied by a slide show is available online: https://www.youtube.com/watch?v=q48GcP8GJaw, accessed November 27, 2023. See documents showing detailed preparations for the day and more photos at https://www.tsu.edu/academics/library/pdf/governor-for-a-day-virtual-exhibit.pdf, accessed December 3, 2023.

3. Charlotte Phelan, "State Senator Barbara Jordan Wins Her Battles through the System," *Houston Post*, May 24, 1970.

4. Quotes from Jordan's speech taken from recording found online: https://www.youtube.com/watch?v=q48GcP8GJaw, accessed November 27, 2023.

5. Jordan and Hearon, *Barbara Jordan: A Self-Portrait*, 166–168. Pronounced "boog-uh-loo," bugaloo was a fast dance of African American and Latino origins performed by moving the body in short, quick movements; though associated with the moonwalk, it has many iterations, beginning with James Brown in 1964. It is difficult to know what the dance looked like in 1972.

6. 1 John 3.

7. Jordan and Hearon, *Barbara Jordan: A Self-Portrait*, 169–170. While Jordan went with her mother to the hospital, Nancy Earl and Anne Appenzellar remained at the hotel to help Jordan's out of town guests and call the funeral home in Houston.

8. Rogers, *Barbara Jordan: American Hero*, 168.

9. Jordan and Hearon, *Barbara Jordan: A Self-Portrait*, 167, 169, 171, 172.

10. Jordan and Hearon, *Barbara Jordan: A Self-Portrait*, 171.

11. Malcolm Boyd, "Where Is Barbara Jordan Today? *Parade Magazine*, February 16, 1986, 12, emphasis in original.

12. William H. Chafe, *Private Lives/Public Consequences, Personality and Politics in Modern America* (Cambridge: Harvard University Press, 2005); Meg Greenfield, *Washington* (Washington, DC: Public Affairs: 2002), especially chap. 2. For other motivations, including family backgrounds, existing role models, and competitive personality traits, see also Jerrold M. Post, *Dreams of Glory: Narcissism and Politics* (New York: Cambridge University Press, 2015); Joseph A. Schlessinger, *Political Parties and the Winning of Office* (Ann Arbor: University of Michigan Press, 1991); Richard L. Fox and Jennifer L. Lawless, "Explaining Nascent Political Ambition," *American Journal of Political Science* (July 2005): 642–659.

13. Rogers, *Barbara Jordan: American Hero.*

14. Molly Ivins, "A Profile of Barbara Jordan," *Texas Observer*, November 12, 1972.

15. Jordan and Hearon, *Barbara Jordan: A Self-Portrait*, 46–47.

16. Jordan and Hearon, *Barbara Jordan: A Self-Portrait*, 62.

17. Ivins, "A Profile of Barbara Jordan."

18. Greenfield, *Washington*, 30–31: "Washington also gets the teachers' pets, the most likely to succeed; the ones who got excellent grades; the ones who were especially good-looking in an old clothing ad way; the ones who got the chamber of commerce boy or girl of the year award; or the ones who figured out how to fake it and still make it—that whole range of smiling but empty-faced youth leaders who were universally admired, though no one could have told you for exactly what."

19. Ivins, "A Profile of Barbara Jordan."

20. Fenno Papers, Box 1, Folder 1, Interviews, 1972.

21. Shelby Hearon Papers, Box 3, Folder 14, "Outline II," Harry Ransom Center, Austin, TX.

22. These chapter drafts emphasize her father's disappointment at her lack of discipline and ambition when she first started TSU. Shelby Hearon Papers, Box 3, Folder 14, "Outline II," Harry Ransom Center, Austin, TX.

23. Greenfield, *Washington*, 110.

24. Rogers, *American Hero*, 144.

25. Phelan, *Houston Post*, May 24, 1970.

26. Phelan, *Houston Post*, May 24, 1970.

27. Barbara Jordan interview with Paul Duke, *Washington Straight Talk*, March 3, 1975, American Archive of Public Broadcasting, https://americanarchive.org/catalog/cpb-aacip-512-ms3jw87z64, accessed November 23, 2023.

28. Arthur Ashe interview with Lynn Redgrave, July 1992, https://www.youtube.com/watch?v=SxIAhA7J6Xo, accessed November 23, 2023.

29. Schlesinger, *Political Parties and the Winning of Office*, 34–35.

30. Billie Carr, interview with author, March 29, 2001, Houston, TX.

31. Anna Fels, *Necessary Dreams: Ambition in Women's Changing Lives* (New York: Random House, 2004), 5, 8–9.

32. "Yvonne Burke: Quiet California Legislator with a Subtle Touch," *Washington Post*, October 22, 1972, K3. See also Yvonne Brathwaite Burke (The Historymakers A2001.005), interviewed by Julieanna L. Richardson, July 23, 2001, the Historymakers Digital Archive.

33. See Amanda Turkel and Christine Conetta, "The Long, Hard Fight to Finally Get a Woman at the Top of the Ticket," *Huffington Post*, July 12, 2016, http://tinyletter .com/aterkel/letters/the-long-hard-fight-to-finally-get-a-woman-at-the-top-of-the-ticket, accessed November 23, 2023.

34. Ivins, "A Profile of Barbara Jordan."

35. Molly Ivins, "She's as Cozy as a Pile Driver," *Washington Post*, October 22, 1972, KI.

36. Ivins, "She's as Cozy as a Pile Driver," 1972.

37. R. Darcy and Charles D. Hadley, "Black Women in Politics: The Puzzle of Success," *Social Science Quarterly* 69 (September 1988): 29–45. See also Linda Faye Williams, "The Civil Rights–Black Power Legacy: Black Women Elected Officials at the Local, State, and National Levels," in *Sisters in the Struggle: African American Women in the Civil Rights–Black Power Movement*, ed. Bettye Collier-Thomas and V. P. Franklin (New York: New York University Press, 2001), 306–331. See also Pauline Terrelonge Stone, "Ambition Theory and the Black Politician," *Western Political Quarterly* 33 (March 1980): 94–107.

38. Nancy Baker Jones and Ruthe Winegarten, *Capitol Women: Texas Female Legislators, 1923–1999* (Austin: University of Texas Press, 2000).

39. *Texas Observer*, April 27, 1973.

40. See Stephan Lesher, "The Short, Unhappy Life of Black Presidential Politics, 1972," *New York Times*, June 25, 1972. Chisholm could not escape a detailed, unflattering description of her appearance. Lesher described Chisholm as "not beautiful. Her face is bony and angular, her nose wide and flat, her eyes small almost to beadiness, her neck and limbs scrawny. Her protruding teeth probably account in part for her noticeable lisp."

41. Jordan appeared on the panel. Her presentation focused on voter registration. She hoped that by the time of the presidential race in 1972, more than 37 million women— 15 million of them African American, and half of them young—would register as new Democrats. She also, however, stressed the importance of building coalitions with white voters, and warned of the detrimental political consequences to Black interests if whites fled the cities for the suburbs. "If these conservatives cannot be reached and brought around to reasonable thinking, Blacks can forget it," Jordan cautioned. Other panelists on Jordan's 1970s panel, including former mayor of Cleveland Carl Stokes, Chapel Hill mayor Howard Lee, and Manhattan borough president Percy Sutton, focused on city governance, the challenge of getting elected, and the obstacles to installing black citizens into local bureaucracies. All four politicians discussed how to widen black participation in voting, party participation, and governance. Ethel Payne, "Salons Talk to Black Politics in the 70s," *Chicago Defender*, December 6, 1971.

42. "Inside Story of Squabble in Black Caucus," *Chicago Defender*, November 22, 1971; and Ethel Payne, "Inside Dope at the Black Caucus Meet," *Chicago Defender*, November 27, 1971. For background on Chisholm, see Julie Gallagher, "Waging the Good Fight: The Political Career of Shirley Chisholm, 1953–1982," *Journal of African American History* 92, no. 3 (Summer 2007): 392–416. For an account of her early political career, see Shirley Chisholm,

Unbought and Unbossed (New York: Signet Press, 1970; expanded 40th anniversary ed., 2010), (), and Shirley Chisholm, *The Good Fight* (New York: Harper and Row, 1973). Latest biography is Anastasia C. Curwood, *Shirley Chisholm: Champion of Black Feminist Power Politics* (Chapel Hill: University of North Carolina Press, 2023).

43. Fenno, *Going Home*, 103.

Chapter 10

1. Roger Wilkins, "A Black at the Gridiron Dinner," *Washington Post*, May 26, 1970. For his background, see his *Eyes on the Prize* (EOTP) interview, October 17, 1988, http://digital .wustl.edu/cgi/t/text/text-idx?c=eop;cc=eop;rgn=main;view=text;idno=wil5427.0886.174, accessed November 24, 2023.

2. Wilkins interview, EOTP, question 15.

3. "Black Politics: New Way to Overcome," *Newsweek*, June 7, 1971, 30–39.

4. The crash of a United flight at Midway Airport killed African American Illinois congressman George Collins and black CBS correspondent Michelle Clark; as a result, Collins's widow, Cardiss Collins, took her husband's seat and joined Chisholm, Jordan, and Burke in Congress. Payne fails to mention that E. Howard Hunt's wife, who was carrying cash "hush money" to give to her husband and the other Watergate burglars, was also on the plane and died in the crash. Ethel Payne, "1972—A Reflection," *Chicago Defender*, January 6, 1973. Dave Carter, "Rep. Cardiss Collins Sworn in, Digs in," *Chicago Defender*, June 9, 1973.

5. The *New York Times* took note of Jordan's struggle to refute the charge that she had "sold out to downtown money." Paul Delaney, "Black Politicians Found to Disregard Plea for Unity," *New York Times*, June 11, 1972, 58.

6. Edward T. Clayton, *The Negro Politician: His Success and Failure* (Chicago: Johnson Publishing Company, 1964), 104.

7. Before Harold Washington, Alderman Anna R. Langford opposed the Daley machine in Chicago. She denounced Black Daley supporters for adhering to the party's interests while neglecting those of Black Chicagoans: "No matter how terrible conditions became in Chicago—the construction of concrete concentration camps known as public housing, the murder of a Black alderman, the notoriously open buying of votes and the unashamed stealing of votes at elections—there was always a Daley-controlled Black lackey to pass out political goodies to 'keep the natives quiet.'" Langford won her race for city alderman and represented one of the poorest areas of Chicago, Englewood, and the Sixteenth Ward. She lost in 1967, defeated by corruption and organizational inexperience. But she regrouped and won office in 1971. Anna R. Langford, "How I 'Whupped' the Tar out of the Daley Machine," in *What Black Politicians Are Saying*, ed. Nathan Wright Jr. (New York: Hawthorne Books, 1972), 5–30.

8. *Chicago Defender*, December 16, 1972.

9. The "club" system relegated women in the Democratic Party to fundraising and other menial tasks while preserving elected office and real party power as a male domain. Chisholm bucked machine politics by endorsing Republican John Lindsay for mayor. She was also known on the floor of the legislature in Albany as a politician who would not necessarily follow the line of the party whip but vote her conscience and the interests of

her constituents over that of the party. Chisholm, *Unbought and Unbossed*. Read more at: https://www.brainyquote.com/quotes/quotes/s/shirleychi158401.html, accessed November 24, 2023.

10. See "Black Politics: New Way to Overcome," *Newsweek*, June 7, 1971, 32 for a profile of Clay.

11. Ivins, "She's as Cozy as a Pile Driver," KI. See also Rogers, *American Hero*, 132–137 for a detailed description of Jordan's favorable relations with President Johnson.

12. Fenno, *Going Home*, 100–103, relates the story in Jordan's own words.

13. "National Hotline," *Chicago Defender*, August 5, 1972.

14. *Chicago Defender*, October 28, 1972.

15. *Chicago Defender*, November 2, 1972.

16. *Chicago Defender*, November 9, 1972.

17. Ethel Payne, "Black Politicians Remain in the Democratic Fold," *Chicago Defender*, November 9, 1972.

18. Jesse Jackson, "Country Preacher," *Chicago Defender*, November 11, 1972.

19. Rogers, *American Hero*, 176.

20. Author's interview with Mark Talisman, 2008.

21. Author's interview with Alan Steelman, August 18, 2010. Steelman also was liberally minded and inspired to run for office because of his love of General Eisenhower. He had worked as a low-level bureaucrat in the Nixon administration, but then quit and returned to Dallas to work in the Republican Party.

22. Author's interview with Steelman.

23. Author's interview with Steelman.

24. Ethel Payne, "First Days on the Hill, An Exciting Experience," *Chicago Defender*, January 13, 1973; "Sorors Welcome Sister to Congresswoman's Seat," *Chicago Defender*, February 3, 1973. "We are particularly proud of Barbara Jordan," said Mrs. Lilian P. Benbow, president of the sorority.

25. *Chicago Defender*, February 6, 1973; "South Scores Significant Political Gains," in *Baltimore Afro-American*, February 17, 1973.

26. "Jammed Gallery Cheers Caucus 'State of the Union,'" *Baltimore Afro-American*, February 10, 1973.

27. The conflict is further explained in John A. Lawrence, *The Class of '74: Congress after Watergate and the Roots of Partisanship* (Baltimore, MD: Johns Hopkins University Press, 2018), 42–43.

28. "Frosh Demos Plan Debate," *Baltimore Afro-American*, April 28, 1973; James Naughton, "Freshman House Democrats Fight Nixon Control," *New York Times*, April 12, 1973. Lawrence, *The Class of '74*, 42–43.

29. "Better Voter Turnout Could Change Complexion of '73 House Seats, Political Study Shows," *Baltimore Afro-American*, March 31, 1973.

30. All quotes in paragraph from "Jordan v Nixon: Welfare, OEO Cuts Scored," *Evening Star and the Washington News*, April 17, 1973.

31. Rena Pedersen, "Jordan Asks: Why are we Bombing Cambodia?" Houston Chronicle, May 3, 1973. [Scrapbook of Barbara Jordan's Activities, January–May 1973], book, 1973;

https://texashistory.unt.edu/ark:/67531/metapth611519/m1/1/?q=Barbara%20jordan %20and%20nancy%20earl, accessed December 3, 2023, University of North Texas Libraries, The Portal to Texas History, https://texashistory.unt.edu; crediting Texas Southern University.

32. "Democratic National Committee Includes 36 Minority Members," *Baltimore Afro-American*, April 14, 1973.

33. Fenno, *Coming Home*, 102 describes Jordan's chagrin at the DSG rules. "These great advocates of opening up the system wouldn't let one freshman sit on their executive committee. I thought that was very revealing." The CBC, she told Fenno "was just as bad."

34. "Congresswoman Honored at Watergate," *Baltimore Afro-American*, May 26, 1973; "The Washington Scene," *Jet Magazine*, May 17, 1973, 38.

35. "Trade Union Chiefs Meet," *Baltimore Afro-American*, June 9, 1973. "UAW Civil Rights Confab Set," *Chicago Defender*, June 13, 1973.

36. "Poor Peoples Legal Bill Watered Down," *Wichita Times*, June 28, 1973.

37. "Gibson Says Federal Cutbacks Hurting Cities," *Baltimore Afro-American*, July 7, 1973.

38. "Representative Jordan Decries the Nation's Paralysis," *Forward Times*, June 30, 1973, [Barbara Jordan Scrapbook, May–October, 1973], book, 1973; https://texashistory .unt.edu/ark:/67531/metapth616548/, accessed December 3, 2023, University of North Texas Libraries, The Portal to Texas History, https://texashistory.unt.edu; crediting Texas Southern University.

39. "Four Congresswoman Charge U.S. Derelict," *Chicago Defender*, July 14, 1973; "Congresswomen Ask Sterilization Study," *Baltimore Afro-American*, July 21, 1973.

40. "Letter to the Hon. Caspar Weinberger" and "Joint Press Release," 1973, of congresswomen Yvonne Brathwaite Burke, Shirley Chisholm, Cardiss Collins, and Barbara Jordan, Papers of the Leadership Conference on Civil Rights, Government Agencies, Congressional Black Caucus, National Strategy Session, Part 2, Box 88, Folder 2, Library of Congress.

41. "USS Doris Miller Goes to Sea after Commissioning Ceremony," *Baltimore Afro-American*, July 14, 1973.

42. Angela Terrell, "Sticking Together," *Washington Post*, February 23, 1973.

43. The organization was located on Connecticut Avenue in Washington, DC. See a description of the 1973 Annual Report: https://lcdl.library.cofc.edu/lcdl/catalog/lcdl:90110, accessed December 3, 2023.

44. Fenno, *Going Home*, 110.

45. *Chicago Defender*, July 23, 1973; Photo spread, "63rd Urban League Parley Draws 5,000," *Chicago Defender*, August 8, 1973.

46. "Women Criticize Black Caucus Men," *New York Times*, July 29, 1973, 23.

47. Lillian Wiggins, "Women in Politics at UL Convention," *Baltimore Afro-American*, August 4, 1973, 5. "I don't want to be carried out on a stretcher," Chisholm said.

48. *New York Times*, July 29, 1973, 23.

49. Wiggins, *Baltimore Afro-American*, August 4, 1973, 5.

50. *New York Times*, July 29, 1973, 23.

51. Wiggins, *Baltimore Afro-American*, August 4, 1973, 5.

52. Louis Fitzgerald, "An Affair to Remember," *Chicago Defender*, August 6, 1973.

53. Ethel Payne, "A Shift in Scenery," *Chicago Defender*, August 11, 1973.

54. *Chicago Defender*, August 7, 1973.

55. *Chicago Defender*, August 8, 1973.

56. *Baltimore Afro-American*, August 4, 1973.

57. "US Sec'y Rogers Cites NCNW Victory at Regal Celebration," *Chicago Defender*, July 28, 1973; "Bethune Memorial Unveiled as 98th Birthday Observed," *Baltimore Afro-American*, July 21, 1973.

58. "Deltas Open Convention," *Chicago Defender*, August 13, 1973.

59. Letter from Barbara Jordan, February 15, 1972, Texas State Senate, Personal File Series, Correspondences, 1971–1972, Barbara Jordan Archives, Texas Southern University, Houston, Texas.

60. Toni Morrison, "What the Black Woman Thinks about Women's Lib," *New York Times*, August 22, 1971.

61. Shirley Chisholm, "Coalitions: The Politics of the Future," in *What Black Politicians Are Saying*, ed. Nathan Wright Jr., (New York: Hawthorn Books, 1972), 92.

62. Morrison, "What the Black Woman Thinks about Women's Lib."

63. Rogers, *Barbara Jordan: American Hero*, 189. Jordan cosponsored the bill with Democrat Martha Griffiths of Michigan.

64. All quotes from the author's interview with Louis Stokes, Washington, DC, May 2, 2008.

65. Author's interview with Louis Stokes, Washington, DC, May 2, 2008.

66. Amiri Baraka interview, question 32, EOTP interview.

67. Author's interview with Louis Stokes, Washington, DC, May 2, 2008.

68. "Statement of Chairman, Congressman Louis Stokes," July 31, 1973, Box I 88, Folder 9, Papers of the Leadership Conference on Civil Rights, Library of Congress, Washington, DC.

69. Quoted in Fenno, *Going Home*, 108.

70. *Chicago Defender*, September 17, 1973, 4.

71. For a succinct overview of Rayburn's famous quotes and philosophy of political leadership see Ray Hill, "Mr Speaker: Sam Rayburn of Texas," *The Knoxville Focus*, November 16, 2014. https://www.knoxfocus.com/archives/mr-speaker-sam-rayburn-texas/, accessed December 5, 2023.

72. *Wall Street Journal*, October 23, 1973.

73. "The New Black Pragmatism," *Wall Street Journal*, May 23, 1974.

74. Author's interview with Mark Talisman, January 9, 2008, Washington, DC. Mary Beth Rogers, *American Hero*, 252.

75. Author's telephone interview with Rufus "Bud" Myers, May 19, 2017.

76. O'Neill, Dev. [Barbara Jordan, Nancy Earl, and Two Unidentified Gentlemen], photograph, 1973~; https://texashistory.unt.edu/ark:/67531/metapth843484/m1/1/?q=nancy%20earl, accessed December 5, 2023, University of North Texas Libraries, The Portal to Texas History, https://texashistory.unt.edu; crediting Texas Southern University. See also O'Neill,

Dev. [Attendees of the Parliamentary Conference Walk Down the Street], photograph, 1974~; https://texashistory.unt.edu/ark:/67531/metapth843161/m1/1/?q=nancy%20earl, accessed December 5, 2023, University of North Texas Libraries, The Portal to Texas History, https://texashistory.unt.edu; crediting Texas Southern University.

Chapter 11

1. See his obituary. Adam Clymer, "Frank Wills, 52; Watchman Foiled Watergate Break-in," *New York Times*, September 29, 2000.

2. "Hero of Watergate Scandal Here," *Chicago Defender*, June 9, 1973.

3. *Chicago Defender*, October 4, 1973.

4. *Chicago Defender*, September 25, 1974.

5. *Chicago Defender*, March 17, 1975.

6. Gil Scott-Heron, "H20 Gate Blues," track 8, *Winter in America*, recorded September–October 1973, Strata-East Records, 1974, album.

7. Anthony Lewis, "The Glorious Revolution," *New York Times*, July 21, 1975.

8. "Possible Impeachment of the President," Statement from the Office of Rep. Barbara Jordan, October 23, 1973, Rice University Archives, Billie Carr Papers, Series II, Box 4, Folder 4.12.

9. Edward Mezvinsky, with Kevin McCormally and John Greenya, *A Term to Remember* (New York: Coward, McCann, & Geoghegan, 1977), 57. Mezvinsky served with Jordan on the Judiciary Committee and published a memoir of the impeachment process. "Whether it was Barbara Jordan of Texas, Gerry Studds of Massachusetts . . . the assessment of the general mood on Watergate was the same I brought back from Iowa."

10. Nomination of Gerald R. Ford to be Vice President of the United States, Day 1, Hearings Before the Committee on the Judiciary, 93rd Cong. 1st Session, serial no. 16, Testimony of Gerald Ford under questioning by Barbara Jordan, 54.

11. Nomination of Gerald R. Ford to be Vice President of the United States, Day 2, Hearings Before the Committee on the Judiciary, 93rd Cong. 1st Session, serial no. 16, Testimony of Gerald Ford under questioning by Barbara Jordan, 149–152.

12. Nomination of Gerald R. Ford to be Vice President of the United States, Day 2, Hearings Before the Committee on the Judiciary, 93rd Cong. 1st Session, serial no. 16, Testimony of Gerald Ford under questioning by Barbara Jordan, 152. Jordan asked Ford, "Now, I understand your philosophy of Government emphasizes State action, State and local viability. But sometimes, the State and local governments do not become actors on behalf of the citizenry. Do you believe the Government of the United States has any responsibility or any obligation to activate, to motivate, to create efforts on behalf of citizens who are dispossessed repressed or discriminated against?" Ford replied, "I would hope that the local or State governments would do it in the first instance, but I can see where, if there is negligence, disdain, repression, deliberate, that yes, the Federal Government ought to move and try to be helpful."

13. "Black Solons Espied," *Texas Observer*, February 26, 1971; "Jordan, Graves Spied On," *Forward Times*, January 11, 1975. "Graves Says He Has Lost Faith in America—Blames Snooping," *Houston Chronicle*, February 25, 1971.

14. Quoted in "Graves Says He Has Lost Faith in America."

15. Senator Sam Ervin, *Trial Magazine* (March–April 1971), quoted in Draft Speech, "In Defense of Rights" (1973), Barbara Jordan Papers, Texas Southern University.

16. See https://www.medicalnewstoday.com/articles/260150.php, accessed November 24, 2023. Christina Crosby, *A Body Undone: Living on after Great Pain* (New York: New York University Press), 74–75; Barbara Webster, *All of a Piece: A Life with Multiple Sclerosis* (Baltimore, MD: Johns Hopkins University Press, 1989).

17. "Multiple Sclerosis," *British Medical Journal*, February 27, 1977, 531.

18. Dr. Renaud Du Pasquier, "Multiple Sclerosis: The Missing Link," https://www.youtube.com/watch?v=Re8nFuSTh-0, accessed November 24, 2023.

19. Rogers, *Barbara Jordan: American Hero*, 198–202.

20. "Acre Homes Political Icon Beulah Shepard Dies," *Houston Chronicle*, September 12, 2010.

21. Correspondence in "Personal Friends," and "Hospital Stay, December 1973," Barbara Jordan Archive, Texas Southern University.

22. Mezvinsky recalled his Iowan constituents' response to the gap and their concern over Nixon committing tax fraud. Mezvinsky, *A Term to Remember*, 81.

23. Transcript of "A Question of Impeachment," *Bill Moyers Journal*, January 22, 1974, in Papers of J. Anthony Lukas, University Archives, University of Madison, Wisconsin.

24. Mezvinsky, *A Term to Remember*, 92–93.

25. Stanley Kutler, *The Wars of Watergate* (New York: Knopf, 1990), 440. See also congressional biography of Celler, https://bioguideretro.congress.gov/Home/MemberDetails?memIndex=c000264, accessed November 24, 2023. For an analysis of how Celler ran his committee, see the Ralph Nader Congress Project, Peter H. Schuck, Director, *The Judiciary Committees: A Study of the House and Senate Judiciary Committees* (New York: Grossman, 1975). Celler was chair from 1949 to 1973, except for a two-year interregnum from 1953 to 1955. Under Celler, subcommittee chairs in the House Judiciary Committee did not have titles—subcommittees were numbered, not named—or substantial budgets. Celler made sure his own committees received the lion's share of assignments.

26. "The Man with the Judicious Gavel," *Time*, August 5, 1974.

27. *Rolling Stone*, March 28, 1974.

28. One popular text at the time was Michael Lcs Benedict's *The Impeachment and Trial of Andrew Johnson* (New York: W.W. Norton, 1973).

29. Jordan interview in the *Christian Science Monitor*, March 18, 1974.

30. Mezvinsky, *A Term to Remember*, 106.

31. Mezvinsky, *A Term to Remember*, 122–123.

32. *Rolling Stone*, March 28, 1974, 44.

33. "Commencement Speech, Howard University, May 11, 1974," in *Barbara Jordan: Speaking the Truth with Eloquent Thunder*, ed. Max Sherman (Austin: University of Texas Press, 2007).

34. "Commencement Speech, Howard University, May 11, 1974," in *Barbara Jordan: Speaking the Truth with Eloquent Thunder*, ed. Max Sherman (Austin: University of Texas Press, 2007), 15.

35. According to the *Washington Post*, the only speech to draw cheers and fist salutes from the students was that given by Benita Washington, a graduating senior, who praised President James A. Cheek of Howard University as a "black Cesar." "While at Howard," said Cress, "our minds were molded by the Cress theory of color confrontation," she said. The Cress theory, formulated by Howard psychiatrist Dr. Samuel Welsing, held that Blacks were genetically superior to whites because "white skin itself was a genetic defect." *Washington Post*, May 12, 1974.

36. Letter from Nancy Earl to Carol Gray, senior class president, Keuka College, December 20, 1973, Keuka College Archive, Keuka, New York. The folder of material on Barbara Jordan's visit includes correspondence between Jordan and G. Wayne Glick, president of the college, dated July 15, 1974, and the seating arrangements for the graduation lunch.

37. "Transcript of Opening Public Session of House Panel's Hearing on Impeachment," *New York Times*, May 10, 1974, 16.

38. Mezvinsky, *A Term to Remember*, 135, 136.

39. Mezvinsky, *A Term to Remember*, 138.

40. Mezvinsky, *A Term to Remember*, 139.

41. R. W. Apple, "Voices of New South Emerge at Hearing," *New York Times*, July 26, 1974.

42. Mezvinsky, *A Term to Remember*, 148.

43. Mezvinsky, *A Term to Remember*, 152.

44. Mezvinsky stated: "I thought Jordan was right. We had to proceed with great caution and certainly with 'clean hands.' A bill of impeachment would have a tremendous impact on the nation and we should not be accused of having used thumbscrew politics to get it out." Mezvinsky, *A Term to Remember*, 157. Rangel could not believe that an Italian American on the committee would want to keep Nixon's racist slurs from the public. He approached the case as a prosecutor: "I was focused on what I saw as a clear path to his conviction. Barbara Jordan saw something larger and we are all the better for her vision." Charles Rangel, with Leon Wynter, *And I Haven't Had a Bad Day Since: From the Streets of Harlem to the Halls of Congress* (New York: St. Martin's Press, 2007), 193–194.

45. *Atlanta Daily World*, May 16, 1974. The Black newspaper lauded Jordan for her "reasonable" attitude toward impeachment and contrasted her with Charles Rangel.

46. Author's interview with Bob Alcock, September 14, 2003, Washington, DC.

47. *CBS Evening News for Wednesday, May 29, 1974*, House Judiciary Committee/ Impeachment Hearings #234591, Vanderbilt Television News Archive, https://tvnews .vanderbilt.edu/broadcasts/234591, accessed December 3, 2023.

48. Kutler, *The Wars of Watergate*, 490. Kutler cites interviews given by Walter Flowers, June 17, 1975, and Ray Thornton, June 13, 1975 (677, n. 36). For Rodino's statement, see *Washington Post*, June 29, 1974, and *Los Angeles Times*, June 28, 1974.

49. Walter Shapiro, "What Does This Woman Want? Is Barbara Jordan Really Worth All the Fuss?" *Texas Monthly* (October 1976), refers to an interview with Walter Flowers.

50. Doar had still not presented a theory of the case, and the thousands of pages of evidence were still not scheduled to be released to the public. *New York Times*, July 3, 1974.

51. *New York Times*, July 4, 1974.

52. "Witness Tells Rodino's Unit of Hunt's Money Demand," *New York Times*, July 4, 1974.

53. Author's interview with Alcock.

54. It was difficult to condemn Doar's findings as partisan, as they were shared by his Republican-appointed legal counsel on the committee, Albert Jenner. *Time*, July 29, 1974; *NBC Evening News for Friday, July 19, 1974*, House Judiciary Committee/Impeachment/ Doar #477808, Vanderbilt Television Archive, https://tvnews.vanderbilt.edu/broadcasts /477808, accessed December 3, 2023; J. Anthony Lukas, *Nightmare: The Underside of the Nixon Years* (New York: Viking, 1973, 1976), 513.

55. Lukas, *Nightmare*, 528–530.

56. Patrick J. McGeever, "'Guilty Yes, Impeachment No,' Some Empirical Findings," *Political Science Quarterly* 89, no. 2 (June 1974): 289–299; and Gerald B. Finch, "A Comment on Guilty Yes, Impeachment No," *Political Science Quarterly* 89, no. 2 (June 1974): 301–304.

57. Author's interview with Bob Alcock.

58. Lukas, *Nightmare*, 530–531.

59. All quotes from author's interview with Bob Alcock.

60. Author's interview with Bob Alcock.

61. All references from Jordan's speech are taken from both the printed transcript of the delivered speech on July 24, 1974, https://millercenter.org/the-presidency/impeachment /my-faith-constitution-whole-it-complete-it-total, accessed November 30, 2023, and from the draft of the speech she used that evening to make her remarks. The draft has the beginning and the end typed up, but the middle section contains various quotes and the chart created by Bob Alcock. "Original text of Jordan speech before the Judiciary Committee," Barbara Jordan Archives, Texas Southern University, Houston, TX.

62. George A. Kennedy, *Aristotle on Rhetoric: A Theory of Civic Discourse* (New York: Oxford University Press, 1991), 38, and Aristotle, *The Rhetoric*, trans. W. Rhys Roberts (New York: Random House, 1954), 24–25. Scholar George A. Kennedy wrote: "And in *Rhetoric*, Aristotle wrote that 'Persuasion is achieved by the speaker's personal character' or credibility which has to be established at the beginning of the address. And the listener, according to *Rhetoric*, 'decides on a speaker's personal credibility based on what they hear, rather than upon any previous knowledge of the speaker.'" Cited in Linda Diane Horowitz, "Transforming Appearance into Rhetorical Argument: Rhetorical Criticism of Public Speeches of Barbara Jordan, Lucy Parsons, and Angela Y. Davis" (PhD diss., Northwestern University, 1998), 3–4.

63. The rhetorical term is *anamnesis*, which means citing a past author or document from memory; the practice conveys the idea that the speaker is knowledgeable of the received wisdom from the past, and thus establishes her authority or her *ethos*. See http:// rhetoric.byu.edu/Figures/A/anamnesis.htm, accessed November 24, 2023. See also Kennedy, *Aristotle on Rhetoric*, 38, and Aristotle, *The Rhetoric*, 24–25.

64. Examples of synonymia can be found in Shakespeare, "How weary, flat, stale, and unprofitable/ seem to me all the uses of this world" (*Hamlet*, 1, 2, 133) and in the Bible, "Deliver me O Lord from lying lips, from a deceitful tongue" (Psalm 120:2).

65. Her authority to speak existed "not in spite of the fact that she was a black woman, but *because* she was a black woman." Horowitz, "Transforming Appearance into Rhetorical

Argument," 3–4, italics in original. Horowitz makes this point about the 1976 convention speech, 52–53.

66. Rogers, *Barbara Jordan: American Hero*, 219–226, summarizes the committee's vote and reactions to Jordan's speech. See also Letter from Gordon Baxter to the *Houston Post*, August 17, 1974, [Scrapbook of Barbara Jordan's Activities, August 1974–May 1975], book, 1974~/1975; https://texashistory.unt.edu/ark:/67531/metapth616557/m1/20/, accessed November 25, 2023, University of North Texas Libraries, The Portal to Texas History, https://texashistory.unt.edu; crediting Texas Southern University.

67. Jordan and Hearon, *Barbara Jordan: A Self-Portrait*, 182.

68. Rogers, *Barbara Jordan: American Hero*, 219–226, summarizes the committee's vote and reactions to Jordan's speech. "The Vote to Impeach," *Time Magazine*, August 5, 1974.

69. "Probe Termination Relief to Jordan," *Houston Post*, August 1, 1974. Scrapbook of Barbara Jordan's Activities, August 1974–May 1975], book, 1974~/1975~; https://texashistory .unt.edu/ark:/67531/metapth616557/m1/1/, accessed November 25, 2023, University of North Texas Libraries, The Portal to Texas History, https://texashistory.unt.edu; crediting Texas Southern University.

70. Mezvinsky, *A Term to Remember*, 213, 217.

71. *Cleveland Call and Post*, August 10, 1974. "Barbara Belts Nixon," *Chicago Defender*, July 29, 1974.

72. *Chicago Defender*, April 26, 1975.

73. Hazel Garland, *Pittsburgh Courier*, August 10, 1974.

Chapter 12

1. For an analysis of the role of seniority and committee chairs in controlling reform and the pace of legislation in 1972, during the Ninety-second Congress, just before Jordan became a committee member, see Peter H. Schuck (The Ralph Nader Congress Project), *The Judiciary Committees: A Study of the House and Senate Judiciary Committees* (New York: Grossman Publishers, 1975).

2. Ari Berman, *Give Us the Ballot: The Modern Struggle for Voting Rights in America* (New York: Picador, 2015), 112, quoting Mary Beth Rogers.

3. Berman, *Give Us the Ballot*, 110.

4. *South Carolina v. Katzenbach* (1966).

5. *New York Times*, March 12, 1970, 40; see also "Lindsay Opposes Extension of Voting Rights Here," *New York Times*, March 11, 1970, 21, and *New York Times*, June 18, 1970.

6. Quoted in Steven Lawson, *In Pursuit of Power: Southern Blacks and Electoral Politics, 1865–1982* (New York: Columbia University Press), 225.

7. Lawson, *In Pursuit of Power*, 226.

8. "Next Round in Texas Dem Control Fight Comes Saturday," *Houston Chronicle*, May 10, 1974, 24.

9. For a lively portrait of Strauss, see Myra MacPherson, "Mr. Chairman: The Texas Touch of Bob Strauss: Caressing and Cajoling, Rousing and Regrouping, Bullying and Billing the Democrats," *Washington Post*, January 5, 1975.

10. David S. Broder, "Democrats Squabbling over Committee Makeup," *Washington Post*, August 16, 1974, 13; "Rift Ends Charter Session: Pro-Reform Democrats Walk Out,"

Washington Post, August 19, 1974, 1; "Discord among the Democrats," *Washington Post*, August 21, 1974; and "Democratic Chiefs Predict End of Rift over Charter," *Washington Post*, September 12, 1974.

11. David S. Broder, "Democrats Pass Rules to Slow Controversy," *Washington Post*, October 19, 1974.

12. Jordan and Hearon, *Barbara Jordan: A Self-Portrait*, 201–202.

13. See, most recently, John A. Lawrence, *The Class of '74: Congress after Watergate and the Roots of Partisanship* (Baltimore, MD: Johns Hopkins University Press, 2018).

14. Author's interview with Alcock, September 14, 2003, Washington, DC.

15. See, most recently, Krochmal, *Blue Texas.*

16. "Testimony of Nelson Rockefeller," Friday, November 22, 1974, Nomination of Nelson A. Rockefeller to Be Vice President of the United States, House of Representatives, Committee on the Judiciary, 171.

17. Nomination of Nelson A. Rockefeller to Be Vice President of the United States, Hearings, House of Representatives, Committee on the Judiciary. Jordan questioned the governor on November 22, 1974(168–171, 240–242); and December 5, 1974 (1010–1012).

18. Nomination of Nelson A. Rockefeller to Be Vice President of the United States, Hearings, House of Representatives, Committee on the Judiciary, testimony of Arthur O. Eve, December 4, 1974, 343–345.

19. "Rockefeller Wins House Unit Vote 26–12; Full Clearance Next Week Seen Certain," *Wall Street Journal*, December 13, 1974.

20. *New Pittsburgh Courier*, December 14, 1974.

21. "Minorities Win Significant Victory at Mini-Convention," *New Pittsburgh Courier*, December 14, 1974.

22. David Nyhan, "Democrats Demand Economic Controls," *Boston Globe*, December 7, 1974, 1; David S. Broder, "Crisis Plan Pledged," *Washington Post*, December 7, 1974.

23. "Convention Ends with Unity Theme," *Boston Globe*, December 9, 1974. David S. Broder, "Democrats Adopt Their First Charter," *Washington Post*, December 8, 1974.

24. David S. Broder, "Discipline among the Democrats," *Washington Post*, December 11, 1974.

25. Arnold B. Sawislak, "Barbara Jordan Ms. Charisma?" (UPI), *Dallas Times Herald*, December 17, 1974.

26. In 1970, Jordan had played a similar unifying role at an extremely contentious Democratic Party gathering in Texas. She sided with liberals who refused to accept a white conservative, Ben Ramsey, as party chair. As part of a compromise, Jordan became permanent secretary of the party, the first time a Black Democrat had been appointed to state party leadership position, an event she stated was "long overdue." "She then preached party harmony, calling the Democratic party the best for progress." Felton West, "Democratic Platform Called Most Liberal," *Houston Post*, September 16, 1970. [Barbara Jordan Scrapbook, July–October, 1970], book, July 1970; https://texashistory.unt.edu/ark:/67531/metapth616618/m1/43/?q=nancy%20earl, accessed November 28, 2023, University of North Texas Libraries, The Portal to Texas History, https://texashistory.unt.edu; crediting Texas Southern University.

27. Vernon Jarrett, "Reality Tempers Black Euphoria," *Chicago Tribune*, December 11, 1974.

28. Jarrett, "Reality Tempers Black Euphoria."

29. Jules Witcover and David S. Broder, "Labor Chiefs May Resign DNC Posts," *Washington Post*, December 14, 1974.

30. "Congress Is Urged to Save Vote Act: But Justice Department Seeks no Extension of Rights Law in North," *New York Times*, January 11, 1975, 60.

31. "Inclusion of Latins Urged for Voting Act," *Washington Post*, January 24, 1975, 9.

32. *The Voting Rights Act: Ten Years After—A Report of the United States Commission on Civil Rights* (Washington, DC: The Commission on Civil Rights, 1975), 349.

33. *The Voting Rights Act: Ten Years After—A Report of the United States Commission on Civil Rights* (Washington DC: The Commission on Civil Rights, 1975), 103, 146.

34. "Inclusion of Latins Urged for Voting Act," *Washington Post*, January 24, 1975.

35. "Panel Asks for Ten-year Extension of 1965 Act for Voting Rights," *New York Times*, January 24, 1975.

36. "Statement of Commissioner Frankie M. Freeman," in *The Voting Rights Act: Ten Years After—A Report of the United States Commission on Civil Rights* (Washington, DC: The Commission on Civil Rights, 1975), 357–359.

37. *New Pittsburgh Courier*, January 18, 1975; *Call and Post*, January 25, 1975.

38. Vernon Jarrett, "Five Vacant Seats Trigger a Shock," *Chicago Defender*, January 19, 1975.

39. Ethel Payne, "Irresponsibility," *New Pittsburgh Courier*, February 8, 1975.

40. "Political Disaster for Blacks Averted by Hatcher at Democrats' Meeting," *New Pittsburgh Courier*, January 18, 1975.

41. John W. Lewis Jr, "Black Dems Lose Fight for Fairplay in Party," *New Pittsburgh Courier*, February 8, 1975, and Vernon Jarrett, "The Fight over Three Little Words," *Chicago Tribune*, January 26, 1975.

42. John W. Lewis Jr, "White Democrats Reject Effort by Blacks to Eliminate Racism," *Call and Post*, February 8, 1975.

43. John Pierson, "Barbara Jordan's Star Reaches Dizzy Heights for House Sophomore: She Speaks out to Promote Principles—and Herself; A Future Vice President? Singing the Praises of a Byrd," *Wall Street Journal*, February 6, 1975.

44. *Wall Street Journal*, February 6, 1975.

45. Testimony of Hon. Barbara Jordan, Hearings before the Subcommittee on Civil and Constitutional Rights of the Committee on the Judiciary, House of Representatives (94th Congress, First Session), on Extension of the Voting Rights Act, Serial No. 1, Part 1, 79. The *CQ Almanac* online also has a detailed history of the extension hearings: https://library.cqpress.com/cqalmanac/document.php?id=cqal75-1214971, accessed November 24, 2023.

46. Jordan solicited and gathered letters and accounts of such incidents from Texas residents and activists. Voting Rights Act, Barbara Jordan Archive, Texas Southern University.

47. Testimony of Hon. Barbara Jordan, Hearings before the Subcommittee on Civil and Constitutional Rights of the Committee on the Judiciary, House of Representatives (94th Congress, First Session), on Extension of the Voting Rights Act, Serial No. 1, Part 1, 81.

48. Alfreda L. Madison, "Your Voting Rights," *Norfolk Journal and Guide*, March 22, 1975.

49. Madison, "Your Voting Rights."

50. "Hispanics Backed on Voting Rights," *Washington Post*, March 6, 1975, 2.

51. "Vote Rights Expansion Faces Fight," *Washington Post*, March 9, 1975.

52. William Raspberry, "We Still Need the Voting Rights Act," *Washington Post*, March 10, 1975.

53. Raspberry, "We Still Need the Voting Rights Act"; and "Expanding the Voting Rights Act," *Washington Post*, March 21, 1975. The second article quotes more from Al Perez, the lead lawyer for MALDEF (Mexican American Legal Defense and Education Fund), but still sides with Mitchell.

54. "Mexican Americans Charge Subtle Voting Discrimination," *Washington Post*, March 30, 1975.

55. Alfreda L. Madison, "Your Voting Rights," *Norfolk Journal and Guide*, March 22, 1975; "Expanding the Right to Vote," *Washington Post*, April 5, 1975.

56. "Voting Protection Backed for Spanish Americans," *Washington Post*, April 9, 1975, and "Rights Unit Backs Wider Voting Act," *New York Times*, April 10, 1975.

57. Paul Duke, interview with Barbara Jordan, *Washington Straight Talk*, March 24, 1975, American Archive of Public Broadcasting, https://americanarchive.org/catalog/cpb -aacip-512-ms3jw87z64, accessed November 19, 2023. "Because there is a basic dispute here about how you extend this act whether you have a simple extension, which would continue to make the law applicable to blacks only, or whether you would prevent the law to embrace Mexican Americans and other minorities. . . . There is this controversy, this underlying conflict. It's not that the civil rights leaders don't want brown people, Mexican American people included, it is they don't want to jeopardize the possible extension of the act by an effort to expand the act, but I happen to think that that is a very tenuous kind of an argument."

58. "Congresswoman Barbara Jordan Relates to Pittsburghers," *New Pittsburgh Courier*, March 8, 1975.

59. "Congressman Jordan Makes Political Move," *Atlanta Daily World*, March 20, 1975; *New Pittsburgh Courier*, March 22, 1975.

60. "Rep. Jordan Says Texas Racial Attitudes Rule out Senate Try," *New Pittsburgh Courier*, March 29, 1975.

61. And "whether that might mean a dramatic change in the South's traditional impact on the national Government." "House Veterans Readjust to Liberal Trend in South," *New York Times*, February 25, 1975.

62. "Cash Payoff Is Denied by Connally," April 15, 1975, *Washington Post*.

63. Jordan and Hearon, *Barbara Jordan: a Self Portrait*, 222–223.

64. Rogers, *Barbara Jordan: American Hero*, 232–239.

65. Jordan and Hearon, *Barbara Jordan: A Self Portrait*, 225. Connally called her to say thank you. Two white and ten Black residents of DC served on the jury, and none cited Jordan's testimony as a factor in their unanimous not guilty verdict. For a detailed account of the trial, see Larry L. King, "Williams for the Defense: The Trial of John Connally," *The Atlantic*, July 1975, 37–49.

66. Paula Giddings, "Will the Real Barbara Jordan Please Stand," *Encore*, May 9, 1977.

67. Jordan and Hearon, *Barbara Jordan: A Self-Portrait*, 225–226.

68. Jordan and Hearon, *Barbara Jordan: A Self-Portrait*, 224-225.

69. John Guiniven, "Remembering Senator Robert Byrd," http://www.roanoke.com /webmin/opinion/remembering-sen-robert-c-byrd/article_f6648f0e-86ed-516e-a06a -41d6a3aa7ed9.html, accessed November 24, 2023; Robert C. Byrd, *Addresses on the History of the US Senate*, vol 1. (Washington DC: GPO), 566. In his senate history, Byrd recalled the time Connally, then part of the Nixon administration, asked if he would consent to be nominated to the Supreme Court. (Byrd turned him down.) Connally also consulted with Byrd during the Watergate crisis.

70. All quotes are from author's interview with Bob Alcock. "Preclearance started getting notoriety in Texas, I didn't think we would be successful. I didn't think we'd get the expansion."

71. Hearings before the Committee on Rules, U.S. House of Representatives, HR 6674, HR 5727, and HR 6219, (Washington, DC: Reynolds Reporting Associates, May 14, 1975), Statement of Barbara Jordan, 111–112, and subsequent discussion, 112–120.

72. Pierson, "Comet in Congress," *Wall Street Journal*, February 6, 1975.

73. "Panel Blocks Bid to Exempt Texas from '65 Vote Law," *New York Times*, April 10, 1975.

74. "Voter Protection Spurred in Texas," *New York Times*, April 23, 1975.

75. "Voter Protections Spurred in Texas"; Howard Glickstein, "Mexican Americans Need Voter Safeguards Too," *Los Angeles Times*, April 27, 1975.

76. Memorandum from Charles B. Rangel to CBC members, April 24, 1975, with attached approval sheet, Papers of the Congressional Black Caucus, Howard University, Washington, DC.

77. Memorandum from Charles B. Rangel to CBC members, April 24, 1975, and attached handwritten memo by Parren Mitchell, dated April 28, 1975, Papers of the Congressional Black Caucus, Howard University.

78. "Panel Blocks Bid to Exempt Texas from 65 Vote Law," *New York Times*, April 30, 1975, and "Panel Rejects Bid to Ease Vote Law," *Washington Post*, May 1, 1975.

79. "House Unit Rejects Voting Rights Shift," *New York Times*, May 1, 1975.

80. "A 10 Year Extension of Vote Act Backed," *New York Times*, May 2, 1975; "House Judiciary Extends Vote Act," *Washington Post*, May 3, 1975.

81. "Voting Act Extension May Be in Trouble," *Baltimore Afro-American*, May 24, 1975.

82. Alfreda L. Madison, "Your Congressmen," *Norfolk Journal and Guide*, June 21, 1975.

83. Louis Stokes, interview with author, May 2, 2008, Washington, DC.

84. "Caucus Fought Hard for Vote Act Extension," *Baltimore Afro-American*, June 14, 1975; "Efforts to Ease Voting Rights Bill Rejected," *Washington Post*, June 4, 1975; "House Votes 341 to 70 to Extend and Broaden Voting Rights Act," *New York Times*, June 5, 1975; "Big Step for Rights," *Chicago Defender*, June 11, 1975.

85. "Full Voting Rights," *New York Times*, June 17, 1975. For an excellent summary of all of the challenges made on the House floor see Richard Lyons, "House Votes to Extend Voting Rights Statute," *Washington Post*, June 5, 1975.

86. "Full Voting Rights," *New York Times*, June 17, 1975.

87. Lawson, *In Pursuit of Power*, 245–246.

88. "Senators Defeat Attempts to Dilute Vote Rights Bill," *New York Times*, July 18, 1975.

89. "Voting Act Extension Is Pressed," *Washington Post*, July 19, 1975; "Senate Calls Up Voting Rights Bill," *New York Times*, July 19, 1975.

90. Spencer Rich, "Voting Act Debate Is Restricted," *Washington Post*, July 20, 1975.

91. Delaying tactics of Allen detailed in Spencer Rich, "Voting Act Extension Gains," *Washington Post*, July 22, 1975.

92. "Spencer Rich, "Voting Act Extension Gains," *Washington Post*, July 22, 1975, and "2nd Crucial Vote Due on Voting Act," *Washington Post*, July 23, 1975.

93. "Voting Rights Bill Modified in Senate," *Washington Post*, July 24, 1975.

94. "Senate Rejects Bid by South on Voting," *New York Times*, July 23, 1975.

95. "Voting Rights Bill Modified in Senate," *Washington Post*, July 24, 1975, and Richard L. Madden, "Senate Modified Voting Act Plan," *New York Times*, July 24, 1975.

96. Spencer Rich, "Voting Act Approved by Senate," *Washington Post*, July 25, 1975, and "A Voting Rights Advance," *Washington Post*, July 28, 1975; Richard L. Madden, "Senators Vote to Extend Voting Rights Act 7 Years," *New York Times*, July 25, 1975.

97. Richard L. Madden, "Congress Passes 7 Year Extension of Voting Right Act," *New York Times*, July 29, 1975; "Ford Hails Gain in Voting Rights," *Washington Post*, August 7, 1975.

98. Jordan and Hearon, *Barbara Jordan: A Self Portrait*, 209–212.

99. Jordan and Hearon, *Barbara Jordan: A Self Portrait*, 213.

100. Spencer Rich, "Byrd Will Seek '76 Nomination," *Washington Post*, January 10, 1976.

101. Rogers, *American Hero*, 240–255, provided the first detailed examination of Jordan's key role in the battle to renew, expand, extend, and pass the 1975 Voting Rights Act. Rogers also details some of Jordan's other legislative triumphs including a consumer protection law that sought to eliminate price-fixing.

102. Meg Greenfield, *Washington* (New York: Public Affairs, 2001), 35–36.

Chapter 13

1. At the end of 1975, she and Earl bought land and slowly built a new house on Onion Creek. Jordan had nearly $100,000 in the bank. For Jordan's finances, see Rogers, *Barbara Jordan: American Hero*, 251. Jordan earned $55,000 a year and earned an additional $15,000 each year from giving speeches. She rented a sparsely furnished apartment overlooking the Potomac.

2. Jordan and Hearon, *Barbara Jordan: A Self-Portrait*, 237, 238–240, Rogers, *American Hero*, 252–254 describes the house.

3. Shelby Hearon Papers, Ransom Center, Box 3, folder 18, Outline III. The published account of the gathering is in Jordan and Hearon, *Barbara Jordan: A Self-Portrait*, 237–40.

4. Bobby Hebb, "Sunny," 1963. https://www.lyrics.com/lyric/13923043/Bobby+Hebb, accessed November 19, 2023.

5. Shelby Hearon Papers, Ransom Center, Box 3, folder 18, Outline III.

6. Jordan and Hearon, *Barbara Jordan: A Self-Portrait*, 239.

7. Jordan and Hearon, *Barbara Jordan: A Self-Portrait*, 240.

8. Jordan's matter-of-fact descriptions of how her family and her other friends accepted Earl reflects, perhaps, that Jordan's self-identity and her strong relationships with women were already well known to her family and closest friends. See Marlon B. Ross, "Beyond the Closet as Raceless Paradigm," in *Black Queer Studies: A Critical Anthology*, ed. E. Patrick Johnson and Mae Henderson, (Durham, NC: Duke University Press, 2005), 180.

9. CBS paid Jordan $1800 a year for her monthly commentary. For context, ABC proposed to pay George McGovern $25,000 to comment on the upcoming 1976 Presidential nominating conventions. Warren Weaver, "Broadcast Pay of Congressmen is Approved by Election Panel," *New York Times*, December 3, 1975.

10. Meg Greenfield, "The New Lone Star of Texas," *Newsweek*, March 3, 1975.

11. Greenfield, "The New Lone Star of Texas," italics in original.

12. Liz Carpenter, "Women Who Could Be President," *Redbook* (July 1975). Before the Democratic convention in 1976, "She finds herself being promoted as a future House Speaker, a U.S. Senator, a possible vice-presidential candidate, or perhaps, some day, even president." *Houston Chronicle*, February 14, 1976, 16. See also "Barbara Jordan Could Be President," *Forward Times*, June 17, 1972.

13. Rogers, *Barbara Jordan: American Hero*, 248.

14. "I remember going to her [and saying,] Barbara, I have all these groups in my congressional district and all of them want you as a speaker . . . but what I'd like for you to do is agree is to go out there and speak to a conglomerate . . . a big event. . . . She agreed to do it." Author's interview with Louis Stokes, Washington, DC, May 2, 2008.

15. "Sellout Crowd Hails Jordan," *Cleveland Call and Post*, October 25, 1975.

16. "Sellout Crowd Hails Jordan," *Cleveland Call and Post*, October 25, 1975, and "Rep. Jordan Blasts System," *Los Angeles Sentinel*, November 6, 1975. See also her remarks at a benefit for California congressman Ron Dellums, October 4, 1975, Rogers, *Barbara Jordan: American Hero*, 249.

17. "If you just look at election results in places like Oakland, and Berkeley, and you see the latest statements which are even being made now by Eldridge Cleaver, the political arena, that's where the radicals have gone." Paul Duke interview with Barbara Jordan, *Washington Straight Talk*, March 24, 1975, American Archive of Public Broadcasting, https://americanarchive.org/catalog/cpb-aacip-512-ms3jw87z64, accessed November 19, 2023

18. See "Enforcing a Congressional Mandate: LEAA and Civil Rights," *Yale Law Journal* 85, no. 5 (April 1976): 721–740. Footnotes 9, 29, 40, and 41 detail Jordan's role, including her testimony and submitted statement in the "Hearings Before the Subcommittee on Crime," House Comm. on the Judiciary, 94th Cong., 2nd Sess. (March 11, 1976), 443–444. Jordan, along with John Conyers, felt frustrated that civil rights mandates were ignored by federal agencies. Jordan's bill intended to force the LEAA to review whether its recipients, such as local police departments, violated civil rights laws and cut federal funding if that was the case. The bill also sought to make it easier for local agencies and individuals to sue it for civil rights violations.

19. Barbara Jordan, "Civil Rights Law—Toward Effective Enforcement," *Call and Post*, December 10, 1977.

20. Author's interview with Bob Alcock, September 14, 2003, Washington, DC.

21. Jordan and Hearon, *Barbara Jordan: A Self-Portrait*, 214–215.

22. Rogers, *Barbara Jordan: American Hero*, 250. Rogers based her information on interviews with Nancy Earl and Jordan's physician.

23. Jordan and Hearon, *Barbara Jordan: A Self-Portrait*, 227.

24. Christopher Lydon, "Carter Defends All-White Areas: Says Government Shouldn't Try to End 'Ethnic Purity' of Some Neighborhoods," *New York Times*, April 7, 1976.

25. Foster Post, "Blacks Must Separate Rhetoric and Reality," *Oakland Post*, April 14, 1976, 20.

26. *Meet the Press*, May 29, 1976. California lieutenant governor Mervyn Dymally, Vernon Jordan, Jesse Jackson, and A. J. Cooper, an Alabama mayor, also appeared on the show.

27. Rogers, *Barbara Jordan: American Hero*, 257.

28. William L. Chaze, "Barbara Jordan: A Little Dramatic, a Little Aloof, a Lot of Clout," *Times Herald*, April 1976.

29. Chaze, "Barbara Jordan: A Little Dramatic, a Little Aloof, a Lot of Clout," *Times Herald*, April 1976.

30. Chaze, "Barbara Jordan: A Little Dramatic, a Little Aloof, a Lot of Clout," *Times Herald*, April 1976.

31. "Rep Barbara Jordan Blasts President Ford for Supporting Segregated Private Schools," *Washington Post*, June 15, 1976. Jordan responded on behalf of the Congressional Black Caucus.

32. *Washington Post*, June 15, 1976.

33. *Atlanta Daily World*, June 20, 1976.

34. *Atlanta Daily World*, June 24, 1976.

35. Nicholas C. Chriss, "'Boss Lady' Jordan Gains in Influence," *Los Angeles Times*, July 13, 1976.

36. Mary Russell, "'Eloquent Orator from Texas': People Listen When Jordan Steps to the Podium," *Washington Post*, July 12, 1976.

37. *Norfolk Journal and Guide*, October 25, 1975.

38. William Claiborne, "Newly Unified Democrats Await a Rhetorical Feast," *Washington Post*, July 11, 1976. "The Democratic party, which gave television audiences bloody street riots in Chicago in 1968 and rancorous all night debates in Miami in 1972, has begun assembling here amidst uncharacteristic repose. Beginning Monday, it will show off its newfound unity and ready itself for the ritual of nominating Jimmy Carter for the presidency." Claiborne called it "a carefully orchestrated, nationally televised feast of rhetoric and unbridled propaganda for the party and the candidate."

39. *Wall Street Journal*, July 13, 1976.

40. Mary Beth Rogers, *American Hero*, 264; Jordan and Hearon, *Barbara Jordan: A Self-Portrait*, 228–235.

41. Author's telephone interview with Rufus "Bud" Myers, May 19, 2017.

42. R. W. Apple, "Party Is United," *New York Times*, July 13, 1976; Jimmy Breslin, "No one could help a hero in the arena," *Chicago Tribune*, July 13, 1976.

43. Rogers, *Barbara Jordan: American Hero*, 265.

44. The text of the final speech, along with various drafts can be found in Jordan, Barbara, 1936-1996. [Barbara Jordan's Keynote Address before the Democratic National Convention, July 12, 1976], text, July 12, 1976; https://texashistory.unt.edu/ark:/67531 /metapth595528/m1/9/, accessed December 5, 2023, University of North Texas Librar- ies, The Portal to Texas History, https://texashistory.unt.edu; crediting Texas Southern University.

45. See https://www.rev.com/blog/transcripts/rep-barbara-jordan-1976-democratic -national-convention-keynote-speech-transcript for the speech as it was delivered. It con- tains Jordan's adlibs that deviated from the prepared text, accessed December 6, 2023.

46. "Barbara Jordan's Keynote Address," July 12, 1976.

47. Richard Reeves, *Convention* (New York: Harcourt, Brace, Jovanovich, 1977), 75.

48. R. W. Apple, "Party Is United," *New York Times*, July 13, 1976.

49. "United Dems Are 'Hell Bent on Victory,'" *Chicago Tribune*, July 13, 1976. "Rep. Jordan started the first wave of enthusiasm at the convention, receiving long, standing applause when she walked to the podium and a 'we want Barbara' chant when she finished. She was interrupted by applause 24 times in her 25-minute speech."

50. Dave E. Rosenbaum, "Black Woman Keynoter," *New York Times*, July 13, 1976. "Throughout the convention floor—in the Ohio section and the Mississippi section, and especially in the Texas section—they rose and cheered when she walked onto the podium." Robsenbaum appeared alarmed at Jordan's new responsibilities in Congress. "In part because of her work on the Judiciary Committee during the impeachment proceed- ings and in part because of her success in other legislative efforts, she was placed at the beginning of her second term in Congress on the Democratic Steering and Policy Com- mittee. That committee among its other duties, makes committee assignments for House Democrats."

51. Quoted in Reeves, *Convention*, 104.

52. All quotes from Rosenbaum, "Black Woman Keynoter."

53. Reeves, *Convention*, 104.

54. Rogers, *Barbara Jordan: American Hero*, 273–274.

55. Larry Rohter, "Getting in on the Act to Turn out the Vote for Jimmy Carter," *Wash- ington Post*, August 5, 1976.

56. Althea Fonville, "Jordan Not Talking on Carter Plan for Blacks," *Pittsburgh Courier*, October 23, 1976.

57. Fonville, "Jordan Not Talking on Carter Plan for Blacks."

58. Walter Shapiro, "What Does This Woman Want?" *Texas Monthly* (October 1976). William Broyles, "The Making of Barbara Jordan," *Texas Monthly* (October 1976).

59. Broyles, "The Making of Barbara Jordan."

60. Broyles, "The Making of Barbara Jordan."

61. Jordan and Hearon, *Barbara Jordan: A Self-Portrait*, 115.

62. Jim Cleaver, "Carter Victory Promises New Hope for Blacks," *Los Angeles Sentinel*, November 4, 1976. "Congresswoman Barbara Jordan and Young have both been mentioned as being among the top choices."

63. *New York Times*, November 4, 1976.

64. Warren Weaver, "South Opens a Door: When Can Jews, Blacks, Women Enter?" *New York Times*, November 7, 1976.

65. *Norfolk Journal and Guide*, December 18, 1976.

66. "Carter Likely to Name Black Attorney General," *Chicago Tribune*, December 8, 1976.

67. Walter Pincus, "Barbara Jordan Caught up in Hardball Politics," *Washington Post*, December 16, 1976.

68. "Corrections," *Washington Post*, December 18, 1976.

69. Chuck Stone, "Black Political Power in the Carter Era," *Black Scholar* 8, no. 4 (1977): 6–15. Carter appointed Andrew Young as UN ambassador and Patricia Roberts Harris to be secretary of HUD.

70. William Raspberry, "Blacks and the Cabinet," *Washington Post*, December 17, 1976.

71. Leslie Gelb, "Rep. Andrew Young Is Expected to Head US delegation at UN," *New York Times*, December 15, 1976.

72. "Young Defends Judge Bell," *Atlanta Daily World*, December 24, 1976; "Bell Reported Carter's Choice from the Start," *New York Times*, December 24, 1976; "Naacp, Caucus Oppose Confirmation of Bell as US Atty General," *Philadelphia Tribune*, January 11, 1977.

73. "Barbara Jordan Doesn't Want Any Old Job," *Cleveland Call and Post*, December 25, 1976; "Barbara Jordan," letter to the editor, *Baltimore Sun*, December 29, 1976.

74. Sam Chudi Ifeagwu, "Rep. Jordan Never Offered Cabinet Post," *Baltimore Afro-American*, April 16, 1977.

75. Ifeagwu, "Rep Jordan Never Offered Cabinet Post," *Baltimore Afro-American*, April 16, 1977.

76. From "Barbara Walters Special," episode aired April 6, 1977, Paley Center for Media, New York, New York. The segment featured Jordan, Elizabeth Taylor, and the Shah of Iran.

77. Paula Giddings, "Will the Real Barbara Jordan Please Stand," *Encore*, May 9, 1977.

78. Author's interview with Andrew Jefferson, March 27, 2001, Houston, TX.

79. Jordan and Hearon, *Barbara Jordan: A Self-Portrait*, 243.

80. Jordan and Hearon, *Barbara Jordan: A Self-Portrait*, 243.

81. Reeves, *Convention*, 73.

82. Reeves, *Convention*, 73.

83. Rosemarie Garland Thomson, "Disabled Women as Powerful Women in Petry, Morrison, and Lorde," *Extraordinary Bodies: Figuring Physical Disability in American Culture and Literature* (New York: Columbia University Press, 1997), 102–134.

84. Jordan interview with Paul Duke, *Washington Straight Talk*.

85. Audre Lorde explained many white fears: "My mother was a very powerful woman. This was so in a time when that word combination of *woman* and *powerful* was almost

un-expressible in the white American common tongue, except or unless it was accompanied by some aberrant explaining adjective like blind or hunchback, or crazy, or Black." Audre Lorde, *Zami: A New Spelling of My Name* (New York: Crossing Press, 1982), 15.

Chapter 14

1. Barbara Jordan and Shelby Hearon, *Barbara Jordan: A Self-Portrait* (New York: Doubleday, 1979), xiii.

2. Hearon's correspondence with Earl and Jordan shows how she used Jung, Erikson's eight stages, and Maslow's "pyramid of needs," (she meant "hierarchy of needs") to lay out the timeline of Jordan's march to "self-actualization." "Yes, of course, in the last third, I want to show that if you are moving on to generativity (which we discussed on phone & not stagnation to use another name for Congress) and integrity (rather than despair) then you have to consolidate what matters. . . . I think the book can be matched against Erikson page by page; against Maslow gestalt by gestalt; disproving the managerial woman's phallic look-alike on every page. And I feel solid and good about that." Letter from Shelby Hearon to Barbara Jordan and Nancy Earl, received February 25, 1978, Correspondence and Notes related to *Self Portrait*, Shelby Hearon private papers in author's possession.

3. "Nancy, I would like in the all too brief time that Barbara and I will have from 20 August to 5 September, for the three of us to make a trip to Houston. Not to talk to other people, but simply a time to 'walk the bounds' with the stories of John Patten, and Sunday mornings and the hot straightening iron, and going back with LBJ for the Congressional race. All of that. Can you save a brief time for us to do that?" Letter from Shelby Hearon to Nancy Earl, May 15, 1977, Correspondence and Notes related to *Self Portrait*, Shelby Hearon private papers in author's possession. And, "I'd like to talk with Bennie and Alice Jordan and Mamie Lee, in other words about the influence of music on the three of you. And I would like to talk to Rosemary about your father, his years at Tuskegee and his years as a preacher." Letter from Shelby Hearon to Barbara Jordan, Sept 1, 1977, Correspondence and Notes related to *Self Portrait*, Shelby Hearon private papers in author's possession.

4. Letter from Hearon to Earl, May 15, 1977, Correspondence and Notes related to *Self Portrait*, Shelby Hearon private papers in author's possession.

5. Letter from Hearon to Earl, May 15, 1977, Correspondence and Notes related to *Self Portrait*, Shelby Hearon private papers in author's possession.

6. Rogers, *American Hero*, 252–254.

7. Letter from Hearon to Jordan, May 29, 1977, Correspondence and Notes related to *Self Portrait*, Shelby Hearon private papers in author's possession.

8. Hearon followed up in 1978 with further interviews in Washington.

9. September 2, 1977, letter from Shelby Hearon to Sally Arteseros, Correspondence and Notes related to *Self Portrait*, Shelby Hearon private papers in author's possession.

10. Letter from Shelby Hearon to editor Sally Arteseros, September 2, 1977, Correspondence and Notes related to *Self Portrait*, Shelby Hearon private papers in author's possession.

11. September 2, 1977, letter from Shelby Hearon to Sally Arteseros, Correspondence and Notes related to *Self Portrait*, Shelby Hearon private papers in author's possession.

12. Hearon's cousin, the author Michael J. Lind, tells the family story in the introduction of his book, *Made in Texas: George W. Bush and the Southern Takeover of American Politics* (New York: Basic Books, 2002). Interview with Hearon and Eleanor Holmes Norton on CSPAN, June 30, 2001, https://www.c-span.org/video/?165001-4/impact-representative-barbara-jordan, accessed November 24, 2023.

13. For a biographical sketch of Hearon and a summary of her work, see "Shelby Hearon: An Inventory of her Papers," at the Harry Ransom Center, https://norman.hrc.utexas.edu/fasearch/findingAid.cfm?eadid=00055, accessed December 3, 2023.

14. Dr. Paul Kelley was a pioneer in the field of educational testing, and Nancy Earl worked for him at the University of Austin in Texas. He and his wife, DeCourcy Kelley, became friends with Jordan and Earl. See DeCourcy Kelley's obituary, https://www.legacy.com/us/obituaries/statesman/name/decourcy-kelley-obituary?id=26313176, accessed November 24, 2023.

15. Marjorie Spruill, *Divided We Stand: The Battle over Women's Rights and Values That Polarized American Politics* (New York: Bloomsbury, 2017).

16. "Barbara Jordan to Keynote Pennsylvania Womankind Confab," *Philadelphia Tribune*, May 3, 1977.

17. "Barbara Jordan: Women Should Back Own Cause," *Pittsburgh Courier*, July 2, 1977.

18. "Rep Jordan Hits Carter on Welfare," *Baltimore Afro-American*, July 2, 1977, and "Rep. Jordan Warns of 'Shift to the Right,'" *New York Times*, June 28, 1977.

19. Hazel Garland, "Things to Talk About," *Pittsburgh Courier*, July 16, 1977.

20. "Washington Workshop Helps Women Hone Their Political Skills," *New York Times*, July 4, 1977. This five-day "campaign skills conference" aimed at women running for public office was held in Washington, DC, at the same time Jordan was speaking in Pittsburgh. Tellingly, only eighteen women attended that workshop.

21. "Washington Workshop Helps Women Hone Their Political Skills," *New York Times*, July 4, 1977.

22. Myra MacPherson, "Looking Over Jordan: Black, Women's Groups Complain as the Eloquent Texan Goes Her Own Way," *Washington Post*, October 30, 1977. This piece echoed many of the same accusations of "aloofness" brought up by Barbara Walters when she interviewed Jordan earlier that year (televised April 6, 1977).

23. See https://www.womenonthemovetx.com/the-conference/, accessed November 17, 2023. Quote about Jordan is contained the film clip on the website entitled "Key Players."

24. Anna Quindlen, "Anticipating a Historic Occasion, Women Stream to Conference," *New York Times*, November 18, 1977.

25. Edith M. Austin, "10 Northern California Black Women Delegates to IWY Confab in Houston," *Sun Reporter* (San Francisco, CA), November 17, 1977.

26. Barbara Jordan, "Keynote Speech," National Women's Conference, Houston, Texas, November 18, 1977, https://texashistory.unt.edu/ark:/67531/metapth611534/m1/5/, accessed November 24, 2023.

27. Barbara Jordan, "Keynote Speech," National Women's Conference, Houston, Texas, November 18, 1977, https://texashistory.unt.edu/ark:/67531/metapth611534/m1/5/, accessed November 24, 2023.

28. Sally Quinn, "The Pedestal Has Crashed: Pride and Paranoia in Houston," *Washington Post*, November 23, 1977; Barbara Jordan, "Keynote Speech."

29. Jon Margolis and Meg O'Connor, "Feminists and Foes Test Strength," *Chicago Tribune*, November 20, 1977, emphasized importance of Jordan's speech for striking the right tone.

30. Quinn, "The Pedestal Has Crashed."; Barbara Jordan, "Keynote Speech."

31. Quinn, "The Pedestal Has Crashed."

32. Annette Samuels, "Confab: Women Must Fight Harder," *New York Amsterdam News*, November 26, 1977.

33. Edith Herman, "Houston's Over: Now All Eyes Turn to Washington," *Chicago Tribune*, November 27, 1977.

34. "Pass ERA before 1979," *Chicago Tribune*, November 20, 1977.

35. *New York Times*, December 11, 1977.

36. *Washington Post*, December 11, 1977.

37. "Jordan Won't Seek 4th Term, Is Undecided on Future Plans," *Washington Post*, December 11, 1977.

38. *Call and Post*, December 17, 1977.

39. Letter to the editor, *Los Angeles Sentinel*, January 19, 1978.

40. *Los Angeles Sentinel*, December 15, 1977.

41. Ron Dellums quoted in Suzanne Braun Levine and Mary Thom, *Bella Abzug: An Oral History* (New York: Farrar, Strauss and Giroux, 2007), 127–128.

42. Shelby Hearon Papers, draft of chap. 9 of *Barbara Jordan: A Self-Portrait*, Shelby Hearon Papers, Harry Ransom Center s, Austin, TX. The many unpublished musings in this draft include Hearon "hoping for a non sexist world." All subsequent quotes are from this source.

43. Jordan and Hearon, *Barbara Jordan: A Self Portrait*, 253–256.

44. Author's interview with Bob Alcock, September 14, 2003.

45. Author's interview with Lee Hamilton, director of the Woodrow Wilson Center, Washington, DC, October 16, 2007.

46. Dale Rusakoff, "A Public Airing of Private Ills: In Media Glare, Candidates Now Disclose Infirmities," *Washington Post*, September 24, 2002.

47. Robert McRuer, *Crip Theory: Cultural Signs of Queerness and Disability* (New York: New York University Press, 2006). See also Rosemarie Garland-Thomson, *Extraordinary Bodies: Figuring Physical Disability in American Culture and Literature* (New York: Columbia University Press, 1997).

48. *Harvard Crimson*, October 20, 1978. Speaking at a reception for Black students at Kirkland House, Harvard University, Jordan used a "crutch" metaphor in a discussion with Black students: "We shouldn't use Black as a crutch. I don't feel like hobbling on the crutch and making it an excuse for mediocrity."

49. Rogers, *Barbara Jordan: American Hero*, 287–288.

50. Letter from Hearon to Barbara Jordan and Nancy Earl, postmarked April 21, 1978, Correspondence and Notes related to *Self Portrait*, Shelby Hearon private papers in author's possession.

51. *Atlanta Daily World*, March 7, 1978.

52. "Toward 7 More Years of ERA Ratification," *New York Times*, April 23, 1978.

53. Equal Rights Amendment Extension, Hearings Before the Subcommittee on Civil and Constitutional Rights, House Comm. On the Judiciary, 95th Cong. 1st and 2nd sessions, serial no. 41, Day 2, Testimony of Barbara Jordan, Tuesday, May 18, 1978, 236–242. "Adversaries on ERA Square Off on Hill over New Deadline," *Washington Post*, May 19, 1978.

54. "Over 40,000 ERA Backers March on Hill," *Washington Post*, July 10, 1978.

55. *Washington Post*, August 18, 1978.

56. Jack Bass, *Unlikely Heroes: A Vivid Account of the Implementation of the Brown Decision in the South by Southern Federal Judges Committed to the Rule of Law* (Tuscaloosa: University of Alabama Press, 1990).

57. Elaine Jones (The HistoryMakers A2006.151), interviewed by Julieanna L. Richardson, March 6, 2007, The HistoryMakers Digital Archive. Session 2, tape 9, story 7. "Elaine Jones recalls lobbying to preserve the U.S. Court of Appeals for the Fifth Circuit." The HistoryMakers is a digital archive of life oral histories relating to the African American experience. Additional information on the project is available at www.thehistorymakers .org, accessed November 24, 2023.

58. Deborah Barrow and Thomas G. Walker, *A Court Divided: The Fifth Circuit Court of Appeals and the Politics of Judicial Reform* (New Haven, CT: Yale University Press, 1988). Many of the quotes that follow also appear in this text.

59. Elaine Jones (The HistoryMakers A2006.151), interviewed by Julieanna L. Richardson, March 6, 2007, The HistoryMakers Digital Archive. Session 2, tape 9, story 7. "Elaine Jones recalls lobbying to preserve the U.S. Court of Appeals for the Fifth Circuit."

60. Barrow interview with Barbara Jordan, Austin, TX, March 22, 1983.

61. Barrow interview with Barbara Jordan, Austin, TX, March 22, 1983. Barrow and Walker, *A Court Divided*.

62. Testimony of Griffin Bell, Hearings before the Subcommittee on Monopolies and Commercial Law, 95th Cong. 1st sess. 1977, September 27, 1977, 88.

63. David S. Broder, "When Merit Selection Got Mugged," *Washington Post*, April 19, 1978.

64. *Baltimore Sun*, February 28, 1978.

65. Barrow interview with Barbara Jordan, Austin, TX, March 22, 1983.

66. Barrow interview with Barbara Jordan, Austin, TX, March 22, 1983.

67. Barrow interview with Barbara Jordan, Austin, TX, March 22, 1983.

68. Barrow interview with Barbara Jordan, Austin, TX, March 22, 1983.

69. Elaine Jones, The HistoryMakers Digital Archive. Session 2, tape 9, story 7. "Elaine Jones recalls lobbying to preserve the U.S. Court of Appeals for the Fifth Circuit."

70. Meg Greenfield, *Washington* (New York: Public Affairs, 2001), 103–104.

Chapter 15

1. Walter Shapiro, "What Does This Woman Want?" *Texas Monthly* (October 1976): 134.

2. Liz Carpenter, "Women Who Could Be President," *Redbook* (July 1975). Seven hundred men and women were asked what woman could serve as president; 44 percent named

Jordan. Before the Democratic convention in 1976, "she finds herself being promoted as a future House Speaker, a U.S. Senator, a possible vice-presidential candidate, or perhaps, some day, even president." *Houston Chronicle*, February 14, 1976, 16. After Jordan was sworn in as "Governor for a Day," Black Houstonians envisioned her in the Oval Office. See "Barbara Jordan Could Be President," *Forward Times*, June 17, 1972. Richard E. Price, "Naming of Black Woman to Supreme Court Urged," *Washington Post*, May 26, 1975.

3. "Rep. Barbara Jordan Speaks to 150 at Kirkland House," October 20, 1978, Barbara Jordan Scrapbook, June–October, 1978, https://texashistory.unt.edu/ark:/67531 /metapth616585/m1/7/, accessed November 24, 2023, University of North Texas Libraries, The Portal to Texas History, https://texashistory.unt.edu; crediting Texas Southern University.

4. "Barbara Jordan Denies Report She Has Terminal Bone Disease," *Washington Post*, quoting the *Dallas Morning News*, January 19, 1979.

5. Stanley L. McLelland and Jordan were very close, and he often traveled with her. He was an important source for much of the personal information about Jordan for Mary Beth Rogers, *Barbara Jordan: American Hero*. He died November 20, 2020.

6. Rogers, *Barbara Jordan: American Hero*, 301–303.

7. Rogers, *Barbara Jordan: American Hero*, p. 304.

8. See Joseph Nocera, "The Failure of Barbara Jordan's Success," *Washington Monthly* 11, no 1 (March 1979): 36–46. Nocera bashed Jordan for not living up to her potential, for her self-interest and ambition, and for her modest accomplishments. Charlayne Hunter Gault, "Independent, Pragmatic, and Self-Centered," *Ms.* 7, no. 8 (February 1979): 43–44. Alton Hornsby, "Barbara Jordan: A Self Portrait by Barbara Jordan and Shelby Hearon," *Journal of Southern History* 36, no. 1 (February 1980): 137–138, gave a slightly less hostile but similarly dismissive review, stating that the book showed Jordan's "flaws," including her "naivety," and compared its "simplistic approach" to a Horatio Alger story.

9. Kaye Northcott, "Without a Doubt," *New York Times*, February 18, 1979.

10. See "It Pays to Be a Ghost," *New York Times*, March 18, 1979, on the phenomenon of journalists ghostwriting the memoirs of public figures. Hearon was named as a coauthor, but the article cites *Barbara Jordan: A Self Portrait* as part of a growing trend of books that revealed the private lives of public figures.

11. Author's interview with Judge Andrew Jefferson, March 27, 2001.

12. Rogers, *American Hero*, 314–320, describes some of Jordan's inner circle in Austin.

13. Rogers, *American Hero*, 350.

14. Tobin Siebers, "Disability as Masquerade," *Literature and Medicine* 23, no. 1 (Spring 2004): 1–22, 2–3.

15. Siebers, 2-3.

16. According to Mary Beth Rogers, in addition to Nancy Earl, Jordan trusted Stan McLelland and her LBJ school secretary Sharon Tutchings, "to protect her from anyone who attempted to intrude on her time or life." She preferred to be with people who were polite, reserved, and discreet. Rogers, *American Hero*, 318.

17. "Rep. Barbara Jordan Speaks to 150 at Kirkland House," October 20, 1978, Barbara Jordan Scrapbook, June–October, 1978.

18. Paula Giddings interview with Mario Silva of Gulf Coast Community Services, cited in Paula Giddings, "Will the Real Barbara Jordan Please Stand?" *Encore* magazine, May 9, 1977, 19.

19. See https://en.wikipedia.org/wiki/Community_Reinvestment_Act#cite_note-Federal _Reserve-3, accessed November 24, 2023, for a history of the act, citing a speech by Ben Bernanke on the intent of the original law: https://www.federalreserve.gov/newsevents /speech/Bernanke20070330a.htm, accessed December 4, 2023.

20. Interview with Algenita Scott Davis, July 19, 2006, University of Houston Oral History Project, https://digital.lib.uh.edu/collection/houhistory, accessed November 24, 2023.

21. Interview with Algenita Scott Davis, July 19, 2006, University of Houston Oral History Project, https://digital.lib.uh.edu/collection/houhistory, accessed November 24, 2023.

22. When she appeared on the television news show *60 Minutes*, Jordan correctly predicted that "Jimmy Carter will be renominated, not reelected." "The President appears to have some difficulty taking in the reality of a strong woman. . . . The President views women in a subservient or secondary or peripheral kind of a role and not in a central, decisive, intelligent role" (*60 Minutes*, June 17, 1979).

23. Previously, on the *Dick Cavett Show*, Jordan had said "our president has a problem with women who think, manage and analyze" (*Dick Cavett Show*, February 15, 1979).

24. David Remnick, "TV Ads Give Moral Majority PAWs," *Washington Post*, June 25, 1981; see https://www.pfaw.org/about-us/, accessed November 24, 2023.

25. David S. Broder, "Democrats: Back from the Dead," *Washington Post*, August 23, 1981.

26. For the San Marcos speech, see Rogers, *Barbara Jordan: American Hero*, 320–326.

27. Rogers, *Barbara Jordan: American Hero*, 320–326. Jordan was the only American on the panel; she became friends with esteemed judges and political leaders from Ghana, Sri Lanka, Argentina, and Algeria. After Nelson Mandela was released from prison, Jordan traveled to South Africa and met with him. In 1984 Jordan "electrified" the audience gathered in Washington, DC, for the Joint Center for Political and Economic Studies. She held "Reaganomics" responsible for the nation's "deepest, darkest," recession: "I apologize to all the Republicans who may have gotten into this room." *Washington Post*, March 3, 1984.

28. Paul Delaney, "The Struggle to Rally Black America," *New York Times*, July 15, 1979.

29. Barbara Jordan, "Salute to Black Elected Officials," Address to the Seventh Annual Dinner, Joint Center for Political Studies, and the Fourth National Policy Institute, Washington, DC, March 2, 1984.

30. "Ex Officials Praise Bork: Others See Him as a Threat," *New York Times*, September 22, 1987.

31. Testimony of Barbara Jordan to the Senate Judiciary Committee, Day 6, Hearings on the Nomination of Robert Bork to the Supreme Court, September 21, 1987. Transcript from CSPAN, https://www.c-span.org/video/?10163-1/bork-nomination-day-6-part-1, accessed November 25, 2023.

32. Testimony of Barbara Jordan to the Senate Judiciary Committee, Day 6, Hearings on the Nomination of Robert Bork to the Supreme Court, September 21, 1987. Transcript from CSPAN, https://www.c-span.org/video/?10163-1/bork-nomination-day-6-part-1, accessed November 25, 2023.

33. Testimony of Barbara Jordan to the Senate Judiciary Committee, Day 6, Hearings on the Nomination of Robert Bork to the Supreme Court, September 21, 1987.

34. Quoted in Michael Pertschuk, *The People Rising: The Campaign against the Bork Nomination* (New York: Thunder's Mouth Press, 1989,), 269. See Barbara Jordan, "Krauthammer Needs a Lesson on What's Fair and What's Foul," letter to the *Washington Post*, November 12, 1988.

35. Barbara Jordan, "How Do We Live with Each Other's Deepest Differences?" remarks, Dayton, Ohio, June 28, 1990, Public Affairs Library, LBJ School of Public Affairs, Austin, Texas. Quoted in Rogers, *Barbara Jordan: America Hero*, 330.

36. When she returned home, she went to a gathering at the LBJ ranch for a birthday party for Philip Bobbitt. Rogers, *Barbara Jordan: American Hero*, 332.

37. "Jordan's Condition Is Improved," *Washington Post*, August 1, 1988.

38. Rogers, *Barbara Jordan: American Hero*, 335. Jordan defended Democratic attacks on Bush's campaign. Barbara Jordan, "Krauthammer Needs a Lesson on What's Fair and What's Foul."

39. Several versions of this Liebovitz photo of Jordan can be found online. Liebovitz used many politicians and celebrities in the series. https://www.symmetrykills.com /american-express, accessed December 4, 2023.

40. See Rosemarie Garland-Thomson, "Seeing the Disabled: Visual Rhetorics of Disability in Popular Photography," in *The New Disability History: American Perspectives*, ed. Paul K. Longmore and Lauri Umansky, (New York: NYU Press, 2001), 335–374.

41. Garland-Thomson, "Seeing the Disabled," 335–374. The photo of Judy Heuman is an official portrait from her work with a federal government agency.

42. Garland-Thomson, "Seeing the Disabled," 369–370.

43. Nancy Mairs, *Waist-High in the World: A Life Among the Nondisabled* (Boston: Beacon Press, 1996).

44. "In both queer and disabled contexts," Samuels writes, "coming out can entail a variety of meanings, acts, and commitments." Ellen Samuels, "My Body, My Closet: Invisible Disability and the Limits of Coming Out," in *The Disability Studies Reader*, 5th ed., ed. Lennard J. Davis (New York: Routledge, 2017), 343–359, 346–347. See also Marlon B. Ross, "Beyond the Closet as Raceless Paradigm," in *Black Queer Studies*, ed. E. Patrick Johnson and Mae G. Henderson (Durham, NC: Duke University Press, 2005), 161–190.

45. Interview: An Ethical Guru Monitors Morality," *Time Magazine*, June 3, 1991, 9–10; Rogers, *American Hero*, 338–339.

46. "Interview: An Ethical Guru Monitors Morality," *Time Magazine*, June 3, 1991, 9–10.

47. In January 2022, the estimate of undocumented citizens nationwide was 11.35 million. See https://cis.org/Report/Estimating-Illegal-Immigrant-Population-Using-Current -Population-Survey, accessed November 25, 2023.

48. "New Voice in Immigration Debate: Former Congresswoman Jordan Expresses Optimism over Policy 'Furor," *Washington Post*, April 13, 1994.

49. See "Where Have You Gone Barbara Jordan? Our Nation Turns Its Lonely Eyes to You," *This American Life*, episode 665, January 11, 2019, https://www.thisamericanlife.org /665/transcript, accessed November 25, 2023.

50. "Where Have You Gone Barbara Jordan?"

51. Author's zoom interview with Susan Martin, January 3, 2020.

52. Rogers, *Barbara Jordan: American Hero*, 343–351, and "Where Have You Gone Barbara Jordan?"

53. "Where Have You Gone Barbara Jordan?" Rogers, *American Hero*, 343–350.

54. Rogers, *Barbara Jordan: American Hero*, 351.

55. Rogers, *Barbara Jordan: American Hero*, xvi.

56. Ron Coddington caricature of Barbara Jordan for Tribune News Service, January 1, 1994, https://www.gettyimages.com/detail/news-photo/ron-coddington-caricature-of-barbara-jordan-news-photo/168789573, accessed November 25, 2023.

57. Quoted in "Where Have You Gone Barbara Jordan?"

58. Quoted in "Where Have You Gone Barbara Jordan?"

59. "At Funeral, Praise for Barbara Jordan," *New York Times*, January 21, 1996.

60. "Friends Celebrate Home-Going of Former Rep. Barbara Jordan," *Washington Post*, January 21, 1996.

61. In order to be buried in the Texas State cemetery, an individual had to have been elected or appointed to state office, or had some connection to state government. Some of the rules have been relaxed, yet the history of disfranchisement and segregation would have made in impossible for Black Texas leaders from the past to be so honored. For the history of the cemetery and qualifications see https://cemetery.tspb.texas.gov/faq.asp, accessed December 4, 2023.

62. Author's telephone interview with Rufus "Bud" Myers, Jordan's chief of staff, May 19, 2017.

63. "The Barbara Jordan Statue at UT: A Welcome Return to a Champion of Justice," *Austin Chronicle*, April 24, 2009, https://www.austinchronicle.com/arts/2009-04-24/770404/, accessed November 25, 2023.

64. "Barbara Jordan Statue's 10-Year Anniversary Commemorated by UT Orange Jackets," *Daily Texan*, March 28, 2019, https://thedailytexan.com/2019/03/29/Barbara-jordan-statues-10-year-anniversary-commemorated-by-ut-orange-jackets/, accessed November 25, 2023. Other speakers remarked on Jordan's importance as a symbol of women's achievements, multiracial inclusivity, and the fight for civil rights.

65. *Austin Chronicle*, July 6, 2007, https://www.austinchronicle.com/arts/2007-07-06/499190/, accessed November 25, 2023.

66. "The Marble Ceiling," from "The Education of an Able-Bodied Ally," November 13, 2006, http://disabilityally.blogspot.com/2006/11/marble-ceiling.html, accessed November 25, 2023.

67. Richard Pearson, "Ex-Congresswoman Barbara Jordan Dies," *Washington Post*, January 18, 1996. Frances X. Clines, "Barbara Jordan Dies at 59: Her Voice Stirred the Nation," *New York Times*, January 18, 1996. Reportedly the *Houston Chronicle* named Earl as Jordan's companion. See J. Jennings Moss, "Barbara Jordan: The Other Life—Lesbianism Was a Secret the Former Congresswoman Took to Her Grave," *Advocate*, March 5, 1996, 39–44, 44.

68. See, for example, Lisa L. Moore, "Looking Back at Barbara Jordan," *QT Voices*, July 7, 2022. *QT Voices* is the online magazine of the LGBTQ Studies Program at the University of Texas at Austin. Dr. Moore is a Professor of Women's and Gender Studies at UT

Austin where she directs the LGBTQ Studies program. https://notevenpast.org/looking
-back-at-barbara-jordan/, accessed December 4, 2023.

69. She reportedly responded, "I was her good friend. I was there morning and night
to help her get showered and get dressed and go to work. She had lots of companions.
People can say whatever they want. She was a friend of mine. You can write what you want."
J. Jennings Moss, "Barbara Jordan: The Other Life—Lesbianism Was a Secret the Former
Congresswoman Took to Her Grave," *Advocate*, March 5, 1996, 39–44, 44.

70. Nancy J. Earl, death notice. https://www.legacy.com/us/obituaries/statesman/name
/nancy-earl-obituary?id=50134208, accessed December 4, 2023.

71. Emma Balter, "How a Houston Columnist's Coming Out and Firing Ignited the
Community," *Houston Chronicle*, October 6, 2022. Quotes from Palomo appeared in *Advo-
cate*, March 5, 1996.

72. By 1992 AIDS had become the number 1 cause of death for US men ages 25–44.
By 1994 AIDS was the leading cause of death for all Americans in this age group. See
"AIDS in the 90s, Did You Know?" American Psychological Association Timeline, https://
www.apa.org/pi/aids/youth/nineties-timeline#:~:text=The%20Epidemic%20Grows&text
=In%201991%2C%20the%20red%20ribbon,ages%2025%2D44%20years%20old, accessed
November 21, 2023.

73. J. Jennings Moss, "Barbara Jordan: The Other Life—Lesbianism Was a Secret the
Former Congresswoman Took to Her Grave," *Advocate*, March 5, 1996, 39–44, 44.

74. See Rosa Maria Pegueros, "Barbara Jordan, E. Bradford Burns and Me: Coming
Out in Public Life," for "Setting Out II: University of Rhode Island Annual Symposium
on Lesbian, Gay, and Transgender Issues," April 10–12, 1996, https://userpages.umbc.edu/
~korenman/wmst/come_out.html, accessed November 21, 2023.

75. Barbara Smith, "Toward a Black Feminist Criticism," *Radical Teacher* 7 (March
1978): 20–27, 26.

76. "Right to Closets," in *off our backs* 8, no. 11 (December 1978): 16, emphasis in the
original. The race of the author is not clear, but she is writing to show solidarity with a pre-
vious letter written by a Black woman.

77. Deborah Gray White, "Mining the Forgotten: Manuscript Sources for Black Women's
History," *Journal of American History* 74, no. 1 (June 1987): 237–242, discusses the factors that
contribute to the paucity of personal documents among Black women; see Karen Vallgarda,
"Introduction: The Politics of Family Secrecy," *Journal of Family History* 47, no. 3 (2022):
239–247, citing Eve Kosofsky Sedgwick, *Touching Feeling: Affect, Pedagogy, Performativity*
(Durham, NC: Duke University Press, 2003), 123–151, on balancing, exposing, and protect-
ing a subject's personal life. For the tensions over sexual secrets and public life, see Erving
Goffman, *Stigma: Notes on the Management of Spoiled Identity* (Englewood Cliffs, NJ: Pren-
tice Hall, 1963); James Kirchick, *Secret City: The Hidden History of Gay Washington* (New
York: Henry Holt, 2022). For recent biographies of Black women that wrestle with similar
questions about secrecy and disclosure, see Shanna Greene Benjamin, *Half in Shadow: The
Life and Legacy of Nellie Y. McKay* (Chapel Hill: University of North Carolina Press, 2021);
and Imani Perry, *Looking for Lorraine: The Radiant and Radical Life of Lorraine Hansberry*
(Boston: Beacon Press, 2019).

78. A new sculpture honoring Jordan in Houston is currently underway. https://glasstire.com/2021/11/10/jamal-cyrus-and-charisse-pearlina-weston-to-collaborate-on-barbara-jordan-monument-in-houston/#:~:text=The%20City%20of%20Houston%20Mayor's,Library%20at%20the%20Gregory%20School., accessed November 25, 2023.

79. "The Marble Ceiling," in The Education of an Able-Bodied Ally, November 13, 2006. http://disabilityally.blogspot.com/2006/11/marble-ceiling.html, accessed December 4, 2023.

80. Lisa L. Moore, "Looking Back at Barbara Jordan," *QT Voices*, July 7, 2022.

81. Dr. Rambie Briggs, quoted in Rogers, *Barbara Jordan: American Hero*, xvi and 354.

Conclusion

1. In *The Two Reconstructions: The Struggle for Black Enfranchisement*, political scientist Richard Valelly has traced the links between the 1975 provisions and the subsequent 1982 reauthorization, along with the court's subsequent rulings upholding Section 5's oversight of election procedures. Matt Stiles, "Clinton Wins Texas but Obama Takes Harris County," *Houston Chronicle*, March 8, 2008, noted the overwhelming turnout in Houston: "A record number of local voters cast nearly 406,000 votes for Democrats with more than 56 percent choosing Obama." This article reported on the results of the primary election. In follow-up Texas caucuses (a combined primary process known as the "Texas Two-Step"), Obama emerged as the overall victor in Texas. See "2008 Texas Presidential Primary and Caucuses," Wikipedia, https://en.wikipedia.org/wiki/2008_Texas_Democratic_presidential_primary_and_caucuses#:~:text=The%20contest%20between%20the%20two,more%20support%20in%20the%20caucuses, accessed December 4, 2023. For results in other southern states, see Mary Ellen Curtin and Matthew Dallek, "On Voting Rights, the Court Finds Consensus: Behind the Act That Helped Elect Obama," *Atlantic* (June 2009).

2. Paul Delaney, "Civil Rights Unity Gone in Redirected Movement," *New York Times*, August 29, 1973, citing the Joint Center for Political Studies.

3. "It does not take much of a decrease in Black voters to alter the outcome of elections in the most competitive states. In 2020, Mr. Biden won Arizona, Georgia, Nevada and Wisconsin, each by fewer than 35,000 votes." See Maya King and Reid J. Epstein, "As Biden Runs Again, Black Voters' Frustration Bubbles," *New York Times*, April 29, 2023.

4. See Merle Black, "The Transformation of the Southern Democratic Party," *Journal of Politics* 66, no. 4 (November 2004): 1001–1017. And see Alan I. Abramowitz, "From Strom to Barack: Race, Ideology, and the Transformation of the Southern Party System," *American Review of Politics* 34 (Fall 2013): 207–226; on 212, the shift of Black voters to the Democrats is attributed to Lyndon Johnson "fully embracing" the cause of civil rights.

SELECTED BIBLIOGRAPHY

Papers and Archival Collections

American Friends Service Committee (AFSC). Papers. Philadelphia, PA.

Bond, Julian, and Southern Election Fund (SEF). Papers. Albert and Shirley Small Special Collections Library, University of Virginia, Charlottesville, VA.

Carr, Billie. Papers. Fondren Library, Rice University Archives, Houston, TX.

Cole, Thomas. Interviews and research for *No Color Is My Kind*, Rosenberg Library, Galveston, TX.

Congressional Black Caucus. Papers. Howard University, Washington, DC.

Convict and Conduct Record Ledgers. Texas Department of Criminal Justice. Archives and Information Service Division, Texas State Library and Archives Commission (TSLAC), Austin, TX.

Fenno, Richard F., Jr. Papers. Rare Books, Special Collections, and Preservation, River Campus Libraries, University of Rochester, Rochester, NY.

Graves, Curtis. Clipping Files. Houston Metropolitan Research Center (HMRC), Houston, TX.

Harlan, Louis, and Raymond Smock, eds. *The Booker T. Washington Papers*, vol. 2 (University of Illinois Press, 1981.

Hearon, Shelby. Papers. Harry Ransom Center, University of Texas, Austin, TX.

Jensen, Elizabeth. Papers. The Quaker Collection, Haverford College, Haverford, PA.

Jordan, Barbara. Papers. Texas Southern University, Houston, TX.

Keuka College Archives and Special Collections (KCASC), Lightner Library, Keuka, NY.

Leadership Conference on Civil Rights. Papers. Library of Congress, Washington, DC.

Legislative Reference Library, Austin, TX.

Lukas, J Anthony. Papers. University Archives, University of Madison, Madison, WI.

National Association for the Advancement of Colored People (NAACP), Papers, Branch Files, Library of Congress Manuscript Division, Washington, DC.

National Association for the Advancement of Colored People (NAACP), Papers, Part 26: Selected Branch Files, 1940–1955, Series A: The South, Series, Group II, Series C, Branch Department Files, Geographical File: Texas State Conference, 1946. 202 pp.

National Association for the Advancement of Colored People (NAACP), Papers, Library of Congress Manuscript Division, Washington, DC.

Papers of the NAACP, Part 01: Meetings of the Board of Directors, Records of Annual Conferences, Major Speeches, and Special Reports Series: Annual Conference Proceedings, 1910–1950, Folder Title: 1940 Annual Conference.

Papers of the NAACP, Part 01: Meetings of the Board of Directors, Records of Annual Con-
 ferences, Major Speeches, and Special Reports, Series: Annual Conference Proceedings,
 1910–1950, Folder Title: 1941 Annual Conference.
Payne, Ethel. Papers. Library of Congress, Washington, DC.
Perry, Helen Glover. Papers. Houston Metropolitan Research Center (HMRC), Houston, TX.
Sampson, Edith Spurlock. Papers (1927–1979). Schlesinger Library, Radcliffe Institute
 Repository, Cambridge, MA.
Texas Labor Archives. Special Collections, University of Texas at Arlington Library, Arling-
 ton, TX.
Thurman, Howard and Sue Bailey Thurman. Collections, Howard Gotlieb Archival
 Research Center, Boston University, Boston, MA.

Private Collections

Affidavits of Stafford Summers and Julius White, July 16, 1918.
Correspondence and Notes related to *Barbara Jordan: A Self Portrait.*
Defendant's Amended Motion for a New Trial, The State of Texas vs John Patten, in the
 Criminal District Court of Harris County, Texas, filed July 15, 1918.
Shelby Hearon, Private Papers in author's possession.

Black-Owned Newspapers

Atlanta Daily World
Baltimore Afro-American
Chicago Defender
Cleveland Call and Post
Evening Star and the Washington News
Forward Times (Houston)
Houston Informer
Informer and Texas Freeman
Los Angeles Sentinel
New Pittsburgh Courier
New York Amsterdam News
Norfolk Journal and Guide
Pittsburgh Courier

Non–Black-Owned Newspapers

Austin American Statesmen
Austin Chronicle
Baltimore Sun
Boston Globe
Chicago Daily Tribune
Chicago Tribune
Daily Texan
Dallas Morning News
Dallas Times Herald

Harvard Crimson
Houston Chronicle
Houston Post
Las Vegas Review
Los Angeles Times
New York Times
Oakland Post
Philadelphia Tribune
Post Tribune
Texas Observer
Times Herald
Wall Street Journal
Wichita Times
Washington Monthly
Washington Post

Magazines

Advocate
Atlantic Monthly
Boston Law School Magazine
Christian Science Monitor
Commentary
Encore Magazine
Essence Magazine
Friends Journal
Jet Magazine
Ms.
Newsweek
New York Times Magazine
Parade Magazine
Redbook
Rolling Stone
Texas Monthly
Time

Interviews

Alcock, Bob. Mary Ellen Curtin, Washington, DC, September 14, 2003.
Armstrong, Bob. Mary Ellen Curtin, Austin, TX, April 12, 2004.
Ashe, Arthur. Lynn Redgrave, BBC interview, July 1, 1992, https://www.youtube.com/watch ?v=SxIAhA7J6Xo, accessed November 27, 2023.
Ball, Eddie. Mary Ellen Curtin, Lake Livingston, TX, April 14, 2004.
Baraka, Amiri. *Eyes on the Prize II* (EOTP), March 31, 1989, http://repository.wustl.edu /concern/videos/12579x28g, accessed November 27, 2023.
Barnes, Ben. Mary Ellen Curtin, Austin, TX, April 12, 2004.

Belafonte, Harry., *Eyes on the Prize II* (EOTP), May 15, 1989, http://digital.wustl.edu/cgi
/t/text/text-idx?c=eop;cc=eop;rgn=main;view=text;idno=bel5427.0417.013, accessed
November 27, 2023.

Carr, Billie. Mary Ellen Curtin, Houston, TX, March 29, 2001.

Christie, Joe William. M. Scott Sosebee, Austin, TX, August 15, 2011, Charlie Wil-
son Oral History Project, Stephen F. Austin State University, https://www.sfasu.edu
/heritagecenter/5369.asp, accessed November 27, 2023.

Cruz, Lauro. Mary Ellen Curtin, Austin, TX, November 4, 2003.

Curtis, Anna. Mary Ellen Curtin, Houston, TX, April 14, 1999.

Davis, Algenita Scott. July 19, 2006, University of Houston Oral History Project, https://
digital.lib.uh.edu/collection/houhistory, accessed November 27, 2023.

Eckhardt, Nadine. Mary Ellen Curtin, Austin, TX, November 3, 2003.

Elliott, Bill. Mary Ellen Curtin, Houston, TX, July 17, 2009.

Farenthold, Frances "Sissy." Mary Ellen Curtin, Houston, TX, March 25, 2001.

Graves, Curtis. Mary Ellen Curtin, Atlanta, GA, September 13, 2003.

Hall, Robert E. "Bob." Mary Ellen Curtin, Houston, TX, March 26, 2001.

Hamilton, Lee. Mary Ellen Curtin, Woodrow Wilson Center, Washington, DC, October 17,
2007.

Harrison, Cecile. Mary Ellen Curtin, Houston, TX, April 13, 2004 and November 6, 2003.

Hooey, Myrtlene. Mary Ellen Curtin, Houston, TX, July 16, 2009.

Horn, Don. Mary Ellen Curtin, Houston, TX, March 30, 2001.

Jefferson, Andrew. Mary Ellen Curtin, Houston, TX, March 27, 2001.

Johnson, Jake. Mary Ellen Curtin, telephone interview, April 19, 2004.

Jones, Elaine. (A2016.151), interviewed by Juliana Richardson, March 6, 2007, History-
Makers Digital Archives, accessed November 27, 2023.

Jordan, Barbara. Ronald E. Marcello, University of North Texas Oral History Collection,
July 7, 1970, OH 0113, Willis Library, UNT Special Collections, Denton, TX.

Jordan, Barbara. Julian Bond, "Southern Regional Council Interview with Barbara Jordan,"
Texas State Senate CSR Series, Organizations, General, 1967–1972, Barbara Jordan
Archives, Texas Southern University, Houston, TX.

Jordan, Barbara. Paul Duke, *Washington Straight Talk*, March 3, 1975, American Archive of
Public Broadcasting, https://americanarchive.org/catalog/cpb-aacip-512-ms3jw87z64,
accessed November 27, 2023.

Jordan, Barbara. Barbara Walters, "The Barbara Walters Special," ABC, televised April 6, 1977.

Jordan, Barbara. *Dick Cavett Show,* February 15, 1979.

Jordan, Barbara. Deborah Barrow, March 22, 1983, Austin, TX. Transcript in author's
possession.

Jordan, Barbara. Roland C. Hayes, March 28, 1984, LBJ Library Oral Histories, LBJ Pres-
idential Library, https://discoverlbj.org/item/oh-jordanb-19840328-1-84-89, accessed
November 27, 2023.

King, Otis. Mary Ellen Curtin, Houston, TX, July 21, 2009.

Lawson, Rev. William. Mary Ellen Curtin, Houston, TX, March 30, 2001.

Martin, Susan. Mary Ellen Curtin, skype interview, January 3, 2020.

Mauzy, Oscar. E. Dale Odum, University of North Texas Oral History Collection, November 3, 1967, OH 0016, Willis Library, UNT Special Collections, Denton, TX.

Mauzy, Oscar. E. Dale Odum, University of North Texas Oral History Collection, July 25, 1968, OH 0030, Willis Library, UNT Special Collections, Denton, TX.

Mauzy, Oscar. Ronald E. Marcello, University of North Texas Oral History Collection, June 25, 1969, OH 0037, Willis Library, UNT Special Collections, Denton, TX.

Mauzy, Oscar. Ronald E. Marcello, University of North Texas Oral History Collection, December 1, 1969, OH 0041, Willis Library, UNT Special Collections, Denton, TX.

Mauzy, Oscar. Ronald E. Marcello, University of North Texas Oral History Collection, June 23, 1971, OH 0081, Willis Library, UNT Special Collections, Denton, TX.

Maverick, Maury Jr. Chandler Davidson, 1975, Texas Politics Research Collection, Fondren Library, Rice University, https://hdl.handle.net/1911/93698 accessed November 27, 2023.

Mease, Quentin. Mary Ellen Curtin, Houston, TX, April 2, 2001.

Myers, Rufus "Bud". Mary Ellen Curtin, telephone interview, May 19, 2017.

Peavy, Honorable John W., Jr. (A2016.130), interviewed by Larry Crowe, December 2, 2016, HistoryMakers Digital Archive, accessed November 27, 2023.

Perry, Wilhelmina E. (formerly Jones). Mary Ellen Curtin, telephone interview, July 23, 2009.

Punch, Nellye Joyce. Mary Ellen Curtin, telephone interview, April 14, 1999.

Scarbrough, Sara. Mary Ellen Curtin, Houston, TX, July 24, 2009.

Schwartz, A.R. "Babe."Mary Ellen Curtin, Austin, TX, November 5, 2003.

Schwartz, A.R. "Babe." Robert Calvert, University of North Texas Oral History Collection, November 27, 1967, OH 0017, Willis Library, UNT Special Collections, Denton, TX.

Schwartz, A.R. "Babe." Ronald E. Marcello, University of North Texas Oral History Collection, May 6, 1970, OH 0060, Willis Library, UNT Special Collections, Denton, TX.

Schwartz, A.R. "Babe." Ronald E. Marcello, University of North Texas Oral History Collection, November 9, 1971, OH 0187, Willis Library, UNT Special Collections, Denton, TX

Sherman, Max and William P. Hobby. Mary Ellen Curtin, London, UK, October 6, 2003.

Steelman, Alan. Mary Ellen Curtin, Washington, DC, August 18, 2010.

Stokes, Louis. Mary Ellen Curtin, Washington, DC, May 2, 2008.

Talisman, Mark. Mary Ellen Curtin, Washington, DC, January 9, 2008 and Bethesda, MD, May 11, 2017.

Wasserman, Oscar. Mary Ellen Curtin, telephone interview, July 20, 2011.

Wilkins, Roger. *Eyes on the Prize II*, October 17, 1988, http://digital.wustl.edu/cgi/t/text/text-idx?c–cop;cc=eop;rgn=main;view=text;idno=wil5427.0886.174, accessed November 27, 2023.

Wilson, Charles. James Riddlesperger, University of North Texas Oral History Collection, January 1, 1972, OH 0216, Willis Library, UNT Special Collections, Denton, TX

Digital Sources

Coddington, Ron. Caricature of Barbara Jordan for Tribune News Service, January 1, 1994, https://www.gettyimages.com/detail/news-photo/ron-coddington-caricature-of-barbara-jordan-news-photo/168789573, accessed November 27, 2023.

Dase, Amy E. "Hell Hole on the Brazos: A Historic Resources Study of Central State Farm" (2004), https://int.nyt.com/data/documenthelper/151-hell-hole-on-the-brazos/f39a6d5be573318f1fa3/optimized/full.pdf, accessed November 27, 2023.

"The Education of an Able-Bodied Ally," November13, 2006, http://disabilityally.blogspot.com/2006/11/marble-ceiling.html, accessed November 27, 2023.

Hearon, Shelby, and Eleanor Holmes Norton, CSPAN, 2001. https://www.c-span.org/video/?165001-4/impact-representative-barbara-jordan, accessed November 27, 2023.

Jordan, Barbara. Online Archive of selected papers and photographs from the Barbara Jordan Papers at Texas Southern University. Portal to Texas History, https://texashistory.unt.edu, accessed, December 2, 2023.

Jordan, Barbara. Governor For a Day slideshow. Images and audio from Jordan's Governor for a Day celebration, June 10, 1972, https://www.youtube.com/watch?v=q48GcP8GJaw, accessed November 27, 2023.

Jordan Barbara. Governor for a Day, Virtual Exhibit, https://www.tsu.edu/academics/library/pdf/governor-for-a-day-virtual-exhibit.pdf, accessed December 3, 2023.

Jordan, Barbara. Keynote Address, National Women's Conference, Houston, November 1977, https://texashistory.unt.edu/ark:/67531/metapth611534/m1/5/, accessed November 27, 2023.

Funeral for Rep. Barbara Jordan, January 20, 1996, https://www.c-span.org/video/?69467-1/barbara-jordan-funeral, accessed November 27, 2023.

Meek, Miki. "Where Have You Gone Barbara Jordan? Our Nation Turns Its Lonely Eyes to You." *This American Life*, episode 665, January 11, 2019, of. https://www.thisamericanlife.org/665/transcriptA, accessed November 27, 2023.

NAACP Records, Manuscript Division, Library of Congress (089.00.00), Memorandum Courtesy of the NAACP, Digital ID no. na0089p1, //www.loc.gov/exhibits/naacp/world-war-ii-and-the-post-war-years.html, accessed November 27, 2023.

Schaeffer, Katherine. "The Changing Face of Congress in 8 Charts." Pew Research Center, February 7, 2023, https://www.pewresearch.org/fact-tank/2023/02/07/the-changing-face-of-congress/, accessed March 22, 2023.

Texas Handbook online. https://tshaonline.org/handbook/online/articles/fpawp, accessed November 27, 2023.

U.S. Government Documents

Equal Rights Amendment Extension, Hearings Before the Subcommittee on Civil and Constitutional Rights, House Comm. On the Judiciary, 95th Cong. 1st and 2nd sessions, serial no. 41, Day 2, Testimony of Barbara Jordan, Tuesday, May 18, 1978, 236-242

Hearings Before the Committee on Rules, U.S. House of Representatives, HR 6674, HR 5727, and HR 6219, May 14, 1975, (Washington DC: Reynolds Reporting Associates), Stenographic Transcript of Hearing.

Hearings before the Subcommittee on Monopolies and Commercial Law, 95th Cong. 1st sess. 1977, Testimony of Griffin Bell, September 27, 1977, 88.

Hearings before the Subcommittee on Civil and Constitutional Rights of the Committee on the Judiciary, House of Representatives, 94th Congress, First session, on Extension of the Voting Rights Act, "Testimony of Hon. Barbara Jordan." serial no.1, part 1, 79.

Hearings Before the Subcommittee on Crime, House Comm. on the Judiciary, 94th Cong., 2nd Session, on the Law Enforcement Assistance Administration, "Testimony of Hon. Barbara Jordan," serial no. 42, Part 1, 442–449.

Nomination of Gerald R. Ford to be Vice President of the United States, Days 1 and 2, Hearings Before the Committee on the Judiciary, 93rd Cong. 1st Session, serial no 16, "Testimony of Gerald Ford."

Nomination of Nelson A. Rockefeller to be the Vice President of the United States, Hearings Before the Committee on the Judiciary, House of Representatives, 93rd Congress, 2nd Session, serial no. 45.

The Voting Rights Act: Ten Years After, A Report of the United States Commission on Civil Rights (Washington DC: 1975).

US Bureau of Statistics. "Internal Commerce: Cotton Trade of the United States and the World's Cotton Supply and Trade." Washington, DC: United States Department of the Treasuries, Bureau of Statistics, 1900.

Ancestry.com

United States Census

1900 US Census (Twelfth Census)
1910 US Census (Thirteenth Census)
1920 US Census (Fourteenth Census)
1940 US Census (Sixteenth Census)

City Directories

Houston, City Directory, 1905.
Houston, City Directory 1911.
Houston, City Directory, 1915.
Houston, City Directory, 1918.

Privately Published Records

"History of the Good Hope Baptist Church." Souvenir Program, 1945, Good Hope Missionary Baptist Church, Houston, Texas.

Jackson. A. W. *A Sure Foundation: A Sketch of Negro Life in Texas.* Houston: Privately published, A. W. Jackson, 3304 Holman Avenue, circa 1940. Houston Public Library, Digitized Archives.

The Red Book of Houston: A Compendium of Social, Professional, Religious, Educational, and Industrial Interests of Houston's Colored Population (Houston: Sotex Publishing Co., 1915), https://archive.org/details/redbookofhouston00sote/page/n5/mode/2up, accessed November 22, 2023.

Dissertations, Master's Theses, and Unpublished Research

Banks, Melvin James. "The Pursuit of Equality: The Movement for First Class Citizenship among Negroes in Texas, 1920–1950." DSS, Syracuse University, 1962.

Collier, Eleanor Rust. "The Boston University School of Law, 1872–1960." Unpublished paper, Pappas Law Library, Boston University School of Laws, Boston, Massachusetts, 1960.

Davidson, Chandler. "Negro Politics and the Rise of the Civil Rights Movement in Houston, Texas." PhD diss, Princeton University, 1968.

Gillette, Michael. "The NAACP in Texas, 1937–1957." PhD diss., University of Texas at Austin, 1984.

Harrison, Cecile. "The Human Side of Black Political Experience." PhD diss., University of Texas at Austin, 1977.

Horowitz, Linda Diane. "Transforming Appearance into Rhetorical Argument: Rhetorical Criticism of Public Speeches of Barbara Jordan, Lucy Parsons, and Angela Y. Davis." PhD diss., Northwestern University, 1998.

Justice, Blair. "An Inquiry into Negro Identity and a Methodology for Investigating Potential Racial Violence." PhD diss., Rice University, May 1966.

Laine, Alice Kathryn. "An In-Depth Study of Black Political Leadership in Houston, Texas." PhD diss., University of Texas at Austin, 1978.

Levengood, Paul Alejandro. "For the Duration and Beyond: World War Two and the Creation of Modern Houston, Texas." PhD diss., Rice University, February 1999.

Montes, Rebecca. "Working for American Rights: Black, White, and Mexican American Dockworkers during the Great Depression." PhD diss., University of Texas, Austin, 2005.

Perry, Wilhelmina Elaine Jones. "The Urban Negro with Special Reference to the Universalism-Particularism Pattern Variable." PhD diss., University of Texas, Austin, Department of Sociology, 1967.

SoRelle, James. "'The Darker Side of "Heaven': The Black Community in Houston, Texas, 1917–1945." PhD diss., Kent State University, 1980.

Wilson, John Ralph. "Origins: The Houston NAACP, 1915–1918." Master's thesis, Department of History, University of Houston, 2005.

Legal Cases

Graves v. Barnes, 343 F. Supp. 704 (1972).

Kilgarlin v. Martin, 252 F. Supp. 404 (S.D. Texas, 1966).

Smith v Allwright, 321 US 649 (1944).

South Carolina v. Katzenbach, 383 U.S. 301 (1966).

White v. Regester, 412 U.S. 755 (1973).

INDEX

ableism, 332, 339–40, 348–49. *See also* health

Abzug, Bella, 314, 315

affirmative action, 263, 264–65, 266–67, 272

AFL-CIO, 118, 131, 159, 264–65

Albert, Carl, 217–18, 219, 229, 240, 291–92

Alcock, Bob: Jordan's health, 238, 320; Jordan's pragmatism, 260–61; Nixon's impeachment, 246, 247, 248, 249; Voting Rights Act, 261, 274; working congressional system, 281

Ali, Muhammad, 2, 145

ambition: Black Houston validating, 204; characterized as self-aggrandizement, 206; love of winning, 124–25, 201; mixed reactions to, 209; positive force for justice, 210; striving to please father, 199; used to criticize Jordan, 267, 298–99, 300–302, 331; voter's lauding, 305

American Friends Service Committee (AFSC), 113–14, 126

Appenzellar, Anne, 164, 410n7

Apple, R. W., 294–95, 297

Armstrong, Bob, 170–71

Ashe, Arthur, 202–3

Badillo, Herman, 270, 271, 277

Bailey, Louise, 90–91

Baker v. Carr, 130, 337

Baldwin, James, 85, 128

Ball, Eddie, 104–5, 131–32

Baraka, Amiri, 9, 147, 148–50, 227

Barbara Jordan: A Self-Portrait (autobiography), 307–8, 309–10, 331–32. *See also* Hearon, Shelby

Barnes, Ben, 172, 174, 177, 178, 181–82, 193

Barrow, Deborah J., 325, 327

Belafonte, Harry, 149

Bell, Griffin, 302, 324–29

Bethune, Mary McLeod, 17, 94, 224–25

Black Baptist church: Baptist Covenant, 94; motherhood ideals, 30–31, 32, 33; as political space, 61–63, 190–91; Women's Convention, 30–31; women's roles, 17, 30, 46–47. *See also* Good Hope Missionary Baptist Church

Black motherhood, 30–32, 33, 98, 99. *See also* Black women; gender roles and relations; racism; sexism

Black political power: Democratic Party and, 6–9, 258, 266; protecting Black lives, 59; white primary and, 58–59. *See also* Black power; Black voters; voting rights

Black politicians: Baraka's dismissal of, 149–50; criticizing Black activists, 140; Democratic Party and, 213–14, 226–27, 228, 357–59; as effective legislators, 203, 227–28; gender as point of fissure, 203, 208–9, 222–23; increase during 1980s, 356; new political agenda, 147; pigeonholing of, 213; as race leaders, 146–47; record of service, 203–4; undermined at National Black Political Convention, 149–50. *See also* Black women politicians; Congressional Black Caucus; *individual politicians*

Black power: 1972 election, 215; appeal of, 141, 143–44, 145; Black Panthers, 145–46; Black politicians denouncing, 140; vs civil rights, 129–30; Jordan and, 129, 140, 144–46, 150; as speech theme, 143–44

Black voters: coalition politics, 117; outreach to, 104, 105, 106, 163; Texas campaigns, 112, 121, 134–35, 136, 137, 186–89; voting power, 63, 100, 112, 119, 192–93. *See also* block workers; disenfranchisement; voting rights; Voting Rights Act; white primary

Black women: Black Baptist churches, 17, 30, 46–47; Black women journalists, 148, 224, 255, 266, 269, 312, 317–18; civil rights movement and opportunities for, 207; Jordan's feminism and, 225; as leaders, 17–19, 100, 203; motherhood, 30–32, 33, 98, 99; political activism, 100, 101; white supremacy catering

ACKNOWLEDGMENTS

Writing this book has been a privilege, a humbling experience, and the journey of a lifetime. Researching Barbara Jordan took me to places I had never been before and introduced me to inspiring individuals I otherwise would never have known or studied. I learned so much and appreciated it all. I can only thank a fraction of the people who helped, but I will do my best.

My family was my rock. Adam Fairclough and our children, Arthur and Jennifer, have my love and gratitude. They understood the necessity of my solo sojourns to Texas and—much later—the many hours spent writing never-ending drafts. Adam shared his amazing organizational skills as well as his tremendous knowledge. When all was finally ready, he offered advice and changes to the manuscript that made everything better. My siblings, my in-laws, and my cousins have cheered me on for many years. To all of them I can only say thank you for your patience, your love, and your faith in me and in this project. My late parents, John T. and Jane G. Curtin, would have been very proud—not to mention pleased and relieved—to finally see this book in print. Their love, humor, nonmaterialistic values, and simple respect for their children's pursuits and endeavors gave me the best family and upbringing anyone could ever have. I owe them everything, and I miss them deeply.

I began this study "a long, long time ago," during one of my first teaching jobs at what is now Texas State University in San Marcos, Texas. Kenneth Margerison, Victoria Bynum, Gregg Andrews, Mary Brennan, Frank de la Teja, Gene Bourgeouis, Rebecca Czuchry, Bev Tomek, and Gina Sconza offered early encouragement and enthusiasm. I appreciate their collegiality and friendship. I especially thank Cynthia Brandimarte, a friend and an exceedingly accomplished and knowledgeable public historian of Texas. Cindy supported this project from its small beginnings. She gave me the courage to take on Texas.

I wish to thank my colleagues in the Department of History at the University of Essex in the UK and the Arts and Humanities Research Board for offering

financial support and encouragement for this research. The companionship of Alison Rowlands, Erna von der Walde, Manuel Barcia, Catherine Crawford, Joan Davies, Steve Smith, James English, Rochelle Rowe, Jo Palmer-Tweed, Nigel and Carol Rigby, and Eva-Lynn Jagoe sustained me in a new country. Dr. Jeremy Krikler—an inspiring colleague and scholar—possesses infectious optimism. He made me believe, and laugh, when the going got tough. Tony Swift remains a true friend. The late Hugh Brogan's monumental biography of Alexis de Tocqueville inspired me; his personal collection of back issues of the *Texas Observer* were invaluable. Belinda Waterman and Lisa Willis patiently educated me on the ins and outs of a new system. The late Jane Corby was a brilliant and talented administrator whose efficiency, warmth, and intelligence represented the best of everything British. I miss her.

This project received an incalculable boost with the support of the Woodrow Wilson Center in Washington, DC, which awarded me a residential fellowship in 2007–2008. Dorothy Fort, then an undergraduate at American University, provided excellent research support. The Wilson Center also introduced me to a constellation of new friends and colleagues who have sustained my work. Since 2008 our "Redline" writing group of Wilson Fellows, including Matthew Dallek, Robyn Muncy, Flip Strum, and M. T. Connolly, has been going strong. It is no exaggeration to state that without the emotional support and fearless leadership of Dr. Strum of the Redline group, I would never have made it over the line. I am indeed a fortunate scholar to have such a wonderful crew to lean on, and I thank them profusely.

While living in Washington, DC, I have had the privilege of teaching at George Washington University—where Tyler Anbinder and Eric Arnesen offered support and advice—and American University (AU), where I now direct the program in American studies in the Department of Critical Race, Gender, and Culture Studies (CRGC). I feel so fortunate to have secured a teaching position at AU and to have had the privilege to contribute to both the Department of History and the CRGC. Eric Lohr, Pam Nadell, Max Friedman, Mary Frances Giandrea, April Shelford, Theresa Runstedtler, Lisa Leff, Martin Oliver, and Sybil Roberts—I cannot thank you enough for making me feel at home and appreciated. I continue to learn from my brilliant colleagues in American studies, Tanja Aho, Elizabeth Rule, Christina Juhasz-Wood, Kat Vester, and Tyler Christensen. Their courses and innovative scholarship on disability, bodies, sexuality, ethnicity, and gender helped me make sense of many aspects

of my research, and I thank them. CRGC Chair Eileen Findlay offered crucial advice and comments when I needed them most, and I thank her for being such a relentless advocate for me and our department. Daily support from Monica Morin and Allison Johntry in our CRGC office kept me grounded, and I thank them both. Grants from the Mellon Foundation allowed short spurts of research in Boston and Keuka College.

Many other friends and fellow scholars have offered support and advice. Talitha LeFlouria and Sheila Bernard's pathbreaking research on incarceration inspires me every day; their friendship over the years helped me persevere and I thank them. The support of Joan Browning and the late Connie Curry, along with their stories and insights from the civil rights movement, meant the world. I am grateful for the friendship of Ellen Leander, Kevin Morison, Michelle Engert, Terry Stewart, and the "Eaton moms" here in DC, and a special thanks goes out to Marianne Eby for her kind wisdom. For the last six years, I have learned about leadership from Ms. Andrea Thomas, President and CEO of the United Planning Organization (UPO), Washington, DC's oldest anti-poverty nonprofit and community action agency. I thank her for her work and for her genuine interest in this project. Old friends Anne Schwartz, Ravinatha Aryasinha, Kathleen Murray, Kate Starr, Allison Williams, Eric Stenclik, and Jonathan Rubin made a point of staying in touch, and I thank them for caring.

My cohort from graduate school at Duke University went on to change the world with prizewinning scholarship, academic work, and activism—along the way, they also changed me, and I feel immensely grateful. Anthropologists Molly Mullin, Joanne Passaro, and the late Carol Smith opened up new vistas. Historians Ann Farnsworth, Richard Stoller, Miriam Shadis, Elise Goldwasser, Mandakini Arora, Nick Biddle, Andy Neather, Herman Bennett, Jennifer Morgan, and Tim Tyson all inspired me with their brilliance and offered unswerving encouragement, laughter, and support. No one is more generous with his time than Bill Chafe, whose insights, scholarship, and kindness continue on. I am deeply grateful to him. Anne Valk and the late Leslie Brown always had kind and encouraging words for me about this project, and I appreciate their faith. Christina Greene and Kirsten Fischer have my unending gratitude. Both read and commented on the entire manuscript, offering brilliant insights, crucial edits, and practical suggestions, a true labor of love and friendship.

My interviewees deserve special acknowledgment. All took time from their busy lives to speak with me, a stranger and an outsider, not just about one

person—Barbara Jordan—but also about their own families and aspirations. Several took me back to the time of segregation. Their stories and experiences immeasurably enriched what I learned from books and sources. I cherished these meetings and encounters, and I thank them.

Archivists, librarians, and fellow researchers at the following institutions helped me enormously: the Barbara Jordan Archives at Texas Southern University; Houston Metropolitan Research Center; the Harry Ransom Center at the University of Texas at Austin; Good Hope Missionary Baptist Church; the Labor Archives at the University of Texas at Arlington; Southern Methodist University; University of Houston Archives; University of Wisconsin at Madison; University of Rochester; University of Virginia; Howard University; Boston University; Keuka College; the Gregory Center; the Oral History Collection at the University of Texas at Denton; Rice University; the Library of Congress; and the National Archives. The Clements Center of Southern Methodist University in Dallas provided a crucial summer grant, and Cindy Havens gave enormous assistance. As I began my research, legendary political scientist Chandler Davidson of Rice University shared the names of important individuals to interview, as well as enthusiasm, and I am thankful to have known him. I am grateful to the brilliant historian Merline Pitre of Texas Southern University who offered early support and insights and whose pathbreaking biography of NAACP leader Lulu White paved the way. Thomas G. Walker of Emory University cheerfully shared a Jordan interview, and I thank him. I also wish to acknowledge the amazing Mary Beth Rogers, a long-time Democratic party activist and writer who continues to offer insightful work on Texas politics. Rogers took on the monumental task of writing the first full-length biography of Barbara Jordan. Her book, *Barbara Jordan: American Hero*, provided an invaluable road map, and her interviews with individuals in Austin helped enormously.

Researching and interpreting this material took many years, and I often became overwhelmed and discouraged at what I thought was a failing endeavor. But at various points along the way, help came when it was least expected or even deserved. Once, while I rushed to return microfilm at Texas Southern University, a young woman working at the desk stopped our conversation, put her hand out, and asked God to bless me and this project. She reassured me of the importance of Barbara Jordan, and I thank her. I remain amazed and grateful for the support of the wonderful Janis Scott, a.k.a. the "Bus Lady" of Houston, who took me, a stranger, under her wing and provided laughter, invaluable

conversations, research suggestions, and companionship during a brief research trip to Houston. Her stories of her mother's work as a Jordan block worker confirmed I was on the right track. Shelby Hearon unexpectedly mailed a box of additional research materials to me, a treasure trove of research notes, documents, and correspondence with Nancy Earl. She encouraged this next iteration of Jordan's life, and I appreciate her generosity.

At various points over the years, several institutions extended invitations to give talks on Barbara Jordan, and I thank them profusely for those opportunities. Alex Byrd of Rice University sponsored an amazing conference, "Race and Place in Houston," which allowed me to develop ideas about Good Hope and Rev. Albert A. Lucas. He included me, and I am grateful for his support. I also wish to thank Rebecca Sharpless of Texas Christian University, Stephanie Cole of the University of Texas at Arlington, and Nancy Beck Young of the University of Houston for their kind invitations and enthusiasm for this project. I wish to thank Todd Moye, of the University of Texas at Denton, who always gave cheerful encouragement and facilitated my work with the invaluable Oral History archives housed at his institution. I wish to thank Max Krochmal, now of the University of New Orleans, who read and offered comments at an early stage. His crucial study, *Blue Texas*, established the significance of the "Democratic Coalition" in Texas and helped me enormously. During a crucial point in my research, Landon Storrs generously allowed me to stay at her Houston home—I thank her from the bottom of my heart! An Organization of American Historians session on women and politics organized by Dr. Kate Haulman helped to crystalize some of the arguments made here. Thank you Kate. I wish to thank Daniel Geary and Joe Ryan-Hume of Trinity College Dublin for inviting me to participate in their timely workshop reconsidering liberalism.

Bob Lockhart of the University of Pennsylvania Press poured hours of time and loads of care into this project. As I experienced his forbearance and listened to his careful analysis, I felt guided and optimistic. I thank him for the faith he showed in me and in this book. I am tremendously grateful to series editor and outstanding historian Keisha N. Blain. Keisha carefully read this manuscript several times and offered insightful, detailed suggestions and criticisms that sharpened everything and pushed me to think much harder about the big arguments as well as the quotidian details. Without her, this book would never have come to be, and I greatly appreciate her sharp insights, genuine interest, encouragement, and commitment to seeing things to the end. I also wish to

thank the outside readers at Penn Press who generously gave detailed suggestions for improvements. I hope I have rewarded their efforts.

This book is dedicated to the memory of three individuals who inspired me by their examples of selflessness, dedication to justice, and care for others. Zachary Schnitzer, who would have been my son-in-law, was a young advocate for the homeless who had committed his life to social work. Zach demonstrated to me that small steps improved lives, and I miss his kind disposition, good cheer, and optimism. Larry Goodwyn—journalist, scholar, teacher, editor, activist, and intellectual provocateur—urged me to "give myself permission" to go beyond the expected and blaze new research trails in Texas. Barbara Jordan, he said, was "serious business," and I could not agree more. Raymond Gavins, my dissertation advisor, was the first African American to receive a PhD in history from the University of Virginia and the first Black historian in the Duke history department. Yet it was always apparent that his degree from Virginia Union University, a historically Black university founded in 1865, gave him the greatest pride and satisfaction. Professor Gavins introduced the caring ethos of HBCUs and deep knowledge of Black institutions and experiences to Duke University. His passion for and dedication to documenting and interpreting Black life in segregation lives on through his scholarship and his students. I remain forever in his debt.